A professional image editor's guide to the creative use of Photoshop for the Macintosh and PC

Martin Evening

AMSTERDAM • BOSTON • HEIDELBERG • LONDON • NEW YORK • OXFORD PARIS • SAN DIEGO • SAN FRANCISCO • SINGAPORE • SYDNEY • TOKYO Focal Press is an imprint of Elsevier

Focal Press is an imprint of Elsevier The Boulevard, Langford Lane, Kidlington, Oxford, OX5 1GB, UK 30 Corporate Drive, Suite 400, Burlington, MA 01803, USA

First published 2010

Copyright © 2010, Martin Evening. Published by Elsevier Ltd. All rights reserved.

The right of Martin Evening to be identified as the author of this work has been asserted in accordance with the Copyright, Designs and Patents Act 1988

No part of this publication may be reproduced or transmitted in any form or by any means, electronic or mechanical, including photocopying, recording, or any information storage and retrieval system, without permission in writing from the publisher. Details on how to seek permission, further information about the Publisher's permissions policies and our arrangement with organizations such as the Copyright Clearance Center and the Copyright Licensing Agency, can be found at our website: www.elsevier.com/permissions

This book and the individual contributions contained in it are protected under copyright by the Publisher (other than as may be noted herein).

British Library Cataloguing in Publication Data

Evening, Martin.

Adobe Photoshop CS5 for photographers : a professional image editor's guide to the creative use of Photoshop for the Macintosh and PC.

1. Adobe Photoshop. 2. Photography—Digital techniques. I. Title 006.6'86-dc22

Library of Congress Control Number: 2010924449

ISBN: 978-0-2405-2200-5

For information on all Focal Press publications visit our website at focalpress.com

Printed and bound in the United States of America

10 11 12 11 10 9 8 7 6 5 4 3 2 1

Trademarks/Registered Trademarks Brand names mentioned in this book are protected by their respective trademarks and are acknowledged.

1

1 Photoshop Fundamentals

An overview of the book chapters	2
How to use this book	4
Photoshop installation	7
The Photoshop interface	8
Tabbed document windows	0
Managing document windows	
Image document window details14	4
Dynamic zoom views14	
Title bar proxy icons (Macintosh)1	
Rulers, Guides & Grid	
'Snap to' behavior	
Pixel Grid view1	
Application bar	
The Photoshop panels	
Panel arrangements and docking2	
Panel positions remembered in workspaces2	
Customizing the menu options	
Customizing the keyboard shortcuts2	
Task-based workspaces	
Working with a dual display setup20	
Adobe™ Configurator 2 application	
Extensions panels	
Photoshop CS5 Tools panel	
Options bar	
Tool Presets panel	
Selection tools	
Color Range	
Modifier keys	
Painting tools	
On-the-fly brush changes	
On-screen brush adjustments	
Brush panel	
Brush panel options	
Pressure sensitive control	
Brush tool presets	
Mixer brush	
Bristle shapes	

Tools for filling	48
Tools for drawing	49
Image editing tools	
Working with Layers	52
Automating Photoshop	53
Move tool	54
Layer selection using the move tool	54
Navigation and information tools	56
Flick panning	57
Bird's-eye view	57
Rotate view tool	58
Notes tool	59
Screen view modes	
Preset Manager	
History	
The History panel	
History settings and memory usage	
History brush	
Use of history versus undo	
Snapshots	
Non-linear history	
When files won't open	
Save often	
Using Save As to save images	
File formats	
Photoshop native file format	
Smart PSD files	
PSB (Large Document Format)	
TIFF (Tagged Image File Format)	
Pixel order	
Byte order	
Save Image Pyramid	
TIFF compression options	
Flattened TIFFs	
Photoshop PDF	
PDF security	
Adobe Bridge CS5	
The Bridge interface	
Custom workspaces in Bridge Slideshows	
Mini Bridge	
Opening files from Bridge	
Opening photos from Bridge via Camera Raw	
What's new in Camera Raw 6.0	
Easter eggs	
Lucio, egge	01

2 Configuring Photoshop 85	
What you will need	
Macintosh	
Windows	
The ideal computer setup	
Choosing a display	
Wide dynamic range displays	
Video cards	
Display calibration and profiling	
Calibration hardware	
The calibration/profiling procedure	
White point	
Gamma	
Luminance	
Device calibration and measurement	
The profiling process	
Do you want good color or just OK color?	
Color management settings	
Synchronizing the Color Settings	
Extras	
Backing up your image data	
Photoshop preferences	100
General preferences	
Interface preferences	
File Handling preferences	105
File compatibility	
Camera Raw preferences	
TIFF and PSD options	
Recent File list	
Performance preferences	
Memory usage	
32-bit and 64-bit RAM limits	
History & Cache	
Scratch disks	
Scratch disk performance	
Interface connection	
Hard drive speed	
RAID setups	
RAID 0 (striping)	
RAID 1 (mirroring)	
Internal RAID	
External RAID	
GPU settings	
Cursors preferences	118

Transparency & Gamut
Color Picker gamut warning 119
Units & Rulers
Guides, Grid & Slices
Plug-ins
Type preferences

3 Camera Raw Image Processing 125

Camera Raw advantages
The new Camera Raw workflow 126
Does the order matter?
Raw capture
JPEG capture
Editing JPEGs and TIFFs in Camera Raw129
Alternative Raw processors
A basic Camera Raw/Photoshop workflow131
A Lightroom/Photoshop workflow
Camera Raw support
DNG compatibility
Getting raw images into Photoshop
Image ingestion
Importing images via Photo Downloader
Tethered shoot imports 143
Tethered shooting via Canon EOS Utility
Importing images via other programs147
Lightroom imports
Importing photos via Lightroom 3 149
Basic Camera Raw image editing 152
Working with Bridge and Camera Raw 152
General controls for single file opening 154
Full size window view
General controls for multiple file opening 156
Opening raw files as Smart Objects
Saving photos from Camera Raw
The histogram display163
Image browsing via Camera Raw164
Camera Raw preferences
Auto tone corrections
Camera-specific default settings 167
Camera Raw cache size 169
DNG file handling169
Sharing XMP metadata 170
Opening TIFF and JPEGs 170
Process Versions
Camera Raw cropping and straightening 171

Basic panel controls174White balance174Using the white balance tool175The tone adjustment controls176Exposure176Recovery176Blacks176Fill Light177Suggested order for the basic adjustments177Basic image adjustment procedure178Preserving the highlight detail180When to clip the shadows183Shadow levels after a conversion184Digital exposure186Brightness188Contrast191Negative Clarity191Negative Clarity191Negative Clarity192Vibrance and Saturation194Tone Curve panel200Recovering out-of-gamut colors201Adjusting the Hue and Saturation202Lens Corrections panel204Defringe205Lens Vignetting control208Post Crop Vignetting control208Post Crop Vignetting control208Post Crop Vignetting control208Post Crop Vignetting control208Lens Carera' look settings' profiles211Adding Grain effects214Camera Calibration panel216Carera Calibration panel216Carera Yook settings' profiles217Custom camera profile calibrations218DNG Profile Editor220Spot removal tool224Spot removal tool224Spot remova	How to crop and straighten	172
Using the white balance tool175The tone adjustment controls176Exposure176Recovery176Blacks176Fill Light177Suggested order for the basic adjustments177Basic image adjustment procedure178Preserving the highlight detail180When to clip the shadows183Shadow levels after a conversion184Digital exposure186Brightness188Contrast190Clarity191Negative Clarity192Vibrance and Saturation194Host Curve panel196Correcting a high contrast image198HSL/Grayscale panel200Recovering out-of-gamut colors201Adjusting the Hue and Saturation202Lens Vignetting control208Post Crop Vignetting style options210Highlights slider216Camera Calibration panel216New Camera Raw profiles217Custom camera profile calibrations218DNG Profile Editor220Spot removal tool226Red eye removal226		
Using the white balance tool175The tone adjustment controls176Exposure176Recovery176Blacks176Fill Light177Suggested order for the basic adjustments177Basic image adjustment procedure178Preserving the highlight detail180When to clip the shadows183Shadow levels after a conversion184Digital exposure186Brightness188Contrast190Clarity191Negative Clarity192Vibrance and Saturation194Host Curve panel196Correcting a high contrast image198HSL/Grayscale panel200Recovering out-of-gamut colors201Adjusting the Hue and Saturation202Lens Vignetting control208Post Crop Vignetting style options210Highlights slider216Camera Calibration panel216New Camera Raw profiles217Custom camera profile calibrations218DNG Profile Editor220Spot removal tool226Red eye removal226	White balance	174
The tone adjustment controls 176 Exposure 176 Recovery 176 Blacks 176 Fill Light 177 Suggested order for the basic adjustments 177 Basic image adjustment procedure 178 Preserving the highlight detail 180 When to clip the shadows 183 Shadow levels after a conversion 184 Digital exposure 186 Brightness 188 Contrast 190 Clarity 191 Negative Clarity 192 Vibrance and Saturation 194 Tone Curve panel 196 Correcting a high contrast image 198 HSL/Grayscale panel 200 Recovering out-of-gamut colors 201 Adjusting the Hue and Saturation 202 Lens Vignetting control 208 Post Crop Vignetting control 208 Post Crop Vignetting control 208 Post Crop Vignetting style options 210 Highlights slider 216 New Camera Raw profiles 216		
Exposure176Recovery176Blacks176Fill Light177Suggested order for the basic adjustments177Basic image adjustment procedure178Preserving the highlight detail180When to clip the highlight detail180How to clip the shadows183Shadow levels after a conversion184Digital exposure186Brightness188Contrast190Clarity191Negative Clarity192Vibrance and Saturation194Tone Curve panel196Correcting a high contrast image198HSL/Grayscale panel200Recovering out-of-gamut colors201Adjusting the Hue and Saturation202Lens Corrections panel204Defringe205Lens Vignetting control208Post Crop Vignetting control208Post Crop Vignetting control208Post Crop Vignetting style options210Highlights slider212Adding Grain effects214Camera Calibration panel216New Camera Raw profiles216New Camera Raw profiles217Custom camera profile calibrations218DNG Profile Editor220Spot removal tool224Synchronized spotting with Camera Raw225Red eve removal226		
Recovery176Blacks176Fill Light177Suggested order for the basic adjustments177Basic image adjustment procedure178Preserving the highlight detail180When to clip the highlight detail180When to clip the highlights183Shadow levels after a conversion184Digital exposure186Brightness188Contrast190Clarity191Negative Clarity.192Vibrance and Saturation194Tone Curve panel196Correcting a high contrast image198HSL/Grayscale panel200Recovering out-of-gamut colors201Adjusting the Hue and Saturation202Lens Corrections panel204Defringe205Lens Vignetting control208Post Crop Vignetting control208Post Crop Vignetting control208Post Crop Vignetting style options210Highlights slider212Adding Grain effects214Carmera Calibration panel216New Carmera Raw profiles217Custom carmera profile calibrations218DNG Profile Editor220Spot removal tool224Synchronized spotting with Carmera Raw225Red eve removal226	,	
Blacks176Fill Light177Suggested order for the basic adjustments177Basic image adjustment procedure178Preserving the highlight detail180When to clip the highlight detail182How to clip the shadows183Shadow levels after a conversion184Digital exposure186Brightness188Contrast190Clarity191Negative Clarity192Vibrance and Saturation194Tone Curve panel206Correcting a high contrast image196Correcting a high contrast image201Adjusting the Hue and Saturation202Lens Corrections panel204Defringe205Lens Corrections panel206Effects panel208Post Crop Vignetting control208Post Crop Vignetting control208Post Crop Vignetting control208Post Crop Vignetting style options210Adding Grain effects214Camera Calibration panel216New Camera Raw profiles216Camera Calibration panel216New Camera Raw profiles216Camera Toxik et dirgs' profiles217Custom camera profile calibrations218DNG Profile Editor220Spot removal tool224Synchronized spotting with Camera Raw225Red eye removal226		
Fill Light177Suggested order for the basic adjustments177Basic image adjustment procedure178Preserving the highlight detail180When to clip the highlights182How to clip the shadows183Shadow levels after a conversion184Digital exposure186Brightness188Contrast190Clarity191Negative Clarity192Vibrance and Saturation194Tone Curve panel196Correcting a high contrast image198HSL/Grayscale panel200Recovering out-of-gamut colors201Adjusting the Hue and Saturation202Lens Corrections panel206Effects panel208Post Crop Vignetting control208Post Crop Vignetting control208Post Crop Vignetting style options210Highlights slider212Adding Grain effects214Camera Calibration panel216New Camera Raw profiles216Camera Calibration panel216Camera Took settings' profiles217Custom camera profile calibrations218DNG Profile Editor220Spot removal tool224Synchronized spotting with Camera Raw225Red eye removal226		
Suggested order for the basic adjustments177Basic image adjustment procedure178Preserving the highlight detail180When to clip the highlights182How to clip the shadows183Shadow levels after a conversion184Digital exposure186Brightness188Contrast190Clarity191Negative Clarity192Vibrance and Saturation194Tone Curve panel196Correcting a high contrast image198HSL/Grayscale panel.200Recovering out-of-gamut colors201Adjusting the Hue and Saturation202Lens Vignetting control206Effects panel206Effects panel208Post Crop Vignetting control208Post Crop Vignetting control208Post Crop Vignetting style options210Highlights slider212Adding Grain effects214Camera Calibration panel216New Camera Raw profiles216Camera Took settings' profiles216Camera Took settings' profiles216Camera Tool collors226Red eye removal225Red eye removal226		
Basic image adjustment procedure178Preserving the highlight detail180When to clip the highlights182How to clip the shadows183Shadow levels after a conversion184Digital exposure186Brightness188Contrast190Clarity191Negative Clarity192Vibrance and Saturation194Tone Curve panel196Correcting a high contrast image198HSL/Grayscale panel200Recovering out-of-gamut colors201Adjusting the Hue and Saturation202Lens Corrections panel204Defringe205Lens Vignetting control206Effects panel208Post Crop Vignetting control208Post Crop Vignetting style options210Highlights slider212Adding Grain effects214Camera Calibration panel216New Camera Raw profiles217Custom camera profile calibrations218DNG Profile Editor220Spot removal tool224Synchronized spotting with Camera Raw225Red eye removal226		
Preserving the highlight detail180When to clip the highlights182How to clip the shadows183Shadow levels after a conversion184Digital exposure186Brightness188Contrast190Clarity191Negative Clarity192Vibrance and Saturation194Tone Curve panel196Correcting a high contrast image198HSL/Grayscale panel200Recovering out-of-gamut colors201Adjusting the Hue and Saturation202Lens Corrections panel204Defringe205Lens Vignetting control208Post Crop Vignetting control208Post Crop Vignetting style options210Highlights slider212Adding Grain effects214Carmera Calibration panel216New Camera Raw profiles216Carmera 'look settings' profiles217Custom camera profile calibrations218DNG Profile Editor220Spot removal tool224Synchronized spotting with Carmera Raw225Red eye removal226		
When to clip the highlights182How to clip the shadows183Shadow levels after a conversion184Digital exposure186Brightness188Contrast190Clarity191Negative Clarity192Vibrance and Saturation194Tone Curve panel196Correcting a high contrast image198HSL/Grayscale panel200Recovering out-of-gamut colors201Adjusting the Hue and Saturation202Lens Corrections panel204Defringe205Lens Vignetting control208Post Crop Vignetting control208Post Crop Vignetting style options210Highlights slider212Ading Grain effects216Camera Calibration panel216New Camera Raw profiles217Custom camera profile calibrations218DNG Profile Editor220Spot removal tool224Synchronized spotting with Camera Raw225Red eye removal226		
How to clip the shadows183Shadow levels after a conversion184Digital exposure186Brightness188Contrast190Clarity191Negative Clarity192Vibrance and Saturation194Tone Curve panel196Correcting a high contrast image198HSL/Grayscale panel200Recovering out-of-gamut colors201Adjusting the Hue and Saturation202Lens Corrections panel204Defringe205Lens Vignetting control206Effects panel208Post Crop Vignetting control208Post Crop Vignetting style options210Highlights slider212Adding Grain effects214Camera Calibration panel216New Camera Raw profiles216Camera 'look settings' profiles216Dus Profile Editor220Spot removal tool224Synchronized spotting with Camera Raw225Red eye removal226		
Shadow levels after a conversion184Digital exposure.186Brightness188Contrast190Clarity191Negative Clarity.192Vibrance and Saturation194Tone Curve panel196Correcting a high contrast image198HSL/Grayscale panel.200Recovering out-of-gamut colors.201Adjusting the Hue and Saturation.202Lens Corrections panel204Defringe205Lens Vignetting control.206Effects panel.208Post Crop Vignetting control.208Post Crop Vignetting style options.210Highlights slider212Adding Grain effects.214Carnera Calibration panel.216New Carnera Raw profiles217Custom carnera profile calibrations.218DNG Profile Editor220Spot removal tool.224Synchronized spotting with Carnera Raw.225Red eye removal.226		
Digital exposure.186Brightness.188Contrast.190Clarity.191Negative Clarity.192Vibrance and Saturation194Tone Curve panel196Correcting a high contrast image198HSL/Grayscale panel.200Recovering out-of-gamut colors.201Adjusting the Hue and Saturation.202Lens Corrections panel204Defringe205Lens Vignetting control.206Effects panel.208Post Crop Vignetting control.208Post Crop Vignetting style options.210Highlights slider212Adding Grain effects.214Carnera Calibration panel.216New Carnera Raw profiles217Custom carnera profile calibrations.218DNG Profile Editor220Spot removal tool.224Synchronized spotting with Carnera Raw225Red eye removal.226		
Brightness188Contrast190Clarity191Negative Clarity192Vibrance and Saturation194Tone Curve panel196Correcting a high contrast image198HSL/Grayscale panel200Recovering out-of-gamut colors201Adjusting the Hue and Saturation202Lens Corrections panel204Defringe205Lens Vignetting control206Effects panel208Post Crop Vignetting control208Post Crop Vignetting style options210Highlights slider212Adding Grain effects214Camera Calibration panel216New Camera Raw profiles217Custom camera profile calibrations218DNG Profile Editor220Spot removal tool224Synchronized spotting with Camera Raw225Red eye removal226		
Contrast190Clarity191Negative Clarity192Vibrance and Saturation194Tone Curve panel196Correcting a high contrast image198HSL/Grayscale panel200Recovering out-of-gamut colors201Adjusting the Hue and Saturation202Lens Corrections panel204Defringe205Lens Vignetting control206Effects panel208Post Crop Vignetting control208Post Crop Vignetting style options210Highlights slider212Adding Grain effects214Camera Calibration panel216New Camera Raw profiles217Custom camera profile calibrations218DNG Profile Editor220Spot removal tool224Synchronized spotting with Camera Raw225Red eye removal226		
Clarity191Negative Clarity192Vibrance and Saturation194Tone Curve panel196Correcting a high contrast image198HSL/Grayscale panel200Recovering out-of-gamut colors201Adjusting the Hue and Saturation202Lens Corrections panel204Defringe205Lens Vignetting control206Effects panel208Post Crop Vignetting control208Post Crop Vignetting style options210Highlights slider212Adding Grain effects214Camera Calibration panel216Camera libration panel216Camera rolok settings' profiles217Custom camera profile calibrations218DNG Profile Editor220Spot removal tool224Synchronized spotting with Camera Raw225Red eye removal226		
Negative Clarity192Vibrance and Saturation194Tone Curve panel196Correcting a high contrast image198HSL/Grayscale panel200Recovering out-of-gamut colors201Adjusting the Hue and Saturation202Lens Corrections panel204Defringe205Lens Vignetting control206Effects panel208Post Crop Vignetting control208Post Crop Vignetting style options210Highlights slider212Adding Grain effects214Camera Calibration panel216New Camera Raw profiles217Custom camera profile calibrations218DNG Profile Editor220Spot removal tool224Synchronized spotting with Camera Raw225Red eye removal226		
Vibrance and Saturation194Tone Curve panel196Correcting a high contrast image198HSL/Grayscale panel200Recovering out-of-gamut colors201Adjusting the Hue and Saturation202Lens Corrections panel204Defringe205Lens Vignetting control206Effects panel208Post Crop Vignetting control208Post Crop Vignetting style options210Highlights slider212Adding Grain effects214Camera Calibration panel216Camera 'look settings' profiles217Custom camera profile calibrations218DNG Profile Editor220Spot removal tool224Synchronized spotting with Camera Raw225Red eye removal226		
Tone Curve panel196Correcting a high contrast image198HSL/Grayscale panel200Recovering out-of-gamut colors201Adjusting the Hue and Saturation202Lens Corrections panel204Defringe205Lens Vignetting control206Effects panel208Post Crop Vignetting control208Post Crop Vignetting style options210Highlights slider212Adding Grain effects214Camera Calibration panel216Camera 'look settings' profiles217Custom camera profile calibrations218DNG Profile Editor220Spot removal tool224Synchronized spotting with Camera Raw225Red eye removal226		
Correcting a high contrast image198HSL/Grayscale panel200Recovering out-of-gamut colors201Adjusting the Hue and Saturation202Lens Corrections panel204Defringe205Lens Vignetting control206Effects panel208Post Crop Vignetting control208Post Crop Vignetting style options210Highlights slider212Adding Grain effects214Camera Calibration panel216New Camera Raw profiles217Custom camera profile calibrations218DNG Profile Editor220Spot removal tool224Synchronized spotting with Camera Raw225Red eye removal226		
HSL/Grayscale panel.200Recovering out-of-gamut colors.201Adjusting the Hue and Saturation.202Lens Corrections panel.204Defringe205Lens Vignetting control.206Effects panel.208Post Crop Vignetting control.208Post Crop Vignetting style options.210Highlights slider212Adding Grain effects.214Camera Calibration panel.216New Camera Raw profiles217Custom camera profile calibrations.218DNG Profile Editor220Spot removal tool.224Synchronized spotting with Camera Raw225Red eye removal.226		
Recovering out-of-gamut colors.201Adjusting the Hue and Saturation.202Lens Corrections panel204Defringe205Lens Vignetting control.206Effects panel.208Post Crop Vignetting control.208Post Crop Vignetting style options.210Highlights slider212Adding Grain effects.214Camera Calibration panel.216New Camera Raw profiles216Camera 'look settings' profiles.217Custom camera profile calibrations.218DNG Profile Editor220Spot removal tool224Synchronized spotting with Camera Raw225Red eye removal.226		
Adjusting the Hue and Saturation.202Lens Corrections panel204Defringe205Lens Vignetting control206Effects panel208Post Crop Vignetting control208Post Crop Vignetting style options210Highlights slider212Adding Grain effects214Camera Calibration panel216New Camera Raw profiles216Camera 'look settings' profiles217Custom camera profile calibrations218DNG Profile Editor220Spot removal tool224Synchronized spotting with Camera Raw225Red eye removal226		
Lens Corrections panel204Defringe205Lens Vignetting control206Effects panel208Post Crop Vignetting control208Post Crop Vignetting style options210Highlights slider212Adding Grain effects214Camera Calibration panel216New Camera Raw profiles217Custom camera profile calibrations218DNG Profile Editor220Spot removal tool224Synchronized spotting with Camera Raw225Red eye removal226		
Defringe205Lens Vignetting control206Effects panel208Post Crop Vignetting control208Post Crop Vignetting style options210Highlights slider212Adding Grain effects214Camera Calibration panel216New Camera Raw profiles217Custom camera profile calibrations218DNG Profile Editor220Spot removal tool224Synchronized spotting with Camera Raw225Red eye removal226		
Lens Vignetting control206Effects panel208Post Crop Vignetting control208Post Crop Vignetting style options210Highlights slider212Adding Grain effects214Camera Calibration panel216New Camera Raw profiles216Camera 'look settings' profiles217Custom camera profile calibrations218DNG Profile Editor220Spot removal tool224Synchronized spotting with Camera Raw225Red eye removal226		
Effects panel.208Post Crop Vignetting control.208Post Crop Vignetting style options.210Highlights slider212Adding Grain effects.214Camera Calibration panel.216New Camera Raw profiles216Camera 'look settings' profiles217Custom camera profile calibrations.218DNG Profile Editor220Spot removal tool.224Synchronized spotting with Camera Raw225Red eye removal.226		
Post Crop Vignetting control.208Post Crop Vignetting style options.210Highlights slider212Adding Grain effects.214Camera Calibration panel.216New Camera Raw profiles216Camera 'look settings' profiles217Custom camera profile calibrations.218DNG Profile Editor220Spot removal tool.224Synchronized spotting with Camera Raw225Red eye removal.226	Lens Vignetting control	206
Post Crop Vignetting style options 210 Highlights slider 212 Adding Grain effects 214 Camera Calibration panel 216 New Camera Raw profiles 216 Camera 'look settings' profiles 217 Custom camera profile calibrations 218 DNG Profile Editor 220 Spot removal tool 224 Synchronized spotting with Camera Raw 225 Red eye removal 226		
Highlights slider 212 Adding Grain effects 214 Camera Calibration panel 216 New Camera Raw profiles 216 Camera 'look settings' profiles 217 Custom camera profile calibrations 218 DNG Profile Editor 220 Spot removal tool 224 Synchronized spotting with Camera Raw 225 Red eye removal 226		
Adding Grain effects. 214 Camera Calibration panel. 216 New Camera Raw profiles 216 Camera 'look settings' profiles 217 Custom camera profile calibrations. 218 DNG Profile Editor 220 Spot removal tool 224 Synchronized spotting with Camera Raw 225 Red eye removal 226		
Camera Calibration panel		
New Camera Raw profiles 216 Camera 'look settings' profiles 217 Custom camera profile calibrations 218 DNG Profile Editor 220 Spot removal tool 224 Synchronized spotting with Camera Raw 225 Red eye removal 226	Adding Grain effects	214
Camera 'look settings' profiles	Camera Calibration panel	216
Custom camera profile calibrations	New Camera Raw profiles	216
DNG Profile Editor	Camera 'look settings' profiles	217
DNG Profile Editor	Custom camera profile calibrations	218
Spot removal tool		
Synchronized spotting with Camera Raw		
Red eye removal		
	Localized adjustments	
Adjustment brush		
Initial Adjustment brush options		

Brush settings	
Adding a new brush effect	
Editing brush adjustments	
Previewing the brush stroke areas	
Auto masking	
Hand-coloring in Color mode	
Graduated filter tool	
Angled gradients	
Adding clarity and contrast	
Camera Raw settings menu	
Export settings to XMP	
Update DNG previews	
Load Settings Save Settings	
Camera Raw defaults	
Presets panel	
Saving and applying presets	
Copying and synchronizing settings	
Working with Snapshots	
DNG file format	
The DNG solution	
DNG compatibility	
DNG Converter	

4 Sharpening and Noise Reduction 251

Vhen to sharpen	2
One-step sharpening	2
Capture sharpening	2
Capture sharpening for scanned images	3
Process Versions	4
Improvements to Camera Raw sharpening	4
Sample sharpening image25	7
Detail panel	7
Sharpening defaults	8
The sharpening effect sliders	8
Amount slider	9
Radius slider	0
The suppression controls	1
Detail slider	1
Interpreting the grayscale previews	3
Radius and Detail grayscale preview	3
Masking slider	4
Masking slider example	
Some real world sharpening examples	6
Sharpening portrait images	6

Sharpening landscape images	
Sharpening a fine-detailed image	
How to save sharpening settings as presets	
Capture sharpening roundup	
Selective sharpening in Camera Raw	
Negative sharpening	
Extending the sharpening limits	
Noise removal in Camera Raw	
Detail panel noise reduction sliders	
Localized sharpening in Photoshop	
Smart Sharpen filter	
Basic Smart Sharpen mode	
Advanced Smart Sharpen mode	
Removing Motion Blur	
Creating a depth of field brush	
Removing noise in Photoshop	
Third-party noise reduction	
Reduce Noise filter	
Advanced mode noise reduction	
JPEG noise removal	
Saving the Reduce Noise settings	

5 Image Editing Essentials

Pixels versus vectors
Photoshop as a vector program
Image resolution terminology
ppi: pixels per inch
lpi: lines per inch
dpi: dots per inch
Desktop printer resolution
Choosing the right pixel resolution for print
The optimum number of pixels
Repro considerations
The relationship between ppi and lpi
But we always use 300 ppi!
Creating a new document
Altering the image size
Image interpolation
Nearest Neighbor
Bilinear interpolation
Bicubic interpolation
The advanced bicubic interpolation methods
Bicubic Smoother
Bicubic Sharper

Step interpolation		300
The image histogram		302
Basic Levels editing and the histogra	am	305
8-bit versus 16-bit image editin	g	307
Comparing 8-bit with 16-bit edi	ting	308
16-bit and color space selectior	1	309
The RGB edit space and color gamut		310
Direct image adjustments		312
Adjustment layers and Adjustme	ents panel	312
Adding an adjustment layer pro-	cedure	313
	fields	
Levels adjustments		316
Analyzing the histogram		316
	ntrast	
Curves adjustment layers		320
Saving and loading curves		324
Output levels adjustments		326
Using Curves to improve contra	ıst	328
Curves luminance and saturatio	.n	328
Luminosity and Color blending	modes 3	330
	urve	
	ail	
	ırves	
	/es	
	0	

Multiple adjustment layers	. 357
Adjustment layer masks	
Masks panel controls	
Editing a mask using the Masks panel	
Color Range adjustment layer masking	
Blend mode adjustments	
Cropping	
Selection-based cropping	
Perspective cropping	
Image rotation	
Canvas size	
Content-aware scaling	
How to protect skin tones	
How to remove objects from a scene	
Big data	

6 Black and White 377

Converting color to black and white	
The dumb black and white conversions	
Smarter black and white conversions	
Black & White adjustment presets	
Split color toning with Color Balance	
Curves adjustment split toning	
Camera Raw black and white conversions	
Pros and cons of the Camera Raw approach	
Camera Raw Split Toning panel	
Camera Raw color image split toning	
Black and white output	

7 Extending the Dynamic Range 391

Multiple raw conversions	
Place-A-Matic script	
High dynamic range imaging	
HDR essentials	
Fuji Super CCD	397
Alternative approaches	
Bracketed exposures	
Displaying deep-bit color	
Capturing a complete scenic tonal range	400
HDR shooting tips	401
HDR file formats	
How to fool Merge to HDR	402
Merge to HDR Pro	404
-	

Tone mapping HDR images 406
Local Adaptation
Removing ghosts
How to avoid the 'HDR' look
Manual tone mapping

8 Image Retouching 415

Basic cloning methods
Clone stamp tool
Clone stamp brush settings 416
Healing brush
Choosing an appropriate alignment mode 420
Clone Source panel and clone overlays 420
Upside-down cloning
Better healing edges
Spot healing brush
Clone and healing sample options 427
Patch tool
Spot healing in Content-Aware mode 430
Content-Aware filling
Alternative history brush spotting technique
Flat field calibration
Portrait retouching
Beauty retouching
Liquify
Liquify tool controls
Reconstructions
Mask options
View options
Saving the mesh
Straightening a fringe with Liquify

9 Layers, Selections and Masking 451

Selections and channels	452
Selections	
Quick Mask mode	
Creating an image selection	
Modifying selections	456
Alpha channels	
Adding to an image selection	
Selections, alpha channels and masks	
Anti-aliasing	
Feathering	

Layers	461
Layer basics	
Image layers	
Shape layers	462
Text layers	
Adjustment layers	
Layers panel controls	
Layer styles	
Adding layer masks	
Viewing in Mask or Rubylith mode	
Removing a layer mask	
Adding an empty image layer mask	
Creating a layer mask from Transparency	
Masks panel	
Refine Edge command	
View modes	
Edge detection	
Adjust Edge section	
Refine Edge output	
Working with the quick selection tool	
Combining a quick selection with Refine Edge	
Color Range masking	
Layer blending modes	
Advanced Blending options	
Knockout options	
Blend Interior effects	
Creating panoramas with Photomerge	
Depth of field blending	
Working with multiple layers	
Color coding layers	
Layer group management	
Nested group layer compatibility	
Managing layers in a group	
Clipping masks	
Ways to create a clipping mask Masking layers within a group	
Clipping layers and adjustment layers	
Layer linking	
Selecting all layers	
Layer selection using the move tool	
Layer mask linking	
Layer locking	
Lock Transparent Pixels	
Lock Image Pixels	
Lock Layer Position	
Lock All	509

Transform commands	510
Repeat Transforms5	
Numeric Transforms	513
Transforming selections and paths5	513
Transforms and alignment5	514
Using transforms to create a kaleidoscope pattern	515
Warp transforms	518
Puppet Warp5	520
Pin rotation5	521
Pin depth5	522
Multiple pin selection5	522
Smart Objects	522
Drag and drop a document to a layer5	526
Smart Objects	528
Photoshop paths	532
Path modes	533
Drawing paths with the pen tool5	533
Pen path drawing tutorial5	533
Pen tool shortcuts summary5	535
Rubber Band mode5	535
Vector masks5	536
Isolating an object from the background5	537

10 Essential Filters for Photo Editing 539

Filter essentials	
16-bit filters	
Blur filters	
Adding a Radial Blur or Spin Blur to a photo	540
Average Blur	
Gaussian Blur	
Motion Blur	
Surface Blur	
Box Blur	
Shape Blur	
Lens Blur	546
Depth of field effects	
Applying Lens Blur to a composite image	548
Smart Filters	550
Applying Smart Filters to pixel layers	551
Ragged borders with the Refine Edge adjustment	556
Lens Corrections	558
Custom lens corrections	558
Selecting the most appropriate profiles	562
Adobe Lens Profile Creator	563
Interpolating between lens profiles	563
Lens Correction profiles and Auto-Align	
Filter Gallery	566

11 Image Management 567	
The Bridge solution	568
Configuring the General preferences	
Launching Bridge	
Rotating the thumbnails and preview	
Arranging the Bridge contents	
Customizing the panels and content area	
Bridge workspace examples	
Working with multiple windows	
Slideshow mode	
Thumbnail settings	
Cache management	
Advanced and miscellaneous preferences	
One-click previews	
Deleting contents	
Stacking images	
Auto-stacking	
Bridge panels	
Folders panel	
Favorites panel	
Preview panel	
Review mode	
Managing images in Bridge	
Image rating and labeling	
Sorting images in Bridge	
Filter panel	
Metadata panel	
Image metadata	
File Info metadata	
IPTC Extensions	
Other types of metadata	
Future uses of metadata	
Edit history log	
Hidden metadata	
Keywording	
Keywords panel	
Image searches	
Collections panel	
Smart collections	
Output to Web and PDF	
Web output	
Output gallery styles	
Output gallery settings	
Output preferences	
PDF Output	
The PDF Output panels	

PDF Output options	
Bridge automation	
Renaming images	
Renaming schemes	
Undoing a Batch Rename	
Applying Camera Raw settings	
Mini Bridge	
The Mini Bridge interface	
View options	
Filter and Sort order menus	
Navigator and Preview pods	
Searching images	

631

12 Color Management

Reducing the opportunities for error	
Working with Grayscale	
Advanced Color Settings	
Conversion options and rendering intents	
Black Point Compensation	
Use Dither (8-bit per channel images)	
Blend RGB colors using gamma	663
Custom RGB and workspace gamma	
RGB to CMYK	
CMYK setup	
Creating a custom CMYK setting	665
Ink Colors	666
Dot gain	667
Gray Component Replacement (GCR)	668
Black generation	668
Undercolor Addition (UCA)	669
Undercolor Removal (UCR)	669
Choosing a suitable RGB workspace	669
Rendering intents	670
Perceptual	670
Saturation (Graphics)	670
Relative Colorimetric	
Absolute Colorimetric	671
Fine-tuning the CMYK end points	674
CMYK to CMYK	676
Lab color	676
Info panel	677
Keeping it simple	678

13 Print Output 679

Print sharpening	
Judge the print, not the display	
High Pass filter edge sharpening technique	
Soft proof before printing	
Making a print	
Photoshop Print dialog	
Printer selection and print scaling	
Output settings	
Color Management	
Proof Setup in the Print dialog	
Proof print or aim print?	
Configuring the Print Settings (Mac and PC)	
Saving the print presets	
Print output scripting	
Ensuring your prints are centered	
Custom print profiles	

14 Output for the Web 699	
Sending images over the Internet	
Email attachments	
Uploading to a server	
FTP software	
File formats for the Web	
JPEG	
Choosing the right compression type	
TIFF compression for FTP transfer	
GIF	
PNG (Portable Network Graphics)	
Save for Web & Devices	
Web browser previews	710
Optimize image settings	710
Save options	711
GIF Save for Web & Devices	712
Zoomify™ Export	

15 Automating Photoshop 715

Working with actions	716
Playing an action	716
Recording actions	717
Troubleshooting actions	719
Limitations when recording actions	
Actions only record changed settings	720
Background layers and bit depth	
Action recording tips	721
Inserting menu items	
Batch processing actions	722
Creating a droplet	
Image Processor	
Scripting	
Script Event Manager	
Automated plug-ins	
Crop and Straighten Photos	
Fit Image	
-	

Index

728

Remote profiling for RGB printers	
Consultancy services	
Pixel Genius PhotoKit plug-in	
www.pixelgenius.com	

Foreword

by John Nack

s Photoshop for photographers? And do photographers really need Photoshop? A couple of years ago, these questions might have seemed a little silly. No professional photographer would seriously consider foregoing Photoshop's image-manipulation power, whether to apply subtle color corrections or to make radical image alterations. Now, however, new workflowcentric applications like Adobe Lightroom have come into the market. With these tools focusing purely on photographers' needs, how relevant does Photoshop remain?

To me the situation is a bit like what I've found with photography: yes, you can start out and sometimes get by with a limited set of equipment, but the more you know, the more you value specialized tools that can make the difference in critical scenarios. It's quite true that many photographers will spend more time in Bridge/ Camera Raw, Lightroom, and the like and less in Photoshop proper, but for many demanding shots, only the full power of Photoshop will do.

Martin is in a unique position to explain the new balance of power – when to use a raw converter/image manager, and when to use the imaging tools in Photoshop itself. Throughout his long and intimate relationship with both the Photoshop and Lightroom development teams, he's helped shape today's digital imaging world.

You know the old cliché 'Those who can't do, teach,' right? No one says that about Martin Evening. He earns his knowledge the hard way, making a living as a highly regarded fashion photographer. His workflow advice comes not from theory, but from the practice of keeping a business in motion.

I came to work on Photoshop only after logging many years earning a living with the product day in and day out, and I greatly value the insights that come only from those who really practice their craft. Martin is one of the best examples of those teacher-practitioners. I could not have been more honored than to have stood beside him as we were both inducted into the Photoshop Hall of Fame in 2008.

When it's all said and done, tools – whether hardware or software – are just tools, and it's your ideas and images that matter. You'll find that Martin knows both sides of the equation and never lets the techniques distract from the vision. I think you'll find his perspective and experience invaluable.

John Nack Principal Product Manager, Adobe Photoshop Adobe Systems

Introduction

hen I first started using Photoshop, it was a much simpler program to get to grips with compared with what we see today. Since then Adobe Photoshop CS5 has evolved to supply photographers with all the tools they need. My aim is to provide you with a working photographer's perspective of what Photoshop CS5 can do and how to make the most effective use of the program.

One of the biggest problems writing a book about Photoshop is that while new features are always being added, Adobe rarely removes anything from the program. Hence, Photoshop has got bigger and more complex over the 14 years or so I have been writing this series of books. When it has come to updating each edition this has begged the question, 'what should I add and what should I take out?' This edition of the book is actually slightly bigger than previous versions, but is completely focused on the essential information you need to know when working with Photoshop, Camera Raw and Bridge, plus all that's new in Photoshop CS5 for photographers. Consequently, you'll find a lot of the content goes into greater detail than before on subjects such as Camera Raw editing and high dynamic range imaging.

I work mostly as a professional studio photographer, running a busy photographic business close to the heart of London. On the days when I am not shooting or working on production, I use that time to study Photoshop, present seminars and write my books. This is one of the reasons why this series of Photoshop books has become so successful, because I am a working photographer first and an author second. Although I have had the benefit of a close involvement with the people who make the Adobe Photoshop program, I make no grandiose claims to have written the best book ever on the subject. Like you, I too have had to learn all this stuff from scratch. I simply write from personal experience and aim to offer a detailed book on the subject of digital photography and Photoshop.

This title was initially aimed at intermediate to advanced users, but it soon became apparent that all sorts of people were enjoying the book. As a result of this, I have over the years adapted the content to satisfy the requirements of a broad readership. I still provide good solid professional-level advice, but at the same time I try not to assume too much prior knowledge, and make sure everything is explained as clearly and simply as possible. The techniques shown here are based on the knowledge I have gained from working alongside some of the greatest Photoshop experts in the industry – people such as Jeff Schewe and the late Bruce Fraser, who I regard as true Photoshop masters. I have drawn on this information to provide you with the latest thinking of how to use Photoshop to its full advantage. So rather than me just tell you 'this is what you should do, because that's the way I do it', you will find frequent references to how the program works and reasons why certain approaches or methods are better than others. These discussions are often accompanied by diagrams and step-by-step tutorials that will help improve your understanding of the Photoshop CS5 program.

We have recently seen some of the greatest changes ever in the history of photography, and for many photographers it has been a real challenge to keep up with all these latest developments. My philosophy is to find out which tools in Photoshop allow you to work as efficiently and as non-destructively as possible, plus take into account any recent changes in the program that require you to use Photoshop differently. Although there are lots of ways to approach using Photoshop, you'll generally find with Photoshop CS5 that the best tools for the job are often the simplest. Hopefully, the key points you will learn from this book are that Camera Raw is the ideal, initial editing environment for all raw images (and sometimes non-raw images too). Then, once an image has been optimized in Camera Raw, you can use Photoshop to carry out the fine-tuned corrections, or more complex retouching. There is much to cover in this book, but you should find that the way the chapters have been ordered, plus the accompanying content on the DVD, will help you understand how to get the most out of Photoshop CS5.

Book and DVD contents

The DVD contents are presented in the form of a Photoshop CS5 Help Guide. Just load the DVD into your computer, or, for improved performance, I suggest you copy the entire contents across to your hard drive. Next, double-click on the welcome.htm file to launch the Photoshop CS5 Help Guide into your web browser. The Help Guide contains movie versions of some of the step-by-step techniques shown in this book and you may also be interested to know that many of the images used in the movies are also provided on the DVD, along with the relevant extracts from the book in a PDF format. The Help Guide is designed to run on Macintosh and PC systems, and only requires you to install Flash and QuickTime on your computer in order to view them correctly. If you should experience any problems running the disc, please always refer to the FAQ section on the disc for guidance on how to configure your computer for optimum viewing. There is also a website that's been set up to promote this book where you will also find a Help page should you encounter problems running the movies from the DVD. Go to: www.photoshopforphotographers.com. I am always happy to respond to readers emails, but if you email me regarding a problem with the DVD or a missing disc, you will recieve a standard reply that directs you to the above website link.

This book can be considered an 'essentials' guide to working with Photoshop CS5. If you want to take your Photoshop skills to the next level you might like to take a look at *Adobe Photoshop CS5 for Photographers: The Ultimate Workshop*, which I am coauthoring with Jeff Schewe. In this book we will mainly be concentrating on various advanced Photoshop tricks and techniques. It will be like attending the ultimate training workshop on Photoshop CS5. You can expect this title to be released a few months after the publication of this book.

Acknowledgments

I must first thank Andrea Bruno of Adobe Europe for initially suggesting to me that I write a book about Photoshop aimed at photographers; plus none of this would have got started without the founding work of Adam Woolfitt and Mike Laye who helped establish the Digital Imaging Group (DIG) forum for UK digital photographers. Thank you to everyone at Focal Press: David Albon, Ben Denne, Kate Iannotti, Lisa Jones and Graham Smith. The production of this book was done with the help of Rod Wynne-Powell, who tech edited the final manuscript and provided me with technical advice, Matt Wreford who helped with the separations, Soo Hamilton for the proofreading and Jason Simmons, who designed the original book layout template. I must give a special mention to fellow Photoshop alpha tester Jeff Schewe for all his guidance and help over the years (and wife Becky), not to mention the other members of the 'pixel mafia': Katrin Eismann, Seth Resnick, Andrew Rodney and Bruce Fraser, who sadly passed away in December of 2006.

Thank you also to the following clients, companies and individuals: Adobe Systems Inc., Neil Barstow, Russell Brown, Steve Caplin, Ansell Cizic, Kevin Connor, Harriet Cotterill, Eric Chan, Chris Cox, Eylure, Claire Garner, Greg Gorman, Mark Hamburg, Peter Hince, Thomas Holm, Ed Horwich, Carol Johnson, Julieanne Kost, Peter Krogh, Ian Lyons, John Nack, Thomas Knoll, Bob Marchant, Marc Pawliger, Pixl, Herb Paynter, Red or Dead Ltd, Eric Richmond, Addy Roff, Martin Soan, Gwyn Weisberg, Russell Williams, *What Digital Camera* and X-Rite. Thank you to the models, Courtney Hooper, Natasha De Ruyter, Alex Kordek and Sundal who featured in this book, plus my assistant Harry Dutton (who also stars as a model in a few shots).

Lastly, thanks to all my friends and family, my wife Camilla who has been so supportive over the last year, and especially my late mother for all her love and encouragement.

Martin Evening, March 2010

Chapter 1

Photoshop Fundamentals

et's begin by looking at some of the essentials of working with Photoshop, such as how to install the program, the Photoshop interface and what all the different tools and panels do, as well as introducing the Bridge and Camera Raw interfaces.

A lot of big changes were made to the Photoshop CS4 interface and this has continued to be the case with Photoshop CS5. Even if you are already quite familiar with how Photoshop works, or have read previous editions of this book, I would still recommend you begin by reading through this chapter first to learn about some of the things that are new in this latest version of Photoshop. You can also use this chapter as a reference as you work through the remainder of the book.

An overview of the book chapters

Chapter 1: Photoshop fundamentals

The chapter you are reading introduces the Photoshop interface and some of the main program features such as the tools, panels, layers, Camera Raw, plus Bridge image browsing. This provides a general introduction to how Photoshop works.

Chapter 2: Configuring Photoshop

This chapter contains a guide to all the Photoshop preference panels, how to optimize your computer system, how much RAM is required, and what sort of accessories you are likely to find useful.

Chapter 3: Camera Raw image processing

If you shoot digitally, you will most likely want to shoot in raw mode. This chapter provides essential reading on how to prepare digital raw images before opening them in Photoshop and includes information on all the new Camera Raw 6.0 features.

Chapter 4: Sharpening and noise reduction

This chapter is about how to use the sharpening and noise reduction sliders in Camera Raw to apply capture sharpening to your photographs, before they are edited in Photoshop. I also discuss some of the sharpening and noise reduction tools and techniques that are available in Photoshop.

Chapter 5: Image editing essentials

This chapter focuses on the general Photoshop image editing controls such as how to set the levels to improve the tone contrast and how to adjust the colors. The foundation skills taught in this chapter are essential learning whether or not you choose to process your photos in Camera Raw first.

Chapter 6: Black and white

This chapter shows you how to create optimum black and white conversions from a color original and how to reproduce traditional darkroom techniques.

Chapter 7: Extending the dynamic range

In this chapter I discuss high dynamic range image editing and other techniques that can be used to extend the dynamic range of images that have been captured digitally. This should be of particular interest now that the Merge to HDR tools in Photoshop CS5 have been significantly improved.

Chapter 8: Image retouching

This chapter shows various retouching techniques and strategies for removing blemishes and other objects from a photograph.

Chapter 9: Layers, selections and masking

This chapter focuses on the use of channels, layers, layer masks and paths and how these can be used to seamlessly mask different image elements. Also included is a section on working with the new improved Refine Edge command as well as a look at the new Puppet Warp feature in Photoshop CS5.

Chapter 10: Essential filters for photo editing

This chapter explores the Photoshop filters that are particularly relevant for photographic retouching work, such as Liquify and the Lens Correction filter.

Chapter 11: Image management

These days, photographers can end up having to process several hundred images from a single shoot. Good image management is all about helping you to keep track of your photos and find them when you need them. There is also a section in this chapter on working with the new Mini Bridge extension panel.

Chapter 12: Color management

We all need to be concerned about color management. It should be a simple matter of calibrating the monitor and selecting the correct color settings in Photoshop, but somehow life is never that easy. This chapter provides an intermediate level guide on how to manage your colors successfully.

Chapter 13: Print output

This chapter follows on from the previous one and shows you how to get your prints to match what you see on the display. I also discuss the importance of tailored output sharpening, demonstrating a sample print sharpening technique.

Chapter 14: Output for the Web

Alternatively, you may be interested in outputting your images for on-screen publication. This chapter covers preparing images for the Web and multimedia presentations.

Chapter 15: Automating Photoshop

This final chapter describes some of the ways you can work more efficiently in Photoshop and how to avoid repetitive tasks through the use of actions and other automation techniques.

Task-based workflow

In all the talk about what's new in Photoshop, you will most probably hear the term 'task-based workflow' being used. This partly refers to the way the Photoshop interface can be customized to suit the different ways individual users work with the program, as well as offering easier and more direct access to the image adjustments and adjustment preset settings. For example, if you are mainly interested in video editing work, you can select the 'Motion' workspace setting. This provides access to the Photoshop panels that are most important for video editing work. For general photographic retouching work you are better off selecting either the 'Essentials' or 'Photography' workspaces, as these workspace layouts allow you to access the more commonly used panels for Photoshop image editing. The other interesting feature is the way both the Mac and PC layouts can be contained in an application window, giving the added benefit of making the workspace layout choices more robust. This is because as you resize the application window, the panel, positions adjust to suit. Adjustment layers are applied via an Adjustments panel, which makes the adjustment editing process more direct. You can select an image adjustment to work with and guickly switch back and forth between editing the adjustment settings and working on the image. You also have direct access to all the different image adjustment presets that ship with Photoshop and can guickly experiment to see what happens when you choose different adjustment effects.

How to use this book

In writing this book I have tried not to assume too much prior Photoshop knowledge on the part of the reader. I have also structured the chapters in the book so that they follow a typical Photoshop workflow, starting with an introduction to the Photoshop interface through to the tasks of image management and print output. This is in many ways a personal guide and one that highlights the areas of Photoshop that I find most interesting, or at least those which I feel should be of most interest. It is not a complete comprehensive guide about everything that's in Photoshop, but it is one of the most thorough and established books out there; one that's especially designed for photographers.

As always, the guiding philosophy throughout this book is to provide you with the most up-to-date advice. Photoshop has changed quite a lot over the years, as has digital camera technology. As a result of this, as each new version of Photoshop comes out I have often found it necessary to revise many of the techniques and workflow steps that are described in the book. It is inevitable in a book like this that the author will want to put forward their own personal views on how you should or shouldn't do things. I am probably no different, but I would point out that the advice I give is based on over 16 years of experience in which I have worked extensively with the Photoshop engineering team at all stages of the program's development. Not only that, but I have also been fortunate enough to work closely with some of the leading Photoshop gurus such as Katrin Eismann, the late Bruce Fraser, Mac Holbert, Ian Lyons, Andrew Rodney, Seth Resnick, Jeff Schewe and Rod Wynne-Powell. The techniques I describe here have therefore evolved over a long period of time and the methods taught in this book reflect the most current expert thinking about Photoshop. What you will read here is a condensed version of that accumulated knowledge. I recognize that readers don't want to become bogged down with too much technical jargon, so I have aimed to keep the explanations simple and relevant to the kind of work most photographers do.

My approach to digital imaging is as follows. I aim to preserve all of the information that was captured in the original and wherever possible I prefer to work non-destructively. By doing this I can keep all my options open. In this book I recommend that you shoot in raw mode (where it is appropriate to do so) and make full use of the tools that are available in Camera Raw to prepare your images before you open them up in Photoshop. For example, the ideal time to carry out the capture sharpening is when you are working in Camera Raw. Therefore, I have placed the Capture sharpening chapter towards the beginning of the book. I recommend you use the wide gamut ProPhoto RGB workspace because this can help you to preserve more color detail through to print. I also suggest editing your images in 16-bits per channel so that you can preserve the maximum number of levels of tone information and keep your options open for whatever you might want to do to an image in the future. Later in this book I will also be showing you how to use adjustment layers and Smart Object layers to keep your pixel image settings fully editable.

As with the CS4 book, this version has been re-edited to put most of its emphasis on the Photoshop tools that are most essential to photographers as well as all that's new in Photoshop CS5. There is also a *Photoshop for Photographers Help Guide* on the DVD that accompanies this book, where you will find a lot of extra material with descriptions of all the tools and Photoshop panels. Just load the DVD into your computer, or for improved performance copy the contents across to your hard drive. Then double-click on the *welcome.htm* file to launch the DVD contents welcome page into your default web browser.

Figure 1.1 shows an example of the Tools and Panel page that's included in the Web-based DVD Help Guide. From there you can then visit the various sub-sections. For example, in the Tool Panels section you can click on a tool icon to be taken to a page that contains a complete, illustrated description of what each tool does. In the other sections, you'll find descriptions of the Photoshop panels, layer styles, plus a guide to all the keyboard shortcuts that are in Photoshop, Camera Raw and Bridge. There is also a whole chapter on digital capture and how digital cameras work, a chapter on sharpening scanned images in Photoshop, plus a copy of Chapter 12 on color management. These are available as PDF documents which can be read and printed out using Adobe Acrobat or Adobe Reader programs. You'll also find a number of Photoshop CS5 movie tutorials you can watch, as well as demo versions of some of the images that were used in this book.

Macintosh and PC keys

Throughout this book I refer to the keyboard modifier keys used on the Macintosh and PC computers. Where the keys used are the same on both platforms, such as the *Shift* key, these are printed in gray. Where the keys used are different on each system, I show the Macintosh keys in magenta and the PC equivalents in blue. So, if the shortcut used is Command (Mac) and Control (PC) this appears abbreviated in the text as: \mathfrak{B} and \mathfrak{ctrl} .

Figure 1.1 The *Photoshop for Photographers Help Guide* is on the DVD at the back of the book. You can click on one of the main tabs to select a topic, such as the Tools and Panels section shown here, where you can find out more about a particular tool or panel.

Photoshop fundamentals

Chapter 1

Photoshop installation

Installing Photoshop is as easy as installing any other application on your computer, but do make sure that your web browser and any other Adobe programs are closed prior to running the installation setup. After entering your serial number details, you will be asked to enter your Adobe ID or create a new Adobe ID account. This has to be done first in order to activate Photoshop. The reason for this is to limit unauthorized distribution of the program. Basically, the standard license entitles you to install Photoshop on up to two computers, such as a desktop and a laptop.

Adobe Photoshop activation limits

You can install Photoshop on any number of computers, but only a maximum of two installations can be active at any one time. To run Photoshop on more computers than this requires a deactivation and reactivation only rather than a complete uninstall and reinstall. There are added benefits to registering your product, as this entitles you to various reward goodies.

Adobe Photoshop CS5 4 Enter an Adobe ID Create an Adobe ID ter your software and set up access to Adobe CS Lis ting an Adobe ID registers your soft and sets up access to Adobe CS Live Need an Adobe ID? Already have an Adobe ID? ul Address (Adobe ID) SERIAL NUM Email (Adobe ID) ADOBE ID OPTIONS SKIP THIS STEP SKIP THIS STEP BACK Adobe Photoshop CS5 A **Install Options** ADOBE PHOTOSHOP CS CC3 M WELCOME SERIAL NUMBER OPTIONS Total install: 1.9 GE 4- 1.9 GB (171 5 GB AV BACK

Figure 1.2 The Photoshop installer procedure is identical on both Mac and PC systems. As you run through the installation process you will be asked to register the program by entering your Adobe ID or create a new Adobe ID account.

Macintosh default workspace

The Macintosh default workspace setting uses a classic layout where the panels appear floating on the desktop. If you go to the Window menu and select 'Application Frame', you can switch to the Application window layout shown in Figure 1.3.

The Photoshop interface

The Photoshop CS5 interface shares the same design features as all the other CS5 creative suite programs. Because there is now a greater level of interface design consistency between all the programs that make up the Creative Suite, this makes it easier to migrate from working in one CS5 program to another. You can also work with the Photoshop program as a single application window on both the Mac and PC platforms (Figures 1.3 and 1.4). This arrangement is more in keeping with the interface conventions for

Tools panel Options bar Application bar Mac OS menu

Tabbed window document Workspace options Photoshop panels

Figure 1.3 This shows the Photoshop CS5 Application Frame view for Mac OS X. To switch between the classic mode and the Application Frame workspace, go to the Window menu and select or deselect the Application Frame menu item.

Chapter 1

Figure 1.4 The Photoshop CS5 interface for the Windows OS, showing the default Essentials program workspace.

Windows, plus you also have the ability to open and work with Photoshop image documents as tabbed windows.

The Photoshop panels are held in placement zones with the Tools panel normally located on the left, the Options bar and Application bar running across the top and the other panels arranged on the right, where they can be docked in various ways to economize on the amount of screen space that's used yet still remain easily accessible. This default arrangement presents the panels in a docked mode, but over the following few pages we shall look at ways you can customize the Photoshop interface layout. For example, you can reduce the amount of space that's taken up by the panels by collapsing them into compact panel icons (see Figure 1.21).

OpenGL display performance

If the video card in your computer has OpenGL and you have 'Enable OpenGL Drawing' selected in the Photoshop Performance preferences, you can take advantage of the OpenGL features that Photoshop supports. For example, when OpenGL is enabled you will see smootherlooking images at all zoom display levels, plus you can temporarily zoom back out to fit to screen using the Bird's-Eye view (page 57), or use the rotate view tool to rotate the on-screen image display (see page 58).

New CS5 interface features

A number of things have been done to improve the overall user interface experience. The key changes are improved support for Windows 7 users. Those users who are working with a dual monitor setup will notice that new documents are opened on whichever display the current target document is on. Also, Mac OS X users will now see a 'Reveal in Finder' option in the document tab contextual menu for pre-existing (saved) images.

Tabbed document windows

Let's start by looking at the way document windows can be managed in Photoshop. The default preference setting forces all new documents to open as tabbed windows, where new image document windows appear nested in the tabbed document zone, just below the Options bar. In Figure 1.5 I have emphasized the tabbed document zone, where you can see there are currently four image documents open. This approach to managing image documents can make it easier to locate a specific image when you have several image documents open at once. This is because you can now select an open image by clicking on the relevant tab. Previously you often had to click and drag on the document title bars to move the various image windows out the way until you had located the image document you were after.

Of course, not everyone has welcomed tabbed document opening. If you find this annoying you can always deselect the 'Open Documents as Tabs' option in the Interface preferences (circled in Figure 1.6). This allows you to revert to the old behavior where new documents are opened as floating windows. On the other hand you can have the best of both worlds by clicking on a tab and dragging it out from the docked zone. This action lets you convert a tabbed document to a floating window (as shown in Figure 1.7). Alternatively, you can right mouse-click on a tab to access the contextual menu where you can choose from various window command options such as 'Move to a New Window' or 'Consolidate All to Here'. The latter gathers all floating windows and converts them into tabbed documents. You can also use the N-up display options (see Figure 1.10) to manage the windows.

With Mac OS X, you can mix having tabbed document windows with a classic panel layout. If you disable the Application Frame mode (Figure 1.3) and use the Open Documents as Tabs preference or the Consolidate All to Here contextual menu command, you can have the open windows arranged as tabbed documents.

	ESSENTIALS	DESIGN PAINTING	PHOTOGRAPHY	3D >> O CS Live *
CI Resize Windows To Fit 🗆 Zoom All Windows 🗹 Scrubby Zoom (Actual Pixels) (Fit Screen) (Fit	Il Screen Print Size			
👷 🛞 W1BY1137.psd @ 16.7% (RG. 🛛 🛞 © W1BY7498_499_500.tif @ 16.7% (RGB/8") 🛛 🛞 W1BY3510.tif @ 16	6.7% (Bac 🛞 © W1BYC	530.psd @ 16.7% (-44	SWATCHES STYLES +

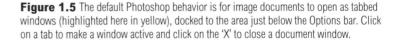

Switching between windows

The formal state of the state o

Figure 1.6 The Photoshop Interface preferences.

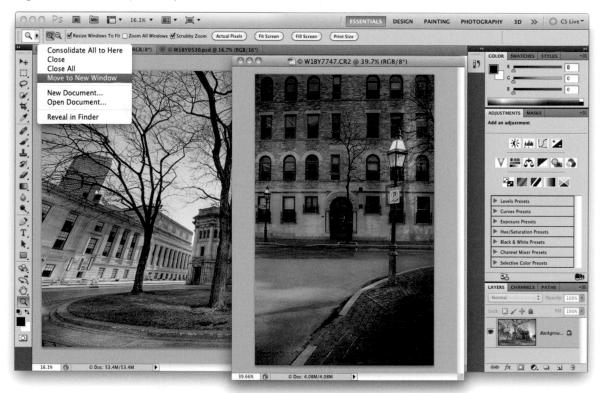

Figure 1.7 This screen shot shows the two ways you can convert a tabbed document to a floating window, either by dragging a tab out from the tabbed windows zone, or by using the contextual menu.

Synchronized scroll and zoom

In the N-up display menu (Figure 1.10) and Window \Rightarrow Arrange submenu, there are controls that allow you to match the zoom, location (and rotation) of all open images, based on the current foreground image window. The Match Zoom command matches the zoom percentage based on the current selected image, while the Match Location command matches the scroll position. You can also synchronize the scrolling or magnification by depressing the *Shift* key as you scroll or zoom in and out of any window view.

Multiple window views

Multiple window views are useful if you wish to compare different soft proof views before making a print. See Chapter 13 for more about soft proofing in Photoshop.

Managing document windows

Documents can also be tabbed into grouped document windows by dragging one window document across to another (see Figure 1.8). It is also possible to create a second window view of the image you are working on, where the open image is duplicated in a second window. For example, you can have one window with an image at a Fit to Screen view and the other zoomed in on a specific area. Any changes you make to the image can be viewed simultaneously in both windows (Figure 1.9). You can also vary the way multiple document windows are displayed on the screen. With floating windows you can Choose Window \Rightarrow Arrange \Rightarrow Cascade to have all the document windows cascade down from the upper left corner of the screen, or choose Window \Rightarrow Arrange \Rightarrow Tile to have them appear tiled edge to edge. For Tabbed document windows you can use the Document Layout menu to choose any of the 'Nup' options that are shown in Figure 1.10. This document layout method offers a much greater degree of control. It lets you choose from one of the many different layout options shown in Figure 1.10 and gives you access to the Match Zoom and Match Location controls discussed in the accompanying sidebar.

Figure 1.8 Floating windows can be grouped as tabbed document windows by dragging the title bar of a document across to another until you see a blue border (as shown above). You can also click on the title bar (circled in red) to drag a group of tagged document windows to the tabbed windows zone.

Figure 1.9 To open a second window view of a Photoshop document, choose Window ⇒ Arrange ⇒ New Window for (document name). Any edits that are applied to one document window are automatically updated in the second window.

Photograph: Eric Richmond.

Figure 1.10 This shows the 'N-up' display options for tabbed document windows.

Figure 1.11 If you go to the Info panel options menu (circled) and choose Panel Options... this opens the Info Panel Options dialog. Here, you can choose which status items you would like to see displayed in the Status Information section of the Info panel. The above Info panel screen shot shows all the status information items along with the Show Tool Hints info display.

Image document window details

The boxes in the bottom left corner of the image window display extra information about the image (see Figure 1.12). The left-most box displays the current zoom scale percentage for the document view. Here, you can type in a new percentage for any value you like from 0.2% to 1600% up to two decimal places and set this as the new viewing resolution. In the middle is a Work Group Server button that can be used to check in or check out a document that is being shared over a WebDAV server. To the right of this is the status information box, which can be used to display information about the image. If you mouse down on the arrow to the right of this box, you will see a list of all the items you can choose from to display here (these are described on the page opposite). This box can only show a single item at a time. However, if you open the Info Panel Options shown in Figure 1.11, you can check any or all of the Status Information items shown here so that the items that are ticked appear in the middle section of the Info panel. In addition to this, you can also choose to enable Show Tool Hints. These appear at the bottom of the Info panel and will change according to any modifier keys you have held down at the time, to indicate any extra available options.

If you mouse down in the Status Information box, this displays the width and height dimensions of the image, along with the number of channels and image resolution (Figure 1.13). If you hold down the **H** *ctrl* key as you mouse down on the status information box, this shows the image tiling information.

Dynamic zoom views

The Zoom status box also has a scrubby slider option. If you hold down the **#** *ctrl* key as you click inside the Zoom Status box (see Figure 1.12 below) you can dynamically zoom in and out as you drag left or right. The zoom tool Options bar also offers a new scrubby zoom option, which I describe later on page 56.

Title bar proxy icons (Macintosh)

Macintosh users will see a proxy image icon in the title bar of any floating windows. The proxy image icon appears dimmed when the document is in an unsaved state and is reliant on there being a preview icon saved with the image. For example, many JPEGs will not have an icon until they have been resaved as something else. If you hold down the **H** or *ctrl* key and mouse down on the proxy icon in the title bar you will see a directory path list like the one shown below in Figure 1.13. You can then select a folder location from the directory path and open this up in the Finder.

(Mac only) (Mac only)

Figure 1.13 This shows the window layout of a Photoshop document as it appears on the Macintosh. If you mouse down in the Status Information box, this displays the file size and resolution information. If you hold down (#) *ctrl* key as you mouse down in the Status Information box, this displays the image tiling information. Lastly, if you mouse down on the arrow icon next to the Status Information box, you can select the type of information you wish to see displayed there (the status items are described on the right).

Version Cue

Current Version Cue status.

Document Sizes

The first figure represents the file size of a flattened version of the image. The second, the size if saved including all layers.

Document Profile

The profile assigned to the document.

Document Dimensions

This displays the physical image dimensions, as would be shown in the Image Size dialog box.

Measurement Scale

Measurement units (extended version only).

Scratch Sizes

The first figure displays the amount of RAM memory used. The second shows the total RAM memory available to Photoshop after taking into account the system and application overhead.

Efficiency

This summarizes how efficiently Photoshop is working. Basically it provides a simplified report on the amount of scratch disk usage.

Timina

Displays the time taken to accomplish a Photoshop step or the accumulated timing of a series of steps. Every time you change tools or execute a new operation, the timer resets itself.

Current Tool

This displays the name of the tool you currently have selected. This is a useful aidemémoire for users who like to work with most of the panels hidden.

32-bit Exposure

This Exposure slider control is only available when viewing 32-bit mode images.

View menu options

The View Extras items can also be selected via the View menu. To turn ruler visibility on or off, choose View \Rightarrow Rulers (**HR**) *ctt***(R**) and use the View \Rightarrow Show submenu to toggle the visibility of the Guides (**H(r**) *ctt***(r**), or Grid (**H(r**) *ctt***(r**). If a tick mark appears next to an item in the View \Rightarrow Show menu, it means it is switched on. Select the item in the menu again and release the mouse to switch it off.

Altering the Ruler units

If the ruler units need altering, just *ctrl* right mouse-click on one of the rulers and select a new unit of measurement. If the rulers are visible but the guides are hidden, dragging out a new guide will make all the other hidden guides reappear again.

Figure 1.14 The New Guide dialog.

Figure 1.15 This shows an image displaying the rulers and guides. To place a new guide, select Show Rulers from the menu list shown here or choose View \Rightarrow Rulers. You can then drag from either the horizontal or vertical ruler to place a new guide. If you hold down the *Shift* key as you drag, this makes the guide snap to a ruler tick mark (providing View \Rightarrow Snap is checked). If you hold down the *Shift* key as you drag this allows you to switch dragging a horizontal guide to dragging it as a vertical (and vice versa). Lastly, you can use **SH** *ctrl* to toggle hiding/showing all extras items, like Guides.

Rulers, Guides & Grid

If you mouse down on the View Extras menu in the Application bar (circled in Figure 1.15), you can switch on the following view items: Guides, Grids or Rulers. Guides can be added at any time (providing the Rulers are displayed) and flexibly positioned anywhere in the image area. To add a new guide, you just mouse down on the ruler bar and drag a new guide out and release the mouse to drop the guide in place. Once placed, guides can be used for the precise positioning and alignment of image elements. If you are not happy with the positioning, you can select the move tool and drag the guide into the exact required position. But once positioned, it is sometimes a good idea to lock the guides (View \Rightarrow Lock Guides) to avoid accidentally moving them again. You can also position a guide using View \Rightarrow New Guide... and enter the exact measurement coordinate for the horizontal or vertical axis in the New Guide dialog (Figure 1.14). The Grid (Figure 1.16) provides a means for aligning image elements to a horizontal and vertical axis (to alter the grid spacing, open the Photoshop preferences and select Guides & Grid).

Figure 1.16 This shows an image displaying the Grid view, which can be used to help align objects to a horizontal and vertical axis. The Grid view can be enabled via the Display options in the Application bar or by choosing View \Rightarrow Show \Rightarrow Grid. **(3) (4) (7) (1) (7**

'Snap to' behavior

The Snap option in the View menu allows you to toggle the 'snap to' behavior for the Guides, Grid, Slices, Document bounds and Layer bounds. The shortcut for toggling the 'snap to' behavior is **H** Shift ; ctrl Shift ; . When the 'snap to' behavior is active and you reposition an image, type or shape layer, or use a crop or marguee selection tool, these will snap to one or more of the above. It is also the case that when 'snap to' is active, and new guides are added with the Shift key held down, a guide will snap to the nearest tick mark on the ruler, or if the Grid is active, to the closest grid line. Objects on layers will snap to position when placed within close proximity of a guide edge. The reverse is also true: when dragging a guide, it will snap to the edge of an object on a layer at the point where the opacity is greater than 50%. Also note that when Smart Guides are switched on in the View \Rightarrow Show menu, these can help you align layers as you drag them with the move tool (see page 122 for more details).

Pixel Grid view

The Pixel Gird view described in Figure 1.17 is only seen if you have OpenGL enabled and the Pixel Grid option selected in the View menu. It is useful when editing things like screen shots and can, for example, aid the precise placement of the crop tool.

Figure 1.17 The Pixel Grid view can be enabled by going to the View ⇒ Show menu and selecting 'Pixel Grid'. When checked, Photoshop displays the pixels in a grid whenever an image is inspected at a 500% magnification or greater.

Figure 1.18 The CS Live menu.

Application bar

The Application bar allows you to quickly access essential controls such as the N-up document layout options and the View Extras items I just mentioned such as Rulers, Guides or the Grid. Those I haven't covered yet include a button to launch the Bridge program (see pages 76–80) from where you can double-click on an image in the content panel thumbnail grid to open it in Photoshop. The Mini Bridge button that's next to it allows you to open the new Mini Bridge extension panel, which is like a cut-down version of the main Bridge program (see page 81). The Zoom Scale box shows the current zoom setting and you can use this menu to quickly select a 25%, 50%, 100% or 200% zoom view setting. The Screen display mode options (discussed on page 60) allow you to select the desired screen view mode to work with. The Workspace settings are displayed in an expandable menu that can be dragged out from the right. This allows you to quickly switch between different workspace settings (see pages 24-25). The main difference between the Mac and PC versions of Photoshop CS5 is that the Photoshop menu remains static at the top of the screen in the Macintosh interface (Figure 1.19), whereas in Windows the application menu items are incorporated into the Application bar itself (Figure 1.20). The CS Live menu options shown in Figure 1.18 provide you with links to external Adobe website resources.

Figure 1.20 The Photoshop CS5 Application bar (Windows OS).

Chapter 1 Photoshop fundamentals

The Photoshop panels

The default workspace layout settings place the panels in a docked layout where they are grouped into column zone areas on the right. However, the panels can also be placed anywhere on the desktop and repositioned by mousing down on the panel title bar (or panel icon) and dragging them to a new location. A double-click on the empty panel tab area (circled red in Figure 1.21) compacts the panel upwards and double-clicking on the tab area unfurls the panel again. A double-click on the darker gray panel header bar (circled blue in Figure 1.21) collapses the panel into the compact icon view mode and double-clicking on the same panel header expands the panel again. Some expanded panels, such as the Info panel are of a fixed size, while others, such as the Layers panel have a resize tab in the bottom right corner. This allows you to adjust the width and height of these panels.

Panels can be organized into groups by mousing down on a panel tab and dragging it across to another panel (Figure 1.22). When panels are grouped in this way they'll look a bit like folders in a filing cabinet. Just click on a tab to bring that panel to the front of the group and to separate a panel from a group, mouse down on the panel tab and drag it outside the panel group again.

Figure 1.21 Photoshop panels can be collapsed with a double-click in the empty panel tab area (circled in red), while a doubleclick on the dark gray panel header (circled in blue) shrinks the panel to the compact panel size shown here.

tab and drag it outside the panel group.

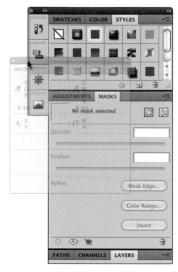

Figure 1.23 As you reposition a panel and prepare to dock it inside or to the edges of the other panels, a thick blue line indicates that when you release the mouse, this is where the panel will attach itself.

Figure 1.24 When panels are docked you can adjust the width of all the panels at once by dragging anywhere along the side edge of the panels.

Panel arrangements and docking

The default 'Essentials' workspace arranges the panels using the panel layout shown in Figures 1.3 and 1.4 (seen at the beginning of this chapter), but there are quite a few other different workspace settings to choose from. It is also easy to create custom workspace settings by arranging the panels to suit your own preferred way of working and save these as a new setting. Panels can be docked together by dragging a panel to the bottom or side edge of another panel and in Figure 1.23 you can see how an example of the thick blue line that appears as a panel is made to hover close to the edge of another panel. Release the mouse at this point and the panel will become docked to the side or to the bottom of the other panels.

When panels are compressed (as shown in the middle and bottom examples in Figure 1.21), you can drag on either side of the panel to adjust the panel's width. At the most compact size, only the panel's icon is displayed, but as you increase the width of a panel (or column of panels), the panel contents expand and you'll get to see the names of the panels appear alongside their icons (see Figure 1.24).

Just remember, if you can't find a particular panel, then it may well be hidden. If this happens, go to the Window menu, select the panel name from the menu and it will reappear again on the screen. It is worth remembering that the *Tab* key shortcut (also indicated as *I*) on some keyboards) can be used to toggle hiding and showing all the panels, while *Tab Shift* toggles hiding/ showing all the currently visible panels except for the Tools panel and Options bar. These are useful shortcuts to bear in mind. So, if you are working in Photoshop and all your panels seem to have disappeared, just try pressing *Tab* and they'll be made visible again.

In the Figure 1.25 example, the tabbed image documents fill the horizontal space between the Tools panel on the left and the three panel columns on the right. I have also shown here how you can mouse down on the column edge to adjust the column width (see the double arrow icon that's circled in red). Photoshop panels can be grouped into as many columns as you like within the application window, or positioned separately outside the application window, such as on a separate monitor (see 'Working with a dual monitor setup' on page 26).

Chapter 1 Photoshop fundamentals

Figure 1.25 This shows a multi column workspace layout with some of the panels grouped in a docked, compact icon layout, outside the main application window. Note that the application frame is always topmost and can sometimes obscure any floating panels.

Panel positions remembered in workspaces

In CS5 there has been a subtle improvement to the way Photoshop remembers panel positions after switching workspaces. Now when you select a workspace and modify the panel layout, the new layout position is remembered when you next return to using that particular workspace. In the past it was always necessary to resave the workspace setting after you had made any refinements to the layout of the panels.

Closing panels

To close a panel, click on the Close button in the top right corner (or choose 'Close' from the panel options fly-out menu).

Show All Menu Items

In Basic mode, a Show All Menu Items command will appear at the bottom of each menu list. You can select this menu item to restore the menus so that they show the full list of menu options.

Help menu searches

Here is an interesting tip for Mac users who are running Mac OS X 10.5 or later. If you go to the Photoshop Help menu and start typing the first few letters for a particular menu command, the Help menu lists all the available menu options. Now roll the mouse over a search result: Photoshop locates the menu item for you and points to it with an arrow.

	New Open Browse in Bridge	೫N ೫0 ℃೫0
	Browse in Mini Bridge	1.40
	Open As Smart Object Open Recent	Þ
1	Share My Screen	
1	Create New Review	
1	Device Central	
	Close	жW
1	Close All	W 36 7
	Close and Go To Bridge	12 3€ W
1	Save	36 S
	Save As	公祝S
	Check In	
- 1	Save for Web & Devices	
	Revert	F12
	Place	
	Import	Þ
	Export	
	Automate	•
	Scripts	Þ
	File Info	飞合第1
	Print	36 P
	Print One Copy	TOXP

Figure 1.26 The Custom workspace menu options, which are shown here using the 'New in CS5' setting that color codes all the new menu items in blue.

Customizing the menu options

As the number of features in Photoshop has grown over the years, the menu choices have become quite overwhelming and this is especially true if you are new to Photoshop. However, if you go to the Edit menu and choose Menus..., this opens the Keyboard Shortcuts and Menus dialog shown in Figure 1.27, where you can customize the menu options and decide which menu items should remain visible. This Customize menu feature is like a 'make simpler' command. You can hide those menu options you never use and apply color codings to the menu items you use most often so that they appear more prominent. For example, if you select the 'Basic' workspace, this setting abbreviates the menu lists in Photoshop and hides the more advanced features. This is therefore a useful workspace for someone who is just beginning to learn Photoshop since they will find it easier to locate the menu commands they need when starting out. The philosophy behind this feature is: 'everything you do want with nothing you don't'. Another example is the 'New in CS5' workspace (Figure 1.26). This applies a custom menu setting in which all the new Photoshop CS5 menu items are color coded blue.

Kephnood Snothuuts Menus			_	
				OK
Set: New in CS 5			0	Cancel
Menu For: Application Menus				
Application Menu Command	Visibility	Color		
▼ File			0	
New		None	JI	
Open	۲	None		
Browse in Bridge	. 🗩	None		
Browse in Mini Bridge		Blue		
Open As Smart Object		None	-111	
Open Recent>		None		
2) Show All Menu Item 3) To temporarily see I Color Menu Items: 1) To add color to a m	idden menu items, click nu item, click in the Colo	bottom of a menu that contains hidden items. on Show All Menu Items or X + click on the menu.		

Figure 1.27 The Keyboard Shortcuts and Menus dialog.

Customizing the keyboard shortcuts

Keyboard Shortcuts

Set: Photoshop Defaults

While you are in the Keyboard Shortcuts and Menus dialog, you can click on the Keyboard Shortcuts tab to reveal the keyboard shortcut options shown below in Figure 1.28 (or you can go to the Edit menu and choose Keyboard Shortcuts...) In this dialog you first select which kinds of shortcuts you want to create, i.e. Application Menus, Panel Menus or Tools. You can then navigate the menu list, click in the Shortcut column next to a particular menu item and hold down the combination of keys you wish to assign as a shortcut for that particular tool or menu item. Now the thing to be aware of here is that Photoshop has already used up nearly every key combination there is, so you are likely to be faced with the choice of reassigning an existing shortcut, or using multiple modifier keys such as: **H** Shift or *ctrl alt Shift* plus a letter or Function key, when creating new shortcuts.

Creating workspace shortcuts

OK

Cancel

If you scroll down to the Window section in the Keyboard Shortcuts for Application Menus, you will see a list of all the currently saved Workspace presets. You can then assign keyboard shortcuts for your favorite workspaces. This will allow you to jump quickly from one workspace setting to another by using an assigned keyboard shortcut.

Application Menu Command	Shortcut	Accept
Window		Undo
Arrange>		Use Default
Cascade		Use Default
Tile		Add Shortcut
Float in Window		Delete Shortcut
Float All in Windows		
Consolidate All to Tabs		Summarize
Match Zoom		
Match Location		
Match Rotation		
Match All		
New Window		
Minimize	Control+#+M	
Bring All to Front		
Workspace>		
Custom 1		
Dual monitor	Opt+#+F13	Ă.

Keyboard Shortcuts and Menus

1 8 8 8

Figure 1.28 The Keyboard Shortcuts and Menus dialog showing the keyboard shortcut options for the Photoshop Application Menus commands.

Name:	Dual Monitor	Save
- Cap	ture	Cancel
	locations will be saved in this workspace. bard Shortcuts and Menus are optional.	
Ke	yboard Shortcuts	
MM	inus	

Figure 1.29 The Save Workspace menu in Photoshop can be used to save custom panel workspace setups. These can be recalled by revisiting the menu and highlighting the workspace name. To remove a workspace, choose Delete Workspace... from the menu.

Task-based workspaces

You can use the Workspaces list in the menu bar to access alternative panel layouts, tailored for different types of Photoshop work. Note that you can expand the Workspaces list by dragging the double-bar that's circled in red outwards (depending on how much screen width you have available). You can also save a current panel arrangement as a new custom workspace via the Workspace list menu or by going to the Window menu and choosing Workspace \Rightarrow Save Workspace... This opens the dialog box shown in Figure 1.29, which asks you to select the items you would like to have included as part of the workspace (the workspace settings can also include specific keyboard shortcuts and menu settings). The saved workspace will then appear added to the Application bar workspace list (Figure 1.30).

Figure 1.30 The Workspace list settings can be accessed via the Application bar menu shown here, or via the Window \Rightarrow Workspace submenu. Workspace settings are now automatically updated as you modify them. However, to reset a workspace back to the default setting, you can do so via the Workspace list menu (circled in blue above).

The Workspace settings in Photoshop CS5 are now more accessible and one of the big improvements has been to force all workspace settings to include panel locations and have them update as you modify the layout you are working in. This means if you select a workspace and fine-tune the panel layout or other settings, these tweaks are automatically updated. When you switch to another workspace and back to the original, the updated settings are remembered (although you do have the option of reverting to the original saved setting). As you can see in Figure 1.29, saving keyboard shortcuts and menus is optional and the way things stand now, if you choose not to include these settings as part of the workspace, the menu and keyboard shortcuts used in the last selected workspace remain sticky. Let's say you save a custom workspace that excludes saving menus and shortcuts. If you switch to a workspace setting that makes use of specific menus or keyboard shortcuts and switch back again you can add these menu and shortcuts settings to the current workspace setting (until you reset).

Reordering the workspaces

As you add a new workspace it will appear to the left of the Workspace list. However, you can reorganise the order the workspaces appear in by dragging and dropping them to a new position.

Saved workspaces location

Custom and modified workspaces are saved to the following locations: User folder/Library/Preferences/ Adobe Photoshop CS5 Settings/ (Mac), userfolder/AppData/Roaming/Adobe/ Adobe Photoshop CS5/Adobe Photoshop CS5 Settings/ (Windows Vista).

Figure 1.31 Here is an example of the Photography workspace in use.

Working with a dual monitor setup

If you have a second computer display, you can arrange things so that all the panels are placed on the second display, leaving the main screen clear to display the image document you are working on. Figure 1.32 shows a screen shot of a Dual monitor panel layout workspace that I use with my computer setup. In this example I have ensured that only the panels I use regularly are visible. The important thing to remember here is to save a panel layout like this as a workspace setting so that you can easily revert to it when switching between other workspace settings.

Figure 1.32 This shows an example of how you might like to arrange the Photoshop panels on a second display, positioned alongside the primary display.

Chapter 1 Photoshop fundamentals

Adobe[™] Configurator 2 application

Essential tools

File Edit

Adobe Configurator 2 is a small application that can be used to create custom Extension panels containing all your favorite and most-used Photoshop shortcuts. It's a perfect solution for those customers who wish Photoshop could be made less complicated. Basically, you can use the Configurator interface that's shown in Figure 1.33 to drag and drop various tools and menu commands to the workspace area. Using Configurator you can design a custom panel that contains all your favorite and most-used tools and commands. Once you are happy with the layout you can choose File \Rightarrow Export to save it as a new Photoshop panel. To load the exported panel, relaunch Photoshop, go to the Window \Rightarrow Extensions submenu in Photoshop and select the new panel from the menu list. Configurator 2 provides built-in support for localized languages, can include HTML links and includes container objects to help create more efficient panel layouts.

TOOLS t 0 0 Width: 300 0 S . COMMANDS 1 槛 0 Height: 568 1 -2 ACTION/SCRIPT . 9 3 5 • WIDGETS T D New Open Close Close All MinHeight - CONTAINERS Width: Accordion Open As Smart Object Save Save As New Open Close Close All Mainht Canvas Open As Smart Object Save Save As Locale: en US Content-Aware Scale Fade Copy Merged IDE HBox Content-Aware Scale Fade Copy Merged HDivided Bo Auto-Align Layers Auto-Blend Layers Tab Navigator Auto-Align Layers Auto-Blend Layers Adv. TabNavigato oninit Color Settings Assign Profile Convert to Profile Color Settings Assign Profile Convert to Profile B VBox onClose Apply Image Crop Trim Reveal All Apply Image Crop Trim Reveal All VDIvidedBo JECT Shadow/Highlight HDR Toning Puppet Warp Shadow/Highlight HDR Toning Puppet Warp 90 degrees CW 90 degrees CCW 90 degrees CW 90 degrees CCW Convert to Smart Object New Smart Object via Copy **Outline View** Mean Median Range Convert to Smart Object New Smart Object via Copy Color Range Refine Edge Feather R Canvas Mean Median Range Spot Healing Brush Too Convert for Smart Filters Liquify Gaussian Blur CLasso Tool Color Range Refine Edge Feather Lens Blur Lens Correction Add Noise TA Crop Tool Unsharp Mask Proof Colors Keyboard Shortcuts + Move Tool Convert for Smart Filters Liquify Gaussian Blur Tile Cascade New Window Rectangular Marguee Too Lens Blur Lens Correction Add Noise () Elliptical Marquee Tool Unsharp Mask Proof Colors Keyboard Shortcuts Tile Cascade New Window

PANEL

Essential took

2

ESSENTIAL TOOLS

Figure 1.33 This shows on the left the Configurator 2 interface and on the right what the exported Extension panel looked like when it was opened in Photoshop.

Connecting Photoshop to the Internet

Many of the Extension panels require Photoshop be connected to the Internet in order for them to function. To check whether this is the case, go to the Photoshop menu, choose Preferences ⇒ Plug-ins and makes sure the 'Allow Extensions panels to connect to the Internet' option is checked and then restart Photoshop.

Extensions panels

There are now a number of Extension panels you can load into Photoshop CS5, which I have grouped together in Figure 1.34. These have all been built using Adobe AIRTM, which is based on Adobe Flash technology. For example, Configurator 2 is actually an AIR application for building custom tool and command selection panels for Photoshop or InDesign. The extension panels shown here are initial examples of how this technology can be used to create panels for Photoshop that allow you to extend (pun intended) how you work.

Figure 1.34 shows most of the Extensions panels that are now available in Photoshop CS5 as well as those that you can download and install separately. Let's start with the Kuler panel, which was actually one of the first AIR panels to be released by Adobe and is designed as a creative tool for exploring different sets of color harmonies. You can also explore more of these on-line via this panel and choose from the many custom color sets other users have created.

Next, we have the CS Review panel. This allows you to share and get feedback on your creative projects, but you must first sign in to the CS Review service to create a review using this panel.

With the Access CS Live panel you need to sign in here too using your Adobe ID and password. Once you have done so you can use this panel to share your screen and communicate with up to two other Adobe registered users. Basically, the concept here is similar to using SkypeTM or Apple's iChatTM to hold on-line conferences.

The Knowledge and Toolbox panels are not included in the main Photoshop install, but are available as optional downloads from the Adobe website. The intention here is that when installed the content of these two panels is directly linked to whichever workspace you are currently in. Therefore, when you are working in the Photography workspace the Toolbox and Knowledge panels are able to show content that is specifically related to photographic editing tasks.

Lastly, there is the Mini Bridge panel which I haven't included here because it deserves a more thorough discussion. You can read more about Mini Bridge on page 81 as well as in the latter section of Chapter 11.

Avoidance	•	•	•
Image: Sign in Image	KULER *I	CS REVIEW *	ACCESS CS LIVE
Highest Rated All Time Civistmas halp Autum shades Preace Sandy stand basis Preace Circuis Grow Star Trek Circuis Grow Circuis Gro	About Browse Create		Sign In
Christmas halp Christmas halp Freeze Christmas halp Christmas halp Christmas halp Christmas halp Christmas halp Christmas Black. Spring filing Spring filing	Q		CS Review
Christmas help Automm shades Fremze Create, share, and get feedback on your create projects all from within Adobe Create a Selection Corver all Adobe Photosof. Prote colleagues and clems to provide feedback using just a with adobe Photosof. Prote colleagues and clems to provide feedback using just a with adobe Photosof. Prote colleagues and clems to provide feedback using just a with adobe Photosof. Prote colleagues and clems to provide feedback using just a with adobe Photosof. Prote colleagues and clems to provide feedback using just a with adobe Photosof. Prote colleagues and clems to provide feedback using just a with adobe Photosof. Prote colleagues and clems to provide feedback using just a with adobe Photosof. Prote colleagues and clems to provide feedback using just a with adobe Photosof. Prote colleagues and a be edited or removed at any time. To apply a drop shadow to a layer, get started by opening problemozy. Create a Selection Color Range Transform Inverse Feather Border Nue the Elgev contant (File > Sm Sub ent # Madow > Elgev States of the Layer Style stated adjust the size of the drop shadow and choose the Drop Shadow and the agrees to adjust the size of the drop shadow and choose the Drop Shadow and the state of the drop shadow and choose the Drop Shadow and the state of the drop shadow and choose the Drop Shadow and the state of the drop shadow and choose the Drop Shadow and the state of the dro	Highest Rated 👻 All Time 👻		Create New Review
Autumn shades Firenze Citrus Crove Stars More Citrus Crove Citrus Crove Stars More A Vintage Hallon Preferenze Cereman Mory Stars More Cardinal Cereman Mory Cardinal Cereman Mory Stars More Stars More Stars More Cardinal Christmas Black Spring Fling Avoidance Avoidance Stars More Stars More Stars More Sign In Mountain Cag Cardinal Christmas Black Sign In Sign In Movidance Stars More Stars More <td>Christmas help</td> <td></td> <td>Learn More</td>	Christmas help		Learn More
Image may account crattle projects all from within Added Cratter SuiteS. Invite a Neview within Added Cratter SuiteS. Invite a Neview in thin Added Cratter SuiteS. Invite a Neview in thin Added Photoshop8. Invite colleagues are browser. See comments in the context of the suites a Neview using the CS Review service or crate a Neview or Cost of the Neview or Case of the Case or Cost of the Neview or Case of the Case or Case of the Case of t		Welcome to Adobe® CS Review	人 Acrobat.com
Citrus Grove Citrus Grove <t< th=""><th>Firenze</th><th></th><th>Acrobat.com Home</th></t<>	Firenze		Acrobat.com Home
Sandy store ba: Creatus Stule®. Initiate a Review from within Adobe Photospops. Inverse comments in the context of your image. It's that simple: C S Revues and Resources Manage may account Explore CS Live Services Star Trek Star Trek Star Trek Star Trek Cosy days Rejections Mountain Crage Rejections Star Trek Sign in to the CS Review service to create a Review using the CS Review panel. Learn More Sign in Mountain Crage Sign in Sign In Sign in Mountain Crage Sign in Sign In Sign in Sign i	Citrus Grove		Share My Screen
Im waring this A Vintage Hallo A Vintage Hallo A Vintage Hallo A Vintage Hallo Reflections German Mops Star Trek Star Trek Register or sign in to the CS Review service to create a Review using the CS Review panel. Mountain Crag Register or sign in to the CS Review service to create a Review using the CS Review panel. Star Trek Sign in Star Trek Sign in Avoidance Sign in Avoidance Sign in You can enhance a layer by adding a shadow, stroke, sa sheen, or other special layer effect. These effects are easy to apply ad fong shadow to a layer, get started by opening DrogShadow. You End the Vindow > Elayers panel is open, then select the Treve of the layer man. Select a Toolbox: Selection Create a Selection Select All Make Selection from Path Select All Select All Reselect Adjust and Refine Edge In werse Transform Inverse Border Use the Elizay command (File > Save command	sandy stone be	Creative Suite®. Initiate a Review from	CS News and Resources
of your image. It's that simple. Reflections Sur Trek Cory days Cory days Mountain Crag Corrate a Review using the CS Review panel. Learn More Christmas Black. Spring Fling Avoidance Avoidance Spring Fling Avoidance Spring Fling Soring Fling Soring Fling Sorial Context a state of the spring fling Sorial Context and the spring fling Color ange Select a Toolbox: Selection Clore Range Color Range Adjust and Refine Selection Reselect Adjust and Refine Selection Reselect Reselect Adjust and Refine Selection Reselect Reselect Reselect Reselect Reselect Reselect All	Im wearing this		Manage my account
Reflections German Mops Corran Mops Sign In Sign In <	A Vintage Hallo	1 1	Explore CS Live Services
Star Trek Cosy days Mountain Crag Cardinal Christmas Black Spring Fling Avoidance Avoidance Avoidance Sign In Vu can enhance a layer by adding a shadow, stroke, sa sheen, or other special layer effect. These effects are east to apply and can be edited or removed at any time. To apply a drop shadow to a layer, get started by opening DropShadow . DocLoox Select a Toolbox: Select allow Color Range Make Selection from Path Select All Reselect Adjust and Refine Selection Refine Edge Transform Inverse Feather Border Use the Save command (File > Save c	Reflections	or your mage, it's that simple.	
Cosy days Mountain Grag Cardinal Spring Fling Avoidance Avoidance Image: Spring Fling Avoidance Image: Spring Fling			
Cocy days Mountain Grag Cardinal Spring Fling Avoidance Avoidance Spring Fling Christmas Black Spring Fling Avoidance Sign in Sign in Correct Special layer deter. These effects are case to apply and can be edited or removed at any time. To apply and can be edited or removed at any time. To apply and can be edited or removed at any time. To apply and can be edited or removed at any time. To apply and can be edited or removed at any time. To apply and can be edited or removed at any time. To apply and can be edited or removed at any time. To apply and can be edited or removed at any time. To apply and can be edited or removed at any time. To apply a drop shadow to a layer, get started by opening DropShadow. TOOLBOX Image: Color Range Color Range Color Range Make Selection from Path Select All Select All Reselect Adjust the layer style settings In the Structure area of the Layer Style dialog box, drag the Distance silder to adjust the size of the drop shadow and thoose the Drop Shadow effect. Image: Transform Inverse Feather Border Use the Save command [File > Save			
Image: Select All Reselect Make Selection Color Range Make Selection Select All Refine Edge Transform Transform Inverse Fasher Border Solution Cardinal Super Selection Select All Reselect Adjust and Refine Edge Inverse Transform Inverse Border Use the Solution of the size of the drop shadow and control o		,	O KNOWLEDGE
Christmas Black Sign In Spring Fling Avoidance Avoidance Avoidance Avoidance Sign In Stare Stare Create a Selection Stare Make Selection from Path Select All Reselect Adjust and Refine Edge<		Learn More	
Spring Fling Avoidance Start Start <t< td=""><td></td><td></td><td></td></t<>			
Avoidance		Sign In	Add a drop snadow
sheep, or other special layer effect. Inese effects are easies to apply and can be edited or removed at any time. To apply a drop shadow to a layer, get started by opening DropShadow. Coll BOX Select a Toolbox: Selection Create a Selection Color Range Make Selection from Path Select All Reselect Adjust and Refine Selection Refine Edge Transform Inverse Feather Border Use the Stare command [File > Save command [File			You can enhance a layer by adding a shadow, stroke, satin
TOOLBOX Toolbox: Select a Toolbox: Selection Create a Selection Image Color Range Double-click to the right of the layer name to open the Layer Style dialog box, and to open the Layer Style dialog box, and thoose the Drop Shadow effect. Make Selection from Path Select All Select All Reselect Adjust and Refine Selection Image Transform Inverse Feather Border		+ <u>유</u> Share - 관광고 습	apply a drop shadow to a layer, get started by opening A <u>DropShadow</u> .
2. Apply a drop shadow layer effect Outload of the layer style of the layer name of the layer style dialog box, and to open the Layer style dialog box, and those the Drop Shadow effect. Make Selection from Path Select All Refine Selection Refine Edge Transform Inverse Feather Border			Make sure the Window $> \square$ Layers panel is open, then select the layer to which you want to apply the shadow
Color Range Double-click to the right of the layer name to open the Layer Style dialog box, and choose the Drop Shadow effect. Make Selection from Path Select All Select All Reselect Adjust and Refine Selection In the Structure area of the Layer Styles dialog box, drag the Distance slider to adjust the size of the drop shadow and cook to apply the new style to your image. Transform Inverse Feather Border	Create a Selection		2. Apply a drop shadow layer effect
Color Range to open the Layer Style dialog box, and choose the Drop Shadow effect. Make Selection from Path Select All Select All Reselect Adjust and Refine Selection In the Structure area of the Layer Styles dialog box, and choose the Drop Shadow effect. Refine Edge Select All Transform Inverse Feather Border Use the Estave command [File > Save	0 4 0 DI	3000	Double-click to the right of the layer name
Make Selection from Path Select All Reselect Adjust and Refine Selection In the Structure area of the Layer Styles dialog box, drag the Distance slider to adjust the size of the drop shadow and co OK to apply the new style to your image. Transform Inverse Feather Border Use the Estate command [File > Save			
Adjust and Refine Selection In the Structure area of the Layer Styles dialog box, drag the Distance slider to adjust the size of the drop shadow and corrections Mending there is the size of the drop shadow and corrections OK to apply the new style to your image. Transform Inverse Feather Border Use the Essee command [File > Save	Make Selectio	n from Path	Choose the prop shadow check
Adjust and Refine Selection Inverse Image: Constraint of the selection Inverse Inverse Inverse Feather Border Use the Essare command [File > Save	Select All	Reselect	
Refine Edge OK to apply the new style to your image. Transform Inverse Feather Border Use the Estave command (File > Save)	Adjust and Refine Sel	ection	Index Defect Defect dialog box, drag the Distance slider to
Transform Inverse Feather Border 4. Save your work Use the E Save command [File > Save	Refine	Edge	adjust the size of the drop shadow and click
Feather Border Use the 🖹 Save command [File > Save	Transform	Inverse	
	Feather	Border	4. Save your work Use the Save command [File > Save]
Save and Load Selection	Save and Load Selecti	on	to preserve your work for posterity!
Save Load	Save	Load	

29

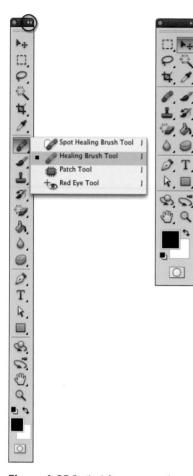

Figure 1.35 On the left you can see the default single column panel view. However, you can click on the double arrow (circled) to toggle between this and the double column view shown on the right. Where tools are marked with a triangle in the bottom right corner, you can mouse down on the tool to see all the other tools that are nested in that particular group.

Photoshop CS5 Tools panel

The Tools panel that's shown in Figure 1.35 contains 71 separate tools. Clicking any tool automatically displays the tool Options bar (if it is currently hidden) from where you can manage the individual tool settings (see page 32). Many of the tools in the Tools panel have a triangle in the bottom right corner of the tool icon, which indicates there are extra tools nested in this tool group. You can mouse down on a featured tool, select any of the other tools in this list and make that the selected tool for the group (see Figure 1.35).

You will notice that most of the tools (or sets of tools) have single-letter keystrokes associated with them. These are displayed whenever you mouse down to reveal the nested tools or hover with the cursor to reveal the tool tip info (providing the 'Show Tool Tips' option is switched on in the Photoshop Interface preferences). You can therefore use these shortcuts to quickly select a tool without having to go via the Tools panel. For example, pressing \mathbf{V} on the keyboard selects the move tool and pressing \mathbf{O} will select one of the healing brush group of tools (whichever is currently selected in the Tools panel). Photoshop also features spring-loaded tool selection behavior. If instead of clicking you hold down the key and keep it held down, you can temporarily switch to using the tool that's associated with that particular keystroke. Release the key and Photoshop reverts to working with the previously selected tool again.

Where more than one tool shares the same keyboard shortcut, you can cycle through the other tools by holding down the *Shift* key as you press the keyboard shortcut. If on the other hand you prefer to restore the old behavior whereby repeated pressing of the key would cycle through the tool selection options, go to the Photoshop menu, select Preferences \Rightarrow General and deselect the 'Use Shift Key for Tool Switch' option. Personally, I prefer using the Shift key method. You can also **Solar** alt-click the tool icon in the Tools panel to cycle through the grouped tools.

There are specific situations when Photoshop will not allow you to use certain tools and displays a prohibit sign (\otimes). For example, you might be editing an image in 32-bit mode where only some tools can be used to edit the image. Clicking once in the image document window calls up a dialog explaining the exact reason why you cannot access or use a particular tool.

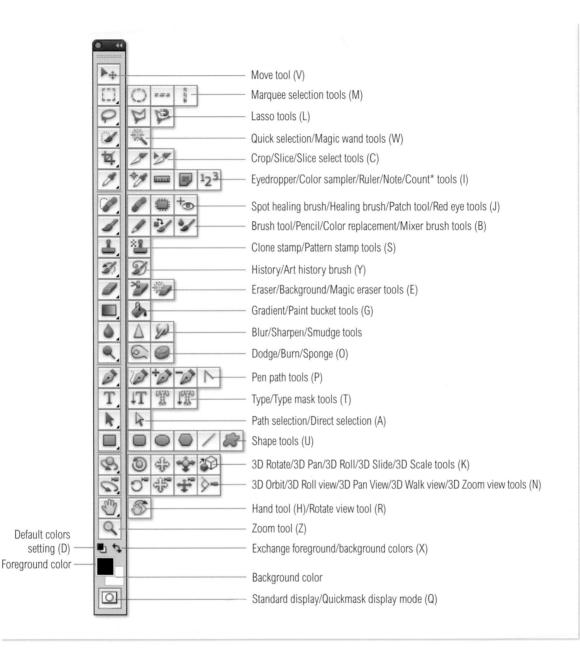

Figure 1.36 This shows the Tools panel with the keystroke shortcuts shown in brackets. *Note that the count tool is only available in the extended version of Photoshop.

Hovering tool tips

In order to help familiarize yourself with the Photoshop tools and panel functions, a Help dialog box normally appears after a few seconds whenever you leave a cursor hovering over any one of the Photoshop buttons or tool icons. Note that this is dependent on keeping the 'Show Tool Tips' option selected in the Interface preferences.

Options bar

The Options bar (Figure 1.37) normally appears at the top of the screen, just below the Application bar, and you will soon appreciate the ease with which you can use it to make changes to any of the tool options. However, it can be removed from its standard location and placed anywhere on the screen by dragging the gripper bar on the left edge (circled in Figure 1.37).

The Options bar contents will vary according to which tool you have currently selected and you'll see several examples of the individual Options bar layouts in the rest of this chapter (a complete list of the Options bar views can be seen in the Photoshop CS5 for Photographers Help Guide on the DVD). Ouite often you will see 'tick' and 'cancel' icons on the right-hand side of the Options bar and these are there so that you can OK or cancel a tool that is in a modal state. For example, if you were using the crop tool to define a crop boundary, you could use these buttons to accept or cancel the crop, although you may find it easier to use the *Enter* key to OK and the *esc* key to cancel such tool operations. To reset a tool or all tools, *ctrl* right mouse down on the tool icon in the Options bar and choose 'Reset Tool' or 'Reset All Tools'. As I mentioned earlier on page 20, you can use the Shift Tab shortcut to toggle hiding the panels only and keeping just the Tools panel and Options bar visible.

Figure 1.37 The Options bar, which is shown here docked to the Application bar.

Tool Presets panel

Many of the Photoshop tools offer a wide range of tool options. In order to manage these settings more effectively, the Tool Presets panel can be used to store multiple saved tool settings, which can then also be accessed via the Options bar (Figure 1.38), or the Tool Presets panel (Figure 1.39).

With Tool Presets you can access any number of tool options very quickly and this can save you the bother of having to reconfigure the Options bar settings each time you choose a new tool. For example, you might find it useful to save crop tool presets for all the different image dimensions and pixel resolutions you typically use. Likewise, you might like to store pre-configured brush preset settings, rather than have to keep adjusting the brush shape and attributes. To save a new tool preset, click on the New Preset button at the bottom of the Tool Presets panel and to remove a preset, click on the Delete button that's next to it.

If you mouse down on the Tool Presets options button (circled in Figure 1.39), you can use the menu shown in Figure 1.40 to manage the various tools presets. In Figure 1.39 the 'Current Tool Only' option was deselected, which meant that all the tool presets could be accessed at once. This can be useful, because clicking on a preset simultaneously selects the tool and the preset at the same time. Most people though will find the Tool Presets panel is easier to manage when the 'Current Tool Only' option is checked.

You can use the Tool Presets panel to save or load pre-saved tool preset settings. For example, if you create a set of custom presets, you can share these with other Photoshop users by choosing Save Tool Presets... This creates a saved set of settings for a particular tool. Another thing that may not be immediately apparent is the fact that you can also use tool presets to save type tool settings. This again can be useful, because you can save the font type, font size, type attributes and font color settings all within a single tool preset. This feature can be really handy if you are working on a Web or book design project.

One important thing to bear in mind here is that since there has been a major update to the Photoshop painting engine, any painting tool presets that are created in Photoshop CS5 will not be backward compatible with earlier versions of the program. Similarly, you won't be able to import and use any painting tool presets that were created in earlier versions of Photoshop either.

Figure 1.39 The Tool Presets panel.

Figure 1.40 The Tool Presets options.

[]]	Rectangular marquee tool (M)
()	Elliptical marquee tool (M)
F# 4	Single row marquee tool
1 1 1 1	Single column marquee tool
1	Quick selection tool (W)
×	Magic wand tool (W)
P	Lasso tool (L)
ゼ	Freeform lasso tool (L)
13	Magnetic lasso tool (L)

New Paste Into commands

The standard Paste command pastes the copied pixels as a new layer centered in the image. The Paste Special submenu offers three options. The Paste In Place command (**Herric Shift V etri Shift V)** pastes the pixels that have been copied from a layer to create a new layer with the pixels in the exact same location. If the pixels have been copied from a separate document, it pastes the pixels into the same relative location as they occupied in the source image. Paste Into pastes the clipboard contents inside a selection, while Paste Outside pastes the clipboard contents outside a selection.

Figure 1.41 The first time you use the Macintosh **H** keyboard shortcut, this pops a dialog asking you to select the desired default behavior: do you want this shortcut to hide the Photoshop application, or hide all extras?

Selection tools

In Photoshop the usual editing conventions apply: pixels can be cut, copied or pasted and mistakes undone by using the Edit \Rightarrow Undo command (\Re Z ctr)Z), or by selecting a previous history state via the History panel. The \Re H ctr H keyboard shortcut can be used to hide an active selection, but note that on a Macintosh, the first time you use the \Re H keyboard shortcut, this opens the new dialog shown in Figure 1.41.

The Photoshop selection tools are mainly used to define a specific area of the image that you wish to modify, or have copied. The use of the selection tools in Photoshop is therefore just like highlighting text in a word processor program in preparation to do something with the selected content. In the case of Photoshop, you might want to make a selection to define a specific area of the image, so that when you apply an image adjustment or a fill, only the selected area is modified. Alternatively, you might use a selection to define an area you wish to copy and paste, or define an area of an image that you want to copy across to another image document as a new layer.

The marquee selection tool options include the rectangular, elliptical and single row/single column selection tools. In Figure 1.42 I have shown the elliptical marquee tool in use and below that, in Figure 1.43, an example of how you can use the *Shift* key to add to a rectangular marquee selection. The lasso tool can be used to draw freehand selection outlines and has two other modes: the polygon lasso tool, which can draw both straight line *and* freehand selections, plus the magnetic lasso tool, which is like an automatic freehand lasso tool that is able to auto-detect the edge you are trying to trace.

The quick selection tool is a bit like the magic wand tool as it can be used to make selections based on pixel color values; however the quick selection tool is a little more sophisticated than the standard magic wand and hence it has been made the default tool in this particular tool group. As you read through the book you'll see a couple of examples where the quick selection tool can be used to make accurate selections based on color, and how these can then be modified more precisely using the Refine Edge command. For full descriptions of these and other tools mentioned here don't forget to check out the *Photoshop CS5 for Photographers Help Guide* that is on the DVD.

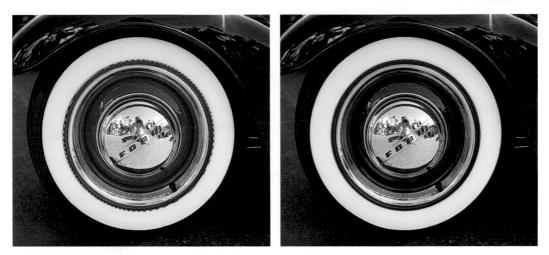

Figure 1.42 A selection can be used to define a specific area of an image that you wish to work on. In this example, I made an elliptical marquee selection of the inner tire wheel and followed this with an image adjustment to desaturate the red color.

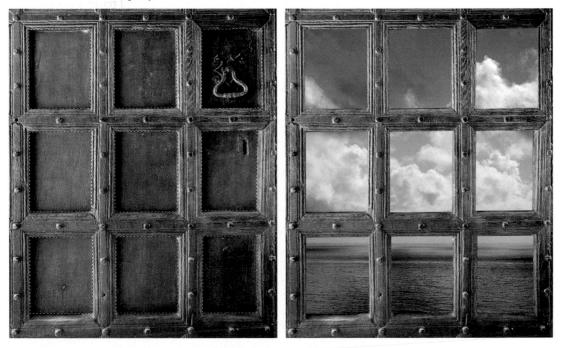

Figure 1.43 In this example I used the rectangular marquee tool to marquee one of the inner panels and followed this by holding down the *Shift* key to select more panels with the rectangular marquee. I deleted the selected areas and placed the cut-out image as a layer above a seascape image (see Figure 1.66 for an example of how Photoshop layers work).

Color Range tip

A Color Range selection tool can only be used to make discontiguous selections. However, it is possible to make a selection first of the area you wish to focus on and then choose Color Range to make a color range selection within the selection area.

Out-of-gamut selections

Among other things, you can use the Color Range command to make a selection based on out-of-gamut colors. This means you can use Color Range to make a selection of all the 'illegal' RGB colors that fall outside the CMYK gamut and apply corrections to these pixels only. To be honest, while Color Range allows you to do this, I don't recommend using Photoshop's out-ofgamut indicators to modify colors in this way. Instead, I suggest you read the section on soft proofing in Chapter 13.

Color Range

In the Photoshop Select menu you will see an item called 'Color Range', which is a color-based selection tool (Figure 1.44). While the quick selection and magic wand tools create selections based on luminosity, Color Range can be used to create selections that are based on similar color values. Some important new functionality was added to Color Range in Photoshop CS4 turning this into a very powerful selection making tool.

To create a Color Range selection, go to the Select menu, choose Color Range... and click anywhere in the image window (or Color Range preview area) to define an initial selection. To add colors to the selection, select the Add to Sample eyedropper and keep clicking to expand the selection area. To subtract from a selection, click on the Subtract from Sample eyedropper and click in the image to select the colors you want to remove from the selection. You can then adjust the Fuzziness slider to adjust the tolerance of the selection, which increases or decreases the number of pixels that are selected based on how similar the pixels are in color to the already sampled pixels.

If the Localized Color Clusters box is checked, Color Range can process and merge data from multiple clusters of color samples. As you switch between 'sampling colors to add to a selection' and 'selecting colors to remove', Photoshop calculates these clusters of color samples within a three-dimensional color space. As you add and subtract colors Photoshop produces a much more accurate color range selection mask based on the color sample data. When Localized Color Clusters is checked, the Range slider lets you determine which pixels are to be included based on how far or near a color is from the sample points that are included in the selection.

The selection preview options for the document window can be set to None (the default), Grayscale, a Matte color such as the White Matte example shown in Figure 1.45, or as a Quick Mask. Overall I find that Grayscale is a really useful preview mode if you want to get a nice large view in the document window of what the Color Range selection will look like – this is especially useful if you find the small Color Range dialog preview too small to judge from. This is just a brief introduction to the Color Range and you'll find a further example coming up later in Chapter 9.

Chapter 1 Photoshop fundamentals

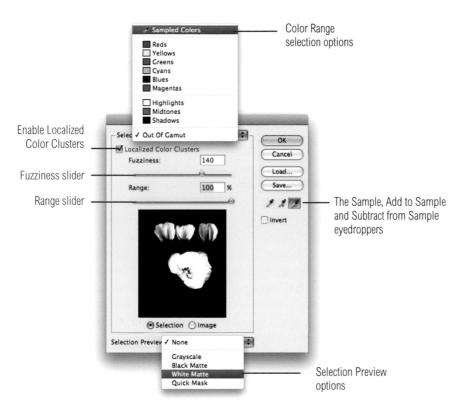

Figure 1.44 This shows the Color Range dialog with expanded menus that show the full range of options for the Color Range selection dialog.

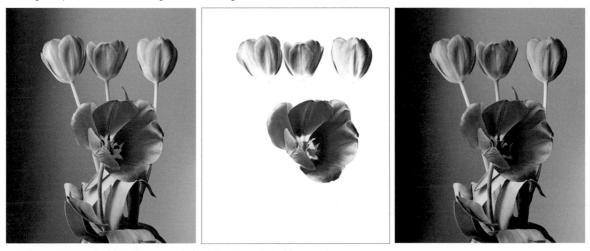

Figure 1.45 This shows a before image (left), Color Range White Matte preview (middle) and a color adjusted image (right), made using a Color Range selection.

Martin Evening Adobe Photoshop CS5 for Photographers

Figure 1.46 These composite screen shots show Quick Mask views of selections created by dragging out from the center with *Shift* held down (top), with all held down (middle) and *Shift* Shift all (bottom).

Modifier keys

Macintosh and Windows keyboards have slightly different key arrangements (hence the reason for me including double sets of instructions throughout the book), where the \Re key on the Macintosh is equivalent to the *ctrl* key on a Windows keyboard and the Macintosh \bigotimes key is equivalent to the *alt* key in Windows. Although on most Macintosh keyboards you'll find the Option key is labeled 'Alt' anyway (see Figure 1.47).

Windows users (and Mac users using a 'Mighty Mouse', or equivalent mouse) can use the right mouse button to access the contextual menus (Mac users can also use the *ctrl* key to access these menus) and, finally, the *Shift* key which is the same on both Mac and PC computers.

These keys are commonly referred to as 'modifier' keys, because they can modify tool behaviors. In Figure 1.46 you can see how if you hold down the *Shift* when drawing an elliptical marquee selection this constrains the selection to a circle. If you hold down **Shift** when drawing a marquee selection it centers the selection around the point where you first clicked on the image. If you hold down *Shift Shift alt* when drawing an elliptical marquee selection, this constrains the selection to a circle and centers the selection around the point where you first clicked. The Spacebar is a modifier key too in that it allows you to reposition a selection midstream.

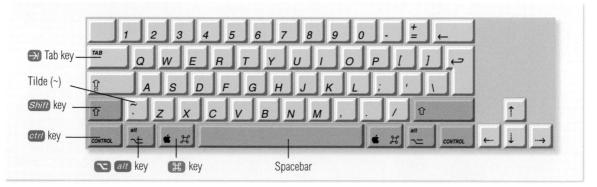

Figure 1.47 This shows the modifier keys (shaded in brown), showing both the Macintosh and Windows equivalent key names. The other keys commonly used in Photoshop are the Tab and Tilde keys, shown here shaded in blue.

Chapter 1 Photoshop fundamentals

After you have created an initial selection the modifier keys will behave differently. In Figure 1.48 you can see how if you hold down the *Shift* key as you drag with the marquee or lasso tool, this adds to the selection (holding down the *Shift* key and clicking with the magic wand tool also adds to an existing selection). If you hold down the **C** all key as you drag with the marquee or lasso tool, this subtracts from an existing selection (as does holding down the **C** all key and clicking with the magic wand tool). And the combination of holding down the *Shift* **C** *Shift* all keys together whilst dragging with a selection tool (or clicking with the magic wand) will create an intersection of the two selections. As well as using the above shortcuts, you will find there are also equivalent selection mode options in the Options bar for the marquee and lasso selection tools (see Figure 1.49).

Modifier keys can also be used to modify the options that are available elsewhere in Photoshop. For example, if you hold down the **S** *alt* key as you click on, say, the marquee tool in the Tools panel, you will notice how this allows you to cycle through all the tools that are available in this group. Whenever you have a Photoshop dialog box it is also worth exploring what happens to the dialog buttons when you hold down the **S** *alt* key. You will often see the button names change to reveal more options. Typically, the Cancel button changes to say 'Reset' when you hold down the **S** *alt* key.

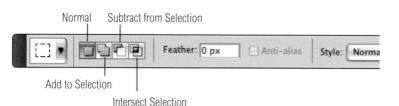

Figure 1.49 The Options bar has four modes of operation for each of the selection tools: Normal; Add to Selection; Subtract from Selection; and Intersect Selection. These are equivalent to the use of the modifier modes described in the main text when the tool is in Normal mode.

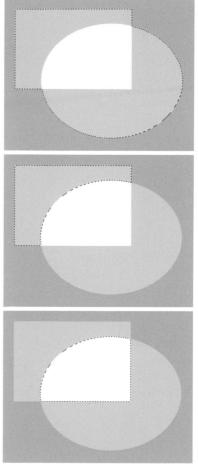

Figure 1.48 These composite screen shots show examples of selections that have been modified after the initial selection stage. The top view shows an elliptical selection combined with a rectangular selection with Shift held down, adding to a selection. The middle view shows an elliptical selection combined with a rectangular selection with Salt held down, which subtracts from the original selection. The bottom view shows an elliptical selection combined with a rectangular selection with Shift Shift at held down, which results in an intersected selection.

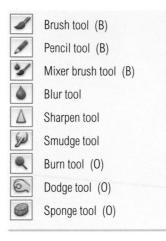

The new round brush presets

As mentioned in the main text, there are now just six round brush presets. These allow you to select hard or soft brushes with either no pressure-linked controls, the brush size linked to the amount of pressure applied, or brush opacity linked to the amount of pressure applied.

Tool Preset Picker

Painting tools

The next set of tools we'll focus on are the painting tools, which include: the brush, pencil, mixer brush, blur, sharpen, smudge, burn, dodge and sponge tools. These can be used to paint, or to edit the existing pixel information in an image. If you want to keep your options open, you will usually find it is preferable to carry out your paint work on a separate new layer. This allows you to preserve all of the original image on a base layer and you can easily undo all your paint work by turning off the visibility of the paint layer.

When you select any of the painting tools, the first thing you will want to do is to choose a brush, which you can do by going to the Brush Preset Picker (the second item from the left in the Options bar) and select a brush from the drop-down list shown in Figure 1.50. Here you can choose from the many different types of brushes, including the bristle shape brushes that are new to Photoshop CS5. The Size slider can be used to adjust the brush size from a single pixel to a 2500 pixel-wide brush and, if one of the standard round brushes is selected, you can also use the Hardness slider to set varying degrees of hardness for the brush shape. Note here that there are now only six round brush presets: soft round/hard round, soft round pressure size/hard round pressure size, and soft round opacity/hard round opacity.

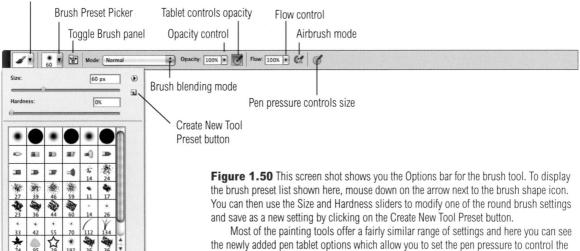

opacity and/or the size of the selected painting tool.

Chapter 1 Photoshop fundamentals

On-the-fly brush changes

Instead of visiting the Brush Picker every time you want to adjust the size or hardness of a brush, you will often find it is quicker to use the square bracket keys as described in Figures 1.51 and 1.52 to make such on-the-fly changes. Also, if you ctrl right mouseclick on the image you are working on, this opens the Brush Preset menu, directly next to the cursor. Click on the brush preset you wish to select and once you start painting, the Brush Preset menu closes (or alternatively, use the *esc* key). Note that if you are painting with a WacomTM stylus you can close this pop-up dialog by lifting the stylus off the tablet and squeezing the double-click button. If you ctrl Shift-click or right mouse Shift-click in the image while using a brush tool, this opens the blending mode list shown in Figure 1.53. These blend modes are like rules which govern how the painted pixels are applied to the pixels in the image below. For example, if you paint using the Color mode, you'll only alter the color values in the pixels you are painting.

Figure 1.51 There is no need to visit the Brush or Tool presets each time you want to change the size of a brush. You can use the right square bracket key **1** to make a brush bigger and the left square bracket key **1** to make it smaller.

Figure 1.52 You can combine the square bracket keys with the Shift key on the keyboard. You can use *Shift* 1 to make a round brush edge harder and use *Shift* 1 to make a round brush edge softer. Note that this only applies when editing one of the round brush presets.

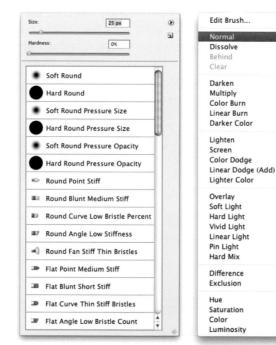

Non-rotating brushes

If you use the rotate tool to rotate the canvas, Photoshop CS5 now prevents the brushes from rotating too. You can continue to paint with the same brush orientation at all canvas rotation angles.

Brush preview overlay color

If you go to the Photoshop Cursors preferences you can customize the overlay color that's used for the brush preview.

Hue, brightness and saturation

When you use the key combination described here to access the HUD Color Picker, you can hold down the Spacebar to freeze the cursor position. You can then select a hue color from the hue wheel/strip, freeze the hue color selection and switch to select a brightness/saturation value.

On-screen brush adjustments

Providing you have the OpenGL option enabled in the Performance preferences. Photoshop offers you on-screen brush adjustments and a HUD (heads up display) Color Picker. If you hold down the *ctrl* keys (Mac), or the *alt* key and right-click (PC), dragging to the left makes the brush size smaller and dragging to the right, larger. Also, if you drag upwards this makes a round brush shape softer, while dragging downwards makes a round brush shape harder. Note here how the brush hardness is represented with a quick mask type overlay. If you hold down the *H ctrl* keys (Mac), or the alt Shift keys and right-click (PC), this opens the Heads Up Display Color Picker where, for as long as you have the mouse held down, you can move the cursor over the outer hue wheel or hue strip, to select a desired hue color, and then inside the brightness/saturation square to select the desired saturation and luminosity. The point where you release the mouse selects the new foreground color. Figure 1.54 shows examples of how the paint tool cursor looks for both the on-screen brush size/hardness adjustments and the Hue Wheel HUD Color Picker displays.

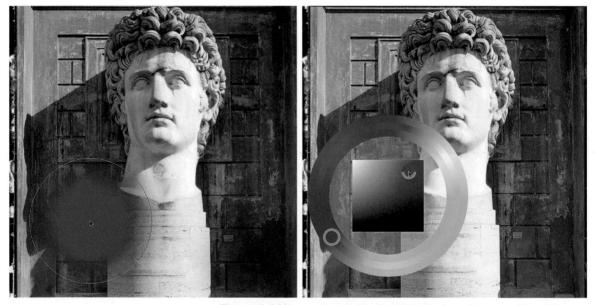

Figure 1.54 You can dynamically adjust the brush size and hardness of the painting tool cursors on-screen, or open the Heads Up Display Color Picker using the modifier keys described in the main text (providing OpenGL drawing is enabled). See Chapter 2 for more information on how to select alternative HUD display options.

Chapter 1 Photoshop fundamentals

Brush panel

Over in the Brush panel, if you click on the Brush Presets button (circled in Figure 1.56) this opens the Brush Presets panel listing the same brush presets list as shown in Figure 1.50. You can then append or replace these brush presets by going to the panel fly-out menu shown below and selecting a new brush settings group from the list.

So far we have looked at the Brush options that are used to determine the brush shape and size, but if you click on any of the brush attribute settings shown in Figure 1.56, the brush presets list changes to reveal the individual brush attribute options (see Figure 1.57). The brush attributes include things like how the opacity of the brush is applied when painting, or the smoothness of the brush. You can therefore start by selecting an existing brush preset, modify it, as in the Figure 1.55 example, and then click on the Create new brush button at the bottom to define this as a new custom brush preset setting.

Figure 1.55 In this example, I selected the Aurora brush preset and adjusted Size Jitter and Angle Jitter in the Shape Dynamics settings, linking both to the angle of the pen. I then set turquoise as the foreground color, purple for the background color and used a pen pressure setting to vary the paint color from the foreground to the background. I created the doodle shown here by twisting the pen angle as I applied the brush strokes.

Airbrush mode

If you are looking for the airbrush tool you'll find there is an Airbrush mode button in the Options bar for most of the paint tools.

Brush Presets	Size Jitter	0%
Brush Tip Shape	Control: Off	
Shape Dynamics	Minimum Diameter	
Scattering		1
] Texture	Tilt Scale	
🛛 Dual Brush 🛛 🛱		an providence of the
Color Dynamics	Angle Jitter	0%
🕈 Transfer 🛛 🛱	0	
Noise	Control: Off	•
Wet Edges	Roundness Jitter	0%
Airbrush	0	
Smoothing	Control: Off	
Protect Texture	Minimum Roundness	
	Flip X Jitter	🗌 Flip Y Jitter

Figure 1.57 If you click on a brush attribute setting in the list on the left, the right-hand side of the panel display the options that are associated with each attribute. Specific brush panel settings can be locked by clicking on the Lock buttons.

Brush panel options

The following notes and tips on working with the Brush panel will apply to most, but not all, of the painting tools. To create your own custom brush preset settings click on any of the brush attribute items that are listed on the left-hand side of the panel.

The Jitter controls introduce some randomness into the brush dynamics behavior. For example, increasing the Opacity Jitter means that the opacity will respond according to how much pen pressure is applied and there is a built-in random fluctuation to the opacity that varies more and more as the jitter value is increased. Meanwhile, the Flow Jitter setting governs the speed at which the paint is applied. To understand how the brush flow dynamics work, try selecting a brush and quickly paint a series of brush strokes at a low and then a high flow rate. When the flow rate is low, less paint is applied, but as you increase the flow setting more paint is applied. Other tools like the dodge and burn toning tools use the terms Exposure and Strength, but these essentially have the same meaning as the opacity controls. The Shape Dynamics can be adjusted to introduce jitter into the size angle and roundness of the brush and the scattering controls enable you to produce broad, sweeping brush strokes with a random scatter, while the Color Dynamics let you introduce random color variation to the paint color. The Foreground/Background color control that's included in this section lets you vary the paint color between the foreground and background color, according to how much pressure is applied (see Figure 1.55). The Dual Brush and Texture Dynamics can introduce texture and more interactive complexity to the brush texture (it is worth experimenting with the Scale control in the Dual Brush options) and the Texture Dynamics can utilize different blending modes to produce different paint effects. The new Transfer Dynamics allow you to adjust the dynamics for the buildup of the brush strokes - this relates particularly to the new ability to paint using wet brush settings.

Pressure sensitive control

If you are using a pressure sensitive pen stylus, you will see additional options in the Brush panel that enable you to link the pen pressure of the stylus to how the effects are applied. You can therefore use these options to determine things like how the paint opacity and flow are controlled by the pen pressure or by the angle of tilt or rotation of the pen stylus. But note also here that the tablet pressure controls can now also be controlled via the buttons in the Options bar for the various painting tools (I've highlighted these new tablet button controls in Figure 1.50).

Brush tool presets

When you have finished adjusting the Brushes panel dynamics and other settings, you can save combinations of the brush preset shape/size, Brushes panel attribute settings, plus the brush blending mode (and brush color even) as a new Brush tool preset. To do this, go to the Tool Presets panel and click on the New Preset button at the bottom (circled in Figure 1.58). Or, you can mouse down on the Tool Preset Picker in the Options bar and click on the New Brush setting button. Give the brush tool preset a name and click OK to append this to the current list. Once you have saved a brush tool preset, you can access it at any time via the Tool Presets panel or via the Tool Preset menu in the Options bar.

Mixer brush

The mixer brush is a new brush tool that allows you to paint more realistically in Photoshop. With the mixer brush you can mix colors together as you paint, picking up color samples from the image you are painting on, and set the rate at which the brush picks up paint from the canvas and the rate at which the paint dries out. The mixer brush can be used with the new bristle tips or with the traditional Photoshop brush tips (now referred to as 'static tips') to produce natural-looking paint strokes. The combination of the mixer brush and bristle tip brushes provide a whole new level of sophistication to the Photoshop paint engine. The only downside is that the user interface has had to become even more complicated. The brush controls are split between the Brush panel, the Brush Presets panel, the Options bar and the new Bristle preview. It's not particularly easy to pick up a brush and play with it unless you have studied all these brush options in detail and can understand how the user interface is meant to work. Fortunately, the Tool Presets panel can help here and the easiest way to get started is to select one or two of the new brush presets and experiment painting with these brush settings to gain a better understanding of what the new brush settings can do. In the meantime, let's take a look at the Options bar settings for the mixer brush that's shown in Figure 1.59.

Wacom[™] tablets

Photoshop is able to exploit all of the pressure responsive built-in Wacom[™] features. You will notice that as you alter the brush dynamics settings, the brush stroke preview below changes to reflect what the expected outcome would be if you had drawn a squiggly line that faded from zero to full pen pressure (likewise with the tilt and thumb wheel). This visual feedback is extremely useful as it allows you to experiment with the brush dynamics settings in the Brushes panel and learn how these affect the brush dynamics behavior.

Airbrush Soft Round 50% flow Aurora Aurora Chalk Build Up Chalk with Medium Heavy Flow Close Cross Hatch Fuzzy Cluster Loose Fuzzy Cesture Tool Small Current Tool Only		OL PRESETS	
Chalk Build Up Chalk with Medium Heavy Flow Close Cross Hatch Fuzzy Cluster Loose Fuzzy Gesture Tool Small	ŝ	Airbrush Soft Round 50% flow	1
Image: Chalk with Medium Heavy Flow Image: Close Cross Hatch Image: Close Cross Hatch Image: Fuzzy Cluster Loose Image: Fuzzy Cesture Tool Small	å	Aurora	
Close Cross Hatch Fuzzy Cluster Loose Fuzzy Cesture Tool Small	6	Chalk Build Up	
Fuzzy Cluster Loose Fuzzy Gesture Tool Small	6	Chalk with Medium Heavy Flow	v
/ Fuzzy Gesture Tool Small	0	Close Cross Hatch	
	1	Fuzzy Cluster Loose	
Current Tool Only	0	Fuzzy Gesture Tool Small	
	Ø	Current Tool Only	J)
		New Tool Preset	:
New Tool Preset	me:	Brush Tool Soft Round 65	ОК
		Include Color	Cance

Figure 1.58 The Tool Presets panel. When you click on the New Preset button (circled) this opens the New Tool Preset dialog, where you can save and name the current tool settings as a new tool preset.

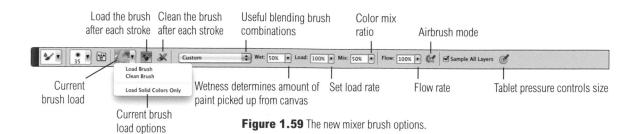

Figure 1.60 The Load swatch displays the main reservoir well color in the outer area and the pickup well color in the center. Clicking on the mixer brush current brush load swatch launches the Photoshop Color Picker.

Wet/Mix/Flow numeric shortcuts

Typing in a number changes the wetness value. Holding down the Shift all Shift keys while entering a number changes the Mix value. Lastly, holding down just the Shift key as you enter a number changes the Flow value. Note, you should type '00' to set any of the above values to zero.

Mixer brush presets

Sampled fill colors are retained whenever you switch brush tips or adjust the brush tip parameters. You can also include saving the main reservoir well and pickup well colors with mixer brush tool presets.

The mixer brush tool has two wells: a reservoir and a pickup. The reservoir well color is defined by the current foreground color swatch in the Tools panel or by C all-clicking in the image canvas area. This is the color you see displayed in the Load preview swatch. The pickup well is one that has paint flowing into it and continuously mixes the colors of where you paint with the color that's contained in the reservoir well. Clicking on 'Clean brush' from the 'Current brush load' options immediately cleans the brush and clears the current color, while clicking 'Load brush' fills with the current foreground color again. The 'Load brush after each stroke' button does what it says, it tells the mixer brush to keep refilling the pickup well with color and therefore the pickup well becomes progressively contaminated with the colors that are sampled as you paint. The 'Clean brush after each stroke' button empties the reservoir well after each stroke and effectively allows you to paint from the pickup well only (Figure 1.60 shows an example of how the well colors are displayed in the Options bar).

The Paint wetness controls how much paint gets picked up from the image canvas. Basically, when the wetness is set to zero the mixer brush behaves more like a normal brush and deposits opaque color. As the wetness is increased so is the streaking of the brush strokes. The 'Set load rate' is a dry-out control. This determines how much paint gets loaded into the main reservoir well. With low load rate settings you'll get shorter brush strokes where the paint dries out quickly and as the load rate setting is increased you get longer brush strokes.

The Mix ratio slider determines how much of the color picked up from the canvas (that goes into the pickup well) is mixed with the color stored in the main reservoir well. A high Mix ratio means more ink flows from the pickup to the reservoir well, while the Flow rate control determines how fast the paint flows as you paint. With a high Flow setting, more paint is applied as you paint. If you combine this with a low Load rate setting you'll notice how at a

Chapter 1 Photoshop fundamentals

high Flow setting the paint flows out quickly and results in shorter paint strokes. At a lower Flow rate you'll notice longer (but less opaque) brush strokes.

Bristle shapes

If you select one of the new bristle tip brush shapes you can click on the Brush Tip Shape option in the Brush panel (Figure 1.62) to reveal the Bristle Qualities options. These brush tips can be used in conjunction with any of the Photoshop painting tools. When a bristle tip (as opposed to a traditional 'static' Photoshop brush tip) is selected you can also click the Bristle preview button (circled in Figure 1.62) to display the floating Bristle preview panel shown in Figure 1.61. As you adjust the slider controls in the Brush panel the Bristle preview provides visual feedback as to how this affects the current bristle tip behavior.

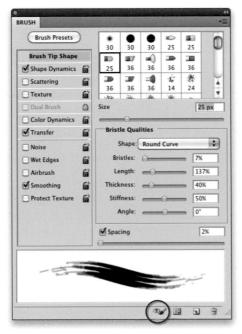

Figure 1.62 The Bristle tip Brush panel options. The Bristles slider determines the density of the number of bristles within the current brush size. The Length determines the length of the bristles relative to the shape and size of the selected brush. The Thickness determines the thickness of each bristle. The Stiffness controls the stiffness or resistance of the bristles. The Angle slider determines the angle of the brush position – this isn't so relevant for pen tablet users, but more so if you are using a mouse. Lastly, the Spacing slider sets the spacing between each stamp of the brush stroke.

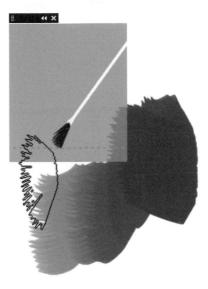

Figure 1.61 This shows the Bristle preview, which can be enabled by clicking on the button circled in Figure 1.62. It can be toggled in size, moved around the screen, or closed. The Brush preview can also be turned on or off via the View/Show menu (or use (H) ctrl(H). Shift-clicking and () all -clicking also affect the angle of the brush seen in the preview.

Dodge and burn tools

The dodge and burn tools were much improved in Photoshop CS4. However, you are still limited to working directly on the pixel data. If you do want to use the dodge and burn tools, I suggest you work on a copied pixel layer. Overall, I reckon you are better off using the Camera Raw adjustment tools to dodge and burn your images, or use the adjustment layers technique that is described in Chapter 5.

Neutral Density Gradient Tool Preset

I should mention that in Photoshop CS5 there is now a new Linear gradient preset called 'Neutral Density'. This uses a 60% opacity black to transparent with a Normal blend mode. You could use this to add a darkening gradient to the top of an image, but a darkening image adjustment masked by a linear gradient is still a more effective solution.

Tools for filling

The various shape tools, including the line tool, are really of most use to graphic designers who wish to create things like buttons or need to add vector shapes to a design layout. In Figure 1.63, you can see an example of how a filled, custom shape vector layer was placed above a pixel layer that had been filled with a gradient.

The paint bucket tool is another type of fill tool and is a bit like a combination of a magic wand selection combined with an Edit \Rightarrow Fill using the foreground color. As much as I like to ignore the paint bucket, I can be proved wrong. Recently, photographer Stuart Weston showed me how he used the paint bucket tool to add small filled patches of color to a large composite fashion advertising image – I have to say, the final image did look very good.

The gradient tool will certainly be of interest to photographers. For example, you can use the Adjustment layer menu to add gradient fill layers to an image. Gradient fill layers can be applied in this way to create gradient filter type effects. However, you will also find that the gradient tool comes in use when you want to edit the contents of a layer mask. For example, you can add a black to white gradient to a layer mask to apply a graduated fade to the opacity of a layer.

Figure 1.63 In this example I filled the background using the gradient tool in linear mode using the 'Chrome' preset. The sun was added as a custom shape layer filled with a solid pale yellow color, to which I added an outer glow layer style effect.

Tools for drawing

If you want to become a really good retoucher, then you are at some stage going to have to bite the bullet and learn how to use the pen tools. The selection tools are fine for making approximate selections, but whenever you need to create precision selections or masks the pen tools are essential, as I have shown below in Figure 1.64.

The pen tool group includes the main pen tool, a freeform pen tool (which in essence is not much better than the lasso or magnetic lasso tools) plus modifier tools to add, delete or modify the path points. There are several examples coming up in Chapter 9 where I will show how to use the pen tools to draw a path.

Figure 1.64 If you need to isolate an object and create a cut-out like the one shown here, the only way to do this is by using the pen and pen modifier tools to first draw a path outline. You see, with a photograph like this, there is very little color differentiation between the object and the background and it would be very difficult for an auto masking tool to accurately predict the edges in this image. So I timed myself and it only took 8 minutes to draw the path outline that was used to create the cut-out shown on the right.

tool (B)

督	Crop tool (C)
▶.	Move tool (V)
0	Eraser (E)
1	Magic eraser (E)
2	Background eraser (E)
2	Clone stamp (S)
2	Pattern stamp (S)
	Spot healing brush (J)
P	Healing brush (J)
#	Patch tool (J)
+0	Red eye tool (J)
1	Color replacement tool

Image editing tools

Starting from the top, we have the crop tool that can be used to trim pictures or enlarge the canvas area. This tool, by the way, now features two new crop preview options: a Rule of Thirds and a Grid mode (you can read more about these in the Image editing essentials chapter). The eraser tools are still there should you wish to erase the pixels directly, although these days it is more common to use layer masks to selectively hide or show the contents of a layer. The background eraser and magic eraser tools do offer some degree of automated erasing capabilities, but I would be more inclined to use the quick selection tool combined with a layer mask for this type of masking.

The clone stamp tool has been around since the beginning of Photoshop and is definitely an essential tool for all kinds of retouching work. You can use the clone stamp to sample pixels from one part of the image and paint with them in another (as shown in Figure 1.65). The clone stamp tools were joined a few years back by the healing brush and patch tool. The healing brush can be used in almost exactly the same way as the clone stamp, except it cleverly blends the pixels around the edges where the healing brush retouching is applied, to produce almost flawless results. The patch tool is similar to the healing brush except you first use a selection to define the area to be healed. The spot healing brush is rather clever because you don't even need to set a sample point: you simply click and paint over the blemishes you wish to see removed. This tool has now been enhanced with a contentaware healing mode that allows you to tackle with real ease what were once really tricky subjects to retouch.

Providing you use the right flash settings on your camera it should be possible to avoid red eye from ever occurring in your flash portrait photographs. But for those times when the camera flash leaves your subjects looking like beasts of the night, the red eye tool provides a fairly basic and easy way to auto-correct such photos. Meanwhile, the color replacement brush is kind of like a semi-smart color blend mode painting tool that analyzes the area you are painting over and replaces it with the current foreground color, using either a Hue, Color, Saturation or Luminosity blend mode. It is perhaps useful for making quick and easy color changes without needing to create a Color Range selection mask first.

Photoshop fundamentals

Chapter 1

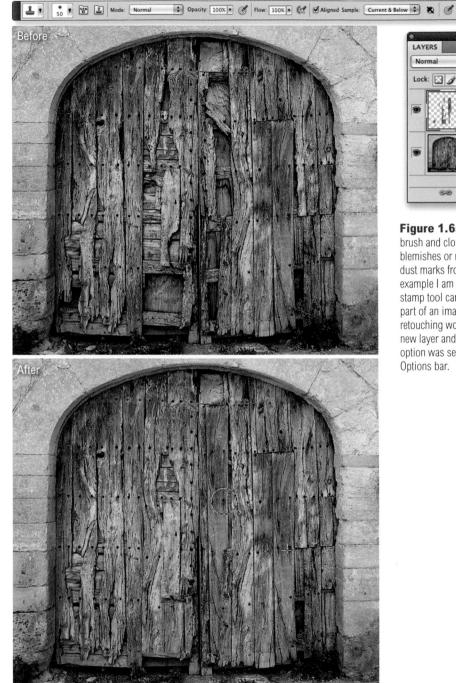

Figure 1.65 I mostly use the healing brush and clone stamp tools to retouch small blemishes or remove any remaining sensor dust marks from my photographs. In this example I am able to show how the clone stamp tool can be used to paint detail from one part of an image onto another. Note how the retouching work here is applied to an empty new layer and the Sample: 'Current & Below' option was selected in the clone stamp tool Options bar.

Blending modes

Layers can be made to blend with the layers below them using any of the 27 different blending modes that are in Photoshop. Layer effects/styles allow you to add effects such as drop shadows, gradient/pattern fills or glows to any layer, plus custom layer styles can be loaded from and saved to the Styles panel.

Drag and drop layers

New to Photoshop CS5 is the ability to drag and drop a file to a Photoshop document and place it as a new layer.

Figure 1.66 The above Layers panel view shows the layer contents of a typical layered Photoshop image and the diagram on the right shows how these layers are used to build a composite photograph that's made up of all these layers.

Working with Layers

Photoshop layers allow you to edit a photograph by building up the image in multiple layered sections, such as in the example shown below in Figure 1.66. A layer can be an image element, such as a duplicated background layer, a copied selection that's been made into a layer, or content that has been copied from another image, or you can have text or vector shape layers. You can also add adjustment layers which are like image adjustment instructions applied in a layered form.

Layers can be organized into layer group folders, which makes the layer organization easier to manage, and you can also apply a mask to the layer content using either a pixel or vector layer mask. You will find there are plenty of examples throughout this book in which I show you how to work with layers and layer masks.

Chapter 1 **Photoshop fundamentals**

Automating Photoshop

Why spend any more time than you have to performing repetitive tasks, when Photoshop is able to automate these processes for you? For example, the Actions panel will let you load and save Photoshop actions, which are basically recorded Photoshop steps. Figure 1.67 shows a screen shot of the Actions panel, where it is shown displaying an expanded view of the Default Actions set. As you can see from the descriptions, these actions can perform automated tasks such as add a vignette to a photo or create a wood frame edge effect. OK, these are not exactly the sort of actions you would use every day, but if you go to the panel fly-out menu and select Load Actions... you will be taken to the Photoshop CS5/ Presets/Photoshop Actions folder. Here you will find lots of useful actions that are worth installing. By saving and loading actions it is easy to share favorite Photoshop recipes with other users – all you have to do is to double-click an action icon to automatically install it in the Actions panel, and if Photoshop is not running at the time, this also launches the program.

To run an action, you will usually need to have a document of images. You can also go to the File \Rightarrow Automate menu and choose 'Create Droplet...'. Droplets are like self-contained batch action operations located in the Finder/Explorer. All you have to do is drag an image file to a droplet to initiate a Photoshop action process (see Figure 1.68). I will be explaining later in Chapter 15

Figure 1.68 With Photoshop droplets you can apply a batch action operation by simply dragging and dropping an image file or a folder of images onto a droplet that has been saved to the Finder/Explorer.

Make 1024x768

1024x768 folde

Tiff folde

Figure 1.67 The Actions panel.

Nudging layers and selections

The keyboard arrow keys can be used to nudge a layer or selection in 1 pixel increments, or 10 pixel increments when the *Shift* key is held down. A series of nudges count as a single Photoshop step in history and can be undone with a single undo (#2 *ctrl C*) or a step back in history.

Move tool

The move tool can perform many functions such as move the contents of a layer, directly move layers from one document to another, copy layers, apply transforms, plus select and align multiple layers. In this respect the move tool might be more accurately described as a move/transform/alignment tool. The move tool can also be activated any time another tool is selected simply by holding down the *H ctrl* key (except for when the slice tools, hand tool, pen or path selection tools are selected). If you hold down the **C** alt key while the move tool is selected, this lets you copy a layer or selection contents. It is also useful to know that using **C** all plus **H** ctrl (the move tool shortcut) lets you make a copy of a layer or selection contents when any other tool is selected (apart from the ones I just listed). If the Show Transform Controls box is checked in the move tool Options bar (Figure 1.69), a bounding box will appear around the bounds of the selected layer, and when you mouse down on the bounding box handles to transform the layer, the Options bar switches modes to display the numeric transform controls.

▶ ♥ ♥ ♥ Alto-Select: Group ♦ □ Show Transform Controls 한글라고 입음을 품금을 타야하네 하

Auto layer/layer group selection

When the move, marquee, lasso or crop tool are selected, a **H c***trl ctrl alt* + right mouse-click selects a target layer based on the pixels where you click. When the move tool only is selected, **H c***trl alt* -click selects a layer group based on the pixels where you click.

Group or layer

The move tool Options panel contains a menu that allows you to choose between 'Group' or 'Layer' auto-selection. When 'Layer' is selected, Photoshop only autoselects individual layers, but when 'Group' is selected, Photoshop can auto-select whole layer groups. Figure 1.69 The move tool Options bar with the Auto-Select layer option checked.

Layer selection using the move tool

When the move tool is selected, dragging with the move tool moves the layer or image selection contents (the cursor does not have to be centered on the object or selection, it can be anywhere in the image window). However, when the Auto-Select Layer option is switched on (circled in Figure 1.69), the move tool auto-selects the uppermost layer containing the most opaque image data below the cursor – this can be useful when you have a large numbers of image layers stacked up. Multiple layer selection is also possible with the move tool, because when the move tool is in Auto-Select Layer mode you can marquee drag with the move tool from outside the canvas area to select multiple layers, the same way as you can make a marquee selection using the mouse cursor to select multiple folders or documents in the Finder/Explorer (see Figure 1.70). It is also worth noting that if you have the move tool selected and the Auto-Select Layer option is unchecked, holding down **H** *ctrl* temporarily inverts the state of the move tool to Auto-Select Layer mode.

Where you have many layers that overlap, remember there is a contextual mode for the move tool that can help you target specific layers (use *ctrl*) right mouse-click to access the contextual layer menu). Any layer with an opacity greater than 50% will show up in the contextual menu. This then allows you to select a specific layer from below the cursor.

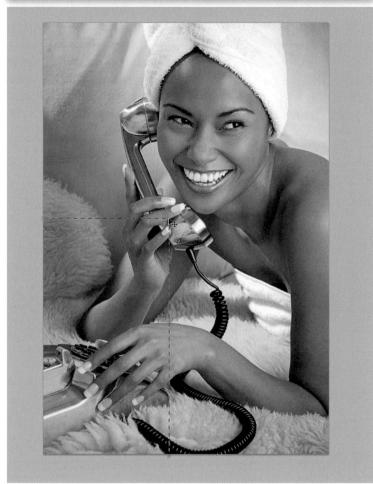

Figure 1.70 When the move tool is selected and the Auto-Select box is checked, you can marquee drag with the move tool from outside of the canvas area inwards to select specific multiple layers. If the Auto-Select Layer option is deselected, you can instead hold down the **St ctrl** key to temporarily switch the move tool to the 'Auto-Select' mode.

Align/Distribute layers

When several layers are linked together, you can click on the Align and Distribute buttons in the Options bar as an alternative to navigating via the Layer ⇒ Align Linked and Distribute Linked menus (see Chapter 9 for more about the Align and Distribute commands).

Layer selection shortcuts

Client: ET Nail Art Model: Susannah @ Storm Makeup: Camilla Pascucci

S	Hand tool (H)
5	Rotate View tool (R)
Q	Zoom tool (Z)
8	Eyedropper tool (I)
*	Color sampler tool (I)
لتتتنآ	Ruler tool (I)
¹ 2 ³	Count tool (I)
	Notes tool (I)

8-bit +, X :	15.43	8-bit	
	12.88		
#1 R : G : B :	235 227 205	#2 R: # G: B:	108 129 38
Doc: 70.7M	/70.7M	1	

Figure 1.71 The Info panel showing an eyedropper color reading, a measurement readout plus two color sampler readouts below.

Figure 1.72 This shows the Open GL evedropper wheel. The outer gray circle is included to help you judge the inner circle colors more effectively. The top half shows the current selected color and the bottom half, the previous selected color. The sample ring display can be disabled in the eyedropper options.

Navigation and information tools

To zoom in on an image, you can either click with the zoom tool to magnify, or drag with the zoom tool, margueeing the area you wish to inspect in close-up. This combines a zoom and scroll function in one (a plus icon appears inside the magnifying glass icon). To zoom out, just hold down the **C** all key and click (the plus sign is replaced with a minus sign). You can also zoom in by holding down the Spacebar + the **H** key (Mac) or the *ctrl* key (PC). You can then click to zoom in and you can also zoom out by holding down the Spacebar + the C key (Mac) or the alt key (PC). This keyboard shortcut calls up the zoom tool in zoom out mode and you can then click to zoom out.

When you are viewing an image in close-up, you can select the hand tool from the Tools panel (**H**) and drag to scroll the image on the screen, plus you can also hold down the Spacebar at any time to temporarily access the hand tool (except when the type tool is selected). The hand and zoom tools also have another navigational function. You can double-click the hand tool icon in the tools panel to make an image fit to screen and double-click the zoom tool icon to magnify an image to 100%. There are also further zoom control options in the zoom tool Options bar (Figure 1.73).

The eyedropper tool can be used to measure pixel values directly from a Photoshop document and these values are displayed in the Info panel shown in Figure 1.71. Photoshop CS5 now also features a new Heads Up Display, which I have described in Figure 1.72. The color sampler tool can be used to place up to four color samplers in an image to provide persistent readouts of the pixel values, which is useful for those times when you need to closely monitor the pixel values as you make image adjustments.

The ruler tool can be used to measure distance and angles in an image and, again, this data is displayed in the Info panel. But note that the count tool is only available in the extended version and is perhaps more useful to those working in areas like medical research where, for example, you can use the count tool to count the number of cells in a microscope image.

🔍 🕈 👰 🖉 Resize Windows To Fit 🗆 Zoom All Windows 🖉 Scrubby Zoom 🛛 Actual Pixels) (Fit Screen) (Fill Screen) (Print Size

Figure 1.73 You can use the Zoom tool Options bar buttons to adjust the zoom view. If OpenGL is enabled 'Scrubby Zoom' will be checked. This overrides the marguee zoom behavior - dragging to the right zooms in and dragging to the left zooms out. Personally, I prefer to keep this option deselected.

Flick panning

With OpenGL enabled in the Photoshop Performance preferences, you can also check the 'Enable Flick Panning' option in the General preferences (see page 101). When this option is activated, Photoshop will respond to a flick of the mouse pan gesture by continuing to scroll the image in the direction you first scrolled, taking into account the acceleration of the flick movement. When you have located the area of interest just click again with the mouse to stop the image from scrolling any further.

Bird's-eye view

Another OpenGL option is the Bird's-eye view feature. If you are viewing an image in a close-up view and hold down the *H* key as you click with the mouse and hold, the image view swiftly zooms out to fit to the screen and at the same time shows an outline of the close-up view screen area (a bit like the way the Navigator panel view works). With the *H* key and mouse key still held down, you can click and drag to reposition the close-up view outline, release the mouse and the close-up view will re-center to the newly selected area in the image (see Figure 1.74).

Figure 1.74 If a window document is in OpenGL mode and in a close-up view, you can hold down the **(F)** key and click with the mouse to access a bird's-eye view of the whole image. You can then drag the rectangle outline shown here to scroll the image and release to return to a close-up of the image centered around this new view.

More zoom keyboard shortcuts

Traditionally, the # ~ 0 ctrl alt 0 shortcut is used to zoom to a 100% pixels view and the # 0 ctrl 0 shortcut is used to zoom out to a fit to view zoom view. Photoshop now also uses the **H** *ctrl* **1** shortcut to zoom to 100%. This was first implemented in CS4 in order to unify the window document zoom controls across all of the Creative Suite applications. As a consequence of this, the channel selection shortcuts have been shifted along two numbers. **# 2** *ctrl* **2** selects the composite channel, **H** 3 *ctrl* 3 selects the Red channel, **H 4** *ctrl* **4** the Green channel and so on. The Tilde key has also changed use. Prior to CS4 (#) ~ ctrl selected the composite color channels (after selecting a Red, Green or Blue channel). It now toggles between open window documents. Another handy zoom shortcut is # + ctrl + to zoom in and \Re - ctrl - to Zoom out (note the 🛃 key is really the 🚍 key). If your mouse has a wheel and 'Zoom with Scroll Wheel' is selected in the preferences, you can use it with the call key held down to zoom in or out. If OpenGL is enabled you can carry out a continuous zoom by simply holding down the zoom tool (and use **C** alt to zoom out). If you have a recent Macintosh Pro Laptop, CS5 supports two-fingered zoom gestures such as drawing two fingers together to zoom in and spreading two fingers apart to zoom out.

Windows 7 Multi-touch support

If you are using Windows 7 operating system and have multi-touch aware hardware, CS5 now supports touch zoom in and out, touch pan/flicking as well as touch canvas rotation.

Rotate view shortcut

The rotate view tool uses the **R** keyboard shortcut, which was previously assigned (before CS4) to the blur/sharpen/sponge tool set. I reckon this has been generally accepted as a positive move, but you can if desired, use the Keyboard Shortcuts menu described on page 23 to reassign the keyboard shortcuts to whichever scheme you prefer.

Rotate view tool

If OpenGL is enabled in the Performance preferences, you can use the rotate view tool to rotate the Photoshop image canvas (as shown below in Figure 1.75). Having the ability to quickly rotate the image view can sometimes make it easier to carry out certain types of retouching work, rather that be forced to draw or paint at an uncomfortable angle. To use the rotate view tool, first select it from the Tools panel (or use the **R** keystroke) and click and drag in the window to rotate the image around the center axis. As you do this, you will see a compass overlay that indicates the image position relative to the default view angle (indicated in red). This can be useful when you are zoomed in close on an image. To reset the view angle to 'Normal' again, just hit the **esc** key or click on the Reset View button in the Options bar.

Photograph: Eric Richmond.

Figure 1.75 This shows the rotate view tool in action.

Notes tool

The notes tool is handy for adding sticky notes to open images. Open note windows were removed in CS4 and Photoshop instead now uses a Notes panel (Figure 1.76) to store recorded note messages. This method makes the notes display and management easy to control. I use this tool quite a lot at work, because when a client calls me to discuss a retouching job, I can open the image, click on the area that needs to be worked on and use the Notes panel to type in the instructions for whatever further retouching needs to be done to the image (often with the receiver in one hand and me typing with the other!) If the client you are working with has Photoshop, they can use the notes feature to mark up images directly, which when opened in Photoshop can be inspected as shown in Figure 1.77 below.

here on th	e loose fly-awa e right.]	iy nair stra	nas seen	
	2/3			

Figure 1.76 The Notes panel.

Figure 1.77 This shows an example of the notes tool being used to annotate an image.

Client: Gallagher Horner. Model: Veronica at M&P

Full screen view mode

The Full screen mode with menu bar and Full Screen modes are usually the best view modes for concentrated retouching work. These allow full movement of the image, not limited by the edges of the document bounds. In other words, you can scroll the image to have a corner centered in the screen and edit things like path points outside the bounds of the document. Also note that the F key can be used to cycle between screen modes and Shift F to cycle backwards.

Figure 1.78 This shows examples of two of the three screen view modes for the Photoshop interface. Here you can see the Standard Screen Mode view (top) and Full Screen Mode with Menu Bar (bottom). The absolute Full Screen mode, which isn't shown here, displays the image against a black canvas and with the menus and panels hidden.

Screen view modes

In Figure 1.78 I have highlighted the Application bar screen view mode options, which allow you to switch between the three main screen view modes. The standard screen view displays the application window the way it has been shown in all the previous screen shots and lets you view the document windows as floating windows or tabbed to the dock area. In Full Screen Mode with Menu Bar, the frontmost document fills the screen, while allowing you to see the menus and panels. Lastly, the Full screen view mode displays a full screen view with the menus and panels hidden.

Preset Manager

The Preset Manager lets you manage all your presets from within the one dialog. The Preset Manager can keep track of: Brushes, Swatches, Gradients, Styles, Patterns, Layer effect contours and Custom shapes. For example, Figure 1.79 shows how you can use the Preset Manager to edit a current set of Tool presets. You can append or replace an existing set of presets via the 'Preset Manager' options, and the Preset Manager can also be customized to display the preset information in different ways, such as in the Figure 1.80 example, where I used a Large List to display large thumbnails of all the currently loaded Gradients presets.

Preset Type: Tools		Done
Healing Brush 21 pixels	🗭 Art History Brush 20 pixels	
Magnetic Lasso 24 pixels	Circular Rainbow	Load
🛱 Crop 4 inch x 6 inch 300 ppi	LeDyed Impressionist 25 pixels	Save Set.
Crop 5 inch x 3 inch 300 ppi		
🛱 Crop 5 inch x 4 inch 300 ppi	# Paintbrush Oval 45 pixels Multiply	(Rename.
Crop 5 inch x 7 inch 300 ppi	🖋 Transparent Red Spray Paint	Delete
Crop 8 inch x 10 inch 300 ppi	Sackground Eraser 30 pixels	Delete
Fill with Bubbles Pattern	Desaturate 13 pixels	
T Horizontal Type Tool Myriad Pro Regular 24		
T Vertical Type Tool Myriad Pro Regular 24 pt		
S Point White Star		
/ 0.5 cm Black Arrow		
😹 Starburst Color Target		
🗊 Starburst Color Target		

Figure 1.79 You can use the Photoshop Preset Manager to load custom settings or replace them with one of the pre-supplied defaults. Presets include: Brushes, Swatches, Gradients, Styles, Patterns, Contours, Custom Shapes and Tools.

Preset Type: Gradients	Text Only
Foreground to Background	Small Thumbnail Large Thumbnail
Foreground to Transparent	Small List
Black, White	V Large List
	Reset Gradients
Red, Green	Replace Gradients
Violet, Orange	Color Harmonies
Blue, Red, Yellow	Color Harmonies 2 Metals
Blue, Yellow, Blue	Neutral Density Noise Samples
Orange, Yellow, Orange	Pastels Simple
Violet, Green, Orange	Special Effects
	▼ Spectrums

Figure 1.80 Apart from being able to load and replace presets, you are able to choose how the presets are displayed. In the case of Gradients, it is useful to be able to see a thumbnail preview alongside the name of the gradient.

Saving presets as Sets

As you create and add your own custom preset settings, you can manage these via the Preset Manager. For example, this means that you can select a group of presets and click on the Save Set... button to save these as a new group of presets. The thing to be aware of here is that tool preset settings can easily get deleted when you update or reinstall Photoshop. So by saving out custom-edited sets of Brush or Tool presets settings, it is then easy to reload these later as you need them.

Loading presets

If you double-click any Photoshop setting that is outside the Photoshop folder, this automatically loads the Photoshop program and appends the preset to the relevant section in the Preset Manager.

History brush (Y) Art history brush (Y)

HIST	TORY		+=
N	2	_P2E7125.dng	
		Open	-
	D	Levels 1 Layer	
1	自	Master Opacity Change	
-		Black & White I Layer	

Figure 1.81 A previous history step can be selected by clicking on the history step name in the History panel. In its default configuration, you will notice how when you go back in history, the history steps that appear after the one that is selected will appear dimmed. If you have moved back in history, and you then make further edits to the image, the history steps after the selected history step will become deleted. However, you can change this behavior by selecting Allow Non-linear History in the History panel options (see Figure 1.82).

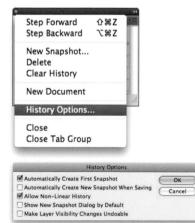

Figure 1.82 The History Options are accessed via the History panel fly-out menu. These allow you to configure things like the Snapshot and Non-linear history settings. I usually have the 'Allow Non-Linear History' option checked, as this enables me to use the History feature to its full potential (see page 67).

History

The History feature was first introduced in Photoshop 5.0 and back then it was considered a real breakthrough feature. This was because, for the first time, Photoshop was able to offer multiple undos during a single Photoshop editing session. History can play a really important role in the way you use Photoshop, so I thought this would be the best place to describe this feature in more detail and explain how history can help you use Photoshop more efficiently.

As you work on an image, Photoshop is able to record a history of the various image states as steps, which can be viewed in the History panel (Figure 1.81). If you want to reverse a step, you can still use the conventional Edit \Rightarrow Undo command (\Re Z *ctrl* Z), but if you visit the History panel, you can go back as many stages in the edit process as you have saved history steps. History steps can also be saved as Snapshots, which temporarily prevents them from slipping off the end of the list and becoming deleted as more history steps are created. One can therefore look at history as a multiple undo feature in which you can reverse through up to 1000 image states. However, it is actually a far more sophisticated tool than just that. For example, there is a 'non-linear history' option for multiple history path recording (see the History Options dialog in Figure 1.82) and a history source column that allows you to select a history state to sample from when working with the history brush. Painting from history can save you from tedious workarounds like having to create more layers than are really necessary in order to preserve fixed image states that you can sample from. With history you don't have to do that and by making sensible use of the Snapshots feature, you can keep the number of layers that are needed to a minimum.

The History panel

The History panel displays the sequence of Photoshop steps that have been applied during a Photoshop session and its main purpose is to let you manage and access the history steps recorded by Photoshop. To revert to a previous step, drag the slider up the list of history steps or, alternatively, you can click directly on a specific history step. For example, in Figure 1.81 I carried out a simple one-step undo by clicking on the one but last history step.

	Preference	ces	CONSTRUCTION OF CONSTRUCTION
Ceneral Interface File Handling Performance Cursors Transparency & Gamut Units & Rulers Cuides, Crid & Slices Plug-Ins Type 3D	Performance Memory Usage Available RAM: 11568 MB Ideal Range: 6362–8329 MB Let Photoshop Use: 8098 MB (70%) +	History & Cache Optimize Cache Levels and Tile Size for documents that are: Tall and Thin Default Big and Flat History States: 20 • Cache Levels: 4 • Cache Levels: 4 • Cache Tile Size: 128K ‡ Cache Tile Size: 128K ‡	OK Cancel Prev Next
	Scratch Disks Active? Drive Free Space Information Active? Drive Free Space Information RAID S25.86CB Active? All S25.86CB Active? All S25.86CB Active? All S25.86CB Active? Drive 3 1212.87CB Active? All S26.81CB Active? Drive 3 1212.87CB Active 3 1212.87CB Active? Drive 3 1212.87CB Active 3 1212	CPU Settings Detected Video Card: NVIDA CeForce 7300 CT OpenCL Engine Enable OpenGL Drawing (Advanced Settings)	

Figure 1.83 The number of recorded history states can be set via the History & Cache section of the Performance preferences dialog.

History settings and memory usage

When the maximum number of recordable history steps has been reached, the earliest history step at the top of the list is discarded. With this in mind, the number of recorded histories can be altered via the Photoshop Performance preferences (Figure 1.83). Note that if you reduce the number of history states (or steps) allowed, any subsequent action will immediately cause all earlier steps beyond this new limit to be discarded. To set the options for the History panel, mouse down on the fly-out menu and select History Options... (Figure 1.82). I'll come on to the Snapshot settings shortly, but at this stage you may want to consider enabling 'nonlinear' history. This will allow you to select a previous history step, but instead of undoing those steps between the earlier state and the latest and deleting them, non-linear history allows you to shoot off in a new direction and still preserve all the original history steps. 'Make Layer Visibility Changes Undoable' makes switching layer visibility on or off a recordable step in history, although this can be annoying when turning the layer visibility on or off prevents you from using undo/redo to undo the last Photoshop step.

Figure 1.84 This picture shows the underlying tiled structure of a Photoshop image. This is the clue to how history works as economically as possible. The history stores the minimum amount of data necessary at each step in Photoshop's memory. So if only one or two tile areas are altered by a Photoshop action, only the data change in those tiles is recorded.

History stages	Scratch disk
Open file	461 MB
Levels adjustment	721 MB
16 bit to 8 bit	945 MB
Healing brush	986 MB
Healing brush	998 MB
Healing brush	1010 MB
Marquee selection	982 MB
Feather selection	1011 MB
Inverse selection	1010 MB
Add adjustment layer	1140 MB
Flatten image	1110 MB

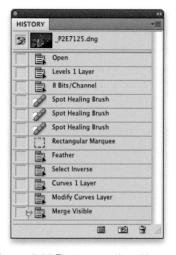

Figure 1.85 The accompanying table shows how the scratch disk usage can fluctuate during a typical Photoshop session. The image I opened here was 95 MB in size and 3 GB of memory was allocated to Photoshop. The scratch disk overhead is usually quite big at the beginning of a Photoshop session, but notice how there was little proportional increase in scratch disk size with each added history step.

Conventional wisdom would suggest that a multiple undo feature is bound to tie up vast amounts of scratch disk space to store all the previous image steps. However, proper testing of history indicates that this is not really the case. It is true that a series of global Photoshop steps may cause the scratch disk usage to rise, but localized changes will not. This is because the history feature makes clever use of the image cache tiling structure to limit any unnecessary drain on the memory usage. Essentially, Photoshop divides an image up into tiled sections and the size of these tiles can be set in the Performance preferences (see Chapter 2 for advice on how to optimize the cache tile size). Because of the way Photoshop images are tiled, the History feature only needs to memorize the changes that take place in each tile. If a brush stroke takes place across two image tiles, only the changes taking place in those tiles need to be updated (Figure 1.84). If a global change takes place, such as a filter effect, the whole of the image area is updated and the scratch disk usage rises accordingly. A savvy Photoshop user will want to customize the History feature to record a reasonable number of histories, while at the same time be aware of the need to change this setting if the history usage is likely to place too heavy a burden on the scratch disk. The Figure 1.85 example demonstrates that successive histories need not consume an escalating amount of memory. After the first adjustment layer had been added, the successive adjustment layers had little impact on the scratch disk usage (only the screen preview was being changed). The healing brush work only affected the tiled sections and by the time I got to the 'flatten image' stage the scratch disk/memory usage had begun to bottom out.

If the picture you are working with is exceptionally large, then having more than one undo can be both wasteful and unnecessary, so you should perhaps consider restricting the number of recordable history states. On the other hand, if multiple history undos are well within the scratch disk memory limits of your system, then make the most of them. If excessive scratch disk usage does prove to be a problem, the Purge History command in the Edit \Rightarrow Purge menu provides a useful way to keep the scratch disk memory usage under control. Above all, remember that the History feature is not just there as a mistake correcting tool, it has great potential for mixing composites from previous image states.

Chapter 1 Photoshop fundamentals

History brush

The history brush can be used to paint from any previous history state. To do this you need to leave the current history state as it is and select a source history state for the history brush by clicking the box in the column next to the history step you wish to sample from. In Figure 1.86 you can see how I set the Levels history step as the history source (the small history brush icon indicates which history step or snapshot is currently being used as the source). I was then able to paint with the history brush from this previous history state. The history brush therefore allows you to selectively restore the previously held image information as desired. In the Figure 1.86 example I was able to use the history brush to paint over the areas that had been worked on with the healing brush and use the history brush to restore those parts of the picture back to the previous Levels adjusted history state.

Use of history versus undo

As you will have seen so far, the History feature is capable of being a lot more than a repeat Edit \Rightarrow Undo command. Although the History feature is sometimes described as a multiple undo, it is important not to confuse Photoshop history with the role of the Undo command. For example, there are a number of Photoshop procedures that are *only undoable* through using the Edit \Rightarrow Undo command, like intermediate changes made when setting the shadows and highlights in the Levels dialog. Plus there are things which can be undone using Edit \Rightarrow Undo that have nothing to do with Photoshop's history record for an image. For example, if you delete a swatch color or delete a history state, these actions are only recoverable by using Edit \Rightarrow Undo. The Undo command is also a toggled action – this is because the majority of Photoshop users like having the ability to switch quickly back and forth to see a before and after version of the image. The current combination of having Undo commands and a separate History feature has been carefully planned to provide the most flexible and logical approach. History is not just an 'Oh I messed up. Let's go back a few stages' feature, the way some other programs work; it is a tool designed to ease the workflow and provide you with extra creative options in Photoshop. A key example of this is the Globe Hands image that was created by Jeff Schewe. The story behind this image and it's influence on the History feature is told in Figure 1.88.

Art history brush

The art history brush is something of an oddity. It is a history brush that allows you to paint from history but does so via a brush which distorts the sampled data and can be used to create impressionist type painting effects. You can learn more about this tool from the *Photoshop CS5* for *Photographers Help Guide* that's on the DVD.

		_P2E7158.dng	
		Open	
3		Levels	-
	2	Spot Healing Brush	
_	P	Spot Healing Brush	-
1	1 A	Spot Healing Brush	

Figure 1.86 A previous history state can be selected as the source for the history brush by going to the History panel and clicking in the box to the left of the history step you want to paint from using the history brush.

Filling from history

When you select the Fill... from the Edit menu there is an option in the Contents Use menu to choose 'history'.

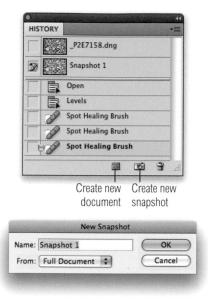

Figure 1.87 To record a new snapshot. click on the New Snapshot button at the bottom of the History panel. This records a snapshot of the history at this stage. If you **C** *alt* -click the button, there are three options: Full Document, which stores all layers intact; Merged Layers, which stores a composite; and Current Layer, which stores just the currently active layer. Note that if you have the Show New Snapshot dialog by Default turned on in the History panel options, the New Snapshot dialog appears directly, without you having to C all-click the New Snapshot button. The adjacent Create New Document button can create a duplicate image of the active image in its current history state.

Snapshots

Snapshots are stored above the History panel divider and used to record the image in its current state so as to prevent this version of the image from being overwritten, for as long as the document is open and being edited in Photoshop. The default settings for the History panel will store a snapshot of the image in its opened state and you can create further snapshots by clicking on the Snapshot button at the bottom of the panel (see Figure 1.87). This feature is particularly useful if you have an image state that you wish to store temporarily and don't wish to lose as you make further adjustments to the image. There is no real constraint on the number of snapshots that can be added, and in the History panel options (Figure 1.82) you can choose to automatically generate a new snapshot each time you save the image (which will also be timestamped). The Create New Document button (next to the Snapshot button) can be used to create a duplicate image state in a new document window and saved as a separate image.

Figure 1.88 Photographer Jeff Schewe has had a long-standing connection with the Adobe Photoshop program and its development. The origins of the History feature can perhaps be traced back to a seminar where he used the Globe Hands image shown here to demonstrate his use of the Snapshot feature in Photoshop 2.5. Jeff was able to save multiple snapshots of different image states in Photoshop and selectively paint back from them. This was all way before layers and history were introduced in Photoshop. Chief Photoshop Engineer Mark Hamburg was suitably impressed by Jeff's technique, and the ability to paint from snapshots became an important part of the History feature. Everyone had been crying out for a multiple undo in Photoshop, but when history was first introduced in Photoshop 5.0 it came as quite a surprise to discover just how much the History feature would allow you to do.

Photoshop fundamentals

Chapter 1

Non-linear history

The 'non-linear history' option lets you branch off in several directions and experiment with different effects without needing to add lots of new layers. Non-linear history is not an easy concept to grasp, so the best way to approach this is to imagine a series of history steps as having more than one 'linear' progression, allowing the user to branch off in different directions in Photoshop instead of in a single chain of events (see Figure 1.89). Therefore, while you are working on an image in Photoshop, you have the opportunity to take an image down several different routes; a history step from one branch can then be blended with a history step from another branch without having to save duplicate files.

Non-linear history requires a little more thinking on your part in order to monitor and recall image states, but ultimately makes for a more efficient use of the available scratch disk space. Overall, I find it useful to have non-linear history switched on all the time, regardless of whether I need to push this feature to its limits or not.

Non-linear history in use

On pages 434-435 in Chapter 8 you can see a practical example of how the History feature might be used in a typical Photoshop retouching session.

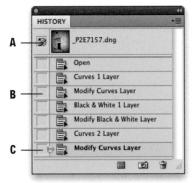

Figure 1.89 The 'non-linear history' option allows you to branch off in different directions and simultaneously maintain a record of each history path up to the maximum number of history states that can be allowed. Shown here are three history states selected from the History panel: the initial opened image state (A), another with a Curves layer adjustment (B) and thirdly, an alternative version where I added a Black and White layer adjustment layer followed by a Curves adjustment layer to add a sepia tone color effect (C).

Corrupt files

There are various reasons why a file may have become corrupted and refuses to open. This will often happen to images that have been sent as attachments and is most likely due to a break during transmission somewhere, resulting in missing data.

00	🔿 🎟 GardenScreenSnapz003.t.
	GardenScreenSnapz0 2.9 MB Modified: 14 Jun 2008 15:00
► Spot	light Comments:
▶ Gene	eral:
More	Info:
▶ Nam	e & Extension:
♥ Oper	1 with:
-	Preview
Use the	his application to open all documents his.
Cch	ange All
▶ Previ	ew:
▶ Shar	ing & Permissions:

Figure 1.90 The header information in some files may contain information that tells the operating system to open the image in a program other than Photoshop. On a Macintosh go to the File menu and choose File \Rightarrow Get Info and under the 'Open with' item, change the default application to Photoshop. On a PC you can do the same thing via the File Registry.

Figure 1.91 When files won't open up directly in Photoshop the way you expect them to, then it may be because the header is telling the computer to open them up in some other program instead. To force open an image in Photoshop, drag the file icon on top of the Photoshop application icon or an alias or shortcut thereof, such as an icon placed in the dock or on the desktop.

When files won't open

You can open an image file in Photoshop in a number of ways. You can use the Bridge program or Mini Bridge panel (which are described on pages 76–81), or you can simply double-click a file to open it. As long as the file you are about to open is in a file format that Photoshop recognizes, it will open in Photoshop and, if the program is not running at the time, this action should also launch Photoshop.

Every document file contains a header section, which among other things tells the computer which application should be used to open it. For example, Microsoft Word documents will (naturally enough) default to opening in Microsoft Word. Photoshop can recognize nearly all types of image documents regardless of the application they may have originated from, but sometimes you will see an image file with an icon for another specific program, like Macintosh Preview, or Internet Explorer. If you double-click these particular files, they will open in their respective programs. To get around this, you can follow the instructions described in Figure 1.90. Alternatively, you can use the File \Rightarrow Open command from within Photoshop, or you can drag a selected file (or files) to the Photoshop program icon, or a shortcut/alias of the program icon (Figure 1.91). In each of these cases this allows you to override the computer operating system that normally reads the file header to determine which program the file should be opened in. If you use Bridge as the main interface for opening image files in Photoshop, then you might also want to open the File Type Association preferences (that are described in Chapter 11) to check that the file format for the files you are opening are all set to open in Photoshop by default.

Yet, there are times when even these methods may fail and this points to one of two things. Either you have a corrupt file, in which case the damage is most likely permanent. Or, the file extension has been wrongly changed. It says .psd, but is it really a PSD? Is it possible that someone has accidentally renamed the file with an incorrect extension? In these situations, the only way to open it will be to rename the file using the *correct* file extension, or use the Photoshop File \Rightarrow Open command and navigate to locate the mis-saved image (which once successfully opened should then be resaved to register it in the correct file format).

Save often

It goes without saying that you should always remember to save often while working in Photoshop. Thankfully you won't come across many crashes when working with the latest Macintosh and PC operating systems, but that doesn't mean you should relax too much, since there are still some pitfalls you need to be aware of.

Choosing File \Rightarrow Save always creates a safe backup of your image, but as with everything else you do on a computer, do make sure you are not overwriting the original with an inferior modified version. There is always the danger that you might make permanent changes such as a drastic reduction in image size, accidentally hit 'Save' and lose the original in the process. If this happens, there is no need to worry so long as you don't close the image. You can always go back a step or two in the History panel and resave the image in the state it was in before it was modified.

When you save an image in Photoshop, you are either resaving the file (which overwrites the original) or are forced to save a new version using the Photoshop file format. The determining factor here will be the file format the image was in when you opened it and how it has been modified in Photoshop. Over the next few pages I'll be discussing some of the different file formats you can use, but the main thing to be aware of is that some file formats do restrict you from being able to save things like layers, pen paths or extra channels. For example, if you open a JPEG format file in Photoshop and modify it by adding a pen path, you can choose File \Rightarrow Save and overwrite the original without any problem. However, if you open the same file and add a layer or an extra alpha channel, you won't be able to save it as a JPEG any more. This is because although a JPEG file can contain pen paths, it cannot contain layers or additional channels, so it has to be saved using a file format that is capable of containing these extra items.

I won't go into lengthy detail about what can and can't be saved using each format, but basically, if you modify a file and the modifications can be saved using the same file format that the original started out in, then Photoshop will have no problem saving and overwriting the original. If the modifications applied to an image mean that it can't be saved using the original file format, it will default to using the PSD (Photoshop document) format and save the image as a new document via the Save As dialog (Figure 1.92). You can also choose to save such documents using

Graphic Converter

If you are still having trouble trying to open a corrupted file, the Graphic Converter program can sometimes be quite effective at opening mildly corrupted image files.

History saves

Alas, it is not possible to save a history of everything you did to an image, but if you go to the Photoshop preferences you can choose to save the history log information of everything that was done to the image. This can record a log of everything that was done during a Photoshop session and be saved to a central log file or saved to the file's metadata.

The other thing you can do is go to the Actions panel and click to record an action of everything that is done to the image. The major downfall here is that Actions cannot record everything. For example, you cannot record brush strokes within an action.

The 'save everything' file formats

There are four main file formats that can be used to save everything you might add to an image, such as image layers, type layers, and channels, and also support 16-bits per channel. These are: TIFF, Photoshop PDF, (the large document format), PSB and, lastly, the native Photoshop file format, PSD. I mostly favor using the PSD format when saving master RGB images.

Quick saving

As with all other programs, the keyboard shortcut for saving a file is: **H**S **ctrl**S. If you are editing an image that has never been saved before or the image state has changed (so that what started out as a flattened JPEG, now has layers added), this action will pop the Save As... dialog. Subsequent saves may not show the Save dialog. But if you do wish to force the Save dialog to appear to save a copy version, then use: **H**SS **ctrl a**tt **S**.

Figure 1.92 If the file format you choose to save in won't support all the components in the image, such as layers, then a warning triangle alerts you to this when you attempt to save the document, reminding you that the layers will not be included. Note that the Mac OS dialog shown here can be collapsed or expanded by clicking on the downward pointing disclosure triangle to toggle the expanded folder view. the TIFF or PDF format. In my view, both TIFF and PSD formats are a good choice here for saving any master image since these file formats can contain anything that's been added in Photoshop.

When you choose File \Rightarrow Close All, if any of the photos have been modified, a warning dialog alerts you and allows you to close all open images with or without saving them first. For example, if you make a series of adjustments to a bunch of images and then change your mind, with this option you can quickly close all open images if you don't really need them to be saved.

Using Save As... to save images

If the image you are about to save has started out as, say, a flattened JPEG but now has layers, this will force the Save As dialog shown in Figure 1.92 to appear as you save. However, you can also choose 'File \Rightarrow Save As...' any time you wish to save an image using a different file format, or if you want, you can save a layered image as a flattened duplicate. In the Save As dialog you have access to various save options and in the Figure 1.92 example I was able to select the JPEG format when saving a layered, edited image. As you can see, a warning triangle appears to alert you if Layers (or other non-compatible items) can't be stored when choosing JPEG. In these circumstances, incompatible features like this are automatically highlighted and grayed out in the Save As dialog, and the image is necessarily saved as a flattened version of the master.

Save As	: _P2E6829	.jpg		
▶) (# ■ Ⅲ) (🗐 Desktop		•	2 search
Na	me		Date M	odified
CES 0			1 Nove	ember 2007 10:56
Desktop	Wconversions	s	18 Jun	e 2008 13:21
martin_e	sktop stuff		1 Nove	ember 2007 10:52
Movies Eur	ro setting cus	tom.csf	5 June	2008 10:18
Pictures	IR images		22 Jan	uary 2008 16:07
Forma	t: JPEG			•
Use Adobe Dialog	Save:	As a Copy		Notes
		Alpha Channe	els	Spot Colors
	A	Layers		
	Color:	Use Proof Set	un Wo	rking CMVK
	color.			Adobe RGB (1998)
	A File must	the saved as a copy with t		
		. De saveu as a copy with t	ms selectio	m.

File formats

Photoshop supports nearly all the current, well-known image file formats. And for those that are not supported, you will find that certain specialized file format plug-ins are supplied as extras on the Photoshop application DVD. When these plug-ins are installed in the Plug-ins folder they allow you to extend the range of file formats that can be chosen when saving. Your choice of file format when saving images should be mainly determined by what you want to do with a particular file and how important it is to preserve all the features (such as layers and channels) that may have been added while editing the image in Photoshop. Some formats such as PSD and PSB are best suited for archiving master image files, while others, such as TIFF, are ideally suited for prepress work. Here is a brief summary of the main file formats in common use today.

Photoshop native file format

The Photoshop file format is a universal format and therefore a logical choice when saving and archiving your master files, since the Photoshop (PSD) format will recognize and contain all known Photoshop features, but so too will the TIFF and PDF file formats. However, there are several reasons why I find it preferable to save the master images using the PSD format. Firstly, it helps me to distinguish the master layered files from the flattened output files (which I usually do save as TIFFs). More importantly, when saving layered images, I generally find the PSD format is faster and more efficient compared with using TIFF. The native Photoshop format is usually the most efficient format to save with because large areas of contiguous color, such as a white background, are recorded using an LZW type of compression that makes the file size more compact, but without degrading the image quality in any way.

Smart PSD files

Adobe InDesign and Adobe Dreamweaver will let you share Photoshop format files between these separate applications so that any changes made to a Photoshop file will automatically be updated in the other program. This modular approach means that most Adobe graphics programs are able to seamlessly integrate with each other.

Maximum compatibility

Only the Photoshop, PDF, PSB and TIFF formats are capable of supporting all the Photoshop features such as vector masks and image adjustment layers. However, for Photoshop (PSD) format documents to be completely compatible with other programs (especially Lightroom) you must ensure you have the 'Maximize PSD and PSB Compatibility' checked in the Photoshop File Handling preferences. The reason for this is because Lightroom is unable to read layered PSD files that don't include a saved composite within the file. If PSD images fail to be imported into Lightroom, it is most likely because they were saved with this preference switched off.

Saving 16-bit files as JPEGs

For those who prefer to edit their images in 16-bit, it always used to be frustrating when you would go to save an image as a JPEG copy, only to find that the JPEG option wasn't available in the Save dialog File Format menu. The reason for this is because 16-bit isn't supported by the JPEG format. With Photoshop CS5, when you choose Save As... for a 16-bit image, the JPEG file format is now available as a save option, whereby Photoshop carries out the necessary 16-bit to 8-bit conversion as part of the JPEG save process. This now allows you to guickly create JPEG copies without having to temporarily convert the image back to 8-bit. Note, however, that only the JPEG file format is now supported in this way.

PSB (Large Document Format)

The PSB file format is provided as a special format that can be used when saving master layered files that are in 32-bits per channel mode and/or when you need to save files that exceed the normal $30,000 \times 30,000$ pixel dimensions limit in Photoshop. The PSB format has an upper limit of $300,000 \times 300,000$ pixels. However, the only photographic application I can think of where you might need such a large file would be if you were creating a long panoramic image. Even so, a lot of applications and printer RIPs cannot handle files that are greater than 2 GB anyway, but there are exceptions, such as ColorByte's ImagePrint and Onyx's PosterShop. For this reason the $30,000 \times 30,000$ limit has been retained for all existing file formats in Photoshop, where the TIFF specification is limited to 4 GB and the native Photoshop PSD format is limited to a maximum size of 2 GB. You also have to bear in mind that only Photoshop CS or later is capable of reading the PSB format.

TIFF (Tagged Image File Format)

The main formats used for publishing work are TIFF and EPS. Of the two, TIFF is the most universally recognized, industry-standard image format. TIFF files can readily be placed in QuarkXpress, InDesign and any other desktop publishing (DTP) or word processing documents, but this does not necessarily imply that it is a better format, because the PDF file format has also been gaining popularity for DTP work. The TIFF format is more open though and, unlike the EPS format, you can make adjustments within the DTP program as to the way a TIFF image appears in print.

Labs and output bureaux generally request that you save your output images as TIFFs, as this is the file format that can be read by most other imaging computer systems. If you are distributing a file for output as a print or transparency, or for someone else to continue editing your master file, it will usually be safer to supply the image using the TIFF format.

TIFFs saved using Photoshop 7.0 or later support alpha channels, paths, image transparency and all the extras that can normally be saved using the native PSD and PDF formats. Labs or service bureaux that receive TIFF files for direct output will normally request that a TIFF file is flattened and saved with the alpha channels and other extra items removed. For example, earlier versions of Quark Xpress had a nasty habit of interpreting any path that was present in the image file as a clipping path.

Pixel order

The Photoshop TIFF format has traditionally saved the pixel values in an interleaved order. So if you were saving an RGB image, the pixel values would be saved as clusters of RGB values using the following sequence: RGBRGBRGB. All TIFF readers are able to interpret this pixel order. The Per Channel pixel order option saves the pixel values in channel order, where all the red pixel values are saved first, followed by the green, then the blue. So the sequence is more like: RRRGGGBBB. Using the Per Channel order can therefore provide faster read/write speeds and better compression. Most third-party TIFF readers should support Per Channel pixel ordering, but there is a very slim chance that some TIFF readers won't.

TIFF Options	
Image Compression NONE LZW ZIP JPEG Quality: Maximum \$ small file large file	OK Cancel
Pixel Order Interleaved (RGBRGB) Per Channel (RRGGBB) Byte Order IBM PC Macintosh]
 Save Image Pyramid Save Transparency Layer Compression RLE (faster saves, bigger files) ZIP (slower saves, smaller files) Discard Layers and Save a Copy 	

Figure 1.93 This dialog shows the save options that are available when you save an image as a TIFF.

Redundant formats

Note that the Filmstrip file format is no longer supported in Photoshop CS5. The same applies to the PICT format. Photoshop is still able to read raster PICT files (though not QuickDraw PICTs), it just won't allow you to write to the PICT file format.

Byte order

The byte order can be made to match the computer system platform the file is being read on, but there is usually no need to worry about this and it shouldn't cause any compatibility problems.

Save Image Pyramid

The 'Save Image Pyramid' option saves a pyramid structure of scaled-down versions of the full resolution image. TIFF pyramid-savvy DTP applications (and there are none I know of yet) will then be able to display a good quality TIFF preview, but without having to load the whole file.

TIFF compression options

An uncompressed TIFF is usually about the same megabyte size as the figure you'll see displayed in the Image Size dialog box, but the TIFF format in Photoshop offers several compression options. LZW is a lossless compression option, where the image data is compacted and the file size is reduced, but without any image detail being lost. Saving and opening takes longer when LZW is utilized so some clients request that you do not use it. ZIP is another lossless compression encoding that like LZW is most effective where you have images that contain large areas of a single color. JPEG image compression offers a lossy method, which can offer even greater levels of file compression, but, again, be warned that this option can cause problems downstream with the printer RIP if it is used when saving output files for print. If there are layers present in the image, separate compression options are available for the layers. RLE stands for Run Length Encoding and provides the same type of lossless compression as LZW. The ZIP compression is another form of lossless compression. Alternatively, you can choose 'Discard Layers and Save a Copy', which saves a copy version of the master image as a flattened TIFF.

Flattened TIFFs

If an open image contains alpha channels or layers, the Save dialog shown in Figure 1.92 indicates this and you can keep these items checked when saving as a TIFF. If you have 'Ask Before Saving Layered TIFF Files' switched on in the File Saving preferences, a further alert dialog will warn you that 'including layers will increase the file size' the first time you save an image as a layered TIFF.

Photoshop PDF

The PDF (Portable Document Format) is a cross-platform file format that was initially designed to provide an electronic publishing medium for distributing documents without requiring the recipient to have a copy of the program that originated the document. Acrobat enables others to view documents the way they are meant to be seen, even though they may not have the exact same fonts that were used to compile the document. All they need is the free Adobe ReaderTM program.

Adobe PDF has now gained far wider acceptance as a reliable and compact method of supplying pages to printers, due to its color management features and ability to embed fonts, and compress images. It is now becoming the native format for Illustrator and other desktop publishing programs and is also gaining popularity for saving Photoshop files, because it can preserve everything that a Photoshop (PSD) file can. Adobe ReaderTM and its predecessor Acrobat ReaderTM are free, and can easily be downloaded from the Adobe website. But the full Adobe AcrobatTM program is required if you want to distill page documents into the PDF format and edit them on your computer.

Best of all, Acrobat documents are small in size and can be printed at high resolution. I can create a document in InDesign and export it as an Acrobat PDF using the Export command. Anyone who has installed the Adobe Reader program can open a PDF document I have created and see the layout just as I intended it to be seen, with the pictures in full color plus text displayed using the correct fonts. The Photoshop PDF file format can be used to save all Photoshop features, such as Layers, with either JPEG or lossless ZIP compression, and is backwards compatible in as much as it saves a flattened composite for viewing within programs that are unable to fully interpret the Photoshop CS5 layer information.

PDF security

The PDF security options allow you to restrict file access to authorized users only. This means that a password has to be entered before an image can be opened in either Adobe Reader, Acrobat or Photoshop. You can also introduce a secondary password for permission to print or modify the PDF file in Acrobat. Note: this level of security only applies when reading a file in a PDF reader program and you can only password protect the opening of a PDF

PDF versatility

The PDF format in Photoshop is particularly useful for sending Photoshop images to people who don't have Photoshop, but do have the Adobe Reader[™] program on their computer. If they have a full version of Adobe Acrobat[™] they will even be able to conduct a limited amount of editing, such as editing the contents of a text layer. Photoshop is also able to import or append any annotations that have been added via Adobe Acrobat.

Placing PDF files

The Photoshop Parser plug-in allows Photoshop to import any Adobe Illustrator, EPS or generic single/multi-page PDF file. Using File ⇒ Place, you can select individual pages or ranges of pages from a generic PDF file, rasterize them and save them to a destination folder. You can also use File ⇒ Place to extract all or individual image/vector graphic files contained within a PDF document as separate image files (see Figure 1.94). file in a program like Photoshop. Once opened, it will then be fully editable. Even so, this is still a useful feature to have, since PDF security allows you to prevent some unauthorized, first level access to your images. There are two security options: 40-bit RC4 for lower-level security and compatibility with versions 3 and 4 of Acrobat; and 128-bit RC4, for higher security using Acrobat versions 5 or later. However, because the PDF specification is an open-source standard, some other PDF readers are able to bypass these security features and can quite easily open a passwordprotected image! The security features are not totally infallible, but marginally better than using no security at all.

Figure 1.94 If you try to open a generic Acrobat PDF from within Photoshop by choosing File \Rightarrow Open, or File \Rightarrow Place, you will see the Import PDF or Place PDF dialog shown here. This allows you to select individual or multiple pages, or selected images only and open these in Photoshop or place them within a new Photoshop document.

Adobe Bridge CS5

Bridge (Figure 1.95) is designed to provide you with an integrated way to navigate through the folders on your computer and complete compatibility with all the other Creative Suite applications. The Bridge interface allows you to inspect images in a folder, make decisions about which ones you like best, rearrange them in the Content panel, hide the ones you don't like, and so on.

Chapter 1 Photoshop fundamentals

Figure 1.95 The Bridge interface consists of three column zones used to contain the Bridge panel components. This allows you to customize the Bridge layout in any number of ways. For a complete overview of the components that make up the Bridge interface please refer to Chapter 11.

77

Return to Photoshop

Most of the time you will probably click on the Launch Bridge button in Photoshop to go to Bridge and, when you have selected an image to open, this will take you back to Photoshop again of course. But you can also toggle between the two programs by using $\Re \sim O$ ctrl alt O to go from Photoshop to Bridge. Once in Bridge you can use the same keyboard shortcut to return to Photoshop again, although to be more precise, this shortcut always returns you to the last used application. So if you had just gone to Bridge via Illustrator, the # C Ctrl alt O shortcut will in this instance take you from Bridge back to Illustrator again.

Figure 1.96 If you click on the Switch to Compact mode button (circled in blue in Figure 1.95), this shrinks the Bridge window to a compact, Content panel only view like the one shown here, and if you click on the Ultra Compact mode button (circled here in red), this compacts the window further to display the title and Application bars only. To return to a full window view, click on the Switch to Full mode button (circled in blue). Note that compact Bridge windows are always displayed in front of all other windows on the display, even when you are working in another program.

You can use Bridge to quickly review the images in a folder and open them up in Photoshop, while at a more advanced level, you can perform batch operations, share properties between files by synchronizing the metadata information, apply Camera Raw settings to a selection of images and use the Filter panel to finetune your image selections. It is very easy to switch back and forth between Photoshop and Bridge, and one of the key benefits of having Bridge operate as a separate program is that Photoshop isn't fighting with the processor whenever you use Bridge to perform these various tasks.

The Bridge interface

Bridge can be accessed from Photoshop by choosing File \Rightarrow Browse in Bridge... or by clicking on the Launch Bridge button circled in red in the Application bar in Figure 1.95 (you can also set the Photoshop preferences so that Bridge launches automatically as you launch Photoshop). Bridge initially opens a new window pointing to the last visited folder location. You can also have multiple Bridge windows open at once and this is useful if you want to manage files better by being able to drag them from one folder to another. Having multiple windows open also saves having to navigate back and forth between different folders. To make Bridge windows more manageable, you can click on the Switch to Compact mode button (circled in blue in Figures 1.95 and 1.96) to toggle shrinking/expanding a Bridge window.

It makes sense to resize the Bridge window to fill the screen and if you have a dual monitor setup you can always have the Photoshop application window on the main display and the Bridge window (or windows) on the other. Image folders can be selected via the Folders or Favorites panels and the folder contents viewed in the content panel area as thumbnail images. When you click on a thumbnail, an enlarged view of the individually selected images can be seen in the Preview panel and images can be opened by double-clicking on the thumbnail. The main thing to be aware of is that you can have Bridge running alongside Photoshop without compromising Photoshop's performance and it is considered good practice to use Bridge in place of the Finder/Explorer as your main tool for navigating the folders on your computer system and opening documents. This can include opening photos directly into Photoshop, but of course, you can use Bridge as a browser to open up any kind of document: not just those that are linked to the Adobe Creative Suite programs, but others such as Word documents can be made to open directly in their host applications.

New to Bridge CS5 is the addition of the 'Airtight' gallery styles in the Output panel (mentioned in the accompanying sidebar). The other new features are IPTC extensions in the File Info dialog, an improved Batch Rename dialog as well as a brand new Mini Bridge extension panel for Photoshop (see page 81).

Custom workspaces in Bridge

The Bridge panels can be grouped together in different ways and the panel dividers dragged, so for example, the Preview panel can be made to fill the Bridge interface more fully and there are already a number of workspace presets which are available to use from the Application bar. In the Figure 1.97 example you can see Bridge being used with the Output workspace setting, which offers a special Output Preview panel for previewing print layouts or Web Galleries directly in Bridge before you proceed to make a print or generate a complete Web Gallery.

Slideshows

You can also use Bridge to generate slideshows. Just go to the View menu and choosing Slideshow, or use the **H** *L ctrl L* keyboard shortcut. Figure 1.98 shows an example of a Slideshow and instructions on how to access the Help menu.

Bridge output modes

Up until version CS4, Bridge had always had to rely on Photoshop to use the Contact Sheet and Web Photo Gallery automate functions. These were done away with in Photoshop CS4 and replaced with the Output workspace tools that are now found in Bridge. On the plus side, this makes the contact sheet and web Gallery generation easier to access and is certainly an improvement over what went on before. Bridge CS5 does now also include a few extra Lightroom-style, 'Airtight' Web Galleries. Even so. Adobe have not vet done anything to speed up the output process and Bridge is still as dog slow as ever when it comes to processing contact sheets or a Web Gallery output. If you regularly need to prepare a lot of contact sheets or Web Galleries, there is no doubt that Lightroom is the better program to use. The tools in Lightroom are much better suited for these kinds of tasks, and the contact sheet generation in Lightroom in draft mode is roughly 100 times faster than Bridge CS5.

Figure 1.97 You can use the different workspaces to quickly switch Bridge layouts. This example shows the Output workspace in use, which one can use to edit print or Web Gallery layouts.

Figure 1.98 You can use the Bridge application View \Rightarrow Slideshow mode to display selected images in a slideshow presentation, where you can make all your essential review and edit decisions with this easy-to-use interface (press the \square key to call up the Slideshow shortcuts shown here).

Mini Bridge

The main Bridge program now has a little cousin called Mini Bridge, which, rather than being an alternative, standalone application, is added as a Photoshop Extension panel (see Extensions panels on page 28). This can be viewed as an add-on feature for Bridge rather than a replacement as such. I see this as offering a simpler user interface for doing the types of things photographers need to do most. It provides a simplified interface for image browsing, but without offering refinement features such as keyword sorting, metadata editing, or Web and print output. While Mini Bridge is unlikely to replace all your main Bridge needs, it arguably allows you to browse more conveniently from within the Photoshop interface. Hopefully, it will encourage more Photoshop users to work with Bridge.

Launching Mini Bridge

To launch Mini Bridge you can go to the Window menu and choose Extensions ⇒ Mini Bridge. Or, you can click on the Launch Mini Bridge button located in the Photoshop application bar and circled below in Figure 1.99.

Figure 1.99 Mini Bridge is shown here as an open panel docked to the panel groups on the right.

Saving from raw files

If you save an image that's been opened up from a raw file original, Photoshop will by default suggest you save it using the native Photoshop (PSD) file format. You are always forced to save it as something else and never to overwrite the original raw image. Most raw formats have unique extensions anyway like .crw or .nef. However, Canon did once decide to use a .tif extension for some of their raw file formats (so that the thumbnails would show up in their proprietary browser program). The danger here was that if you overrode the Photoshop default behavior and tried saving an opened Canon raw image as a TIFF, you risked overwriting the original raw file.

Auto logic in Camera Raw

The Auto setting in Camera Raw has been improved so that, most of the time, selecting 'Auto' gives you better and more consistent results than could be achieved with previous versions of Camera Raw.

Opening files from Bridge

There are a lot of things you can do in Bridge by way of managing and filtering images and other files on your computer. You will find a more detailed analysis of Bridge in Chapter 11. For now, all that you really need to familiarize yourself with are the Favorites and Folders panels and how you can use these to navigate the folder hierarchy. The Content panel is then used to inspect the folder contents and you can use the Preview panel to see an enlarged preview of the image (or images) you are about to open. Once photos have been selected, just double-click the images within the Content panel (not the Preview panel) to open them directly into Photoshop.

Opening photos from Bridge via Camera Raw

If you are opening a raw or DNG image, these will automatically open via the Camera Raw dialog shown in Figure 1.100 and if you are opening multiple raw images you will see a filmstrip of thumbnails appear down the left-hand side of the Camera Raw dialog. There is also a preference setting in Bridge CS5 that allows you to open up JPEG and TIFF images via Camera Raw too.

The whole of Chapter 3 is devoted to looking at the Camera Raw controls and I would say that the main benefits of using Camera Raw are that any edits you apply in Camera Raw are non-permanent and this latest version in Photoshop CS5 offers yet further major advances in raw image processing. If you are still a little intimidated by the Camera Raw dialog interface, you can for now just click on the Auto button (circled in Figure 1.100). When the default settings in Camera Raw are set to 'Auto', Camera Raw usually does a pretty good job of optimizing the image settings for you. You can then click on the Open Image button without concerning yourself too much just yet with what all the Camera Raw controls do. This should give you a good image to start working with in Photoshop; the beauty of working with Camera Raw is that you never risk overwriting the original master raw file (but do heed the warning in the sidebar about saving raw TIFF files). If you don't like the auto settings Camera Raw gives you, then it is relatively easy to adjust the tone and color sliders and make your own improvements upon the auto adjustment settings.

Photoshop fundamentals

What's new in Camera Raw 6.0

The big news in Camera Raw 6.0 is the improved demosaicing along with improvements made to the sharpening and noise reduction. The new demosaicing provides a noticeable improvement in the quality of the raw processing for most supported raw formats, while the capture sharpening provides more accurate halo generation at lower Radius settings. The noise reduction in Camera Raw 6.0 has been completely revamped to provide stronger and more targeted noise reduction control. There are also Grain sliders for applying creative effects along with new Post crop Vignetting settings, which offer better vignette adjustments that are more similar to those produced using the main Lens Correction vignette sliders. From a photographer's perspective these are really compelling features and good enough reasons to upgrade.

- + 33.3% AG_4199.CR to RGB: 8 bit: 2428 by 3589 (8.7MP): 240 pp (Save Image ...) Figure 1.100 When you select a single raw image in Bridge, and double-click to open, you will see the Camera Raw dialog shown here. The Basic panel controls are a good place to get started, but as was mentioned in the text, the Auto button can often apply an adjustment that is ideally suited for most types of images. Once you are happy, click on the Open Image button at the bottom to open it in Photoshop.

Full Screen mode

If you click on the Full Screen mode button in Camera Raw, you can quickly switch the Camera Raw view to Full Screen mode.

ATWs

Being a member of the team that makes Photoshop has many rewards, but one of the perks is having the opportunity to add little office in-jokes in a secret spot on the Photoshop splash screen. It's a sign of what spending long hours building a new version of Photoshop will do to you! The instructions for how to access these are described in the main text.

Photoshop code names

Nearly every version of the Photoshop beta program has traditionally contained a reference to a music track or a movie. Past honored music artists have included: Adrian Belew, William Orbit and Lou Reed.

Photoshop On-line

Photoshop On-line... is available from the Help menu and lets you access any latebreaking information along with on-line help and professional Photoshop tips. Photoshop help is also available as a PDF (there's a link in the upper left corner of the Help page).

Figure 1.101 Can you find Merlin?

Easter eggs

We'll round off this chapter with some of the hidden items that are in Photoshop. If you drag down from the system or Apple menu to select About Photoshop... the splash screen reopens and after about 5 seconds the text starts to scroll, telling you lots of stuff about the Adobe team who wrote the program, etc. Hold down alt and the text scrolls faster. Last, but not least, you'll see a special mention to the most important Photoshop user of all... Now hold down \mathfrak{B} *ctt* alt and choose About Photoshop... Here, you will see the White Rabbit beta test version of the splash screen (Figure 1.102). When the credits have finished scrolling, carefully *alt*-click in the white space above the credits, but below the image, to see what are known as Adobe Transient Witticisms appearing one at a time above the credits. If you want to see another Easter egg, go to the Layers panel, hold down **alt** and choose Panel Options from the panel submenu (see Figure 1.101).

Figure 1.102 The White Rabbit beta splash screen.

Chapter 2

Configuring Photoshop

n order to get the best performance out of Photoshop, you need to ensure that your computer system has been optimized for image editing work. When I first began writing the 'Photoshop for Photographers' series of books, it was always necessary to guide readers on how to buy the most suitable computer for Photoshop work and what hardware specifications to look for. These days I would suggest that almost any computer you buy is now capable of running Photoshop and can be upgraded later to run Photoshop faster. As always, I try to avoid making distinctions between the superiority of the Macintosh or PC systems. If you are an experienced computer user, you know what works best for you and I see no reason to evangelize my preference for using a Mac. All I'll say on this subject is that throughout my computer career, the Mac is what I have grown

64-bit processing support

It is well worth installing as much RAM memory as possible in your computer, as the RAM figures guoted here are the minimum recommended amounts. Personally, I would advise installing at least 4 GB RAM if you can. If you are working with a 32-bit operating system you can only install a 32-bit version of Photoshop CS5 and allocate up to 4 GB (less whatever the operating system frameworks take up, so effectively up to around 3.5 GB). However, 64-bit processing is now the new standard for the latest computer hardware and if you are running a 64-bit operating system, you can install a 64-bit version of Photoshop CS5, which offers the key benefit of letting you take advantage of having more than 4 GB of RAM memory installed in your computer. This has the potential to boost the speed for some operations (like the time it takes to open large documents).

For more information on this subject, check out Scott Byer's Adobe blog: http://tiny.cc/qDSRS, as well as John Nack's coverage of this topic at: http://tiny.cc/aNqcP. up with and it feels like home. The same argument would apply if I had always been a Windows PC user. This shouldn't be a big deal. Apart from anything else, once you have bought a bunch of programs, you are kind of locked into using that particular system and, if you switch, you face the prospect of having to buy most of your favorite software packages all over again.

What you will need

Today's entry level computers contain everything you need to get started running Photoshop, but here is a guide to the minimum system requirements for Macintosh and Windows system computers.

Macintosh

Photoshop CS5 can only be run on the latest Intel-based Macs running Mac OS 10.5 or later including Snow Leopard® (10.6). The minimum RAM requirement is 1 GB (but more RAM memory is recommended), plus Photoshop CS5 requires an estimated 2 GB of free hard disk space to install the program. You will also need a computer display with at least a 1024 x 768 pixel resolution driven by a 16-bit (or greater) graphics card with at least 256 MB video RAM, plus you will also need a DVD drive. All the current range of Apple Macintosh computers are capable of meeting these requirements, although with some of the older Intel Mac computers you may need to upgrade the video graphics card.

Windows

Photoshop CS5 can run on Intel Xeon, Xeon Dual, Centrino or Pentium 4 processors running Windows[®] XP with Service Pack 3 or higher, as well as Windows[®] Vista with Service Pack 1, Windows[®] Vista[®] 64-bit and Windows[®] 7. The minimum RAM requirement is 1 GB (but more is recommended) and Photoshop CS5 requires an estimated 1 GB of free hard disk space to install the program. You will also need a computer display with at least 1024 x 768 pixel resolution driven by a 16-bit (or greater) graphics card with at least 256 MB video RAM, plus you will also need a DVD drive. Almost any new PC system you buy should have no trouble meeting these requirements, but if you have an older computer system, do check that you have enough RAM memory and a powerful enough graphics card.

Chapter 2 Configuring Photoshop

The ideal computer setup

Your computer working environment is important. Even if space is limited there is much you can do to make your work area an efficient place to work in. Figure 2.1 shows a general view of the office area from where I run my photography business and do all my Photoshop work and, as you can see, it allows three operators to work simultaneously. The desk unit was custom built to provide a large continuous worktop area with good cable management in order to minimize the number of stray leads hanging all over the place. The walls are painted neutral gray with paint I was able to get from a local hardware store, which when measured with a spectrophotometer is almost a perfect neutral color. The under shelf lighting uses cool fluorescent strips that bounce off behind

Figure 2.1 This is the office area where I carry out all my Photoshop work. It has been custom built so that the desk area remains as clear as possible. The walls are painted neutral gray to absorb light and reduce the risk of color casts affecting what you see on the monitor screens. The lighting comes from daylight balanced tubes which backlights the monitor screens. I usually have the light level turned down quite low, in order to maximize the monitor viewing contrast.

Chip speed

Microchip processing speed is expressed in megahertz, but performance speed also depends on the chip type. A 2 GHz Pentium class 4 chip is not as fast as a 2 GHz Intel Core Duo processor. Speed comparisons in terms of the number of megahertz are only valid between chips of the same series. Many of the latest computers are also enabled with twin processors or more, although having extra cores is mainly beneficial when running certain types of filter operations. Another crucial factor is the bus speed, which refers to the speed of data transfer from RAM memory to the CPU (the central processing unit, i.e. the chip). CPU performance can be restricted by slow system bus speeds, so faster is definitely better, especially for Photoshop work where large chunks of data are being processed.

Eizo ColorEdge

Eizo have established themselves as offering the finest quality LCD displays for graphics use. The ColorEdge CG301 is the flagship model in the range. With a 30" wide screen, it is capable of providing uniform screen display from edge to edge, encompasses the Adobe RGB gamut, and comes with ColorNavigator calibration software that can be used with X-Rite calibration devices. This display is more expensive than most, but is highly prized for its color fidelity. the displays to avoid any light hitting the screens directly. The window is north east facing, so I never have too many problems with direct sunlight entering the room and what daylight does enter the office can be controlled using the venetian blinds. It is also important to choose operator chairs that are comfortable, ideally one with arm rests and adjustable seating positions so that your wrists can rest comfortably on the table top, and the monitor should be level with your line of view or slightly lower.

Once you start building an imaging workstation, you will soon end up with lots of electrical devices. While these in themselves may not consume a huge amount of power, do take precautions against too many power leads trailing from a single power point. To prevent damage or loss of data from a sudden power cut, I suggest you place an uninterruptible power supply unit (UPS) between your computer and the mains source. These devices can also smooth out any voltage spikes or surges in the electricity supply.

Choosing a display

The display is one of the most important components in your computer setup. It is what you will spend all your time looking at as you work in Photoshop and you really don't want to economize by buying a cheap display that is unsuited for graphics use. The only ones you can buy these days are liquid crystal displays (LCDs), which range in size from the small screens used on laptop computers to the big 30" desktop displays. An LCD display contains a translucent film of fixed-size liquid crystal elements that individually filter the color of a backlit, fluorescent light source. Therefore, the only hardware adjustment you can usually make is to adjust the brightness of the backlit screen. The contrast of an LCD is also fixed, but LCDs are generally more contrasty than CRT monitors ever were, which is not a bad thing when doing Photoshop work for print output.

Because LCDs are digital devices they tend to produce a more consistent color output, but they do still need to be calibrated and profiled of course. Once profiled though, the display's performance should remain fairly consistent over a long period of time. On the other hand, with some displays there may be some variance in the image appearance depending on the angle from which you view the display, which means that the color output of an LCD may only appear correct when the display is viewed front on. This very much depends on the design of the LCD display and the worst examples of this can be seen with ultra-thin laptop screens. However, the evenness of output from high quality desktop LCD screens is certainly a lot more consistent. The higher grade LCD screens do feature relatively good viewing angle consistency, are not too far off from providing a neutral color at a D65 white balance, and won't fluctuate much in performance. As with everything else in life, you get what you pay for.

Wide dynamic range displays

It is interesting to speculate what computer displays will be like in the future. Dolby recently acquired BrightSide Technologies who developed an LCD display that uses a matrix of LED lights instead of a fluorescent light source to pass light through the LCD film (Figure 2.2). These displays have an incredible dynamic range and are capable of displaying a 16-bit per channel image with an illumination range that makes an ordinary 8-bit display look dull and flat by comparison. We may one day even see display technologies that can get closer to simulating the dynamic range of natural light. These will be great for viewing computer games and video, but for Photoshop print work we will want the display we are looking at to match our expectations of what can be reproduced on a print.

Video cards

The graphics card in your computer is what drives the display. It processes all the pixel information and converts it to draw the color image that's seen on the display. An accelerated graphics card enables you to do several things. It allows you to run your display at higher screen resolutions and hold more image display view data in memory, and it uses the display profile information to finely adjust the color appearance. When more of the off-screen image data remains in video memory the image scrolling is enhanced and this generally provides faster display refreshes. In the old days, computers would be sold with a limited amount of video memory and if you were lucky you could just about manage to run a small display in millions of colors. When you buy a computer today the chances are that it will already be equipped with a good, high performance graphics card that is easily capable of meeting

NEC LCD3090

The NEC LCD3090 30" display has won a lot of praise from industry color gurus and is what I use as my main display. This display is a huge improvement upon the old, 30" Apple Cinema display which I now use as the secondary monitor. Meanwhile, Apple's passion for glossy displays means that their newer displays are actually worse than the old ones. I have found it impossible to calibrate the new iMac displays and make them useable for Photoshop image editing. The only viable solution has been to run a secondary display off the iMac I take on location, which kind of defeats the reason for having an iMac in the first place!

Adding a second display

To run a second display you may need to buy an additional video graphics card that provides a second video port. You can then have this located alongside the main display and use it to contain all the Photoshop panels and keep the main screen area clear of clutter.

Figure 2.2 This shows the Dolby DR37-P 37" wide extended dynamic range screen.

Which video card is best?

If you do want to take advantage of what OpenGL can offer in Photoshop, it might be necessary for you to purchase a new video card. At the time of writing, there is a long list of the video cards that are capable of providing OpenGL support in Photoshop CS5 for Mac OS X 10.5 (or later), Windows Vista and limited support for Windows XP and Windows 7. Adobe do list the GPU cards that are recommended for Photoshop use, but it is difficult though to point to any one group of cards and say these are best. This is because the OpenGL performance in Photoshop is down to not just the card, but also the computer platform and operating system used. For example, a great many Mac Pro users such as myself will have been using NVIDIA GeForce 7300 GT video cards to drive their displays. These were the default cards Apple installed for a while. Although the 7300 GT is regarded as being compatible with Photoshop CS4 and CS5, they happen to perform OpenGL tasks rather poorly. Therefore, the impression gained by a lot of Mac users has been that OpenGL isn't particularly fast. Fortunately, the later Mac Pro computers now offer a better choice of video cards. As a general rule you can assume that more on-board memory indicates better graphics processing power, but you might also want to check out anecdotal evidence of what other Photoshop users find works best for them with their particular computers and operating systems.

all your needs. A video card will probably have at least 256 MB of dedicated memory, which is enough to satisfy the minimum requirements for Photoshop CS5. However, with the advent of the latest OpenGL features, it is now worth considering video cards that were previously considered only necessary for gaming and 3D work. Check the Adobe Help site to find out which cards are designated as being compatible for Photoshop CS5 and OpenGL.

Display calibration and profiling

We now need to focus on what is the most important aspect of any Photoshop system: getting the display to show your images in Photoshop correctly and ensuring that the display colors can be relied upon to match the print output. This basic advice should be self-evident, because we all want our images in Photoshop to be consistent from session to session and match in appearance when they are viewed on another user's system.

The initial calibration process should get your display close to an idealized state. The next step is to build a display profile that describes how well the display actually performs after it has been calibrated, which at a minimum describes the white point and chosen gamma. The more advanced LCD displays such as the Eizo ColorEdge and NEC LCD3090 do provide hardware calibration for a more consistent and standardized output, but the only adjustment you can make on most LCD displays is to adjust the brightness.

Calibration hardware

Let's now look at the practical steps for calibrating your display. First, get rid of any distracting background colors or patterns on the computer desktop. Consider choosing a neutral color theme for your operating system (the Mac OS X system has a graphite appearance setting especially for Photoshop users!) If you are using a PC, go to Control Panels \Rightarrow Appearance \Rightarrow Themes, choose Display and click the Appearance tab (Figure 2.3). Click on the active and inactive window samples and choose a gray color for both. If you are using Windows XP, try choosing the silver color scheme. This is all very subjective of course, but personally I think these adjustments improve the look of both operating systems.

The only reliable way to calibrate and profile your display is by using a hardware calibration system. Some displays, such as the LaCie range, can be bought with a bundled hardware calibrator,

1 An uncalibrated and unprofiled display cannot be relied on to provide an accurate indication of how colors should look.

2 The calibration process simply aims to optimize the display for brightness and get the luminance within a desired range.

3 The profiling process takes into account the target white balance and gamma. The profiling process also measures how a broad range of colors are displayed.

4 To create a profile of this kind you need a colorimeter device. A calibrator such as the X-Rite i1Display 2 or i1Photo with the i1Match or Profile Maker Professional software will produce accurate results, although there are now several other devices that are equally as good. Once calibrated and profiled, you will have a computer display that can be relied upon when assessing how your colors will reproduce in print.

Figure 2.3 This shows the operating system Appearance options for Macintosh (top) and Windows XP (bottom).

Figure 2.4 The X-Rite i1 Photo is a popular spectrophotometer that can be used with the accompanying software to calibrate and build an ICC profile for your display.

but there are many other types of stand-alone calibration packages to consider. The ColorVision Monitor Spyder and Spyder2Pro Studio are affordable and are sold either with PhotoCal or the more advanced OptiCal software. Colorimeter devices can only be used to measure the output from a display. Unlike the more expensive spectraphotometers, you can't use them to measure print targets, but when it comes to profiling a display they are just as good.

The X-Rite product range includes the i1 system which is available in several different packages. The i1 Photo (Figure 2.4) is an emissive spectrophotometer that can measure all types of displays and build printer profiles too when used in conjunction with the ProfileMaker 5 or i1 Match software, while the EZ Color is a low cost colorimeter device bundled with the i1 Display 2 software. The newest product in their range is the ColorMunki Photo, which is an integrated calibration/profiling device that can work with everything, including LCD beamer projectors.

If all you are interested in is calibrating and profiling a computer display, there is no great advantage in choosing a spectrophotometer over the more economically priced colorimeter devices. Whatever you do, I certainly advise you to include a calibrator/software package with any display purchase.

The calibration/profiling procedure

Over the next few pages I have shown how to use the i1Match 3.6.2 software with an X-Rite monitor calibration device and described the steps that would be used for an advanced display calibration. Other calibration software packages will differ of course, but the basic principles should be similar to other software programs. The first step is to select the type of device you want to calibrate (in this instance, an LCD display) and then select the Basic or Advanced options.

White point

The white point information tells the video card how to display a pure white on the screen so that it matches a specific color temperature. Unlike the old CRT displays, it is not possible to physically adjust the white point of an LCD screen. For this reason, it is usually better to select the native white point option when calibrating an LCD display (as shown in Figure 2.5), rather than calibrate to a prescribed white point value. Remember that all colors are seen relative to what is perceived to be the whitest white in a scene and the eye will naturally compensate from the white point seen on the display to the white point used by an alternative viewing light source (see accompanying sidebar on the white point setup).

Gamma

The gamma setting tells the video card how much to adjust the midtone levels compensation. You typically have three options to choose from here: 1.8, 2.2 or Native Gamma. Quite often you are told that PC users should use 2.2 gamma and Macintosh users should use 1.8 gamma. But 2.2 can be considered the ideal gamma setting to use regardless of whether you are on a Mac or a PC. You can build a correct display profile using a 1.8 gamma option, but 2.2 is closer to the native gamma of most displays. However, in Figure 2.5 you can see that I actually selected the 'Native Gamma' option. Most LCD screens have a native gamma that is fairly close to 2.2 anyway, and if you choose 'Native' rather than 2.2 you can create a satisfactory display profile without forcing the video card to stretch the display levels any more than is necessary.

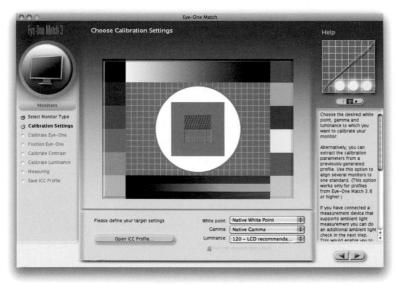

Figure 2.5 I like using the i1Match software because it is easy to set up and use. In this case, I wanted to calibrate and profile an LCD display. I set the white point and Gamma to 'Native' and the luminance to 120 candelas m², which is a recommended target setting for desktop LCD displays.

White point setup

There is a lot of seemingly conflicting advice out there on how to set the white point in a calibration setup. In the days when CRT displays were popular there was a choice to be made between a 5000K and a 6500K white point for print work. My advice then was to use 6500K, since most CRT displays would run naturally at a white point of 6500K, although some people regarded 5000K as being the correct value to use for CMYK proofing work. In reality though, the whites on your display would appear far too yellow at this setting. 6500K may have been cooler than the assumed 5000K standard, but 6500K proved to be much better for image editing viewing. These days, most LCD displays have a native color temperature that is around 6000-7000K and it is now considered best to choose the native white point when calibrating and profiling an LCD display.

The main thing to remember here is that your eyes adjust quite naturally to the white point color of any display, in the same way as your eyes constantly adjust to the fluctuations in color temperature of everyday lighting conditions. Therefore, your eyes will judge all colors relative to the color of the whitest white, so the apparent disparity of using a white point for the display that is not exactly the same as that of a calibrated viewing lightbox is not something you should worry about. As I say, when it comes to comparing colors, your eyes will naturally adapt as they move from the screen to the viewing lightbox.

Display gamma and brightness

Note that the gamma you choose when creating a display profile does not affect how light or dark an image will be displayed in Photoshop. This is because the display profile gamma only affects how the midtone levels are distributed. Whether you use a Mac or PC computer, you should ideally choose the Native Gamma or a gamma of 2.2.

The Macintosh 1.8 gamma option

The link between 1.8 gamma and the Macintosh system dates back to the early days of Macintosh computing when the only printer you could use with the Mac was an Apple black and white laser printer. At the time, it was suggested that the best way to match the screen appearance to the printer was to set the monitor gamma to 1.8. I once asked an engineer who designs display calibration software why they still included 1.8 gamma as an option and he replied that it's only there to comfort Mac users who have traditionally been taught to use 1.8. So now you know.

Luminance

You need to make sure that the brightness of the LCD display is within an acceptable luminance range. The target luminance will vary according to which type of display you are using and a typical modern LCD display will have a luminance of 250 candelas m² or more at its maximum luminance setting, which is way too bright for image editing work in subdued office lighting conditions. A target of around 120–140 candelas m² is ideal for a desktop LCD display and for laptops the ideal luminance to aim for is around 100–110 CD m².

It is important to note that as displays get older they do tend to lose brightness, which is one of the reasons why you will need to use a calibration device like the X-Rite i1 Photo shown in Figure 2.4, to recalibrate from time to time. There may also come a point where the display becomes so dim that it can no longer be successfully calibrated or considered reliable enough for Photoshop image editing.

Device calibration and measurement

With the i1Match software you will be asked to calibrate the device (Figure 2.6) before proceeding to measure the brightness of the display (Figure 2.7). It is at this stage that the Luminance indicator appears and you can tweak the display brightness until the target luminance is reached.

The profiling process

When you click on the forward arrow button in Figure 2.7, i1Match will start flashing a series of colors on the screen, while the calibration device measures them. Once it has completed doing this, it generates a display profile named with today's date. All you have to do then is click OK to establish this as the new display profile to use so that it replaces the previous display profile. You might also want to set a reminder for when the next monitor profile should be made. With LCD displays, regular calibration is not quite so critical and it will probably be enough for you to profile the display just once a month or so. Also, do you really need to hang on to old display profiles? I recommend that you purge the Colorsync Profiles folder on your system of older display profiles to avoid confusion. All you really need is one good up-to-date profile for each display.

Is the display too bright? These days, some LCD displays can be way too bright for digital imaging work. I

recently tried to calibrate one of the new glossy Apple displays and measured a brightness of 250 candelas m² at the minimum brightness setting. Brand new LCD displays do lose their brightness after 100 hours or so of use, which may make them become more useable. However, some of the new glossy displays appear to be incapable of revealing detail in the extreme highlight range. The thing is, these types of displays may look great for playing video games and watching TV, but they are not ideal for image editing work. This isn't just a problem with Apple, there are lots of unsuitable displays out there, which is why I now recommend purchasing a display that is specifically designed with digital image editing in mind.

Luminance

Luminance Indicator

Stop

Target (cd/m2):

Current (cd/m2):

140.0

140.7

Figure 2.6 Here, i1Match asks you to calibrate the device, by placing it on the base unit to measure the white tile, before hanging the device over the screen.

va Ana Matri

Set your luminance

Figure 2.7 In this step you are asked to set the contrast to maximum (skip this step if calibrating an LCD) and then adjust the brightness. i1Match measures the current display brightness and shows you the measured value in a separate window. You can then adjust the display hardware brightness controls until you get a good match.

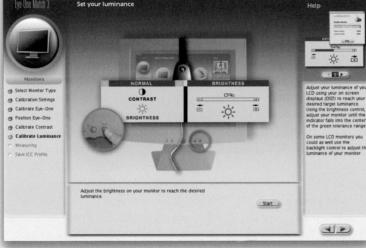

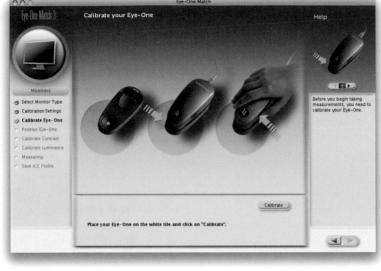

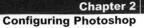

Figure 2.8 In this last step, the i1Match software starts measuring a sequence of colors that are flashed up on the display and from this builds an ICC profile of the display, which is automatically saved to the correct system folder where it will be picked up by the system and referenced by Photoshop's color management system.

Do you want good color or just OK color?

Let me summarize in a few paragraphs why you should pay special attention to how your images are displayed in Photoshop and why good color management is essential.

These days the only real option is to buy a good quality LCD display that is designed for graphic use. Once you have chosen a good display you need to consider how you are going to calibrate and profile it. This is crucial and if done right it means you can trust the colors you see on the display when determining what the print output will look like. In the long run you are going to save yourself an awful lot of time and frustration if you calibrate and profile the display properly right from the start. Not so long ago the price of a large display, plus a decent video card, would have cost a small fortune and display calibrators were considered specialist items. These days, a basic display calibration and profiling device can cost about the same as a medium-sized external hard drive, so I would urge anyone setting up a computer system for Photoshop to put a display calibrator and accompanying software package high on their spending list.

All the display calibrator products I have tested will automatically place the generated display profile in the correct system folder so that you are ready to start working straight away in Photoshop, with your display properly calibrated and with the knowledge that Photoshop automatically knows how to read the profile you have just created.

Color management settings

One of the very first things you should do after installing Photoshop is to adjust the color management settings. The default Photoshop Color Settings are configured using a general setting for the region you live in, which will be: North America, Europe or Japan. If you are using Photoshop for design work or photography, you will want to change this to a regional 'prepress' setting. Go to the Edit menu and select Color Settings, which opens the dialog shown in Figure 2.9. Next, go to the Settings menu and select

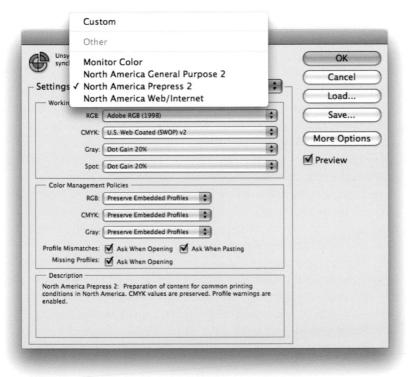

Figure 2.9 The Photoshop Color Settings. All the Photoshop color settings can be managed from within this single dialog (**H** Shift **K** ctrl Shift **K**) and shared with other Creative Suite applications (see Figure 2.10).

Eyeball calibration

Another option is to use a non-device calibration method, such as the Display Calibration Assistant that is part of the Mac OS X operating system. This is better than doing nothing, but is still not a proper substitute for proper hardware calibration and profiling. If you don't invest in a calibration/measuring device, your only other option is to load a canned profile for the display and keep your fingers crossed. This approach is better than doing nothing, but rarely all that successful, so I would still urge you to consider buying a proper calibration device and software package.

Color managing the print output

This leaves the question of how to profile the print output? Getting custom profiles built for your printer is a good idea, and it is a topic that I'll be covering in some detail in Chapter 12. However, calibrating and building a profile for your display is by far the most important first step in the whole color management process. Get this right and the canned profiles that came with your printer should work just fine. Follow these instructions and you should get a much closer match between what you see on the display and what you see coming out of your printer. Although without doubt, a custom print profile will help you get even better results.

Figure 2.10 The pie chart icon in the Color Settings dialog tells you if the Color Settings have been synchronized across the Creative Suite or not.

one of the prepress settings. The individual prepress settings only differ in the default RGB to CMYK conversions that are used, and these will depend on the geographical area you are working in (I also suggest you check out pages 647–648 for instructions on how to check if you are using the right settings for a photography setup). So if you live and work in the US, choose North America Prepress 2 and you will mostly be fine with that setting. Please note that choosing a prepress setting changes the RGB working space from sRGB to Adobe RGB. This is a good thing to do if vou intend editing RGB photographs in Photoshop (although I would personally recommend using ProPhoto RGB). The prepress settings also adjust the policy settings so as to preserve embedded profiles and alert you whenever there is a profile mismatch. I would also suggest you turn off the 'Ask When Opening' option in the Profile Mismatches section. This minimizes the number of times you are shown the profile mismatch warning dialog when working with image files that are in different color spaces. When you customize the color settings presets in this way, the preset menu will say 'Custom'. I suggest that you then save and name this preset so that these settings are easy to access in future.

Once this is done, the Color Settings will remain set until you change them. After that, all you need to worry about is making sure that the calibration and profile for your display are kept up-to-date. You don't need to worry too much more about the ins and outs of Photoshop color management just yet, but as your Photoshop knowledge increases you will definitely want to read in more detail about the color management system in Chapter 12 as well as Chapter 13 on print output. Color management does not have to be intimidatingly complex, nor does it have to be expensive. So the question is, do you want good color or simply OK color? Or, to put it another way, can you afford not to?

Synchronizing the Color Settings

If you are using other programs that are part of the Adobe Creative Suite, such as Illustrator and InDesign, it is a good idea to keep the Color Settings synchronized across all of these programs (see Figure 2.10). Once you have selected a desired color setting in Photoshop, I suggest you open Bridge and synchronize the Color Settings there too. This ensures that the same color settings are used throughout all the other programs in the Creative Suite.

99

Chapter 2 Configuring Photoshop

Extras

An internal $16 \times$ or faster DVD/CD drive is usually fitted as standard in most computers. Devices such as a graphics tablet, external hard drive and other peripheral devices can be connected using one of the following interface connection methods.

USB is a universal interface connection for Mac and PC. The older USB 1 connection was regarded as being very slow, but the newer USB 2 interface connection is more universal and faster, especially for those working on a PC system. You can have up to 127 USB devices linked to a single computer and you can plug and unplug a USB device while the machine is switched on. FireWire also has the potential to provide fast data transfer rates of 49 MB per second (and is faster still using FireWire 800) and is popular with Macintosh users.

Backing up your image data

The Mac and PC operating systems encourage you to place all your image files in the users 'Pictures' or 'My Pictures' folder. This might work fine if all you are shooting are JPEG snaps, but it is unlikely to suffice once you start capturing lots of raw images. So your first consideration should be to store your image files on hard drives that have plenty enough capacity to anticipate your image storage needs for at least the next year or two. The next thing you need to consider is how accessible is your image data? Suppose a power supply unit failure or some other glitch prevented you from turning on the computer? For this reason I find it is helpful to store important image data on drives that can easily be accessed and removed. One solution is to store your data on separate internal hard drives where the drive caddies can easily be swapped over to the internal bay of another computer. Or, you can store the data on external hard drive units that can simply be plugged in to another computer.

The next thing is to implement a backup strategy for your images and other important data files. For each main hard drive you should have at least one matching sized external hard drive that you can regularly back up the data to. These hard drives should be kept somewhere safe so that in case of a fire or theft you have access to recently backed up versions of all your essential data. One suggestion is to have two external backup drives for each main drive. That way you can swap over the backup drives and

Figure 2.11 Wacom[™] pad and pen.

Graphics tablets

I highly recommend you get a digitizing graphics tablet like the one shown in Figure 2.11. This is a pressure responsive device which makes drawing easier and can be used alongside the mouse as an input device. Bigger is not necessarily better though. Some people like using the A4 sized tablets, while others find it easier to work with an A5 or A6 tablet. You don't have to move the pen around so much with smaller pads and these are therefore easier to use for painting and drawing. Once you have experienced working with a pen, using the mouse is like trying to draw while wearing boxing gloves! The latest Wacom Intuos[™] range now features a cordless mouse with switchable pens. and the Wacom Cintig[™] device is a combination of LCD monitor and digitizing pen pad. This radical new design will potentially introduce a whole new concept to the way we interact with the on-screen image. I don't know if it is going to be generally seen as the ideal way of working with photographs, but there are those who reckon it makes painting and drawing a more fluid experience.

Backup strategies

For more detailed information on how to back up your files, please refer to Chapter 11 on image management.

Figure 2.12 When any paint or fill tool is selected, you can hold down the **H C C t i** keys (Mac), or hold down the **all Shift** keys and right-click (PC), to open the Heads Up Display Color Picker. The two main Heads Up Display options are the Hue Strip (top) and the Hue Wheel (bottom). These are available in different sizes from the HUD Color Picker menu.

continually have a secondary backup version stored permanently off-site or kept in a fireproof safe.

In the lifetime of the Photoshop program we have seen many different storage systems come and go: floppy disks, Syquests, Magneto Opticals... the list goes on. Although you can still obtain devices that are capable of reading these media formats, the question is, for how long? What will you do in the future if a specific hardware device fails to work? The introduction of recordable CD/DVD media has provided a reasonably consistent means of storage and for the last 14 years nearly all computers have been able to read CD and DVD discs. DVD drives have also evolved to provide much faster read/write speeds and DVD media may be able to offer increased storage space in the future. We are already seeing bigger disc media storage systems such as Blu-ray Disc make an impact. So how long will CD and DVD media remain popular and be supported by future computer hardware devices? More to the point, how long will the media discs themselves last? It is estimated that aluminium and gold CD discs could last up to 30 years, or longer, if stored carefully in the right conditions, such as at the right temperature and away from direct sunlight, while DVD discs that use vegetable dyes may have a shorter lifespan. I wouldn't bet on DVD or Blu-ray media providing a long-term archive solution, but even so, I reckon it is worth keeping extra backups of your data on such media. The one advantage write-once media has over hard drive storage is that your data is protected from the prospect of any virus attacks. If a virus were to infect your computer and damage your data files, a backup procedure might simply copy the damage over to the backup disks.

Photoshop preferences

The Photoshop preferences are located in the Edit menu in Windows and the Photoshop menu in OS X; these let you customize the various Photoshop functions. A new preference file is generated each time you exit Photoshop, and deleting or removing this file will force Photoshop to reset all of its preference settings. The preference file is stored along with other program settings in the system level Preferences folder (Mac) or C:/ Documents and Settings/Current User/Application Data/Adobe/ Photoshop/11.0/Adobe Photoshop CS5 Settings (PC).

General preferences

When you open the preferences you will first be shown the General preferences (Figure 2.13). I suggest you leave the Color Picker set to 'Adobe' (unless you have a strong attachment to the system Color Picker). Photoshop CS5 now features new HUD (Heads Up Display) Color Picker options for selecting new colors when working with the eyedropper or paint tools (Figure 2.12). Note that the HUD Color Picker is only accessible when OpenGL drawing is enabled (see page 110). In the Image Interpolation options I suggest you leave this set to 'Bicubic'. If you need to override this setting then you can always do so in the Image Size dialog.

In the main Options section, 'Auto-Update Open Documents' can be used if you know you are likely to share files that are open in Photoshop but have been updated by another application. It used to be important when ImageReady was provided as a separate Web editing program to accompany Photoshop, but has less relevance now and can be left switched off. Only check the Beep When Done box if you want Photoshop to signal a sound alert each time

Resetting the preferences

If you hold down 🛞 🗨 Shift

ctrl all Shift during the startup cycle, this pops a dialog box that allows you to delete the current Photoshop preference file.

Backing up the preference file

After configuring the preference settings I suggest you make a duplicate of the Photoshop preference file and store it somewhere safe. Having ready access to a clean preference file can speed up resetting the Photoshop settings should the working preference file become corrupted.

	and the second secon	Preferences	
General	Color Picker: Adobe	•	ОК
Interface File Handling	HUD Color Picker: Hue Strip	\$	Cancel
Performance	Image Interpolation: Bicubic (best fo	r smooth gradients)	Prev
Cursors Transparency & Gamut Units & Rulers Guides, Grid & Slices Plug-Ins Type 3D	Options Auto-Update Open Documents Beep When Done Dynamic Color Sliders Export Clipboard Use Shift Key for Tool Switch Resize Image During Place Animated Zoom Zoom Resizes Windows Zoom with Scroll Wheel		Next
	 ✓ Zoom Clicked Point to Center ✓ Enable Flick Panning ✓ Place or Drag Raster Images as S 	mart Objects	
	• Both	Choose)Photoshop Edit Log.txt	
	Res	et All Warning Dialogs	

Figure 2.13 The General preferences dialog.

Resize Image During Place

When the 'Resize Image During Place' preference item is checked, if you use File ⇒ Place... to place a photo in a document that is smaller than the placed image, the placed file is placed in a bounding box scaled to the dimensions of the target image. This can help speed up your workflow when pasting lots of documents, especially now that Photoshop CS5 allows you to drag and drop Photoshop compatible files to place them in an image. a task is completed. The 'Dynamic Color Sliders' option ensures that the colors change in the Color panel as you drag the sliders, so keep this selected. If you need to be able to paste the Photoshop clipboard contents to another program after you exit Photoshop, then leave the Export Clipboard box checked. Otherwise, I suggest you switch this off. The 'Use Shift Key for Tool Switch' option answers the needs of those users who wish to disable using the Shift key modifier for switching tools in the Tools panel with repeated keystrokes (see page 30). The 'Resize Image During Place' is useful if you want placed items to be automatically scaled to match the size of the image you are pasting/placing them in (see sidebar). The 'Animated Zoom' option is another OpenGL only option, which is intended to provide smoother transitions on screen when using the $\mathbb{H} - ctrl - or \mathbb{H} + ctrl + keys to$ zoom in or out. Also, check the 'Zoom Resizes Windows' option if you want the image window to shrink to fit whenever you use a keyboard zoom shortcut such as $\mathbb{H} - ctrl - or \mathbb{H} + ctrl + .$ Then there is the 'Zoom with Scroll Wheel' option which enables you to zoom in and out using the scroll wheel on a mouse (when this option is selected, holding down the *Shift* key makes the zoom operate quicker). Instead of selecting this option you can also hold down the **C** alt key to temporarily access the zoom wheel behavior. When the 'Zoom Clicked Point to Center' option is checked, the image zooms in centered around the point where you click; the best way to understand the distinction between having this option on or off is to see what happens when you click to zoom in on the corner of a photo. When checked, the corner point of the photo will keep recentering as you zoom in. I discussed the 'Flick panning' option earlier in Chapter 1, on page 57. This again is dependent on OpenGL being enabled for this option to take effect. 'Place or Drag Raster Images as Smart Objects' is new to Photoshop CS5 and does what it says. It allows you to drag a Photoshop compatible file directly from the Finder/Explorer or from Bridge to place it as a new layer in an open document.

A history log is useful if you wish to keep track of everything that has been done to an image and the History Log options let you save the history log directly in the image file metadata, to a saved text file stored in a pre-configured folder location, or both. The edit log items can be recorded in three modes: 'Sessions' records which files are opened and closed and when. The 'Concise' mode records an abbreviated list of which tools or commands were applied (also recording times). Both these modes can provide basic feedback that could be useful in a studio environment to monitor the time spent on a particular project and to help calculate billing. The 'Detailed' mode records everything, such as the coordinates used to make a crop. This mode can be useful, for example, in forensic work.

You will often come across warning dialogs in Photoshop that contain a 'Don't Warn Me Again' checkbox. If you have at some stage clicked in these boxes to prevent a warning dialog appearing again you can undo this by clicking on the 'Reset All Warning Dialogs' button in the General preferences.

Interface preferences

If you refer to the screen view modes shown on page 60, you will see examples of two of the three main screen modes that are available in Photoshop. The outer canvas areas can be customized by selecting alternative colors via the Interface preferences (Figure 2.14). You

ALL PROPERTY AND AND A		Preferences		
Ceneral Interface File Handling Performance Cursors Transparency & Gamut Units & Rulers Guides, Grid & Slices Plug-Ins Type 3D	General Standard Screen Mode: Full Screen with Menus: Full Screen: Show Channels in Color Show Menu Colors Show Tool Tips Enable Gestures Panels & Documents Auto-Collapse Iconic I Auto-Show Hidden Pa	Color Gray Color Gray Color Black Color Black Color Panels	Border Drop Shadow 🗘 Drop Shadow 🛟 None 🛟	OK Cancel Prev Next
	Open Documents as T Changes will take of time you start Photons	English: UK : Small :		

Figure 2.14 Interface preferences.

Canvas color and the paint bucket

An alterative way to alter the color of the outer canvas area is to select the paint bucket tool, choose a new foreground color and hold down the *Shift* key as you click with the paint bucket in the canvas area. This replaces the existing canvas with the current foreground color.

Customizing the UI Font Size

LCD computer displays are getting bigger all the time and are only really designed to operate at their best when using the finest resolution setting. This can be great for viewing photographs, but the downside is that the application menu items are getting smaller and smaller. The 'UI (user interface) Font Size' option allows you to customize the size of the smaller font menu items in Photoshop so that you don't have to strain your eyes too hard to read them. For example, when using a large LCD screen, the 'Medium' font size option may make it easier to read the smaller font menu items from a distance. can also adjust the border, which can be shown as a drop shadow, thin black line, or with the border style set to 'None'. There is also another way you can set the canvas color, which has been around for a while (see sidebar: Canvas color and the paint bucket). The useful thing to know here is you can use these interface preference items as a way to quickly reset the default canvas and borders.

The 'Show Channels in Color' option is a somewhat redundant feature as it does not really help you visualize the channels any better. If anything it is a distraction and best left unchecked.

Photoshop allows you to create custom menu settings and use colors to highlight favorite items, but this particular feature can be disabled by unchecking the 'Show Menu Colors' option. When 'Show Tool Tips' is checked a tool tips box will appear for a few seconds after you roll over various items in the Photoshop interface. Tool tips are an excellent learning tool, but they can become irritating after a while, so you can use this checkbox to turn them on or off as desired. The 'Enable Gestures' option is relevant to some laptop users, where the trackpad can be set to respond to specific finger gestures. This can be both a good or a bad thing: some users have found it rather distracting when carrying out Photoshop work and prefer to switch this option off.

In the Panels & Documents section, the 'Auto-Collapse Iconic Panels' option allows you to open panels from icon mode and autocollapse them back to icon mode again as soon as you start editing an image, while 'Auto-Show Hidden Panels' reveals hidden panels on rollover.

When the 'Open Documents as Tabs' option is checked, new documents will always open as tabbed documents, docked to a single document window in the Photoshop workspace. Uncheck this if you wish to restore the previous Photoshop document opening behavior. When the 'Enable Floating Document Window Docking' option is checked, this allows you to drag one window to another as a tabbed document (see page 12).

The UI in the 'UI Text Options' stands for 'user interface' and these settings allow you to choose an alternative UI language (if available) and UI text size. The default setting is 'Small', which most users will find plenty big enough (especially now the panel headers kind of scream at you with the all caps lettering). For those fortunate to have very large, high resolution displays it can be helpful to increase the UI text size (see sidebar).

File Handling preferences

In the File Handling preferences (Figure 2.15) you will normally want to include image previews when you save a file. It is certainly useful to have image thumbnail previews that are viewable in the system dialog boxes, although the Bridge program is capable of generating large thumbnails regardless of whether a preview is present or not. You can also choose to save a Windows and Macintosh thumbnail with your file to enable better cross-platform compatibility. Appending a file with a file extension is handy for knowing which format a document was saved in and is absolutely necessary when saving JPEG and GIF web graphics that need to be recognized in an HTML page. If you are exporting for the Web, you may want to check the 'Use Lower Case' option for appending files. However, instances of where servers trip up on upper case naming are fairly rare these days. The 'Save As to Original Folder' option is useful if you want this to be the default option. It makes sure that you are always able to save new versions of an image to the same folder that the original file came from. If this option is

Economical Web saves

There are times though when you don't need previews. Web graphic files should be uploaded as small as possible without a thumbnail or platform-specific header information. If you use 'Save for Web & Devices', this removes the previews and keeps the output files compact in size.

Ceneral Interface File Saving Options OK File Handling Image Previews: Always Save Cancel Performance Image Previews: Always Save Cancel Cursor Image Previews: Always Save Previews: Always Save Cancel Previews: Always Save Image Previews: Always Save Previews: Always Save Previews: Always Save Units & Rulers Image Previews: Always Save Image Previews: Always Save Image Previews: Always Save As to Original Folder Image Previews: Always Save As to Previews: Always S

Figure 2.15 The File Handling preferences.

Version Cue and enable Adobe Drive

Adobe Version Cue[®] is a workgroup file management option that is included with the Creative Suite. Version Cue caters for those working in a networked environment, where two or more operators have shared network access to files that they will be working on using different programs within the Creative Suite. When a user 'checks out' a file, only he or she can edit it. The other users who have shared access to the files will only be able to make edit changes after the file has been checked back in. This precautionary file management system means that other users cannot overwrite a file while it is being edited. Version Cue now consists of two elements: the Version Cue Server and Adobe Drive. The Version Cue Server can be installed locally or on a dedicated computer and used to host Version Cue projects. Adobe Drive connects to the Version Cue servers, where the connected server appears as a hard drive in the Finder/Explorer as well as in the Open and Save As dialog boxes.

left unchecked, Photoshop shows you the last used folder location when you choose File \Rightarrow Save As...

File compatibility

Photoshop CS3 allowed JPEG and TIFF images to open via Camera Raw, for the first time, as if they were raw files. A number of people had misgivings about this, partly because of the potential confusion it might cause, but also because of the way it was implemented in Photoshop CS3. For example, you had the Photoshop File Handling preferences doing one thing, plus another setting in the Bridge preferences, and there was no simple way to summarize how these should be configured in order to get JPEG or TIFF images to open up via Camera Raw the way you would expect. In fact, even fellow Photoshop experts were just as confused as everyone else as to how to manage the preference settings in these two different locations. To be honest, it was a bit of a mess, but things have been improved somewhat since then.

The 'Prefer Adobe Camera Raw for Supported Raw Files' option always launches Adobe Camera Raw as your favored raw processor when opening a proprietary raw file. Some cameras may embed an sRGB profile tag in the EXIF metadata of a JPEG capture file (where the profile used isn't a correct sRGB profile anyway). If you check the 'Ignore EXIF profile tag' option, Photoshop ignores this particular part of the metadata and reads from the (correct) embedded profile data instead.

Camera Raw preferences

You can click on the Camera Raw Preferences... button to open the dialog shown in Figure 2.16. At the bottom are the JPEG and TIFF Handling preferences where you have three options with which to decide how JPEG and TIFF images should be opened in Photoshop. These are now fairly easy to understand and predictable in their behavior. If 'Disable JPEG (or TIFF) support' is selected this safely takes you back to the way things were before, where all JPEG or TIFF files open in Photoshop directly. If 'Automatically open all supported JPEGs (or TIFFs)' is selected, this causes all supported JPEGs (or TIFFs) to always open via Camera Raw. However, if 'Automatically open JPEGs (or TIFFs) with settings' is selected, Photoshop only opens JPEG or TIFF images via Camera Raw *if* they have previously been edited via Camera Raw. When this option is selected you have the option in Bridge to use a double-click to open a JPEG directly into Photoshop, or use **HR** *ctrl R* to force JPEGs to open via Camera Raw. Note that when you edit a JPEG or TIFF in Camera Raw in this way, the next time you use a double-click to open, the file will now default to opening via Camera Raw.

So why should you want to open JPEGs (or TIFFs for that matter) in Camera Raw? This is useful if you shoot in JPEG mode and wish to use Camera Raw to process the JPEG masters (as you would a raw capture image) without actually editing the master files. This is because Camera Raw records all the edits as separate instructions. The same argument applies to opening TIFF files via Camera Raw, but the important thing to note here is that Camera

	Camera Raw Preferences	(Version 6.0.0.152)	
General			ОК
Save image settings in:	Sidecar ".xmp" files	•	Cancel
Apply sharpening to:	All images	•	Cunter
Default Image Settings -			
Apply auto tone adj	ustments		
Apply auto grayscale	e mix when converting to g	rayscale	
Make defaults speci	fic to camera serial number		
Make defaults speci	fic to camera ISO setting		
Select Location	/Users/martin_evening/Library/	Caches/Adobe Camera Ra	w/
DNG File Handling			
🗌 Ignore sidecar ".xmj	o" files		
🗹 Update embedded Jl	PEG previews: Full Size		
JPEG and TIFF Handling			
IPEG: Disable JPEG su	pport		•
JPEG: Disable JPEG su			

Figure 2.16 This shows the Camera Raw preferences dialog with the JPEG and TIFF Handling options at the bottom.

Layered files in a DTP layout

Adobe InDesign allows you to place Photoshop format (PSD) files in a page layout, but, if you do so, the 'Maximize PSD and PSB File Compatibility' option must be checked in the File Handling preferences (in order to generate a flattened composite). If you use layered TIFF, PSD (or Photoshop PDF) files in your page layout workflow, you can modify the layers in Photoshop and the page design image preview will immediately be updated. This way you don't run the risk of losing synchronization between the master image that is used to make the Photoshop edits and a flattened version of the same image that is used solely for placing in the layout. If you want to 'round trip' your images this way, TIFF is the more universally recognized file format. The downside is that you may end up with bloated files and these can significantly increase the file transmission times. It so happens that a lot of the image files used in the production of this book have been placed as layered TIFF RGB files, which allows me to edit them easily in Photoshop. Keeping the files as layered RGBs is perfect at the text editing stage, but the final TIFF files that are used to go to press are all flattened CMYK TIFFs.

Raw can only open flattened TIFFs and cannot open TIFFs that contain saved layers. The main reason why it might be useful to use Camera Raw to open a TIFF image is if you want to process TIFF scan images via Camera Raw to take advantage of things like the capture sharpening controls in the Detail panel section.

TIFF and PSD options

A TIFF format file saved in Photoshop 6.0 or later can contain all types of Photoshop layer information and a flattened composite is always saved in a TIFF. If you then place a layered TIFF image in a page layout, only the flattened composite will be read by the program when the page is finally converted to print. Some people argue that there are specific instances where a layered TIFF might trip up a print production workflow, so it might be safer to never save layers in a TIFF, but you know, there are a large number of Photoshop users who successfully use layered TIFFs when saving master images. My advice is not to be put off including layers. When the 'Ask Before Saving Layered TIFF Files' option (Figure 2.15) is checked, Photoshop presents you with an option to either flatten or preserve the layers when saving a layered image as a TIFF. If this is unchecked, then the layer information is saved regardless and you'll see no warning dialog.

However, standard Photoshop PSD files created in Photoshop CS5 are not going to be 100% compatible if they are likely to be read by someone who is using an earlier version of Photoshop and this has always been the case with each upgrade of the program. Setting the Maximize PSD and PSB Compatibility to 'Always' allows you to do the same thing as when saving a flattened composite with a TIFF. This option ensures that a flattened version of the image is always included with the saved Photoshop file and the safe option is to keep this checked. For example, if vou include a Smart Object layer, the Photoshop file will not be interpreted correctly when read by Photoshop CS or earlier unless you maximize the compatibility of the saved PSD. In these circumstances, if Photoshop is unable to interpret an image it will present an alert dialog. This will warn that certain elements cannot be read and offer the option to discard these and continue, or to read the composite image data. Discarding the unreadable data will allow another user to open your image, but when opened it will be missing all the elements you added and most likely look

very different from the file you intended that person to receive. If on the other hand they click the Read Composite Data button and a composite was saved, the image will open using a flattened composite layer which looks the same as the image you created and saved. If no composite was created, they will just see a white picture and a multi-language message saying that no composite data was available.

Maximizing PSD compatibility lets images load quicker in Bridge; another crucial point is that Lightroom is only able to read layered PSD files that have this option turned on. If there is no saved composite, Lightroom won't be able to import it.

If you set the preference for the 'Maximize PSD and PSB File Compatibility' option in Figure 2.15 to 'Ask', Photoshop CS5 will show a 'Don't show this message again' message in the Maximize Compatibility warning dialog, which will appear after you choose to save an image using the PSD file format (See Figure 2.17). If the 'Maximize Compatibility' option is checked, the default from now on will be to 'Always' maximize compatibility. If the option is unchecked, it will be set to 'Never' from now on.

Maximize Compatibility	ОК
Turning off Maximize Compatibility may interfere with the use of PSD or PSB files in other applications or with other versions of Photoshop.	Cancel
This dialog can be turned off in Preferences > File Handling > File Compatibility.	

Figure 2.17 The Photoshop Format Options dialog.

Recent File list

The Recent File list (Figure 2.15) refers to the number of image document locations that are remembered in the Photoshop File \Rightarrow Open Recent submenu. You might want to set this to the maximum limit allowed which is 30.

Performance preferences

The Performance preferences section (Figure 2.18) lets you configure all the things that influence how efficiently Photoshop is able to run on your computer. The memory usage can be set using a sliding percentage scale and you will notice how Photoshop

Speed and efficiency test

To help evaluate the performance efficiency of your computer setup, here is a really useful weblink to a site hosted by a company called Retouchartists.com: retouchartists.com/pages/speedtest.html. From there you can download a test file which contains a sample image and a Photoshop action that was created by Alex Godden. All you have to do is time how long it takes for the action to complete to gauge and compare how fast your computer is running. You can then compare your speed test results with those of other Photoshop users.

Restart to activate preferences

Some Photoshop preferences only take effect after you quit and restart the program. For example, the Scratch Disk preference settings in the Performance preferences (see page 110) only come into effect after a restart, while the OpenGL preferences only come into effect after you open or create a new window in Photoshop.

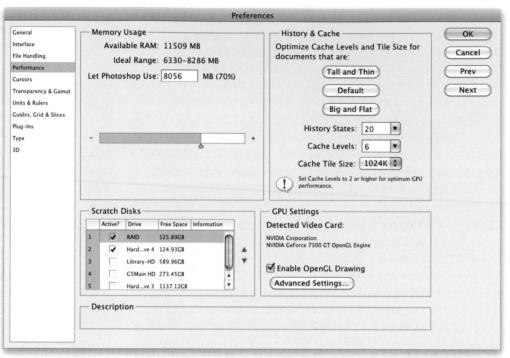

R: KG: R	62 95 67	C:	75% 40% 75%
8-bit		K: 8-bit	35%
₩¥:	121.73 90.01	₽ ₩: H	
	.5M/27.1M ty: 100%*		
		ove layer or se gree increme	

Figure 2.19 You can monitor how efficiently Photoshop is running by getting the Info panel options to display an Efficiency readout. If the efficiency reading drops below 100% this means that Photoshop is having to rely on the designated scratch disk as a virtual memory source.

Figure 2.18 The Performance preferences, where you can configure the Memory Usage, History, Cache, Scratch Disks and GPU settings. Note that in the Scratch Disks section you can check which volumes to use as scratch disks. Highlight a particular disk, then use the arrows to move it up or down the list; tick it to make it active.

provides a hint as to what the ideal range should be for your particular computer. The History & Cache section now includes a 'Cache Tile Size' option and buttons to help you configure the ideal settings here. In the Scratch Disks section you can drag to rearrange the currently available disk volumes in order of priority and, lastly, the GPU settings allow you to enable OpenGL drawing, if your video card allows it.

Memory usage

The amount of RAM memory you have installed determines how efficiently you can work in Photoshop. Each time you launch Photoshop a certain amount of RAM memory is set aside for use by the program. How much depends on the amount that is set in the Memory Usage section as a percentage of the total amount of RAM that is available for Photoshop to use. The figure you see in the Memory Usage section is the RAM reserved for Photoshop imaging use (although the RAM you set aside for Photoshop can be shared by other applications when it is not actively being used by Photoshop). Adobe recommend that you allocate a minimum of 1 GB RAM memory, which means that if you allow an additional 200 MB of RAM for the operating system, you will need to have at least 1.5 GB of RAM installed. If you also take into account the requirements of other programs and the likelihood that newer operating systems may need even more memory, it is safer to suggest you actually need a minimum of 2 GB RAM memory in total. Don't forget that you will also need to allow some RAM memory to run Adobe Bridge at the same time as Photoshop.

The Memory Usage section therefore provides a guide for the ideal RAM setting for your computer and indicates what the ideal range should be. On a Windows system the default setting is 50% of the total available RAM and on a Mac it is 70% (the figure shown here is now more accurate in Photoshop CS5). Note that if the memory is set too high, Photoshop may end up competing with the operating system for memory and this can slow performance, although as I mentioned earlier, the memory assigned to Photoshop is freed up whenever Photoshop is not running. You can always try allocating 5% above the recommended upper limit, relaunch Photoshop and closely observe the efficiency status bar or Info panel Efficiency readout (Figure 2.19). Anything less than 100% indicates that Photoshop is running short of physical memory and having to make use of the scratch disk space. If you allocate too high a percentage, this can compromise Photoshop's efficiency. So the trick is to find the optimum percentage before you see a drop in performance. You may find the speed test described in the sidebar on page 109 is a useful tool for gauging Photoshop performance.

32-bit and 64-bit RAM limits

The amount of RAM that is available to Photoshop is obviously dependent on the total amount of RAM memory that's installed on your computer. If you run Photoshop on a computer with a 32-bit operating system that has 4 GB or more of RAM installed, a maximum of 2.6 GB of RAM (Mac) can be allocated to Photoshop and a maximum of 3 GB of RAM in the case of Windows systems. Even if you are hit by the 4 GB RAM limit on a 32-bit system and you have more than 4 GB memory installed, the RAM above 4 GB can

RAM memory upgrades

Most PCs and Macs use DIMMs (Dual In-line Memory Modules). The specific RAM memory chips may vary for each type of computer, so check carefully with the vendor that you are buying the right type for your particular machine. RAM memory used to cost a small fortune, but these days the price of RAM is almost inconsequential. If you have four RAM slots on your machine, you should easily be able to install 4×1 GB RAM or 4×2 GB RAM memory chips, which will give you 4 or 8 GB of installed RAM. A good suggestion is to install an absolute minimum of 1 GB of RAM per processing core on your computer, while the ideal balance is more like 2 GB of RAM per core. If you aim for 4 GB of RAM per core, you will see significant benefits with certain memory-intensive filter operations. For all other types of operations the speed benefits are not quite so dramatic.

Assigning scratch disks at startup

If you hold down the **H C tri ati** keys as you launch Photoshop, this will pop the Disc options on the screen and allow you to add or change the Scratch Disk settings.

Cache tile size and batch processes

There are certain types of Photoshop operations (such as a Radial Blur filter) that can make heavy demands on the computer hardware, utililizing nearly all of your processors. If you raise the cache tile size in the Performance preferences to 1024 or 1028K this means the data to be processed is divided into bigger chunks, and this in turn can make a big improvement to batch processing times. The optimum choice of tile size here will depend on whether you are using an Intel or AMD processor (see page 113). also be used by the operating system as a cache for the Photoshop scratch data. So although you can't allocate this extra memory directly, installing extra memory can still help boost Photoshop's performance on a 32-bit system.

Photoshop CS4 saw 64-bit processing enabled for the PC platform and Photoshop CS5 now adds 64-bit support for Macintosh computers too. Providing you have the latest 64-bit enabled hardware and a 64-bit computer operating system, you can install or run Photoshop in 64-bit mode. The main advantage this brings is increased RAM memory access beyond the 4 GB physical limit. In terms of speed you won't necessarily find a 64-bit version of Photoshop to be that much faster than a 32-bit version, except for when you are working with very large files or carrying out memory-intensive operations.

History & Cache

In the History & Cache section the default number of History States is 20. You can set this to any number you like from 1–1000, but remember that the number of histories you choose does have a bearing on the scratch disk usage.

The Cache Level settings affect the speed of the screen redraws. Whenever you are working with a large image, Photoshop uses a pyramid type structure of lower resolution cached versions of the full resolution picture. Each cached image is a quarter scale version of the previous cache level and is temporarily stored in memory to provide speedier screen previews. Basically, if you are viewing a large image on screen in 'Fit to screen' display mode, Photoshop uses a cache level that is closest to the fit to screen resolution to provide a screen refresh view of any edit changes you make at this viewing scale. The cached screen previews can therefore provide you with faster screen redraws and larger images can benefit from using a higher cache level, since a higher setting provides faster screen redraws but at the expense of sacrificing the quality of the preview. This is because a lower resolution cache preview is not as accurate as viewing an image at Actual Pixels.

The optimization buttons can help you set the cache levels to an appropriate value. If you mostly work on small images such as Web design layouts, which are small in pixel dimension size but may contain lots of complex layers, you'll gain better performance by clicking the Tall and Thin button to set the Cache Levels to 2. If you mostly work with large images, but not quite so many layers, you can click on the Big and Flat button to set the Cache Levels to 5, although you may wish to override this and set the cache levels even higher than this.

The Cache Tile Size can be adjusted according to what is the most appropriate setting for the type of work you do. There used to be an optional Bigger Tiles plug-in that you could install in order to boost Photoshop performance when editing large images. This has now been done away with and the tiling options are instead now incorporated into the Performance preferences. The Cache Tile Size can be set anywhere from 128K–1024K, and tests suggest the optimum settings to choose from are 128K/1024K for the newer Intel processors and 132K/1028K for AMD processors. For image editing work with large photo-sized documents where throughput, i.e. image size, is more of a consideration, it is better to choose a larger Cache Tile Size here.

Scratch disks

Photoshop can utilize the free hard disk space that's allocated in the Scratch Disks section as an extension of RAM memory. Photoshop always makes the most efficient use of the real RAM memory and tries to keep as much RAM as possible free for memory-intensive calculations. Low-level data, like the 'last saved' version of the image, is stored in the scratch disk memory giving priority to the current version and last undo versions being held in RAM. Normally, Photoshop uses all the available free RAM as buffer memory in which to perform real-time calculations and mirrors the RAM memory contents on the scratch disk. Photoshop does this whenever there is a convenient opportunity to do so. For example, after you open a new image you may notice some disk activity as Photoshop writes from the RAM memory buffer to the scratch disk. Photoshop then continually looks for ways to economize the use of RAM memory, writing to the hard disk in the background whenever there are periods of inactivity. Scratch disk data is also compressed when it is not in use (unless an optional plug-in extension that prevents this has been loaded at startup).

When Photoshop exhausts its reserves of RAM memory, it is forced to use the extra space on the scratch disk as a source of virtual memory and this is where you will start to see a major slowdown in efficiency. When the Efficiency indicator (Figure 2.19) drops

Scratch disk checks

When you launch Photoshop it checks to see how much hard disk space is free for scratch disk usage and if for any reason have less scratch disk space than RAM memory space, the RAM memory will be restricted by the amount of scratch disk space that is available.

Move don't copy

To copy selections and layers between documents, use the drag and drop method with the move tool. This saves on memory usage and also preserves the current clipboard contents.

Scratch disk usage and history

The scratch disk usage will vary according to how many history states you have set in the History & Cache section and also how you use Photoshop. Generally speaking, Photoshop stores a version of each history state, but it does not always store a complete version of the image for each history state. As was explained in Chapter 1, the History feature only needs to save the changes made in each image tile. So if you carry out a series of brush strokes, the history only stores changes made to the altered image tiles. For this reason, although the scratch disk usage increases as you add more history steps. in practice the usage does not increase in such large chunks, unless you were to perform a series of global filter changes.

Scratch	Disks		OK
First:	RAID	•	Cance
Second:	Hard Drive 4	•	Cance
Third:	None		
Fourth:	None		

Figure 2.20 If you hold down the **# C** *ctrl alt* keys during the startup cycle as you launch Photoshop, this reveals the Scratch Disk Preferences dialog, allowing you to configure the Scratch Disk options during startup. below 100% this means that the RAM buffer is full and Photoshop is now relying exclusively on the hard disk scratch disk space as a memory reserve. This is because the Photoshop calculations are limited to the read/write speeds of the primary scratch disk, followed by the secondary disk, and so on. Should you experience a temporary slowdown in performance you might want to purge Photoshop of any excess data that's temporarily held in memory. To do this, choose Edit \Rightarrow Purge and select Undo, Clipboard, Histories or All.

The primary scratch disk should ideally be one that is separate to the disk that's running the operating system and Photoshop. It is no good partitioning the main disk volume and designating an empty partition as the scratch disk, because the disk drive head will simply be switching back and forth between different sectors of the same disk as it tries to do the job of running the computer system and provide scratch disk space. For optimal image editing, you ideally want the scratch disk to be a fast, separate disk volume with a minimum of 20–40 GB of free space and as free as possible of any disk fragmentation. Note also the instructions in Figure 2.20 that describe how to alter the scratch disk settings during startup.

Scratch disk performance

With all this reliance on the scratch disk (or multiple scratch disks) to read/write data from the RAM memory buffer, the hard disk performance of the scratch disk plays an important role in maintaining Photoshop efficiency. There is provision in Photoshop for as many as four scratch disks. Each individual scratch file created by Photoshop can be a maximum of 2 GB and Photoshop can keep writing scratch files to a scratch disk runs out of room to accommodate all the scratch files during a Photoshop session, it then starts writing scratch files to the secondary scratch disk, and so on. This makes for more efficient and faster disk usage. Let's now look at the important factors that affect the speed of the scratch disk.

Interface connection

Most modern Macs and PCs have IDE, ATA or SATA drives as standard. A fast internal hard disk is adequate for getting started, but for better performance, you should really install a second internal or external hard drive and have this dedicated as the primary scratch disk (make this the number one scratch disk in the Performance preferences). Your computer will most likely have the choice of a USB or FireWire connector for linking external devices. USB 2 offers a much faster connection speed than the old USB 1, while FireWire (IEEE 1394) is regarded as being faster still. With USB or FireWire you can hot swap a drive between one computer and another. This is particularly useful when you wish to shuttle very large files around quickly. With the advent of FireWire 800 we are now seeing an appreciable improvement in data transfer speeds. FireWire drives basically use a Bridge Chipset to provide the FireWire connection and, since the Oxford Chipset came out, have been able to enhance the throughput closer to the theoretical limit. Note that it is the data transfer and not the data access time that is the measure of disk speed to look out for.

Hard drive speed

Most desktop computers use internal drives which run at 7200 rpm and you can easily find spare internal drives that run at this speed or faster. For example, there are drives that even run at 10,000 or 15,000 rpm, but these are hard to come by and are expensive, plus they are more limited in disk capacity. Laptop computers usually have slower hard drives fitted as standard (typically 5400 rpm). It may therefore be worth checking if you can select a faster speed hard drive as a build-to-order option. External SATA drives (eSATA) are now regarded as faster than FireWire 800 and are sometimes available as multiport drives like the LaCie d2 series. In theory these are better.

RAID setups

RAID stands for Redundant Array of Independent Disks, and a simple way to explain RAID is that it allows you to treat multiple drives as a single drive volume to provide either increased data integrity, capacity, transfer rates or fault-tolerance compared to a single volume. How it does this depends on the RAID level you choose. You need a minimum of two disks to configure a RAID system and most off-the-shelf RAID solutions are sold as a bay dock that can accommodate two or more drives with a built-in RAID controller. A RAID disk can be connected via internal SCSI or using an external FireWire 400/800 connection.

Virtual memory tricks

The Apple Macintosh and Windows operating systems are able to make efficient use of memory using their own virtual memory management systems. The Windows VM file should be set to at least 1.5 times your physical memory size.

Software RAIDs

It used to be the case that software-created RAIDs such as the one included with the Mac OS X Disk Utilities program were a lot slower than a dedicated system. True, the read/write speeds from a software RAID will still be somewhat slower than a true dedicated RAID system since a software RAID will be stealing some of your computer processor cycles, but these days the speed loss is not so bad as it used to be. For example, a software-driven internal striped RAID 0 can bring about a 45% increase in disk access speed. Overall I recommend that if you do choose to go down the internal RAID route, you use a dedicated device with a RAID controller.

Figure 2.21 A RAID system drive setup contains two or more drives linked together that can provide either faster disk access or more secure data backup.

RAID 0 (striping)

A RAID 0 setup is an ideal choice for use as a Photoshop scratch disk. With a RAID 0 setup, two or more drives are striped together to create a single large volume drive. For example, if two 400 GB drives are striped using a RAID 0 setup you will end up with a single 800 MB volume. RAID 0 is useful where you require fast hard drive access speeds, because the drive access speed increases proportionally to the number of drives that are added. So, if you have a 2×400 GB drive RAID 0 system, the hard drive access speed should be two times that of a single 800 GB drive. A RAID 0 setup can offer faster speeds but will be less reliable, since if one drive fails, all the stored data is lost on the combined volume.

RAID 1 (mirroring)

A RAID 1 setup stores duplicate data across two drives. This means that if you have, say, two 400 GB drives configured in a RAID 1 setup, the data on one drive is mirrored on the other and the total drive capacity will be equal to that of a single drive (in this case, 400 GB). RAID 1 systems are used as a way to protect against sudden drive failure since if one drive fails, a mirror copy of that data can immediately be accessed from the other drive and if you replace the defunct drive with a new one, the RAID 1 system rebuilds a copy of the data on the new drive. A RAID 1 setup offers greater security but the downside is that RAID 1 read/write speeds are slower because the RAID 1 system has to constantly back up the data between one drive and the other.

Internal RAID

You can fit an internal RAID system with a do-it-yourself kit consisting of two internally mounted drives and a RAID controller card. This should not be too challenging to install yourself, but if you are in any doubt about whether you are capable of doing this then you should get a qualified computer specialist to install such a system on your computer. The advantage of an internal RAID is that it is always there whenever you turn the computer on, and is an economical solution compared with buying an external RAID drive setup. Most PC tower computer systems should have plenty of free hard drive bays, which will make it fairly easy for you to install internal RAID. An internal RAID setup will definitely speed up the time it takes Photoshop to read and write data to the scratch disk. However, if you have more hard drives running simultaneously this will mean more power consumption, which in turn can generate extra heat and possibly more noise too. Be warned that this heat may cause problems for the cooling system in your computer and put extra strain on the internal power supply unit.

External RAID

External RAID hard drive units (Figure 2.21) are not overly expensive and you can easily buy a ready assembled bay dock with a couple of drives and a built-in RAID controller that can be configured for RAID 0. The speed will be governed not just by the number of drives making up the RAID but also by the speed of the cable connection. Most RAID systems these days will connect to the computer via a FireWire 400/800 or SATA connection, which may again require a special card in order to connect to the computer (for now). At the time of writing it seems that computers in the future are more likely to support SATA as standard. My own personal experience has led me to be rather wary of relying on SATA. I have had two SATA RAID units fail or have problems maintaining a connection to the computer. For this reason I have chosen to stick with FireWire 800, and even this I find isn't completely reliable on the Mac OS X system.

GPU settings

Photoshop is able to detect the graphics card used by your computer and whether it has a built-in Graphics Processor Unit (GPU) capability. If so, you can then check the 'Enable OpenGL Drawing' option to make full use of the graphics processor memory on the GPU enabled graphics card. As was explained earlier, in Chapter 1, this preference setting affects images opened in Photoshop on a per-window document basis.

The main advantages of enabling OpenGL are: smooth views when using odd number viewing percentages, image rotation, flick panning, smooth animated zooms, the bird's-eye view zoomout feature plus pixel grid display at view magnifications greater than 500%. Note that OpenGL is only available on later operating systems, which are basically the ones that are required anyway to run Photoshop CS5.

OpenGL video cards

OpenGL-enabled video cards are able to offload processor-intensive activity from the CPU to the video card's GPU (Graphics Processing Unit). An OpenGL card also uses its own on-board RAM to lessen the burden on the CPU and this results in faster overall video performance.

Cache pyramid structure

If you have OpenGL switched off, or your video card does not support OpenGL, you may sometimes notice how layered Photoshop images are not always displayed with complete accuracy at anything other than the 100% magnification. For example, if you have added a pixel layer that has a sharp edge, you might see a line appear along the edges when it is viewed at smaller viewing percentages. This is simply the image cache at work and nothing to worry about - it is speeding up the display preview at the expense of accuracy. If you have to work on an image (without OpenGL) at a less than 100% magnification, then do make sure the magnification is a wholly divisible number of 100%. In other words, it is better to work at 50%, 25% or 12.5% magnification, rather than at 66% or 33%. Note also that the number of cache levels will affect the structure of a TIFF file when the 'Save Image Pyramid' option is selected (see Figure 1.93 on page 73).

Figure 2.23 This is an example of the brush cursor using the Full Size Brush Tip mode with Show Crosshair in Brush Tip.

Clicking the Advanced Settings... button opens the OpenGL settings dialog shown in Figure 2.22. If you know what you are doing you can adjust these to gain the best performance from your particular OpenGL-enabled video card.

			(or
Mode:	Basic	(\$)	OK
basic Ope	e uses the least amount of GPU men InGL features. Use this mode when fects or general slowdowns in your d	experiencing	Cancel
or when r	unning other applications that preod		
or when r			

Figure 2.22 The advanced OpenGL settings dialog.

Cursors preferences

We now come to the Cursor preferences (Figure 2.24). The painting cursors can be displayed as a painting tool icon, a precise crosshair or with the default setting, which shows an outline of the brush shape at its 'most opaque' size in relation to the image magnification. You can also choose to display a Full Size Brush Tip, representing the entire outer edge reach of a soft-edged brush, although it is debatable whether this improves the appearance of the painting cursors or not (see Figure 2.23). When the Normal Brush Tip is selected, the brush cursor size represents the boundary of the brush shape up to where the brush opacity is 50% or denser in opacity, whereas the full size cursor represents the complete brush area size. The 'Show Crosshair in Brush Tip' option allows you to display a crosshair inside the brush size cursor. In the Other Cursors section, the Standard option represents all the other tools using a standard tool icon. I suggest you change this to the Precise setting, because this will make it easier for you to target the placement of certain tools such as the crop tool or clone stamp.

The *Caps Lock* key can be used to toggle the cursor display. When the Standard paint cursor is selected, the *Caps Lock* toggles between a Standard and Precise cursor view. When the Precise or Brush Tip painting cursor option is selected, the *Caps Lock* toggles between a Precise and a Brush Tip cursor view. When the Standard cursor mode is selected for all other cursors, the *Caps Lock* toggles between the Standard and Precise cursor views.

	Preference	ces	
Ceneral Interface File Handling Performance Cursors Transparency & Gamut Units & Rulers Guides, Grid & Slices Plug-Ins Type 3D	Preference Painting Cursors Standard Precise Normal Brush Tip Full Size Brush Tip Show Crosshair in Brush Tip Show only Crosshair While Painting	Other Cursors	OK Cancel Prev Next
	Brush Preview Color:		

Figure 2.24 The Cursors preferences.

Transparency & Gamut

The Transparency settings (Figure 2.26) determine how the transparent areas in an image are represented on the screen. If a layer contains transparency and is viewed on its own with the background layer visibility switched off, the transparent areas are normally shown using a checkerboard pattern. These preferences let you decide how the checkerboard grid size and colors are displayed on the screen.

Color Picker gamut warning

The Gamut Warning is accessed via the View menu (\Re Shift Y) *ctr* Shift Y). This alerts you to any colors that will be out of gamut after a conversion is made from, say, RGB to CMYK, or whichever color space is currently loaded in the View \Rightarrow Proof Setup menu. The default overlay color is a neutral gray at 100% opacity, but I suggest reducing the opacity to make the gamut warning appear as a semi-transparent overlay.

Color Picker gamut warning

If you have the Photoshop Color Picker dialog open, you can choose View ⇒ Gamut Warning to apply a gamut warning overlay to the Color Picker colors (see Figure 2.25).

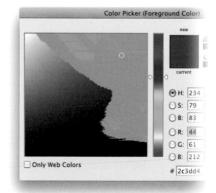

Figure 2.25 This shows the Photoshop Color Picker with a gamut warning applied.

Removing the checkerboard

If you go to the preferences shown here you can select different grid sizes and colors, but you can also select 'None'. When this is selected the transparent areas are displayed as solid white. So, if you are working on an image in RGB mode and you choose View \Rightarrow Gamut Warning, Photoshop highlights these out-of-gamut colors with a color overlay. The gamut warning is, in my view, a rather crude instrument for determining whether colors are in gamut or not, since a color that is only slightly out of gamut will be highlighted as strongly as a color that is hugely out of gamut. A good quality graphics display coupled with a custom proof setup view mode is a much more reliable guide.

A CARLES AND A CARLE	Prefe	rences	
General Interface File Handling Performance Cursors Transparency & Gamut Units & Rulers	Transparency Settings Grid Size: Medium		OK Cancel Prev Next
Guides, Grid & Slices Plug-Ins Type 3D	Color:	Opacity: 100 💌 %	

Figure 2.26 The Transparency display settings are editable. You have a choice of Transparency display settings: None, Small, Medium or Large grid pattern, and a choice of different grid colors.

Units & Rulers

You can use the Units & Rulers preferences section to set the ruler measurements (inches or centimeters, etc.) and the units used. Note that as well as using the preferences options shown here, the measurement units can also be changed via the Info panel submenu or by *ctrl* right mouse-clicking on a ruler to open the contextual menu (you can also double-click the ruler bar as a shortcut for opening the preference window shown in Figure 2.27).

General Interface File Handling Rulers: cm Performance Type: points + Cursors Curlere Size	
Transparency & Gamut Column Size Units & Rulers Width: 180 points * Guides, Grid & Slices Gutter: 12 points * Pug-ins Type 3D New Document Preset Resolutions 3D Print Resolution: 300 pixels/inch * Screen Resolution: 72 pixels/inch * Point/Pica Size Point/Pica Size PostScript (72 points/inch) Traditional (72.27 points/inch) 	OK Cancel Prev Next

Figure 2.27 The ruler units can be set in pixels, inches, cm, mm, points, picas or as a percentage. The percentage setting is ideal for recording actions that you wish to apply proportionally at any image size.

The 'New Document Preset Resolution' options allow you to decide what the default pixel resolution should be for print output or screen display work whenever you select a preset from the File \Rightarrow New Document dialog (Figure 2.28). The Screen Resolution has typically always been 72 ppi. But there is no real significance to the resolution that is set here if an image is only destined to appear in a Web page design. Web browser programs are only concerned with the physical number of pixels an image has and the resolution setting actually has no relevance. The Print Resolution setting is more useful as this does have an important bearing on what size an image will eventually print.

Figure 2.28 The New Document Preset Resolution settings will have a bearing on the resolution used when selecting a new document preset from the File ⇒ New Document dialog. In this example, if I were to select the U.S. Paper, International Paper or Photo preset, the file resolution would be set to whatever the Print Resolution is in the Units & Rulers preferences.

Ensuring preferences are saved

Once you have configured your preferences and got everything set up just the way you want, it is a good idea to Quit and restart Photoshop. This then forces Photoshop to save these preferences as it updates the preference file.

Layer Edges
 Selection Edges
 Target Path

Grid

Guides

Count Smart Guides Slices Notes Pixel Grid JD Axis All None

Show Extras Options...

Guides, Grid & Slices

These preferences let you choose the colors for the Guides, Smart Guides and Grid (Figure 2.29). Both Grid and Guides can be displayed as solid or dashed lines, with the added option of dotted lines for the Grid. The number of Grid subdivisions can be adjusted to suit whatever project you are working on and the Slices options include a Line Color style and whether the Slice Numbers are displayed or not.

	Preferences	
General Interface File Handling Performance Cursors Transparency & Gamut Units & Rulers Guides, Grid & Slices	Cuides Color: Cyan Style: Lines Smart Guides Color: Magenta	OK Cancel Prev Next
Piug-ins Type 3D	Grid Color: Custom Gridline Every: 2 cm + Style: Lines Subdivisions: 4 - Slices Line Color: Light Blue Show Slice Numbers	

Figure 2.29 The Guides, Grid & Slices preferences.

Figure 2.30 The View \Rightarrow Show menu options include Layer Edges. When this is selected the currently selected layer or layers will be indicated with a rectangular color edge border. The Smart Guides option is useful as a visual aid for aligning layer elements. The Smart Guides (shown here in pink) will flash on and off to indicate when a layer element is aligned to other layers in the image.

Plug-ins

The Plug-ins folder will automatically be recognized by Photoshop so long as it resides in the same application folder. Figure 2.31 shows how you can also choose an Additional Plug-ins Folder that may be located in another application folder such as Adobe Bridge so that these plug-ins can in effect be shared with Photoshop. To do this click on the Choose... button to locate the additional plug-ins folder.

Photoshop can now install what are known as Extensions panels (such as the Configurator panel described on page 27). If the 'Load Extensions Panels' option is checked this will load all the installed panels on startup. Furthermore, if the 'Allow Extensions to Connect to the Internet' option is checked, this allows such panels to connect over the Internet, allowing them to access new content plus any important panel updates. This is particularly relevant with things like the Access CS Live panel that needs to be connected to the Internet in order for it to work.

Accessing older plug-ins

For various reasons, a number of plug-ins and extensions have been removed from the standard Photoshop install. If you happen to have a copy of Photoshop CS3 or older, you can copy certain items such as the Contact Sheet II and WebPhotoGallery plug-ins to the Photoshop CS5 Plug-ins/Automate folder (see pages 611 and 617). However, now that Photoshop can be enabled as a 64-bit program, these older 32-bit plug-ins will not work in a 64-bit version of Photoshop. If you desperately need them you'll need to switch to (or install) a 32-bit version of Photoshop CS5.

	Preferences	
General Interface File Handling Performance Cursors Transparency & Gamut Units & Rulers	Additional Plug-Ins Folder None> Extension Panels Allow Extensions to Connect to the Internet Load Extension Panels	OK Cancel Prev Next
Guides, Grid & Slices Plug-Ins Type 3D	Changes will take effect the next time you start Photoshop.	

Figure 2.31 The Plug-ins preferences.

Ŧ	Futura	Sample	1
T	Gadget	Sample	1
0	Adobe Garamond Pro	Sample	1
ħ	Geeza Pro		1
Ŧ	Geneva	Sample	1
Ŧ	Georgia	Sample	1
0	Gill Sans (T1)	Sample	1
a	Gill Sans (TT)	Sample	1
T	Gill Sans	Sample	
V 10	Helvetica	Sample	Į
Ŧ	Helvetica Neue	Sample	1
T	Herculanum	SAMPLE	1
T	Hoefler Text	10000 cm	1
Ŧ	Humana Serif ITC TT	Sample	1
Ŧ	Humana Serif Md ITC TT	Sample	1
T	Impact	Sample	

Figure 2.32 Photoshop presents the font lists using a WYSIWYG menu listing.

Type tool initialization

When you select the type tool for the first time during a Photoshop session, there will be a brief pause in which Photoshop initializes the type tool engine. If the type tool was selected when you last closed Photoshop, the initialization process will happen during the startup cycle.

Type preferences

Lastly, we come to the Type preferences (Figure 2.33), which are mainly of importance to graphics users rather than photographers. We could all do with smart quotes I guess, but the smart quotes referred to here is a preference for whether the text tool uses vertical quotation marks or rounded ones that are inverted at the beginning and end of a sentence. The 'Show Asian Text Options' is there for Asian users, to enable the Chinese, Japanese and Korean text options in the Character panel. The 'Show Font Names in English' option will be of more significance to non-English language users, as it allows them the option to display the font names in English, as an alternative to their own native language. The 'Enable Missing Glyph Protection' option will switch on automatic font substitution for any missing glyph fonts (those swirly graphic font characters).

The Type tool Options panel also provides a WYSIWYG menu listing of all the available fonts when you mouse down on the Font Family menu (see Figure 2.32). The Font Preview Size menu determines the font sizes used when displaying this list and shouldn't be confused with the UI Font Size preference that is in the General preferences section.

			Preferences	
General Interface File Handling Performance. Cursors Transparency & Gamut Units & Rulers Guides, Grid & Slices Plug-Ins Type 30	Type Options Use Smart Quotes Show Asian Text O Enable Missing Gly Show Font Names i Font Preview Size:	ph Protection Small		OK Cancel Prev Next

Figure 2.33 The Type preferences.

Chapter 3

Camera Raw Image Processing

n the 13 or so years that I have been writing this series of books, the photography industry has changed out of all recognition. When I first began writing about Photoshop, most photographers were shooting with film cameras, getting their pictures scanned, and only a few professionals were shooting with high-end digital cameras. In the last few years the number of photographers who shoot digitally has grown to the point where it is the photographers who shoot film who are now in the minority. I therefore reckon that the vast majority of photographers reading this book will be working with pictures that have been shot using a digital SLR or high-end digital camera that is capable of capturing files in a raw format that can be read by Adobe Camera Raw in Photoshop. This is why I have devoted a whole chapter (and more) to discussing Camera Raw image processing.

From light to digital

The CCD or CMOS chip in your camera converts the light hitting the sensor into a digital image. In order to digitize the information, the signal must be processed through an analog-to-digital converter (ADC). The ADC measures the amount of light hitting the sensor at each photosite and converts the analog signal into a binary form. At this point, the raw data simply consists of image brightness information coming from the camera sensor. The raw data must then be converted somehow and the raw conversion method used can make a huge difference to the quality of the final image output. Most cameras will have an on-board microprocessor that is able to convert the raw data into a readable image file, which in most cases will be in a JPEG file format. The quality of a digital image is primarily dependent on the lens optics used to take the photograph, the recording capabilities of the CCD or CMOS chip and the analog-to-digital converter, but it is the raw conversion process that matters most. If you choose to process the raw data on your computer instead, you have much greater control than is the case if you had let your camera automatically guess which are the best raw conversion settings to use.

Camera Raw advantages

Although Camera Raw started out as an image processor exclusively for raw files, since version 4.0 it has also been capable of processing any RGB image that is in a JPEG or TIFF file format. This means that you can use Camera Raw to process any image that has been captured by a digital camera, or any photograph that has been scanned by a film scanner and saved as an RGB TIFF or JPEG. Camera Raw allows you to work non-destructively – anything you do to process an image in Camera Raw is saved as an instruction edit and the pixels in the original file are never altered. In this respect, Camera Raw treats your master files as if they were your negatives and you can use Camera Raw to process an image in any way that you like without ever altering the original.

The new Camera Raw workflow

When Camera Raw first came out it was regarded as a convenient tool for processing raw format images, without having to leave Photoshop. The early versions of Camera Raw had controls for applying basic tone and color adjustments, but Camera Raw could never on its own match the sophistication of Photoshop. Because of this, photographers would typically follow the Camera Raw workflow steps described below in Figure 3.1. They would use Camera Raw to do all the 'heavy lifting' work such as adjusting the white point, exposure and contrast and from there output the picture to Photoshop, which is where they would to carry out the remaining image editing.

Camera Raw 6 in Photoshop CS5 offers much more extensive image editing capabilities and it is now possible to replicate in

- \Rightarrow Set the white point
- \Rightarrow Apply a camera calibration fine-tuned adjustment
- \Rightarrow Set the highlight and shadow clipping points
- \Rightarrow Adjust the brightness and contrast
- \Rightarrow Adjust the color saturation
- \Rightarrow Compensate for chromatic aberrations and vignetting
- \Rightarrow Apply basic sharpening and noise reduction
- \Rightarrow Apply a crop
- ⇒ Open images in Photoshop for further image editing

Figure 3.1 Camera Raw 1.0 offered a limited but useful range of image adjustments, and this remained unchanged through to version 3.0 of Camera Raw.

Camera Raw some of the things that would normally have been done only in Photoshop. The net result of all this is that you can (and should) use Camera Raw as your first port of call when preparing any photographic image for editing in Photoshop. Let's be clear, Camera Raw does not replace Photoshop. It simply enhances the workflow and offers a better set of tools to work with in the early stages of an image editing workflow. Add to this what I mentioned earlier about being able to work with JPEG and TIFF images, and you can see that Camera Raw is a logical place for any image to begin its journey through Photoshop.

If you look at the suggested workflow listed in Figure 3.2, you will see that Camera Raw 6 now has all the tools you need to optimize and enhance a photograph. It can also be argued that if you use Camera Raw to edit your photographs, this replaces the need for Photoshop adjustments such as Levels, Curves and Hue/Saturation. To some extent this is true, but as you will read later in Chapter 5, these Photoshop adjustment tools are still relevant for fine-tuning images that have been output from Camera Raw, especially when you want to edit your photos directly or apply certain kinds of image effects that require the use of adjustment layers or additional image layers.

- \Rightarrow Set the white point
- \Rightarrow Apply a Camera Profile camera calibration adjustment
- \Rightarrow Set the highlight and shadow clipping points
- ⇒ Compensate for missing highlight detail using Recovery
- ⇒ Compensate for hidden shadow detail using Fill Light
- \Rightarrow Make basic brightness and contrast adjustments
- \Rightarrow Boost the midtone contrast (Clarity)
- \Rightarrow Fine-tune the tone curve contrast
- ⇒ Fine-tune the color saturation/vibrance plus HSL color
- \Rightarrow Compensate for chromatic aberrations and vignetting
- \Rightarrow Retouch spots using the clone or heal brush
- \Rightarrow Make localized adjustments (brush or graduated filter)
- \Rightarrow Full capture sharpening and noise reduction
- \Rightarrow Apply a crop and/or a rotation
- \Rightarrow Open images in Photoshop for further image editing

Figure 3.2 Camera Raw 6 has now extended the list of things that can be done to an image at the Camera Raw editing stage.

Camera Raw support

Camera Raw has kept pace with nearly all the latest raw camera formats in the compact range and digital SLR market, but only supports a few of the higherend cameras such as the Leaf systems and latest Hasselblad H2 and H3 cameras (which also support the DNG format). Camera Raw performance on the Macintosh platform has also been enhanced.

Figure 3.3 The camera's on-board processor is used to generate the low resolution JPEG preview image that appears in the LCD screen. The histogram is also based on the JPEG preview and is therefore a poor indicator of the true exposure potential of a raw capture image.

Does the order matter?

When you edit an image in Camera Raw it does not matter which order you apply the adjustments in. The lists shown in Figures 3.1 and 3.2 are presented as just one possible Camera Raw workflow. So for example, you could refer to the list of steps in Figure 3.2 and start by applying the crop and work your way through the remainder of the list backwards. However, you are normally advised to start with the major adjustments, such as setting the White point and Exposure in the Basic panel first before going on to fine-tune the image using the other controls.

Raw capture

If you are shooting with a professional digital back, digital SLR, or an advanced compact digital camera, you will almost certainly have the capability to shoot using the camera's raw format mode. The advantages of shooting raw as opposed to JPEG mode are not always well understood. If you shoot using JPEG, the files are compressed by varying amounts and this file compression enables you to fit more captures on to a single card. Some photographers assume that shooting in raw mode simply provides you with uncompressed images without JPEG artifacts, but there are some more important reasons why capturing in raw mode is better than shooting with JPEG. The main benefit is the flexibility this gives you. The raw file is like a digital negative, waiting to be interpreted any way you like. It does not matter about the color space or white balance setting that was used at the time of capture, since these can all be set later in the raw processing. You can also liken capturing in raw mode to shooting with negative film, since when you shoot raw you are recording a master file that contains all the color information that was captured at the time of shooting. To carry the analogy further, shooting in JPEG mode is like taking your film to a high street photo lab, throwing away the negatives and then making scans from the prints. If you shoot JPEGs, the camera is deciding automatically at the time of shooting how to set the white balance and tonal corrections, often clipping the highlights and shadow detail in the process. In fact, the camera histogram you see on the camera LCD is based on the JPEG interpretation capture data regardless of whether you are shooting in raw or JPEG mode (see Figure 3.3).

When shooting raw, all you need to consider is the ISO setting and camera exposure. But this advantage can also be seen by some to be its biggest drawback: since the Camera Raw stage adds to the overall image processing, this means more time has to be spent working on the images, plus there will be an increase in the capture file size and download times. For these reasons, news photographers and others will find that JPEG capture is preferable for such work.

JPEG capture

When you shoot in JPEG mode, your options are more limited since the camera's on-board computer makes its own automated decisions about how to optimize for tone, color, noise and sharpness. When you shoot using JPEG or TIFF, the camera is immediately discarding up to 88% of the image information that's been captured by the sensor. This is not as alarming as it sounds, because as you'll know from experience, you don't always get a bad photograph from a JPEG capture. But consider the alternative of what happens if you shoot using raw mode. The raw file is saved to the memory card without being altered by the camera. This allows you to work with all 100% of the image data that was captured by the sensor. If you choose to shoot in JPEG capture mode you have to make sure that the camera settings are absolutely correct for things like white balance and exposure. There is some room for manoeuvre when editing JPEGs, but not as much as you get when editing raw files. In JPEG mode, your camera will be able to fit more captures onto a card, and this will depend obviously on the capture file size and compression settings used. However, it is worth noting that at the highest quality setting, JPEG capture files are sometimes not that much smaller than those stored using the native raw format. What you will find is that the length of the burst capture rate is greater when shooting in JPEG mode and for some photographers, such as those who cover sports events, speed is everything.

Editing JPEGs and TIFFs in Camera Raw

Not everyone has been keen on using Camera Raw to open nonraw images. However, the Camera Raw processing tools are so powerful and intuitive to use that why shouldn't they be available to work on other types of images? The idea of applying further

It's 'raw' not 'RAW'

This is a pedantic point, but raw is always spelt using lower case letters and never all capitals, which would suggest that 'raw' was some sort of acronym, like JPEG or TIFF, which it isn't.

Adobe Photoshop Lightroom

The Adobe Photoshop Lightroom program is designed as a raw processor and image management program for photographers. It uses the exact same Adobe Camera Raw color engine that is used in Photoshop, which means that raw files that have been adjusted in Lightroom can also be read and opened via Photoshop. Having said that, there are compatibility issues to be aware of whereby only the most recent version of Camera Raw is able to fully interpret the image processing carried out in Lightroom and vice versa. Lightroom does have the advantage of offering a full range of workflow modules designed to let you edit and manage raw images all the way from the camera import stage through to print and Web output. There is no differentiation made between a raw or non-raw file other than how the default settings are applied when a photo is first imported. When you choose to open a Lightroom imported, non-raw file (a JPEG, TIFF or maximum compatibility PSD) into Photoshop, Lightroom offers you the choice to apply or not apply Lightroom edited image adjustments.

Camera Raw processing may seem redundant in the case of JPEGs, but despite these concerns, Camera Raw does happen to be a good JPEG image editor. So from one point of view, Camera Raw can be seen as offering the best of all worlds, but it can also be seen as a major source of confusion (is it a raw editor or what?)

Perhaps the biggest problem so far has been the implementation rather than the principle of non-raw Camera Raw editing. Earlier in Chapter 2, I made the point that opening JPEGs and TIFFs via Camera Raw was made unnecessarily complex in Photoshop CS3, but with the changes made in Photoshop CS4, this issue has been resolved and the Camera Raw file opening behavior for non-raw files is now much easier to configure and anticipate (see page 106 for the full details).

On the other hand, if you look at the Lightroom program, I think you will find that the use of Camera Raw processing on non-raw images works very well there indeed. I'll be explaining the Lightroom approach to non-raw editing a little later, but it has to be said that the process of editing non-raw files in Lightroom is much easier to get to grips with, since now Lightroom manages to process JPEGs quite seamlessly (see sidebar).

Alternative Raw processors

While I may personally take the view that Camera Raw is a powerful raw processor, there are now other alternative raw processing programs photographers can choose from. Some camera manufacturers supply their own brand of raw processing programs, which either come free with the camera or you are encouraged to buy separately. Other notable programs include Capture One, which is a favored by a lot of professional shooters, Bibble (www.bibblelabs.com), FotoStation (www.fotostation. com) and Apple's Aperture, which can also be seen as a rival for Adobe's own Lightroom program. If you are using some other program to process your raw images and are happy with the results you are getting then that's fine. Even so, I would say that the core message of this chapter still applies, which is to use the raw processing stage to optimize the image so that you can rely less on using Photoshop's own adjustment tools to process the photograph afterwards. Overall it makes good sense to take advantage of the non-destructive processing in Camera Raw to freely interpret the raw capture data in ways that you can't do using Photoshop alone.

A basic Camera Raw/Photoshop workflow

The standard Camera Raw workflow should be kept quite simple. Select the photo you wish to edit and double-click the thumbnail in Bridge to open it in Camera Raw. Or, you can use the **H R ett R** shortcut to open in Camera Raw via Bridge (this is discussed later on page 152). In the example that's shown over the next few pages, I mainly used the Basic panel controls to adjust the white balance, the shadow and highlight clipping plus tone contrast. These basic adjustments can be used to produce a wellbalanced color master image that can then be edited in Photoshop, where layers and filters can be added as necessary. Any special effects or black and white conversions are best applied at the end in Photoshop (as shown in Step 5).

1 In this first step I opened a window in Bridge, selected a raw photo that I wished to edit and double-clicked on the highlighted thumbnail to open it via Camera Raw in Photoshop.

Martin Evening Adobe Photoshop CS5 for Photographers

2	Camera Raw 6.0 - Canon EOS-1Ds Mark III			*0
		Preview	Basic	(III)
		A A	White Balance: As Shot	•
		R f/11 1/4	Temperature	5450
	and the state of the second	G: ISO 200 24	Tint	-7
		Basic White Balance: As Shor Temperature	Exposure Auto Default	-0.50
		Tint	Recovery	14
The second se		Auto Defai	Fill Light	0
ANTINA		Recovery Fill Light	Blacks	18
A CARANTA AND A		Blacks	Brightness	0
	New York Comments	Brightness Contrast	Contrast	+54
		Clarity	Clarity	0
		Vibrance	Vibrance	0
- 16.6% ¢	W18Y1075.dng		Saturation	0
(Save Image)	ProPhoto RG8: 8 bit: 5616 by 3744 (21.0MP): 300 pp	Open Image Cancel		
A STATE OF TAXABLE AND A STATE OF TAXABLE	A second s	and the second of the second		

2 This shows the photograph opened via the Camera Raw dialog hosted by Photoshop, where I clicked 'Auto' (circled) to apply the Camera Raw Auto settings.

Camera Raw 6.0 - C	anon EQS-1Ds Mark III		# Q
<0/>/>/>/>×0/2	Preview 🕒	Basic	IE 4
		White Balance: Custom	
	K (/11 //	Temperature	5021
	C: B: ISO 200 24		-3
	Batic White Balance: Costom Temparature	Auto Default Exposure	+0.10
	Tint	Recovery	0
	Auto Data Exposure	Fill Light	9
	Recovery	Blacks	20
	Pin Spin	Brightness	-9
	Brightness Contrast	Contrast	+25
	Clarity Vibrance	Clarity	+25
	Vibrance Saturation	Vibrance	+13
- 16.6% 4 W16Y1075.dng		Saturation	0
(Save Image) ProPinato RG#: 8 bit: 5616 bv 32	144 (21.0MP: 300 spl Open Image Cancel		

3 I was then able to use the panel controls on the right to optimize the tone color and contrast and improve the look of the photograph. Once I was happy with the way the image looked I clicked the Open Image button to continue editing in Photoshop.

4 The Open Image button rendered a pixel image version of the raw file that could then be edited in Photoshop using all the tools that Photoshop has to offer.

5 In this step I added a black and white adjustment layer to the top of the layer stack. This allowed me to preserve the color data in the retouched image and retain the ability to switch the conversion on or off.

Lightroom 3 beta

At the time of writing, Lightroom 3 is only available as a public beta program. However, the screen shots shown here provide a good indication of how the final version of Lightroom 3 will work in conjunction with Photoshop CS5.

A Lightroom/Photoshop workflow

The following workflow applies to working in Lightroom and Photoshop, and I have included this here in order to illustrate an alternative approach to incorporating Camera Raw style processing within a Photoshop workflow. In this example you can see how Camera Raw adjustments are applied at the beginning stage to optimize the master image. An Edit-copy is opened in Photoshop and when the retouching is complete, you can use the Develop controls in Lightroom to further edit the copy image, such as applying a black and white conversion.

1 The Lightroom/Photoshop workflow starts off in more or less the same way as the Camera Raw/Photoshop workflow. Here, I selected a photo from the Lightroom Catalog, went to the Develop module (shown here) and applied some basic image adjustments to optimize the tones and colors. When I wanted to take the photo into Photoshop, I went to the Photo menu and choose Edit in \Rightarrow Edit in Adobe Photoshop CS5 (**BE etrice**). This opened the selected master photo in Photoshop as a pixel image copy of the original master, ready for me to edit. When I saved the image this added the copy photo to the catalog (in the same folder location) and added an '-Edit' suffix to the file name.

2 As before, I could use Photoshop to further edit the Edit-copy pixel image that was rendered from Lightroom.

3 As the rendered '-Edit' image was worked on in Photoshop and saved, the Lightroom catalog preview was updated. In Lightroom, I was able to apply further edit adjustments in the Develop module. In this instance I was able to use Lightroom to convert the photo to black and white, rather than adding an extra adjustment layer in Photoshop. As you can see, I was able to achieve a lot stronger black and white conversion using Lightroom.

Forward compatibility for raw files

Adobe's policy is to provide on-going Camera Raw support throughout the life of a particular Photoshop product. This means if you bought Photoshop CS4, you would have been provided with free Camera Raw updates, up until version 5.6. Once a new Photoshop program comes out, Camera Raw support is continued for those new customers only. Consequently, you are obliged to upgrade your version of Photoshop if you wish to take advantage of the support offered for new cameras. However, you won't be completely blocked off from doing so. If you refer to the end of this chapter you can read about the free DNG Converter program that is always released at the same time as any Camera Raw updates. What you can do is to use DNG Converter to convert any supported raw camera format file to DNG. When you do this, the DNG file can then be read by any previous version of Camera Raw.

Camera Raw support

Camera Raw won't 'officially' interpret the raw files from every digital camera, but over 275 different raw formats are now supported, and Adobe is committed to providing intermittent free Camera Raw updates that will always include any new camera file interpreters as they become available. This generally happens about once every three months and sometimes sooner if a significant new camera is released. It is probably no coincidence that Thomas Knoll, who is a Canon EOS 1Ds user, always happens to have a new Camera Raw update for the 1Ds soon after a new model comes out! Camera Raw updates don't usually include new features, although the Camera Raw 4.1 update for Photoshop CS3 was unique in that it offered a whole new refined approach to image sharpening. There is always a chance this might happen again, but for the most part, Camera Raw updates are provided in order to offer additional camera support, and/or improved integration with Lightroom. For example, the Camera Raw 4.5 update was released so that Photoshop CS3 users could read raw files that had been edited in Lightroom 2.

Now understand that while not all raw camera file formats are supported, this is in no way the fault of Adobe. Certain camera manufacturers have in the past done things like encrypt the white balance data, which makes it difficult for anyone but themselves to decode the raw image data. The Camera Raw team have always done their best to make Camera Raw compatible with the latest digital cameras, but sometimes there have been obstacles which aren't directly Adobe's fault.

DNG compatibility

The DNG file format is an open standard file format for raw camera files. DNG is a file format that was devised by Adobe and there are already a few cameras such as Leica, and most noticeably the Hasselblad H3, that can shoot directly to DNG, plus there are now quite a few raw processor programs that can read DNG, including Camera Raw and Lightroom of course. Basically, DNG files can be read and edited just like any other proprietary raw file format and it is generally regarded as a safe file format to use for archiving your digital master files. For more about the DNG format I suggest you refer to pages 248–250 at the end of this chapter.

Getting raw images into Photoshop

There was a time, not so long ago, when one would simply scan a few photographs, put them in a folder and double-click to open them up in Photoshop. These days most photographers are working with large numbers of images and it is therefore important to be able to import and manage those images efficiently. When Photoshop 7 came along, Adobe introduced the File Browser. which was like an alternative open dialog interface incorporated within Photoshop. The File Browser offered a superior way to manage your images, allowing you to preview and manage multiple images at once. The File Browser was superseded by the Bridge program in Photoshop CS2. As image browser programs go, Bridge's main advantage is that you have ready access to Photoshop. You can open up single or multiple images and apply batch operations all directly from within Bridge. If you compare Bridge with other browser programs, it has enough basic functionality to suit most photographers' needs, although it has to be said that Bridge has yet to provide the full functionality that professional photographers have come to rely on in other programs, such as those which are dedicated to the task of managing large numbers of photographs (such as Lightroom or Aperture).

Image ingestion

The first thing we should look at is how to get the images from the camera on to the computer, ready to be worked on, such as when shooting in the studio with a setup like the one shown in Figure 3.4. This process is sometimes referred to as 'image ingestion', which is not a particularly elegant phrase, but is how some people like to describe this process.

Bridge features a Photo Downloader utility program that makes the downloading process much easier to carry out than was the case in earlier versions of Bridge. Over the next few pages I have outlined all the steps that are required when working with the Photo Downloader. For comparison purposes I have followed this up with an example of how to use the Adobe Photoshop Lightroom program, because this is the method I normally use when bringing photographs into the computer for Photoshop editing.

DNG conversion problems

The DNG conversion process aims to preserve all the proprietary MakerNote information that is contained in the raw original. If the data is there, external DNG-compatible software should have no problem reading it. However, there are known instances where manufacturers have placed MakerNote data in odd places, such as alongside the embedded JPEG preview, which is discarded during the conversion process. Basically, the DNG format allows full compatibility between different products, but this in turn is dependent on proper implementation of the DNG spec by third parties.

Figure 3.4 Here is a typical studio setup where I have an iMac computer stationed close to the actual shooting area, ready to process the captured images from the shoot. With the setup shown here I am ready to either import camera card images via a FireWire card reader or shoot tethered.

Adobe Photoshop CS5 for Photographers

Importing images via Photo Downloader

		1		
	8	3		
		- 8		

1 To begin with I inserted a camera card into the computer via a FireWire or USB 2.0 card reader. The card should mount on the desktop or appear in the My Computer window as a new mounted volume.

Date Time Date Created DDMMYYYY DDMMYYYY DDMMYYYY DDMMYYYY DDMMYYYY	Get P						
EOS_DIGITAL Import Settings Location: //PSbook2009/PS-book Choose Create Subfolder(s): Custom Name Import Settings PS-book Import Settings Import Settings Rename Files: Shot Date (yyddmm) + Custom Name Import Settings PSbook Import Settings Import Settings PS-book Import Settings Import Settings PSbook Import Settings Import Settings Import Settings Import Settings Import Settings PSbook Import Settings Import Settings Import Settings Import Setings Import Setings <td></td> <td>have from</td> <td></td> <td></td> <td></td> <td></td> <td></td>		have from					
72 Files Selected - 2.10CB 29/07/2009 Import Settings Location: //PSbook2009/PS-book Create Subfolder(s): Custom Name PS-book Ps-book Rename Files: Shot Date (yyddmm) + Custom Name PSbook + 1 Example: 092907_PSbook_0001.CR2 Import To DNG Settings Options Compatibility: Windows Mac OS Unix Preview Current Filename: 20072009_URG_0077000.CR2 Yations Yations							
29/07/2009 Import Settings Location: //PSbook2009/PS-book Create Subfolder(s): Custom Name PS-book Ps-book Rename Files: Shot Date (yyddmm) + Custom Name PSbook + 1 Example: Open Adobe Bridge Options Compatibility: Windows Mac 05 Unix Preview Current filename: Mac 05 Unix Preview Current filename: Mac 05 Windows Mac 05 Preview Current filename: Mode Bridge Preview Options Compatibility: Windows Mac 05 Unix Preview Current filename: 27 files/Wind berge Preview 27 files/Wind berge Preview 27 files/ Wind berge 27 files/ Wind berge 27 files/ Wind berge 27 files/ Wind berge while importing							
Location: //P5book2009/P5-book Choose Create Subfolder(s): Custom Name P5-book Rename Files: Shot Date (yyddmm) + Custom Name P5book FSbook P5book P5book P5book Preserve Current Filename in XMP Options Compatibility: Windows Mac OS Unix Preview Current Filename: 29072095 Options Compatibility: Windows Mac OS Unix Preview Current Filename: 29072009 Preview Current Filename:							
Create Subfolder(s): Custom Name PS-book Rename Files: Shot Date (yyddmm) + Custom Name PSbook PSbook PSbook PSbook PSbook Preserve Current Filename in XMP Options Compatibility: Windows I Mac 05 Unix Preview Current Filename: X020209_MC_0077000.CR2 Preview Current Filename: X0202709_MC_0077000.CR2 Preview Current Filename: X02077CB2 New Filename: X02077CB2 New Filename: X02077CB2 Preview Current Filename: X02077CB2 Preview	Import Settings						
PS-book PS-book Rename Files: Shot Date (yyddmm) + Custom Name PSbook + 1 PSbook + 1 Example: 092907_PSbook_0001.CR2 Ø Preserve Current Filename in XMP Gottoms Ø Open Adobe Bridge Convert To DNG Settings Preview Current filename: Mac OS Unix Preview Current filename: Mac OS Unix Preview Current filename: 20072009_UMC_0077000.CR2 Z filefs) will be remanded at the target place while importing		/PSbook2009/PS-book Choose					
PS-DOOK Rename Files: Shot Date (yyddmm) + Custom Name PSbook PSbook PSbook PSbook Psbook Preserve Current Filename in XMP Ø Open Adobe Bridge Convert To DNG Settings Ø Delete Original Files	Create Subfolder(s):	Custom Name		Photo Download	der - Advanced Renam	10	
Rename Files: Shot Date (yyddmm) + Custom Name PSbook + 1 Fxample: 092907_PSbook_0001.CR2 Preserve Current Filename in XMP Four Digits Open Adobe Bridge Convert To DNG Convert To DNG Settings Delete Original Files Preview Current filename: Mane Delete Original Files Preview	PS	S-book					- Ок
Rename Files: Shot Date (yyddmm) + Custom Name PSbook + 1 Example: 092907_PSbook_0001.CR2 Preserve Current Filename in XMP Four Digits Options Compatibility: W Depet Adobe Bridge Compatibility: Convert To DNG Settings Delete Original Files Preview Current filename: MG_0077.CR2 Ver filename: Windows Delete Original Files Zifeloj will be renamed at the target place while importing				Date Created	DDMMYYYY		Cancel
Image: Source State Image: Source State Image: Source State Image: Sequence Numbe Image Image: Source State Image: Source State	Rename Files:	Shot Date (yyddmm) + Custom Name	Text			- +)
✓ Preserve Current Filename in XMP ✓ Open Adobe Bridge ○ Convert To DNG ✓ Delete Original Files ✓ Delete Original Files	PS	Sbook + 1	Current Filename	Name 🛟	Original Case)
✓ Open Adobe Bridge Compatibility: Windows ✓ Mac OS Unix ○ Convert To DNG Settings Preview ✓ Delete Original Files Current filename: IMG_0077.CR2 ✓ To DNG Settings			Sequence Numbe		Four Digits		
Current filename: IMG_0077.CR2 Current filename: IMG_0077000.CR2 Z0072009_IMG_0077000.CR2 Z0072009_IMG_0077000.CR2 Z0072009_IMG_0077000.CR2 Z007209_IMG_0077000.CR2 Z007200_IMG_0077000.CR2 Z007200_IMG_0077000.CR2 Z007200_IMG_0077000.CR2 Z007200_IMG_0077000.CR2 Z007200_IMG_0077000.CR2 Z007200_IMG_0077000.CR2 Z007200_IMG_0077000_IMG_007000_IMG_007000_IMG_00000_IMG_0000_IMG_0000_IMG_0000_IMG_0000_IMG_0000_IMG_00000_IMG_0000_IMG_0000000_IMG_00000_IMG_00000_IMG_000000_IMG_00000_IM	Z	Open Adobe Bridge		dows	ic OS	Unix]
Delete Original Files New filename: 29072009_IMG_0077000.CR2 72 file(s) will be renamed at the target place while importing		Convert To DNG Settings					-
72 file(s) will be renamed at the target place while importing	7	Delete Original Files			12		
Save Copies to:							
/Backup Choose	/B	ackup (Choose)					

None Custom Name Today's Date (yyyymmdd) Shot Date (yyydmm) Shot Date (ddmmyy) Shot Date (ddmm) Shot Date (ddmm) Shot Date (ddmmm)

Figure 3.5 The subfolder naming options.

2 The next thing was to launch Bridge CS5 and choose File \Rightarrow Get Photos from Camera... This opened the Photo Downloader dialog shown here, where I could start by selecting where to download the files from (in this instance, the EOS_Digital camera card). Next, I chose a location to download the photos to. Here, I selected the Pictures folder. I then selected 'Custom Name' from the Create Subfolder(s) menu (see Figure 3.5) and typed in a name for the shoot import (this name is appended to the Location setting to complete the file path). If the 'Delete Original Files' option is checked, Photo Downloader gives you the option to delete the files from the camera card once they have been successfully downloaded to the computer. I then checked the 'Save Copies to:' option and clicked on the Choose... button to locate a backup folder to save the files to.

Chapter 3 **Camera Raw image processing**

Backup insurance

Your camera files are vulnerable to loss for as long as they remain in one location only, especially when they only exist on the camera card, which can easily get lost or the data might be corrupted. This is why it is always a good idea to get the camera files off the card and safely stored on a computer hard drive as soon as possible. Not only that, it is also a good idea to make a backup of the camera files as you do so. Note that Bridge will apply the settings setup in the Photo Downloader to the files that are copied to the main folder location. But, the files that are copied to the backup location will be plain clone copies of the original camera files. The backup copy files will not be renamed (as are the main import files). This is a good thing because should you make a mistake during the rename process you always retain a backup version of the files just as they were named when captured by the camera. Basically, backup files are like an insurance policy against both a drive failure as well as any file renaming mix-ups.

Copy to main import folder location Computer Hard Drive EOS_DIGITAL Copy to backup folder location

3 Lets review the Photo Downloader settings that have been applied so far. The camera card contained the images I wished to import and the Photo Downloader settings had so far been configured to copy these files to the primary disk location (which in this instance would be the computer hard drive), and at the same time make a backup copy of all the images to a secondary location (in this case, a backup hard drive). With the setup shown here, I was able to use Photo Downloader to make renamed copies of the files to the principal drive/folder location and, if desired, convert the files to DNG as I did so. With this type of configuration I would end up with two copies of each image: one on the main computer and one on the backup drive.

Backup Hard Drive

Adobe Photoshop CS5 for Photographers

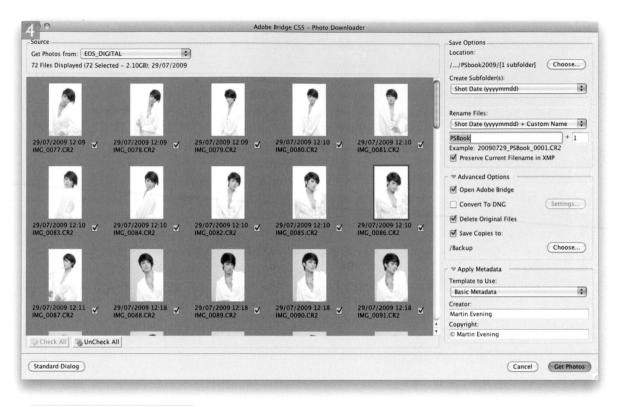

Do not rename files Today's Date (yyyymmdd) Shot Date (vvvvmmdd) Shot Date (yyddmm) Shot Date (ddmmvv) Shot Date (ddmm) Shot Date (yyyyddmmm) Shot Date (ddmmmyyyy) Custom Name Shot Date (yyyymmdd) + Custom Name Shot Date (yyddmm) + Custom Name Shot Date (ddmmyy) + Custom Name Shot Date (ddmm) + Custom Name Shot Date (vvvvddmmm) + Custom Name Shot Date (ddmmmyyyy) + Custom Name Custom Name + Shot Date (yyyymmdd) Custom Name + Shot Date (vvddmm) Custom Name + Shot Date (ddmmyy) Custom Name + Shot Date (ddmm) Custom Name + Shot Date (vyvyddmmm) Custom Name + Shot Date (ddmmmvvvv) Same as Subfolder Name

Figure 3.6 Here are the options for the Rename Files menu, highlighted in the dialog above.

4 I then clicked on the Advanced dialog button in the bottom left corner (see Step 2), which revealed this expanded version of the Photo Downloader dialog. This allowed me to see a grid preview of all the images I was about to import from the card. I could now decide which images were to be imported by clicking on the thumbnail checkboxes to select or deselect individual photos. You can also use the Check All and Uncheck All buttons in the bottom left of the dialog to select or deselect all the thumbnails at once.

The Rename Files section allowed me to choose a renaming scheme from the options shown in Figure 3.6. Which you should choose here will depend on what works best for you, and this is a topic I will explore in greater detail in the Image Management chapter. In this example I chose to rename using the shoot date followed by a custom shoot name. I could see how the renaming would work by inspecting the Example filename below, where as you can see, the imported files were automatically renumbered beginning from the start number entered here. If you check the 'Preserve Current Filename in XMP', this gives you the option to use the Batch Rename feature in Bridge to recover the original filename at a later date.

The Advanced Options let you decide what happens to the imported images after they have been renamed. You will most likely want to check the 'Open Adobe Bridge' option so that Bridge displays the image download folder contents as the images are being imported. In the Apply Metadata section you can also choose a pre-saved metadata template (see Chapter 11) and enter your author name and copyright information. This is then automatically embedded in the metadata of all the files as they are imported.

If the 'Convert to DNG' option is selected, this can be used to convert raw images to the DNG file format as they are imported. For some people it can be useful to carry out the conversion straight away, but be warned that this will add to the time it takes to import all the photos.

Previe	14
	Preview: Medium Size
Comp	pression
₫ c	ompressed (lossless)
Image	e Conversion Method
• Pi	reserve Raw Image
0 c	onvert to Linear Image
d	he image data is stored in the original "mosaic" ormat, if possible, which maximizes the amount of ata preserved. Mosaic image data can be converted to inear data, but the reverse is not possible.
Origi	nal Raw File
E	mbed Original Raw File
	mbeds the entire non-DNG raw file inside the DNG ile. This creates a larger DNG file, but it allows the original raw file to be extracted later if needed.

5

Converting to DNG

To read more about converting proprietary raw files to DNG and the conversion settings shown here, please refer to pages 248–250 at the end of this chapter.

5 If you click on the Settings... button (next to the 'Convert to DNG' option in Photo Downloader) this opens the DNG Conversion Settings dialog shown here. If you select the 'Medium Size' JPEG Preview option, this will generate a standard size preview for the imported pictures – there is no point in generating a full size preview just yet since you may well be changing the camera raw settings soon anyway, so to get reasonably fast imports it is better to choose 'Medium Size'. Check the 'Compressed' option if you would like smaller file sizes (note that this uses lossless compression and does not risk degrading the image quality). In the Image Conversion Method section I suggest you don't choose 'Convert to Linear Image', but choose 'Preserve Raw Image' as this keeps the raw data in the DNG in its original state. And lastly, you can choose to embed the original raw data (along with the DNG data) in the DNG file, but I would advise against this unless you really need to preserve the proprietary raw file data.

	From: EOS_DIGITAL	
N N	To: //Pictures/PSbook2009/PS-book	11%
IN SE	File 9 of 72: Copying File	_ 11%
IMG_0085.CR2		
	St	op

6 After I clicked on the Get Photos button in the Photo Downloader dialog, the images started to download from the card to the disk location specified in the Save Options in Step 4. The above progress dialog showed me how the download process was proceeding.

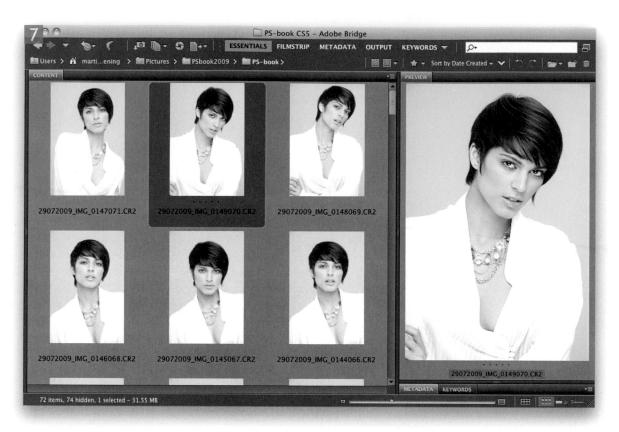

Deleting camera card files

It isn't actually necessary to delete the files from the camera card first, because formatting a card in the camera deletes everything that is on the card anyway. Formatting the card is good housekeeping practice as this helps guard against future file corruptions occurring with the card. However, I find that if I am in the midst of a busy shoot it is preferable to get into a routine of deleting the files before you put the card back in the camera. Otherwise I am always left with the nagging doubt: 'have I downloaded all the files on this card yet? Is it really safe to delete everything on this card?' **7** Because the 'Open Adobe Bridge' option had been selected, once all the photos were downloaded, Bridge opened a new window to display the imported photos that were now in the main download images folder.

8 Also, because the 'Delete Original Files' option was selected, the above warning dialog appeared once the downloads to the primary destination folder (and backup folder) were complete. This step conveniently cleared the camera card of all the images that were stored on it and prepared it for reuse in the camera. Be warned that this step bypasses any opportunity to confirm if you really want to delete these files. Once you click 'Yes', the files are permanently deleted from the card. When I put a card back in the camera I usually reformat it anyway before shooting a fresh batch of photos to that card (see sidebar).

Tethered shoot imports

There is no direct support for tethered shooting in Bridge CS5, but if Bridge were able to do so, it would have to offer tethered support for many if not all the cameras that Camera Raw already supports. Enabling full tethered shoot functionality is difficult enough to do for one camera let alone several hundred. This is why those software programs that do offer tethered shooting, such as Capture One and Bibble, only do so for a narrow range of popular digital SLR cameras. However, it is possible to shoot in tethered mode with Bridge, but it all depends on the capabilities of your camera and whether it has a suitable connection socket and if the supplied camera software allows you to download files directly to the computer. Many cameras (especially digital SLR cameras) will most likely come with some kind of software that allows you to hook your camera up to the computer via a FireWire or USB 2 cable (Figure 3.7). If you are able to download files directly to the computer, then Bridge can monitor that folder and this gives you a next best solution to a dedicated software program that is designed to operate in tethered mode.

The only drawback to shooting tethered is that the camera must be wired up to the computer and you don't have complete freedom to wander around with the camera. If you have a wireless communication device then it may be possible to shoot in a direct import mode to the computer, without the hassle of a cable, but at the time of writing, wireless shooting isn't particularly speedy when shooting raw files with a typical digital SLR.

Over the next few pages I have described a method for shooting in tethered mode with a Canon EOS camera, using the Canon EOS Utility program that ships with most of the Canon EOS digital cameras. This program lets you download camera files as they are captured, to a designated watched folder. Nikon owners will find that Nikon Capture includes a Camera Control component that allows you to do the same thing as the Canon software, and establishes a watched folder to download the images to. The latest version of Nikon Capture supports all the D Series cameras as well as the Nikon Coolpix 8700. Alternatively, you might want to consider buying Bibble Pro 5 software from Bibble Labs (www. bibblelabs.com). Bibble Pro costs a lot less than Nikon Capture. It enables tethered shooting with a wide variety of digital cameras and, again, allows you to establish a watched folder for the downloaded images, which you can monitor using Bridge CS5.

Figure 3.7 Here is a photograph taken of me at work in the studio, shooting in tethered mode.

Which utility?

One of the problems with the Canon system is the way the utility programs have been named and updated with succeeding generations of cameras. First of all there was EOS Viewer Utility and now EOS Utility, which have both interacted with a program called EOS Capture. On top of this you also have to make sure that you are using the correct version of 'utility' software for your camera. It would help if there were just one program that was updated to work with all Canon cameras.

Which transfer protocol?

Nikon and Canon systems both offer FTP and PTP transfer protocols. Make sure you select the right one, as failure to do so can result in an inability to get tethered shooting to work. This information can be found in the camera manufacturer's manual for your camera model.

EOS Utility

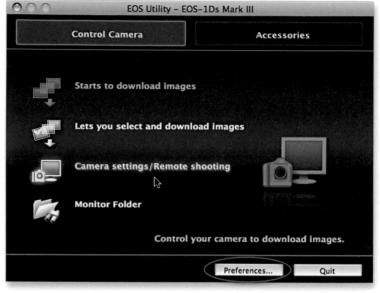

1 To begin with, make sure the camera is tethered to the computer correctly and is switched on, then launch EOS utility and click the Preferences button (circled) to open the Preferences dialog shown in Step 2 below.

2 Preferences	Preferences
Destination Folder	Linked Software
Destination Folder	Software to link
/Users/martin_evening/Desktop/watched folder Browse	None Settings
A subfolder into which the image will be saved will automatically be created in this folder. Create subfolder next time this function is used	
Download Images	
Remote Shooting	
Monitor Folder	
Shooting Date Customize	
Example:	
Users/martin_evening/Desktop/watched folder	
Cancel OK OK	Cancel OK

2 In the Destination Folder section, click on the Browse... button and select a destination folder that the camera captures are to be downloaded to. This could be an existing folder, or a new folder, such as the 'Watched folder' selected here. Meanwhile, in the Linked Software section, set the 'Software to link' as 'None'.

Tethered shooting via Canon EOS Utility

The second s	
Shooting Date+Prefix+	
	Customize
File Prefix	
PSBook	
Assign Sequence No.	
Number of Digits	4
Start	1
Example:	
20080702_PSBook_0	
(xxx: file extension	will be the same as the original file name)

3 You will also need to set up a file renaming scheme. You could carry out the file renaming in Bridge afterwards, but establishing this beforehand can save time and helps reduce the risk of error when it's applied automatically as the files are captured. In this example, I selected the Shooting Date+Prefix+Number file naming scheme and set the start count number to '1'.

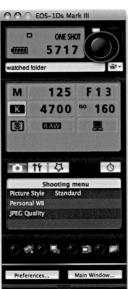

4 I clicked OK to the Camera Settings in Step 3 and then clicked on the 'Camera settings/ Remote shooting' option that the cursor is pointing to in Step 1. This opened the Camera control window shown here, where you can configure the camera settings remotely. As soon as this window appears you are ready to start shooting.

Lightroom conflicts

If you are also running Lightroom, the one thing to watch out for here is that the watched folder you select in Step 2 does not conflict with any watched folder that might currently be monitored by Lightroom. If this is the case, you will need to disable the auto-import feature in Lightroom first before using it to import photos that can be viewed via Bridge.

Auto-renumbering

When you select a numbering option in the File Name section, the numbering will keep on auto-updating until such time as you change the file prefix name. This is useful to know because it means that if you were to lose a camera connection or switch the camera off between shoots, the EOS Utility program knows to continue the file renaming of the import files from the last number used.

Remote shooting controls

As soon as the Camera control window appears you know that you have succeeded in establishing a tethered connection and are ready to start shooting. This can be done by pressing the shutter on the camera, or alternatively, you can use the EOS Capture utility to capture the photos remotely from the computer by clicking on the large round button (circled in Step 4). You can also use this window to adjust the camera settings by selecting any of the status items in the window and using the left/right keyboard arrow keys to navigate between the various mode options, and using the up/down keys to decrease or increase the individual settings.

Show Thumbnail Only ЖΤ Grid Lock ✓ Show Reject Files Show Hidden Files ✓ Show Folders Show Items from Subfolders Show Linked Files Sort Ascending Order 1 Refresh By Filename F5 By Type ✓ By Date Created By Date Modified By Size By Dimensions By Resolution By Color Profile By Label By Rating By Keywords Manually

5 As you start shooting, the EOS utility enables the import of the camera files directly into the watched folder you established in Step 1 and renames them (as configured in Step 2). All you need to do now is point Bridge at the same watched folder as was configured in the EOS Utility preferences and you'll see the pictures appear in Bridge directly. Of course, if you are shooting continuously in the studio or location with a setup like this, then you will most likely wish to see the newest pictures appear first at the top of the content area in the Bridge window. To do this, go to the View menu and check if the Ascending Order item in the Sort menu is deselected (as shown in the screen shot on the left). Do this and the files will now be sorted in reverse order with the most recent image appearing first.

When you have finished shooting in tethered mode, you will either need to move the files from the watched folder and place them elsewhere, or rename the folder. The main thing to be aware of here is that every time you start a new shoot, you will either want to choose a new job folder to download the photos to, or move the files from this folder to a new location and make sure that the watched folder you are linking to has been emptied. Of course, you could always create an Automator workflow action (Mac) or VB script (Windows PC) that allowed you to press a button to do the transfer and clearing of the watched folder.

Importing images via other programs

Figure 3.8 highlights some of the various methods that can be used for importing images. There is no one program that can do everything perfectly, but of these, I would say that Capture One is the only program capable of ticking all the essential boxes (as long as your camera is supported). ImageIngester is a great little utility that can provide a fast and robust import workflow and the standard version for Mac and PC is currently available as a demo version. One of the plus points about ImageIngester is that the newest version allows you to download from up to eight cards simultaneously. It can also provide raw file verification, apply default Camera Raw settings and incorporate GPS tagging.

Ever since Adobe Photoshop Lightroom made its first appearance, I have been using it in the studio and on location to import images from cards as well as when shooting in tethered mode. In fact, I have now stopped using Bridge completely at the import stage. With this in mind I thought I should show you how I use Lightroom to import new photos into the computer. It would be less than honest of me to pretend otherwise, but I should mention that I do still use Bridge for various other browsing tasks. For example, it would be difficult to manage a project such as this without using Bridge to manage the files that are used in the book.

ImageIngester [™] pro	ogram
--------------------------------	-------

The ImageIngester[™] program designed by Marc Rochkind is aimed at photographers who shoot raw files, and who need to ingest hundreds of images from a typical shoot. You can download the ImageIngester program demo from the following link: www.basepath.com/ ImageIngester/.

	Direct integration with Bridge	File renaming	Full auto renumbering	Secondary backup of data	Convert to DNG	Import settings saved for concurrent imports	Tethered shooting	Preview and pre- selection of import files
Photo Downloader in Bridge	1	1	1	1	1	1		1
Tethered shooting via Bridge	1						√*	
DNG Converter		1	1		1	1		
Lightroom Import Photos		1	1	1	1	1	1	1
ImageIngester Standard		1	1	1	1	1		
Capture One		1	1	1	1	1	1	

Figure 3.8 In this table I have compared the features that are available when using some of the various different methods for importing camera images into the computer. As you can see, there is no one perfect solution out there that will let you do everything. The latest public beta version of Lightroom 3 does now include the ability to shoot tethered, but does not provide as extensive support or as many options as other methods of tethered shooting.

* In these instances, tethered shooting is only possible if done in conjunction with a camera manufacturer's import software.

Bridge versus Lightroom

The main thing to note here is that Bridge is a file browser, while Lightroom is a dedicated cataloging program. The times that I find Bridge most useful are when I am working on a project like this book and have hundreds of files to manage that are stored in specific book folders. The times where I find Lightroom useful are when I wish to source the master original files. The Lightroom cataloging features allow me to search and navigate these much quicker than when working in Bridge.

Lightroom imports

One of the main reasons I have adopted Lightroom as my program of choice for importing and managing photos is because I need a program that is dedicated to the management of images. With Lightroom, photos have to be explicitly imported into the Lightroom catalog before you can work on them, but once they are there, they are easier to manage and retrieve when needed. With Bridge you do have the immediacy of being able to browse the entire contents of your computer, but the trade-off here is that because you can browse everything, this doesn't always make it so easy to locate the photos you are specifically looking for.

In the Lightroom Import Photos dialog you have similar options to those found in Photo Downloader, such as the ability to make backups, rename the files and apply basic metadata information. But in addition to this you have the option to apply develop settings and add custom keywords on import. You can also use the Import Photos dialog to report suspected duplicate files and prevent these from being re-imported. This can be useful if you happen to reuse a card and forgot to delete the photos that had been downloaded previously. Above all, Lightroom 3 (which at the time of writing is available as a public beta) now offers a brand new import dialog which makes the import process even more streamlined.

After the files have been imported into Lightroom, the imported images will appear listed in the Folders panel of the Library module. This displays all the images that have been imported so far using the same disk volume and hierarchy structure as the folders that are found in the system folder organization (see Step 4 on page 151). Moving files or folders in Lightroom is like moving files or folders at the system level (or via Bridge), except you must use Lightroom to do the moving. If you do this outside Lightroom, you can end up breaking the links to your master images, and this will be indicated by a '?' mark in Lightroom. One of the main features of Lightroom is that Develop module edits in Lightroom are applied in the form of metadata instructions (just like Camera Raw) and the master image originals are always preserved. To open pictures from Lightroom into Photoshop, you need to create an Edit-copy of the master image (with or without Lightroom adjustments) for editing in Photoshop, just as you would when opening a file from Bridge. The Edit-copy files are then saved back to the folder they came from and added to the Lightroom catalog.

and the second se		Preferences		
	General Presets	External Editing File Handling Interface		
		☑ Show splash screen during startup ☑ Automatically check for updates		
Default Catalog	1			EOS_DIGIT
When s	starting up use this catalog:	Load most recent catalog		200_0101
Import Options				
	nport dialog when a memory	card is detected		
-	Camera generated folder nan			
	PEG files next to raw files as s			
	red mes next to raw mes as s	separate photos		
Completion Sou	unds			
	unds shed importing photos play:	No Sound	•	
When finis			•	
When finis	shed importing photos play:			
When finis When finis	shed importing photos play:			
When finis When finis	ihed importing photos play: shed exporting photos play:	No Sound		
When finis When finis Prompts Catalog Setting	shed importing photos play: shed exporting photos play: (No Sound		

Importing photos via Lightroom 3

1 The Lightroom 3 preferences are accessed via the Lightroom menu (Mac) or Edit menu (PC). If you check the 'Show import dialog when a memory card is detected' option (circled), Lightroom automatically launches the Import Photos dialog each time a card is inserted.

2 This shows the Import Photos dialog. Here, you can quickly scroll through the thumbnails of the images you are about to import and choose which ones to include in the import.

Adobe Photoshop CS5 for Photographers

-	CS5Book-0077.cr2		
Shoot	Name - Filename nu	mber suffix	1
image Nar	1e		
	Filename		Insert
Numbering	1		
	[Import # (1)		Insert
	(Image # (1)	•	Insert
	Sequence # (1)		Insert
Additional			
	Date (YYYY)	•	Insert
Custom			
	Shoot Name		Insert
	Custom Text		Insert

Figure 3.9 The Filename Template Editor offers far more versatile options for creating file renaming templates. And, more importantly, Lightroom keeps track of files as they are imported and will auto-update the renumbering until you next change the Import Photos settings. **3** If importing from a camera card, the quickest option is to select the 'Copy' option shown here. Alternatively, you can select 'Copy as DNG'. This makes a duplicate copy of all the images that are on the memory card and converts them to the DNG format.

In the File Handling panel we have the Render Preview options. Choosing 'Standard-Sized Previews' may slow down the import process since it forces Lightroom to render previews of the images before displaying them in Lightroom. 'Minimal' is a much faster option, while Embedded & Sidecar files makes immediate use of previews that may already be embedded in the files that are to be imported. As mentioned on page 148, checking 'Don't Import Suspected Duplicates' is a good idea as it can help prevent you accidentally importing files twice. You can also check the 'Make a Second Copy To:' option and choose a folder to store backups of the files as they are imported.

The File Renaming panel makes use of file renaming templates such as the one shown in Figure 3.9. Here, you can enter custom text for use in the file renaming plus set a start number for the numbering sequence.

In the Apply During Import panel you can apply a pre-created Develop setting (such as a Lightroom/Camera Raw image adjustment) at the import stage. Copyright and contact information can be added by selecting a pre-created metadata template from the Metadata menu. Custom keywords can be used to add information that relates specifically to the image collection you are about to import. As you type in the first few letters of a keyword, Lightroom will try to auto-complete a name for you and pop a menu of possible keywords. This can help you avoid spelling mistakes and be consistent in your keywording.

In the Destination panel I prefer to organize the imported images into a single named folder. Once you have configured all the import settings, you can click 'Import' to start copying the images to the computer.

4 As the images are imported, the thumbnails will start to appear one by one in the content area. You shouldn't normally encounter any problems when importing files from a camera card, but if you choose the 'Copy as DNG' option, you will be alerted to any corruptions in the files as they are imported. Once you have successfully imported all the images across to the computer and backup drive (if applicable), you can now safely delete all the images that are on the card, eject the card and prepare it for reuse.

The Adobe Photoshop Lightroom 3 book

If you want to find out more about Lightroom, I will be writing a complete guide about this new program called *The Adobe Photoshop Lightroom 3 Book*, which is to be published by Adobe Press.

Closing Bridge as you open

If you hold down the 💉 all key as you double-click to open a raw image, this closes the Bridge window as you open the Camera Raw dialog hosted by Photoshop.

Installing updates

You will find that Adobe release regular Camera Raw updates which keep abreast of all the latest upcoming cameras, adding these to the Camera Raw database. From now on you'll find the update process is easier to follow as there are now standard installers: one for Mac and one for PC that automatically update Camera Raw for you rather than require you to manually search for the correct folder location to copy the plug-in to. Note also that whenever there is an update to Camera Raw there is also an accompanying update for the Lightroom program as well as for Adobe DNG Converter.

Basic Camera Raw image editing

Working with Bridge and Camera Raw

The mechanics of how Photoshop and Bridge work together are designed to be as simple as possible so that you can open single or multiple images or batch process images quickly and efficiently. Figure 3.10 summarizes how the file opening between Bridge, Photoshop and Camera Raw works. Central to everything is the Bridge window interface where you can browse, preview or make selections of the images you wish to process. The way most people are accustomed to opening images is to select the desired thumbnail (or thumbnails) and open using one of the following three methods: use the File \Rightarrow Open command, use a double-click, or use the **HO** *ctrl* **O** shortcut. The way things are set up in Bridge, all of the above methods will open a selected raw image (or images) via the Camera Raw dialog hosted by Photoshop. If the image is not a raw file, it will open in Photoshop directly. Alternatively, you can use File ⇒ Open in Camera Raw... or use the **H** *R ctrl R* shortcut to open images via the Camera Raw dialog hosted by Bridge, which allows you to perform batch processing operations in the background without compromising Photoshop's performance. If the 'Double-click edits Camera Raw Settings in Bridge' option is deselected in the General Bridge preferences, Shift double-clicking allows you to open an image or multiple selection of images in Photoshop directly, bypassing the Camera Raw dialog.

Opening single raw images via Photoshop is quicker than opening them via Bridge, but when you do this Photoshop then becomes tied up managing the Camera Raw processing and this prevents you from doing any other work in Photoshop. The advantage of opening via Bridge is that Bridge can be used to process large numbers of raw files in Camera Raw, while freeing up Photoshop to perform other tasks. You can then toggle between the two programs. For example, you can be processing images in Camera Raw while you switch to working on other images that happen to be already opened in Photoshop.

Regarding JPEG and TIFF images, Camera Raw can be made to open these as if they were raw images, but please refer to page 170 for a summary of the JPEG and TIFF handling behavior in Camera Raw.

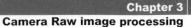

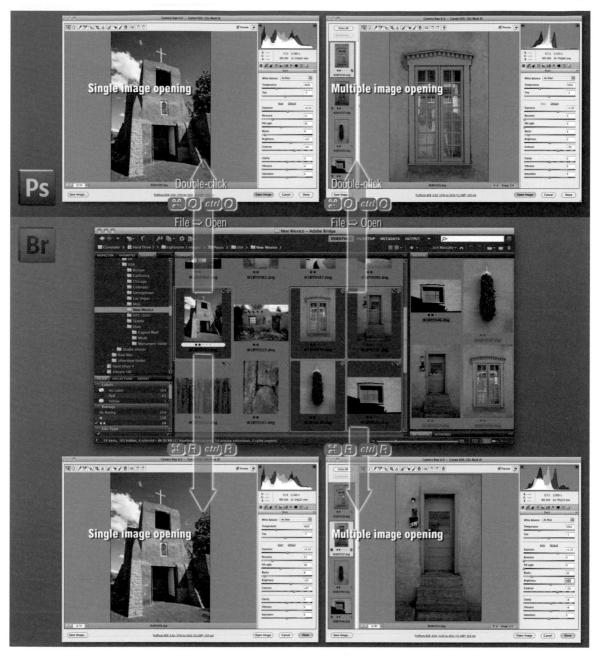

Camera Raw tools

Zoom tool (Z)

Use as you would the normal zoom tool to zoom the preview image in or out.

Hand tool (H) Use as you would the normal hand tool to

scroll an enlarged preview image.

White balance tool (I) The white balance tool is used to set the White Balance in the Basic panel.

Color sampler tool (S)

This allows you to place up to nine color sampler points in the preview window.

to, Target adjustment tool (T)

This allows you to use the cursor to mouse down on an image and apply targeted image adjustments, dragging the cursor up or down.

🛱. Crop tool (C)

The crop tool can apply a crop setting to the raw image, which is applied when the file is opened in Photoshop.

🔬 Straighten tool (A)

Use this tool to drag along a horizontal or vertical line to apply a 'best fit', straightened crop.

🕜 Spot removal (B)

Use to remove sensor dust spots and other blemishes from a photo.

🐌 Red eye removal tool (E)

For removing red eye from portraits shot using on-camera direct flash.

🖌 Adjustment brush (K)

Use this brush tool to paint in localized adjustments.

🖉 Graduated filter (G)

Use the Graduated filter to apply graduated localized adjustments.

I≡ ACR preferences (ℜ ctrl−K)

Opens the Adobe Camera Raw preferences dialog.

🔿 Rotate counterclockwise (L)

Rotates the image 90° counter clockwise.

C Rotate clockwise (R)

Rotates the image 90° clockwise.

General controls for single file opening

When you open a single image, you will see the Camera Raw dialog shown in Figure 3.11 (which in this case shows Camera Raw hosted via Bridge). The status bar shows which version of Camera Raw you are using and the make of camera for the file you are currently editing. In the top left section you have the Camera Raw tools, which I have listed on the left, and below that is the image preview area where the zoom setting can be adjusted via the pop-up menu at the bottom. The initial Camera Raw dialog displays the Basic panel control settings and in this mode the Preview checkbox allows you to toggle previewing any global adjustments that have been made in Camera Raw. Once you start selecting any of the other panels, the Preview toggles showing only the changes that have taken place within a particular panel.

The histogram represents the output histogram of an image and is calculated based on the RGB output space that has been selected in the Workflow options. As you carry out the Basic panel Exposure and Blacks adjustments, the shadow and highlight triangles in the histogram display indicate the shadow and highlight clipping. As either of these get clipped, the triangles will light up with the color of the channel, or channels, that are about to be clipped, and if you click on them, they display a color overlay (blue for the shadows, red for the highlights) to indicate which areas in the image are currently being clipped.

At the bottom are the Workflow options, which when clicked will open the Workflow Options dialog shown in Figure 3.12. The destination color space should ideally match the RGB workspace setting established in the Photoshop color settings, and I would suggest setting the bit depth to 16-bits per channel, as this ensures that the image bit depth integrity is maintained when the image is opened in Photoshop. The file size setting lets you open images using smaller or larger pixel dimensions than the default capture file size (these size options are indicated by + or - signs) and the Resolution field lets you set the file resolution in pixels per inch or per centimeter, but note that the value selected has no impact on the actual pixel dimensions of the image.

Figure 3.11 This shows the Camera Raw dialog (hosted by Bridge), showing the main controls and shortcuts for the single file open mode. You can tell if Camera Raw has been opened via Bridge, because the Done button is highlighted. This is an 'update' button that you click when you are done making Camera Raw edits and wish to save these settings, but without opening the image.

If you click on the Workflow options (circled), this opens the Workflow Options dialog shown in Figure 3.12, where you can adjust the settings that determine the color space the image will open in, the bit-depth, cropped image pixel dimensions plus resolution (i.e. how many pixels per inch). You can also choose here to sharpen the rendered image for print or screen output. These options are relevant if you are producing a file to go directly to print or for a website. If you intend carrying out any type of further retouching then leave this set to 'None'. Lastly, there is an option to open in Photoshop as a Smart Object (see pages 158–161).

Space:	ProPhoto RGB		•	OK)
Depth:	16 Bits/Channel		•	Cancel
Size:	5616 by 3744 (21.0 MP)			
Resolution:	300	pixels/inch		
harpen For:	None	Amount: Standard	:	
	Doon in	Photoshop as Smart Objects		

Figure 3.13 After opening or applying 'Done' to an image via the Camera Raw dialog, you will see a settings badge appear in the top right corner of the image thumbnail (circled). This indicates that an image has been edited in Camera Raw.

Full size window view

The Toggle Full screen mode button () can be used to expand the Camera Raw dialog to fill the whole screen, which can make Camera Raw editing easier when you have a bigger preview area to work with. Click this button again to restore the previous Camera Raw window size view.

General controls for multiple file opening

If you have more than one photo selected in Bridge, you can open these all up via Camera Raw at once. If you refer back to Figure 3.10, you can see a summary of the file opening behavior, which is basically as follows. If you double-click, or use File \Rightarrow Open ($\Re \circ \mathfrak{ctr} \circ$), this opens the multiple image Camera Raw dialog hosted via Photoshop (as shown in Figure 3.14) and if you choose File \Rightarrow Open in Camera Raw..., or $\Re \cap$ $\mathfrak{ctr} \circ \mathfrak{R}$, this opens the multiple image Camera Raw dialog hosted via Bridge.

The multiple image dialog contains a filmstrip of the selected images running down the left-hand side of the dialog and you can select individual images by clicking on the thumbnails in the filmstrip, or use the Select All button to select all the photos at once. You can also make custom selections of images via the Filmstrip using the Shift key to make continuous selections, or the (#) *ctrl* key to make discontinuous selections of images. Once you have made a thumbnail selection you can then navigate the selected photos by using the navigation buttons in the bottom right section of the preview area to progress through them one by one and apply Camera Raw adjustments to the individual selected images. The Synchronize... button then allows you to synchronize the Camera Raw settings adjustments across all the images that have been selected, based on the current 'most selected' image. This will be the thumbnail that's highlighted with a blue border. When you click on the Synchronize... button, the Synchronize dialog (Figure 3.15) lets you choose which of the Camera Raw settings you want to synchronize. You can learn more about this and how to synchronize Camera Raw settings on page 245, as well as how to copy and paste Camera Raw settings via Bridge.

Once a photo has been edited in Camera Raw you will notice a badge icon appears in the top right corner (Figure 3.13), which indicates that this photo has had Camera Raw edits applied to it.

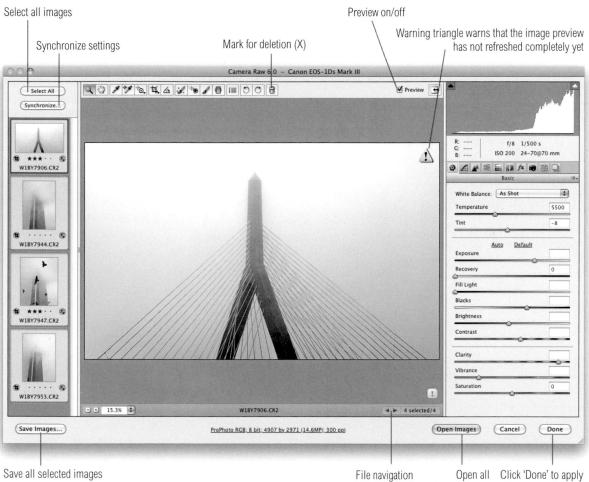

controls

selected images adjustments and exit

Figure 3.14 Here is a view of the Camera Raw dialog, in the multiple file open mode. hosted in Photoshop (you can tell because the Open Images button is highlighted here). This screen shot shows the filmstrip of opened images on the left where all four of the opened images are currently selected and the top image (highlighted with the blue border) is the one that is 'most selected' and displayed in the preview area. Camera Raw adjustments can be applied to the selected photos one at a time, or synchronized with each other, by clicking on the Synchronize settings button. This opens the Synchronize dialog shown in Figure 3.15. Note that if you hold down the 😒 all key as you do so, this will bypass the Synchronize dialog options and synchronize everything.

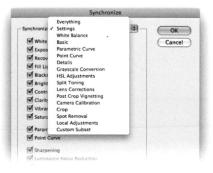

Figure 3.15 The Synchronize dialog.

Opening raw files as Smart Objects

One of the top requests we hear for Photoshop is to have Camera Raw style adjustment layers. It's a nice idea, but limited by the fact that some of the Camera Raw adjustments rely on masking methods and therefore can't be applied as layers, in the same way as filters can't be applied as adjustment layers (although, having said that, there is now a Vibrance adjustment control for Photoshop). What we can do though is to use the Smart Objects feature in Photoshop to convert raw images or layers into Smart Objects, which are like independent images within an image that can be processed non-destructively.

In the case of Camera Raw, Smart Object opening is almost like a hidden feature, but once discovered, can lead to all sorts of exciting possibilities. There are two ways to go about this. You can click on the Workflow options link highlighted in Figure 3.16 to open the Workflow Options dialog and select the 'Open in Photoshop as Smart Objects' option. If checked, this will make *all* Camera Raw processed images open as Smart Object layers in Photoshop whenever you click on the Open Image button. The other option is to simply hold down the *Shift* key as you click on the Open Image button.

Let's now look at a practical example of opening two raw images as Smart Object layers and merging them in Photoshop.

	Workflow Options		
Space:	ProPhoto RGB	•	ОК
Depth:	16 Bits/Channel	•	Cancel
Size:	5616 by 3744 (21.0 MP)	•	
Resolution:	300 pixels/inch		
Sharpen For:	None Amount: Standard	\$	

Figure 3.16 If you click on the Workflow options link (circled above), this opens the Workflow Options dialog, where you can check the 'Open in Photoshop as Smart Objects' option. Alternatively, hold down the *Shift* key as you click the Open Image button.

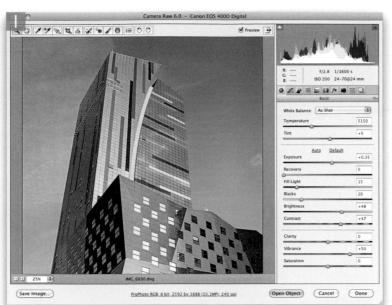

1 In this first step, I opened a raw image of a building and held down the *Shift* key as I clicked on the Open Image button, to open it as a Smart Object layer in Photoshop.

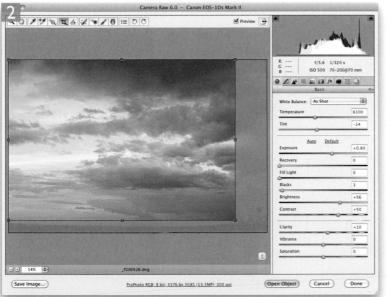

2 In this next step, I selected a new image, this time a photo of a sky, and again, held *Shift* key as I clicked on the Open Image button, to open this too as a Smart Object layer.

Opacity: 100%
Fill: 100%

P2E69...

0

+38

LAYERS

Lock: E

+ 0

3 In Photoshop I dragged the Smart Object layer of the sky across to the Smart Object layer image of the building, to add it as a new layer. I then made a selection of the outline of the building and applied it as a layer mask to create the merged photo shown here.

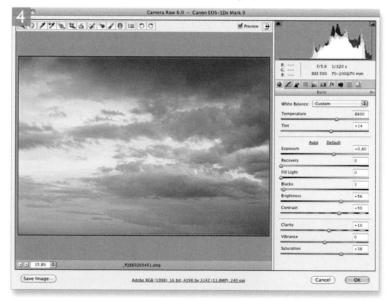

4 Because both of these layers were raw image Smart Objects, I was able to double-click the top layer thumbnail (circled) to open the Camera Raw dialog and edit the settings. In this case I decided to give the sky look more of a sunset color balance.

♥ MG_6830 S≈ fx. ○ O. □	and the second second
Basic	
White Balance: Custom	•
Temperature	8800
Tint	+14
Auto Default Exposure	+0.80
Fill Light	0
Blacks	3
Brightness	+56
Contrast	+50
Clarity	+10

Vibrance

Saturation

Chapter 3

Camera Raw 6.0 ~ Canon EOS 400D Digital

Preview

f/2.8 1/1600 s ISO 200 24-70@24 mr

4

+5

+0.35

23

+48

+47

+53

0

(Cancel) OK

Cu

Auto Default

Fill Light

Blacks

Clarity

ance

- + 20,8% 4

(Save Image...)

6 This shows the Photoshop image with the revised Smart Object layers. The thing to bear in mind here is that edits made to the Smart Object layers are completely non-destructive.

raw image Smart Object layer via Camera Raw and allowed me to warm the colors and add

5 The same thing happened when I double-clicked the lower layer. This too opened the more contrast to the building.

683015451.CR

Adobe RCB (1998): 16 bit: 2592 by 2988 (7.7MP): 240 ppi

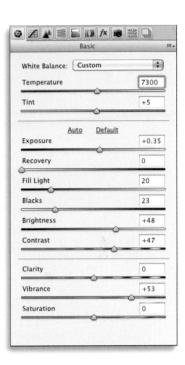

Saving images via Camera Raw

If you hold down the **S** at key as you click on the Save... button, this will bypass the Save dialog box and save the image (or images) using the last used Save Options settings. This is handy if you want to add file saves to a queue and continue making more edit changes in this or the single view Camera Raw dialog.

Saving a JPEG as DNG

Although it is possible to save a JPEG or TIFF original as a DNG via Camera Raw, it is important to realize that this step does not actually allow you to convert a JPEG or TIFF file into a raw image. Once an image has been rendered as a JPEG or TIFF it cannot be converted back into a raw format. Saving to DNG merely allows you to use DNG as a container format for a JPEG or TIFF and brings no special advantages.

Resolving naming conflicts

A save operation from Camera Raw will auto-resolve any naming conflicts so as to avoid overwriting any existing files in the same save destination. This is important if you wish to save multiple versions of the same image as separate files and avoid overwriting the originals.

Saving photos from Camera Raw

When you click on the Save Images... button you have the option of choosing a folder destination to save the images to and a File Naming section to customize file naming. In the Format section you can choose which file format to use when rendering a pixel version from the raw master. These options include: PSD, TIFF, or JPEG. If you have used the crop tool to crop the image in Camera Raw, the PSD options allow you to preserve the cropped pixels by saving the image with a non-background layer (in Photoshop you can use Image \Rightarrow Reveal All should you later wish to revert to an uncropped state). The JPEG and TIFF format saves provide the usual compression options and if you save using the DNG format you can convert any raw original to DNG, but see the sidebar about saving JPEGs and TIFFs as DNG. The file save processing is then carried out in the background, allowing you to carry on working in Bridge or Photoshop (depending on which program is hosting Camera Raw at the time) and you'll see a progress indicator (circled in Figure 3.17) showing how many photos there are left to save.

Save images.	2 Z remaining	Adobe KG8 (1998): 16 bit: 3497 by 3744 (13.1MP): 300 ppi	Open Images	Cancel	Done
		Save Options			
				ALCONTRACTORS	

lect Folder) /Users/mart	in_evening/Desktop/		Cancel
laming			
nple: _MG_2281.psd ument Name	(a) +	→ +	
n Numbering: ile Extension: .psd			
at: Photoshop			
eserve Cropped Pixels			
at: Photoshop	•		

Figure 3.17 Clicking on the Save Images... button opens the Save Options dialog shown here. After configuring the options and clicking on the Save button, you will see a status report next to the Save Images button that shows how many images remain to be processed.

The histogram display

The Camera Raw Histogram provides a preview of how the Camera Raw output image histogram will look after the image data has been processed and output as a pixel image (such as a TIFF, PSD or JPEG). The histogram appearance is affected by the tone and color settings that have been applied in Camera Raw but, more importantly, it is also influenced by the RGB space selected in the Workflow Options (see Figure 3.18). It can therefore be quite interesting to compare the effect of different output spaces when editing a raw capture image. For example, if you edit a photo in an RGB space like ProPhoto or Adobe RGB and then switch to sRGB, you will most likely see some color channel clipping in the shadow region of the histogram. Such clipping can then be addressed by readjusting the Camera Raw settings to suit the smaller gamut RGB space. Overall, this exercise is useful in demonstrating why it is better to output your Camera Raw processed images using either the ProPhoto or Adobe RGB color spaces.

	Workflow Options		
Space:	Adobe RGB (1998)	:	ОК
Depth:	16 Bits/Channel	:	Cancel
Size:	5616 by 3744 (21.0 MP)	:	
Resolution:	300 pixels/inch	:	
harpen For:	None Amount: Standard	\$	
ProPt	ioto RGB	RGB	
Color	match RGB		

Figure 3.18 This shows how to access the Workflow Options, plus an example of how the Camera Raw histogram may vary depending on which color space is selected.

Digital camera histograms

Some digital cameras provide a histogram display that enables you to check the quality of what you have just shot. This too can be used as an indication of the levels captured in a scene. However, the histogram you see displayed is usually based on a JPEG capture image. If you are shooting in JPEG mode, that's what you are going to get. If you prefer to shoot using raw mode, the histogram you see on the back of the camera does not provide an accurate guide to the true potential of the image you have captured (see also, Figure 3.3 on page 128).

Deleting images

As you work with Camera Raw to edit your shots, the *Delete* key can be used to mark images that are to be sent to the trash. This places a big red X in the thumbnail, which can be undone by hitting *Delete* again.

Image browsing via Camera Raw

In a multiple view mode, the Camera Raw dialog can also be used as a 'magnified view' image browser. You can match the magnification and location across all the selected images to check and compare details, inspect them in a sequence and apply ratings to selected images.

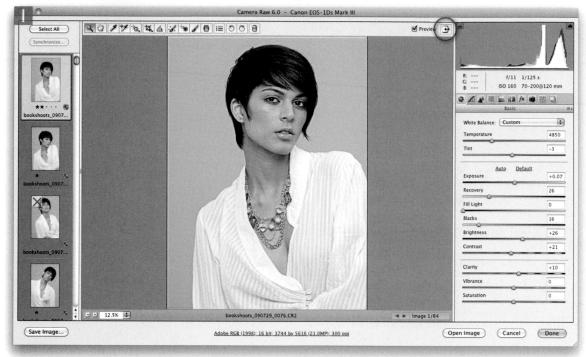

Selecting rated images only

If you **#** *ctrl*-click on the Select All button, this selects the rated images only. This means that you can use star ratings to mark the images you are interested in during a 'first pass' edit and then use the above shortcut to make a quick selection of just the rated images only. 1 If you have a large folder of images to review, the Camera Raw dialog can be used to provide a synchronized, magnified view of the selected pictures. The dialog is shown here in a normal window view, but you can click on the Full Screen mode button (circled) to expand the dialog to the Full screen view mode.

2 Here, I selected the first image in the sequence and clicked on the Select All button. I then used the zoom tool to magnify the preview. This action synchronized the zoom view used for all the selected images in the Camera Raw dialog, plus I was able to use the hand tool to synchronize the scroll location for the selected photos.

3 Once this had been done I could deselect the thumbnail selection and start inspecting the photographs. This could be done by clicking on the file navigation controls (circled) or by using the e by keyboard arrow keys to progress through the images one by one. I could then mark my favorite pictures by using the usual Bridge shortcuts: **H**> ettl> progressively increases the star rating for a selected image; **H**< ettl<

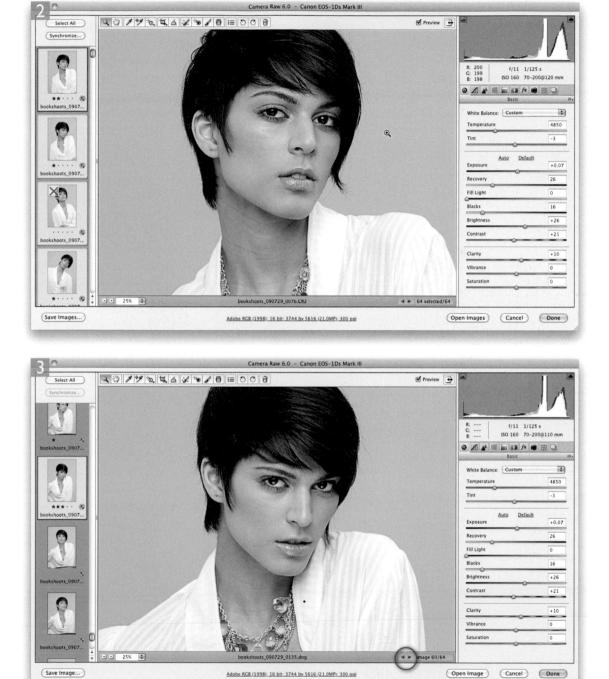

165

XMP sidecar files

Camera Raw edit settings are written as XMP metadata and this data is stored in the central Camera Raw database on the computer and can also be written to the files directly. In the case of JPEG, TIFF and DNG files, these file formats allow the XMP metadata to be written to the XMP space in the file header. However, in the case of proprietary raw file formats such as CR2 and NEF, it would be unsafe to write XMP metadata to incompletely documented file formats. To get around this, Camera Raw writes the XMP metadata to XMP sidecar files that accompany the image in the same folder and stay with the file when you move it from one location to another via Bridge.

Camera Raw preferences

The Camera Raw preferences (Figure 3.19) can be opened by clicking on the Open Preferences button in the Camera Raw dialog (**\mathbf{K}** *ctrl* **(K**) or by clicking on the Camera Raw Preferences... button in Photoshop's File Handling preferences.

Let's look at the General section first. In the 'Save image settings in' section I suggest you choose 'Sidecar ".xmp" files'. TIFF, JPEG and DNG files can store the XMP data in the header, but if the XMP data can't be stored internally within the file itself, this forces the image settings to be stored locally in XMP sidecar files that accompany the image files.

Should you wish to preview adjustments with the sharpening turned on, but without actually sharpening the output the 'Apply sharpening to' option can be set to 'Preview images only'. This is because you might want to use a third-party sharpening program in preference to Camera Raw. However, with the advent of Camera Raw's improved sharpening, you will now want to leave this set to 'All images' to make full use of Camera Raw sharpening.

	Camera Raw Preferences (Version 6.0).0.152)
General		ОК
Save image settin	gs in: Sidecar ".xmp" files	Cancel
Apply sharpening	ng to: All images	
Default Image Sett	ings	
Apply auto ton	e adjustments	
Apply auto gra	yscale mix when converting to grayscale	
Make defaults	specific to camera serial number	
Make defaults	specific to camera ISO setting	
(Select Location.) /Users/martin_evening/Library/Caches/Adobe	: Camera Raw/
DNG File Handling		
🗌 Ignore sidecar	".xmp" files	
🗹 Update embed	ded JPEG previews: Medium Size	
JPEG and TIFF Han	dling	
JPEG: Automatic	ally open JPEGs with settings	
TIFF: Disable T	FF support	

Figure 3.19 Camera Raw preferences dialog.

Auto tone corrections

Camera Raw has the useful ability to apply auto tone corrections. To do this, just click on 'Auto' (**HU** *ctrl***U**) in the Camera Raw dialog (circled in Figure 3.20).

In the Camera Raw preferences Default Image Settings section, you can also select 'Apply auto tone adjustments' as a Camera Raw default. When this is switched on, Camera Raw automatically applies an auto tone adjustment to new images it encounters that have not yet been processed in Camera Raw, while any images you have edited previously via Camera Raw will remain as they are. Auto tone adjustments work really well on most images, such as outdoor scenes and naturally-lit portraits (note the auto algorithm has been updated and improved in both Camera Raw 5.0 and 6.0), but works less well on photographs that have been shot in the studio under controlled lighting conditions. In these instances it can be something of a nuisance and is best left switched off.

The 'Apply auto grayscale mix when converting to grayscale' option refers to the HSL/Grayscale controls, where Camera Raw will apply an auto slider grayscale mix adjustment when converting a color photograph to black and white.

Camera-specific default settings

The next two options in the Default Image Settings section allow you to make any default settings camera-specific. Basically, if you go to the Camera Raw fly-out menu options shown in Figure 3.21, there is an option that allows you to 'Save New Camera Raw Defaults' as the new default setting to be used every time Bridge or Camera Raw encounters a new image. On its own, this menu item allows you to create a default setting based on the current Camera Raw settings and apply this to all subsequent photos (except where you have already overridden the default settings). However, if the 'Make defaults specific to the camera serial number' option is selected in the Camera Raw preferences (Figure 3.19), selecting 'Save New Camera Raw Defaults' only applies this setting as a default to files that will match the same camera serial number. Similarly, if the 'Make defaults specific to camera ISO setting' option in Figure 3.19 is checked, this allows you to save default settings for specific ISO values. And when both this and the previous option are checked, you can effectively have, in Camera Raw, multiple default settings that take into account the combination of the camera model and ISO setting.

Auto grayscale and white balance

The Auto slider settings are in fact determined by the White Balance setting. If you adjust the Temp and Tint White Balance controls in the Basic panel (Figure 3.20) and then select the Convert to Grayscale box in the HSL/Grayscale panel shown in Figure 6.4 on page 386 (with Auto enabled), you will see the Grayscale sliders readjust according to how the White Balance sliders have been set.

Basic	
White Balance: As Shot	•
Temperature	5550
Tint	+6
Exposure	+0.50
Recovery	0
Fill Light	0
Blacks	3
Brightness	+16
Contrast	+42
0	
Clarity	0
Vibrance	0
Saturation	0

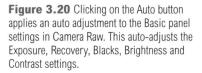

You do have to be careful how you go about using the 'Save New Camera Raw Defaults' option. When used correctly you can cleverly set up Camera Raw to apply appropriate default settings for any camera and ISO setting. However, it is all too easy to make a mistake, or worse still, select the 'Reset Camera Raw Defaults' option and undo all your hard work!

The main thing to watch out for is that you don't include too many Camera Raw adjustments (such as the HSL/Grayscale panel settings) as part of a default setting. One approach is to open a previously untouched image, apply a Camera Calibration panel adjustment plus a Detail panel sharpening setting and save this as a camera-specific default. Alternatively, you might find it useful to adjust the Detail panel noise reduction settings for an image shot at a specific ISO setting and save this as a 'Make defaults specific to camera ISO setting' (Figure 3.19). Or, you might like to combine both Camera Raw preference options and setup defaults for different ISO settings with specific cameras.

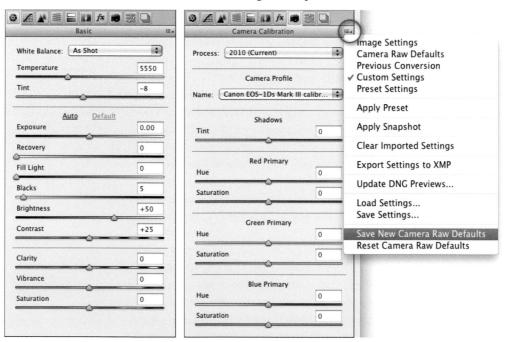

Figure 3.21 You can use the Camera Raw menu option circled here to choose the 'Save New Camera Raw Defaults'. This saves all the current Camera Raw settings as a default setting according to how the preferences are set in Figure 3.19. The important thing to bear in mind here is to only apply the minimal necessary Camera Raw settings before you choose this option. For example, I would suggest keeping the Basic settings neutral.

Camera Raw cache size

When photos are rendered using the Camera Raw engine, they go through an early stage initial rendering and the Camera Raw cache can be used to store a cache of all this data so that when you next reopen an image that has data stored in the cache, it renders the photo quicker in the Camera Raw dialog. The 1 GB default setting is extremely conservative. If you have enough free hard disk space available, you may want to increase the size limit for the cache, or choose a new location to store the central preview cache data. If you increase the limit to, say, 20 GB or more you should see some improvement in Camera Raw's performance.

DNG file handling

Camera Raw and Lightroom both embed the XMP metadata in the XMP header space of a DNG file. There should therefore be no need to use sidecar files to read and write XMP metadata when sharing files between these two programs. However, some third-party programs may create sidecar files for DNG files. If 'Ignore sidecar "xmp" files' is checked, Camera Raw will not be sidetracked by sidecar files that might accompany a DNG file and cause a metadata conflict. Having said that, there are times where it may be useful to read the XMP metadata from sidecar files. For example, I sometimes have raw files on computer A and DNG versions of the same files on computer B. I can save the metadata to the xmp files on computer A, copy these across to computer B and read from the xmp metadata to update the DNG files there.

DNG files have embedded previews that represent how the image looks with the current applied Camera Raw settings. When the 'Update embedded JPEG preview' is checked, this forces the previews in all DNG files to be continually updated based on the current Camera Raw settings, overriding previously embedded previews. However, it is important to point out that DNG previews created by Camera Raw can only be considered 100% accurate when viewed by other Adobe programs such as Lightroom or Bridge and even then, they must be using the same version of Camera Raw. While DNG is a safe format for the archiving of raw data, other DNG compatible programs (that are not made by Adobe), or that use an earlier version of Camera Raw, will not always be able to read the Camera Raw settings that have been applied using the latest version of Camera Raw or Lightroom.

Camera Raw cache

Whenever you open an image in Camera Raw, it builds full, high quality previews direct from the master image data. In the case of raw files, the early stage processing includes the decoding and decompression of the raw data as well as the linearization and demosaic processing. All this has to take place first before getting to the stage that allows the user to adjust things like the Basic panel adjustments. The Camera Raw cache is therefore used to store the unchanging, early stage raw processing data that is used to generate the Camera Raw previews so that the early stage raw processing can be skipped the next time you view that image. If you increase the Camera Raw cache size, more image data can be held in the cache. This in turn results in swifter Camera Raw preview generation when you reopen these photos. Also, because the Camera Raw cache can be utilized by Lightroom, the cache data is shared between both programs.

Figure 3.22 The Process Version update warning triangle.

	Camera Calibration	
Process	2010 (Current) ✓ 2003	
	Camera Profile	
Name:	Adobe Standard	•
	Shadows	
Tint		0
	Red Primary	
Hue	~	0
Satura	tion	0
	Green Primary	
Hue		0
Satura	tion	0
	Blue Primary	
Hue		0
Satura	tion	0

Figure 3.23 The Process Version setting can be accessed via the Camera Calibration panel.

Sharing XMP metadata

While I may prefer to archive files in DNG, I am still wary of converting to DNG too soon. This is especially true when working with Bridge. I find if I keep my raw capture files unconverted I can easily swap the XMP sidecar files from one computer to another as a quick way to transfer and update the image edit information such as the Camera Raw settings and ratings. For example, when I work from a rental studio I'll have a computer in the studio with all the captured files on it and a backup/shuttle disk to take back to the office at my house, from which I can copy everything to the main computer there. If I make any further ratings edits on this main machine, the XMP metadata is automatically updated as I do so. It then only takes a few seconds to copy only the updated XMP files across to the backup disk, replacing the old ones. Back at the studio I can again copy the most recently modified XMP files back to the main computer (overwriting the old XMP files). The photos in Bridge then appear updated with the edits I carried out back at the house. It is only when the initial edits are complete that I feel it is a good time to convert to DNG.

Opening TIFF and JPEGs

Process Versions

For the first time since the introduction of Camera Raw, Adobe have been obliged to add the concept of Process Versions to the Camera Raw processing. This has happened now because Camera Raw 6.0 has seen a complete revision of the capture sharpening and noise reduction which affects the total appearance of the image rather than just one particular aspect of the raw processing. Because of this there are now two Process Versions you can choose from when editing your photos and this applies not just to raw files but also to DNG, TIFF and JPEG images too. When you edit a photo that's previously been edited in an earlier version of Camera Raw, Camera Raw use Process Version 2003 and an exclamation mark button appears in the bottom right corner of the preview to indicate this is an older Process Version image. Clicking on the button updates the file to Process Version 2010, which then allows you to take advantage of the latest sharpening and noise reduction features. Or, you can go to the Camera Calibration panel and select the desired Process Version from the Process menu shown in Figure 3.23. Here you can update to Process Version 2010 by choosing '2010 (Current)'. Should you wish to do so you can use this menu to revert to the previous Process Version 2003. There is one trade-off to bear in mind here. The fact that the Process Version 2010 rendering is more sophisticated has also increased the amount of processing time required to render individual images.

Camera Raw cropping and straightening

You can crop an image in Camera Raw before it is opened in Photoshop, but note that the cropping is limited to the bounds of the image area only. The crop you apply in Camera Raw is updated in the Bridge thumbnail and preview, and applied when the image is opened. However, if you save a file out of Camera Raw using the Photoshop format, there is an option to preserve the cropped pixels so you can recover the hidden pixels later. Meanwhile, the Camera Raw straighten tool can initially be used to measure a vertical or horizontal angle and apply a minimum crop to the image, which you can then resize accordingly. A useful tip I learnt from Bruce Fraser was how you can use the Custom Crop option shown in Figure 3.24 to create a crop size using pixel units to create a custom size output that matches the size required for a specific layout, or one that exceeds the standard output sizes available in the Workflow Options (Figure 3.25).

Removing a crop

To remove a crop, open the image in the Camera Raw dialog again, select the crop tool and choose 'Clear Crop' from the crop menu. Alternatively, you can hit *Delete* or simply click outside of the crop in the gray canvas area.

Figure 3.24 The Camera Raw crop tool menu includes a range of preset crop proportions. You can add your own custom presets by clicking on Custom... (see Figure 3.25 below).

Figure 3.25 This shows the Custom Crop settings that can be accessed via the crop tool menu (Figure 3.24). The crop units can be adjusted to crop according to the 'ratio' (the default option) or by pixels, inches or centimeters. In this example, I set a custom pixel size that enabled me to render files at a larger pixel size than the maximum size currently allowed.

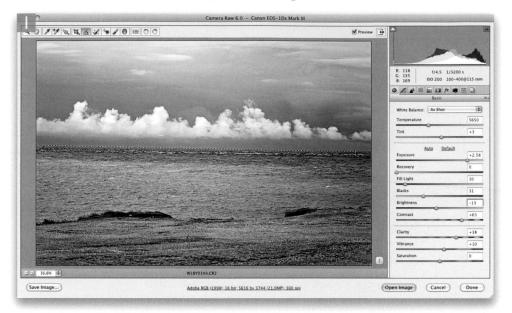

How to crop and straighten

1 To straighten a photograph, I selected the straighten tool from the Camera Raw tools and dragged with the tool to follow the line that I wished to have appear straight.

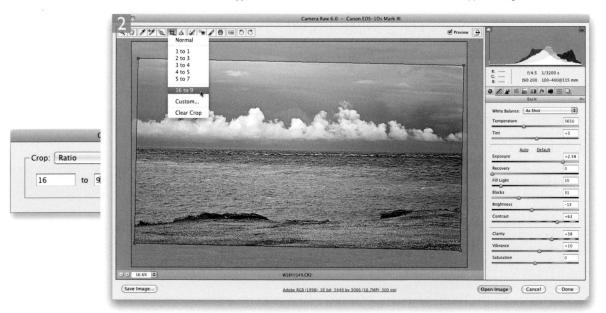

2 This action straightened the image. I could then click on the crop tool to access the crop tool menu and choose a crop ratio preset, or click on Custom... to create a new setting.

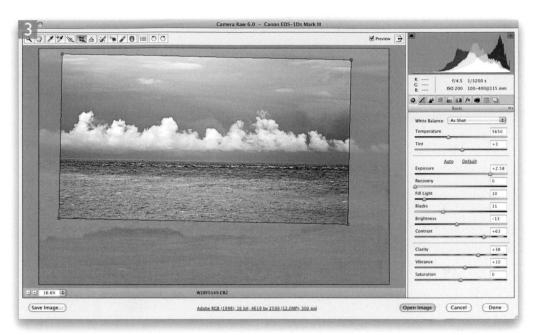

3 After creating and selecting a new custom 16:9 crop ratio setting, I dragged one of the corner handles to resize the crop bounding box as desired.

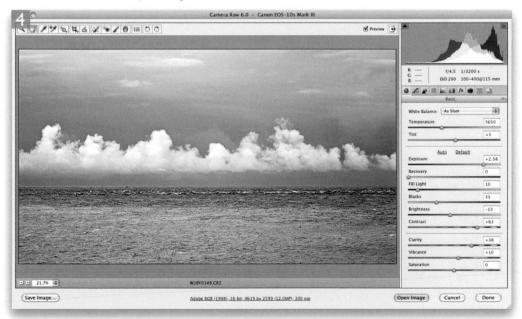

4 Finally, I deselected the crop tool by clicking on one of the other tools (such as the hand tool). This reset the preview to show a fully cropped and straighten-aligned image.

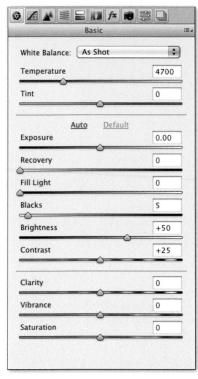

Figure 3.26 The Camera Raw Basic panel controls.

Figure 3.27 WhiBal™ cards come in different sizes and are available from RawWorkflow.com.

Basic panel controls

The Basic controls (Figure 3.26) are best approached and adjusted in the order you find them. I therefore suggest you start by adjusting the white balance adjustments first before working your way down the list. Having said that, you don't necessarily have to follow a strict order here, although it is always important to set the Exposure slider first before you adjust the Brightness slider.

White balance

Let's start though with the white balance controls. These refer to the color temperature of the lighting conditions at the time a photo was taken and essentially describe the warmth or coolness of the light. Quartz-halogen lighting has a warmer color and a low color temperature value of around 3400 K, while daylight has a bluer color (and a higher color temperature value of around 6500 K). If you choose to shoot in raw mode it does not matter how you set the white point settings at the time of shooting, because you can always decide later which is the best white balance setting to use.

Camera Raw was first designed by Thomas Knoll, who was one of the original creators of the Photoshop program. Camera Raw cleverly uses two profile measurements, one made under tungsten lighting conditions and another made using daylight balanced lighting. From this data, Camera Raw is able to extrapolate and calculate the white balance adjustment for any color temperature value that falls between these two white balance measurements, as well as calculating the more extreme values that go beyond either side of these measured values.

The default white balance setting normally uses the 'As Shot' white balance setting that was embedded in the raw file metadata at the time the image was taken. This might be a fixed white balance setting that you had selected on your camera, or it could be an auto white balance that was calculated at the time the picture was shot. If this is not correct you can try mousing down on the White Balance pop-up menu and select a preset setting that correctly describes which white balance setting to use. Alternatively, you can simply adjust the Temperature slider to make the image appear warmer or cooler and adjust the Tint slider to balance the white balance green/magenta tint bias.

Using the white balance tool

The easiest way to set the white balance manually is to select the white balance tool and click on an area that is meant to be a light gray color (Figure 3.28). Don't select an area of pure white as this may contain some channel clipping, which will produce a skewed result (which is why it is better to sample a light gray color instead). You will also notice that as you move the white balance tool across the image, the sampled RGB values are displayed just below the histogram, and when you click to set the white balance, these numbers should appear even.

There are also calibration charts such as the X-Rite ColorChecker chart, which can be used in carrying out a custom calibration, although the light gray patch on this chart has been regarded as being a little on the warm side. For this reason, you may like to consider using a WhiBalTM card (Figure 3.27). These cards have been specially designed for obtaining accurate white point readings under varying lighting conditions.

Color temperature

Color temperature is a term that links the appearance of a black body object to its appearance at specific temperatures, measured in kelvins. Think of a piece of metal being heated in a furnace. At first it will glow red but as it gets hotter, it emits a red, then yellow and then a white glow. Indoor tungsten lighting has a low color temperature (a more orange color), while sunlight has a higher color temperature and emits a bluer light.

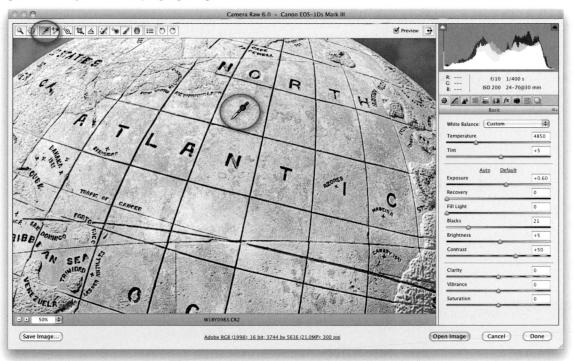

Figure 3.28 To manually set the white balance, select the white balance tool (circled) to locate what should be a light gray neutral area and click to update the white balance.

How Camera Raw calculates

Camera sensors have a linear response to light, and unprocessed raw files therefore exist in a 'linear gamma space'. Human vision on the other hand interprets light in a non-linear fashion, so one of the main things a raw conversion has to do is to apply a gamma correction to the original image data to make the correctly exposed, raw image look the way our eyes would expect such a scene to look (see Digital exposure on pages 186-187). The preview image you see in the Camera Raw dialog presents a gamma corrected preview of the raw data, while the adjustments you apply in Camera Raw are in fact being applied directly to the raw linear data. The reason I mention this is to illustrate one aspect of the subtle but important differences between the tonal edits that can be made in Camera Raw to raw files and those that are applied in Photoshop where the images have already been 'gamma corrected'. Note that in the case of non-raw files, Camera Raw has to temporarily convert the image to a linear RGB space to carry out its calculations.

The tone adjustment controls

The tone adjustment controls allow you to make further adjustments to the highlight and shadow clipping points as well as the overall tone balance and brightness. You can adjust these sliders manually, plus you can click on the Auto button to auto-set the Exposure, Recovery, Blacks, Brightness and Contrast settings.

Exposure

The Exposure slider is used to set the overall brightness, so that the photograph looks 'correctly exposed'. You can use the Exposure slider to visually assess how brightly exposed you want the picture to be and use this as your primary tool for adjusting the image brightness. If you hold down the end at the exposure slider this shows you a threshold preview which indicates where there might be highlight clipping, or you can rely on the highlight clipping indicator shown in Figure 3.30 to tell you which highlights are about to be clipped.

Recovery

You don't have to worry too much about setting the Exposure too bright or clipping the highlights, because the Recovery slider can be used to restore some of the detail which at first may appear lost. The Recovery slider cleverly utilizes the highlight detail in whichever channels contain the best recorded highlight detail and uses this to boost the detail in the weakest highlight channel. There are limits as to how far you can push a Recovery adjustment, but you may be able to recover as much as a stop or more of overexposure. Camera Raw can sometimes use extra tricks such as ignoring digital gain values used to create higher ISO captures. If you hold down the **S** *alt* key as you drag the Recovery slider you will also get to see a Threshold mode preview, which can often make it easier to determine the optimum setting here.

Blacks

The Blacks slider is used to clip the shadow point and here again I find it useful to hold down the **a** *alt* key to obtain a Threshold mode preview to help determine the point where the shadows just start to clip. The main thing is to set the Black slider so that the shadows just begin to clip, though try not to set lower than 2 or 3 if you can help it.

Fill Light

The Fill Light kind of matches the behavior of the Shadow amount slider in the Shadow/Highlight image adjustment. If you drag the Fill Light slider to the right this adds more lightness to the dark tone areas and lightens the darkest shadow areas. However, if you overdo this adjustment it may knock back the contrast too much and you'll end up with an artificial looking result such as the Figure 3.29 example.

Suggested order for the basic adjustments

The first step should be to set the Exposure to get the overall image brightness looking right, taking care not to introduce too much highlight clipping. If necessary, use the Recovery slider to restore any important detail that may be clipped in the highlight areas (see page 181). Next, use the Blacks slider to set the shadow clipping, followed by the Fill Light slider should you need to reveal more detail in the shadow areas. The Brightness and Contrast sliders should be used last to fine-tune the image after you have adjusted these four sliders first.

Figure 3.29 Be careful when setting the Fill Light. Shown here is an extreme example of a solarization type effect that can occur if you apply too much Fill Light. If you upgrade to Process Version 2010, you will notice how Recovery and Fill Light have been much improved to prevent this kind of thing happening. As a result of this, you may need to revisit the Recovery and Fill Light settings after upgrading.

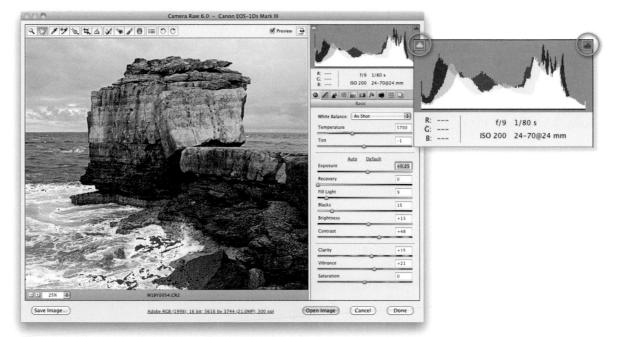

Figure 3.30 If you click on the clipping indicators in the Histogram panel you will see a colored overlay in the preview image that indicates any shadow and highlight clipping.

2	Camera Raw 6.0 - Canon EOS-1Ds Mark III		- • A * = = 11 fx	
		Preview	Basic	
			White Balance: As Shot Temperature	\$
	Stor Aller		Tint	-7
		White Balan Temperatur Tint	Auto Defau	<u>alt</u> 0.00
		(Children)	Recovery	0
The Head State		Exposure Recovery	Fill Light	0
		Fill Light Blacks	Blacks	5
and and a start of the start of the	Contract and and the	Brightness	Brightness	+50
-		Contrast	Contrast	+25
	and a series of the	Vibrance	Clarity	0
1 16.9% ·	W18Y3452 dng		Vibrance	0
ive Image)	ProPhoto RG8: 16 bit: 5498 by 1664 (20.1MP): 300 pp)	(Open Image)	Saturation	0

Basic image adjustment procedure

1 This shows a raw image as viewed in the Camera Raw dialog, using the default settings in the Basic panel. One way to quickly optimize an image is to click on the Auto button. If you then want to reset all the settings you can do so by double-clicking on the individual sliders, or by clicking on the Default button.

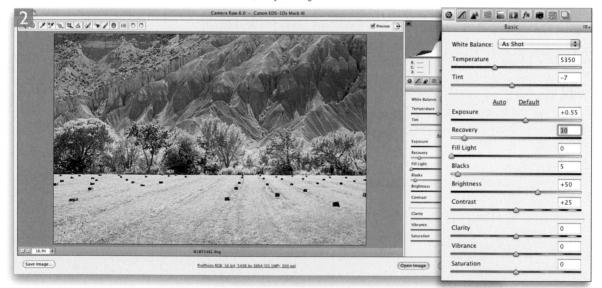

2 In this example I adjusted the Exposure to make the photograph look lighter, to achieve what looked like the best visual brightness. You don't have to worry about blowing out the highlight detail because you can always use the Recovery slider to restore any highlight detail that may be clipped (but without destroying the exposure effect).

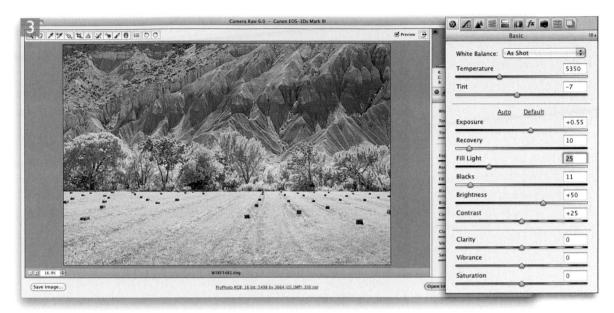

3 The next step was to optimize the shadows. I used the Blacks slider to set the clipping point for the shadow detail and after that I used the Fill Light slider to lighten the darker areas of the photograph. Note that as you adjust the Recovery and Blacks sliders, you can hold down the end with the end of the grad to see a threshold view of the image, which can help you determine how far to drag to set the correct amount of clipping.

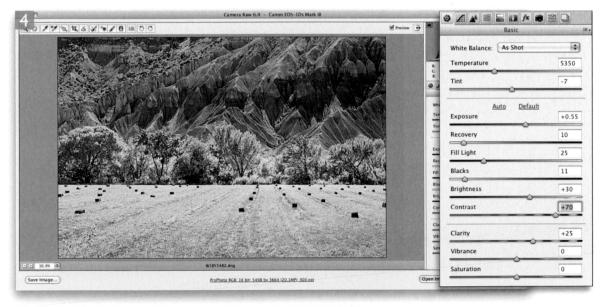

4 Lastly, I used the Brightness and Contrast sliders to fine-tune the tonal balance of the photograph.

White backgrounds

When creating studio shots with a white background, you usually do want the white to reproduce as a pure white. If you try to achieve this with the lighting then you need to make sure you balance the lighting ratios perfectly so that the background values are clipped as pure white and the important highlight detail in the subject matter is not clipped. If time and budget allow, I find it is best not to overblow the white background exposure too much at the capture stage. One can always force the background tones to white when editing the image in Photoshop.

Preserving the highlight detail

As you apply basic adjustments in Camera Raw, you want to make the brightest parts of the photo go to white so the highlights are not too dull. At the same time though, you will want to ensure that important highlight detail is always preserved. This means taking care not to clip the highlights too much, since this might otherwise result in important highlight detail being lost when you come to make a print. You therefore need to bear in mind the following guidelines when deciding how the highlights should be clipped.

Where you should set the highlight clipping point is really dependent on the nature of the image. In most cases you can adjust the Exposure and Recovery sliders so that the highlights just begin to clip and not worry about losing any important highlight detail. If the picture you are editing contains a lot of delicate highlight information then you will want to be careful when setting the highlights so that the brightest whites in the photo are not too close to the point where the highlights get clipped. The reason for this is all down to what happens when you ultimately send a photo to a desktop printer or convert an image to CMYK and send it to the press to be printed. Most photo inkjet printers are quite good at reproducing highlight detail at the top end of the print scale, but at some point you will find that the highest pixel values do not equate to a printable tone on paper. Basically, the printer may not be able to produce a dot that is light enough to print successfully. Some inkjet printers use light colored inks such as a light gray, light magenta and light cyan to complement the regular black, gray, cyan, magenta, yellow ink set and these printers are better at reproducing feint highlight detail. CMYK press printing is a whole other matter. Printing presses will vary, of course, but there is a similar problem where a halftone dot may be too small for any ink to adhere to the paper.

In each of the above cases there is an upper threshold limit where the highlight values won't print. So, when you are adjusting the Exposure and Recovery sliders, it is important to examine the image and ask yourself if the highlight detail matters or not. Some pictures may contain subtle highlight detail (such as in Figure 3.31), where it is essential to make sure the important highlight tones don't get clipped. Other images may look like the example in Figure 3.32. Here, the light reflecting off a shiny metal surface creates bright, specular highlights and the last thing you need to concern yourself with is preserving the highlight detail. I would say that most images contain at least a few specular highlights and it is only where you have a photo like the one shown below that you have to pay particular attention to making sure the brightest highlights don't get clipped.

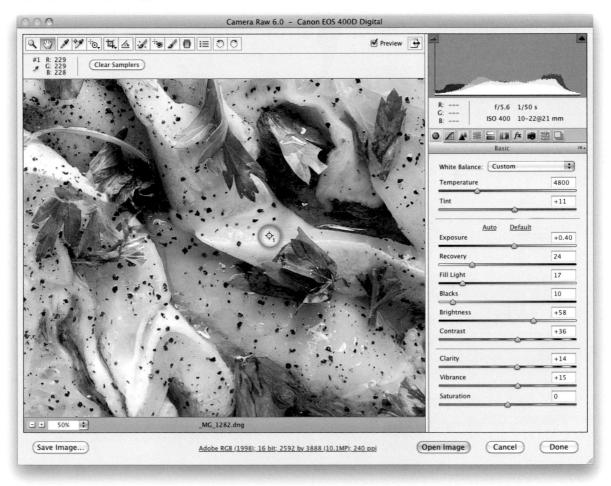

Figure 3.31 In this example it was important to preserve the delicate highlight tones in the fish steaks. To be absolutely sure that I didn't risk making the highlight detail areas too bright, I placed a color sampler (circled) over an area that contained important highlight detail. This allowed me to check that the RGB highlight value did not go too high. In this case I knew that with a pixel reading of 229,229,228, the highlight tones in this part of the picture would print fine using almost any print device.

When to clip the highlights

As I say, you have to be careful when judging where to set the highlight point. If you clip too much then you risk losing important highlight detail. However, what if the image contains bright specular highlights, such as highlight reflections on shiny metal objects? The Figure 3.32 image has specular highlights which contain no detail. It is therefore safe to clip these highlights, because if you were to clip them too conservatively you would end up with dull highlights in your prints. In this case the aim is for the shiny reflections to print to paper white. So when adjusting the Exposure slider for a subject like this, you would use the Exposure slider first to visually decide how bright to make the photo and not be afraid to let the specular highlights blow out to white.

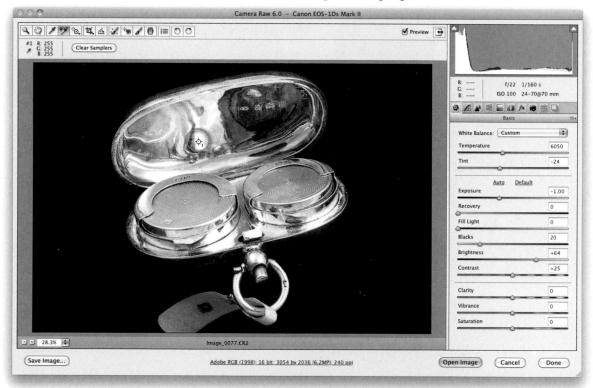

Figure 3.32 The highlights in this photograph contain no detail, so there is no point in trying to preserve detail in the shiny areas as this would needlessly limit the contrast. One can safely afford to clip the highlights in this image without losing important image detail, and as you can see here, the color sampler over the shiny reflection (circled) measures a highlight value of 255,255,255. Images like this usually need no Recovery adjustment.

-

6500

-1

+36

+36

+27

0

Done

(Cancel)

(Open Image)

How to clip the shadows

1 1 10. 14. 4 1. 10 1 0 1 0 0

Clear Samplers

Setting the black clipping point is, by comparison, much easier to decide. Put aside for now any concerns you might have about matching the black clipping point to the printing device, I'll explain how that works over the next two pages. Blacks slider adjustments are simply about deciding where you want the shadows to clip. The default setting is 5 and this will usually be about right for most images. You may want to ease the clipping off to around 2 or 3 on some images, but it is inadvisable to take the setting all the way down to zero. Some photos such as the one shown below in Figure 3.33 can actually benefit from a heavy black clipping so that the dark areas print to a solid black.

Hiding shadow noise

Preview

Raising the threshold point for where the shadows start to clip is one way to add depth and contrast to your photos. It can also help improve the appearance of an image that has very noisy shadows.

Figure 3.33 In this picture of my daughter, Angelica, you can see that the blacks in this photo are well and truly clipped. This is because I deliberately wanted to force any shadow detail in the backdrop to a solid black. As you can see, the color sampler over the backdrop in this picture (circled) showed an RGB reading of 0,0,0.

f/4.5 1/160 s ISO 200 24-70@70 mm 1 -0 White Balance: Cu Temperature Tint Default -0.08 Exposure Recovery 14 Fill Light 14 Blacks 7 Brightness Contrast Clarity Vibrance Saturation - + 25% + W1BY1953.de

Adobe RGB (1998): 16 bit: 4451 by 3744 (16.7MP): 300 ppi

Camera Raw 6.0 - Canon EOS-1Ds Mark III

Save Image ...

20

Is it wrong to set levels manually?

All I am suggesting here is that it is an unnecessary extra step to use Photoshop to set the black output levels to anything higher than the zero black after you have already set the black clipping at the Camera Raw editing stage (or done so in Photoshop). If you do set the black output levels manually to a setting that is higher than zero you won't necessarily get inferior print outputs, providing that is, you set the black levels accurately and don't set them any higher than is needed. And there's the rub: how do you know how much to set the output levels, and what if you want to output a photo to more than one type of print paper? You see, it's easier to let Photoshop work this out for you automatically. Some picture libraries are quite specific about how you set the output levels, but their suggested settings are usually very conservative and unlikely to result in weak shadows when printed to most devices. It is therefore probably better to oblige the libraries and just give them what they ask for, rather than fight them over the logic of their arguments. The only time when you may need to give special consideration to setting the shadows to anything other than zero is when you are required to edit an already converted CMYK or grayscale file that is destined to go to a printing press, where the black output levels have been set incorrectly. However, if you use Photoshop color management properly you are unlikely to encounter such problems.

Shadow levels after a conversion

You will sometimes come across advice saying that the output levels for the black point in an RGB image should be set to something like 20,20,20 (for the Red, Green, Blue RGB values). The usual reason given for this is because anything darker than, say, a 20,20,20 shadow value will reproduce in print as a solid black. Just to add to the confusion, different numbers are suggested for the output levels: one person suggests using 10,10,10, while another advises you use 25,25,25. In all this you are probably left wondering how to set the Blacks slider in Camera Raw, since you can only use it to clip the black input levels and there is no control for setting the black output levels so that they match these suggested output settings.

This is one of those areas where the advice given is more complex than it needs to be. It is well known that because of factors such as dot gain, it has always been necessary to make the blacks in a digital image slightly lighter than the blackest black (0,0,0,) before outputting it to print. As a result of this, in the early days of digital imaging, the only way to get a digital image to print correctly was to *manually* adjust the output levels so that the black clipping point matched the print device. Back then, if you set the levels to 0,0,0, RGB, the blacks would print too dark and you would lose detail in the shadows. Therefore the solution was to set the output levels point to a value higher than this (such as 20,20,20 RGB), so that the blacks in the image matched the blackest black for the print device. These are the historical reasons for such advice, because the black levels had to be adjusted differently for each type of print output including CMYK prepress files.

For the last 12 years or so, Photoshop has had a built-in automated color management system that is designed to take care of the black clipping at the print stage. The advice these days is therefore quite simple: you decide where you want the blackest blacks to be in the picture and clip them to 0,0,0, RGB (as discussed on the previous page). When you save the image out to Photoshop as a pixel image and send the image data to the printer, the Photoshop or print driver software automatically calculates the precise amount of black clipping adjustment that is required for each and every print/paper combination. In the Figure 3.34 example you can see how the black clipping point for different print papers is automatically compensated when converting the data from the edited image to the profile space for the printing paper. Don't just take my word, it is easy to prove this for yourself. Open an image (almost any will do), set the Channel display in the Histogram panel to Luminosity and refresh the histogram to show the most up-to-date histogram view (you do this by clicking on the yellow warning triangle in the top right corner). Once you have done this go to the Edit menu, choose 'Convert to Profile' and select a CMYK or RGB print space. You'll need to refresh the histogram display again, but once you have done so you can compare the before and after histograms and check what happens to the black clipping point.

Figure 3.34 The Histogram panel views on the right show (top) the original histogram for this ProPhoto RGB image. The middle histogram shows a comparison of the image histogram after converting the ProPhoto RGB data to a print profile space for Innova Fibraprint glossy paper printed to an Epson 4800 printer. The print output histogram is overlaid here in green and you can see how the black clipping point has been automatically indented. The bottom example shows the print profile for a Somerset Velvet matte paper printed to an Epson 9600 printer, again colored green so that you can compare it more easily with the before Histogram. The black clipping point is moved inwards even more here because the matte paper needs a higher black clipping point to avoid clogging up the shadow detail. The same thing also happens when you make a CMYK conversion, but the black point will possibly shift inwards even further. Please note that the histograms shown here were all captured using the Luminosity mode since this mode accurately portrays the composite luminance levels in each version of the image.

Original histogram - ProPhoto RGB

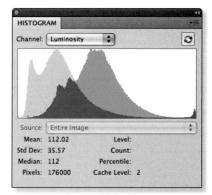

Innova Fibraprint glossy paper

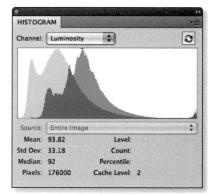

Somerset Velvet matte paper

Martin Evening Adobe Photoshop CS5 for Photographers

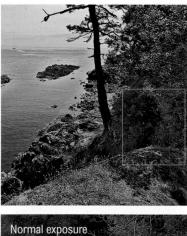

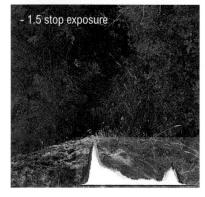

Figure 3.35 This shows the difference the exposure can make in retaining shadow information. The darker the exposure, the fewer discreet levels the CCD chip can capture and this can result in poorly recorded shadow detail.

Digital exposure

Compared with film, shooting with a digital camera requires a whole new approach to determining what the optimum exposure should be. With film you tended to underexpose slightly for chrome emulsions (because you didn't want to risk blowing out the highlights). With negative emulsion film it was considered safer to over-expose as this would ensure you captured more shadow detail and thereby recorded a greater subject tonal range.

When capturing raw images on a digital camera it is best to overexpose as much as it is safe to do so before you clip the highlights. Most digital cameras such as digital SLRs and even the raw-enabled compacts are capable of capturing 12 bits of data, which is equivalent to 4096 recordable levels per color channel. As you halve the amount of light that falls on the chip sensor, you potentially halve the number of levels that are available to record an exposure (see Figure 3.36). Let us suppose that the optimum exposure for a particular photograph at a given shutter speed is f16. This exposure makes full use of the chip sensor's dynamic range and consequently there is the potential to record up to 4096 levels of information. If one were then to halve the exposure to f22, you would only have the ability to record up to 2048 levels per channel. It would still be possible to lighten the image in Camera Raw or Photoshop to create an image that appeared to have similar contrast and brightness. But (and it's a big but) that one stop exposure difference has immediately lost half the number of levels that could potentially be captured by using a one stop brighter exposure. The image is now effectively using only 11 bits of data per channel instead of 12. This is true of digital scanners too. Perhaps you may have already observed how difficult it can be to rescue detail from the very darkest shadows, and how these can end up looking very posterized. Also, have you ever noticed how much easier it is to rescue highlight detail compared with shadow detail when using the Shadows/Highlights adjustment? This is because far fewer levels are available to define the information recorded in the darkest areas of the picture and these levels are easily stretched further apart as you try to lighten the shadows. This is why posterization is always much more noticeable in the shadows (see Figure 3.35). It also explains why it is important to target your digital exposures as carefully as possible so that you capture the brightest exposures possible, but without the risk of blowing out the highlight detail.

Chapter 3 Camera Raw image processing

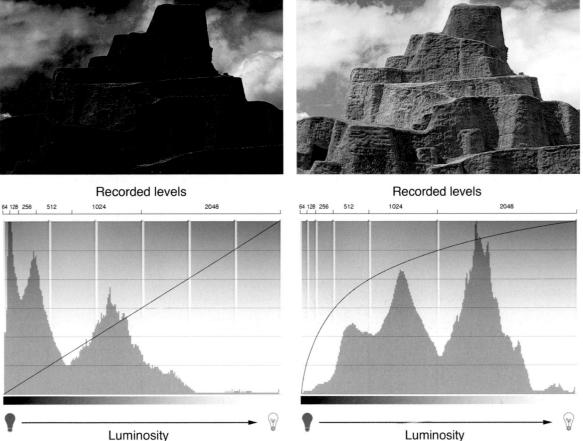

Figure 3.36 If you could inspect a raw capture image in its native, linear gamma state, it would look something like the image shown top left. Notice that the picture is very dark, it is lacking in contrast and the levels (representing the tonal information) in the histogram appear to be mostly bunched up to the left. During the raw conversion process, a gamma curve correction is applied when converting the linear data so that the processed image matches the way we are used to viewing the relative brightness in a scene. The picture top right shows the same image after a basic raw conversion.

As a consequence of this, the more brightly exposed areas will preserve the most tonal information and the shadow areas will end up with fewer levels. A typical CCD sensor can capture up to 4096 levels of tonal information. Half these levels are recorded in the brightest stop exposure range and the recorded levels are effectively halved with every stop decrease in exposure. The digital camera exposure is therefore guite critical. Ideally, you want the exposure to be as bright as possible so that you make full use of the Levels histogram, but at the same time be careful to make sure the highlights don't get clipped.

Camera histograms

As I have mentioned already in this book, the histogram that appears on a compact camera or digital SLR screen is unreliable for anything other than JPEG capture. This is because the histogram you see there is usually based on the camera-processed JPEG and is not representative of the true raw capture. The only way to check the histogram for a raw capture file is to open the image via a raw processing program such as Camera Raw or Lightroom.

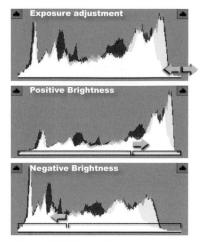

Figure 3.37 The top histogram shows how the Exposure slider adjusts the highlight clipping so that the midtones and shadows adjust smoothly relative to this point. The Brightness slider adjusts the brightness by shifting the levels between the set shadow and highlight points. The middle histogram shows the effect of a positive Brightness adjustment and the bottom histogram shows the effect of a negative Brightness adjustment.

Brightness

There is sometimes some confusion between when to use Brightness and when to use Exposure to adjust an image. To the newcomer they both appear to be doing the same thing, but there is in fact an important difference between the way these two adjustments work.

The Exposure slider is essentially a white clipping point tool that is used to set the highlight clipping point. As you move the slider left or right the image appears to get brighter or darker, but what the Exposure slider adjustment is actually doing is deciding where to set the highlight clipping and smoothly maps all the other tones from the midtones down to the shadows relative to this point.

The Brightness slider is different. It is a midtone correction tool that behaves much like the Gamma (middle input levels) slider in the Photoshop Levels dialog and can also be used to make a photo appear relatively lighter or darker. The difference here is that the Brightness slider adjusts the image tones by compressing one end of the tonal scale as it expands the other. In this respect, the Brightness control should be regarded as a more brutal image adjustment than the Exposure slider, which is why you are always advised to use Exposure first to get the brightness right, use Recovery to compensate for any undesirable clipping and then use the Brightness slider to fine-tune the photo's brightness.

Figure 3.37 illustrates how these adjustments affect the Histogram. In the top histogram view, the Exposure adjustment sets the highlight clipping point and evenly expands or compresses all the tones that are darker than this. The middle histogram shows how if you make a positive, lightening Brightness adjustment, the brighter tone levels are compressed, while the darker tones tone levels are expanded. Conversely, if you apply a negative, darkening Brightness adjustment, the highlight levels are expanded and the shadow tones become more compressed.

Figure 3.38 clearly illustrates the practical consequences of applying an Exposure-led adjustment versus Brightness. In the top image you will notice that where I only used the Brightness slider to lighten the image there is less contrast in the flower petals and therefore less detail. This is because the highlight levels have become compressed and this has resulted in flatter contrast in the midtone/highlight areas. None of this is to suggest that you shouldn't use Brightness. Far from it. Although compressing and expanding the levels is a destructive process, this is just an inevitable part of the digital image editing process. The main point to learn from all this is to use the Exposure slider first to 'expose' the image to obtain the best brightness and use the Brightness slider as a secondary adjustment to 'fine-tune' the brightness.

White Balance: Custom	•
Temperature	5500
Tint	-14
<u>Auto Default</u> Exposure	0.00
Recovery	15
Fill Light	20
Blacks	3
Brightness	+80
Contrast	+25
Clarity	0
Vibrance	0
Saturation	0

Negative Exposure

A negative Exposure adjustment can be used to help recover highlight detail that would otherwise have been clipped. If an image initially appears overexposed, it is best to use the Exposure slider first to find the best exposure, use the Recovery slider to fine-tune detail recovery in the highlights and use the Brightness slider last to fine-tune the image brightness.

White Balance: Custom	D
Temperature	5500
lint 🔿	-14
Contraction of the second s	fault
Exposure	+0.95
Recovery	15
Fill Light	20
Blacks	3
Brightness	+20
Contrast	+25
Clarity	0
Vibrance	0
Saturation	0

Figure 3.38 Superficially these two close-up views look the same. In the top version I used the Brightness slider only to adjust the image brightness. In the lower one I used the Exposure slider first to set the highlight point clipping and brightness and then used the Brightness slider to fine-tune the brightness. You should be able to see more highlight contrast and detail in this version.

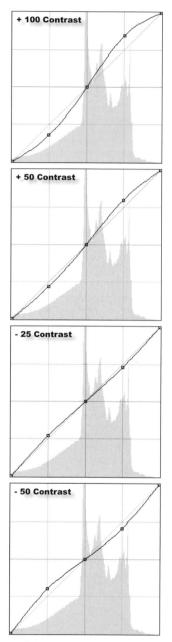

Figure 3.39 The curve shapes shown here approximate the curve shape that is applied by Camera Raw when you adjust the Contrast slider in the Basic panel.

Contrast

The Contrast slider applies a non-linear contrast type adjustment. In Photoshop terms it is equivalent to applying an 'S' shape curve to the image. But unlike the Contrast slider in the legacy version of Photoshop's Brightness/Contrast image adjustment, the Camera Raw Contrast slider never forces the levels to clip at either end of the tonal scale and is completely safe to use. A positive contrast adjustment creates a steeper 'S' shape type curve which therefore increases the image contrast, while a negative Contrast adjustment flattens the curve to create an inverse 'S' shaped curve that flattens the contrast. Figure 3.39 shows a simulation of how the Contrast adjustment to a Photoshop image. Note that the curve shape is also affected by the Brightness amount and the curves shown here represent the contrast curve shape for when Brightness is at its default (+50) setting.

One of the things that tends to confuse some people is the fact that there is a Contrast adjustment in the Basic panel as well as a separate Tone Curve panel for adjusting the contrast, and that these appear to perform the same function. But think of it this way: it is already quite common for people to apply a Contrast adjustment when they initially edit an image and then add a second Contrast adjustment later to fine-tune the first adjustment. There are basically three ways you can edit the contrast in Camera Raw and all of them are equally valid. You might decide the Basic panel Contrast slider is all that you need: just make a simple slider move and you are done. Or, you might choose not to use the Contrast slider at all and use just the Tone Curve to adjust the contrast. Alternatively, you might use the Contrast slider when applying an initial set of Basic panel adjustments, to get the contrast looking close to what looks right, and then use the Tone Curve panel to tweak the contrast further because you like the fine-tune control you get with the Tone Curve sliders. The important thing to understand here is that when you work with Camera Raw, it does not matter that you are applying a Tone Curve Contrast adjustment on top of a Basic panel Contrast slider adjustment. When the image is finally output as a JPEG, TIFF or PSD, all the adjustments you add to the image are eventually applied as a single adjustment.

Clarity

The Clarity slider is the first of three 'Presence' controls in Camera Raw. Adding Clarity to a photo can be thought of as adding sharpness, but it is more accurate to say that Clarity is 'adding localized, midtone contrast'. In other words, the Clarity slider can be used to build up the contrast in the midtone areas by effectively applying a soft, wide radius Unsharp Mask type filter. Consequently, when you add a positive Clarity adjustment, you will notice increased tonal separation in the midtone areas. By applying a small positive Clarity adjustment you can therefore increase the local contrast across narrow areas of detail, and a bigger positive Clarity adjustment increases the localized contrast over broader regions of the photo.

How much Clarity should you add?

All photos can benefit from adding a small amount of Clarity. I would say, a +10 value works well for most pictures. However, you can safely add a maximum Clarity adjustment if you think a picture needs it (such as in the Figure 3.40 example shown below).

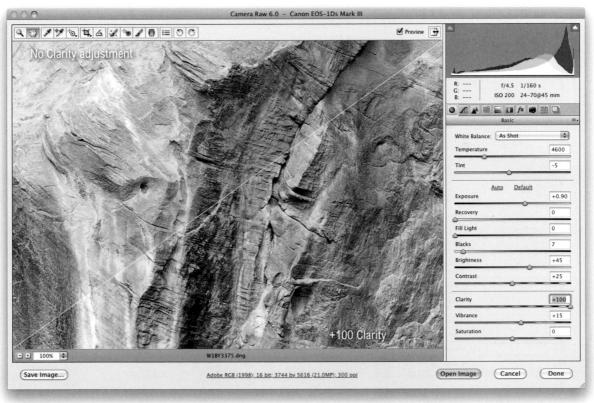

Figure 3.40 This screen shot shows an example of Clarity in action. The left half of the Camera Raw preview shows how the photo looked before Clarity was added and the right half of the preview shows Clarity being applied using a maximum +100 value.

Negative Clarity

Just as you can use a positive Clarity adjustment to boost the midtone contrast, you can also apply a negative Clarity adjustment to soften the midtones. There are two uses that come to mind here. Clicio Barroso and Ettore Causa (who helped beta test the Lightroom program) suggested that a negative Clarity adjustment could be useful for softening the skin tones in portrait and beauty shots (as shown in Figure 3.41). This works great if you use the adjustment brush tool (discussed on pages 227–235) to apply a negative Clarity in combination with a sharpening adjustment. The other idea I had was to use negative Clarity to simulate a diffusion printing technique that used to be popular with a lot of traditional darkroom printers. In Figure 3.42 you can see examples of a before and after image where I used a maximum negative Clarity to soften the midtone contrast to produce a kind of soft focus look. You will also find that this technique works particularly well with photos that have been converted to black and white.

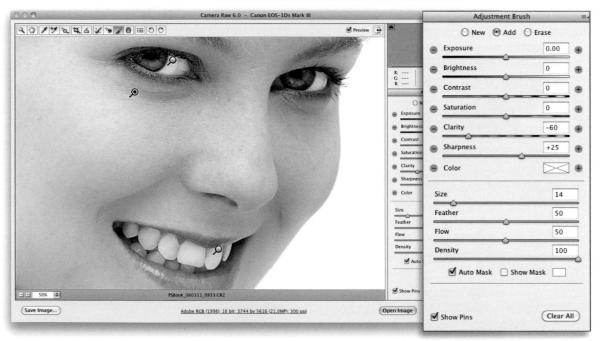

Figure 3.41 This shows the results of an adjustment brush applied using the combination of a -50 Clarity effect with a +25 Sharpness effect to produce the skin softening look achieved here. I applied this effect a little stronger than I would do normally in order to really emphasize the skin softening effect.

Model: Courtney @ Storm

Chapter 3 Camera Raw image processing

000	Camera Raw 6.0 - Canon EOS 4000	D Digital		
		Preview R	¹⁰⁻ Tint	* 3200 +3 +0.27 0 26 8 +59 +40 (d +50 0
25%	_MG_7135.dng			
(Save Image)	Adobe RCB (1998); 16 bit; 2592 by 3888 (10.1MP);	240 ppi Open Image Cance		
000	Camera Raw 6.0 - Canon EOS 4001	D Digital		
		Preview	Basic White Balance: Custom Temperature Tint Tint	

Figure 3.42 This shows a before version (top) and an after version (below), where I applied a -100 Clarity adjustment.

Negative Vibrance and Saturation

Not all of us want to turn our photographs into super-colored versions of reality. So it is worth remembering that you can use the Vibrance and Saturation sliders to apply negative adjustments too. If you take the Saturation down to -100, this converts an image to monochrome, but lesser negative Saturation and Vibrance adjustments can be used to produce interesting pastelcolored effects.

Vibrance and Saturation

The Saturation slider can be used to boost color saturation, but extreme saturation adjustments will soon cause the brighter colors to clip. However, the Vibrance slider can be used to apply what is described as a non-linear color saturation adjustment, which means colors that are already brightly saturated in color remain relatively protected as you boost the vibrance, whereas the colors that are not so saturated receive a greater saturation boost. The net result is a saturation control that allows you to make an image look more colorful, but without the attendant risk of clipping those colors that are saturated enough already. Try opening a photograph of some brightly colored flowers and compare the difference between a Vibrance and a Saturation adjustment to see what I mean. The other thing that is rather neat about the Vibrance control is that it has a built-in skin tone protection filter which does rather a good job of not letting the skin tones increase in saturation as you move the slider to the right. In Figure 3.43, I boosted the Vibrance to +60, which boosted the colors in the dress, but without giving the model too 'vibrant' a suntan.

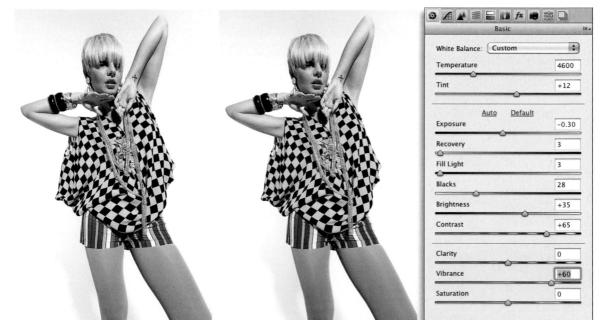

Client: Clipso. Model: Lucy Edwards @ Bookings

Figure 3.43 Boosting the colors using the Vibrance control in the Basic panel.

Camera Raw image processing

Chapter 3

1 In this example you can see what happens if you choose to boost the saturation in a photo using the Saturation slider only to enrich the blue colors. If you look at the histogram

2 Compare what happens when you use the Vibrance slider instead. In this example you will notice how none of the Blue channel colors are clipped. This is because the Vibrance slider boosts the saturation of the least saturated colors most, tapering off to a no saturation boost for the already saturated colors. Hence, there is no clipping in the histogram.

you will notice how the Blue channel is clipped. This is what we should expect, because the Saturation slider in Camera Raw applies a linear adjustment that pushes the already saturated blues off the histogram scale.

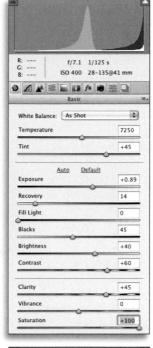

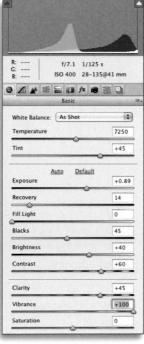

Figure 3.44 The Tone Curve panel, shown here in Point Curve editor mode with the default Medium Contrast tone curve setting.

Tone Curve panel

The Tone Curve panel offers a fine-tuning contrast control that can be applied in addition to the Tone and Contrast adjustments made in the Basic panel. There are two modes for the Tone Curve panel. In the Point Curve editor mode you can manipulate the shape of the tone curve as you would with the Curves adjustment in Photoshop. The default setting used here applies a Medium Contrast curve, which kind of matches the default contrast used by most cameras when producing a JPEG image and probably produces the 'snappiest' looking results. However, it is just a default and you can turn it off by simply setting the curve to 'Linear'. The Parametric Curve editor mode provides a new mechanism for editing the tone curve shape where, instead of clicking to add points and dragging them, you use the slider controls to control the curve shape. This is essentially a more intuitive method to work with, plus you can also use the target adjustment tool in conjunction with the Parametric Curve editor to adjust the tones in an image. Here is an example of how to edit the Tone Curve in Parametric editor mode.

Camera Raw 6.0 - C		Basic	
JINGKANGEOC	Ter	te Balance: As Shot	5300
		Auto Defaul	+2
	Temperature	overy	33
A State State	Exposure	Light	0
and the second second		htness	26
		ntrast	¢ +28
	Contrast Carity Cla	rity	+31
	Vibrance Vib Saturation	rance	+21
2 11.7% 1 CA2006-0216.dng	Sat	uration	0
Save Image) Adobe RGB (1995): 16 bit: 4992 bi	3328/16.6MPI: 240.001 Open Image Ca		

1 In this first example, the image tones were adjusted using the Basic panel controls to produce an optimized range of tones that were ready to be enhanced further. I could have used the Brightness and Contrast sliders next, but the Tone Curve panel provides a simple yet effective interface for manipulating the Contrast and Brightness.

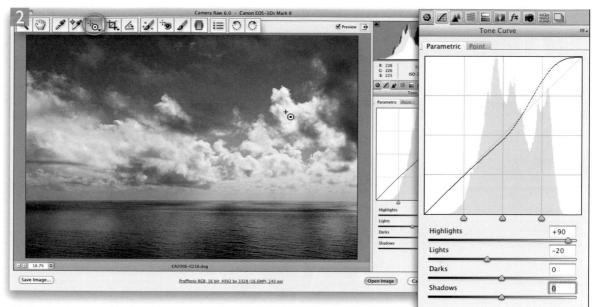

2 In the Tone Curve panel I selected the Parametric Curve option. By dragging the Highlights slider to the right and the Lights slider to the left, I was able to increase the contrast in the sky. One can also apply these adjustments by selecting the target adjustment tool (circled) and clicking and dragging up or down on target areas of the image.

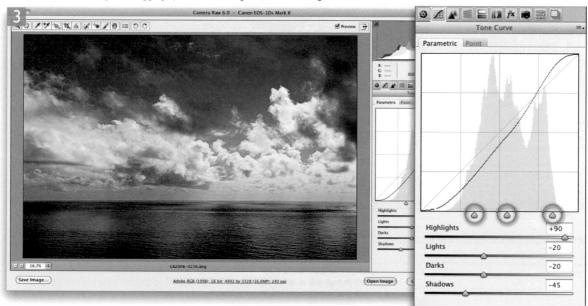

3 I then adjusted the Darks and Shadows sliders to add more contrast in the dark regions of the photograph. In addition to this, I fine-tuned the scope of adjustment for the Tone Curve sliders by adjusting the positions of the three tone range split points (circled).

	Camera Raw 6.0 - Canon EOS-1Ds Mark III			
0/1/10 # 6 % % / 0 = 00	0	Preview	Basic	ii .
1973 B.B.	1		White Balance: Custom	•
		R: f/6.3 1/640 s	Temperature	4901
ACCESS		50 800 12-24@18	Tint	+1
- ANTANA		Basic White Balance: Custom	Auto Default	
		Temperature	4 Exposure	0.00
		Tint	Recovery	0
		Auto Default Exposure	6 Fill Light	0
		Recovery Fill Light	Blacks	5
		Blacks Brightness	s Brightness	+50
		Contrast	+ Contrast	+25
State of the state		Clarity		
	the second states and second	Vibrance	Clarity	+50
		Saturation	Vibrance	+48
- + 16.6x -	W19Y1894.dng		Saturation	0
(Save Image)	Adobe RC8 (1998): 16 bit: 5616 by 3744 (21.0MP): 300 pp	Open Image Cancel	Do	

Correcting a high contrast image

1 This photograph has a wide subject brightness range, and is shown here opened in Camera Raw using the default settings.

2	Camera Raw 6.0 - Canon EOS-1Ds Mark III		◎ A ▲ 🗏 🔚 📖 f× 👼	
2014441 * 10 = 0 C		Preview 🔁 📥	Basic	ie ,
ALL ALL	and the second	and have	White Balance: Custom	•
in the		R: f/6.3 1/640 s G: ISO 800 12-24@18 m	Temperature	4500
		B: 150 800 12-24@18 mil	Tint	-6
		White Balance: Custom Temperature 4 Tint	<u>Auto</u> <u>Default</u> Exposure	-0.95
		Auto Default	Recovery	60
		Exposure Recovery 5	Fill Light	Ō
		Fill Light 0 Blacks 6	Blacks	5
e de la companya de El companya de la comp		Brightness +	Brightness	+50
		Contrast +	Contrast	+25
		Clarity + Vibrance + Saturation 0	Clarity	0
	WIBY1894.dng		Vibrance	0
Save Image	Adobe RGE (1998): 16 bit: 3616 by 3744 (21.0MP): 300 ppi	Open Image Cancel Do	Saturation	0

2 The first step was to take care of the highlights. I adjusted the Exposure slider to apply a negative Exposure adjustment, followed by a Recovery adjustment to hold more of the detail in the highlights.

3	Camera Raw 6.0 - Canon EOS-1Ds Mark III		9 🖉 💒 🗮 🔚 👯 f× 🛤	
0/% % % & / 0 = 00		Preview	Basic	
and the second	Report of the State	and the second	White Balance: Custom	•
	and a page of the	R f/6.3 1/64 C ISO 800 12-2		4500
				-6
		White Balance: Custom Temperature	<u>Auto Default</u> Exposure	-0.95
		Auto Default	-	60
		Exposure Recovery	Fill Light	50
		Fill Light Blacks	Blacks	20
		Brightness	Brightness	+39
		Clarity	Contrast	+45
	Contraction of the second	Vibrance Saturation	Clarity	+15
16.6N 0	W18Y1894.dog		Vibrance	0
ve Image)	Adobe RCB (1998): 16 bit: 5616 by 3744 (21.0MP): 300 pp	Open Image Cancel	Saturation	0

3 I then tackled the Shadow detail by raising the Fill Light setting. When you are required to push the Fill Light adjustment to such extremes, it is not uncommon to have to raise the Blacks (as I did here). The picture was not yet perfect, but we can now see detail at both ends of the tonal scale.

4	Camera Raw 6.0 - Canon EOS-1Ds Mark III			
× 7 / 7 % ¤ △ / * / 0 ≔	00	Preview	Tone Curve	
		Image: Constraint of the second sec	4	
		Highlights		
	and the second second	Lights	Highlights	-48
	and the the second	Darks	Lights	-26
		Shadows	Darks	+33
• 1 16.6% ·	W18Y1894.dng		Shadows	-44
(Save Image)	Adobe RG8 (1998): 15 bit: 5616 by 3744 (21.0MP): 300 ppj	Open Image Cancel		

4 Lastly, I went to the Tone Curve panel and used the slider settings shown here to carefully add contrast to the photograph where it was needed most.

Camera Raw Detail panel

In case you are wondering, the next chapter contains a major section on working with the Detail panel.

HSL color controls

The choice of color ranges for the HSL sliders is really quite logical when you think about it. We may often want to adjust skin tone colors, but skin tones aren't red or yellow, but are more of an orange color. And the sea is often not blue but more of an aqua color. Basically, the hue ranges in the HSL controls are designed to provide a more applicable range of colors for photographers to work with.

HSL/Grayscale panel

The HSL controls provide eight color sliders with which to control the Hue, Saturation and Luminance. These work in a similar way to the Hue/Saturation adjustment in Photoshop, but are in many ways better; based on my own experience I find these controls are more predictable in their response. In Figure 3.45 I used the Luminance controls to darken the blue sky and add more contrast in the clouds, plus I lightened the grass and trees slightly. Try doing this using Hue/Saturation in Photoshop and you will find that the blue colors tend to lose saturation as you darken the luminosity. You will also notice that instead of using the traditional additive and subtractive primary colors of red, green, blue, plus cyan, magenta and yellow, the color slider controls in the HSL panel are based on colors that are of more actual relevance when editing photographic images. For example, the Oranges slider is useful for adjusting skin tones and Aquas allows you to target the color of the sea, but without affecting the color of a sky.

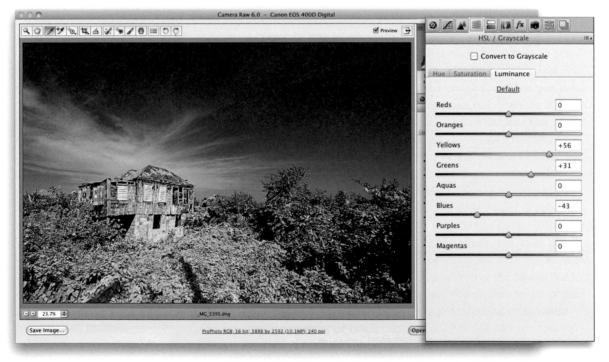

Figure 3.45 In this example, the Luminance sliders in the HSL/Grayscale panel were used to darken the sky and also lighten the colors of the leaves.

Recovering out-of-gamut colors

Figure 3.46 highlights the problem of how the camera you are shooting with is almost certainly capable of capturing a greater range of colors than can be displayed on the monitor or seen in print. Just because you can't see them doesn't mean they're not there! Although a typical monitor can't give a true indication of how colors will print, it is all you have to rely on when assessing the colors in a photo. The HSL Luminance and Saturation sliders can therefore be used to reveal hidden color detail (see Figure 3.47).

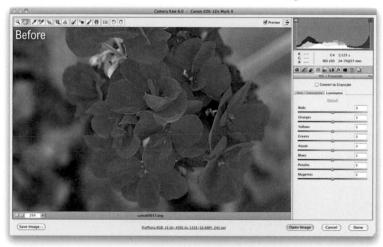

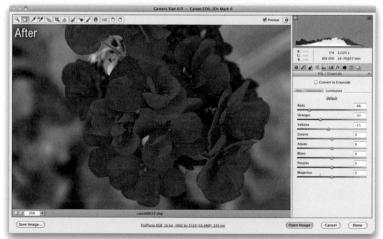

Figure 3.46 This diagram shows a plot of the color gamut of an LCD monitor (the solid shape in the center) compared with the actual color gamut of a digital camera. Assuming you are using a wide gamut RGB space such as Adobe RGB or, better still, ProPhoto RGB, the colors you are able to edit will almost certainly extend beyond what can be seen on the display.

Tech note

The previews shown here are not simple screen grabs, but were mocked up using fully processed ProPhoto RGB images. You can judge the effectiveness of this adjustment by how well the lower one prints.

Convert t	nance
Defa Reds	<u>-66</u>
Oranges	-33
Yellows	-11
Greens	0
Aquas	0
Blues	0
Purples	0
Magentas	0

Grayscale conversions

To find out about how to apply grayscale conversions in Camera Raw, please refer to pages 386–389 in the Black and White chapter.

Emulating Hue/Saturation behavior

In Photoshop's Hue/Saturation dialog, there is a Hue slider that can be used to apply global hue shifts. This can be useful if you are interested in shifting all of the hue values in one go. With Camera Raw you can create preset HSL settings where all the Hue sliders are shifted equally in each direction. Using such presets you can quickly shift all the hues in positive or negative steps, without having to drag each slider in turn.

Adjusting the Hue and Saturation

The Hue sliders in the HSL/Grayscale panel can be used to finetune the hue color bias using each of the eight color sliders. In the Figure 3.48 example, I adjusted the Reds hue slider to make the reds look less magenta and more orange. In other words, this is a useful HSL/Grayscale panel tip for improving the look of snapshot pictures taken with a compact digital camera, where the skin tones can often look too red.

The Saturation sliders allow you to decrease or increase the saturation of specific colors. In the Figure 3.49 example you can see how I was able to use these to knock back specific colors so that everything in the photograph ended up looking monochrome, except for the red guitar in the foreground. Of course, I could have used the adjustment brush to do this, but adjusting the Saturation sliders offers a really quick method for selectively editing the colors in this way. As with the Tone Curve, you can also use the target adjustment tool to pin-point the colors and tones you wish to adjust.

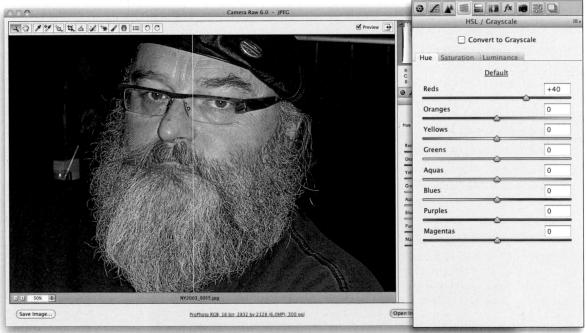

Figure 3.48 This snap shot was taken of my friend Jeff Schewe at a party in New York. Here, I used a positive Reds Hue adjustment to take some of the redness out of the picture to make the skin tones look more natural, but I may have needed to increase the amount used here as we consumed more glasses of wine.

◎ ∡ ▲ ≝ 믈 📖 ᅒ 🗰 🗒 🗋

Hue Saturation Luminance

HSL / Grayscale

Convert to Grayscale

Default

Chapter 3

;≡.

		HSL Conv	Reds	0
		Hue Saturation at	Oranges	0
		Reds	Yellows	0
.1		Oranges		
1		Yellows Greens	Greens	0
		Aquas	Aquas	0
-		Blues	Blues	0
(Purples	ò	
	TAD'	Magentas	Purples	0
			Magentas	0
17.2%	_MG_9992.CR2			
(Save Image)	ProPhoto RG8: 16 bit: 2410 by 3616.(8.7MP): 240 pp)	Open Image		
	Camera Raw 6.0 - Canon EOS 400D Digital		9 A ¥ = = 11	f× 📸 🚆 🖵
10 1 20 4		Preview	HSL / Gray	
+		Statistics Internet	Convert to	Grayscale
+(•	me		
and the second		R:	Hue Saturation Lumin	ance
	30.8	R: G: B: ISO	Hue Saturation Lumin	
	E CE	R: G: ISG I III III IIII IIII IIII IIII IIII	Defai	<u></u>
		C ISC B: ISC B: ISC HISL / Conv		
		C: ISO	Defai	<u></u>
		C 532 B 552 M 552 M	Defat Reds	0
		C 532 B 552 M	Defas Reds Oranges Yellows	0 0 -100
		C 532 B 552 M 552 M	Defai Reds Oranges Yellows	
		C 532 B 552 M	Defau Reds Oranges Yellows Greens Aquas	0 0 -100
		C GC	Defau Reds Oranges Yellows Greens	0 0 -100 0
		C GC P GC C GC Main Main Main Reds Granges Vallows Creens Acuas Purples Purples	Pefav Reds Oranges Yellows Greens Aquas Blues Oranges	Ut 0 0 -100 0 -100 -100 -100 -100
		C 55 E 55 M 55 M 55 M	Defai Reds Oranges Yellows Greens Aquas Blues	ut 0 0 -100 0 -100
		C GC P GC C GC Main Main Main Reds Granges Vallows Creens Acuas Purples Purples	Defau Reds Oranges Yellows Greens Aquas Blues Purples	Ut 0 0 -100 0 -100 -100 -100 -100
		C GC P GC C GC Main Main Main Reds Granges Vallows Creens Acuas Purples Purples	Defau Reds Oranges Yellows Greens Aquas Blues Purples	Ut 0 0 -100 -100 -100 -100 -100 -100 -100
- 1724 -	First Partial	C GC P GC C GC Main Main Main Reds Granges Vallows Creens Acuas Purples Purples	Defau Reds Oranges Yellows Greens Aquas Blues Purples	0 0 -100 0 -100 -100 -100

Camera Raw 6.0 - Canon EOS 400D Digital

Eq.E

Preview

0 🖌 🖌 🗐

Q 7 1 % 2 4 4 1 % 1 0 = 00

Figure 3.49 In this example, I have shown the before version (top) and a modified version (below), where I used the HSL/Grayscale panel Saturation sliders to selectively desaturate some of the colors in this scene. This can be done manually, or by using the target adjustment tool (circled) to target specific colors and drag downwards to desaturate.

Lens Correction filter

The Chromatic Aberration controls discussed here are also available in the Photoshop Lens Correction filter, where there is also now a third, Magenta/Green slider.

Lens Corrections panel

The Lens Corrections controls can help correct some of the optical problems that are associated with digital capture. If you inspect an image closely towards the edge of the frame area, you may notice some color fringing, which will be most apparent around areas of high contrast. This is mainly a problem you get with cheaper lens optics, but it can even occur with a good lens when photographing brightly colored subjects. The Chromatic Aberration controls in

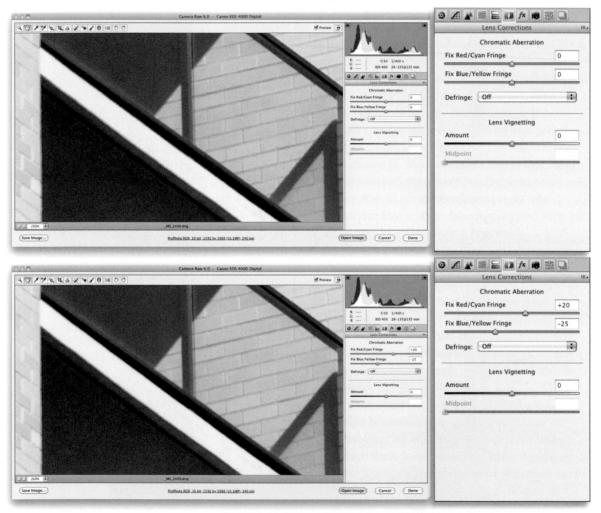

Figure 3.50 The top screen shot shows a 200% close-up view of an image where you can see strong color fringing around the strong contrast edges. In the lower version I used a Chromatic Aberration correction to remove the color fringes.

the Lens Corrections panel can be used to help remove any visible color fringing (Figure 3.50).

To correct for chromatic aberrations you do need to be viewing the photo at a magnification of 100% or higher. The Red/Cyan Fringe adjustment works by adjusting the scale size of the Red channel relative to the Green channel, and the Blue/Yellow Fringe slider adjusts the scale size of the Blue channel relative to the Green channel. The net result is that with careful manipulation of both these sliders you should be able to remove all signs of chromatic aberration across the whole image, even though you are only analyzing one small section of the photo.

Defringe

The Defringe options provide an extra level of defringing in addition to the manual slider adjustments. To be honest, the Highlight Edges and All Edges settings usually have a very subtle effect, but if you are going to use this, I would suggest choosing the All Edges option (Figure 3.52), as it can also sometimes help clean up any remaining color fringes.

Figure 3.51 If you hold down the Sale (1) key as you make adjustments to the Blue/ Yellow Chromatic Aberration controls you can hide the Red/Cyan color fringing (but you must be viewing at 100% magnification or higher). You can do the same with the Red/ Cyan Chromatic Aberration controls to hide the Blue/Yellow color fringing.

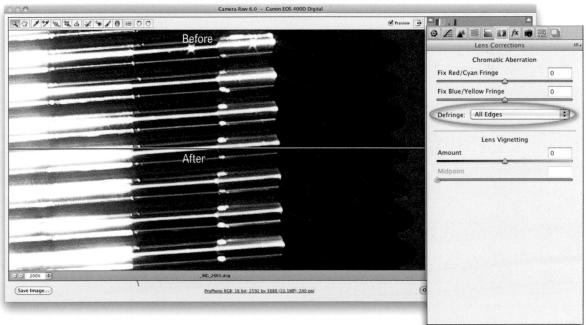

Figure 3.52 The top half of this Camera Raw preview shows the 'before' version and the bottom half view shows the preview with the 'All Edges Defringe' option selected. I have to say that with the new Camera Raw 6.0 demosaicing, the difference is very slight now.

UV filters and edge detail

Fixing a UV filter over the lens is generally considered a good way to filter out the UV light when photographing outdoors, plus it can also offer a first line of defence against the lens getting damaged. However, this is not such a good idea for wide-angle or wide-angle zoom lenses since the light entering the lens from the extreme edges is forced to go through the UV filter at an angle and this can cause the image to degrade more at the edges of the frame since the light passes through the filter glass at an oblique angle.

Lens Vignetting control

With certain camera/lens combinations you may see some brightness fall-off occur towards the edges of the picture frame. This is a problem you are more likely to encounter with wide angle lenses and you may only notice this particular lens deficiency if the subject contains a plain, evenly-lit background. The Lens Vignetting Amount slider can be used to correct for this by lightening the corners relative to the center of the photograph, while the Midpoint slider can be used to offset the rate of fall-off. As you increase the Midpoint value, the exposure compensation is accentuated more towards the outer edges.

Vignetting is not always a result of the lens used. In the studio I am fond of shooting with extreme wide-angle lenses and the problem here is that it's often difficult to get the backdrop evenly lit at all four corners. In these kinds of situations I find it sometimes helps to use the Lens Vignetting slider to compensate for the fall-off in light towards the corners of the frame by lightening the edges (as shown in Figure 3.53 below).

Client: Clipso. Model: Lucy Edwards @ Bookings. Figure 3.53 This is an example of the Lens Vignetting sliders being used to compensate for light fall off on a studio backdrop, to produce a more even-balanced white.

1 Here is an example of a photograph shot with a wide-angle lens, where lens vignetting can be seen in the corners of the frame.

2 In this example, I used the Lens Corrections panel to compensate for the vignetting. I set the Amount slider to +28, and adjusted the Midpoint to fine-tune the correction. The aim here was to obtain an even exposure at the corners of the photograph.

Combined effects

Now that we have Post Crop Vignetting controls as well as the standard Lens correction vignette sliders, you can achieve even more varied results by combining different combinations of slider settings, whether a photo is cropped or not.

Effects panel Post Crop Vignetting control

A lot of photographers have got into using the Lens Vignetting controls as a creative tool for darkening or lightening the corners of their pictures. The only problem here is that the lens vignetting can only be applied to the whole of the image frame area. However, you can also use the Post Crop Vignetting sliders to apply a vignette relative to the cropped image area. This means you can use the Lens Vignetting controls for the purpose they were intended (to counter any fall-off that occurs towards the edges of the frame) and use the Post Crop Vignetting sliders in the Effects panel as a creative tool for those times when you deliberately wish to lighten or darken the edges of a photo via Camera Raw. The Post Crop Vignetting Amount and Midpoint sliders work identically to the Lens Vignetting controls, except in addition to this, you can adjust the Roundness and the Feathering of the Vignette adjustment.

Client: Andrew Collinge Hair & Beauty. Hair by Andrew Collinge artistic team, Make-up: Liz Collinge. **1** In this first example I applied a -70, darkening vignette offset with a +45 Midpoint setting. This adjustment was not too different from a normal Lens Vignetting adjustment, except it was applied to the cropped area of an image.

2	Camera Raw 6.0 - Canon EOS-1Ds Mark III			0 2 0
277244		Preview	Effects	ii a
		Registerst	Size	0 ing
		Post Crop V Style: Paint Overlay Amount Midpoint Boundness	Style: Paint Overlay Amount Midpoint	-100
		Feather Highlights	Roundness	+100
			Feather	30
			Highlights	
■ • 24.1% •	ACollinge_080616_2095.dng		-	
(Save Image)	ProPhoto RGB: 16 bit: 2048 by 2582 (5.3MP): 300 ani	(Open Image) (Cano		

2 In this next version, I adjusted the Roundness slider to make the vignette shape less elliptical and adjusted the Feather slider to make the vignette edge harder.

30	Camera Raw 6.0 - Canon EOS-1Ds N	Aark III	◎ Æ ▲ ■ 🖴 📖 f×	
27724610		Preview	Effects	
		R	Size	0
	K	Size Roughness Past Crop Seyle: [Paint Overlay Amount Midpoint	Amount	+70
		Roundress Feather Highlights	Midpoint Roundness Feather	0
	ACollings_080616_2095.dng ProfProto RCIR_16_bit: 2043 by 258215.1MPr. 800.	REI (Open Image) (Car	Highlights	<u> </u>

 ${\bf 3}$ For this final version, I applied a +70 vignette Amount to lighten the corners of the cropped image, combined with a low Midpoint and a soft Feather setting.

Post Crop Vignetting style options

So far I have just shown you the options for the 'Paint Overlay' vignette style option. It wasn't named as such before, since this was the only Post Crop Vignette mode available in the previous Vignettes panel. When first introduced, some people were quick to point out that the Post Crop Vignetting wasn't exactly the same

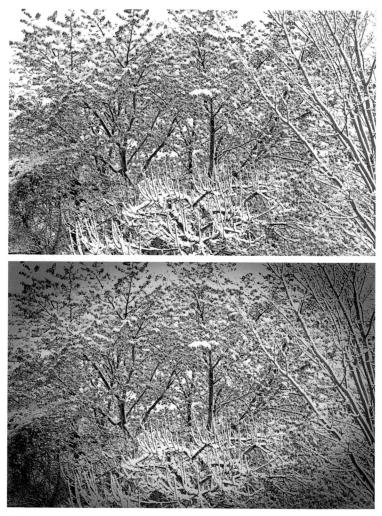

Figure 3.54 In this example I took a photograph of some snow-covered tree branches. Shown here is the before version (top) and one where I had applied a standard Paint Overlay style Post Crop Vignette using the settings shown here.

Grai	n
Amount	0
Size	
Roughness	
Post Crop V	ignetting
Style: Paint Overlay	
Amount	-50
Midpoint	50
Roundness	0
Feather	50
~	

as the Lens Correction vignette effect. You can see for yourself in the Figure 3.54 example how the Paint Overlay vignette applies a soft contrast, hazy kind of effect. This wasn't to everyone's taste (although I didn't particularly mind it) and so Camera Raw 6.0 now offers you two alternative post crop editing modes which more closely match the normal Lens Correction edit mode, yet offer extra scope for adjustment. Where people were once inclined to use the Lens Correction sliders as a creative tool (because the Paint Overlay post crop effect was a bit wishy-washy), they should now think of the Lens Correction sliders as being for lens corrections only and use the Post Crop Vignetting sliders to add different kinds of vignette effects. So let's now look at the new post crop options.

In the Paint Overlay mode example (Figure 3.54), the post crop effect blends either a black or white color into the edges of the frame depending on which direction you drag the Amount slider. The two new 'Priority' modes produce an effect that is now more similar to the Lens Correction effect since the darkening or lightening is created by varying the exposure at the edges. Of the two, the Color Priority (Figure 3.55) is usually the more gentler as this applies the Post Crop Vignette *after* the Basic panel Exposure adjustments, but *before* the Tone Curve stage. This minimizes color shifts in the darkened areas, but it can't perform any highlight recovery when you darken the edges.

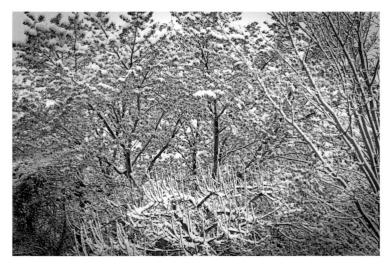

Figure 3.55 This shows an example of a darkening Post Crop Vignette adjustment in which the Color Priority style was used.

6 -1-			
Grain			
Amount	0		
Size			
Roughness			
Post Crop Vig	netting		
Style: Color Priority			
Amount	-50		
Midpoint	50		
Roundness	0		
Feather	50		
0	0		

The Highlight Priority style (see Figure 3.56) tends to produce more dramatic results. This is because it applies the Post Crop Vignette *prior* to the Exposure adjustment. It has the benefit of allowing better highlight recovery, but this can lead to color shifts in the darkened areas.

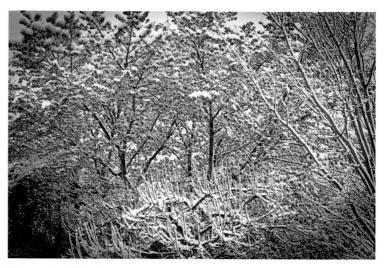

Figure 3.56 This shows an example of a darkening Post Crop Vignette adjustment in which the Highlight Priority style was used.

Highlights slider

You will notice there is also a new Highlights slider which can further modify the effect. In Paint Overlay mode, the Highlights slider has no effect on the image. In the two new priority modes the Highlights slider is only active when applying a negative Amount setting and as soon as you increase the Amount to apply a lightening vignette, the Highlights slider is disabled. As you can see in the Figure 3.57 and 3.58 examples, increasing the Highlights amount allows you to boost the highlight contrast in the vignetted areas, but the effect is only really noticeable in subjects that feature bright highlights. Here it had the effect of lightening the snow-covered branches in the corners of the image, taking them more back to their original exposure value. In these examples the difference is quite subtle, but I find that the Highlights slider usually has the greatest impact when editing a Color Priority Post Crop Vignette.

Figure 3.57 In this example I applied a Highlight Priority Post Crop Vignette style and added a 40% Highlights adjustment to the Highlight Priority vignette. In this instance, the Highlights slider adjustment applied a fairly subtle change to the appearance of this Post Crop Vignette effect.

Figure 3.58 In this example I applied a Color Priority Post Crop Vignette style and added a 40% Highlights adjustment to the Color Priority vignette. If you compare this with the above example in Figure 3.57, you can see how a Highlights slider adjustment can have a more substantial effect on the Post Crop Vignette adjustment in Color Priority mode.

Effects	
Grain	
Amount	0
size	
Roughness	
Post Crop Vignettin	ng
Style: Highlight Priority	•
Amount	-50
Midpoint	50
	0
Roundness	1
toundness	50

Grain	1
Amount	0
šize	
, Roughness)	
Post Crop Vi	gnetting
Style: Color Priority	•
Amount	-50
Midpoint	50
Roundness	0
Feather	50

Figure 3.59 The Effects panel showing the Grain sliders.

Adding Grain effects

Also new to the Effects panel are the Grain sliders (Figure 3.59). The Amount slider determines how much grain is added, while the Size slider controls the size of the grain particles. The default setting is 25 and dragging to the left or right allows you to decrease or increase the grain particle size. Note here that if the Size slider is set any higher than 25, then a small amount of blur is applied to the underlying image. This is done so that the image can blend better with the grain effect. The exact amount of blur is also linked to the Amount setting; the higher the Amount, the more blur that's applied. The Roughness slider controls the regularity of the grain. The Default value is 50. Dragging to the left makes the grain pattern more uniform, while dragging to the right can make the grain appear more irregular. Basically, the Size and Roughness sliders are intended to be used in conjunction with the Amount slider to determine the overall grain effect. In Figure 3.60 you can see a before and after example of a grain effect being applied to a photo in Camera Raw.

The most obvious reason for including these new sliders is so that you can deliberately add a grain effect to give your photos a film-like look. However, if this is your aim you will probably need to apply quite a strong setting in order for the grain effect to appear noticeable in print. Even then, this will only work effectively if you are producing a large-sized print output. The thing is, if you apply a grain effect while looking at the image at a 1:1 view and then make, say, a 10×8 print, the grain effect will mostly be lost due to the downsizing of the image data. Where images are going to be downsized even further to appear on the Web, a grain effect is unlikely to be noticed at all.

It is also possible to use the Grain sliders to add subtle amounts of noise which can be used to disguise ugly image artifacts that can't otherwise be eradicated from the image. Having said this, it is possible to end up needlessly fretting about what you can see on screen at a 1:1 or a 200% view, when the detail you are analyzing will be diffused by the print process. Therefore tiny artifacts you see at a 100% view or higher shouldn't really be worth getting all that concerned about. A low Amount setting will allow you to add a fine amount of noise to a photo and this might well look even more pleasing as you add extra micro detail to a photo. In all honesty though, adding some extra fine grain is still only 'creating the illusion' of an improved image. What you see close-up on the screen won't have much actual bearing on the detailedness of the final print. This is really something that should mainly be reserved for problem photos that can't be fixed with the new noise reduction sliders in the Detail panel (see pages 274–277). In other words, where you have an image that contains really noticeable artifacts, you can try using the Grain sliders to cover these up, but I wouldn't recommend over doing this too much. As you might have gathered, I'm not that enamoured about this new feature. One of the main reasons I prefer shooting with digital cameras is because of the lack of grain you get in the captures.

The micro detail effect

It has been suggested that some raw converter programs have already been adding small amounts of grain by default in order to add micro detail to the image processing, which as I say in the main text, is only creating the illusion of better image quality. Camera Raw doesn't do this by default, but allows you the option to experiment.

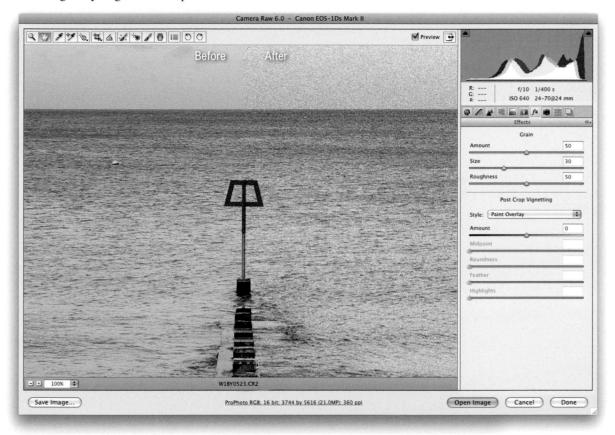

Figure 3.60 This shows a before and after example of a grain effect applied to a photo.

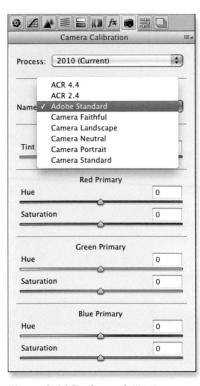

Figure 3.61 The Camera Calibration panel controls can be used to set the desired Process Version and fine-tune the Camera Raw color interpretation. The Camera Profile setting at the top can offer a choice of camera profile settings. These include legacy settings such as ACR 4.3, etc. The recommended default setting to use now is 'Adobe Standard'.

ACR compatible cameras

The list of cameras that are compatible with the latest version of Camera Raw can be found at the Adobe website by following this link: www.adobe.com/products/ photoshop/cameraraw.html.

Camera Calibration panel

The Camera Calibration panel (Figure 3.61) lets you do two things. It allows you to choose which Process Version to use when rendering a raw file and also lets you select an appropriate camera profile. As I explained earlier, if you click on the warning triangle that appears in the bottom right corner of the preview section you can update an image from using Process Version 2003 to using the latest Process Version 2010. You can therefore use the Camera Calibration panel to update the render version used or reverse this process and select the older Process Version 2003 should you need to.

Everyone wants or expects their camera to be capable of capturing perfect colors whether they really need to or not. What is perfect color though? Some photographers may look at a JPEG version of an image and judge everything according to that, while others, who shoot raw, may prefer the default look they get from a particular raw processing program. Apart from anything else, is the display you are using capable of showing all the colors that your camera can capture?

Camera Raw is the product of much camera testing and raw file analysis, carried out by the Camera Raw team. By selecting the most appropriate camera profile in the Camera Calibration panel you can ensure you get the most accurate (or most suitable) color from your camera. Test cameras were used to build a twopart profile of each camera sensor's spectral response under standardized tungsten and daylight balanced lighting conditions. From this, Camera Raw is able to calculate a pretty good color interpretation under these lighting conditions, and beyond, across the full range of color temperatures. This method may not be as accurate as having a proper profile built for your camera, but to be honest, profiling a camera is something that can only really be done where the light source conditions are always the same.

New Camera Raw profiles

You have to bear in mind that many of the initial default Camera Raw profiles were achieved through testing a limited number of cameras. It was later discovered that there could be a discernible variation in color response between individual cameras. As a result of this a wider pool of cameras were evaluated and the default profile settings were updated for certain makes of camera, and in some cases newer versions of the default camera profiles were provided. This is why you will sometimes see extra profiles listed that refer to earlier builds of Camera Raw, such as ACR 2.4 or ACR 3.6, etc. (see sidebar on new camera profile availability). More recently, Eric Chan (who works on the Camera Raw engineering team) managed to improve many of the standard ACR profiles as well as extend the range of profiles that can be applied via Camera Raw. For Camera Raw 5.0 or later, the 'Adobe Standard' profile is now the new default, and this and the other profiles you see listed in the Profile menu options are the result of improved analysis as well as an effort to match some of the individual camera vendor 'look settings' associated with JPEG captured images.

Although Adobe Standard in now the recommended default camera profile, it has been necessary to preserve the older profiles, such as ACR 3.6 and ACR 4.4, since these need to be kept in order to satisfy customers who have relied on these previous profile settings. It wouldn't do to find that all your existing Camera Raw processed images suddenly looked different because the profile had been updated. Therefore, in order to maintain backward compatibility, Adobe leave you the choice of which profiles to use. If you are happy to trust the new 'Adobe Standard' profile, then I suggest you leave this as the default starting point for all your raw conversions. The difference you'll see with this profile may only be slight, but I think you will find this still represents an improvement and should be left as the new default.

Camera 'look settings' profiles

The other profiles you may see listed are designed to let you match some of the camera vendor 'look settings'. The profile names will vary according to which camera files you are editing, so for Canon cameras Camera Raw offers the following camera profile options: Camera Faithful, Camera Landscape, Camera Neutral, Camera Portrait as well as a Camera Standard option. Nikon users may see Mode 1, Mode 2, Mode 3, Camera Landscape, Camera Neutral, Camera Portrait and Camera Vivid profile options. In Figure 3.63 you can see an example of how these can compare with the older ACR and Adobe Standard profiles.

The 'Camera Standard' profile is rather clever because Eric has managed here to match the default camera vendor settings for most of the main cameras that are supported by Camera Raw. By choosing the Camera Standard profile you can get the Camera

New camera profile availability

Not all the Camera Raw supported cameras have new profiles, so you may not see the full list of profile options for every Camera Raw compatible camera, just the newer and most popular camera models.

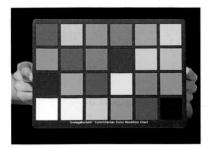

Figure 3.62 X-Rite ColorChecker charts can be bought as a mini chart or the full-size chart you see here.

Raw interpretation to pretty much match exactly the default color renderings that are applied by the camera manufacturer software. This means that if you apply the Camera Standard profile as the default setting in the Camera Calibration panel, Camera Raw applies the same kind of default color rendering as the camera vendor's software and will also match the default camera JPEG renderings. For years, photographers have complained that Camera Raw in Bridge and Lightroom changed the look of their photos soon after downloading. The initial JPEG previews they saw that they liked would quickly be replaced by a different, Camera Raw interpretation. When Camera Standard profile is selected you won't see any jumps in color as the Camera Raw processing kicks in. This is because, as I say, Camera Raw is now able to match the JPEG rendering for many of the supported cameras.

Custom camera profile calibrations

While the Adobe Standard profiles are much improved, they have still been achieved from testing a limited number of cameras. You can, however, create custom standard camera profiles for individual camera bodies. Creating a custom camera calibration profile does require a little extra effort to set up, but it is worth doing if you want to fine-tune the color calibration for each individual camera you shoot with. This used to be done by adjusting the Camera Calibration panel sliders, but is now mainly done through the use of camera profiles. However, the sliders do have their uses still, as I'll explain shortly.

In the early days of Camera Raw I used to shoot an X-Rite ColorChecker chart and visually compared the shot results with a synthetic ColorChecker chart, and adjusted the Camera Calibration panel sliders to achieve a best match. It was all very complex! Fortunately there is now an easier way to calibrate your camera equipment. You will still need to capture an X-Rite ColorChecker chart (Figure 3.62). These can easily be ordered on-line and will probably cost you around \$100. You then need to photograph the chart with your camera in raw mode. It is important that the chart is evenly lit and exposed correctly. The best way to do this is to use two studio lights in a copy light setup, or failing that, use a diffuse light source. Apart from that it does not matter what other camera settings are used, although I would recommend you shoot at a low ISO rating.

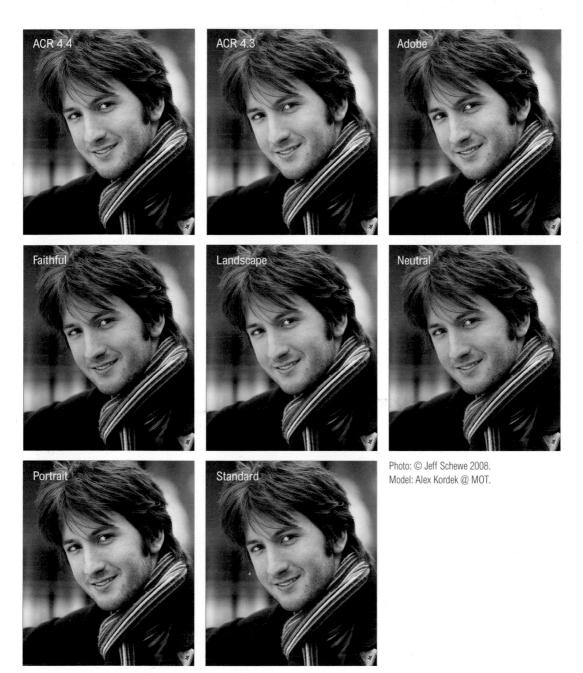

Figure 3.63 This page shows a comparison of the different camera profiles one can now choose from and the effect these will have on the appearance of an image, which in this case was shot using a Canon EOS 1Ds MkIII camera.

Camera profiles and white balance

In the step-by-step example shown here I recommend creating a camera profile using a standard strobe flash lighting setup. This lets you calibrate the camera sensor for the studio lights you shoot with normally. The camera profile measurements can vary slightly for pictures that are shot using different white balance lighting setups. It is for this reason the DNG Profile editor allows you to measure and generate camera profiles in the same way as the Camera Raw team do. For example, If you shoot the ColorChecker chart once with a lighting setup at a measured white balance of 6500 K and again at a white balance of 3400 K, you can measure these two charts using the DNG Profile Editor to create a more accurate custom camera profile.

DNG Profile Editor

In the quest to produce improved camera profiles, a special utility program called DNG Profile Editor was used to help reevaluate the camera profiles supplied with Camera Raw and produce the revised camera profiles. You can get hold of a copy of this program by going to the labs.adobe.com website and doing a search for 'DNG Profiles'. At the time of writing it is currently in version beta 2 and available as a free download. There are a number of things you can do with this utility, but its main strength is that it allows you to create custom calibration profiles for individual cameras. You see, while the default camera profiles can be quite accurate, there may still be a slight difference in color response between your particular camera and the one Adobe used to test with. For this reason you may like to run through the following steps to create a custom calibration for your camera sensor.

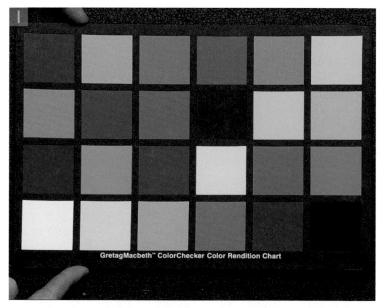

1 As I mentioned in Figure 3.62, you'll first need to photograph an X-Rite GretagMacbeth ColorChecker chart. I suggest you shoot this against a plain dark backdrop and make sure it is evenly lit from both sides, and for the utmost accuracy, is illuminated with the same strobe lights that you normally work with. It is also a good idea to take several photos and bracket the exposures slightly. If the raw original isn't exposed correctly you'll see an error message when trying to run the DNG Profile Editor. The other thing you'll need to do is to convert the raw capture image to the DNG format, which you can do using Adobe DNG Converter (see page 250).

2 The next step is to launch DNG Profile Editor. Go to the File menu and choose File ⇒ Open DNG Image... Now browse to locate the DNG image you just edited and click 'Open'. The selected image appears in a separate window. Go to the Base Profile menu and select the Adobe Standard profile for whichever camera was used to capture the ColorChecker chart.

3 Now click on the Chart tab (circled) and drag the four colored circles to the four corner swatches of the chart. If you are just measuring the one chart, select the 'Both color tables' option and click on the Create Color Table... button. If you are recording two separately shot targets at different white balance settings, use this menu to select the appropriate color table.

Adobe Photoshop CS5 for Photographers

4 The camera profile generation process is pretty much instantaneous. Once this has been done you can then go to the Edit menu and choose File \Rightarrow Export (name of camera) Profile, or use the $\Re e$ ctrife shortcut and rename the profile as desired.

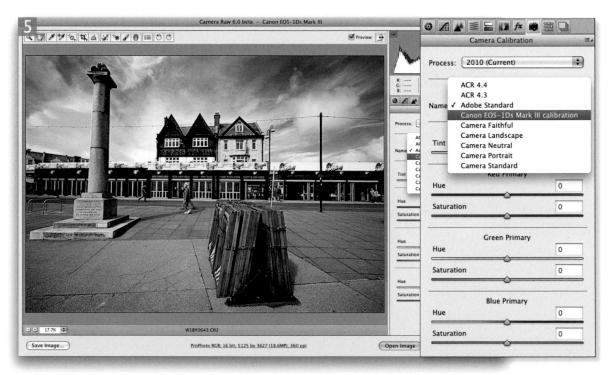

5 Custom camera profiles are saved to a default user folder but won't appear visible in the Camera Calibration panel profile list until you next launch Photoshop or Bridge and open a raw image via Camera Raw. Once you have done this you can select the newly created camera profile and apply it to any photos that have been shot using this camera.

	New Preset	
Presets III III IIII IIIIIIIIIIIIIIIIIIIII	Name: Untitled-1 OK Subse ✓ All Settings White Balance Basic Parametric Curve Point Curve Details HSL Adjustments Split Toning Lens Corrections Post Crop Vignetting Camera Calibration Custom Subset	
	Viorance Saturation Parametric Curve Point Curve Sharpening Luminance Noise Reduction Color Noise Reduction Grain Grain HSL Adjustments	
(J) (F) (F) (F) (F) (F) (F) (F) (F) (F) (F	Apply auto grayscale mix	

6 Here is an extra tip which is worth carrying out. You can save the camera profile selected in the Camera Calibration panel as a custom Camera Raw preset. In the example shown here I went to the Camera Raw Presets panel, clicked on the New Preset button (circled), and in the New Preset dialog shown here selected the Camera Calibration subset setting, so that only the Camera Calibration option was checked. Once I had done this I now had a camera profile preset setting that could easily be applied to any other photographs that had been shot with the same camera. One can also easily apply a setting like this via the Bridge Edit ⇒ Develop settings submenu.

Clearing the retouching work

You can remove individual retouch circles by selecting them and hitting the *Delete* key. Or, you can click on the Clear All button to delete all retouch circles.

Turning off the preview

You can use the Preview option to toggle showing/hiding the spot removal retouching.

Spot removal tool

You can use the spot removal tool (B) to retouch spots and blemishes. Whenever the spot removal tool is active you will see the Spot Removal options appear in the panel section on the right (Figure 3.64). From here you can choose between Heal and Clone type retouching and ideally you should work on the image at a 100% magnification. In Clone mode, the tool behaves like a cross between the spot healing brush and clone stamp tool in Photoshop. It carries out a straightforward clone of the image with a soft feathered edge circle and automatically selects the area to sample from. In Heal mode, the tool behaves like a cross between the spot healing and normal healing brush in Photoshop, where a straight-forward click auto-selects an area to sample from and blends the sampled data with the surrounding data outside the spotting circle. If you then click to select a spot circle you can adjust the destination and/or source point circles. In either case, you can click to select an applied clone circle and use the Type menu to switch from one mode to the other. With both the Clone

Figure 3.64 This screen shot shows the retouch tool in action, with explanations of how to apply and modify the retouch spot circles.

and Heal modes you have the option to adjust the radius of the spot removal tool as well as the opacity. You can use the **LU** keys to tweak the radius, but it is usually simpler to follow the instructions in Figure 3.64 and drag with the cursor instead. The Opacity slider allows you to lower the opacity setting should you wish. You can also click on the Show Overlay box or use the **H** key to toggle showing and hiding the circles so that you can view the retouched image without seeing the retouch circles.

Synchronized spotting with Camera Raw

You can synchronize the spot removal tool across multiple photos. Make a selection of images in Bridge and open them up via Camera Raw (as shown in Figure 3.65). Now click on the Select All button. This selects all the photos and if you now use the spot removal tool, you can retouch the most selected photo (the one shown in the main preview), and the spotting work is automatically updated to all the other selected images.

Keeping the sensor clean

Dust marks are the bane of digital photography and ideally you want to do as much as you can to avoid dust or dirt getting onto the camera sensor. I have experimented with various products and find that the Sensor Swabs used with the Eclipse cleaning solution from Photographic Solutions Inc (www. photosol.com) are reliable products. I use these from time to time to keep the sensors in my cameras free from marks.

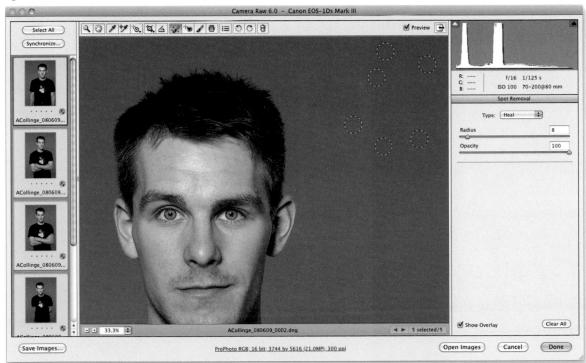

Figure 3.65 Here is an example of the Camera Raw dialog being used to carry out synchronized spotting.

Hiding the red eye rectangles

As with the spot removal tool, you can click on the Show Overlay box to toggle showing and hiding the rectangle overlays (or use the *H* key).

Red eye removal

The remove red eye tool is useful for correcting photos that have been taken of people where the direct camera flash has caused the pupils to appear bright red. To apply a red eye correction, select the red eye removal tool and drag the cursor over the eyes that need to be adjusted. In the Figure 3.66 example I dragged with the mouse to roughly select one of the eyes. As I did this, Camera Raw was able to detect the area that needed to be corrected and automatically adjusted the marquee size to fit. The Pupil Size and Darken sliders can then be used to fine-tune the Pupil Size area that you want to correct as well as the amount you want to darken the pupil by. You can also revise the red eye removal settings by clicking on a rectangle to reactivate it, or use the *Delete* key to remove individual red eye corrections. If you don't like the results you are getting, you can always click on the Clear All button to delete the red eye retouching and start over again.

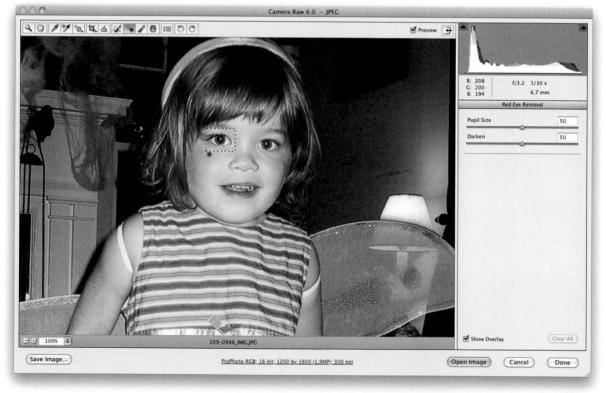

Figure 3.66 Here is an example of the remove red eye tool in action.

Localized adjustments

We now come to the adjustment brush and graduated filter tools, which can be used to apply localized edits to photos in Camera Raw. As with the spot removal and red eye removal tools, you can revise these edits as many times as you like without having to render an interim pixel version of the raw master. Not only that, these are more than just dodge and burn tools. There are a total of seven adjustment effects to choose from, not to mention an Auto Mask option.

Adjustment brush

When you select the adjustment brush tool (\swarrow) the tool options shown in Figure 3.67 will appear in the panel section on the right with the New button selected (you can also use the \ltimes key to toggle between the Adjustment Brush panel and the main Camera Raw panel controls). Below this are the sliders you use to configure the adjustment brush settings before you apply a new set of brush strokes.

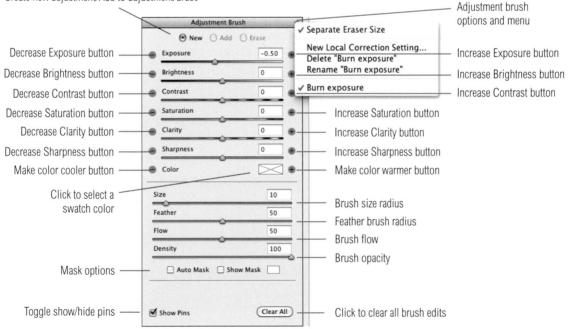

Create new adjustment/Add to adjustment/Erase

Figure 3.67 The Adjustment Brush options.

Hiding and showing brush edits

You can use the Preview button in the Camera Raw dialog to toggle showing and hiding all Adjustment brush edits.

Figure 3.68 The outer edge of the adjustment brush cursor represents the overall size of the brush, while the inner circle represents the softness (feathering) of the brush relative to the overall brush size.

Initial Adjustment Brush options

To apply a brush adjustment, click on the New brush button at the top of the panel and then select the effect options you wish to apply by using either the plus or minus buttons or the sliders. For example, clicking on the Exposure plus button increases the exposure setting to +0.50 and clicking on the negative button sets it to -0.50 (these are your basic dodge and burn settings). The effect buttons therefore make it fairly easy for you to quickly create the kind of effect you are after. Remember, you can only select one effect setting at a time using the buttons, but if you use the slider controls you can fine-tune the adjustment brush effect settings and combine multiple effects in a single setting.

Brush settings

Below this are the brush settings. The Size slider adjusts the brush radius, plus you can use the **ID** keys to make the brush smaller or larger. It is also possible to resize a brush on screen. If you hold down the *ctrl* key (Mac) or use a right mouse-click (Mac and PC), you can drag to resize the cursor before you start using it to retouch the image. The Feather slider adjusts the softness of the brush and you can also use the Shift] keys to make the brush edge softer and *Shift* **[**] to make the brush harder. Note that these settings are reflected in the cursor shape shown in Figure 3.68. The Flow slider is a bit like an airbrush control. If you select a low Flow setting, you can apply a series of brush strokes that successively build to create a stronger effect. As you brush back and forth with the brush, you will notice how the paint effect gains opacity, and if you are using a pressure-sensitive tablet such as a WacomTM, the flow of the brush strokes is automatically linked to the pen pressure that you apply. The Density slider determines the maximum opacity for the brush. This means that if you have the brush set to 100% Density, the flow of the brush strokes can build to a maximum density of 100%. If on the other hand you reduce the density, this limits the maximum brush opacity to a lower opacity value. For example, if you lower the density and paint over an area that was previously painted at a density of 100%, you can paint with the adjustment brush to reduce the opacity in these areas, and if you reduce the Density to 0%, the adjustment brush acts like an eraser tool.

Adding a new brush effect

We are now ready to start painting. When you click on the image preview, a pin marker is added and the Adjustment Brush panel shows that it is now in Add mode (Figure 3.69). As you start adding successive brush strokes, these are collectively associated with this marker and will continue to be so, until you click on the New button and click to create a new pin marker with a new set of brush strokes. The pin markers therefore provide a tag for identifying groups of brush strokes. You just click on a pin marker whenever you want to add or remove brush strokes, or need to re-edit the brush settings that were applied previously. If you want to hide the markers you can do so by clicking on the Show Pins box to toggle showing/hiding the pins, or use the **H** key shortcut.

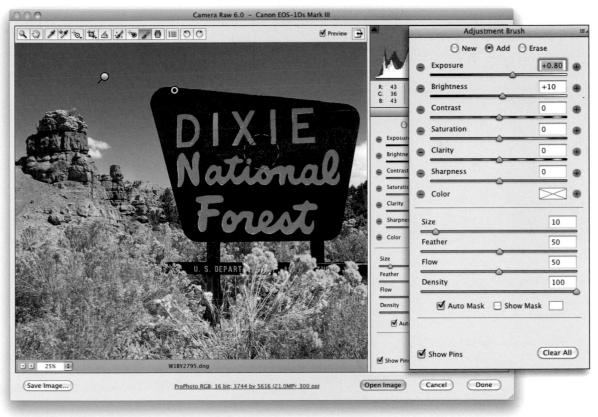

Figure 3.69 In this example I added several pin markers, which represent different groups of brush strokes. The one at the top was used to darken the sky and the one that is currently active was used to lighten the park sign with a positive Exposure value.

Undoing and erasing brush strokes

As you work with the adjustment brush, you can undo a brush stroke or series of strokes using the Undo command (**38 Z** *ctrl* **Z**).

Previewing the mask more clearly

Sometimes it is useful to initially adjust the settings to apply a stronger effect than is desired. This lets you judge the effectiveness of your masking more clearly. You can then reduce the effect settings to reach the desired strength for the brush strokes.

Resetting the sliders

Double-clicking a slider name resets it to zero, or to its default value.

Editing brush adjustments

Previewing the brush stroke areas

If you click on the 'Show Mask' option, you'll see a temporary overlay view of the painted regions (Figure 3.70). The color overlay represents the areas that have been painted and can also be seen as you roll the cursor over a pin marker.

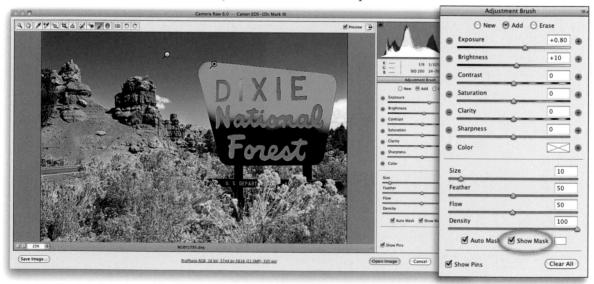

Figure 3.70 In this screen view, the 'Show Mask' option is checked and you can see an overlay mask for the selected brush group. Click on the swatch next to it if you wish to choose a different color for the overlay display.

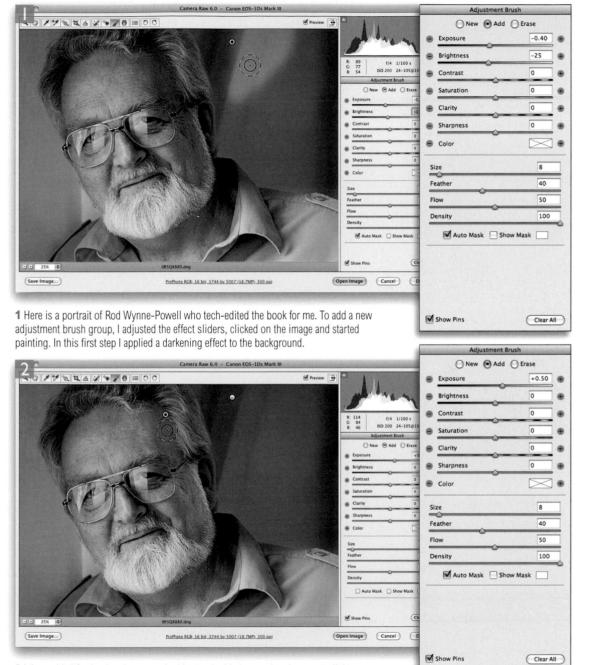

2 I then added further brush groups. In this step I added a new brush group to lighten Rod's forehead.

Photograph: © Jeff Schewe 2008

Figure 3.71 Quite often, all you need to do is to click on an area of a picture with the color you wish to target and drag the adjustment brush in Auto Mask mode to quickly adjust areas of the picture that share the same tone and color.

Auto masking

At the bottom of the Adjustment Brush panel is the Auto Mask option and when this is switched on it cleverly masks the image at the same time as you paint. It does this by analyzing the colors in the image where you first click and then proceeds to apply the effect only to those areas with the same matching tone and color (Figure 3.71). It does this on a contiguous selection basis. For example, in the steps shown here, I dragged with the adjustment brush in Auto Mask mode around the outside of the basket handle to darken the outer area and then dragged separately on the inside of the basket handle to include this in the auto mask brush group. While the Auto Mask can do a great job at auto-selecting the areas you want to paint, at extremes it can lead to ugly 'dissolved pixel' edges. This doesn't happen with every photo, but it's something to be aware of. The other thing to watch out for is a slow-down in brush performance. As you add extra brush stroke groups, the Camera Raw processing takes a knock anyway, but it gets even worse when you apply a lot of auto mask brushing. It is therefore a good idea to restrict the number of adjustment groups to a minimum.

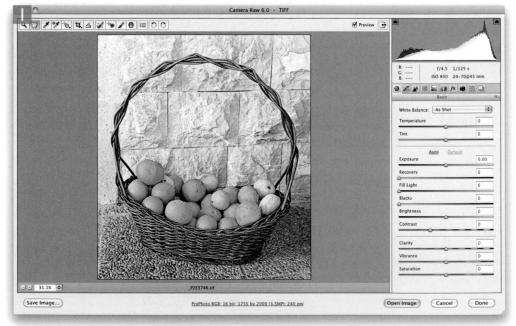

1 This shows the original photograph of a basket of oranges against a stone wall, shown here with just the Basic panel corrections applied.

Clear All

Show Pins

Show Pins

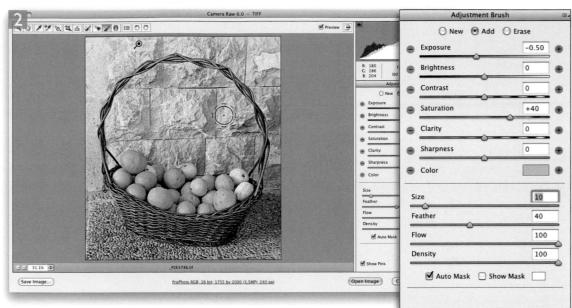

2 I selected the adjustment brush and clicked on the minus Exposure button to set this to -0.50, then dragged the Saturation slider to +40, chose a blue paint color and started painting the wall. Because 'Auto Mask' was checked, the brush effect only adjusted the wall.

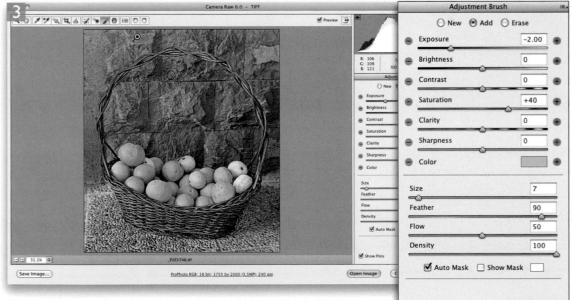

3 To demonstrate how effective the auto masking was in this image, I lowered the Exposure slider to -2.00, which darkened the wall even further. You can see how the basket handle and fruit stood out more as I did this.

(Clear All)

Adjustment brush speed

The fact that you can apply non-destructive localized adjustments to a raw image is a clever innovation, but this type of editing can never be as fast as editing a pixel image in Photoshop. This example demonstrates how it is possible to get quite creative with the adjustment brush tool. In reality though it can be extremely slow to carry out such complex retouching with the adjustment brush, even on a fast computer.

Hand-coloring in Color mode

The adjustment brush tool can also be used to tint black and white images and this is a technique that works well with any raw, JPEG or TIFF image that is in color. This is because the auto mask feature can be used to help guide the adjustment brush to colorize regional areas that share the same tone and color. In other words, if the underlying image is in color, the auto mask has more information to work with. To convert the image to black and white, you can do what I did here and take the Saturation slider in the Basic panel all the way to the left. Alternatively, you can go to the HSL panel and set all the Saturation sliders to -100. The advantage of doing this is that you then have the option of using the HSL panel Luminance sliders to vary the black and white mix (see Chapter 6). After desaturating the image you simply select the adjustment brush and click on the color swatch to open the Color Picker dialog and choose a color to paint with.

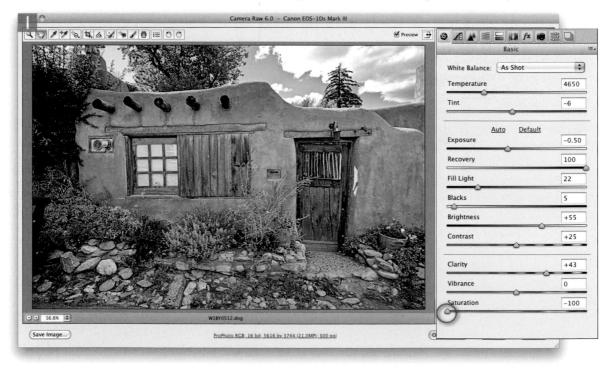

1 The first step was to go to the Basic panel and desaturate the colors in the image by dragging the Saturation slider all the way to the left.

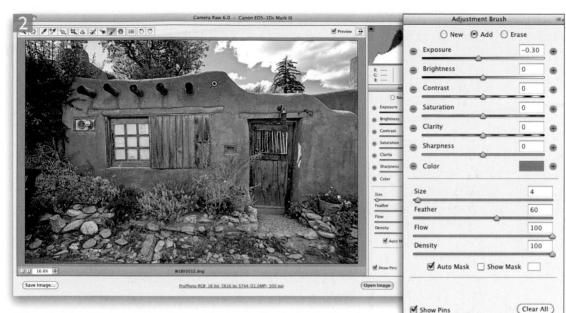

2 Once I had done this I selected the adjustment brush and edited the brush settings. In this instance I clicked on the color swatch to choose an orange color and with 'Auto Mask' selected, started coloring the building.

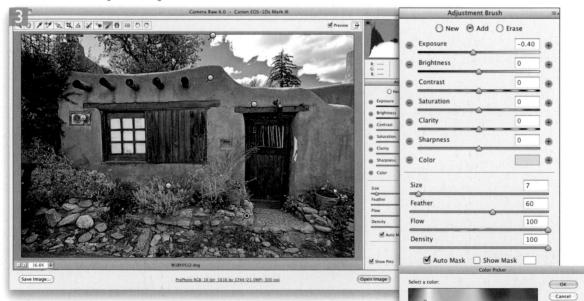

3 I then added several more brush groups to color the photo. In this example, you can see I have the pin marker on the front path selected, where I adjusted the brush settings to apply a yellow color with a -0.40 Exposure setting.

65

Hue: 47

Saturation

Toggle the main panel controls

You can use the **G** key to toggle between the Graduated Filter panel and the main Camera Raw panel controls.

Resetting the sliders

As with the Adjustment Brush options, double-clicking a slider name resets it to zero, or to its default value.

Graduated filter tool

Everything that has been described so far with regards to working with the adjustment brush more or less applies to working with the Graduated filter (Figure 3.72), which allows you to add linear graduated adjustments. To use the graduated filter tool, click in the photo to set the start point (the point with the maximum effect strength), drag the mouse to define the spread of the Graduated filter, and release to set the minimum effect strength point. There is no midtone control with which you can offset a graduated filter effect and there are no graduated filter options other than 'linear'.

Graduated filter effects are indicated by green and red pin markers. The green dashed line represents the point of maximum effect strength and the red dashed line represents the point of minimum effect strength. The dashed line between the two points indicates the spread of the filter and you can change the width by dragging the outer pins further apart, and move the position of the gradient by clicking and dragging the central line.

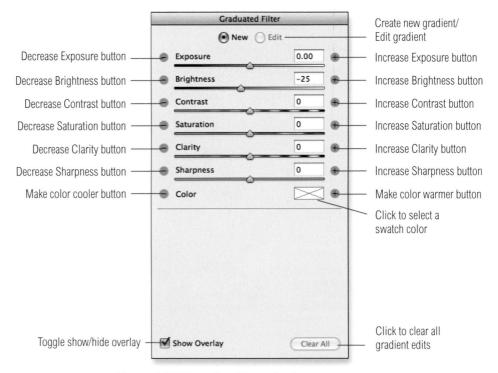

Figure 3.72 The graduated filter tool options.

237

1 This shows how a photograph looked after I had applied just the main Basic panel adjustments that were used to optimize the highlights, shadows, and contrast.

Camera Raw 6.0 - Canon EOS-1Ds Mark III Graduated Filter 19 0. 4. 4 1 0 = 00 Pre Pre in 🔘 New 💿 Edit Exposure -0.30 4 0 f/8 ISO 200 Brightness 0 Graduated Filte Contrast 0 100 O New @E Saturation a 0 Clarity 0 10 0 Sharpness 42 . Color 1 Show Overlay WIEYS124.dng (Save Image ...) ProPhoto RGB: 16 bit: 5616 by 3744 (21.0MP): 300 poi Open Image Cancel 2 I then selected the graduated filter tool, which revealed the Graduated Filter panel Show Overlay (Clear All)

I then selected the graduated lifter tool, which revealed the Graduated Filter panel options. I created a negative Exposure effect setting and dragged with the graduated filter tool from the middle of the sky downward to darken the top third of the picture.

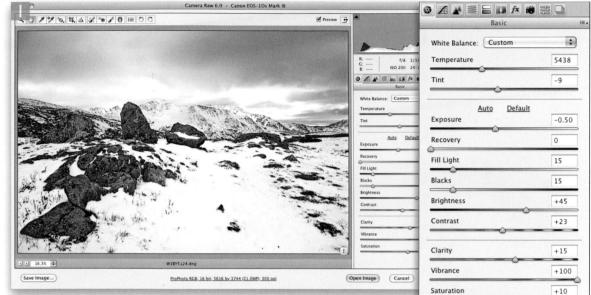

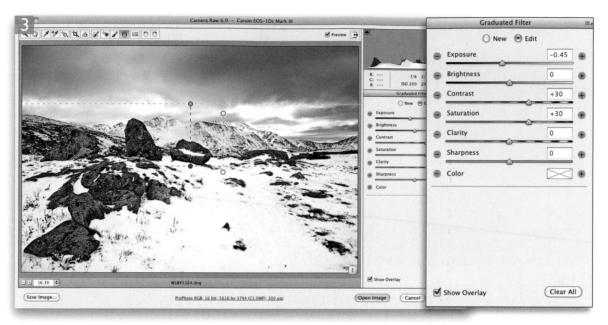

3 I then decided to strengthen this graduated filter effect by decreasing the Exposure setting to -0.45 and added more contrast along with more saturation and more clarity.

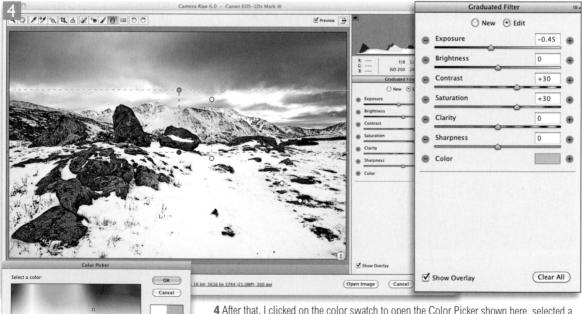

- 25

4 After that, I clicked on the color swatch to open the Color Picker shown here, selected a blue color and added a new Graduated Filter adjustment by dragging from the top of the photograph downward to the horizon.

Hue: 230

Saturation:

Angled gradients

As you drag with the Graduated filter you can do so at any angle you like and edit the angle afterwards. For example, if you click on a pin marker to select it (as shown in Figure 3.73), you can drag the marker, rotating it around the other marker point and if you hold down the *Shift* key you can constrain the angle of rotation to 45° increments.

Adding clarity and contrast

In the final example shown here, I wanted to show a further series of steps using the Graduated filter, but this time I wanted to demonstrate how to add contrast and clarity to an image. The photo below shot early one morning in Chicago at sunrise, but I never really managed to get the dramatic colors that I was after. This was mainly because of the early morning misty sky. I later realized this picture could benefit from some added contrast in the softer parts of the image and this was an ideal opportunity to work with the graduated filter tool.

Figure 3.73 This shows a Graduated filter being rotated, where the red pin marker is being dragged and rotated around the green marker.

	Canon EOS-1Ds Mark II 🚳 🔏 💒 🗮 🔝	f× 💼 🗮 🖸
	e Preview 🕒 Basic	
	White Balance: Custor	m 🗘
	R Temperature	6100
		0
	Exposure	Default +0.60
	Tim Exposure Recovery	0
	Recovery Fill Light	0
	Blacks	21
	Brightness Contrast	+60
	Clarity Contrast	+40
	Wearce Saturation Clarity	+12
18% 4 Chicago060625-0136.dag	Vibrance	+15
FroPhoto RGB. 16 bir: 4992 by	v3328.(16.6MP: 240.np) Open Image Saturation	0

1 Here is the original version in which I had optimized for the highlights, shadows and contrast and added a little clarity and vibrance to bring out more definition and color in the buildings.

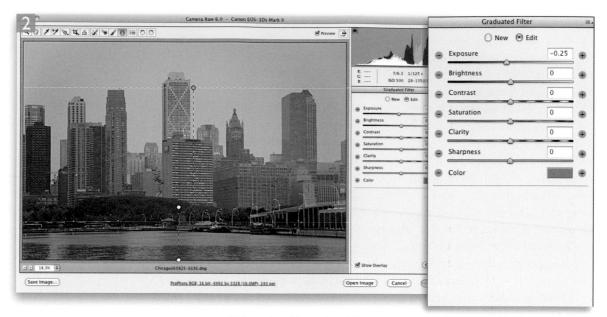

2 I then selected the graduated filter tool and added two color effect gradients: a light blue gradient over the water plus a warm colored gradient to add some warmth to the sky.

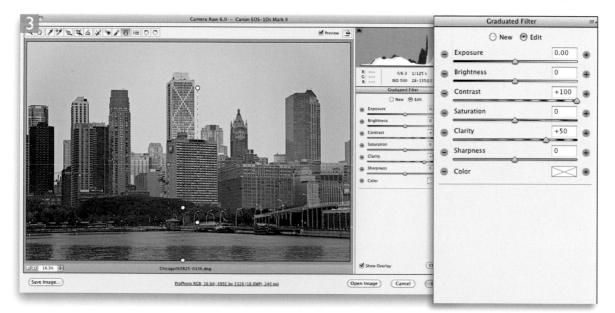

3 But still, the buildings in this photograph lacked presence, so I added a further gradient in which I combined a +100 contrast effect with +50 clarity and dragged from the middle of the picture down to the water line.

Camera Raw settings menu

If you mouse down on the Camera Raw menu (circled in Figure 3.74) this reveals a number of Camera Raw settings options at the top of the list. 'Image Settings' is whatever the Camera Raw settings are for the current image you are viewing. This might be a default setting or it might be a custom setting you created when you last edited the image in Camera Raw. 'Camera Raw Defaults' resets the default settings in all the panels and applies whatever the white balance setting was at the time the picture was captured, while 'Previous Conversion' applies the Camera Raw settings that were applied to the previous saved image. If you proceed to make any custom changes while the Camera Raw dialog is open, you'll also see a 'Custom Settings' option. Whichever setting is currently in use will be shown with a check mark next to it and below that is the 'Apply Preset' submenu that let's you quickly access any presaved presets (which you can also do via the Presets panel that is discussed on the following page).

Figure 3.74 The Camera Raw menu options can be accessed via any of the main panels by clicking on the small menu icon that's circled here.

Figure 3.75 When 'Update DNG Previews' is selected you can force-update the JPEG previews in a DNG file, choosing either a Medium Size or Full Size preview.

Export settings to XMP

If you refer to the Camera Raw preferences shown in Figure 3.19 on page 166, there is an option to save the image settings either as sidecar ".xmp" files, or save them to the 'Camera Raw database'. If the 'sidecar ".xmp" files' option is selected, the image settings information is automatically written to the XMP space in the file header. This is the case with most file formats including DNGs. In the case of proprietary raw files such as CR2s or NEFs, it would be unsafe for Camera Raw to edit the header information of an incompletely documented file format. To get around this the settings information is stored using XMP sidecar files which share the same base file name and accompany the image whenever you use Bridge or Lightroom to move a raw file from one location to another. Storing the image settings in the XMP space is a convenient way of keeping the image settings data stored locally to the individual files instead of it only being stored in the central Camera Raw database. If 'Save image settings in Camera Raw database' is selected you can always use the 'Export Settings to XMP' option from the Camera Raw options menu (Figure 3.74) to manually export the XMP data to the selected images. For example, if you are editing a filmstrip selection of images and only wanted to save out the XMP data for some images, but not all, you could use the 'Export Settings to XMP' menu command to do this.

Update DNG previews

DNG files can store a JPEG preview of how the processed image should look based on the last saved Camera Raw settings. If you refer again to the Camera Raw preferences (Figure 3.19), there is an option to 'Update embedded JPEG previews'. When this is checked, the DNG JPEG previews are automatically updated, but if this option is disabled in the Camera Raw preferences you can manually update the JPEG previews by selecting 'Update DNG Previews...' from the Camera Raw options menu (Figure 3.74). This opens the Update DNG Previews dialog shown in Figure 3.75.

Load Settings... Save Settings...

These Camera Raw menu options allow you to load and save precreated XMP settings. Overall, I find it preferable to click on the New Preset button in the Preset panel (discussed opposite) when you wish to save a new Camera Raw preset.

Camera Raw defaults

The 'Save New Camera Raw Defaults' Camera Raw menu option creates a new default setting based on the current selected image. Note that these defaults are also affected by the 'Default Image Settings' that have been selected in the Camera Raw preferences (see 'Camera-specific default settings' on pages 167–168).

Presets panel

The Presets panel is used to manage saved custom Camera Raw preset settings.

Saving and applying presets

To save a preset, you can go to the Camera Raw fly-out menu and choose Save Settings... Or, you can click on the Add Preset button in the Presets panel to create a new Camera Raw preset (circled in Figure 3.76). A preset can be one that is defined by selecting all the

New Camera Raw defaults

The 'Save New Camera Raw Defaults' option will make the current Camera Raw settings sticky every time from now on when Camera Raw encounters a new file. This includes images processed by Bridge. So for example, if you were working in the studio and had achieved a perfect Camera Raw setting for the day's shoot, you could make this the new Camera Raw default setting. All subsequent imported images will use this setting by default. At the end of the day you can always select 'Reset Camera Raw defaults' from the Camera Raw options menu to restore the default Camera Raw camera default settings.

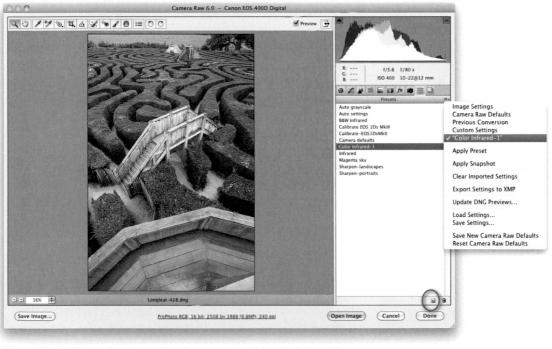

Figure 3.76 When the Presets panel is selected, you can click on the button at the bottom (circled) to add Camera Raw settings as a new preset. In this example I saved an Infrared Color preset using the New Preset settings shown in Figure 3.77. You can also use the Load Settings... and Save Settings... menu options to load and save new presets.

Camera Raw preset wisdom

Before you save a Camera Raw preset, it is important to think carefully about which items you need to include in a preset. When saving presets it is best just to save the bare minimum number of options. In other words, if you are saving a grayscale conversion preset, you should save the grayscale conversion option only. If you are saving a camera body and ISO-specific camera default, you might want to save just the Camera Calibration, Sharpening, Luminance Noise Reduction and Color Noise Reduction settings. The problem with saving too many attributes is that although the global settings may have worked great for one image, there is no knowing if they will work as effectively on all other images. It is therefore a good idea to break your saved presets down into smaller chunks.

Camera Raw settings, or it can be one that is made up of a subset of settings (as shown in Figure 3.74). Either way, a saved preset will next appear listed in the Presets panel as well as in the Apply Preset menu (Figure 3.74). Just click on a setting to apply it to an image. To remove a preset setting, go to the Presets panel, select it and click the Delete button at the bottom, next to the Add Preset button (see Figure 3.76).

Figure 3.77 The New Preset dialog can be accessed by clicking on the New Preset button (circled in Figure 3.76). You can choose to save 'All Settings' to record all the current Camera Raw settings as a preset. You can select a subset selection such as: Basic, or HSL Adjustments, or you can manually check the items that you want to include in the subset selection that will make up a saved Camera Raw preset.

Synchronize

Copying and synchronizing settings

000

If you have a multiple selection of photos in the Camera Raw dialog, you can apply synchronized Camera Raw adjustments to all the selected images at once. For example, you can **H** *ctrl*-click or Shift-click to make an image selection via the Filmstrip, or click on the Select All button to select all images. Once you have done this any adjustments you make to the most selected photo are simultaneously updated to all the other pictures too. Alternatively, if you make adjustments to a single image, then include other images in the Filmstrip selection and click on the Synchronize... button, this pops the Synchronize dialog shown in Figure 3.78. Here you can select the specific settings you wish to synchronize and click OK. The Camera Raw settings will now synchronize to the currently selected image. You can also copy and paste the Camera Raw settings via Bridge. Select an image and choose Edit \Rightarrow Develop Settings \Rightarrow Copy Camera Raw Settings ($\Re \simeq C$) *ctrl alt C*). Then select the image or images you wish to paste the settings to and choose Edit \Rightarrow Develop Settings \Rightarrow Paste Camera Raw Settings (\ \ \ Ctrl alt \).

Figure 3.78 When the Synchronize dialog box appears you can select a preset range of settings to synchronize with, or make your own custom selection of settings to synchronize the currently selected images.

+ 16.6% : ok_080311_0188.CR2 ProPhoto RGB: 16 bit: 5297 by 3744 (19.8MP): 300 pp Figure 3.79 In this example, I made a selection of images via the Filmstrip and clicked

the Synchronize... button, which opened the dialog shown in Figure 3.78.

Photograph: © Jeff Schewe 2008

Lightroom snapshots

Snapshots can be created via Lightroom and as long as you have saved and updated the metadata to the file, these can be read by Camera Raw. Similarly, snapshots applied in Camera Raw can also be read in Lightroom. The only limiting factor is whether the Develop settings are compatible between your current version of Camera Raw and Lightroom.

Working with Snapshots

As you work in Camera Raw you can now save favorite Camera Raw settings as snapshots via the Snapshots panel that is shown in the following steps examples. The ability to save snapshots means that you are not limited to applying only one type of Camera Raw rendering to an image. By using snapshots you can easily store multiple renderings within the image file's metadata with minimal overhead, since the Camera Raw snapshots you save will only occupy a very small amount of file space.

Name:	Optimize foreground	ОК
		Cancel

1 The Snapshots panel can be used to store different versions of Camera Raw settings that have been applied to an individual image. When you visit this panel you may already see a snapshot called Import, which will be the setting that was first applied to the photo at the time it was imported. What you can do here is make adjustments to the photo using the usual Camera Raw controls and use this panel to create new saved snapshots. For example, here I adjusted the Camera Raw settings to produce an optimum adjustment for the foreground and rocks in the middle distance. I then clicked on the Add New Snapshot button (circled) to save this setting as a new snapshot called Optimize foreground.

2 I then adjusted the Camera Raw settings, but this time to create an optimum adjustment for the sky and clouds, and saved this as another new snapshot called Optimize sky.

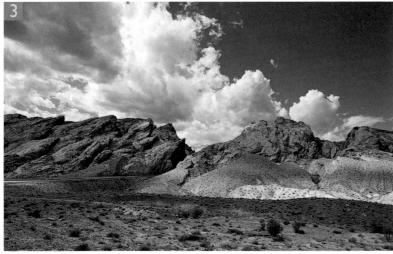

3 I opened the Camera Raw adjusted image as a Smart Object (see page 158) and used the Layers panel contextual menu to select 'New Smart Object via copy'. I was then able to use the quick select tool to create a selection of the sky and from that make a layer mask. Finally, I was able to double-click the Smart Object layers and apply the foreground snapshot for the lower layer and the sky snapshot for the upper layer to produce the final version shown here.

Whose data is it anyway?

If photographers think it is a good thing for the industry to move towards a standardized raw file format, then the DNG format deserves to succeed. It will also encourage other software manufacturers to support DNG and give the camera user even more choice. The only sticking point appears to be those camera manufacturers who have adopted a protective stance about the raw file processing. One gets the impression that there is a certain amount of irritation within some camera companies whenever outsiders have managed to 'crack the code' and successfully reverse engineered their proprietary raw file formats. One manufacturer once went so far as to devize a method of encryption that would defeat any attempts to make the file format more widely accessible. Photographer and Photoshop expert Jeff Schewe raised an important point here: 'After I have taken a photograph and captured an image as a raw file, whose data is it? It's my damn data, and not anyone else's!' Which neatly brings us back to the whole raison d'être of the DNG file format, which is to make raw shooting more accessible for all. The opportunity is there for everyone to gain. Photographers have a file format that will enable them to archive their raw captures with confidence for the future. If the camera manufacturers support the new DNG format they can make their customers happy too. The real choice is down to the consumers. They will decide which camera choice to make and support for DNG should be regarded as an important decision when making future purchases of camera equipment.

DNG file format

In the slipstream of every new technology there follows the inevitable chaos of lots of different new standards competing for supremacy. Nowhere is this more evident than in the world of digital imaging. In the last 15 years or so, we have seen many hundreds of digital cameras come and go along with other computer technologies such as Syquest disks and SCSI cables, and in that time I have probably encountered well over a hundred different raw format specifications. It would not be so bad if each camera manufacturer had adopted a raw format specification that could be applied to all the cameras they produced. Instead we have seen raw formats evolve and change with each new model that has been released and those changes have not always been for the better.

The biggest problem is that with so many types of raw format being developed, how reliable can any one raw format be for archiving your images? Twelve years ago, Adam Woolfitt and myself conducted a test report on a range of professional and semiprofessional digital cameras. Wherever possible, we shot using raw mode. I still have the CD of master files, and if I want to access those images today, I am in some cases going to have to track down a computer running Mac OS 8.6 in order to load the camera manufacturer software that is required to read the data! If that is a problem now, what will the situation be like in 60 years' time?

It is the proprietary nature of all these formats that is the central issue here. At the moment, all the camera manufacturers appear to want to devize their own brand of raw format. As a result of this, if you need to access the data from a raw file, you are forced to use *their* brand of software to do so. Now, while the camera manufacturers are excellent at designing fantastic hardware, the raw processing software that is supplied with their cameras has mostly been quite basic. Just because a company builds excellent digital cameras, it does not follow that they are going to be good at designing the graphics software needed to read and process the raw image data.

The DNG solution

Fortunately there are third-party companies who have devized ways of processing some of these raw formats, which means that you are not always limited to using the software that came with the camera. Adobe is the most obvious example here of a company who are able to offer a superior alternative. At the time of writing, Camera Raw can recognize raw formats from over 275 different cameras.

The DNG (digital negative) file format specification came about partly as a way to make Adobe's life easier for the future development of Camera Raw, and make Adobe Photoshop compatible with as many cameras as possible. DNG is a well thought out file format that is designed to accommodate the many different requirements of the proprietary raw data files in use today. DNG is also flexible enough to adapt to future technologies and has recently been updated to work with cameras that store proprietary lens correction data in the raw file. Because DNG is an open standard, the specification is freely available for anyone to develop and to incorporate it into their software or camera system. It is therefore hoped that the camera manufacturers will continue to adopt the DNG file format and that DNG will at some point be offered at least as an alternative file format choice on the camera.

Using DNG brings several advantages. Since the DNG format is a documented open standard, there is less risk of your raw image files becoming obsolete. There is the potential for on-going support for DNG despite whatever computer program, computer operating system or platform changes may take place in the future. This is less likely to be the case with proprietary raw files. Can you imagine in, say, 25 years' time there will be guaranteed support for the CR2 or NEF files shot with today's cameras?

DNG compatibility

When raw files are converted to DNG the conversion process aims to take all the proprietary MakerNote information that is sitting alongside the raw image data in the raw original and place it into the DNG. Therefore, any external DNG-compatible software should have no problem reading all the raw data that is rewritten as a DNG. However, there are known instances where manufacturers have placed some of the MakerNote data in odd places, such as alongside the embedded JPEG preview, which at one point was discarded during the conversion process (this has now been addressed in Camera Raw 5.6 or later). Basically, the DNG format is designed to allow full compatibility between different products, but this in turn is dependent on proper implementation of the DNG spec by third parties.

DNG adoption

Over the last few years DNG has been adopted by many of the mainstream software programs such as iView (now Microsoft Expression), Capture One, Portfolio and Photo Mechanic. At the time of writing, Hasselblad, Leica, Samsung and Ricoh cameras all support a DNG raw capture format option. You might also like to visit the www.openraw.org site where you can join the Open Raw discussion group and read the results of their 2006 raw survey.

Should you keep the original raws?

It all depends on whether you feel comfortable discarding the originals and keeping just the DNGs. Some proprietary software such as Canon DPP is able to recognize and process dust spots from the sensor using a proprietary method that relies on reading private XMP metadata information. Since DPP is a program that does not support DNG, if you delete the original CR2 files you won't be able to process the DNG versions in DPP. The only solution here is to either not convert to DNG or choose to embed the original raw file data when you convert to DNG. This means you retain the option to extract the CR2 raw originals any time you need to process them through the DPP software. The downside is that you end up with bloated DNG files that are at least double in size.

Maintaining ACR compatibility

If you refer back to page 136, you can read how it is possible to use the DNG Converter program to convert new camera files to DNG and thereby maintain Camera Raw support with older versions of Photoshop and Camera Raw.

DNG Converter

Adobe have made the DNG converter program (Figure 3.80) available as a free download from their website: www.adobe.co.uk/ products/dng/main.html. The DNG converter is able to convert raw files from any camera that is currently supported by Camera Raw. The advantage of doing this is that you can make backups of your raw files in a file format that allows you to preserve all the data in your raw captures and archive them now in a format that has a greater likelihood of support in the future. I personally feel quite comfortable converting my raw files to DNG and then deleting the original camera raw files. I don't see the need to embed the original raw file data in the DNG file, since this unnecessarily increases the file size. However, if you do feel it is essential to preserve complete compatibility, then embedding the original raw file data does allow you to extract the original native raw file from the DNG at some later date. The advantage of this is it provides complete compatibility with the camera manufacturer's software. The downside is that you will more than double the size of your DNG files.

2	Adobe [®] Digital Negative Converter	Adobe
O Sele	ct the images to convert	
0	Select Folder) /Volumes/Library-HD/Persor	nal Photos/USA/Boston2009/ rs
O Sele	ct location to save converted images	
(9)	Save in Same Location	
0	Select Folder) /Volumes/Library-HD/Perso	nal Photos/USA/Boston2009/
	Preserve subfolders	
O Sele	ct name for converted images	
	Name example: MyDocument.dng	
	Document Name 🔹 +	+
	+	•
	Begin numbering:	
	File extension: .dng	
O Pref	erences	
	Compatibility: Camera Raw 5.4 and later	Change Preferences
	JPEG Preview: Medium Size (Don't embed original	change references
	ut DNG Converter	Quit Convert

Figure 3.80 The DNG Converter program

Chapter 4

Sharpening and Noise Reduction

his chapter is all about how to pre-sharpen your photographs in Photoshop and reduce image noise. Here, I will be discussing which types of images need presharpening, which don't, and what are the best methods to use for camera captured or scanned image files.

In previous editions of this book I found it necessary to go into a lot of detail about how to use the Unsharp Mask filter and the Photoshop refinement techniques that could be used to improve the effectiveness of this filter. Now that the sharpening and noise reduction controls in Camera Raw have been much improved, I strongly believe that it is best to carry out the capture sharpening and noise reduction for both raw and scanned TIFF images in Camera Raw, before you take them into Photoshop. The first part of this chapter is therefore devoted entirely to Camera Raw sharpening and noise reduction.

Real World Image sharpening

If you want to learn more about image sharpening in Camera Raw, Lightroom and Photoshop then I can recommend: *Real World Image Sharpening with Adobe Photoshop, Camera Raw, and Lightroom* (2nd Edition) which is available from Peachpit Press, ISBN: 0321637550. The first edition was authored by Bruce Fraser. This new version is an update of Bruce's original book, and now coauthored by Jeff Schewe.

Print sharpening

I should also mention here that this chapter focuses solely on the capture and creative sharpening techniques for raw and non-raw images. I placed this chapter near the beginning of the book quite deliberately, since capture sharpening should ideally be done first (at the Camera Raw stage) before going on to retouch an image. The output sharpening, such as the print sharpening, should be done last. For more about print output sharpening, please refer to Chapter 13.

When to sharpen

All digital images will require sharpening at one or more stages in the digital capture and image editing process. Even if you use the finest resolution camera and lens, it is inevitable that some image sharpness gets lost along the way from capture through to print. At the capture end, image sharpness can be lost due to the quality of the optics and the image resolving ability of the camera sensor, which in turn can also be affected by the anti-aliasing filter that covers the sensor (and blurs the camera-focused image very slightly). With scanned images you have a similar problem: the resolving power of the scanner sensor and the scanner lens optics can lead to scans that are slightly lacking in sharpness. These main factors can all lead to capture images that are less sharp than they should be.

When we come to make a print, all print processes cause some sharpness to be lost, so it is always necessary to add some extra sharpening at the end, just before sending the photograph to the printer. Also, between the capture and print stages you may find that some photographs can do with a little localized sharpening to make certain areas of the picture appear that extra bit sharper. This briefly summarizes what we call a multi-pass sharpening workflow: capture sharpening followed by an optional creative sharpen, followed by a final sharpening for print.

One-step sharpening

It may seem like a neat idea to use a single step sharpening that takes care of the capture sharpening and print sharpening in one go, but it's just not possible to arrive at a formula that can work for all source images and all output devices. There are too many variables that have to be taken into account and it actually makes things a lot simpler to split the sharpening into two stages. A capture image sharpening should be applied at the beginning and an appropriate amount of output sharpening should be applied at the end, dependent on the type of print you are making and the size of the print output.

Capture sharpening

The majority of this chapter focuses on the capture sharpening stage, which is also referred to as 'pre-sharpening'. It is critical that you get this part right because capture sharpening is one of the first things you do to an image before you start the retouching work. The question then is, which images need sharpening and of those that do need sharpening, how much sharpening should you apply?

Let's deal with JPEG capture images first. If you shoot using the JPEG mode, your camera will already have sharpened and attempted to reduce the noise in the capture data, so no further presharpening or noise reduction is necessary. Since JPEG captures will have already undergone such a transformation there is no way to undo what has already been fixed in the image. I suppose you could argue that since some cameras allow you to disable the sharpening in JPEG mode, you could do this separately in Camera Raw, but I think this runs counter to the very reason why some photographers prefer to shoot JPEG in the first place. They do so because they want their pictures to be fully processed and ready to proceed to the retouching stage. So, if you are exclusively shooting in JPEG mode, capture sharpening isn't something you really need to worry about and you can skip the first section of this chapter.

If you shoot in raw mode it won't matter what sharpen settings you have set on your camera; these have no effect on the raw file, since it's an unprocessed image. Any capture sharpening must be done either in the raw processing program or afterwards in Photoshop. Up until recently most experts (myself included) were suggesting that you disable the sharpening in Camera Raw and use Photoshop to apply the capture sharpening. Well, all that changed with the Camera Raw 4.1 update and it now makes sense to carry out the capture sharpening at the Camera Raw image processing stage before you open your images in Photoshop.

Capture sharpening for scanned images

Scanned images may have already been pre-sharpened by the scanning software and some scanners do this automatically without you even realizing it. If you prefer to take control of the capture sharpening yourself you should be able to do so by disabling the scanner sharpening and using whatever other method you prefer. For example, you could use a third-party plug-in like PhotoKit Sharpener[™], or follow the unsharp mask filter techniques I describe in the image sharpening PDF on the DVD. So long as you export your scanned images using the TIFF or JPEG format, you can open these images via Camera Raw, and use the same raw image sharpening methods as original raw files that I describe here.

PhotoKit[™] Sharpener

Bruce Fraser devised the PhotoKit Sharpener plug-in from Pixel Genius, which can be used to apply capture, creative and output sharpening via Photoshop. The work Bruce did on PhotoKit capture sharpening inspired the improvements made to the Sharpening controls in Camera Raw. It can therefore be argued that if you use Camera Raw you won't need to use PhotoKit Sharpener capture sharpening routines. Adobe also worked closely with Pixel Genius to bring the PhotoKit Sharpener output routines to the Lightroom Print module. If you are using Lightroom 2.0 or later, you will be able to take advantage of this. However, if you have Photoshop and Lightroom, PhotoKit Sharpener can still be useful for the creative sharpening and halftone sharpening routines it provides.

Chapter 4

How to use the Unsharp mask filter

The main book no longer covers the manual pre-sharpening techniques that use the Unsharp Mask filter. However, you will find a 20 page PDF document on the DVD that fully describes how to work with the Unsharp Mask filter sliders and outlines some of the advanced ways you can use the Unsharp Mask filter to achieve better capture sharpening results.

So what about all those techniques that rely on Lab mode sharpening or luminosity fades? Well, if you analyze the way Camera Raw applies its sharpening, these controls have almost completely replaced the need for the Unsharp Mask filter. In fact, I would say that the Unsharp Mask filter, has for some time now been a fairly blunt instrument for sharpening images, plus I don't think it is advisable to convert from RGB to Lab mode and back again if its unnecessary to do so. Compare the old ways of sharpening (including the techniques I described in my previous books) with the Camera Raw method and I think you'll find that this is now the most effective, if not the only way to capture sharpen your photos.

Process Versions

As I mentioned in Chapter 3, in order to distinguish between Camera Raw 6.0 and pre-Camera Raw 6.0 sharpening and noise reduction, Camera Raw has seen the introduction of Process Versions. As a result of this, legacy photos that have been edited via Camera Raw or Lightroom are classified as using Process Version 2003 and all photos edited subsequently in Camera Raw 6.0 can be edited using the new Process Version 2010 rendering.

Improvements to Camera Raw sharpening

Camera Raw 6.0 now offers better demosaic processing, sharpening and noise reduction. The combination of these three factors has led to better image processing from this latest version of Camera Raw. Having said that, it should be noted that only those cameras that use the three-color Bayer demosaic method are affected by this change. The demosaic processing for other types of sensor patterns, such as the four-color shot cameras and the Fuji Super CCD, have not been modified. However, improvements have been made in the demosaic processing for specific camera models. For example, an improved green balance algorithm addresses the problem of maze pattern artifacts which were seen with the Panasonic G1 and this may also improve the image resolution for some other camera models too.

Let me try and explain what exactly has changed and how Camera Raw is now different. We can start by looking at the two image examples shown in Figure 4.1, where the top image shows a photograph processed via Camera Raw 5.0 and the bottom one

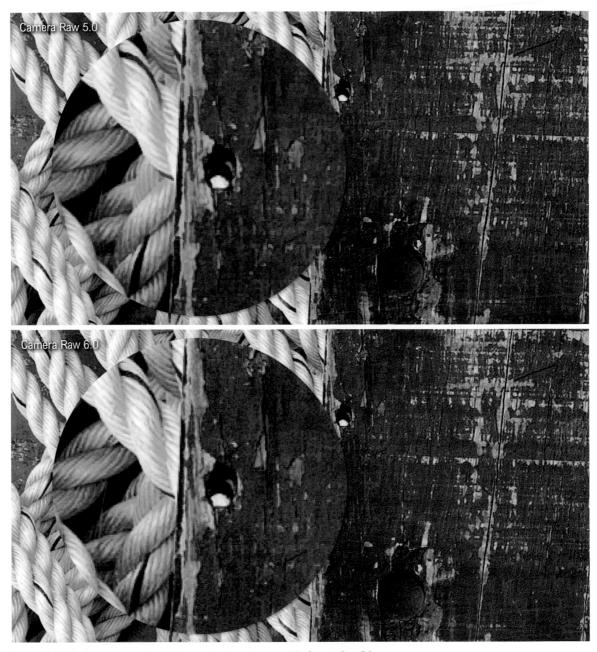

Figure 4.1 This shows a comparison between a raw image processed in Camera Raw 5.0 (top) and Camera Raw 6.0 (bottom) and the inset images show 400% close-up views. This is also available as a layered image on the DVD.

Ideal noise reduction

The thing to understand here is that the ideal noise reduction in the demosaic process isn't where every trace of noise gets removed from the image. OK, so you might think this would be a good thing to achieve, but you would in fact end up with a photograph where in close-up the image detail would look rather plastic and over-smooth in appearance. What the Camera Raw engineers determined was this: it is better to concentrate on eradicating the noise we generally find obtrusive, such as color and luminance pattern noise (which is usually a problem with high ISO capture), but preserve the residual luminance noise that is random in nature. The result of this precise filtering are images that are as free as possible of ugly artifacts, yet retain a fine-grain-like structure that photographers might be tempted to describe as being 'film-like'.

shows the same image processed via Camera Raw 6.0 in Photoshop CS5 using Process Version 2010. These examples include a section that's been enlarged to 400% so that you can see the difference more clearly. The first thing to point out is that the new demosaic process is now more 'noise resistant', which means it does a better job of removing the types of noise that we find unpleasant, such as color artifacts and structured (or pattern) noise. At the same time, the aim has been to preserve some of the residual, non-pattern noise which we do find appealing. The underlying principle at work here is that colored blotches or regular patterns tend to be more noticeable and obtrusive, whereas irregular patterns such as fine, random noise are more pleasing to the eye. The new demosaic process does a better job of handling color artifacts and filters the luminance noise to remove any pattern noise, yet retains some of the fine, grain-like structure. The net result is that Camera Raw is able to do a better job of preserving fine detail and texture, and this is particularly noticeable when analyzing higher ISO raw captures.

The next component is the new revised sharpening. Sharpening is achieved by adding halos to the edges in an image. Generally speaking, halos add a light halo on one side of an edge and a dark halo on the other. To quote Camera Raw engineer Eric Chan (who worked on the new Camera Raw sharpening), 'good sharpening consists of halos that everybody sees, but nobody notices.' To this end, the halo edges in Camera Raw have been made more subtle and rebalanced such that the darker edges are a little less dark and the brighter edges are brighter. They are still there of course but you are less likely to actually 'see' them as visible halos in an image. You should only notice them in the way they create the illusion of sharpness. The Radius sharpening has also been improved. When you select a Sharpen Radius that's within the 0.5-1.0 range the halos are now made narrower. Previously, the halos were still quite thick at these low radius settings and it should now be possible to sharpen fine-detailed subjects more effectively. You'll also read later about how the Detail panel Sharpen settings are linked to the Sharpen mode of the adjustment tools. This means you can use the adjustment brush or Gradient filter as creative sharpening tools to 'dial in' more (or less) sharpness. Lastly, we have the new, improved noise reduction controls which offer more options than before for removing the luminance and color noise from a photograph.

Sample sharpening image

To help explain how the Camera Raw sharpening tools work, I have prepared a sample test image that you can access from the DVD. The Figure 4.2 image has been especially designed to highlight the way the various slider controls work when viewed at 100%. Although this is a TIFF image, it's one where the image has been left unsharpened and the lessons you learn here can equally be applied to sharpening raw photos.

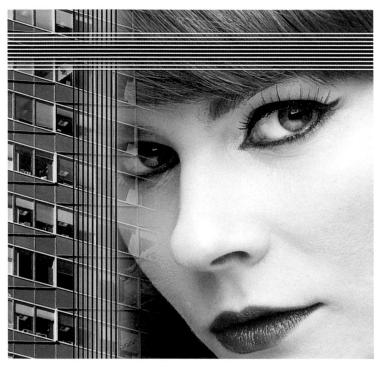

Figure 4.2 The sample image that's used on the following pages can be found on the DVD. To open this photo via Camera Raw, use Bridge to locate the test image and use File \Rightarrow Open in Camera Raw, or use the **B R ctrl R** keyboard shortcut.

Detail panel

To sharpen an image in Camera Raw, I suggest you start off by going to Bridge, browse to select a photo and choose File \Rightarrow Open in Camera Raw, or use the H *atr R* keyboard shortcut. The Sharpening controls are all located in the Detail panel in the Camera Raw dialog (Figure 4.3). If the photo won't open via Camera Raw, check you have enabled TIFF images to open via Camera Raw in the Camera Raw preferences (see page 170).

Detail	
Sharpening Amount	25
Radius	1.0
Detail	25
Masking	10
Noise Reduction	1
Luminance	10
Luminance Detail	50
Luminance Contrast	0
Color	25
Color Detail	10
For a more accurate preview, preview size to 100% or large adjusting the controls in this	r when

Figure 4.3 This shows the Detail panel in the Camera Raw dialog. Note that the Luminance Detail, Luminance Contrast and Color Detail sliders only appear active if the image has been updated to Process Version 2010 (current). Note that in the following steps the screen shots show all the Noise Reduction sliders set at zero. This is because the photo being edited is a TIFF rather than a raw image. When editing a raw photo the above defaults would be used instead.

Sharpenin	
Amount	25
Radius	1.0
Detail	25
Masking	0
Noise Reduc Luminance	0
Luminance Detail	
Luminance Contrast	
Color	25
Color Detail	
)	

Figure 4.4 This shows the default settings for the Detail panel in Camera Raw when processing a raw image.

Sharpening defaults

The Detail panel controls consist of four slider controls: Amount, Radius, Detail and Masking. When you open a raw image via Camera Raw, you will see the default settings shown in Figure 4.4. But as I mentioned earlier, if you open a non-raw image up via Camera Raw, such as a JPEG or TIFF, the Amount setting defaults to 0%. This is because if you are opening a JPEG or TIFF image via Camera Raw it is usually safe to assume that the image has already been pre-sharpened and it is for this reason that the default sharpening for non-raw files is set at zero. You should only apply sharpening to JPEGs or TIFF images if you know for sure that the image has not already been sharpened.

The Noise Reduction sliders can be used to remove image noise and we'll come onto these later, but for now I just want to guide you through what the sharpening sliders do.

The sharpening effect sliders

Let's start by looking at the two main sharpening effect controls: Amount and Radius. These two sliders control how much sharpening is applied and how the sharpening gets distributed.

If you want to follow the steps shown over the next few pages, I suggest you make a copy the Figure 4.1 image from the DVD and use Bridge to open it via the Camera Raw dialog. To do this use File \Rightarrow Open in Camera Raw, or use the $\Re R$ *ctrl* R keyboard shortcut. Then go to the Detail panel section (Figure 4.4). If you are viewing a photo at a fit to view preview size you will see a warning message that says: 'For a more accurate preview, zoom the preview size to 100% or larger when adjusting the controls in this panel', which means you should follow the advice given here and set the image view magnification in the Camera Raw dialog to a 100% view or higher. The test image I created is actually quite small and will probably display at a 100% preview size anyway. The main thing to remember is that when you are sharpening normal images, the preview display should always be set to a 100% view or higher for you to judge the sharpening accurately. In addition to this I should also point out that the screen shots over the next few pages were all captured as grayscale sharpening previews, where I held down the **S** *all* key as I dragged the sliders. Note that you only get to see these grayscale previews if you are viewing the image at a 100% view or bigger if using Process Version 2003.

Amount slider

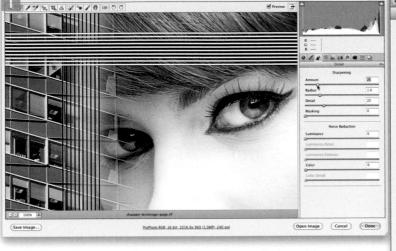

Sharpening	
Amount	25
Radius	1.0
Detail	25
Masking	0
Luminance Detail	
Noise Reductio	0
uminance Contrast	
) Color	0
· · · · · · · · · · · · · · · · · · ·	and the second se

1 The Amount slider is like a volume control. As you increase the Amount the overall sharpening is increased. A default setting of 25% is applied to all raw or raw DNG images, but if you open a TIFF, or JPEG image, Camera Raw assumes the image has already been pre-sharpened and applies a 0% Amount setting. So, if you are editing the image that came from the DVD you will need to set this to 25% to simulate the default setting shown here.

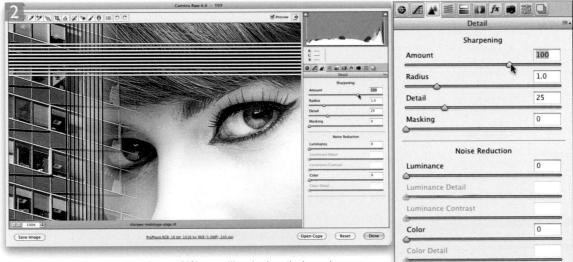

2 As you increase the Amount setting to 100% you will notice how the image becomes sharper. 100% is plenty strong enough, but you can take the Amount even higher. Camera Raw allows this extra headroom because it can sometimes be necessary when you start dampening the sharpening effect using the Detail and Masking sliders.

Amount

Radius

Detail

Masking

Luminance

Color Detail a

Luminance Detail

0

6 Color

6

Radius slider

	31 D1	0.0	Camera Raw 6.0 - TIFF	
Detail		ACIYA 46% >10 =	00	Presiew
Sharpening				James p
mount	25			R C B
dius	0.5			
tail	25			Sharpening Amount 25
asking	0			Radius 0.5 Detail 25 Maxiling 0
Noise Reduction				Noise Reduction Luminance 0
ninance ninance Detail	0	and the second s		Luminance Contrast Color 0
minance Contrast		P		Color Detail
blor	0	0 0 100% 9	sharpen-testimage-page.bl	
olor Detail		(Save Image)	ProPhoto RGE: 16 bit: 1016 by 969 (1.0MP): 240 opi	Open Copy Reset Done

1 The Radius slider is identical to the one found in the Unsharp Mask filter. The Radius determines the width of the halos that are generated around the edges in a photo. A small radius setting can be used to pick out fine detail in a picture, but will have a minimal effect on the soft, wider edges in a picture.

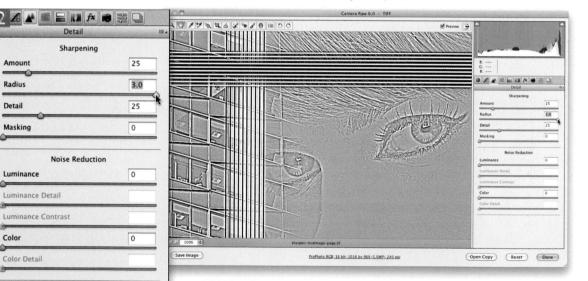

2 A high radius setting will over-emphasize the fine edges, but do more to enhance the soft edges, such as the facial features in a portrait. I have shown here the two extremes that can be used, but for most sharpening adjustments you will want to stick close to a 1.0 Radius and make small adjustments around this setting.

The suppression controls

The Amount and Radius sliders are used to create the sharpening effect, while the next two sliders act as 'suppression' controls. These can be used to constrain the sharpening and target the sharpening effect where it is most needed.

Detail slider

The Detail slider suppresses the halo effects in the image. It allows you to increase the Amount sharpening but without generating too noticeable halo edges in the image. There has always been a certain amount of halo suppression built into the Camera Raw sharpening, but you can now use the Detail slider to fine-tune the Amount and Radius effects by setting Detail to a low value. One of the minor changes in the new Camera Raw 6.0 sharpening means that higher Detail slider settings are more likely to exaggerate the highest possible edge detail in the image. This can result in the Lightroom sharpening emphasizing any areas that contain finetextured detail (and noise). As a result of this you may want to avoid setting the Detail too high if this is likely to cause problems. Another option is to increase the Masking setting.

Detail slider settings

Where I describe the Detail panel as acting like a suppression control, it is important to understand that when the Detail slider is set to 100, this matches the old Camera Raw sharpening where no additional edge halo suppression was employed. Any setting that is less than 100 effectively suppresses the Camera Raw sharpening. Therefore a low Detail setting has a maximum effect and a high Detail setting has a minimum effect.

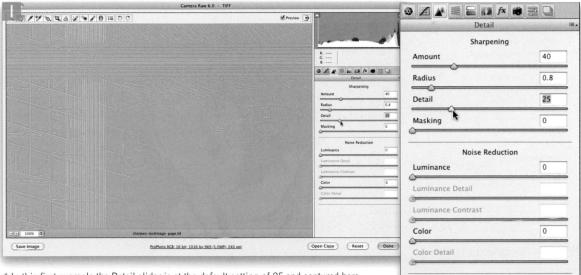

1 In this first example the Detail slider is at the default setting of 25 and captured here with the sharpening effect. At this setting the Detail slider gently suppresses the halo effects to produce a strong image sharpening effect, but without over-emphasizing the fine detail or noisy areas of the image.

Adobe Photoshop CS5 for Photographers

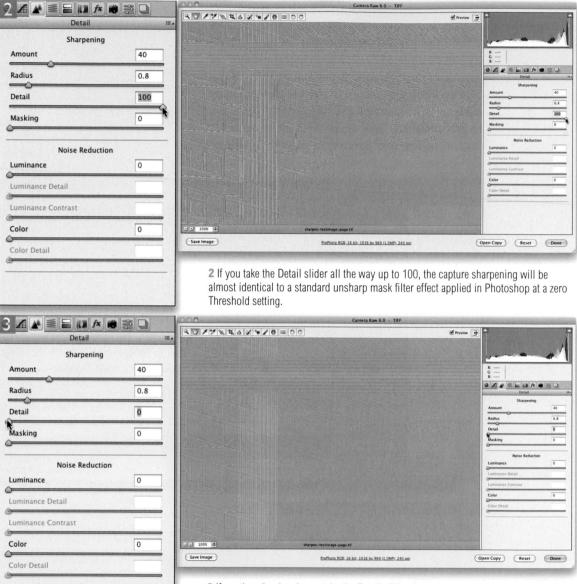

3 If, on the other hand, you take the Detail slider down to zero you can see how the image looks with maximum halo suppression. What we learn from this is how to set the Detail slider between these two extremes. For portraits and other subjects that have soft edges, I would recommend a lowish Detail setting of around 20–30 so that you prevent the flat tone areas from becoming too noisy. For images that have lots of fine detail I would mostly suggest using a higher value of 30–50, because you don't want to suppress the halo edges quite so much. With these types of photos you probably will want to add more emphasis to the fine edges.

Interpreting the grayscale previews

In all the screen shots you have seen so far, I have captured all these with the second and key held down as I dragged on the sliders. In the case of the Amount and Radius adjustments, holding down the second all key allows you to preview the effect these two adjustments have on the full color image by displaying a grayscale image which shows the sharpening effect as applied to the luminance information only.

One of the things that has long been known about the conventional Photoshop unsharp masking method is that a 'normal mode' unsharp mask filter effect sharpens all the color channels equally. It is mainly for this reason that people have in the past strived to sharpen the image luminance detail only, without actually sharpening the color information. This is what the 'convert to Lab mode, sharpen the Lightness channel and convert back to RGB mode' technique is doing. The same principle applies when using an Edit \Rightarrow Fade Unsharp Mask \Rightarrow Luminosity mode fade. With Camera Raw the sharpening is always applied to the luminance of the image, which is why you shouldn't see any unwanted color artifacts generated whenever you apply a sharpening effect. This explains the purpose of the grayscale preview for the Amount slider. It is designed to show you exactly how the sharpening is applied to the luminance of the photo, hiding the color information so that you can judge the sharpening effect more easily.

Radius and Detail grayscale preview

With the Radius and Detail sliders you are seeing a slightly different kind of preview when you hold down the **a**tt key as you adjust these sliders. The grayscale preview you see here displays the sharpening effect in isolation, as if it were a sharpening effect applied on a separate layer. For those of you who are well acquainted with Photoshop layering techniques, imagine a layer in Photoshop that is filled with 50% gray and where the blend mode is set to 'Overlay'. Such a layer has no effect on the layers beneath it until you start darkening or lightening parts of the layer. In Figure 4.5 you can see a mock-up of what the Detail grayscale preview is actually showing you. It effectively displays the sharpening effect in isolation as light and dark areas against a neutral, midtone gray.

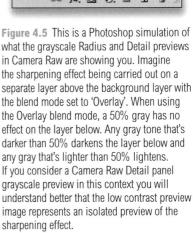

Martin Evening Adobe Photoshop CS5 for Photographers

Figure 4.6 Here is another simulation of what the Camera Raw Masking slider grayscale preview is showing you. As you hold down the (S) (att) key and drag the Masking slider you are effectively previewing a layer mask that masks the sharpening layer effect. In other words, the Masking slider preview shown opposite is kind of showing you a pixel layer mask preview of the masking effect.

Masking slider

The Masking slider can be used to add a filter mask based on the edge details of an image. Essentially, this allows you to target the Camera Raw sharpening so that the sharpening adjustments are more targeted to the edges in the image rather than sharpening everything globally. As you adjust the Masking slider a mask is generated based on the image content, so that areas of the image where there are high contrast edges remain white (the sharpening effect is unmasked) and in the flatter areas of the image where there is smoother tone detail the mask is made black (the sharpening effect is masked). If you take the Masking slider all the way down to zero, no mask is generated and the sharpening effect is applied without any masking. As you increase the Masking, more areas become protected.

I like to think of the effect the Masking slider has on the Camera Raw sharpening as being like a layer mask that masks the layer that's applying the sharpening effect (see the Photoshop example in Figure 4.6). The calculations required to generate the mask are quite intensive, so if you are using a slow computer there may be a short delay as the mask preview is calculated, but on a modern, fast computer you should hardly notice any slow-down here.

I should also mention here how the Masking slider was inspired by a Photoshop edge masking technique that was originally devised by Bruce Fraser. You can read all about Bruce's Photoshop techniques for Input and Output sharpening in an updated version of his book, which is now coauthored with Jeff Schewe: Real World Image Sharpening with Adobe Photoshop, Camera Raw and Lightroom (2nd Edition). This book includes instructions on how to apply the edge masking technique referred to here. As I said earlier, because of how the sharpening controls have been updated in Camera Raw, the Detail panel slider controls now provide a much better capture sharpening workflow solution. For example, the original Photoshop edge masking technique (on which this is based) could only ever produce a fixed width mask edge. While you could vary some of the settings to refine the look of the final mask, it was still rather tricky and cumbersome to do. With Camera Raw it is now much easier to vary the mask width because we now have a single slider control that does everything.

Chapter 4

Masking slider example

1 When the Masking slider is at the default zero setting, no masking is applied. If you hold down the SS all key as you drag the Masking slider, you can see a grayscale preview of the mask that is being generated. At the 50% setting shown here, the mask is

2 In this next screen shot you can see a preview where the Masking slider has been taken to the maximum 100% setting. In this example the masking is a lot stronger and protects all the flat tone areas, leaving only the strongest edges unmasked. The sharpening effect is now only applied to the remaining white areas.

ProPhoto RG8_16 bit_1016 by 969 (1.0MP): 240 gpi

(Save Image)

just starting to protect the areas of flat tone from being sharpened. Camera Raw 6.0 - TIFF WW 9 A A ta 1. 10 10 10 0 M Pro riew 💽 Amount Radius Detail Masking 100 Luminance OF a

Open Copy Reset Done

Construction of the second	Camera Raw 6,0 - TIFF		
		teriev	
		Deta	vening
		Amount Radius Detail	40 1.2 20
		Luminance	80 eduction
		Luminance Detail	0
	iper-endings-pag-di	Color Detail	
Save Image	ProPhoto AGB: 16 bit: 1016 by 968 /1.0MPI: 240 and	Open Copy Res	tet Done

Some real world sharpening examples

Now that I have given you a run down on what the individual sharpening sliders do, let's look at how you would use them in practice to sharpen an image.

Sharpening portrait images

Figure 4.7 shows a 1:1 close-up view of a male portrait where I used the following settings: *Amount: 35, Radius: 1.2, Detail: 20, Masking 70.* This combination of Sharpening slider settings is most appropriate for use with portrait photographs, where you wish to sharpen the important areas of detail such as the eyes and lips, but protect the smooth areas (like the skin) from being sharpened.

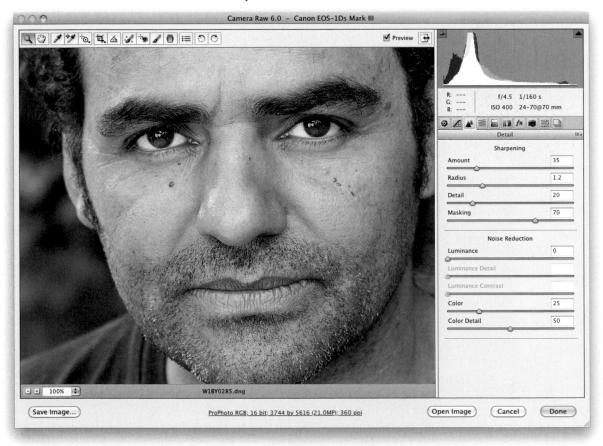

Figure 4.7 Here is an example of the sharpening settings used to pre-sharpen a portrait.

Sharpening landscape images

Figure 4.8 shows the settings that would be used to sharpen a landscape image. The settings used here were: *Amount: 40, Radius: 0.8, Detail: 50, Masking: 10.* This combination of Sharpening slider settings is most appropriate for subjects like the example shown here. You could include quite a wide range of subject types in this category and basically you would use this particular combination of slider settings whenever you needed to sharpen photographs that contained a lot of narrow edge detail. Camera Raw 6.0 now generates narrower halo edges whenever the Radius slider is applied in the 0.5–1.0 range. This has resulted in the ability to apply lower Radius settings to fine-detailed images that need a low radius, but without generating such noticeable halos.

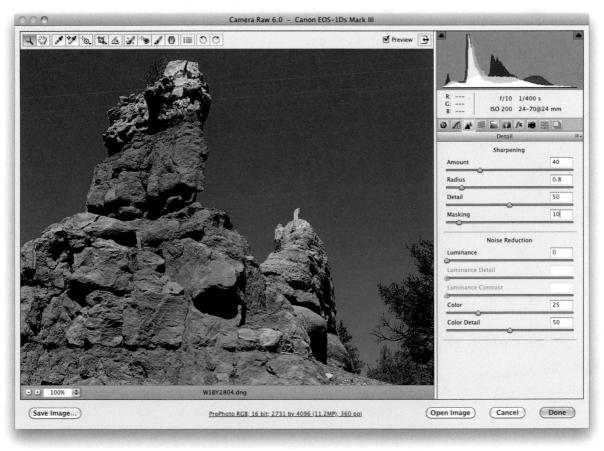

Figure 4.8 Here is an example of the sharpening settings used to pre-sharpen a landscape photo.

Sharpening a fine-detailed image

Figure 4.9 shows an example of a photograph that contains a lot of fine-edge detail, where the Sharpening sliders in the Detail panel needed be taken to extremes. In order to sharpen the fine edges in this picture I had to take the Radius down to a setting of 0.6. I also wanted to emphasize the detail here and therefore ended up setting the Detail slider to +80. This is a lot higher than one would choose to use normally, but I have included this particular image in order to show an example of a photograph that required a unique treatment. As with the previous example, I only needed to apply a very small amount of masking since there were few areas in the photograph where I needed to hide the sharpening.

Figure 4.9 This shows an example of the Detail panel sharpening settings that were used to pre-sharpen a fine-detailed subject.

How to save sharpening settings as presets

You can save the sharpening settings as ACR presets and load them as required, depending on what type of photo you are editing. You could try using the settings in Figure 4.7, 4.8 or 4.9 to create sharpening presets that could in future be applied to other images.

Sharpening		Image Settings Camera Raw Defaults
Amount	40	Previous Conversion
Radius	0.8	✓ Custom Settings Preset Settings
Detail	50	Apply Preset
Masking	10	Apply Snapshot
Noise Reduction		Clear Imported Settings
Luminance	0	Export Settings to XMP
Luminance Detail		Update DNG Previews
Duminance Contrast		Load Settings Save Settings
Color	25	Save New Camera Raw Defaults
Color Detail	50	Reset Camera Raw Defaults
n Image) (Cancel) (Done	

Default sharpening settings

The standard default sharpening setting for raw images uses the settings shown earlier in Figure 4.4. This isn't a bad starting point, but based on what you have learned in the last few examples, you might like to modify this and set a new default. For example, if most of the work you shoot is portraiture, you might like to use the settings shown in Figure 4.7 and set these as a default and make this setting specific to your camera (see pages 167–168).

 ${\tt 1}$ After configuring the Detail panel settings, go to the fly-out menu and choose 'Save Settings . . .'

Save Settings	
Subset: Custom Subset	Save
White Balance	Cancel
Exposure	
Recovery	
Fill Light	
Blacks	
Brightness	
Contrast	a la cara de ser
Clarity	
Uibrance	
Saturation	
Parametric Curve	
Point Curve	
Sharpening	Contract Strenders
Luminance Noise Reduction	
Color Noise Reduction	
🗋 Grain	
Grayscale Conversion	
HSL Adjustments	
Split Toning	

 ${\tt 2}$ This opens the Save Settings dialog shown here. Check the Sharpening box only and click the Save... button.

Settings folder location

On a Mac, the Camera Raw Settings folder location is: username/Library/Application Support/Adobe/Camera Raw/Settings. On a PC, look for: C:/Documents and Settings/username/Application Data/ Adobe/CameraRaw/Settings.

· · ·	
Save As: Sharpen-landscapes.xmp	
Where: Settings	•
Format: Default	•
	(Cancel) Save

3 Now name the setting and save to the default Settings folder. Don't change the directory location you are saving the setting to here.

Auto grayscale	.13
Auto settings	
B&W Infrared	
Calibrate EOS 1Ds MkIII	
Calibrate-EOS1DsMkII	
Camera defaults	
Color infrared	
Infrared	
Magenta sky	
Sharpen-landscapes	
Sharpen-portraits	
	5 8

4 When you need to access the saved setting, go to the Settings panel in the Camera Raw dialog and click on a saved setting to apply it to an image. Since the setting here has been saved with the Sharpening adjustments only, when you select this preset it will only adjust the sharpening sliders when you apply it to another image.

Capture sharpening roundup

Hopefully this section has given you the confidence to now carry out all your capture sharpening in Camera Raw. Remember, the only images that should need pre-sharpening are camera shot raws or scanned TIFFs, although you can process any image in Camera Raw providing it is in a JPEG, TIFF, raw or DNG format and in an RGB or Lab mode color space.

As I explained in the previous section, you should use the Camera Raw Sharpening controls to tailor the capture sharpening adjustment to suit the image content. Soft-edged subjects such as portraits will suit a higher than 1.0 Radius setting combined with a low Detail and high Masking setting. Fine-detailed subjects such as the Figure 4.8 and 4.9 examples will suit using a low Radius, high Detail and low Masking setting. The aim always is to apply enough sharpening to make the subject look visually sharp on the screen, but without over-sharpening to the point where you see any edge artifacts or halos appear in the image. If you overdo the capture sharpening you are storing up trouble for later when you come to retouch the photograph.

Selective sharpening in Camera Raw

With some images it can be tricky to find the optimum settings that will work best across the whole of the image. This is where it can be useful to use the localized adjustment tools to selectively modify the sharpness of an image. Basically, whenever you are using the adjustment brush or the gradient filter tools in Camera Raw you can use the Sharpness slider to add more or less sharpness. In particular, with Camera Raw 6.0 as you increase the Sharpness, the sharpness applied using a brush or gradient increases the sharpness 'Amount' setting based on the other settings already established in the Detail panel Sharpneing section.

Negative sharpening

You can also apply negative local sharpening in the zero to -50 range to fade out existing sharpening. Therefore, if you apply -50 Sharpness as a localized adjustment this means you can use the adjustment tools to disable the capture sharpening. As you apply a negative Sharpness in the -50 to -100 range, you start to apply anti-sharpening, which is effectively a gentle lens blur effect.

Extending the sharpening limits

You can also go beyond the +100/-100 limit set by the Sharpness slider by applying multiple sharpness adjustments. To do this you need to create a new brush group using a positive or negative Sharpness setting and paint on top of an existing brush group. However, when applying a negative sharpness adjustment the effect will eventually max out and won't become any extra blurred beyond a certain point. You can't yet apply what you might call a true lens blur effect in Camera Raw.

Two Smart Object sharpening layers

An alternative approach is to use the 'Open raw files as Smart Objects' technique described on pages 158–161 to open an image twice (see also pages 393–394). You can then apply one set of Detail panel settings to one Camera Raw Smart Object layer and a different type of sharpening effect to the other Camera Raw Smart Object layer. You can then use a layer mask to blend these two layers so that you are able to combine two different methods of sharpening in the one image.

Figure 4.10 Here you can see a full frame view of the photograph that I was editing.

1 In this photograph I left the camera switched to auto focus mode. Although the photo was shot using a smallish lens aperture, the rocks ended up being more in focus than the shipwrecked boat in the background (you can see a full view of the image in Figure 4.10). Obviously I should have switched to manual focus and selected an appropriate hyperfocal distance between the rocks in the foreground and the boat in the distance. Still, this mistake did at least allow me to demo selective sharpening in Camera Raw. To start with I clicked to select the Detail panel and adjusted the sharpening sliders to obtain the optimum sharpness for the rocks, while the shipwrecked boat still remained a little soft. I didn't want to overdo the sharpening here, since to do so would create visible sharpening artifacts in the foreground of the photograph.

2 In this next step I selected the adjustment brush, set the Sharpness to +50, clicked on the image and painted on top of the boat. The objective here was to use the adjustment brush to add more sharpness to this area of the image. The Amount setting for the Sharpness slider effectively added an extra Sharpness Amount using the same Radius, Detail and Masking settings as had already been applied in the Detail panel in Step 1. In this particular example I found it was best to use the adjustment brush, but in some instances you might want to use the Gradient filter instead.

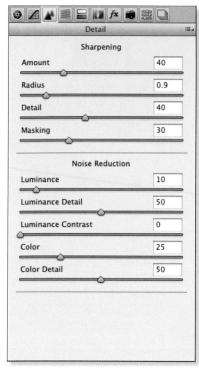

Figure 4.11 The Detail panel showing the Noise Reduction sliders.

Removing random pixels

Camera Raw noise reduction is also able to remove outlying pixels, those additional, random light or dark pixels that are generated when an image is captured at a high ISO setting. Camera Raw can also detect any dead pixels and smooth these out too. You won't normally notice the effect of dead pixels, but they do tend to show up more when carrying out long time exposures. Even then you may only see them appear very briefly on the screen as Camera Raw quickly generates a new preview image.

Noise removal in Camera Raw

All images are likely to suffer from some degree of noise, but the amount of noise present will vary according to a number of factors. The noise we see in scans made from film originals will mainly be down to the actual film grain in the film emulsion (especially if the image originated from a 35mm film emulsion), whether it came from a color negative or chrome original, and what particular film emulsion was used. It can also be due to noise generated during the scanning process itself.

With digital images the noise seen will mainly depend on the quality of the camera sensor and what ISO setting the photograph was shot at. Some sensors definitely perform better than others when used at higher ISO speeds and with the most recent digital SLR cameras we have seen a remarkable improvement in image capture quality at high ISO settings. Another factor is exposure. On page 186 I showed how deliberately underexposing a digital photo can lead to shadow noise problems as you compensate by increasing the Exposure slider amount. In fact, the shadow areas are always the biggest problem, and you should check the shadows first to determine how successful your camera is as at handling image noise. Whenever you shoot using a high ISO setting you will almost certainly encounter some noise. The new improved Noise Reduction sliders in Camera Raw offer better than ever noise reduction for processing digital images, so much so that I reckon Camera Raw should now be able to meet all your noise reduction requirements. As a consequence of this there may be less need to rely on Photoshop or third-party products to carry out the noise reduction. Bear in mind that JPEG capture images will have already been processed in-camera to remove any noise. To take full advantage of Camera Raw noise reduction, you'll need to work with raw capture images.

Detail panel noise reduction sliders

The Noise Reduction controls are shown in Figure 4.11. The Luminance slider is used to smooth out the speckled noise artifacts. The default setting is zero, but I think you'll find that even with low ISO captures it is helpful to apply just a little Luminance noise reduction; in fact my colleague Jeff Schewe likes to describe this as the fifth sharpening slider and suggests you always include adding at least a little Luminance noise reduction

as part of a normal sharpening process. Excessive Luminance slider adjustments can lead to a softening of edge detail and to help counter this, the new Luminance Detail slider acts like a threshold control for the main Luminance slider, where the default setting is 50. When this slider is dragged to the left you will see increased noise smoothing. However, as you do so, important image detail may get treated as noise and also become smoothed. Dragging the slider to the right reduces the amount of smoothing used and so allows you to dial back in any missing edge sharpness. With the Luminance Contrast slider the default setting is 50. The smoothest results are achieved by dragging the slider all the way to the left. However, doing so can sometimes make the noise reduction look unnatural and plastic-looking. Dragging the slider to the right therefore preserves more of the texture contrast in the image, but at the same time this can lead to increased mottling in some high ISO images. It is also worth pointing out here that the Luminance Contrast slider has the greatest effect when the Luminance Detail slider is set to a low value. As you increase the Luminance Detail, the Luminance Contrast slider has less impact on the overall luminance noise reduction.

The Color slider works by separating the color from the luminance information and smooths out the color noise artifacts such as the magenta/green speckles you commonly see in noisy high ISO captures. For the most part you can safely crank the Color noise reduction slider up towards the maximum setting. However, increasing the Color noise reduction slider can also result in color bleeding, which will result in the fine color details in an image becoming desaturated. This kind of problem is one that you are only likely to see with really noisy images that contain fine color edge detail, so it's not something you need to worry about most of the time. The Color Detail slider allows you to help preserve color detail in such images and as you increase the Color Detail slider beyond the default 50 setting you'll notice how it preserves more detail in the color edges. Take care when you use this slider, because as you increase the amount that is applied this can lead to some color speckles reappearing along the preserved edges. In areas that have a strong color contrast you can see an over-sharpening of the color boundary edges. To understand more clearly the effect all of these sliders are having, you may want to zoom in to look at a 400% view.

Is the noise really visible?

Some of the latest digital cameras, such as Nikon and Canon digital SLRs, are capable of capturing images at extremely high ISO settings and although reviewers talk about seeing noise in these captures, I've yet to see much in the way of noticeable noise appear in print, unless you were to print an enlarged detail of what can be seen on the screen at, say, 2:1. The main point I am trying to make here is not to over-obsess when analyzing your images in close-up.

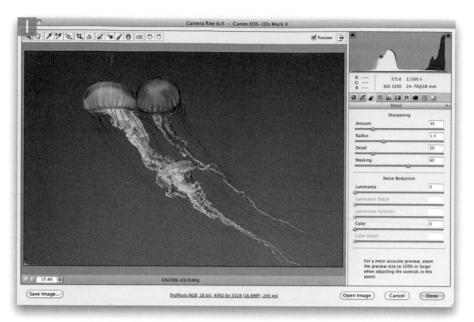

1 Here is a photograph that was shot at 3200 ISO and is a good candidate image with which to demo the Process Version 2010 Color noise reduction.

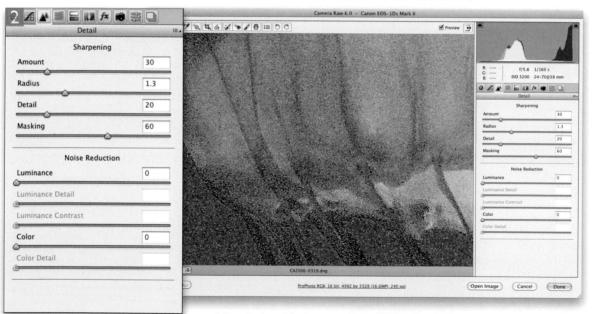

2 Here, I enlarged the image preview to 200% and set the Color slider to zero. As you can see, there were a lot of color noise artifacts in this image.

39	Camera Raw 6.0 - Canon EOS-1Ds Mark II		9 A ¥ 1)
		Preview		Detail	<u></u> !≣.4
		R (/5.6 1/16	Amount	Sharpening)
		G: ISO 3200 24-7		1.	3
		Sharpening	Detail	20)
		Radius Detail	Masking	<u>6</u>	
		Masking	N	loise Reduction	
		Noise Reduction	Luminance	0	
		Luminance Detail	Luminance Det	ail	
	Children Constants	Color Color Detail	Luminance Con	itrast	
			Color	60	
- <u>−</u> 200% 4 CA2000	-0319.dng		Color Detail	3(2
	Photo RGB: 16 bit: 4992 by 3328 (16.6MP); 240 ppj	Open Image Cancel			

3 In this step, I applied a Color noise reduction of 60. The Color Detail slider can do a good job resolving the problem of color edge bleed that is commonly associated with Color noise reductions. However, an excessive amount can cause edges with color contrast to appear unnaturally over-sharpened, so I applied a Color Detail setting here of 30.

4 2	Camera Raw 6.0 - Canon EOS-1Ds Mark II		9 A M = =	11 f× 📸 🗮 🗋
-7/7a44×0=0	0	Preview	Concernent Annener Concernent Annener Annener Annener	Detail III.
A CARLER OF COMPANY		R	Amount	harpening 30
		B ISO 3200	0.1	1.3
		Sharpen Amount	Detail	20
		Radius Detail	Masking	60
		Masking	A STATE OF A	se Reduction
		Noise Redi	Luminance	35
	There is set of the set of the	Luminance Contrast	Luminance Detail	20
Render		Color Color Detail	Luminance Contra	st 70
			Color	60
• • 200X •	CA2006-0319.dng		Color Detail	30
(Save Image)	ProPhoto RGR 16 bit: 4992 by 3328 (16.6MP); 240 pp	Open Image Cance		

4 In this final version I applied a Luminance noise reduction of 35 with a Luminance Detail setting of 20 and a Luminance Contrast setting of 70.

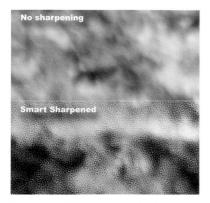

Figure 4.12 Take care when using the Smart Sharpen filter. If you apply an excessive amount of Smart Sharpen this can lead to ugly artifacts like those seen in the bottom half of this screen grab.

Improved sharpen tool

The sharpen tool in Photoshop has been improved in CS5. The new Protect Detail mode utilizes a new algorithm that minimizes any pixelation when the sharpen tool is used to emphasize image details. The Protect Detail mode can therefore faithfully enhance high frequency image details without introducing noticeable artifacts (see Figure 4.13).

Localized sharpening in Photoshop

Smart Sharpen filter

We have so far seen how to apply localized sharpening in Camera Raw. Let me now show you a few ways this can be done directly in Photoshop. One way is to use the Smart Sharpen filter. Don't be too taken in by the fact that it's called a 'smart' sharpening filter. Some people figure this is a kind of 'super unsharp mask' filter and might therefore be a better tool to use for general sharpening. If applied correctly, it can be used to sharpen areas where there is a distinct lack of sharpness, but if used badly it can soon introduce ugly artifacts (see Figure 4.12). The Smart Sharpen filter also runs very slowly compared with the Unsharp Mask filter and Camera Raw sharpening. Therefore, I generally consider Smart Sharpen to be more useful as a tool for 'corrective' rather than one for general sharpening.

Basic Smart Sharpen mode

The Smart Sharpen filter has three blur removal modes: Gaussian Blur is more or less the same as the Unsharp Mask filter, but the Lens Blur method is the more useful as it enables you to counteract optical lens blurring. Lastly, there is Motion Blur removal, which can sometimes be effective at removing small amounts of motion blur from an image. After you have selected a blur removal method, you can use the Amount and Radius slider controls to adjust the sharpening effect.

In the example on the page opposite I first went to the Filter menu and chose 'Convert for Smart Filters', which converted the Background layer to a Smart Object layer. This allowed me to apply the Smart Sharpen filter as a 'smart filter', where I could edit the filter effect coverage by painting on the layer mask. An alternative option would be to duplicate the Background layer and apply the Smart Sharpen filter to that layer, but the advantage of the Smart Object/Smart filter layer approach is that the Smart Sharpen filter settings remain editable – you simply double-click the Smart Sharpen layer to reopen the filter dialog shown in Step 1.

A T 13 Mode: Normal Strength: 50% C Sample All Layers Protect Detail

Figure 4.13 This shows the sharpen tool options, including the new Protect Detail mode.

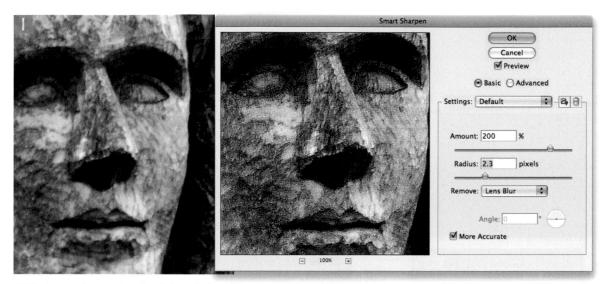

1 This shows a close-up view of a photograph where the main subject was slightly out of focus. I didn't want to apply any further global sharpening as this would have created artifacts in the background. I converted the Background image layer to a Smart Object and applied the Smart Sharpen filter using the settings shown here.

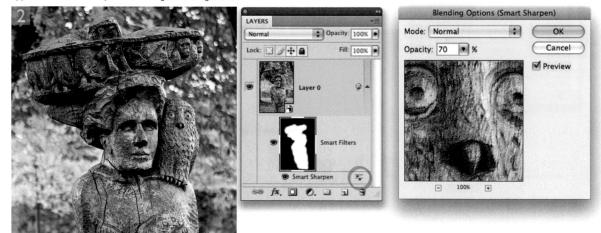

2 The Smart Sharpening effect worked fine on the statue, but created noticeable image artifacts in the background (see Figure 4.12), so I clicked on the Smart Object mask layer, filled with black and painted on this layer with white so that the smart filtering was revealed on the statue only. I then double-clicked the Smart Object layer options (circled) to open the Blending Options dialog and reduced the filter effect Opacity to 70%.

Saving the Smart Sharpen settings

You can save Smart Sharpen settings as you work by clicking on the save settings icon circled below in Figure 4.14, and call these up via the Settings menu in the Smart Sharpen filter dialog.

Advanced Smart Sharpen mode

In Advanced mode you get to see two additional tabbed sections marked Shadow and Highlight. The controls in these sections act like dampeners on the main smart sharpening effect. The Fade Amount slider selectively reduces the amount of sharpening in either the shadow or highlight areas. This is the main control to play with as it will have the most initial impact in reducing the amount of artifacting that may occur in the shadow or highlight areas. Below that is the Tonal Width slider and this operates in the same way as the one you find in the Shadows/Highlights image adjustment: you can use this to determine the tonal range width that the fade is applied to. These two main sliders allow you to subtly control the smart sharpening effect. The Radius also works in a similar way to the Radius slider found in the Shadows/ Highlights adjustment and is used to control the area width of the smart sharpening.

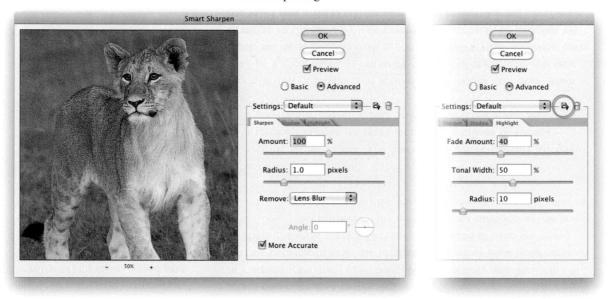

Figure 4.14 In this photograph I set the Smart Sharpen filter to Advanced mode and applied an Amount of 100% at a Radius of 1.0 using the Lens Blur mode with the More Accurate box checked. Once I had selected suitable settings for the main Smart Sharpen, I clicked on the Shadow and Highlight tabs and used the sliders in these sections to decide how to limit the main sharpening effect. A high Fade Amount setting will fade the sharpening more, while the Tonal Width determines the range of tones that are to be faded. Lastly, there is the Radius slider, where you can enter a Radius value to determine the scale size for the corrections.

Sharpening and noise reduction

Chapter 4

Removing Motion Blur

The Motion Blur mode can be used to correct for mild camera shake or small amounts of subject movement in a photograph (see Figure 4.15). If you select the Remove Motion Blur mode, the trick here is to get the angle in the dialog to match the angle of the Motion Blur in the picture and adjust the Radius and Amount settings to optimize the Motion Blur correction. To achieve optimum results with any of these sharpening modes, check the 'More Accurate' option at the bottom This will increase the time it takes the filter to process the image, but I suggest you leave it checked if you want to get the very best results.

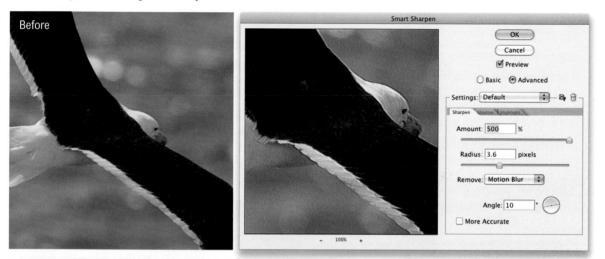

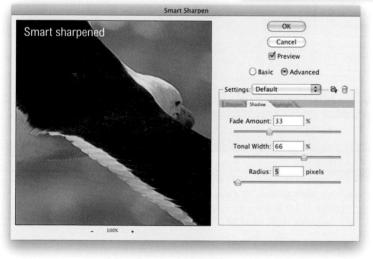

Figure 4.15 The Motion Blur method of smart sharpening is reasonably good at improving sharpness where there is just a slight amount of camera shake or subject movement. In this example I initially set the Amount, Radius and Angle to achieve the most effective sharpening and in Advanced mode I went to the Highlight tab to adjust the Fade Amount and Tonal Width settings so as to dampen the sharpening effect in the highlights. This helped achieve a slightly smootherlooking result.

No to Smart Filter layers

On page 278 I mentioned how it was advantageous to use Smart Filter layers when applying a localized filter effect, mainly because with a Smart Object layer you can go back and revise the filter settings later. Unfortunately you can't apply the technique described here using Smart Object layers, because there are no options to set the layer blending (as shown in Step 2). There is also no way to get the two filter effects applied in Step 3 to merge as one when setting the blend mode to Overlay. Basically, Smart Filter layers are a great idea, but they are still quite limited in their application to tasks such as this.

Adjusting the Depth of field settings

The Unsharp Mask and High Pass filter settings used here were designed to add sharpness to areas that contained a lot of narrow edge detail (such as the edges in a landscape). You will want to vary these settings when treating other types of photographs where you perhaps have wider edges that need sharpening. For example, Bruce's original formula suggests using an Unsharp Mask filter Radius of 4 pixels combined with a 40 pixel Radius in the High Pass filter.

Creating a depth of field brush

On page 279 I showed how you could use the Smart Sharpen filter to remove the blurriness from parts of an image and selectively apply the filter effect through a layer mask. There is also another way you can reduce blur in a photograph and this technique is closely based on a technique first described by Bruce Fraser, in his book the *Real World Image Sharpening with Adobe Photoshop, Camera Raw and Lightroom* (2nd Edition). The only thing I have done here is to change some of the suggested settings, in order to produce a narrower edge sharpening brush. Basically, you can adapt these settings to produce a sharpness layer that is suitable for different types of focus correction.

Of course, you can't really make out-of-focus elements in a picture come back into focus, but you can make the blurred image detail *appear* to look sharper by adding a blended mixture of sharp and soft halos which create the illusion of apparent sharpness. The following technique requires you to first create a duplicate of the Background layer and adjust the Layer Style options so that the filter effects you are about to apply are limited to the midtone areas only and the extreme shadows and highlights are protected.

You will notice that the first step involves changing the blend mode of the duplicate background layer to Overlay. This will initially make the image appear more contrasty, but you will find that once you have applied the Unsharp Mask followed by the High Pass filter, it is only the image edges that are enhanced by the use of this technique. In Step 3 you will notice I apply the Unsharp Mask filter at a maximum strength of 500%, with a Radius of 1.0 pixel and the Threshold set to zero. The purpose of this step is to aggressively build narrow halos around all the edge detail areas, and in particular the soft edges, while the High Pass filter step is designed to add wider, over lapping, soft-edged halos that increase the midtone contrast. When these two filters are combined you end up with a layer that improves the apparent sharpness in the areas that were out-of-focus, but the downside is that the previously sharp areas will now be degraded. By adding a layer mask filled with black, you can use the brush tool to paint with white to selectively apply the adjustment to those areas where the sharpening effect is needed most.

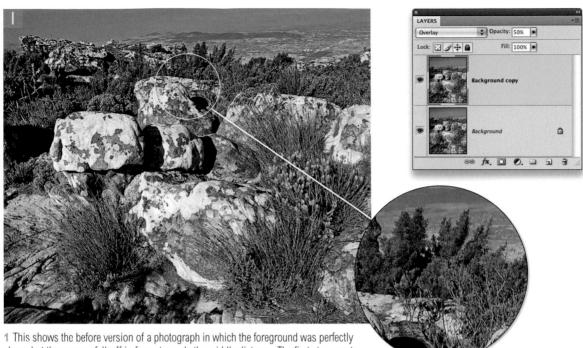

1 This shows the before version of a photograph in which the foreground was perfectly sharp, but there was a fall-off in focus towards the middle distance. The first step was to make a duplicate of the Background layer.

Styles	Blending Options OK
Blending Options: Custom	Blend Mode: Overlay
Drop Shadow	Opacity: 50 % New Style
Inner Shadow	de l
Outer Glow	
Inner Glow	Fill Opacity: 100 % Channels: V R V G V B
Bevel and Emboss	Knockout: None
Contour	Blend Interior Effects as Group
Texture	Blend Clipped Layers as Group
🖂 Satin	Transparency Shapes Layer
Color Overlay	Layer Mask Hides Effects
Gradient Overlay	Vector Mask Hides Effects
Pattern Overlay	Blend If: Gray
Stroke	This Layer: 0 225 / 255
	A d b
Sector Sector	Underlying Layer: 0 / 30 225 / 255

2 I then double-clicked the Background layer to open the Layer Style options and adjusted the settings as follows. The blend mode was set to 'Overlay' and the layer Opacity reduced to 50%. The layer 'Blend If' sliders were adjusted as shown here to provide more protection for the extreme shadows and highlights.

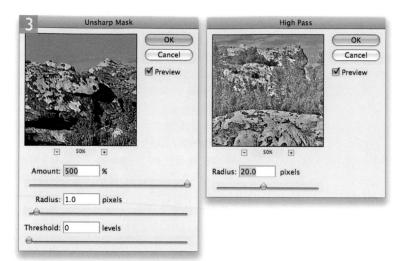

3 I clicked OK to the Layer Style changes and applied an Unsharp Mask filter to the Background copy layer, using an amount of 500% and a Radius of 1.0 pixel. This was followed by a High Pass filter (Filter \Rightarrow Other \Rightarrow High Pass) using a Radius of 20 pixels.

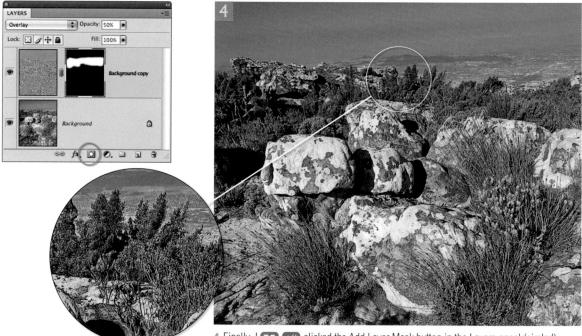

4 Finally, I S all clicked the Add Layer Mask button in the Layers panel (circled). This added a layer mask filled with black, which hid the layer contents. I was then able to select a normal brush and paint on the layer mask with white to reveal the depth of field sharpening layer and, in doing so, add more apparent sharpness to the middle distance.

Removing noise in Photoshop

Overall, Photoshop now provides you with several strategies for reducing noise. For example, with previous versions of Camera Raw all we had were the Luminance and Color sliders, but if you now process your images via Camera Raw 6.0 you can use the new noise reduction sliders to produce better results. When you combine this and the new demosaicing, I would say that Camera Raw 6.0 now offers all the sharpening and noise reduction tools that you are ever likely to need for processing raw images. Personally I regard this as a pretty significant achievement, plus you have the added advantage of being able to quickly and easily synchronize the sharpening and noise reduction settings across multiple selected photos.

In Photoshop itself there is the Reduce Noise filter, which can also do a fairly good job of removing noise, except you can only apply the filter to one image at a time. You could always create an action and apply this as a batch process to a group of images, but this can still be quite a costly exercise in terms of the time it would take to process a group of images. I think the main reason why the Reduce Noise filter still has value (as well as the thirdparty solutions mentioned below) is that you can use it to process scanned film images directly in Photoshop.

Third-party noise reduction

If you are dissatisfied with the results from Photoshop's Reduce Noise filter, there are third-party noise reduction programs you can buy such as Noise NinjaTM from Picturecode, Neat ImageTM or NoisewareTM from Imagenomic. These are just two of the more popular products favored by photographers. Noise Ninja is held in high esteem, but I am personally more familiar with Noiseware and have certainly been impressed by the way it is capable of removing noise from even the most tricky subjects, particularly grainy film scans. Noiseware offers a number of preset settings that can be applied to various types of film scanned sources and manages to do a good job of counterbalancing the need to remove noise while retaining edge sharpness in an image. Both of these are good products, but I would now maintain that the new improved noise reduction capability that's built into Camera Raw may change people's mind as to whether these plug-ins are needed still.

Reduce Noise filter

The Reduce Noise filter can be found in the Filter \Rightarrow Noise menu in Photoshop (Figure 4.16). This filter uses a method of smart noise reduction that is able to remove noise from an image, but without destroying the edge detail in the picture. Overall, the Reduce Noise filter is most useful at reducing the noise from digital capture images. It is less good at reducing the film grain noise that's found in scanned film images. This filter is mainly designed to target the two main problems found in digital images, which are luminance and color noise. Luminance noise is like a very fine speckly grain, while color noise commonly occurs in digital captures that have

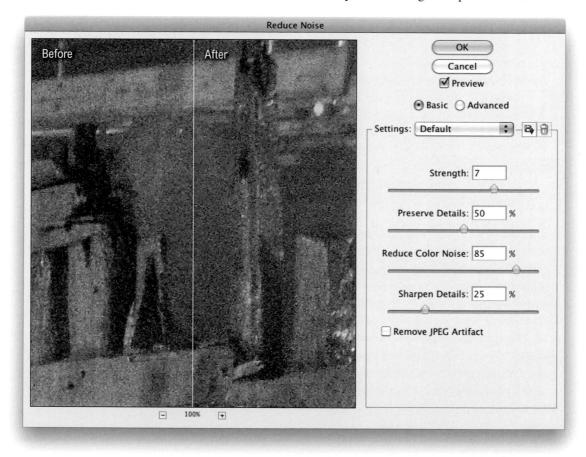

Figure 4.16 Here is the Reduce Noise filter being used to help remove the noise from a digital capture which was shot at 3200 ISO; the Reduce Noise filter helped get rid of most of the noise artifacts.

been shot at high ISO settings. The only problem with this filter is that it is quite memory intensive, so you'll have to be prepared to wait a little while it performs its calculations.

In Basic mode you can simply adjust the strength of the noise reduction and then adjust the controls below (in the order they are displayed) to modify the noise filtering. The Strength slider adjusts the amount of noise reduction that is applied, while the Preserve Details slider helps preserve the edge luminance information. The luminance noise reduction appears strongest when you set Preserve Details to zero %, but as you increase Preserve Details, more edge detail (and often more noise) will become visible. The one thing you have to watch out for is that when you apply extreme settings you can sometimes end up enhancing the underlying noise patterns. Below that is the Reduce Color Noise slider. This allows you to control the color noise suppression and can be quite effective at removing heavy noise. There are times when you may want to crank up the Reduce Color Noise to 100%, in order to remove as much of the noise artifacts as possible, but be aware that adding too much color noise reduction can sometimes cause colors to bleed badly and cause too much softening of the image.

After you have adjusted all of the above settings, it is likely that the image will have suffered some loss in sharpness. The Sharpen Details slider allows you to dial back in some detail sharpness. I would again urge caution here because adding too much sharpening can simply introduce more artifacts.

Advanced mode noise reduction

In Basic mode you are only able to adjust the Reduce Noise settings so that they affect the overall strength and image detail preservation. When the Advanced mode button is checked you can apply the noise reduction adjustments on a per channel basis (see Figure 4.17). This can be useful if you wish to apply differential amounts of noise reduction to individual channels. For example, whether you are treating a digital capture or scanned film emulsion, the Blue channel is usually the noisiest so it can therefore be a good idea to apply more reduction to this channel and less to the Red and Green channels where the noise is usually less of a problem.

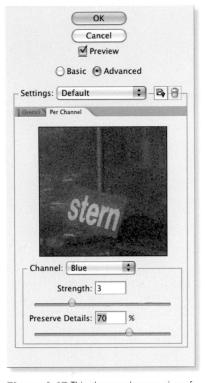

Figure 4.17 This shows a close-up view of the Reduce Noise filter settings in Advanced mode where you can adjust the settings for the individual color channels.

Adobe Photoshop CS5 for Photographers

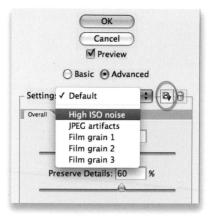

Figure 4.18 If you click on the Settings menu you can access the Reduce Noise filter preset settings. If you click on the button circled here you can save your own custom preset settings.

JPEG noise removal

You can also use the Reduce Noise filter to smooth out JPEG artifacts. If you have a heavily compressed JPEG image, the Reduce Noise filter can certainly help improve the image smoothness, but I reckon you can also use the Reduce Noise filter in this mode to improve the appearance of GIF images too. Of course you will need to convert the GIF image from Indexed Color to RGB mode first, but once you have done this you can use the Reduce Noise filter adjustments to help get rid of the banding by taking the Preserve Details slider down to zero % and raise the Sharpen Details slider to a higher amount than you would use normally. Figure 4.19 shows an example of the Reduce Noise filter being used to smooth the banding in a GIF image.

Saving the Reduce Noise settings

Favorite Reduce Noise settings can be saved by clicking on the Save Changes to Current Settings button which is circled in Figure 4.18. You can also delete saved Reduce Noise settings by clicking on the trash icon next to it.

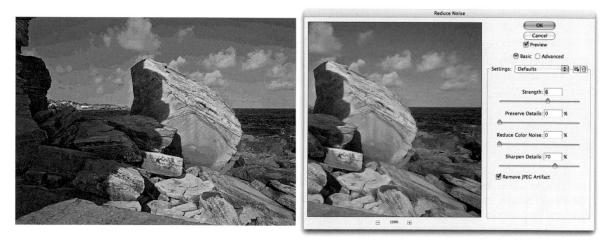

Figure 4.19 The Reduce Noise filter has a 'Remove JPEG Artifact' option that can be used to improve the appearance of an image that has suffered from over-heavy JPEG compression. It can also help rescue a GIF image where color levels information has been lost in the conversion to Indexed Color mode. Note that in order to use the Reduce Noise filter a GIF image will have to be converted to RGB mode first. In this example I checked the Remove JPEG Artifact box. To remove the color banding the Preserve Details had to be set to 0% and to make the image sharp again I set the Sharpen Details to 70%.

Chapter 5

Image Editing Essentials

o far I have shown just how much can be done to improve an image's appearance when editing it in Camera Raw, before you bring it into Photoshop. Some of the techniques described in this chapter may appear to overlap with Camera Raw editing, but image adjustments such as Levels and Curves still play an important role in everyday Photoshop work. This chapter also explains how to work with photos that have never been near Camera Raw, such as images that have been supplied to you directly as TIFFs or JPEGs. I'll start off by outlining a few of the fundamental principles of pixel image editing such as bit depth and the relationship between image resolution and image size. After that we'll look at the main image editing adjustments and how they can be used to fine-tune the tones and colors in a photograph.

Martin Evening Adobe Photoshop CS5 for Photographers

Pixels versus vectors

Digital photographic images are constructed of pixels and as such are resolution-dependent. You can therefore only scale the finite pixel image information so far before the underlying pixel structure becomes apparent. By contrast, vector objects that can be created in programs like Adobe Illustrator are defined mathematically, so if you draw a rectangle, the proportions of the rectangle edges, the relative placement on the page and fill color can all be described using a mathematical description. An object that's defined using vectors can therefore be output at any resolution and it does not matter if the image is displayed on a computer display, a postage stamp or as a huge poster, it will always be rendered with the same amount of detail (see Figure 5.1 below).

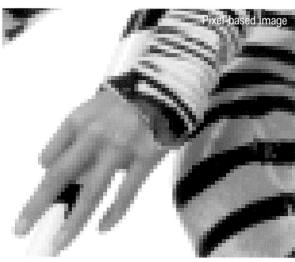

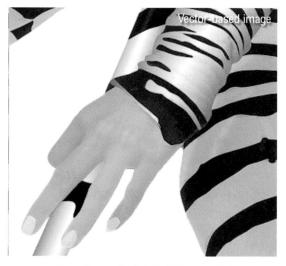

Figure 5.1 Digital images are made up of a mosaic of pixels. This means that a pixel-based digital image will always have a fixed resolution and is said to be 'resolution-dependent'. If you enlarge such an image beyond the size at which it is meant to be printed, the pixel structure will soon become apparent, as can be seen here in the left-hand close-up view. Suppose though the above picture originated not as a photograph, but was drawn as an illustration using a program like Adobe Illustrator. If a picture is constructed using vector paths, it will be resolution-independent. The mathematical numbers used to describe the path outlines shown in the example on the right can then be scaled to reproduce at any size: from a postage stamp to a billboard poster. As you can see in the comparison shown here, the pixel image starts to break up as soon as it is magnified, whereas the outlines in the vector-drawn image will reproduce perfectly smoothly at any size.

'Stalkers' by The Wrong Size. Photograph: © Eric Richmond.

Photoshop as a vector program

Photoshop is mainly regarded as a pixel-based graphics program, but it has the capability to be a combined pixel and vector editor because it does also contain a number of vector-based features that can be used to generate things such as custom shapes and layer clipping paths. This raises some interesting possibilities, because you can create various graphical elements like type, shape layers and layer clipping paths in Photoshop which are all resolutionindependent. These 'vector' elements can be scaled up in size in Photoshop without any loss of detail, just as you can with an Illustrator graphic.

Image resolution terminology

Before I proceed any further let me help explain a few of the terms that are used when describing image resolution, and clarify their correct usage.

ppi: pixels per inch

The term 'pixels per inch (ppi)' should be used to describe the pixel resolution of an image, although the term 'dpi' is also often used to inappropriately describe the digital resolution of an image. It is incorrect to use the term 'dpi' because input devices like scanners and cameras don't produce dots, they produce pixels. Only printers can produce dots! However, it's become commonplace for scanner manufacturers and other software programs to use the term 'dpi' when what they really mean is 'ppi'. Unfortunately this has only added to the confusion, because you often hear people describing the resolution of an image as having so many 'dpi', but if you look carefully, Photoshop and the accompanying user guide always refers to the input resolution as being in 'pixels per inch'. So if you have an image that has been captured on a digital camera, scanned from a photograph, or displayed in Photoshop, it is always made up of pixels, and the pixel resolution (ppi) is the number of pixels per inch in the input digital image. Obviously, those using metric measurements can refer to the number of 'pixels per centimeter'.

Ipi: lines per inch

This is the number of halftone lines or 'cells' in an inch (also described as the screen ruling). The origins of this term go back way before the days of digital desktop publishing. To produce a

Confusing terminology

You can see from this description where the term 'lines per inch' originated. In today's digital world of imagesetters, the definition is somewhat archaic, but is nonetheless commonly used. You may hear people refer to the halftone output as 'dpi' instead of 'lpi', as in the number of 'halftone' dots per inch, and the imagesetter resolution referred to as having so many 'spi', or 'spots per inch'. Whatever the terminology I think we can all logically agree on the correct use of the term 'pixels per inch', but I am afraid there is no clear definitive answer to the mixed use of the terms 'dpi'. 'lpi' and 'spi'. It is an example of how the two separate disciplines of traditional repro and those who developed the digital technology chose to apply different meanings to these same terms.

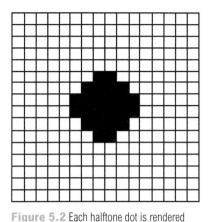

halftone plate, the film exposure was made through a finely etched criss-cross screen of evenly spaced lines on a glass plate. When a continuous tone photographic image was exposed this way, dark areas formed heavy halftone dots and the light areas formed smaller dots, which when viewed from a normal distance gave the impression of a continuous tone image on the page. The line screen resolution (lpi) is therefore the frequency of halftone dots or cells per inch.

dpi: dots per inch

This refers to the resolution of an output device. For example, let's say we have an imagesetter device that is capable of printing small, solid black dots at a resolution of 2450 dots per inch and the printer wishes to use a screen ruling of 150 lines per inch. If you divide the dpi of 2450 by the lpi of 150, you get a figure of 16. Therefore, within a matrix of 16×16 printer dots, an imagesetter can generate individual halftone dots that vary in size on a scale from zero (no dot) to 255. It is this variation in halftone cell size (constructed of smaller dots) which gives the impression of tonal shading when viewed from a distance (see Figure 5.2).

Desktop printer resolution

In the case of desktop inkjet printers the term 'dpi' is used to describe the resolution of the printer head, and the dpi output of a typical inkjet can range from 360 to 2880 dpi. Although this is a correct usage of the term 'dpi', in this context it means something else yet again. Most inkjet printers lay down a scattered pattern of tiny dots of ink that accumulate to give the impression of different shades of tone, depending on either the number of dots, the varied size of the dots, or both. While a correlation can be made between the pixel size of an image and the 'dpi' setting for the printer, it is important to realize that the number of pixels per inch is not the same as the number of dots per inch created by the printer. When you send a Photoshop image to an inkjet printer, the pixel image data is processed by the print driver and converted into data that the printer uses to map the individual ink dots that make the printed image. The 'dpi' used by the printer simply refers to the fineness of the dots. Therefore a print resolution of 360 dpi can be used for speedy, low quality printing, while a dpi resolution of 2880 can be used to produce higher quality print outputs.

by a PostScript RIP from the pixel data and output to a device called an 'imagesetter'. The halftone dot illustrated here is plotted using a 16×16 dot matrix. This matrix can therefore reproduce a total of 256 shades of gray. The dpi resolution of the imagesetter, divided by 16, will equal the line screen resolution. 2400 dpi divided by 16 = 150 lpi screen resolution.

Choosing the right pixel resolution for print

In the past it has been suggested that the optimal pixel resolution for making an inkjet print output should ideally be the printer dpi divisible by a whole number, i.e. if you intended printing at 2880 dpi, the following pixel resolutions could be used: 144, 160, 180, 240, 288, 320, 360. More recently, it has been shown that there isn't any need to make the pixel resolution match any particular formula in relation to the dpi setting used on the printer. The ideal resolution for print is anything in the 180–480 pixel per inch range.

The optimum number of pixels

The only thing to concern yourself with is that you have a sufficient number of pixels to make high quality prints. What then are the minimum number of pixels required to print at a particular size and intended viewing distance? Plus, what is the relationship between the pixel dimensions and image resolution? These questions crop up time and time again. Digital cameras are usually classified according to the number of pixels they can capture. If a sensor contains 3000×4500 pixel elements, it can be said to capture a total of 13.5 million pixels, and therefore be described as a 13.5 megapixel camera. When we talk about the resolution of an image we are principally referring to the number of pixels that are contained in the photo. Basically, every digital image contains a finite number of pixels and the more pixels you have, the greater potential there is to capture more detail.

The pixel dimensions of an image are an absolute value. Therefore, a 2400×1800 pixel image contains 4.32 megapixels and this is an absolute measurement of how many pixels there are in the image. A digital image with this number of pixels could be printed at 12" × 9" at 200 pixels per inch, or it could be printed at 8" × 6" at 300 pixels per inch (see Figure 5.7). So if you want to know how big an image can be printed, you simply divide the number of pixels along either dimension of the picture by the pixel resolution you wish to print at (see Figure 5.3). This can be expressed clearly in the following formula: the number of pixels = physical dimensions × (ppi) resolution. In other words, there is a reciprocal relationship between the pixel size, the physical dimensions and the resolution. If you quote the resolution of an image as being so many pixels by so many pixels, there can be no ambiguity about what you mean.

Megapixels to megabytes

If you multiply the 'megapixel' size by three you will get a rough idea of the megabyte size of the RGB image output. In other words, a 12 megapixel camera can produce a 36 MB RGB, 8-bit per channel image. Quoting megabyte sizes is a less reliable method for describing file sizes because document file sizes can also be affected by the number of layers and alpha channels present and whether the file has been compressed or not. Nevertheless, referring to image sizes in megabytes has become a convenient shorthand when describing a standard uncompressed, 8-bit per channel flattened TIFF image.

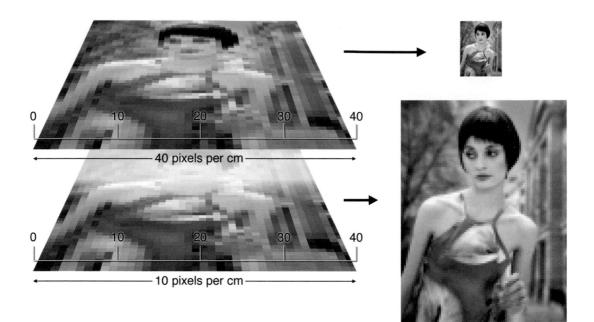

Figure 5.3 In this diagram you can see how a digital image comprised of a fixed number of pixels can have its output resolution interpreted in different ways. For illustration purposes let's assume that the image is 40 pixels wide. The file can be printed small at a resolution of 40 pixels per cm, or printed big (and more pixelated) at a resolution of 10 pixels per cm.

Repro considerations

The structure of the final CMYK print output bears no relationship to the pixel structure of a digital image, since a pixel in a digital image does not equal a cell of halftone dots on the page. To explain this, if we analyze a CMYK cell or rosette, each color plate prints the screen of dots at a slightly different angle, typically: Yellow at 0 or 90 degrees, Black: 45 degrees, Cyan: 105 degrees and Magenta: 75 degrees. If the Black screen is at a 45 degree angle (which is normally the case), the (narrowest) horizontal width of the black dot is 1.41 (the square root of 2) times shorter than the width of the Yellow screen (widest). If we want the frequency of the number of pixels to match the frequency of the halftone cells, then we can work out the ideal pixel resolution to use by multiplying the line screen frequency by a factor of 1.41. This is because using a multiplication factor of 1.41 for the pixel resolution will match the spacing of the 45 degree rotated black plate (see the example on the page opposite).

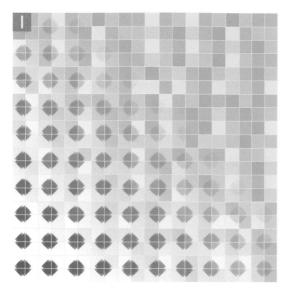

The relationship between ppi and lpi

1 The halftone screen shown here is angled at zero degrees. If the pixel resolution were calculated at $\times 2$ the line screen resolution, the RIP would use four pixels to calculate each halftone dot.

In the case of a CMYK print output, four plates are used, of which only the yellow plate is actually angled at zero degrees. The black plate is normally angled at 45 degrees and the cyan and magenta plates at less sharp angles. If you overlay the same pixel resolution of ×2 the line screen, you will notice that there is no direct relationship between the pixel and line screen resolutions.

³ Let's be clear, there is no single empirical formula that can be used to determine the ideal 'half toning factor'. Should it be $\times 2$ or $\times 1.5$? The black plate is the widest at 45 degrees and the black plate information is usually more prominent than the three color plates. If a half toning factor of $\times 1.41$ (the square root of 2) is used, the pixel resolution will be more synchronized with this angled halftone screen. There is no right or wrong half toning factor – the RIP will process pixel data at any resolution. What we can say though is if there are too few pixels, the print quality will be poor, and having more than the optimum number does not necessarily equate to better output, it just means more pixels. What this shows is the logic behind the $\times 1.41$ minimum halftone factor recommendation.

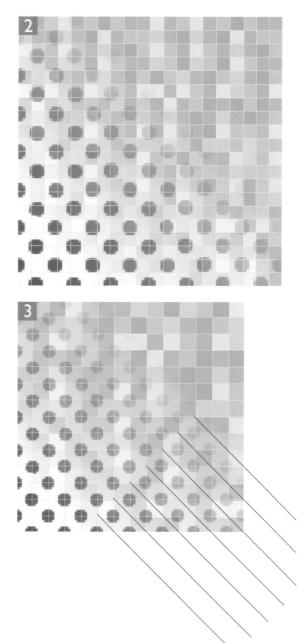

Determining output image size

Image size is determined by the final output requirements and, at the beginning of a digital job, the most important information you need to know is:

- How large will the picture appear on the page, poster, etc.?
- What is the screen frequency being used by the printer – how many lpi?
- What is the preferred halftone factor used to determine the output resolution?
- Will the designer need to allow for page bleed, or want to crop the image?

It is for this reason you will find that the image output resolution asked for by printers is usually at least 1.41 times the halftone screen frequency used. This multiplication is also known as the 'halftone factor', but you will also find that multiples of \times 1.41, \times 1.5 or \times 2 are commonly used, so which is best? You can always ask the printer what they prefer you to supply them with. Some will say that the 1.41:1 or 1.5:1 multiplication produces the sharpest detail, while others may request a ratio of 2:1. I usually reckon that a halftone factor of 1.5:1 should be fine for general image reproduction, but photographic subjects with fine image detail do benefit from using a higher halftone factor. You also have to take into account the screening method used. It is claimed that Stochastic or FM screening permits a more flexible choice of ratios ranging from 1:1 to 2:1.

Let me give you a practical example here. If the line screen used by the printer is, say, 175 lpi, the pixel resolution will therefore need to be around at least 260 pixels per inch (if you use the $\times 1.5$ halftone factor), but probably no more than 350 pixels per inch (if you use the x2 halftone factor). Ultimately it always helps to know in advance the intended line screen, the ideal halftone factor and final print output size. Using this information you can then calculate the ideal image size for the files you are about to supply to the printer. There is no point supplying files that are bigger than necessary as you will simply waste time uploading unnecessarily big files. On the other hand, designers do like having the freedom to take a supplied image and scale it in the design layout program to suit the requirements of a layout. For this reason it may be worth using a $\times 2$ halftone factor. There will then always be enough data in the supplied image to crop or scale up a photo without adversely compromising the final print quality.

But we always use 300 ppi!

There is a common misconception in the design industry that everything must be supplied at 300 pixels per inch. This crops up all the time when you are contacting clients to ask what resolution you should supply your image files at. Somehow the idea has got around that everything from a picture in a newspaper to a 48-sheet poster must be reproduced from a 300 ppi file. It does not always hurt to supply your files at a higher resolution than is necessary, but it can get quite ridiculous when you are asked to supply a 370 MB file in order to produce a $30^{\circ} \times 36^{\circ}$ poster!

Creating a new document

To create a new document in Photoshop with a blank canvas, go to the File menu and choose New... This opens the dialog shown in Figure 5.4, where you can select a preset setting type from the Preset pop-up menu followed by a preset size option from the Size menu. When you choose a preset setting, the resolution adjusts automatically depending on whether it is a preset intended for print or one that's intended for computer screen type work (you can change the default resolution settings for print and screen in the Units & Rulers Photoshop preferences). Alternatively, you can manually enter dimensions and resolution for a new document in the fields below.

The Advanced section lets you do extra things like choose a specific profiled color space. After you have entered the custom settings in the New Document dialog these can be saved by clicking on the Save Preset... button. In the New Document Preset dialog shown below, you will notice that there are also some options that will allow you to select which attributes are to be included in a saved preset.

Pixel Aspect Ratio

The Pixel Aspect Ratio is there to aid multimedia designers who work with stretched screen video formats. So, if a 'non-square' pixel setting is selected, Photoshop creates a scaled document which previews how a normal 'square' pixel Photoshop document will actually display on a stretched wide screen. The title bar will add [scaled] to the end of the file name to remind you that you are working in this special preview mode. When you create a non-square pixel document the scaled preview can be switched on or off by selecting the Pixel Aspect Correction item from the View menu.

Figure 5.4 When you choose File \Rightarrow New, this opens a the New document dialog shown here (top left). Initially, you can go to the Preset menu and choose a preset setting such as: Photo, Web or Film & Video. Depending on the choice you make here, this will affect the size options that are available in the Size menu (shown top right). If you use the New document dialog to configure a custom setting, you can click on the Save Preset... button to save this as a New Document Preset (right). When you do this the new document preset will then appear listed in the main preset menu (top left).

Resolution and viewing distance

In theory the larger a picture is printed, the further away it is meant to be viewed. Because of this you can easily get away with a lower pixel resolution such as 180 or 200 pixels per inch when making a poster print output. There are limits though, below which the quality will never be sharp enough at normal viewing distance (except at the smallest of print sizes). As my late colleague Bruce Fraser used to say, 'in the case of photographers, the ideal viewing distance is limited only by the length of the photographer's nose'.

Altering the image size

The image size dimensions and resolution can be adjusted using the Image Size dialog (Figure 5.5). The Image Size dialog normally opens with the Resample Image box checked, which means that as you enter new pixel dimension values, measurement values, or alter the resolution, the overall image size adjusts accordingly. As you alter one set of units you'll see the others adjust simultaneously. When Resample Image is unchecked, the pixel dimensions will be graved out and any adjustment made to the image will not alter the total pixel dimensions and only affect the relationship between the measurement units and the resolution. Remember the rule I mentioned earlier: the number of pixels = physical dimension \times (ppi) resolution. You can put that to test here and use the Image Size dialog as a training tool to better understand the relationship between the number of pixels, the physical image dimensions and resolution. The Constrain Proportions checkbox links the horizontal and vertical dimensions, so that any adjustment is automatically scaled to both axis. Only uncheck this box if you wish to squash or stretch the image when adjusting the image size.

Auto Resolution	Image Size
Screen: 133 lines/inch CAncel	Pixel Dimensions: 63.6M OK Width: 4445 pixels \$ Height: 2500 pixels \$
and the second	Document Size:
	Width: 37.63 cm 🗘 🦷
	Height: 21.17 cm 🗘 🖉
	Resolution: 300 pixels/inch 🔹
	 ✓ Scale Styles ✓ Constrain Proportions ✓ Resample Image: Bicubic (best for smooth gradients)
	bicubic (best for smooth gradients)

Figure 5.5 To change the image output dimensions while keeping the resolution locked, leave the Resample Image box checked. To change the image output dimensions so that the resolution auto-adjusts to the new image dimensions, leave the Resample Image box unchecked. Click on the Auto... button to open the Auto Resolution dialog shown here. This can help you pick the ideal pixel resolution for repro work based on the line screen resolution.

Chapter 5

Image interpolation

Image resampling is also referred to as 'interpolation' and Photoshop can use one of five methods when calculating how to resize an image. These interpolation options are all located in the menu just below the Resample Image checkbox (see Figure 5.6).

I generally consider it better to 'interpolate up' an image in Photoshop rather than rely on the interpolation methods offered by some scanner software programs. Digital files captured from a scanning back or multi-shot digital camera are extremely clean and because there is no grain present, it is usually possible to magnify a digitally captured image more successfully than you can a scanned image of equivalent size. There are other third-party programs that claim to offer improved interpolation, but there appears to be little evidence that you will actually gain any major improvements in image quality over and above what can be achieved in Photoshop. Here is a guide to how each of the interpolation methods works and which are the best ones to use and when.

Nearest Neighbor

This is the simplest interpolation method of all, in which the pixels are interpolated exactly using the nearest neighbor information. I actually use this interpolation method a lot whenever I need to enlarge dialog box screen grabs by 200% for use in the book. I choose this method because I don't want the interpolation to make the sharp edges of the dialog boxes go fuzzy.

Bilinear interpolation

This calculates new pixels by reading the horizontal and vertical neighboring pixels. It is a fast method of interpolation, and this was perhaps an important consideration in the early days of Photoshop, but I don't see much reason to use it now for anything.

Bicubic interpolation

This provides better image quality when resampling continuous tone images. Photoshop reads the values of neighboring pixels vertically, horizontally and diagonally, to calculate a weighted approximation of each new pixel value. Photoshop intelligently guesses new pixel values, by referencing the surrounding pixels.

10		
1	Nearest Neighbor (preserve hard edges) Bilinear	
	Bicubic (best for smooth gradients)	D
	Bicubic Smoother (best for enlargement)	9
	Bicubic Sharper (best for reduction)	

Figure 5.6 This is a close-up view of the Image Resize dialog, showing the five interpolation options.

Planning ahead

Once an image has been scanned at a particular resolution and manipulated, there is no going back. A digital file prepared for advertising usage may never be used to produce anything bigger than a 35 MB CMYK separation, but you never know. It is therefore safer to err on the side of caution and better to sample down than have to interpolate up. It also depends on how much manipulation you intend doing. Some styles of retouching work are best done at a magnified size and then reduced in size afterwards. Suppose you wanted to blend a small element into a detailed scene. To do such work convincingly, you need to have enough pixels to work with to be able to see what you are doing. For this reason some professional retouchers will edit a master file that is around 100 MB RGB or bigger even. Another advantage of working with large file sizes is that you can always guarantee being able to meet clients' constantly changing demands, even though the actual resolution required to illustrate a glossy magazine double-page full-bleed spread is probably only around 40-60 MB RGB or 55-80 MB CMYK. Some advertising posters may even require smaller files than this, because the print screen on a billboard poster is that much coarser. When you are trying to calculate the optimum resolution you cannot rely on being fully provided with the right advice from every printer. Sometimes it will be necessary to anticipate the required resolution by referring to the table in Figure 5.8. This shows some sample file size guides for different types of print jobs.

The advanced bicubic interpolation methods

The Photoshop bicubic interpolation method has been sufficiently improved to provide the optimum resampling, especially with regard to downsampling image data. However, if you need to apply an extreme image resampling (either up or down in size), I suggest you use either the Bicubic Sharper or Bicubic Smoother interpolation methods described below.

Bicubic Smoother

This is the ideal choice when making pictures bigger, as it will result in smoother, interpolated enlargements. It has been suggested that you can also get good results using Bicubic Sharper when interpolating up before going directly to print. However, this ignores the fact that print sharpening should really be applied as a separate step *after* interpolating the image and the sharpening should ideally be tailored to the final output size (see Chapter 13). It is therefore always better to use Bicubic Smoother followed by a separate print sharpening step. This is because the smooth interpolation prevents any artifacts in the image from being overemphasized and the sharpening can be applied at the correct amount for whatever size of print you are making.

Bicubic Sharper

This method should be used whenever you need to reduce an image in size more accurately. If you use Bicubic Sharper to dramatically reduce a master image in size, this can help avoid the stair-step aliasing that could sometimes occur when using the other interpolation methods.

Step interpolation

Some people might be familiar with the step interpolation technique, where you can gradually increase or decrease the image size by small percentages. This is not really necessary now because you can use Bicubic Sharper or Bicubic Smoother to increase or decrease an image size in a single step. Some people argue that for really extreme image size changes they still prefer to use the 10% step interpolation method.

				Inches	Centimeters	Inches	Centimeters
Pixel size	Megapixels	MB (RGB)	MB (CMYK)	200 ppi	80 ppc	300 ppi	120 ppc
1600 x 1200	2	6	7.5	8 x 6	20 x 15	5.5 x 4	13.5 x 10
2400 x 1800	4.3	12.5	16.5	12 x 9	30 x 22.5	8 x 6	20 x 15
3000 x 2000	6	17.5	23.5	15 x 10	37.5 x 25	10 x 6.5	25 x 17
3500 x 2500	8.75	25	33.5	17.5 x 12.5	44 x 31	11.5 x 8.5	29 x 21
4000 x 2850	11.4	32.5	43.5	20 x 14	50 x 36	13.5 x 9.5	33.5 x 24
4500 x 3200	14.4	41	54.5	22.5 x 16	56 x 40	15 x 10.5	37.5 x 27
5000 x 4000	20	57	76	25 x 20	62.5 x 50	16.5 x 13.5	42 x 33.5

Figure 5.7 The above table shows a comparison of pixel resolution, megapixels,

megabyte file size (for flattened 8-bit TIFFs) and output dimensions at different resolutions,

both in inches and in centimeters.

Output use	Screen ruling	×1.5 Output resolution	MB Grayscale	MB Cmyk	×2 Output resolution	MB Grayscale	MB Cmyk
A3 Newspaper single page	85 lpi	130 ppi	3	12.5	170 ppi	5.5	21.5
A3 Newspaper single page	120 lpi	180 ppi	6	24	240 ppi	10.5	42.5
A4 Magazine mono single page	120 lpi	180 ppi	3	NA	240 ppi	5.3	NA
A4 Magazine mono double page	120 Ipi	180 ppi	6	NA	240 ppi	10.6	NA
A4 Magazine single page	133 lpi	200 ppi	3.7	14.8	266 ppi	6.5	26.1
A4 Magazine double page	133 lpi	200 ppi	8	29.6	266 ppi	13	52.2
A4 Magazine single page	150 lpi	225 ppi	4.7	18.7	300 ppi	8.3	33.2
A4 Magazine double page	150 lpi	225 ррі	9.4	37.4	300 ppi	17	66.4

Figure 5.8 Here is a rough guide to the sort of megabyte file sizes (for flattened 8-bit TIFFs) required to reproduce either a mono or CMYK file for printed use. The table contains

file size information for output at multiples of $\times 1.5$ the screen ruling and $\times 2$ the screen

ruling.

Raw to pixel image conversions

Once a raw image has been rendered as a pixel image you cannot revert to the raw data version because the raw to pixel image conversion is a one-way process. Once you have done this, the only way you can undo something in the raw processing is to revert to the original raw image and generate a new pixel image copy. Although the goal of this book is to show you how to work as non-destructively as possible, this is the one step in the process where there is no going back, and you therefore need to be sure that the photograph you start editing in Photoshop is as fully optimized as possible. In the case of JPEG images, you can edit these in Camera Raw if you like, or use Photoshop to carry out the image optimization.

WYSIWYG image editing

If you want true WYSIWYG editing (what you see is what you get) it is important that you follow the instructions laid out in the Chapter 2 on how to calibrate the display and configure the color settings. Do this and you will now be ready to start editing your photographs with confidence.

Basic pixel editing

In Chapter 3 we explored the use of adjustments and other tools in Camera Raw to optimize a photo before it is opened in Photoshop as a rendered pixel image. The following section is all about the main image adjustment controls in Photoshop and how you can use these to fine-tune your images, or use them as an alternative to working in Camera Raw, such as when editing camera-shot JPEGs or scanned TIFFs. The techniques discussed here should be regarded as essential foundation skills for Photoshop image editing, because however you bring your images into Photoshop, you will at some point need to know how to work with the basic image editing tools such as Levels and Curves.

If you intend bringing your images in via Camera Raw, it can be argued that Photoshop image adjustments are unnecessary, since Camera Raw provides you with everything you need to produce perfectly optimized photos. Even so, you will still find the information in this chapter is important, as these are the techniques every Photoshop user needs to be aware of and use when applying things like localized corrections. So, for now, let's look at some basic pixel image editing principles and techniques.

The image histogram

The histogram graphically represents the relative distribution of the various tones (referred to as Levels) that make up a digital photograph. For example, an 8-bit per channel grayscale image has a single channel and uses 256 shades of gray to describe all the levels of tone from black to white. Black has a levels value of 0 (zero), while white has a levels value of 255 and all the numbers in-between represent the different shades of gray going from black to white. The histogram is therefore like a bar graph with 256 increments, each representing how frequently a particular levels number (a specific gray value) occurs in the image. Figure 5.10 shows a typical histogram such as you'll see in the Histogram, Levels and Curves panels. This diagram also shows how the appearance of the graph relates to the tonal structure of a photographic image.

Now let's look at what that information can actually tell us. The histogram graphically shows the distribution of tones in a digital image. A low-key photograph (such as the one shown in Figure 5.10) will have most of the peaks on the left. Most importantly, it

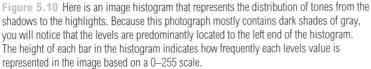

shows the positioning of the shadow and highlight points. When you apply a tonal correction using Levels or Curves, the histogram provides visual clues that help you judge where the brightest highlights and deepest shadows should be. The histogram also tells you something about the condition of the image you are editing. If there are peaks jammed up at either ends of the histogram, this suggests that either the highlights or the shadows have become clipped and that when the original photograph was captured or scanned it was effectively under- or overexposed. Unfortunately, Image editing essentials

Chapter 5

Figure 5.9 The warning triangle in the Histogram panel indicates that you need to click on the Refresh button above to update it.

The Histogram panel

There has always been a histogram in the Levels dialog and there is also a Histogram panel, which when working in Photoshop gives you even more feedback. With the Histogram panel, you can continuously observe the effect your image editing has on the image levels and you can also check the histogram while making any type of image adjustment. The Histogram panel only provides an approximate representation of the image levels. So, to ensure that the Histogram panel is giving an accurate representation of the image levels, it is advisable to force Photoshop to update the histogram view, by clicking on the Refresh button at the top of the panel.

Interpreting an image

A digital image is nothing more than a lot of numbers and it is how those numbers are interpreted in Photoshop that creates the image you see on the display. We can use our eyes to make subjective judgements about how the picture looks, but we can also use the number information to provide useful and usable feedback. The Info panel is your friend. If you understand the numbers, it can help you see the fine detail that your eyes are not sharp enough to discern. Plus we have the Histogram panel, which is also an excellent teaching tool and makes everything that follows much easier to understand.

if the levels are clipped at either end of the scale, you can't restore the detail that has been lost here. If there are gaps in the histogram at this stage, this most likely indicates a poor quality original capture or scan, or that the image had previously been heavily manipulated.

Throughout this book I will try to guide you as best I can to work as efficiently and as non-destructively as possible. Even so, anything we do to adjust the levels to make an image look better will always result in there being some data loss. This is quite normal and an inevitable consequence of the image editing process. The steps on the page opposite illustrate what happens when you edit a photograph. You will notice that as you adjust the input levels and adjust the gamma (middle) input slider, you will end up stretching some of the levels further apart and gaps may start to appear in the histogram. More importantly, stretching the levels further apart can result in less well-defined tonal separation and therefore less detail in these regions of the image. This is particularly a problem at the shadow end of the scale because there are always fewer levels of usable tone information in the shadows compared with the highlights (see the section on Digital exposure on page 186). While moving the gamma slider causes the tones on one side to stretch, it cause the tones on the other side to compress more and these can appear as spikes in the histogram. This too can cause data loss, sometimes resulting in flatter tone separation (there is also an example of this shown in the section on Camera Raw Brightness adjustments on pages 188-189).

The histogram can therefore be used to provide visual feedback on the levels information in an image and indicate whether there is clipping at either end of the scale. However, does it really matter whether we obtain a perfectly smooth histogram or not? If you are preparing a photograph to go to a print press, you would be lucky to detect more than 50 levels of tonal separation from any single ink plate. Therefore, the loss of a few levels at the completed edit stage does not necessarily imply that you have too little digital tonal information from which to reproduce a full-tonal range image in print. Having said that if you begin with a bad-looking histogram, the image is only going to be in a worse state after it has been retouched. For this reason it is best start to out with the best quality scan or capture you can get.

Image editing essentials

Chapter 5

Basic Levels editing and the histogram

This image editing example was carried out on an 8-bit RGB image, so it should come as no surprise that the histogram broke down as soon as I applied a simple Levels adjustment (in the following section we are going to look at the advantages of editing in 16-bits per channel mode).

1 Here is an image that displays an evenly distributed range of tones in the accompanying

Levels

\$

255

255

÷ E,

Preset: Custom

Channel: RGB

1.2

Input Levels:

Output Levels:

been compressed.

0

.

0

Histogram panel view.

OK Cancel

Auto

Options...

2 If I apply a Levels image adjustment and drag the middle (gamma) input slider to the left, this lightens the image and the Histogram panel on the right shows the histogram display after the adjustment has been applied. To understand what has happened here, this histogram represents the newly mapped levels. The levels in the section to the left of the gamma slider have been stretched and the levels to the right of the gamma slider have now

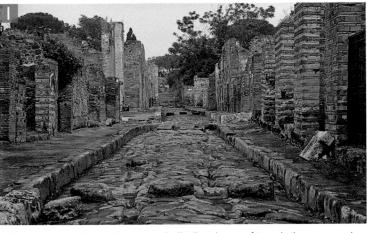

Understanding bit depth

To understand what the bit depth numbers mean, it is best to begin with a grayscale image where there is just luminosity. A 1-bit or bitmapped image contains only black or white pixels. A 2-bit image contains four levels (2²), 3-bit eight levels (2³), and so on, up to 8-bit (2⁸) with 256 levels of gray.

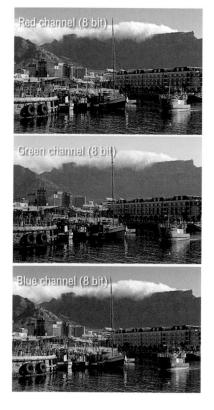

Bit depth

The bit depth refers to the maximum number of levels per channel that can be contained in a photograph. For example, a 24-bit RGB color image is made up of three 8-bit image channels, where each 8-bit channel can contain up to 256 levels of tone, while a 16-bit per channel image can contain up to 32,768 data points per color channel, because in truth, Photoshop's 16-bit depth is actually 15-bit +1 (see sidebar on page 307).

JPEG images are always limited to 8-bits, but TIFF and PSD files can be in 8-bits or 16-bits per channel. Note though that Photoshop only offers 8-bits or 16-bits per channel modes for standard integer channel images, while 32-bit support in Photoshop uses floating point math to calculate the levels values. Therefore, any source image with more than 8-bits per channel has to be processed as a 16-bits per channel mode image. Since most scanners are capable of capturing at least 12-bits per channel data,

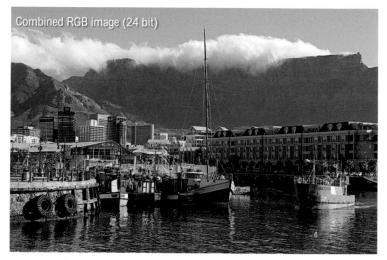

Figure 5.11 The bit depth of an image is a mathematical description of the maximum levels of tone that are possible, expressed as a power of 2. A bitmap image contains 2 to the power of 1 (two levels of tone), in other words, black or white tones only. A normal Photoshop 8-bit grayscale image or an individual color channel in a composite color image contains 2 to the power of 8 (2⁸) and up to 256 levels of tonal information. When three RGB 8-bit color channels are combined together to form a composite color image, the result is a 24-bit color image that can contain up to 16.7 million shades of color (2⁸ x 3).

this means that scanned images should ideally be saved as 16-bits per channel images in order to preserve all of the 12-bits per channel data.

In the case of raw files, a raw image contains all the original levels capture image data, which will usually have been captured at a bit depth of 12-bits, or even 14-bits per channel. Camera Raw image adjustments are mostly calculated using 16-bits per channel, so once again, all the levels information that is in the original can only be preserved when you save a Camera Raw processed raw image using 16-bits per channel mode.

8-bit versus 16-bit image editing

A higher bit depth doesn't add more pixels to an image. Instead, it offers a greater level of precision to the way tone information is recorded by the camera or scanner sensor. One way to think about bit depth is to consider the difference between having the ability to make measurements with a ruler that is accurate to the nearest millimeter, compared with one that can only measure to the nearest centimeter.

There are those who have argued that 16-bit editing is a futile exercise because no one can tell the difference between an image that has been edited in 16-bit and one that has been edited in 8-bit. Personally I believe this to be a foolish argument. If a scanner or camera is capable of capturing more than 8-bits per channel, then why not make full use of the extra tonal information? In the case of film scans, you might as well save the freshly scanned images using the 16-bits per channel mode and apply the initial Photoshop edits using Levels or Curves in 16-bits mode. If you preserve all the levels in the original through these early stages of the edit process, you'll have more headroom to work with and avoid dropping useful image data. It may only take a second or two longer to edit an image in 16-bits per channel compared with when it is in 8-bit, but even if you only carry out the initial edits in 16-bit and then convert to 8-bit, you'll retain significantly more image detail.

My second point is that you never know what the future holds in store for us. On pages 338–341 we shall be looking at Shadows/ Highlights adjustments. This feature can be used to emphasize image detail that might otherwise have remained hidden in the shadows or highlight areas. This feature exploits the fact that

Bit depth status

You can check the bit depth of an image quite easily by looking at the document window title bar, where it will indicate the bit depth as being 8-, 16- or 32-bit.

Why is 16-bits really 15-bits?

If you have a keen knowledge of math, you will notice that Photoshop's 16-bits per channel mode is actually 15-bit as it uses only 32,768 levels out of a possible 65,536 levels when describing a 16-bit mode image. This is because having a tonal range that goes from 0 to 32,767 is more than adequate to describe the data coming off any digital device. Also, because from an engineering point of view, 15-bit math calculations give you an exact midpoint value, which can be important for precise layer blending operations. Here, I started out with a full color image that was in 16-bits per channel mode and created a duplicate that was converted to 8-bits per channel mode. **Comparing 8-bit with 16-bit editing**

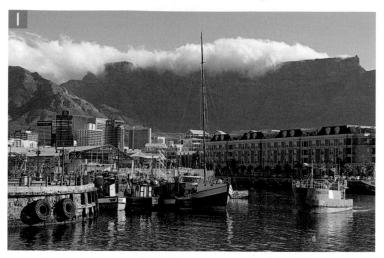

2 With each version I applied two sequential Levels adjustments. The first (shown here on the left) compressed the output levels to an output range of 120–136. I then applied a second Levels adjustment in which I expanded these levels to 0–255 again.

3 The outcome of these two sequential Levels adjustments can clearly be seen when examining the individual color channels. On the left you can see the image histogram for the 8-bit file Green channel and on the right you can see the histogram of the original 16bit file Green channel. As you can see the 16bit version retained a nice, smooth histogram.

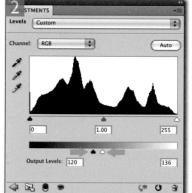

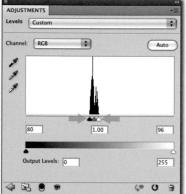

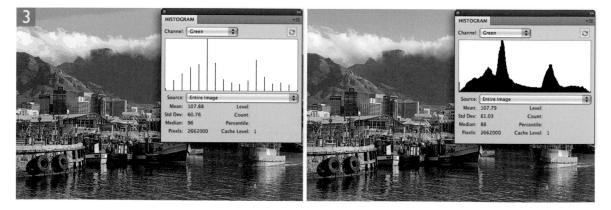

a deep-bit image can contain lots of hidden levels data that can be further manipulated to reveal more detail in the shadows or highlights. A Shadows/Highlights adjustment can still work just fine with 8-bit images, but you'll get better results if you open your raw processed images as 16-bit photos or scan in 16-bit per channel mode first.

Photoshop also offers extensive support for 16-bit editing. When a 16-bit grayscale, RGB, CMYK or Lab color mode image is opened in Photoshop you can crop, rotate, apply all the usual image adjustments, use any of the Photoshop tools and work with layered files. The main restriction is that there are only a few filters that can work in 16-bits per channel mode, such as the Lens Correction and Liquify filter. You may not feel the need to use 16-bits per channel all the time, but I would say for critical jobs where you don't want to lose an ounce of detail, it is essential to make at least all your preliminary edits in 16-bits per channel mode.

In the tutorial shown opposite, I started with an image that was in 16-bits mode and created a duplicate version that was converted to 8-bits. I then proceeded to compress the levels and expand them again in order to demonstrate how keeping an image in 16-bits per channel mode provides a more robust image mode for making major tone and color edits. Admittedly, this is an extreme example, but preserving an image in 16-bits offers a significant extra margin of safety when making everyday image adjustments.

16-bit and color space selection

For a long time now Photoshop experts such as myself have advocated editing in RGB using a conservative gamut color space such as Adobe RGB (if you want to find out more about RGB color spaces then you will need to read Chapter 12 on color management). Although 16-bit editing is not new to Photoshop, it is only since the advent of Photoshop CS that it has been possible to edit more extensively in 16-bit. One of the advantages this brings is that we are no longer limited to editing in a relatively small gamut RGB workspace. It is perfectly safe to use a large gamut space such as ProPhoto RGB when you are editing in 16bits per channel mode because you'll have that many more data points in each color channel to work with (see the following section on RGB edit spaces).

Camera Raw and bit depth output

If you use Camera Raw to process a raw camera file or a 16-bit TIFF, the Camera Raw edits will all be carried out in 16bits. If you are satisfied with the results obtained in Camera Raw and you have managed to produce a perfectly optimized image, it can be argued there is less harm in converting such a file to an 8-bits per channel mode image in Photoshop. However, as I mentioned in the main text, you never know when you might be required to adjust an image further. Keeping a photo in 16-bits gives you the peace of mind, knowing that you've preserved as many levels as possible that were in the original capture or scan.

Martin Evening Adobe Photoshop CS5 for Photographers

Figure 5.12 The Color Settings dialog.

The RGB edit space and color gamut

One of the first things you need to do when you configure Photoshop is to choose an appropriate RGB edit space from the RGB Working Spaces menu in the Edit \Rightarrow Color Settings dialog (Figure 5.12).

For photo editing work, the choice really boils down to Adobe RGB or ProPhoto RGB. The best way to illustrate the differences between these two RGB color spaces is to consider how colors captured by a camera or scanner are best preserved when they are converted to print. Figure 5.13 shows (on the left) top and side views of a 3D plot for the color gamut of a digital camera, seen relative to a wire frame of the Adobe RGB working space. Next to this you can see top and side views of a glossy inkjet print space relative to Adobe RGB. You will notice here how the Adobe RGB

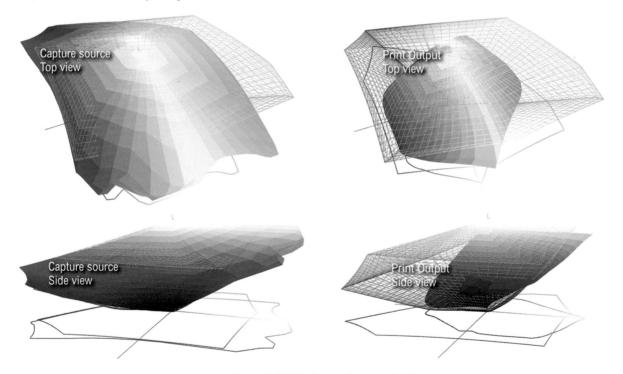

Figure 5.13 This diagram shows, on the left, a top and side view of the gamut of a digital camera source space plotted as a solid shape within a wire frame shape representing the color gamut of the Adobe RGB edit space. On the right is a top and side view of the gamut of a glossy inkjet printer color space plotted as a solid shape within a wire frame of the same Adobe RGB space.

edit space clips both the input and output color spaces. This can be considered disadvantageous because all these potential colors are clipped as soon as you convert the capture data to Adobe RGB. Meanwhile, Figure 5.14 offers a direct comparison showing you what happens when you select the ProPhoto RGB space. The ProPhoto RGB color gamut is so large it barely clips the input color space at all and is certainly big enough to preserve all the other colors through to the print output stage. In my view, ProPhoto RGB is the best space to use if you really want to preserve all the color detail that was captured in the original photo and see those colors preserved through to print.

The other choice I should mention is the sRGB color space, but this is only really suited for Web output work (or when sending pictures to clients via email).

Is ProPhoto RGB too big a space?

In the past there have been concerns that the ProPhoto RGB space is so huge that the large gaps between one level's data point and the next could lead to posterization. This might have been a valid argument when images were mainly edited in 8-bits per channel throughout. In practice, you can edit a ProPhoto RGB image in 16-bits or 8-bits per channel mode, but 16-bits is safer. Plus these days you can use Camera Raw to optimize an image prior to outputting as a ProPhoto RGB pixel image.

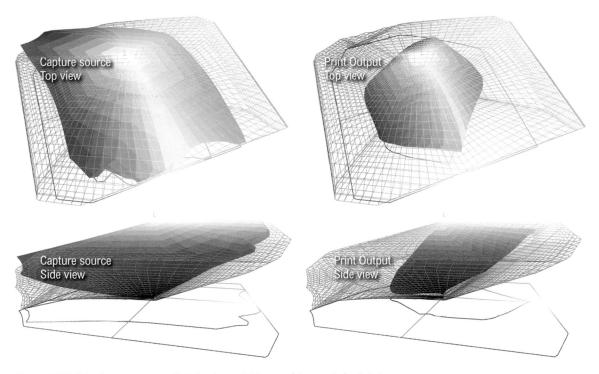

Figure 5.14 This diagram shows, on the left, a top and side view of the gamut of a digital camera source space plotted as a solid shape within a wire frame shape representing the color gamut of the ProPhoto RGB edit space. On the right is a top and side view of the gamut of a glossy inkjet printer color space plotted as a solid shape within a wire frame of the same ProPhoto RGB space.

Adobe Photoshop CS5 for Photographers

Figure 5.15 This shows the basic workflow for applying a normal image adjustment. Go to the Image \Rightarrow Adjustments menu and choose an adjustment type. In this example I selected 'Levels...', adjusted the settings and clicked OK to permanently apply the adjustment to the image.

Direct image adjustments

Most Photoshop image adjustments can be applied in one of two ways. There is the traditional, direct adjustment method where image adjustments can be accessed via the Image \Rightarrow Adjustments menu and applied to the whole image (or image layer) directly. Figure 5.15 shows an example of how one might apply a basic Levels adjustment. Here, I had an image open with a Background layer, then went to the Image Adjustments menu and selected 'Levels...' This opened the Levels dialog where I was able to apply a permanent tone adjustment to the photograph.

Direct image adjustments are appropriate for those times where you don't need the editability that adjustment layers are able to offer. They are also applicable when editing an alpha channel or layer mask, since you can't use adjustment layers when editing Photoshop channels. Lastly, the Shadows/Highlights command is not available as an adjustment layer and can only be applied directly to an image. Although, having said that, you can always apply a Shadows/Highlights adjustment as a Smart Filter to a Smart Object layer (see page 552).

Adjustment layers and Adjustments panel

With adjustment layers, an image adjustment can be applied in the form of an editable layer adjustment. Adjustment layers can be added to an image in several ways. You can go to the Layer \Rightarrow New Adjustment layer submenu, or you can click on the Add new adjustment layer button in the Layers panel to select an adjustment type. As well as this you can also use the Adjustments panel to add adjustment layers and update the adjustment settings. In the Figure 5.16 example you'll see I again started out with an image with a Background layer. I went to the Adjustments panel and clicked on the Levels adjustment button (circled). This added a new Levels adjustment layer above the Background layer and the Adjustments panel switched to display the Levels adjustment controls, shown here in the panel view below.

There are several advantages to the Adjustment layer approach, especially with the way the options are now presented in Photoshop. First of all, adjustment layers are not permanent. If you decide to undo an adjustment or readjust the settings, you can do so at any time. Adjustment layers offer the ability to apply multiple image adjustments and/or fills to an image and for the adjustments to remain 'dynamic'. In other words, an adjustment layer is an image adjustment that can be revised at any time and allows the image adjustment processing to be deferred until the time when an image is flattened. The adjustments you apply can also be masked when you edit the associated layer mask and the mask can also be refined using the Masks panel (which I'll be describing later). Best of all, adjustment layers are no longer restricted to a modal state where you had to double-click the layer first in order to access the adjustment controls. Now that we have an Adjustments panel, you have the potential to quickly access the adjustment layer settings any time you need to. In addition to this you can easily switch between tasks. So, if you click on an adjustment layer to select it, you can paint on the layer mask, adjust the layer opacity and blending options and have full access to the adjustment layer controls throughout.

Adding an adjustment layer procedure

Here's how you would go about adding a new adjustment layer. First, go to the Adjustments panel shown in Figure 5.17 and select an adjustment type by clicking on one of the buttons (you'll see a list of all the buttons over the page and a brief summary of what each one does). Once you have selected an adjustment, the panel switches to display the adjustment controls (which are shaded yellow in Figure 5.18) plus there are additional controls top and bottom for managing the adjustment layers, such as a button to toggle the preview on or off. If you deselect an adjustment layer or click on the 'Return to list' button (circled in Figure 5.18), this takes you back to the Adjustments panel list view shown in Figure 5.17, where you can add a new adjustment layer. As you click on adjustment layers in the Layers panel to select them, the Adjustments panel refreshes the controls view to show the controls and settings for that particular layer.

Keeping the focus on the panel fields

One reason why the Adjustments panel wasn't universally liked when it was introduced in CS4 was because you lost the use of keyboard shortcuts when editing the adjustment settings. Now in Photoshop CS5 you can use the *Shift Enter* keyboard command to enter an 'Adjustment panel edit mode' where, for example, pressing the *Tab* key allows you to jump from one field to the next. Simply press the *esc* key to exit the Adjustments panel edit mode.

Adobe Photoshop CS5 for Photographers

Adjustment panel options

🔆 Brightness Contrast

A basic brightness and contrast tone adjustment.

Levels

Used for setting the black and white clipping points and adjusting the gamma.

La Curves

Used for more accurate tone adjustments.

🛃 Exposure

Primarily for adjusting the brightness of 32-bit images.

Vibrance

A tamer saturation adjustment control.

🛲 Hue/Saturation

A color adjustment for editing hue color, saturation and lightness.

🖧 Color Balance

Basic color adjustments.

📕 Black & White

Used for simple black and white conversions.

🂁 Photo Filter

Adds a coloring filter adjustment.

🍛 Channel Mixer

For adjusting the balance of the individual color channels that make up a color image.

🔁 Invert

Converts an image to a negative.

M Posterize

Used to reduce the number of levels in an image.

🖊 Threshold

Reduces the number of levels to two and allows you to set the midpoint threshold.

Gradient map

Lets you use gradients to map the output colors.

Selective Color

Applies CMYK selective color adjustments based on RGB or CMYK colors.

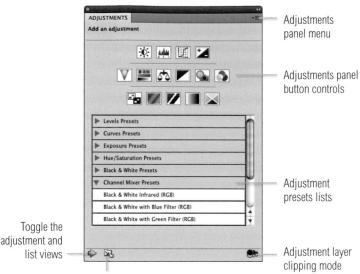

Expand/shrink the panel view

Figure 5.17 The Adjustments panel adjustment list options.

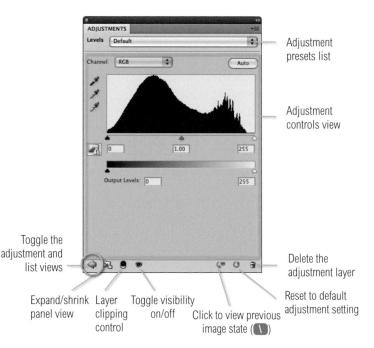

Figure 5.18 The Adjustments panel adjustment mode options.

Adjustments panel controls

Figure 5.17 shows the default Adjustments panel list view, where you can click on any of the buttons to add a new image adjustment. The button icons may take a little getting used to at first, but you can refer to the summary list on the page opposite to help guide you here, or mouse down on the Adjustments panel menu to access a named list of adjustments. You can also use the adjustment presets list to quickly access the pre-supplied image adjustment settings, or your own preset settings for the various image adjustments. Just click on a preset name and this adds a new adjustment layer with the preset settings. It is easy to get carried away with this feature as you can soon end up with a dozen or more adjustment layers. One way to avoid this is to use the Undo command before you select a new adjustment preset. So the routine would be: select an adjustment and see if you like the result. If not, use the **HZ** ctrl Z command to undo adding the adjustment layer and select another preset instead and so on. The Adjustment layer clipping mode button lets you determine whether new adjustments are applied to all the layers that appear below the adjustment layer, or are clipped only to the layer that's immediately below the adjustment layer (see Figure 5.19).

Once you are in the Adjustments panel 'controls' mode (Figure 5.18) you can still access the adjustment presets from the menu list at the top. The difference here is that you can run through the list of presets selecting each in turn, to see what each effect does, but without adding a new adjustment layer. Note that when you are in the 'controls' mode, the Adjustments panel menu allows you to save and load presets, so you can easily add your own custom settings to this list. The middle section contains the main adjustment controls and at the bottom you again have the clipping control to switch between applying the adjustment to all the layers that are below or only to the layer that's immediately below. Next to this there is an eyeball icon for turning the adjustment layer visibility on or off. Further along there is a button for switching between the previous state and the current edited state, where if you click and hold the mouse down (or hold down the **N** key) you can see what the image looked like before the last series of image adjustments were applied. Lastly, there is a Reset button for cancelling the most recent adjustments and a Delete button to remove the current adjustment layer.

Saving files with adjustment layers

Images that contain adjustment layers are savable in the Photoshop native, TIFF and PDF formats. Adjustment layers add very little to the overall file size.

Use Tool Tips

If you have the 'Show Tool Tips' option selected in the Photoshop Interface preferences, this displays the name of an adjustment as you roll the cursor over the button icons.

Undoing adjustment steps

There is a Reset button at the bottom of the controls mode Adjustments panel, but you can also use the Undo command **H Z ctr**/**Z** to toggle undoing and redoing the last adjustment and use the **H C ctr**/**a**/**t Z** shortcut to progressively undo a series of adjustment panel edits.

Figure 5.19 This shows the two clipping layer modes for adding a new adjustment layer. The one on the left is for applying an adjustment to all layers below the adjustment layer. The one on the right is for clipping adjustments only to the layer below.

Auto image adjustments

The Auto button sets the clipping points automatically (the Auto settings are all covered later in this chapter).

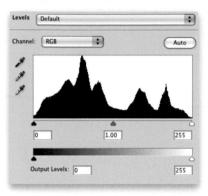

Figure 5.20 This histogram shows an image that contains a full range of tones, without any shadow or highlight clipping and no gaps between the levels.

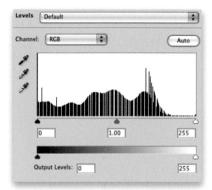

Figure 5.21 A histogram with a comb-like appearance indicates that either the image has already been heavily manipulated or an insufficient number of levels were captured in the original scan.

Levels adjustments

There was a time when every Photoshop edit session would begin with a Levels adjustment to optimize the image. These days, if you use Camera Raw to process your raw or JPEG photos, there shouldn't be so much need to use Levels for this purpose – you should already have optimized the shadows and highlights during the Camera Raw editing. However, it is important and useful to understand the basic principles of how to apply Levels adjustments since there are still times when it is more convenient to apply a quick Levels adjustment to an image, rather than use Camera Raw. Direct Levels adjustments are always useful for editing channels and layer masks and you can also use Levels adjustment layers to create dodging or burning layers. The main Levels controls are shown below in Figure 5.22.

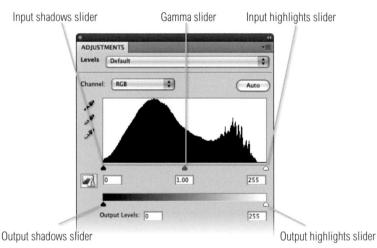

Figure 5.22 This shows a view of the Adjustments panel for adding Levels adjustments. The Input sliders are just below the histogram display and you can use these to adjust the input shadows, highlights and gamma (the relative image brightness between the shadows and highlights). Below this are the Output sliders and you use these to set the output shadows and highlights. It is best not to adjust the output sliders unless you are retouching a prepress file in grayscale or CMYK, or you deliberately wish to reduce the output contrast.

Analyzing the histogram

Levels adjustments can have a big effect on the appearance of the histogram and so it is important to keep a close eye on the histogram shown in the Levels dialog/Adjustment panel as well as the one in the Histogram panel itself. Figure 5.20 shows a nice,

Image editing essentials

smooth histogram where the image was recently optimized in Camera Raw before being opened in Photoshop, while Figure 5.21 shows the histogram for an image that's obviously been heavily manipulated in Photoshop. In Figure 5.23 you can see how the blacks are quite heavily clipped and most of the levels are bunched up to the left, while in Figure 5.24 the highlights are clearly clipped. Although, as I explain below, it isn't necessarily a bad thing to sometimes clip the shadows or highlights in this way.

Figure 5.23 If the levels are bunched up towards the left, this is a sign of shadow clipping. But in this example we would probably want the shadows to be clipped in order to produce a rich black background.

Figure 5.24 If the levels are bunched up towards the right, the highlights may be clipped. But in this image I actually wanted the white background to burn out to white.

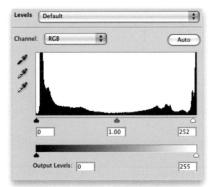

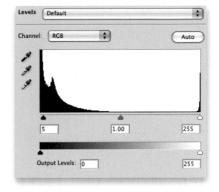

I chose here to use a monochrome photograph, since it would make the following contrast enhancing Levels adjustment clearer to see. The Histogram panel below displays a histogram of the image's levels and as you can see, the tonal contrast could be improved here by expanding the levels. To do this I needed to apply a Levels adjustment.

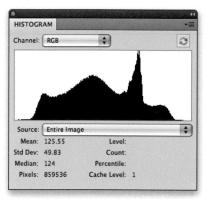

2 One way you can use Levels to improve the tonal contrast is to simply look at the histogram in the Levels adjustment and drag the Input sliders inwards until they meet either end of the histogram. However, you can get a better idea of where to set the endpoints by enabling the Threshold display mode. To do this, I held down the C alt key as I dragged the shadow Input levels slider inwards. The preview now showed a threshold mode view that enabled me to discern more easily where the darkest shadows were in the picture. The threshold view you see here is rather extreme. so I would want to back off from this setting, otherwise the shadows would be too clipped. The general idea here is that the black clipping in the Threshold mode preview indicates the points at which the blackest blacks will be clipped.

Using Levels to improve the contrast

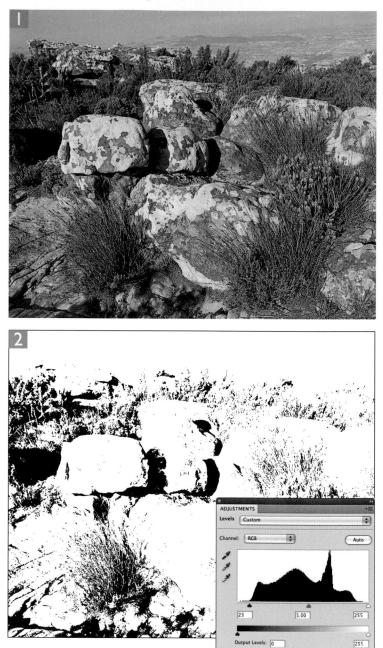

Image editing essentials

Chapter 5

3 The same technique could also be applied adjusting the highlights. Here, I held down the Calt key as I dragged the Highlight slider inwards. As I did this the Threshold display mode started off completely black and the lightest points in the image (where I might want to clip the highlights) appeared first as I dragged the highlights Input levels slider inwards. As in the previous example, this preview shows an extreme adjustment so I needed to ease off a bit and search for the lightest highlight point and then maybe reduce the clipping slightly since I didn't want to risk clipping any of the important (non-specular) highlight detail (see pages 180-181 for more about how to clip the highlights).

4 Here is the final version, which shows what the image in Step 1 looked like after I had applied the Levels adjustment described here. The levels in the photograph were expanded to reveal a fuller range of tones and as you can see, the Histogram panel view now confirms this.

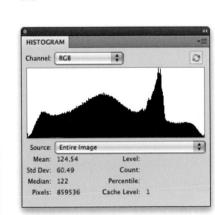

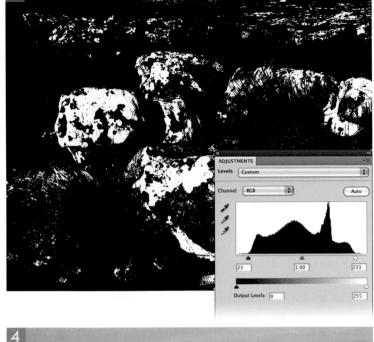

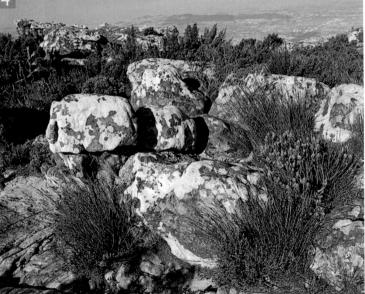

Are Curves all you need?

I have become a firm believer in trying to make Photoshop as simple as possible. There are 22 different items listed in the Image Adjustments menu and of these I reckon that you can achieve almost all the image adjustments you need by using just Curves and Hue/Saturation. While Curves can replace the need for Levels, I do still like to use the Levels dialog, because it is nice and simple to work with, plus there are also a lot of tutorials out there that rely on the use of Levels. You are still likely to come across lots of suggestions on ways to tonally adjust images by various means. And you know what? In most cases these techniques can often be summarized with a single Curves adjustment. It's just that it can sometimes actually work out quicker (and feel a lot more intuitive) to use a slightly more convoluted route. In Photoshop there is often more than one way to achieve a particular effect, but to quote Fred Bunting: there are always those techniques that are 'more interesting than relevant.'

Curves adjustment layers

Any image adjustment that can be done using Levels can also be done using Curves, except with Curves you can accurately control the tonal balance and contrast of the master composite image as well as the individual color channels. You can also target specific points on the tone curve and remap the pixel values to make them lighter or darker and adjust the contrast in that tonal area only.

As with all the other image adjustments, there are two ways you can work with Curves. There is the direct route (using the Image \Rightarrow Adjustments menu) and the Adjustments panel method described here. In the case of Curves, the two layouts are quite different and I have chosen to concentrate on the Adjustments panel here first because I believe this method is more useful for general image editing. However, the direct Curves dialog does offer some unique legacy features that are still worth mentioning.

Figure 5.25 shows the Adjustments panel displaying the Curves controls, where the default RGB units are measured in brightness levels from 0 to 255 and the linear curve line represents the output tonal range plotted against the input tonal range, going from 0 in the bottom left corner to 255 levels top right. The vertical axis represents the output and the horizontal axis the input values (and the numbers correspond to the levels scale for an 8-bit per channel image). When you edit a CMYK image, the input and output axis is reversed and the units are measured in ink percentages instead of levels. The Curves grid normally uses 25% increments for RGB images and 10% increments for CMYK images, but you can toggle the Curves grid display mode by *alt*-clicking anywhere in the grid.

Let's now look at the Curves control options. At the top of the controls section you have a channel selection menu. This defaults to RGB or CMYK, meaning that all channels are affected equally by the adjustments you make. You use this menu to select specific color channels, which can be useful for carrying out color corrections (see Figure 5.26). The Auto button in Curves is the same as the one found in Levels. When you click on this button, it applies an auto adjustment based on how the Auto settings are configured (see Auto image adjustments on pages 344–345). The Input levels sliders work the same way as the ones in Levels and you can drag these with the *addle and the setting at the set at the setting at the set at the set*

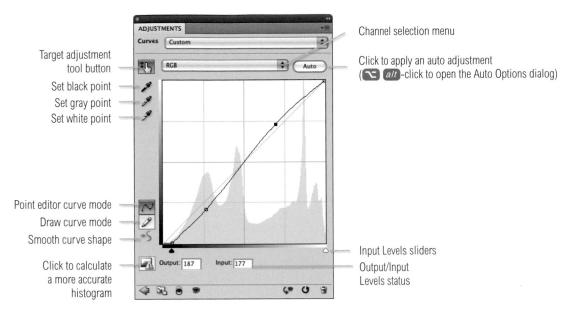

Figure 5.25 The Curves dialog represents the relationship between the input and output levels plotted as a graph. In this example, the shadow end of the curve has been dragged inwards (just as you would in Levels), in order to set the optimum shadow clipping point. You can control both the lightness and the contrast of the image by clicking on the curve line to add curve points and adjust the shape of the curve.

The Output and Input boxes provide numeric feedback for the current selected curve point so that you can adjust the curve points more precisely. You may sometimes see the histogram warning button light up. This warns you that the histogram displayed in the grid area is not an accurate reflection of what the true histogram should be and if you click on this, it forces an update of the histogram view. The Curves dialog uses the Point curve editor mode by default, but there is also a Pencil button for switching to a draw curve mode, which allows you to draw a curve shape directly. While in 'draw curve' mode the Smooth curve shape button is made active and clicking on this allows you to smooth a drawn curve shape. Overall, you are unlikely to need to use the draw curve mode when editing photographic images.

If you double-click the eyedroppers, you can edit the desired black point, gray point and white point colors and then use these eyedroppers to click in the image to set the appropriate black, gray and white point values. There was a time in the early days of Photoshop where the eyedropper controls were important, but

Figure 5.26 The default setting for Levels or Curves applies the user's corrections to the composite of the color channels. If you mouse down on the Channel menu, you can choose to edit individual color channels. This is how you can use Curves to make color adjustments.

Figure 5.27 When the cursor is dragged over the image, a hollow circle indicates where the tone value is on the curve.

Adding curve point tip

In non-target adjustment tool mode, if you select the eyedropper tool from the tools panel, you can **H** *ctrl*-click to add a point to the curve.

there are two reasons why this is less the case now. Firstly, you can accurately set the black and white clipping points in Camera Raw (as described on pages 180–185) and secondly, the color management system in Photoshop automatically maps the black point for you when you convert an image to CMYK, or uses the Photoshop print dialog to make a color managed print output. However, the gray eyedropper can still prove useful for auto color balancing a photo (as described on page 344).

On-image Curves editing

If you click on the target adjustment tool button to activate it and move the cursor over the document window, you will notice a hollow circle that hovers along the curve line. This indicates where any part of the image appears on the curve and if you simply click on the image a new curve point is added to the curve (Figure 5.27). However, if you click to add a curve point and at the same time drag the mouse up or down in the image window, this will simultaneously move the curve up and down at where you just added the curve point. This means that when the target adjustment tool mode is active, you can click and drag directly on the image to make specific tone areas lighter or darker (see the step-by-step example opposite). Note that if you can get the cursor to hover over an existing curve point you can **(H)** *ctrl*-click to delete it from the curve line. With both the eyedropper and the target adjustment tool methods, the pixel sampling behavior is determined by the sample options set for the eyedropper tool (see Figure 5.28). If a small sample size is used, the curve point placement can be quite tricky, because the hollow circle will dance up and down the curve as you move the cursor over the image. However, if you select a large sample size this will average out the readings and make the cursor placement and on-image editing a much smoother experience. Note that in Photoshop CS5 there is now an 'Auto-Select Targeted Adjustment Tool' Adjustments panel mode option that automatically selects the target adjustment tool whenever a Curves adjustment layer is made active.

Figure 5.28 The eyedropper tool Options bar showing the Sample Size options. For on-image selections it can be useful to choose a large sample size. Note also the 'Show Sampling Ring' option that can be used to enable/disable the sample ring display.

323

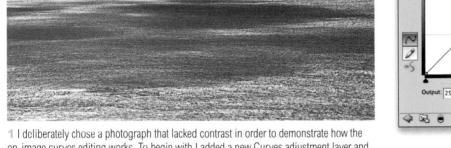

:

Show Sampling Ring

ADJUSTMENTS Curves Default -RGB Auto tim 1 \$ \$ Output: 255 Input: 255 4 2 0 0 60 0 3

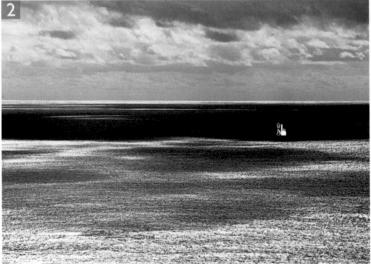

2 I then clicked on the target adjustment tool button (circled) and moved the cursor over the image. I was then able to click with the mouse on the image to add new points to the curve. As I dragged the cursor upwards, this raised the curve upward and lightened the tones beneath where I had clicked in the image. Likewise, as I dragged downwards I was able to darken these tones in the image.

on-image curves editing works. To begin with I added a new Curves adjustment layer and made sure that I had a large sample size set for the eyedropper tool options.

\$ Sample: All Layers

Sample Size: 51 by 51 Average

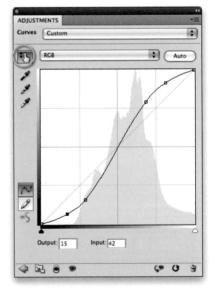

When to use direct curves

The same principles apply here as with the Levels adjustments. Adjustment Curves are the ideal solution for most image editing tasks, but if you wish to edit individual Photoshop channels or layer masks, the only way to do this is by using direct Curves adjustments.

Direct Curves dialog

Many of the options in the direct Curves dialog are the same as those that can be found in the Adjustments panel. However, in addition to these there is a 'Show Clipping' option for turning on the shadow and highlight clipping threshold preview when dragging the black point or white point input sliders. In the Adjustment panel the Curves mode is selected automatically, selecting the Light Curves mode for RGB images (which shows the levels range from 0-255) and the Pigment/Ink Curves mode for CMYK images where the curves values are expressed as percentages (the Pigment/ Ink Curves mode is preferable for repro users who prefer to see the output values expressed as ink percentages when editing CMYK images). In the direct Curves dialog you aren't as restricted as you are in the Adjustments panel because the Curve Display Options section at the bottom allows you to manually choose between the Light Curves mode or the Pigment/Ink Curves mode regardless of the color mode the image is in. There are also button options to switch between showing 25% or 10% increments in the graph display, although you can toggle the display by **C** alt -clicking in the graph area, just as you can in the Adjustments panel.

The remaining options are normally on all the time in the Curves Adjustments panel. However, if you check the 'Channel Overlays' option, this allows you to toggle seeing the individual color channel curves as you edit the main composite channel curve (as seen in Figure 5.29). The Histogram box allows you to toggle displaying the 'cached' histogram within the grid area, while checking the 'Baseline' option allows you to toggle displaying the standard reference line to compare your curve movements against. Lastly, the 'Intersection Line' option allows you to toggle temporarily displaying the intersection lines seen as you mouse down on a curves point. This feature is also on by default in the Adjustment panel and is there is so that you can more easily reference a curve point against the outline of the histogram.

Saving and loading curves

Curve settings can be saved by going to the Curves options menu (circled in Figure 5.30) and selecting the 'Save Preset...' option. Once you have named and saved a setting, the preset will then be accessible via the Presets list menu that appears at the top of both types of Curves dialogs. To delete a preset, make it active then go to the Curves options menu and select 'Delete Current Preset'.

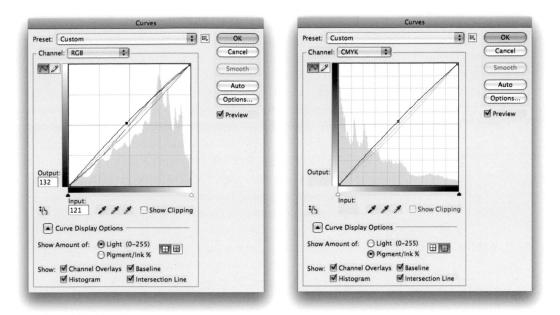

Figure 5.29 Clicking anywhere inside the grid area allows you to switch the grid units from 25% (Light) to 10% (Pigment/Ink) increments.

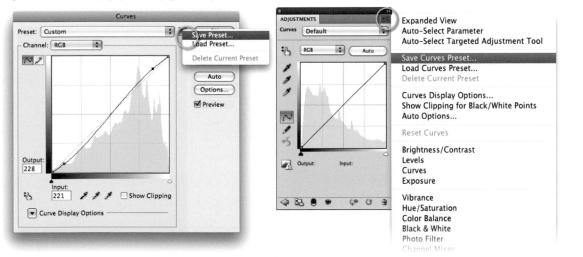

Figure 5.30 You can save any Curves adjustment as a custom preset by choosing 'Save Preset...' from the Curves menu (circled). This pops the Save dialog shown here. Once a Curves setting has been saved, it will appear listed in the Curves preset file list (you can save a Curves setting wherever you like, but it will only remain in the Presets list if you keep it stored in the default Curves folder). Pre-existing Curves settings can be added by going to the same menu and choosing 'Load Preset...' Note: a Curves setting must include the .csv extension for without it you cannot load it back into Curves.

	Save cu	rves in:	
Save As: Ste	ep curve		
Where:	Curves		
		Cance) Save

Threshold mode preview

The Curves input sliders work exactly like the ones found in Levels. You can preview the shadow and highlight clipping by holding down the (alt) key as you drag on the shadow and highlight sliders circled in the Curves dialog shown in Figures 5.31 and 5.32.

Using Curves in place of Levels

You can adjust the shadow and highlight levels in Curves in exactly the same way as you would using Levels. For example, in the Curves adjustment dialogs you have the Input shadows and Input highlights sliders and you can drag these inwards to clip the shadow and highlight levels (Figure 5.31). In Levels you alter the relative brightness of the image by adjusting the gamma slider, while in the Curves adjustment you can add a single curves point and move it left to lighten or right to darken.

Output levels adjustments

If you select a shadow or highlight curves point and move it up or down, you can adjust the output levels for the shadows or highlights. Figure 5.32 shows how to apply equivalent tone adjustments to the output levels in Levels and Curves, while Figure 5.33 shows some further examples of where the output levels have been adjusted.

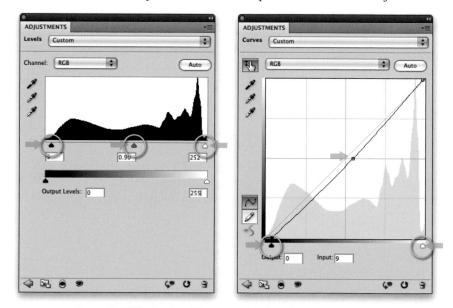

Figure 5.31 The Levels and Curves panel settings shown here can both be used to apply identical adjustments to an image. In the Levels adjustment example I moved the shadows and highlight Input levels sliders inwards. You will notice that the Curves adjustment has an identical pair of sliders with which you can map the shadow and highlight input levels. In the Levels adjustment you will notice how I moved the Gamma slider to the right, to darken the midtones. In the Curves adjustment one can add a point midway along the curve and drag this to the right to achieve an identical kind of 'Gamma' midtone adjustment.

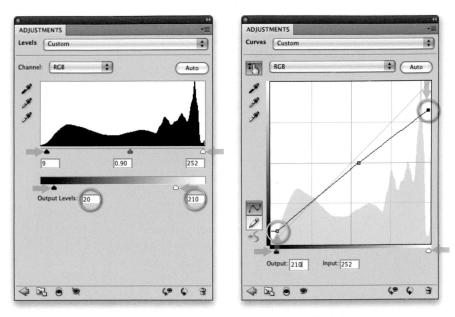

Figure 5.32 The Levels and Curves settings shown here will also apply identical adjustments. In the Levels adjustment I kept the input levels the same and adjusted the output levels to produce an image where the optimized levels were mapped to a levels range of 20–210. In the Curves dialog you can see the highlight point is selected and the curve point has been moved downwards to show a corresponding output value of 210 (the same value as the one entered in the Levels Output Levels).

Figure 5.33 Setting the output levels to something other than zero is not something you would normally want to do, except for those times where you specifically want to dull down the tonal range of an image. In the example shown here, the left section shows standard optimized levels, the middle section shows the same image with reduced highlight output levels and the right section shows the image with reduced shadow output levels.

Using Curves to improve contrast

So far I have shown how a Levels or Curves adjustment can be used to expand the levels in order to achieve an image in which the tones have been fully optimized. However, there are also times where you may wish to modify the contrast, but without clipping the levels at either end of the histogram. This is where Curves adjustments come into their own, because Curves allow you to modify the image tonal contrast with fine-tuned precision.

Figures 5.34–5.36 show three examples of how you can use a Curves adjustment to manipulate the contrast. In Figure 5.34, the shadows and highlights had been optimized, but the curve was left as a straight line between these two points. In this example a Curves adjustment was used to optimize the image contrast in exactly the same way as you could do using Levels. In Figure 5.35, two curve points were added to create a steep 'S' shape curve. By steepening the curve you can increase the contrast in the tones that reside in that portion of the curve. In this example, the shadow and highlight points were optimized and more contrast was added to the midtones. In Figure 5.36, two curve points were added to create a shallow 'S' shape curve. In this example you will notice that although the shadows and highlights have again been optimized, there is now a decrease in contrast in the midtone areas. This occurred where the curve was at its shallowest.

When you first start working Curves you should aim to add just a few points at a time. As you develop your Photoshop skills you can try adding more points, but as you do so, take care to maintain a nice smooth curve shape. Adding more points (especially if they are set too close together) can cause sharp kinks in the curve which in turn can produce an undesirable 'solarized' look, or possibly some banding.

Curves luminance and saturation

A Normal mode Levels or Curves adjustment will adjust both the luminance and the color in an image. This means that as you steepen the curve to increase the contrast, you will at the same time increase both the luminance and color contrast. It can therefore be handy to filter a curves adjustment by choosing a Luminosity blend mode to target the luminance contrast only, or a Color blend mode to target the color contrast only (see pages 330–331).

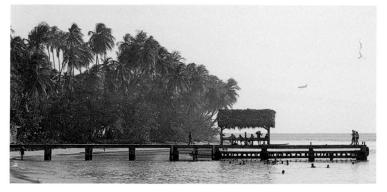

Figure 5.34 This view shows an image where the Curves adjustment simply optimized the input shadows and highlights and no further adjustments were applied to the curve.

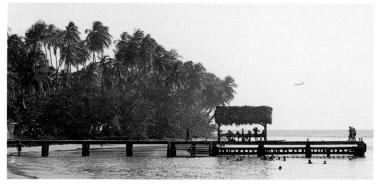

Figure 5.35 In this example, the contrast was increased by adding two extra curve points to create the 'S'-shaped curve shown here.

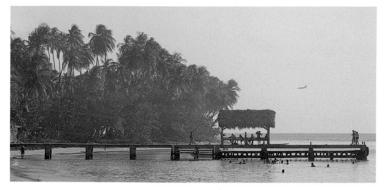

Figure 5.36 In this example I decreased the contrast by adding two curve points to create an 'S'-shaped curve that flowed in the opposite direction to the one shown in Figure 5.35

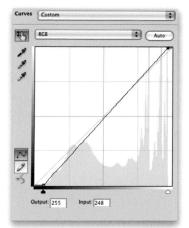

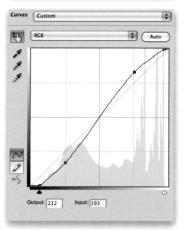

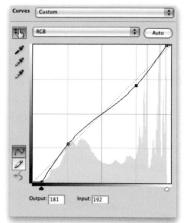

Easier blend mode access

One of the main benefits of the Adjustment layers approach is that you can switch easily between editing the adjustment controls in the Adjustments panel and adjusting the layer opacity and blend mode settings.

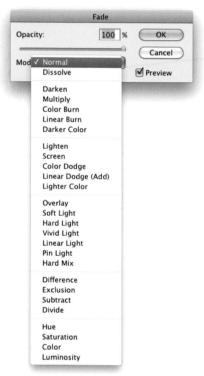

Figure 5.37 The Edit ⇒ Fade dialog.

Luminosity and Color blending modes

One of the problems you may encounter when applying Normal mode tone adjustments is that as you use Levels or Curves to adjust the tonal balance of a picture, the adjustments you make simultaneously affect the color saturation as well. In some instances this might be a desirable outcome. For example, whenever you start off with a flat image that requires a major Levels or Curves adjustment, the process of optimizing the shadows and highlights will leave you with a nice bright-looking picture with increased contrast and colors that are more saturated. This can be considered to be a good thing, but if you are carrying out a careful tone adjustment and want to manipulate the contrast or brightness, *but without* affecting the saturation, changing the blend mode to Luminosity can isolate the adjustment so that it targets the luminosity values only.

This is also where using adjustment layers can come in useful, because you can easily switch the blend modes for any adjustment layer. In the example shown opposite, a Curves adjustment was used to add more contrast to this sunset view of a mountain. When this adjustment was applied in the Normal mode (as shown in Step 1), the color saturation was increased. However, if the same Curves adjustment was applied using a Luminosity blend mode, there was an increase in contrast but without the increase in color saturation. Incidentally, I quite often use the Luminosity blend mode whenever I add a Levels or Curves adjustment layer to an image, especially if the image has already been optimized for color. This is because whenever I add localized corrections I usually don't want these adjustments to further affect the saturation of the image. Similarly, if you are applying an image adjustment (such as Curves) to alter the colors in a photo, you will want the adjustment to target the colors only and leave the luminance values as they are. So whenever you make a color correction using, say, Levels, Curves, Hue/Saturation, or any other method, it is often a good idea to change the adjustment layer blend mode to Color.

If you happen to prefer the direct adjustment method, you can always go to the Edit menu after applying a Curves adjustment (or any other adjustment such as a brush stroke or a filter) and choose 'Fade Curves...' (**#***Shift* **F** *etrl Shift* **F**). This opens the Fade dialog shown in Figure 5.37 where you can change the blend mode of any adjustment as well as fade the opacity.

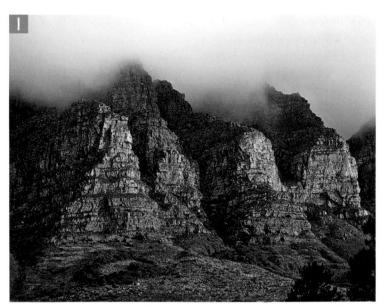

1 When you increase the contrast in an image using a Curves adjustment, you will also end up increasing the color saturation. Sometimes this can produce a desirable result because some photographs may look better when you boost the saturation.

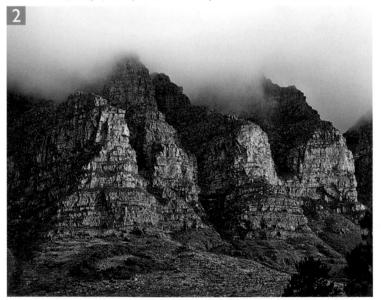

2 In this example I applied the same Curves adjustment as was applied in Step 1, but I changed the layer blend mode to Luminosity. This effectively allowed me to increase the contrast in the original scene, but without increasing the color saturation.

Adobe Photoshop CS5 for Photographers

Curve presets

At the top of the Curves dialog you will see a Preset menu (Figure 5.38). This contains a number of custom Curves presets that are shipped with the program, plus any Curves presets that you have saved recently. The standard Curves presets offer some fairly straightforward settings. For example, you can use these to make an image lighter or darker, or apply different contrast curve shapes. These presets might be useful as starting point settings and you can run through the Presets menu selecting the various curve settings just to see how they will affect the look of an image. Some of the other Curves settings ambitiously aim to apply a crossprocess style effect or convert a color negative scan into a positive image. In my opinion, these settings are a bit hit or miss. If you want to take a color negative scan and make it into a positive, you would need to create special custom Curves settings for each different type of color negative emulsion. In all honesty, if you are going to scan color negatives, then you are probably going to be better off letting the scanner software do the conversion for you.

Figure 5.38 Here is a view of the Curves dialog, showing the Custom Curves menu. Note that if you create a manual Curves setting and then select a preset, the applied setting overwrites the previous Curves setting, but you can always use the Undo command (**38 Z ctrl Z**) to revert to a previous Curves setting.

1 If you use Photoshop to convert a color negative to make a positive, you could try selecting the Color Negative preset shown in Figure 5.38, but this is unlikely to produce a successful conversion.

2 In most instances it will be necessary to adapt the shape of the curve in the composite channel and individual color channels to achieve an optimum negative to positive conversion.

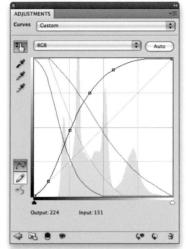

3 In the bottom example I added a saturation boost to the image. Because of the extreme nature of such adjustments, it is better to work on an image that has been scanned in 16-bits per channel.

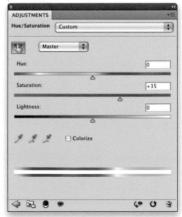

Figure 5.39 In this example I wanted to make the dark tones darker, but without affecting the mid to highlight tones so much. Here is what I did. I placed one curve point on the middle intersection point of the curve and another on the 75% intersection point. I then added a third curve point towards the toe of the curve and dragged downwards to darken the shadows and steepen the curve in the shadow to midtone areas. You will notice that because I had added the other two curve points first, adjusting the third curve point had very little effect on the upper portion of the curve.

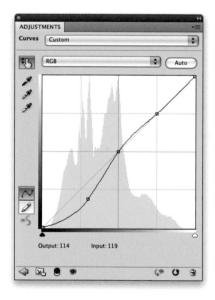

Locking down portions of the curve

As you go beyond adding one or two points to a curve, you need to be careful to keep the curve shape under control. Once you start adding further points to a curve, adjusting a point on one part of the curve may cause the curve shape to move, pivoting around the adjacent points. One solution is to sometimes lay down 'locking' points on the curve, as shown in Figure 5.39.

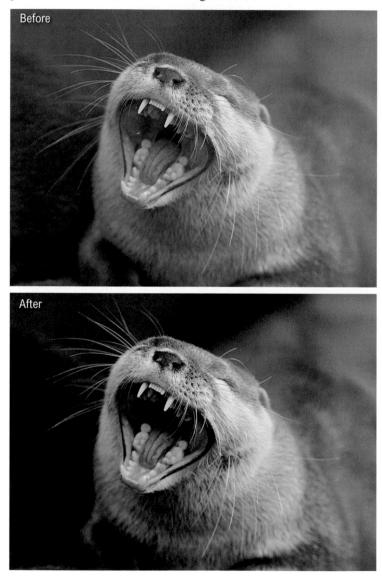

Creating a dual contrast curve

Now let's look at adding even more curve points. There are times where you may want to manipulate the contrast in two sections of the curve at once. For this you may need to place three or more points on the curve such as in the Figure 5.40 example shown below. You are now entering dangerous territory, because if you are not careful you can end up either making some of the tones look solarized, or possibly flatten them, and in the process lose a significant amount of tonal detail.

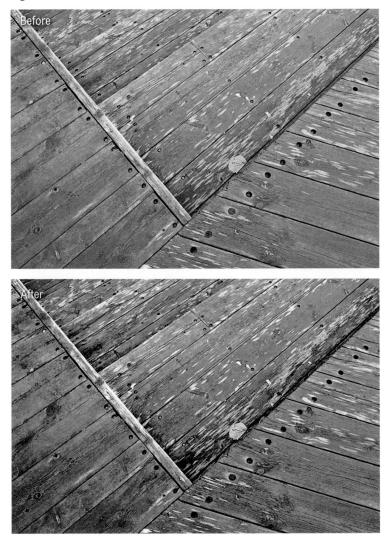

Figure 5.40 In this example I wanted to boost the contrast in the shadows and the highlights separately. To do this, I applied the curve shape shown here where you will see that by using five curve points I was able to lock down the middle portion of the curve and independently steepen the shadow/midtone and highlight portions of the curve. Note that in order to prevent the curve from boosting the color saturation, I set the Curves adjustment blend mode to Luminosity.

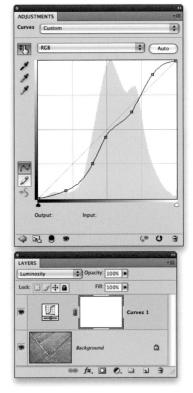

Mask adjustments

The one time when you may find it useful to use the legacy style Brightness/Contrast image adjustment is when you wish to edit the contents of an image layer mask. The crudeness of the Brightness and Contrast adjustments can actually be beneficial when you wish to force the highlight areas of a mask to go to white and the shadow areas to go black.

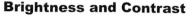

For as long as Photoshop has been around, there has been an adjustment control called Brightness/Contrast. For years now many authors and experts have done their best to discourage people from using this adjustment control. This was because of the potential harm it could do to your pictures. Yet so many people continued to use it, oblivious to the fact that it was never intended for photographic use. However, since Photoshop CS3, the default behavior has been changed so that the Brightness/Contrast adjustment can roughly match the behavior of the Brightness and Contrast sliders found in Camera Raw (see Chapter 3), where the shadow and highlight endpoints are preserved and the image adjustments are constrained to operate between these two points. However, the old legacy behavior is still available as an extra option (Figure 5.41). The main reason for retaining the old style behavior is to maintain compatibility with legacy images where the old style Brightness/Contrast adjustment may have been recorded as part of a Photoshop action.

Figure 5.41 The Histogram panel can be used to demonstrate why the legacy Brightness/ Contrast image adjustment setting is unsuited for photographic tonal corrections. The histogram on the left shows the normal histogram. If you use the Brightness slider to increase the Brightness, all you are doing is shifting all the tones lighter and as a consequence of this the highlight detail may become clipped. If you increase the Contrast, the tones are stretched in both directions and both the shadows and highlights may become clipped.

Image editing essentials

1 This before version shows a photograph that needed a Brightness/Contrast adjustment to brighten the picture.

2 Here is the same photograph after I had applied a Brightness/Contrast adjustment (with the Use Legacy box unchecked). Notice how the histogram in the corrected version preserved the full tonal range from the shadows to the highlights.

OUTH PA PLER Bouthsea BARS CATERING CHILDRENS

Channel:	RGB	•		0
		A.		
Source:	Entire Ima	ge	•	\$
	Entire Imag 83.07	ge Level:	•	\$
Mean:	83.07			\$
	83.07 34.95	Level:		\$

HISTOGR	AM		
Channel:		•	0
	hillin fa		
Source			
	Entire Ima	ge	\$
Mean:	Entire Ima 119.48		\$
	Entire Ima 119.48 54.14	ge Level:	•

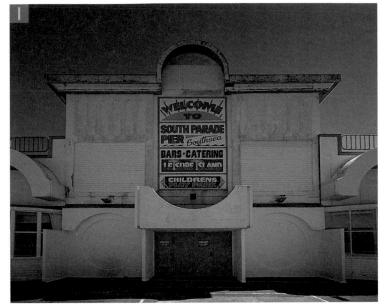

	Contraction of the	%	Cance
Highlights			Load
Amount:	0	%	Save

Figure 5.42 The Shadows/Highlights adjustment dialog is shown here in Basic mode. Checking the Show More Options box will reveal the Advanced mode dialog shown in Figure 5.43.

Shac	lows/Highligh	nts	
- Shadows Amount:	35]%	OK Cance
Tonal Width:	35	%	Load
Radius:	30	- px	Save
		-	0
Highlights			
Amount:	0	%	
Tonal Width:	50	%	
Radius:	30] px	
- Adjustments]	
Color Correction:	+20		
Midtone Contrast:	Ø]	
Black Clip:	0.01	%	
White Clip:	0.01	%	
Save As Defaults			
Show More Options			

Figure 5.43 In the Show More Options mode, the Shadows/Highlights dialog contains a comprehensive range of controls. I would advise you to always leave the 'Show More Options' box checked so that you have this as the default mode for making Shadows/ Highlights adjustments.

Correcting shadow and highlight detail

The Shadows/Highlights image adjustment (Figure 5.42) can be used to reveal more detail in either the shadow or highlight areas of a picture. It is a great image adjustment tool to use whenever you need to expand image tones that are too compressed in the original image, but it can be used to perform wonders on most photos and not just those where you desperately need to recover shadow or highlight detail.

The Shadows/Highlights image adjustment tool makes adaptive adjustments to an image, and it works in much the same way as our eyes do when they automatically compensate and adjust to the amount of light illuminating a subject. Essentially, the Shadows/ Highlights adjustment works by looking at the neighboring pixels in an image and makes a compensating adjustment based on the average pixel values within a given radius. In Advanced mode, the Shadows/Highlights dialog provides additional controls that allow you to make the following fine-tuning adjustments (Figure 5.43).

Amount

This is an easy one to get to get to grips with. The default Amount setting applies a 35% amount to the Shadows. You can increase or decrease this to achieve the desired amount of highlight or shadow correction. I find the default setting does tend to be rather annoying, so I usually try setting the slider to a lower amount, or zero, and click on the Save As Defaults button to set this as the new default setting for each time I open Shadows/Highlights.

Tonal Width

The Tonal Width determines the tonal range of pixel values that will be affected by the Amount setting. A low Tonal Width setting narrows the adjustment to the darkest or lightest pixels only. As the Tonal Width is increased the adjustment spreads to affect more of the midtone pixels as well (see the example shown in Figure 5.44).

Radius

The Radius setting governs the pixel width of the area that is analyzed when making an adaptive correction. To explain this, let's concentrate on what would happen when making a shadow correction. If the Shadow Radius is set to zero, the result is a very flat-looking image. You can increase the Amount to lighten the shadows and restrict the Tonal Width, but if the Radius is low or is

set to zero, Photoshop has very little 'neighbor pixel' information to work with when trying to calculate the average luminance of the neighboring pixels. So if the sample Radius is too small, the midtones also become lightened. If the Radius setting is set too high, this has the effect of averaging all of the pixels in the image and likewise the lightening effect will be distributed such that all the pixels get the lightening treatment and not just the dark pixels. The optimum setting is always dependent on the image content and the pixel area size of the dark or light regions in the image. The optimum pixel Radius width should therefore be about half that amount or less. In practice you don't have to measure the pixel width of the light and dark areas in an image to work this out. Just be aware that after you have established the Amount and Tonal Width settings you should adjust the Radius setting and make it larger or smaller according to how large the dark or light areas are. There will be a 'sweet spot' where the Shadows/Highlights correction is just right.

As you make an adjustment to the Radius setting you will sometimes notice a soft halo appearing around sharp areas of contrast between dark and light areas. This is a natural consequence of the Radius function and is most noticeable when you apply large Amount corrections. Aim for a Radius setting where the halo is least noticeable or apply a Fade... adjustment after applying the Shadows/Highlights adjustment. If I am really concerned with avoiding halos, I sometimes use the history brush to selectively paint in a Shadows/Highlights adjustment.

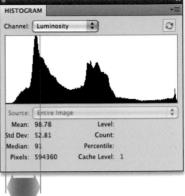

Figure 5.44 The Tonal Width slider determines the range of levels the Shadows/ Highlights adjustment is applied to. For example, if the Shadow adjustment Tonal Range is set to 50, then only the pixels which fall within the darkest range from level 0 to level 50 will be adjusted (such as the deep shadows in this photograph).

HDR Toning adjustment

Photoshop CS5 now also offers an HDR Toning adjustment from the Image ⇒ Adjustments menu. This is described on pages 402–403 and provides an alternative approach to applying Shadows/Highlights type image adjustments.

Image editing essentials

Adobe Photoshop CS5 for Photographers

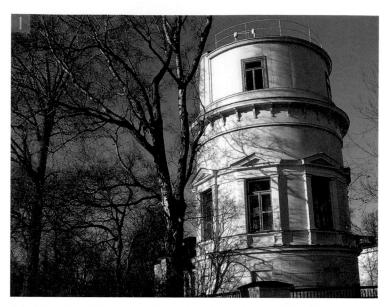

In this photograph there were a lot of dark shadows in the trees. With a little help from the Shadows/Highlights adjustment it is possible to bring out more detail in the shadows, but without degrading the overall contrast.

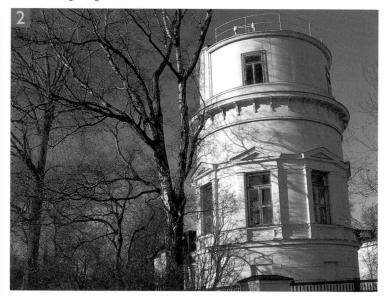

2 I went to the Image menu and chose Adjustments \Rightarrow Shadows/Highlights. I set the Amount to 55% and raised the Tonal Width to 45%. The Radius adjustment was now crucial because this determined the distribution width of the Shadows/Highlights adjustment. As you can see in this step, if the Radius is set to zero the image looks flat.

Shad	ows/Highlig	hts	
- Shadows Amount:	55	%	OK Cancel
Tonal Width:	45	%	Load
Radius:	D	px	Save
Highlights	0	%	
Tonal Width:	27	3%	
Radius:	30	рх	
- Adjustments			
Color Correction:	+20		
Midtone Contrast:	+30		
Black Clip:	0.01	%	
White Clip:	0.01	%	
Save As Defaults Show More Options			

Image editing essentials

3 The other alternative is to take the Radius setting up really high. But this too can diminish the Shadows/Highlights adjustment effect. It is useful to remember here that the optimum Radius setting is 'area size' related and falls somewhere midway between these two extremes. In the end, I went for a Radius setting of 130 pixels for the shadows. This was because I was correcting large shadow areas and this setting appeared to provide the optimum correction for this particular photo. I also increased the Midtone Contrast to +30. This final tweak compensated for any loss of contrast in the midtone areas.

Color Correction

As you correct the highlights and the shadows, the color saturation may change unexpectedly. This can be a consequence of using Shadows/Highlights to apply extreme adjustments. The Color Correction slider lets you compensate for any undesired color shifts.

Midtone Contrast

The midtone areas may sometimes suffer as a result of a Shadows/ Highlights adjustment. Even though you may have paid careful attention to getting all the above settings perfectly optimized so that you successfully target the shadows and highlights, the photograph can end up looking like it is lacking in contrast. The Midtone Contrast slider control lets you restore or add more contrast to the midtone areas.

Shadows			OK
Amount:	55	%	Cancel
Fonal Width:	45]%	Load
Radius:	130	px	Preview
Highlights			1
Amount:	0	%	
Fonal Width:	27]%	
Radius:	30	рх	
Adjustments			1
Color Correction:	+20		
Midtone Contrast:	+30		
Black Clip:	0.01	1%	
White Clip:	0.01	%	

CMYK Shadows/Highlights adjustments

You can use a Shadows/Highlights adjustment on CMYK as well as RGB images.

Adobe Camera Raw adjustments

Shadows/Highlights adjustments can work great on a lot of images, but now that Camera Raw can be used to edit JPEG and TIFF images too, you may like to explore using the Recovery and Fill Light adjustments described on pages 176–177. In many cases Recovery and Fill Light work better than using Shadows/Highlights.

Figure 5.45 The Variations dialog displays color balance variations based on the color wheel model. Here you see the additive primaries (red, green, and blue) and the subtractive primaries, (cyan, magenta, and yellow) placed in their complementary positions on the color wheel. Red is the opposite of cyan; green is the opposite of magenta; and blue is the opposite of yellow. You should use these basic rules to gain an understanding of how to correct color.

Figure 5.46 The Variations interface lets you modify the color of the shadows, highlights or midtones separately. For example, clicking on the More Red thumbnail image will cause the red variant to shift to the center and readjust the surrounding thumbnail previews accordingly, and clicking on the More Cyan thumbnail restores the central preview to its original color balance. In this respect, Variations is just like the Color Balance adjustment, but you also have built-in saturation adjustments and a lighter or darker option. Variations may be a crude tool for color correction work, but it is nonetheless a useful means by which to learn color theory before you proceed to applying the principles learnt here to working with Levels or Curves.

Color corrections

We shall now look at using the image adjustment controls to adjust the colors in an image. Again, almost everything you want to do to edit the color in a flattened pixel image can be achieved using just Levels, Curves and Hue/Saturation. But before we get into how these should be used, we should take a quick look at the Variations adjustment (Figure 5.46). This image adjustment is a good learning tool for beginners, because all the basic image editing tools are combined in a single interface (you can also see how Variations adjustments relate to the color wheel diagram shown in Figure 5.45). Having said that, I would not advise using Variations as a general tool for color correction because it does nothing more than provide a Levels style Gamma slider control to adjust the individual color channels or overall brightness. Anything you do using Variations can be done more simply using Levels (or more accurately using Curves), plus the Variations adjustment can only be applied to 8-bit images. While Variations does have a Saturation control, the Hue/Saturation adjustment provides more versatile controls. The same goes for the Color Balance image adjustment. This too is simply offering you another way to apply Levels style adjustments.

Basic color balancing with Levels

You can correct color casts in an image by using the Input and Output sliders in the Levels dialog to adjust the individual color channels. To edit an individual channel, go to the pop-up menu next to where it says 'Channel', mouse down here and choose a color channel to edit. Let's say you have a picture which looks too blue and you want to add more yellow (such as in the Figure 5.47 example below). If you select the Blue channel in the Levels adjustment and drag the gamma slider to the right, this will make the image more yellow. Another way to neutralize midtones in the Levels or Curves dialog box is to select the gray eyedropper and click on an area in the image that should be a neutral gray. With a levels adjustment, this action automatically adjusts the gamma setting in each color channel to remove the color cast. A Levels adjustment may be adequate enough to carry out basic image corrections, but doesn't provide you with too much control beyond reassigning the highlights, shadows and midpoint color values. The best tool to use for color correction is Curves, because with Curves you can change the color balance and contrast with a degree of precision that is simply not available with most other image adjustments.

Color corrections in RGB

You will note that the instructions for all the color corrections described in this chapter are done using the RGB color mode. This is because RGB is a more versatile color mode for photographers to work in. There are further reasons why I recommend this particular workflow, which I discuss in more detail in Chapter 12.

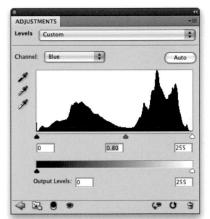

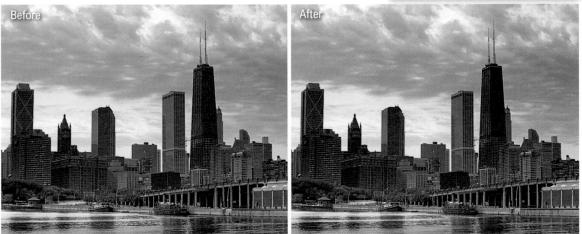

Figure 5.47 With a photograph like the one shown on the left, it is not necessarily a bad thing to have a color cast, but let's say I wanted to apply a basic color correction to make it more yellow. If I add a Levels adjustment, I can select the Blue channel from the Channel menu and move the Input gamma slider to the right. This adjustment decreases the gamma in the Blue channel and makes the midtones in the image more yellow.

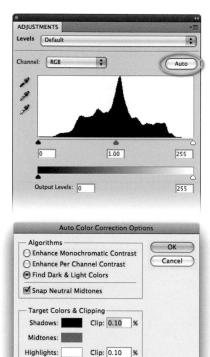

Figure 5.48 The Auto image adjustments can also be accessed when you click on the Options... button in the direct Levels or Curves dialogs, or an adjustment layer dialog. If 'Snap Neutral Midtones' is selected, Auto Color will neutralize these too. You can also customize the clipping values to determine how much the highlights and shadow tones are clipped by the image adjustment.

Save as defaults

Auto image adjustments

The Image menu contains three auto image adjustment options that are designed to provide automated tone and color correction: Auto Tone, Auto Contrast and Auto Color, examples of which are shown in Figure 5.49.

The Auto Tone adjustment (**#** *Shift* **(**) works by expanding the levels in each of the color channels individually. This per-channel levels contrast expansion method will always result in an image that has fuller tonal contrast, but it may also change the color balance of the image too. The Auto Tone adjustment can produce improved results, but sometimes not. If you want to improve the tonal contrast, but without affecting the color balance of the photograph then try using the Auto Contrast adjustment instead (**# Shift (**). This carries out a similar type of auto image adjustment as Auto Tone, except it optimizes the contrast by applying an identical Levels adjustment to each of the color channels.

Lastly, there is the Auto Color adjustment (**Shift B**). This provides a combination of Auto Contrast to enhance the tonal contrast, combined with an auto color correction that maps the darkest colors to black and the lightest colors to white.

If you open the direct Levels or Curves dialogs you will see a button marked 'Options...' just below the Auto button. If you click on it this opens the Auto Color Correction Options shown in Figure 5.48. If you are applying a Levels or Curves adjustment layer, then you'll need to <u>alt</u>-click the Auto button in order to open the Auto Color Correction Options dialog. The algorithms listed here match the auto adjustments found in the Image menu: 'Enhance Per Channel Contrast' is the same as 'Auto Tone'. 'Enhance Monochromatic Contrast' is equivalent to 'Auto Contrast' and 'Find Dark & Light Colors' is the same as 'Auto Color'. Notice however there is also a 'Snap Neutral Midtones' option. When this is checked, a Gamma adjustment is applied in each of the color channels which aims to correct the neutral midtones as well as the light and dark colors. A clipping value can also be set for the highlights and shadows and this determines by what percentage the endpoints are automatically clipped.

Auto Contrast (Enhance Monochromatic Contrast)

Figure 5.49 This shows the three auto adjustment methods (with equivalent descriptions for how they are described in the Levels and Curves Auto Color Correction Options dialogs). Auto Tone optimizes the shadow and highlight points in all three color channels. This generally improves the contrast and color balance of the image. Auto Contrast applies an identical tone balancing adjustment across all three channels that improves the contrast, but without altering the color balance. The Auto Color option maps the darkest and lightest colors to a neutral color (if the swatch colors shown in Figure 5.48 have been altered, you may see a different result). Lastly, I have shown an example of an Auto Contrast adjustment followed by a PhotoKit Color RSA Neutralize effect. There is a demo version of PhotoKit Color available on the DVD that comes with this book.

Auto Tone (Enhance Per Channel Contrast)

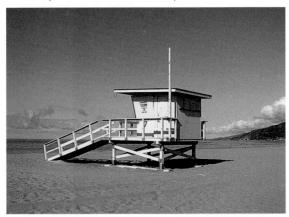

Auto Color (Find Dark & Light Colors + Snap Neutral Midtones)

Auto Contrast + PhotoKit Color RSA Neutralize

Channel selection shortcuts

Along with other changes to channel selection shortcuts, those for selecting the color groups in Curves have changed since CS3. You now need to use SE2 alt 2 to select the composite curve channel, use 😒 3 att 3 to select the Red channel and so on. Likewise, you can use # 2 ctrl alt 2 to load the composite (luminosity) channel as a selection, # ~ 3 ctrl alt 3 to load the Red channel as a selection, etc. For what it is worth, Adobe have made available a plug-in which, when enabled, allows users to restore the old channel selection behavior. This does of course override the new shortcuts described here. Personally, I think it is better to adapt to the new 'universal' shortcuts as these are here to stay. These resolve some of the international keyboard conflicts and help unify the user experience between the other Creative Suite programs.

* 🖷 🚺 🖬	
	3
Levels Presets	
Curves Presets	
Exposure Presets	
Hue/Saturation Presets	
Black & White Presets	
Channel Mixer Presets	
Selective Color Presets	

Color corrections using Levels or Curves

Of all the Photoshop color correction methods described so far, Auto Color probably provides the best automatic one-step tone and color correction method. However, if you prefer to carry out your color corrections manually, I would suggest you forget Variations or Color Balance and explore using Levels or Curves color channel adjustments instead. Earlier I showed how to set the highlight and shadow points in Levels and how to use a gamma adjustment to lighten or darken the image. To keep things simple I used a monochrome photograph. Let's now take things one stage further and use this technique to optimize the individual color channels in an RGB color image.

On these pages I show how you can use the Threshold mode analysis technique to discover where the shadow and highlight endpoints are in each of the three color channels, and use this feedback information to set the endpoints. This is a really good way to locate the shadows and highlights and set the endpoints at the same time, because once you have corrected the highlight and shadow color values in each of the color channels independently, the other colors usually fall into place and the photograph won't require any further color correction.

This photograph has a blue cast in the shadows and a magenta cast in the highlights. The first step was to go to the Adjustments panel and click on the Curves button (circled) to add a new Curves adjustment layer.

Locating the red

highlight point

Locating the red

shadow point

3 Finally, I added a midpoint in the Blue channel and dragged it to the right to add more yellow. This technique of adjusting the color channels one by one can help you remove color casts from the shadows and highlights with greater precision. The trick is to use the Threshold display mode as a reference tool to indicate where the levels start to clip in each channel and consider backing off slightly so that you leave some headroom in the composite/master channel. This then allows you to make general refinements to the Curves adjustment, ensuring that the highlights do not blow out.

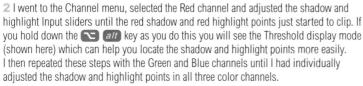

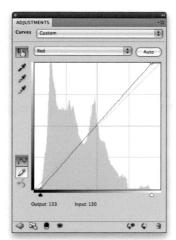

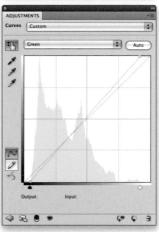

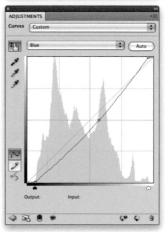

Direct Curves shortcuts

Since Photoshop CS3, the Curves Adjustment panel shortcuts have been adapted to take into account the fact that such curves adjustments are non-modal. As a consequence of this, some of the previous Curves dialog shortcuts were revised, which is why you now need to use the f and keys in both the Curves Adjustments panel and direct Curves dialogs to select the next and previous curve points.

R: G: B:	216 216 216	C: XM: Y:	18% 13% 14%
8-bit		K: 8-bit	1%
+, X: Y:	40.2% 75.6%		
Doc: 61	l8.8K/618.8	IK.	
		nove layer or	
		degree increr	

Figure 5.50 Providing the image you are editing is in RGB mode and you are using one of the standard RGB color spaces such as Adobe RGB, sRGB, ColorMatch RGB or ProPhoto RGB, the Info panel can be used in conjunction with the eyedropper or color sampler tools to read color values in an image and help determine whether the colors are neutrally balanced. Equal Red, Green and Blue values will always mean a color is neutral.

Precise color corrections using Curves

The basic Levels/Curves adjustment technique I have just shown you can be quite effective at correcting the color at the shadows, highlights and midtones. It therefore follows from this that you can utilize the versatility of Curves to adjust the individual channels with even greater precision. As a general rule, once you have corrected for a cast in the highlights and shadows, all the other colors should more or less fall into place and a further tweak to the midtones may be all you need. However, there are still plenty of situations where you may wish to exploit the full potential of a Curves adjustment to improve the color appearance. In the steps shown opposite I found that I needed to make two carefully targeted midpoint Curves adjustments to the Red and Blue channels in order to correct for the blue/cyan cast.

Let's now look at how to make Curves adjustments based on pixel color measurements. If you click on the target adjustment tool button in the Curves dialog (1) and then click anywhere on the image you can add a new control point on the corresponding portion of the curve. This is useful when making basic tone edits, as you can determine where to add curve control points by simply clicking on the image. Also, remember that in Photoshop CS5 there is now an 'Auto-Select Targeted Adjustment Tool' panel option that automatically selects the target adjustment tool when the adjustment layer is made active. If instead you hold down the **H** Shift ctrl Shift keys and click in the document window (with the target adjustment tool $[N_7]$ selected in the Curves panel) you can add control points to all three color channels at once (but not to the main composite curve). So, when adding control points to color correct the white shirt image example that follows on pages 350–351, I # Shift ctrl Shift-clicked on top of each of the color sampler points to add these as control points in all three color channels in the Curves dialog. I was then able to use the Info panel feedback (Figure 5.50) to determine whether the gray/white colors were neutral or not.

When you are editing the points in the Curves dialog, you can *Shift*-click additional points on the curve to select multiple points. Then, as you adjust one control point the others move in unison. When a single point is selected you can select the next point using the *+* key and you can select the previous point by using the *key* (see sidebar on working in the direct Curves dialog).

Image editing essentials

which should have been a neutral gray. I went to the Adjustments panel and chose 'Curves...'

2 This shows the Curves corrected version, where I was able to get rid of the cast in stages by adjusting the shape of the curve in the individual color channels. I first selected the Red color channel from the Channel menu and added a couple of control points to the curve to adjust the color balance for the midtones and highlights. I then went to the Blue channel and added two points to the curve, this time to correct the color for the shadows and highlights in the Blue channel. I simply applied these corrections based on the appearance

and what made the image look right.

F 1 This photograph had a cold blue cast that was particularly noticeable in the backdrop,

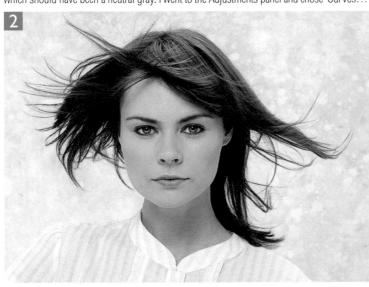

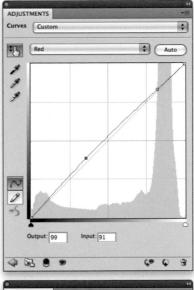

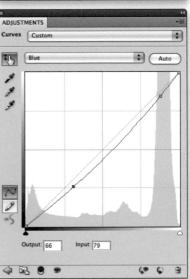

1 Whenever you have a subject that is white or gray, or photographed against a neutral background, any color cast will be extremely noticeable. In this example I selected the color sampler tool and clicked on the image in three different places on the model's white dress, plus once on the backdrop. Each click positioned a new persistent color sampler readout and the readout values were displayed in the Info panel. The intention here was to measure the color at different points of lightness so that these measurements could be used to calculate a precise Curves adjustment.

R:		C:	
B:		Y:	
8-bit		K: 8-bit	
+, X:			
. 1.		ј- н:	
#1 R :	247	#2 R :	217
G:	239 248	∦ G: B:	208 220
.	240		
3 R :	113	#4 R :	152
C:	121	∦ G: B:	157 162
в.		B :	162
Doc: 30.	3M/40.6M		
Clink		fine cropping	6 11
Shift On	t, and Cmd	for additional	options.

2 The color sample points could be repositioned as necessary by dragging on them with the color sampler (you can access the tool while in an image adjustment dialog, by holding down the Shift key). Once the color sampler readouts were in place, it was time to add a Curves adjustment layer. With the Curves dialog open, I zoomed in to get a close-up view of the model's white top where the points had just been placed. I clicked to select the ዄ tool and then 🔀 Shift ctrl Shift-clicked on top of each of the sampler points. This added a corresponding curve control point to the individual RGB channel curves. When I inspected the Red, Green and Blue channels in the Curves dialog I could see three points had been added in each channel.

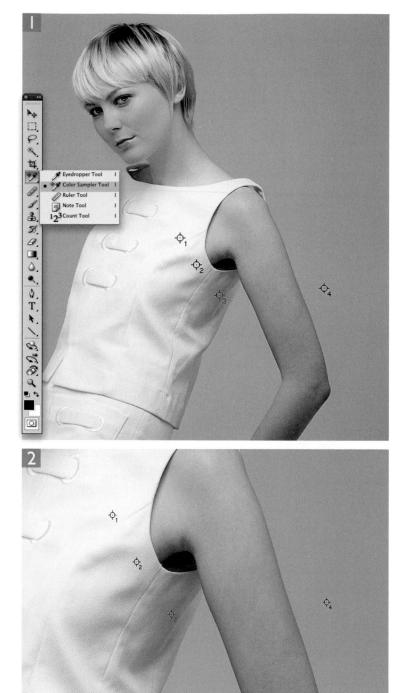

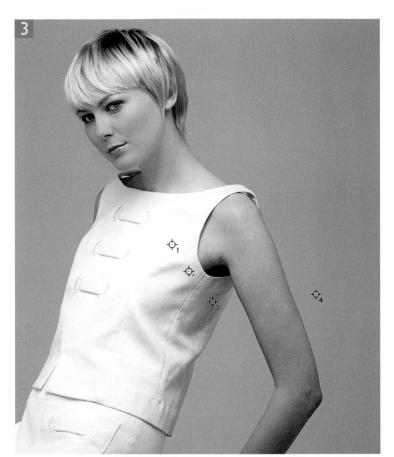

3 Here is an example of the Curves adjustment that was made to the three channels based on the Info panel information. The first RGB readout figure indicates the original input value. At each point I looked at the three numbers to see which of these represented the median value. I then adjusted the points in the other two channels so that these other two output values matched the median value (you can manually drag the point or use the keyboard arrows to balance the output value to match those of the other two channels). Note that Shift +arrow key moves the control points in multiples of 10.

351

Martin Evening Adobe Photoshop CS5 for Photographers

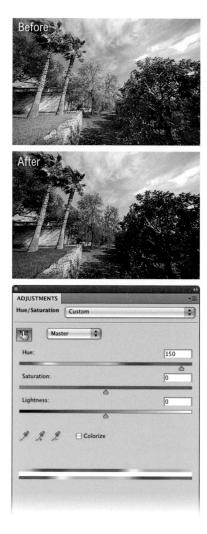

Figure 5.51 This shows an extreme example of how a Hue/Saturation adjustment can be used to radically alter the appearance of a photograph. As you move the Hue slider left or right the colors in the image are mapped to new values. You get an indication of this transformation by looking at the two color ramps at the bottom of the dialog. The top one represents the original 'input' color spectrum and the lower ramp represents how those colors are translated as output colors.

Hue/Saturation

The Hue/Saturation dialog controls are based around the HSB (Hue, Saturation, Brightness) color model, which is basically an intuitive form of the Lab Color model. When you select the Hue/ Saturation image adjustment you can adjust the image colors globally, or you can selectively apply an adjustment to a narrower range of colors. The two color spectrum ramps at the bottom of the Hue/Saturation dialog box provide a visual clue as to how the colors are being mapped from one color to another. These hue values are based on a 360 degree spectrum, where red is positioned mid-slider at 0 degrees and all the other colors are assigned numeric values in relation to this. So cyan (the complementary color of red) can be found at either -180 or +180 degrees. Adjusting the Hue slider alters the way colors in the image are mapped to new color values and Figure 5.51 shows an extreme example of how the colors in a normal color image would look if they were mapped by a strong Hue adjustment. As the Hue slider is moved you will notice that the lower color ramp position slides left or right, relative to the upper color ramp.

Saturation adjustments are easy enough to understand. A positive value boosts the color saturation, while a negative value reduces the saturation in an image. Outside the Master edit mode, you can choose from one of six preset color ranges with which to narrow the focus of a Hue/Saturation adjustment. Once you have selected one of these color range options, you can then sample a new color value from the image window, and this centers the Hue/Saturation adjustments around the sampled color. Use a *Shift*-click in the image area to add to the color selection and an **C** *alt*-click to subtract colors (see page 354). As I have mentioned a few times already, there is now an 'Auto-Select Targeted Adjustment Tool' Adjustment panel option that automatically selects the target adjustment tool when the adjustment layer is made active. In the case of the Hue Saturation adjustment it automatically selects the Saturation slider and targets the appropriate color range.

When the Colorize option is checked, the hue component of the image is replaced with red (Hue value 0 degrees), Lightness remains the same at 0% and Saturation at 25%. You could use this to colorize a monochrome image, but you are better off using the Photo Filter adjustment to do this (see page 356).

Image editing essentials

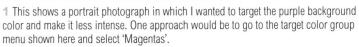

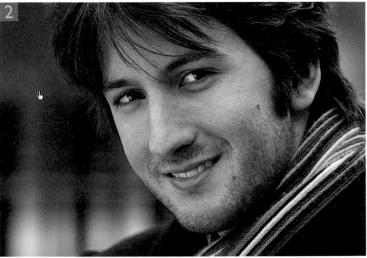

2 Another method was to make the target adjustment tool active (circled) and carry out an
on-image adjustment by dragging on the color area I wished to modify (this also selected
the target color group from the menu). I could then drag left or right to decrease or increase
the saturation. You'll notice I also used the Hue and Lightness sliders to further modify the
adjustment. The Magentas color group could also be narrowed down. In the color ramp
at the bottom, the dark shaded area represented the selected color range, and the lighter
shaded area (defined by the outer triangular markers) represented the fuzziness drop-off
either side of the color selection. I was able to modify the range and fuzziness of the

selection by dragging these slider bars.

	aturation Def	ault		•
15 Hue	✓ Master Reds Yellows Greens Cyans	12 13 14 15 16	0	
Satu	Plune	17 18	0	
Ligh	itness:	۵	0	
9	X] Colorize		
9	A A (] Colorize	•	

ADJUSTMENTS	-
Hue/Saturation Custom	\$
Magentas 🗘	
Hue:	-51
Saturation:	-67
 Lightness:	-47
9 A A ⊡Colorize 255°/285°	330°\0°

Color selection shortcuts

The shortcuts for selecting the color groups in Hue/Saturation have changed since Photoshop CS3. Use 2 att 2 to select the master group, 3 att 3 to select the reds and so on.

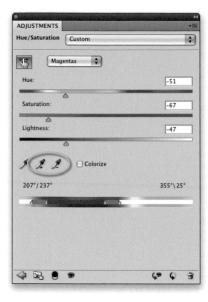

3 As well as manually dragging the sliders, I was also able to use the eyedroppers (circled) to add or subtract from a color range selection. For this step, I selected the plus eyedropper and clicked on the edges of hair to add these colors to the Magentas selection and remove the purple color contamination from the hair. However, you'll also notice that as I widened the color ramp selection, other colors were included in the selection, such as the lips and the scarf.

4 This brings us to the final step, in which I painted on the adjustment layer mask with black in order to hide the Hue/Saturation mask and prevent this adjustment from affecting the skin tones and the scarf. Painting with black restored the colors in these regions to how they were originally.

Photo: © Jeff Schewe 2008

Vibrance

The Vibrance adjustment is available as a direct adjustment and as an Adjustment panel option (Figure 5.52), and allows you to carry out Camera Raw style Vibrance and Saturation adjustments directly in Photoshop. If you refer back to Chapter 3, you will recall that Vibrance applies a non-linear style saturation adjustment in which the less saturated colors receive the biggest saturation boost, while those colors that are already brightly saturated remain relatively protected as you boost the vibrance. The net result is a saturation control that allows you to make an image look more colorful, but without the attendant risk of clipping those colors that are saturated enough already. As you can see in Figure 5.53 below, Vibrance also prevents skin tones from becoming too oversaturated as you increase the amount setting. The Saturation slider you see here is similar to the Saturation slider in the Hue/Saturation adjustment, but applies a slightly gentler adjustment. It matches more closely the behavior of the Saturation slider in Camera Raw.

Figure 5.52 The Vibrance Adjustment panel.

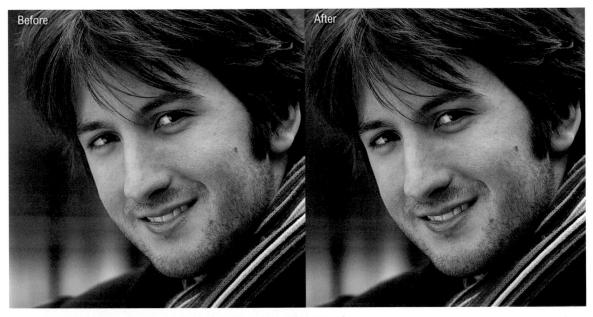

Figure 5.53 This shows a comparison between the before version (left) and the after version (right), in which I boosted the Vibrance by 70%. As you can see, this has made the purple colors in the background and on the scarf appear more saturated. You will notices that the Vibrance adjustment has also increased the saturation of the skin tones, but the saturation boost here is more modest.

Color temperature and film

In the days of color film there were only two choices of film emulsion: daylight and tungsten. Daylight film was rated at 6500 K and was used for outdoor and studio flash photography, while tungsten film was rated at 3400 K and typically used when photographing with artificial tungsten lighting. These absolute values would rarely match the lighting conditions you were shooting with, but would enable you to get roughly close to the appropriate color temperature of daylight/strobe lights or indoor/tungsten lighting.

ADJUSTMENTS Photo Filter	•
O Filter: (Warming Filter (85)	\$
Color:	
Density:	100 %
Preserve Luminosity	2
4 1 0 0	େ ଓ କ

Photo Filter

One of the advantages of shooting digitally is that most digital cameras are able to record a white balance reading at the time of capture and use this information to automatically color correct your photos as you shoot. This can be done either in-camera (selecting the auto white balance option) or by using the 'As Shot' white balance setting in Camera Raw when processing a raw capture image. If you are shooting with color film, the only way to compensate for fluctuations in the color temperature of the lighting is to use the right film (daylight or tungsten balanced) and, if possible, use the appropriate color compensating filters.

However, you can also crudely adjust the color balance in Photoshop by using the Photo Filter adjustment, which is available in the Image \Rightarrow Adjustments menu, or as an Adjustment panel option. The Photo Filter effectively applies a solid fill color layer with the blend mode set to 'Color', although you can achieve a variety of different effects by combining a Photo Filter adjustment with different layer blend modes. The Photo Filter offers a preset range of filter colors, but if you click on the Color button, you can select any color you like (after clicking on the color swatch) and adjust the Density to modify the filter's strength. Figure 5.54 shows a creative application for the Photo Filter adjustment.

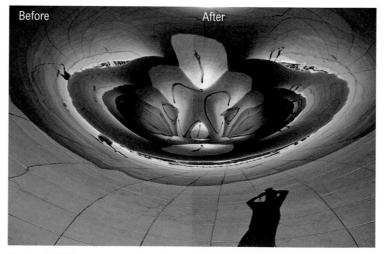

Figure 5.54 The original version (left) had a strong orange cast. To modify this photograph, I added a Photo Filter adjustment. But instead of selecting a filter from the Filter presets list I clicked on the 'Color' swatch option (which opened the Color Picker dialog) and selected a deep blue color to filter the image with.

Multiple adjustment layers

Once you start adding multiple adjustment layers you can preview how an image will look using various combinations of adjustment layers and readjust the settings as many times as you want before applying them permanently to the photo. For example, you might want to use multiple adjustment layers to select different coloring treatments to a photo. Instead of producing three versions of an image, all you need to do is add three adjustment layers, each using a different coloring adjustment and switch the adjustment layer visibility on or off to access each of the color variations (Saving Layer Comps can help here).

While it is possible to keep adding more adjustment layers to an image, you should try to avoid any unnecessary duplication of the layers. It is wrong to assume that when the image is flattened the cumulative adjustments somehow merge to become a single image adjustment. When you merge down a series of adjustment layers, Photoshop applies them sequentially, the same as if you had made a series of normal image adjustments. So the main thing to watch out for is any doubling up of the adjustment layers. If you find you have a Curves adjustment layer above a Levels adjustment layer, it would probably be better to try and combine the Levels adjustment within the Curves adjustment instead. Of course, when you use masked adjustment layers to adjust specific areas of a picture you can easily end up with lots of adjustment layers. One potential drawback of this is that it may slow down the screen preview times. This slowness is not a RAM memory issue, but to do with the extra calculations that are required to redraw the pixels on the screen. If you think this might be happening then try switching off some of the adjustment layers while you are editing the photograph.

To summarize, the chief advantages of adjustment layers are: the ability to defer image adjustment processing and the ability to edit the layers and make selective image adjustments. It is important to stress here that the pixel data in an image can easily become degraded through repeated image adjustments. Pixel data information will progressively become lost through successive adjustments as the pixel values are rounded off. This is one reason why it is better to use adjustment layers, because you can keep revising these adjustments without damaging the photograph until you finally decide to flatten the image.

Grouped adjustments

If you place your image adjustment layers inside a layer group you can use the layer group visibility to turn multiple image adjustments on or off at once (see Figure 5.55). You can also add a layer mask to a layer group and use this to selectively hide or reveal all the image adjustment layers contained within the layer group.

Figure 5.55 This shows an example of how adjustments can be grouped together and a single mask applied to the combined group of layers.

Martin Evening Adobe Photoshop CS5 for Photographers

Curves 1 Curves

Figure 5.56 This shows an example of a darkening adjustment layer applied to an image, but with a black to white gradient applied to the pixel layer mask to fade out the adjustment from the middle of the image downwards.

'Stalkers' by The Wrong Size. Photograph: © Eric Richmond

Adjustment layer masks

As you have seen so far, adjustment layers are always accompanied by a pixel image mask. As with ordinary layers, these can be used to mask the adjustment layer contents. Whenever an adjustment layer is active, you can paint or fill the adjustment layer image mask using black to selectively hide an adjustment effect and paint or fill with white to reveal again. You can also keep editing an adjustment layer mask (painting with black or white) until you are happy with the way the mask is looking (see Figure 5.56).

Having the ability to edit an adjustment layer mask means you can apply such layer adjustments selectively. For example, although Photoshop has dodge and burn tools, and these were improved in Photoshop CS4, they are still not really suited for dodging and burning broad areas of a photograph. If you want to dodge or burn a photo in order to darken a sky or lighten someone's face, the best way to do this is by adding an adjustment layer, filling the mask with black and painting with white to selectively reveal the adjustment layer effect. This is not to say that the dodge and burn tools serve no use. Yes, they were much improved in Photoshop CS4, but they are just not ideal for this type of photographic retouching. Working with adjustment layers is by far the best way to shade or lighten portions of a photograph. You have the freedom to re-edit an adjustment layer, to make the adjustment lighter or darker, plus you can edit the layer mask to precisely control which areas of the image are affected by the adjustment.

Masks panel controls

The Masks panel (Figure 5.58) can be used to refine the mask or masks associated with a layer (such as an additional vector mask). Layer masking is a topic I'll be discussing more fully in Chapter 9, but because it is relevant to masking adjustment layers, I thought it best to briefly introduce the Masks panel features here first.

Adjustment layers are added to the layer stack with a pixel layer mask, so the default mode for the Masks panel shows the pixel mask mode options. If you click on the Vector Mask mode button next to it, you can add and edit a vector layer mask (see Step 4 on page 361). You can tell which mode is active because it will say 'Pixel Mask' or 'Vector Mask' at the top of the panel and the relevant mode button will have a stroked border. The Density slider can be used to adjust the density of the mask. When you have a mask applied to a layer or adjustment layer, where the mask is filled with black, this hides the layer contents completely. However, if you reduce the Density, this lightens the black mask color and therefore allows you to soften the contrast of the mask. So, when Density is set to 50%, the black mask colors only apply a 50% opacity mask and the lighter mask colors are reduced proportionally.

The Feather slider can be used to soften the mask edges up to a 250 pixel radius. Beneath this though is the Mask Edge... button which opens the Refine Edge dialog (Figure 5.57). Here you'll find you have even greater control over the mask edges and softness as well as some new controls in Photoshop CS5 that are described more fully in Chapter 9.

The Color Range button takes you to the Color Range dialog, which allows you to make selections based on color. This means that you can select colors to add to or subtract from a Color Range selection and see the results applied directly as a mask. Beneath this is the Invert button for reversing a masking effect. At the bottom of the panel are options that allow you to: convert a mask to a selection, delete the mask and apply it to the layer, and enable/ disable the mask; and there is a delete button to remove a mask.

	Refine Edge		
\$÷ }-	View Mode		
d-	View (F):) Before (P) After (P)	
37	Border	Show Pord	
	Thickness:	= 10.0	px
	Contrast: 🔴	- 0	%
	Adjust Selection		
	Smooth:	- 0	
	Feather: 🔴	- 0.0	рх
	Shift Edge:	0	3%
	Output	<u> </u>	
	Decontaminate Colo Amount:	ors	7%
	Output To: Selection	- L	•
	Remember Settings]
	Cancel	ОК	

Figure 5.57 This shows the Refine Edge dialog.

Figure 5.58 The Masks panel controls.

Martin Evening Adobe Photoshop CS5 for Photographers

Editing a mask using the Masks panel

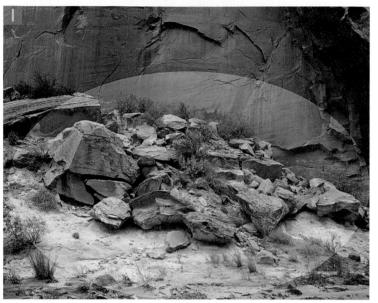

1 You can add a vignette in Photoshop by adding a darkening Levels (or Curves) adjustment, making an elliptical selection and filling the pixel mask with black.

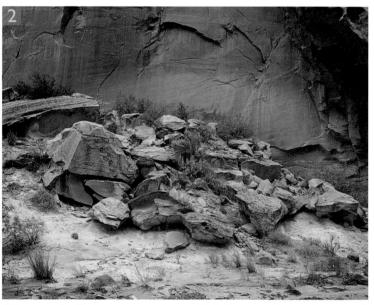

2 If you go to the Masks panel you can increase the Feather amount to make the hard mask edge softer.

0

Image editing essentials

3 Let's say I wanted to soften the transition between the masked and unmasked areas. By decreasing the Density one can make the black areas of the mask lighter and thereby reveal more of the adjustment effect in the center of the image.

started with a subtractive elliptical pen path shape, applied this as a Vector Mask and used the same Masks panel settings as in Step 2 to soften the mask edge.

4 This technique is not just limited to pixel masks. This last step shows how I could have

LAYERS

Color Range adjustment layer masking

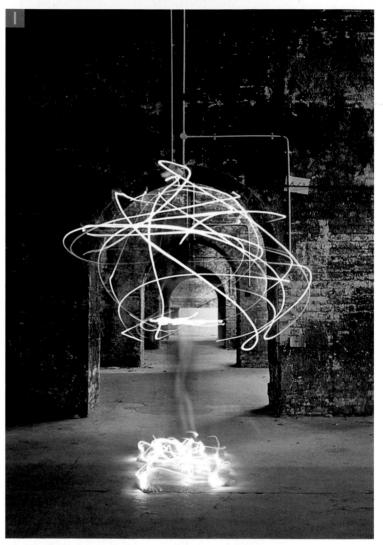

¹ In this example I wanted to demonstrate how to use the Masks panel controls in conjunction with an image adjustment to modify the image shown here so that I could simultaneously control the adjustment effect and the adjustment masking. To start with, I added a new Hue/Saturation adjustment layer. I then went to the Masks panel and clicked on the Color Range button, which opened the Color Range dialog shown here. With the 'Localized Color Clusters' option checked, I used the plus eyedropper tool to add color samples to the selection, sampling the blues in the central area of the photograph, while avoiding the walls. I then adjusted the Fuzziness and Range till I was happy with the way the selection looked and clicked OK to the Color Range selection.

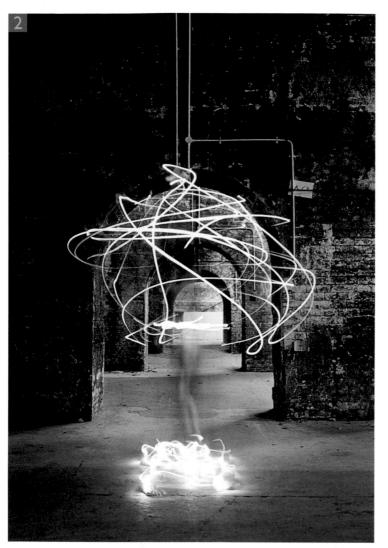

2 I then went to the Masks panel and feathered the selection, adding a 50 pixel feather. You can see a preview of the mask in both the small Masks panel preview as well as in the Layers panel. All I needed to do now was to adjust the Hue/Saturation sliders in the Adjustments panel. For this step I decided to make some of the blue colors more green and reduced the color saturation slightly. The main thing to learn from this particular example is that you can switch back and forth between the Adjustments panel and the Masks panel to re-edit the adjustment effect and masking. When you combine the ease of adjustment editing with the power of the new Masks panel and Color Range selections, Photoshop has the potential to allow you to make selections and modify images like never before.

Photograph: © Eric Richmond

Pixel Mask	
Density:	100%
Feather:	50 px
Refine:	Mask Edge
	Color Range
	Invert

Overlay alternatives

Instead of using the Overlay blend mode, you might also like to use the Soft Light mode to apply a gentle contrast enhancement or the Hard Light blend mode to apply a stronger contrast adjustment.

Figure 5.59 Here is the first of two examples showing how you can use blend modes to adjust an image. In this example I dragged the Background layer down to the New Layer panel button to make a duplicate layer and changed the layer blending mode from Normal to Screen. When the image was saved, the file size doubled to 64 MB.

Figure 5.60 In this example I added a new Levels adjustment layer, but didn't apply any changes to the Levels settings. I then changed the adjustment layer blend mode from Normal to Screen. Both this and the Figure 5.59 example produced identical results, but this time the file size was only increased by 57 kilobytes.

Blend mode adjustments

You can use blend modes to modify an image by adding an adjustment layer above the Background layer, or at the top of the layer stack, and simply changing the blend mode to Screen (to lighten), Multiply (to darken) or Overlay (to add contrast). You don't need to apply a specific type of image adjustment, just add a neutral adjustment layer (any will do) and select one of the above layer blending modes. It is possible to achieve the same types of results by duplicating the Background layer and changing the blend mode of the duplicate layer as shown in Figure 5.59. However, this is actually quite unnecessary and you'll end up with an image that is twice the file size. If you instead add an adjustment layer (as shown in Figure 5.60) this only increases the file size by a few kilobytes.

Blend modes are in effect a shorthand for applying different, set-value curves adjustments. For example, the late Bruce Fraser devised a semi-automated workflow in which he recorded separate Photoshop actions to apply a Screen, Multiply of Overlay neutral adjustment layer, filling the layer mask with black. All he had to do then was select a paint brush or gradient tool to paint on the layer mask with white to reveal the adjustment effect.

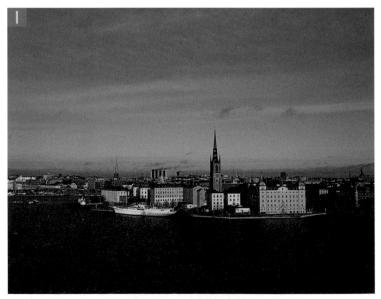

1 This shows a photograph processed using the default Camera Raw settings.

Image editing essentials

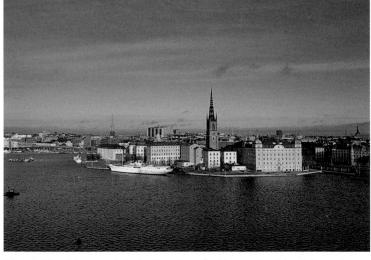

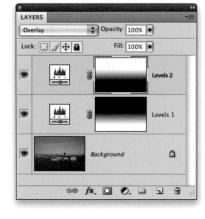

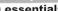

Front Image cropping

If you want a crop to match the dimensions and resolution of a document that is already open in Photoshop, click on that document to make it active. Then click on the Front Image button in the crop Options bar. This loads the document dimensions and resolution into the Crop Options settings. Now select the image you wish to crop and as you drag with the crop tool, the aspect ratio of the front image will be applied. When you OK the crop, the image size will be adjusted to match the front image resolution.

Cropping

The image you are editing will most likely require some kind of crop, in order to focus more attention on the subject. To crop a photo, select the crop tool from the Tools panel and drag to define the area to be cropped. It often helps to zoom in on the corners of image as you make the crop. Here, I find the default scrubby tool option to be an annoyance, so prefer to have this disabled. You can then use the following zoom tool shortcuts: first, hold down the Spacebar followed by the \mathfrak{R} *ctrl* key and marquee drag over the area you want to magnify. To zoom out, use the Spacebar plus \mathfrak{R} att or use \mathfrak{R} o *ctrl* o (which is the shortcut for View \Rightarrow Fit To Window). You can then zoom back in again to magnify another corner of the image to adjust the crop handles.

If the crop tool does not behave as expected try clicking on the Clear button in the tool Options bar, which resets the crop tool. In the normal default mode the crop tool allows you to set any rectangular-shaped crop you like and merely trims away the unwanted pixels without changing the image size or resolution. Figures 5.61 and 5.62 show examples of the normal and modal states for the crop tool options. You will notice that in the modal state we now have a choice of crop guide overlay options. The 'None' option is the same as the previous default mode. The 'Rule of Thirds' mode applies a 3×3 grid overlay, which can be useful when composing an image, while the 'Grid' option can be helpful when aligning a crop to the straight lines in an image.

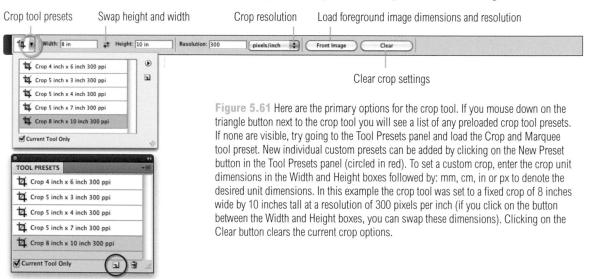

1 I selected the crop tool and dragged across the image to define the crop area. The cursor can then be placed over any of the eight handles in the bounding rectangle to readjust the crop.

3 You can mouse down outside the crop area and drag to rotate the crop around the center point (which can even be positioned outside the crop area). You normally do this to realign an image that is at an angle.

2 Dragging the cursor inside the crop area allows you to move the crop. You can also drag the crop bounding box center point to establish a new central axis of rotation.

4 The shield color and shade opacity can be anything you like. In this example I increased the shade opacity to 100% to produce a completely opaque shield. You can also use **(H)** *ctrl*(H) to hide the bounding box completely and still be able to drag the corners or sides to adjust the crop.

Figure 5.62 After you have dragged with the crop tool and before you commit to the crop, the tool Options bar will change (as shown here) to the crop modal state. The modal crop tool options allow you to change the color and opacity of the shield/shading of the outer crop areas. To apply a crop, you can click on the Apply Crop button in the Options bar, double-click inside the crop area or hit the *Enter* or *Return* keys. Click on the Cancel Crop button or hit the *esc* key to cancel a crop.

Fixed aspect ratio crops

One of the advantages of using the rectangular marquee tool to make a selection crop is that you can set a fixed aspect ratio for the crop in the marquee tool options (see Figure 5.63).

Selection-based cropping

You can also make a crop that is based on an active selection by choosing Image \Rightarrow Crop. Where the selection has an irregular shape, the crop will be made to the outer limits of the selection and the selection will be retained. A practical advantage of this method is that you might want to \Re *ctt*-click a layer to make a selection based on a single layer and then execute a crop (as described in Figure 5.64 below).

Figure 5.63 If you select the rectangular marquee tool you can use the Constrain Aspect Ratio option to make a proportional crop without altering the image resolution or dimension units. Enter the desired proportions in the Width and Height boxes, drag the marquee selection tool across the image to define the area to be cropped and then chose Image \Rightarrow Crop.

Normal		Opacity: 10		
Lock:	14	Fill: 10	DN •	
	Group 1			100
		Layer D	fx	
	0	Layer C	fx	
	C	Layer B	fx	
	A	Layer A	fx	
	Back	tground	٥	

Figure 5.64 Sometimes it is quicker to make a crop from a selection rather than try to precisely position the crop tool. In the example shown here, if I wanted to make a crop of the box containing the letter D, the quickest solution would be to \mathfrak{B} *crrt*-click on the relevant layer in the Layers panel and choose Image \Rightarrow Crop.

Perspective cropping

The crop tool can also be used to crop and correct the converging verticals or horizontal lines in a picture with a single crop action. In the Figure 5.65 example I wanted to correct the converging verticals or 'keystone' effect seen in this photograph. By checking the Perspective box, I was able to accurately reposition the corner handles on the image to match the perspective of the building. I could then apply a crop to straighten the lines that should be vertical. To make a perspective crop adjustment even more precise you can hold down the *Shift* key as you drag a corner handle – this restricts the movement to one plane only. I also find the perspective crop tool is useful when preparing photographs of flat copy artwork as this enables you to always get the copied artwork aligned perfectly.

Disable edge snapping

The edge snapping behavior can be distracting when you are working with the crop tool. This can easily be disabled in the View ⇒ Snap To submenu (or by using the ℜ Shift; ctrl Shift; shortcut).

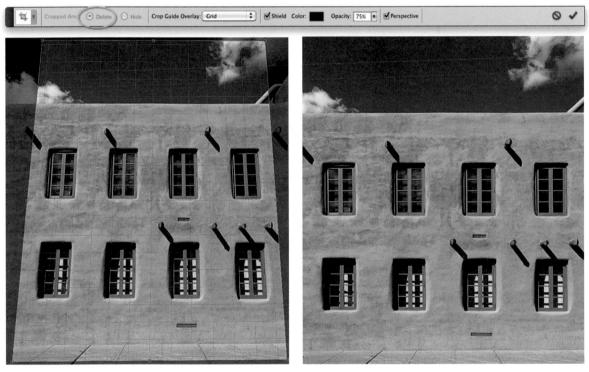

Figure 5.65 The crop tool is great for correcting the perspective in a photograph. Once the crop is defined and the Delete mode (circled) is selected, you can then check the Perspective box in the Options bar and move the corner handles independently. You will probably find it easier if you zoom in to gauge the alignment of the crop edges against the converging verticals in the photograph. This is also a good example of where it was useful to set the Crop Guide Overlay to 'Grid' mode, so as to help align the crop handles. You may finally need to apply a further transform to compensate for any stretching of the image.

Image rotation

If an image needs to be rotated you can use the Image \Rightarrow Rotate controls to orientate a photo the correct way up or flip it horizontally or vertically even. More likely you will want to make a precise image rotation, especially if the horizon line appears to be at an angle. You can correct for this by applying a rotated crop with the crop tool, or you can now use the ruler tool to measure the rotation error and then use the Straighten button in the ruler tool Options bar to correct the image, as described in Figure 5.66 below.

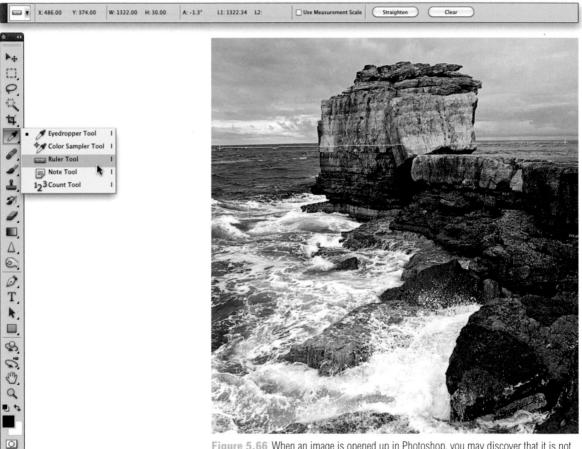

Figure 5.66 When an image is opened up in Photoshop, you may discover that it is not perfectly aligned. Although the crop tool will allow you to both crop and rotate at the same time, there is another more accurate way you can correct the alignment. Select the ruler tool from the Tools panel and drag along what should be a vertical or horizontal edge in the photo. After doing this, go to the tool Options bar and click on the Straighten button. The image will be accurately rotated so that it appears to be perfectly level.

Chapter 5

Canvas size

The Image \Rightarrow Canvas size menu item allows you to enlarge the image canvas area, extending it in any direction. This is useful if you want to extend the image dimensions in order to place new elements. If you check the Relative box you can enter the unit dimensions you want to see added to the current image size. The pixels that are added are then filled using the current background color, but you can also choose other fill options from the Canvas Size dialog (see Figure 5.67). It is also possible to add to the canvas area without using Canvas Size. You can use the crop tool as an 'add canvas tool' by dragging beyond the document boundaries (see Figure 5.68 below).

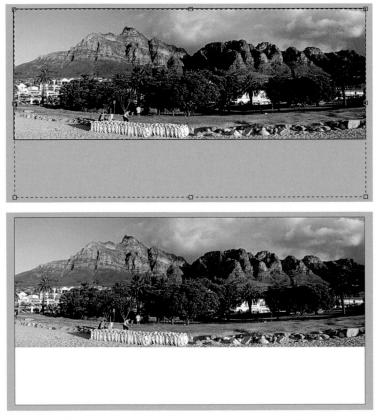

Figure 5.68 To use the crop tool as a canvas size tool, first make a full frame crop, release the mouse and then drag any one of the bounding box handles outside of the image and into the canvas area. Double-click inside the bounding box area or hit *Enter* to add to the canvas size, filling with the background color.

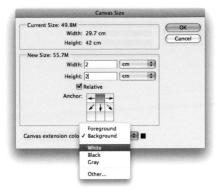

Figure 5.67 To add extra pixels beyond the current document bounds, use the Canvas Size from the Image menu. In the example shown here, the image is anchored so that pixels are added equally left and right and to the bottom of the image only. When the Relative box is checked this allows you to enter the number of units of measurement you wish to add 'relative' to the current image size.

Edge detection success rate

The content-aware scale feature is very clever at detecting which edges you would like to keep and those you would like to stretch or squash, but it won't work perfectly on every image. You can't expect miracles, but if you follow the suggestions on these pages, you will pick up some of the basic tips for content-aware scaling. What I have noticed though is that it does appear to do a very good job of recognizing circular objects and can preserve these without distorting them. Russell Brown has done some very cool demos on working with this feature and I recommend you check them out on his site: www.russellbrown.com/tips_tech.html.

LAYERS		•=
Normal	Opacity: 100	3%
Lock:	Fill: 100)% •
• 6	Layer 0	
	fx. D 0. D	. .

Photograph: © Jeff Schewe 2008

Content-aware scaling

The content-aware scale feature first appeared in Photoshop CS4. It was also the most controversial new feature since it invited Photoshop users to tamper with photographs in ways that were likely to raise the hackles of photography purists. Would this spell the 'death of real photography' (DORP)? That I don't know, but over the next few pages I have outlined some of the ways you can work with this tool and have suggested some practical uses. Advertising and design photographers may certainly appreciate the benefits of being able to adapt a single image to multiple layout designs.

To use this feature, you will need an image that's on a normal layer (not a Background layer). Next, you need to go to the Edit menu and choose 'Content-Aware Scale' (or use the **B Shift C** *ctrl alt Shift* **C** shortcut). You can then drag the handles that appear on the bounding box for the selected layer to scale the image, making it narrower/wider, or shorter/taller. The preview then updates to show you the outcome of the scale adjustment and you can use the Options bar to access some of the extra features discussed here such as the Protect menu options.

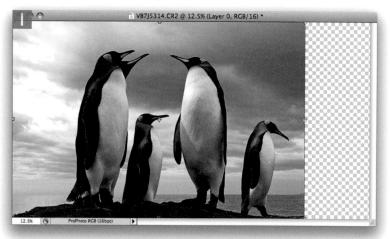

■ Before applying any kind of 'content-aware scaling' you need to double-click the Background layer, or create a new merged copy layer. You can then add extra canvas to the image using either of the methods that were shown on the previous page. For example, you could use the Canvas Size dialog to establish a new canvas size, or simply drag with the crop tool beyond the boundaries of the image. You don't have to do this before applying a content-aware scale adjustment. You could of course always choose Image ⇒ Reveal All after applying the adjustment to reveal the expanded canvas contents.

Chapter 5 Image editing essentials

01

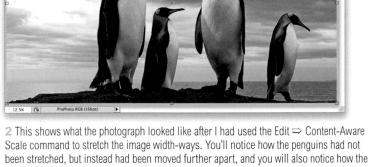

200 x: 2496.00 px △ Y: 1664.00 px W: 100.00% & H: 100.00% Amount 100% Protect: None

VB7J5314.CR2 @ 12.5% (Layer 0, RGB/16) *

left side of the image had been stretched most of all.

3 This shows what happened when I used the Content-Aware Scale command to make the photograph taller. Whenever you scale an image using this method, you have to watch carefully for the point where important parts of the picture start to show jagged edges, or critical areas of the photo (such as the penguins) show signs they are being stretched. When this happens, you'll need to ease off and consider scaling the image in stages. In this example I stretched the photo upwards halfway, clicked OK, and then applied a second scaling to achieve the final content-aware scaled image shown here.

Amount slider

: *

After you have applied a content-aware scale adjustment to a photograph (and before you click OK to apply it), you can use the Amount slider to determine the amount of content-aware scaling that is applied to the layer. If you set this to zero, no special scaling is applied and the image will be stretched as if you had applied a normal transform. You will note that I left the slider setting to 100% in all the examples shown here, in order to demonstrate the full effect of the contentaware scaling.

How to protect skin tones

1 In this example I wanted to show how you can help protect people's faces from being squashed or stretched as you scale an image.

2 In general, you will find that the content-aware scale feature does a pretty good job of distinguishing and preserving the important areas of a photograph and tends to scale the less busy areas of a photograph first, such as a sky, or in this case the mottled backdrop. However, if you click on the Protect Skin Tones button (circled), this will usually ensure that faces in a photograph remain protected by the scaling adjustments. As you can see here, I was able to stretch this picture horizontally so that the couple in this photograph were moved across to the right. I stretched the image quite a bit, but without distorting the faces.

Photograph: © Jeff Schewe 2008

NO R

01

#2

#3

¥4

#5

#6

0 O 1 3

Image editing essentials

How to remove objects from a scene

the Edit ⇒ Content-Aware Scale command. From the Protect menu in the Options bar, I selected the Quick Mask I had just created, and as I scaled the image, the masked figure started to disappear. As before, it is important to watch carefully for jagged edges and not compress the image too much. As you can see, this technique doesn't completely remove all the pixels, but this edited image could easily be tidied up using the healing brush.

Photograph: © Jo Cowler 2003

1 The content-aware scale feature can also be used as a tool to selectively remove objects from a scene. The results won't always be completely flawless, but it can still work pretty well where you wish to squash an image tighter and remove certain elements as you do so. For the first step, I hit the 💽 key to switch to Quick Mask mode (see Chapter 9) and painted on the image to outline the bits that I wished to remove. Remember, white protects and black indicates the areas to remove.

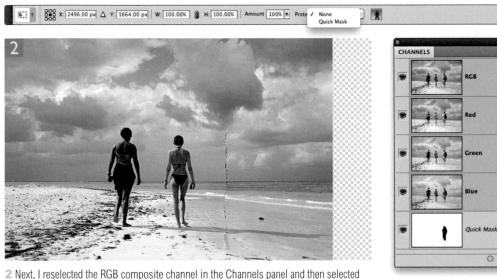

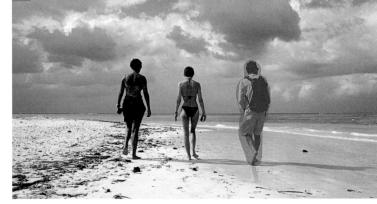

Chapter 5

Background layers and big data

If your image contains a Background layer and you want to preserve the data on this layer after making a 'hide' crop, you must first double-click the Background layer to promote it to a normal layer. If you don't take this step you will still end up deleting everything on this layer when you crop.

Big data

The Photoshop, PDF and TIFF formats all support 'big data'. This means that if any of the layered image data extends beyond the confines of the canvas boundary, it is still saved as part of the image when you save it, even though it is no longer visible. If you have layers in your image that extend outside the bounds of the canvas, you can expand the canvas to reveal all of the big data by choosing Image \Rightarrow Reveal All. Remember though, you will only be able to reveal the big data again providing you have saved the image using the PSD, PDF or TIFF format. Also, when you crop an image that contains normal, non-flattened layers (see sidebar), you are given the option to delete or hide the layered big data by selecting either of these radio buttons in the modal crop Options bar (see Figure 5.69).

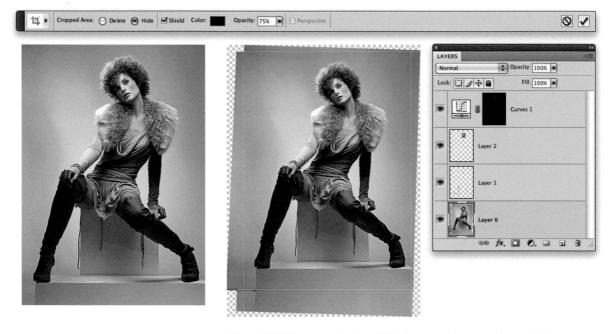

Figure 5.69 The cropped version of this picture contains several layers which when expanded using the Image \Rightarrow Reveal All command show all the hidden 'big data' that extends outside of the cropped view. The Hide option in the crop tool options allows you to preserve the pixels that fall outside the selected crop area instead of deleting them. Note also how the Background layer has been converted to a normal Photoshop layer (Layer 0). This is essential if you wish to preserve all the information on this layer as big data.

Client: Rainbow Room. Model: Nicky Felbert @ MOT.

Chapter 6

Black and White

was eleven years old when I first got into photography. My first darkroom was kept under the stairs of our house and, like most other budding amateurs, my early experiments were all done in black and white. Back then, very few amateur photographers were competent enough to know how to process color, so black and white was all that most of us could manage to work with. For me, there has always been something rather special about black and white photography and digital imaging has done nothing to diminish this. If anything, I would say that the quality of capture from the latest digital cameras, coupled with the processing expertise of Photoshop, and improvements in inkjet printing have now made black and white photography an even more exciting avenue to explore.

Black and white film conversions

Traditional black and white film emulsions all differ slightly in the way they respond to different portions of the visual spectrum (as well as the colors we can't see). This is partly what gives emulsion films their 'signature' qualities. So in a way, you could say that film also uses standard formulas for converting color to black and white, and that these too are like rigid grayscale conversions. You may also be familiar with the concept of using strong colored filters over the lens when shooting with black and white film, and how this technique can be used to emphasize the contrast between certain colors, such as the use of yellow, orange or red filters to add more contrast to a sky. Well, the same principles apply to the way you can use the Black & White adjustment to mix the channels to produce different kinds of black and white conversions.

Adobe Photoshop
Discard color information?
To control the conversion, use Image > Adjustments > Black & White.
Cancel Discard
Don't show again

Figure 6.1 If you convert a color image to grayscale mode, Photoshop pops the dialog shown here which is basically advising you there are better ways to convert to black and white.

Converting color to black and white

The most important tip here is to always shoot in color. Whether you shoot film or shoot digitally, you are far better off capturing a scene in full color and using Camera Raw or Photoshop to carry out the color to mono conversion. Although having said that, you do need to use the most appropriate conversion methods to get the best black and white photographs from your color files.

The dumb black and white conversions

When you change a color image from RGB to Grayscale mode in Photoshop, the tonal values of the three RGB channels are averaged out to produce a smooth continuous tone grayscale. The formula for this conversion consists of blending 60% of the Green channel with 30% of the Red and 10% of the Blue. The rigidity of this color to mono conversion limits the scope for obtaining the best grayscale conversion from a scanned color original (see Figure 6.1). The same thing is true if you make a Lab mode conversion, delete the *a* and *b* channels and convert the image to grayscale mode, or if you were to simply desaturate the image. There is nothing necessarily wrong with any of these methods, but none of these are really making full use of the information that can be contained in a color image.

Smarter black and white conversions

If you capture in color, the RGB master image contains three different grayscale versions of the original scene and these can be blended together in different ways. One of the best ways to do this is to use the Black & White image adjustment in Photoshop, which while not perfect, can still do a good job in providing you with most of the controls you need to make full use of the RGB channel data when applying a conversion. The Black & White slider adjustments will, for the most part, manage to preserve the image luminance range without clipping the shadows or highlights. These adjustments can be applied to color images directly, or by using the Adjustments panel method to add an adjustment layer. The advantage of using an adjustment layer to apply a black and white conversion is that you can quickly convert an image to black and have the option to play with the blending modes to refine the appearance of the black and white outcome. Let's start though by looking at the typical steps used when working with the Black & White adjustment controls.

Black and white

2 To begin with I clicked on the Auto button. This applied an Auto slider setting based on an analysis of the image color content. The Auto setting usually offers a good starting point for most color to black and white conversions and won't do anything too dramatic to the image, but is immediately a lot better than choosing Image \Rightarrow Mode \Rightarrow Grayscale.

ADJUSTMENTS Add an adjustment	·=
* 💻 🗶	4
Levels Presets	
Curves Presets	
Exposure Presets	
Hue/Saturation Presets Black & White Presets	
p place a mile resets	
Selective Color Presets	
	1
\$ B	
ADJUSTMENTS	41 -==
Black & White Custom	
Costom	•
15 Tint	Auto
Reds:	20
۵	
Yellows:	50
Creens:	20
	20
Cyans:	58
A	
Blues:	27
Magentas:	58
6	
4 2 0 0	(° U 3
•	44
LAYERS	*=
Normal Opacity: 100%	
Lock: 🛛 🌶 🗭 🛛 Fill: 100%	
	Black & Whit
eccipine	
	2
Background	۵
88 fx. 🖸 Ø.	

Adobe Photoshop CS5 for Photographers

ADJUSTMENTS	•
Black & White Custom	
∜H □ Tint	Auto
Reds:	37
A Yellows:	60
Greens:	20
Cyans:	-60
la Blues:	-2
lagentas:	58
۵	
4 24 8 9	(° () 3

3 If you don't like the auto setting result, you can adjust the sliders manually to achieve a better conversion. In this example, I lightened the Reds and Yellows and darkened the Cyans.

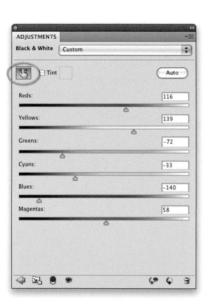

4 Lastly, I clicked on the target adjustment mode button (circled) for the Black & White adjustment. This allowed me to move the cursor over particular areas of interest (such as the sky) and dragged directly on the image to modify the Black & White adjustment. This step selected the nearest color slider in the Black & White adjustment panel. Dragging to the left made the black and white tones go darker and dragging to the right, lighter. The end result was a photograph in which I managed to lighten the sculpture more and increase the contrast in the sky.

Black & White adjustment presets

As with other image adjustments, the Black & White adjustment has a presets menu at the top from where you can select a number of shipped preset settings. Figure 6.3 shows examples of the different outcomes that can be achieved through selecting some of the different presets from this list.

Once you have created a Black & White adjustment setting that you would like to use again you can choose 'Save Preset...' from the Adjustments panel options menu (Figure 6.2). For example, I was able to save the slider settings shown here as a custom preset called 'Red Contrast'.

ADJUSTMENTS		✓ Expanded View
Black & White Red Contrast	;	Save Black & White Preset
Tint	Auto	Load Black & White Preset Delete Current Preset
Reds:	100	Reset Black & White
Yellows:	100	Brightness/Contrast Levels
Greens:	-100	Curves Exposure
Cyans:	-100	Vibrance
A Blues:	-100	Hue/Saturation Color Balance
A Magentas:	100	Black & White Photo Filter
۵		Channel Mixer
		Invert Posterize
4 2 0 0	(* U 3	Threshold Gradient Map
		Selective Color Close
		Close Tab Group
Save		
Save black and white	settings in:	
Save As: Red Contrast.blw		
Where: 🔚 Black and White		
	Cancel	Save

Figure 6.2 Once you have found a Black & White adjustment setting that you would like to use again, you can choose 'Save Black & White Preset...' from the Adjustment panel options menu. The slider settings shown here were saved as a 'Red Contrast' preset. Saved presets can be accessed by mousing down on the presets menu at the top of the Adjustments panel (circled).

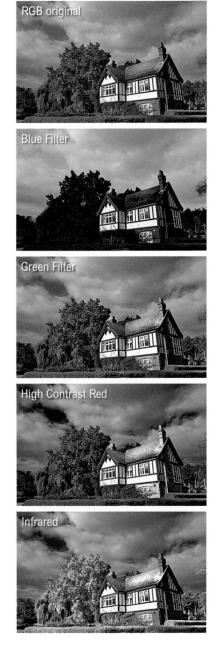

Figure 6.3 This shows examples of different Black & White adjustment presets applied to a color image.

Color blend mode

You will notice that I suggest you use the Color blend mode when applying adjustment layers that are intended to color an image. The advantage of using the Color blend mode is that you are able to alter the color component of an image without affecting the luminosity. This is important if you wish to preserve as much of the tone levels information as possible.

Split color toning with Color Balance

Although the Black & White adjustment contains a Tint option for coloring images, this can only apply a single color overlay adjustment and I have never really found it to be that useful. It is nice though to have the ability to apply a split tone coloring to a photograph and one of the best ways to do this is by using the Color Balance image adjustment. This is ideal for coloring RGB images that have been converted to monochrome using the Black & White adjustment method, mainly because the Color Balance controls are really quite intuitive and simple to use. If you want to colorize the shadows, click on the Shadows radio button and adjust the color settings, then go to the Midtones, make them a different color and so on. Note that it is best to apply these coloring effects with the adjustment layer set to the Color blend mode (see sidebar).

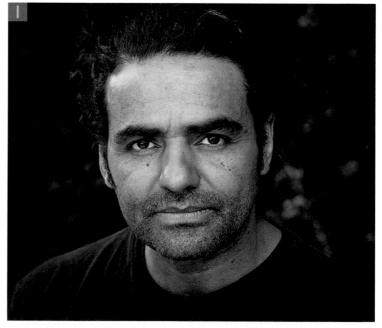

I started here with an RGB color image and converted it to monochrome using the Black & White image adjustment. I then added a Color Balance adjustment layer to colorize the RGB/monochrome image. To do this, I went to the Adjustment panel and selected the Color Balance adjustment. I first of all clicked on the Shadows button and adjusted the Red slider to apply a red color cast to the shadows.

Black and white

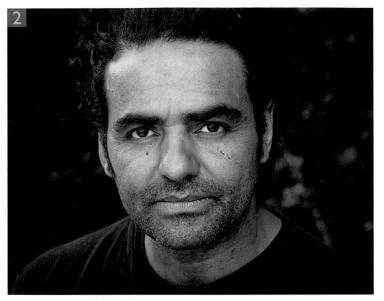

2 I then clicked on the Midtones button and adjusted the color sliders there to add a green/ blue color balance to the midtones. You will notice that I had 'Preserve Luminosity' checked. This helped prevent the image tones from becoming clipped.

3 Finally, I clicked on the Highlights button and added a yellow cast to the highlights. I also set the adjustment layer blending mode to 'Color', which helped preserve the image luminance information.

ADJUSTMENTS			
Color Balance			
Tone: O Shadows			
Midtones			
O Highlights			
Cyan	Red		
A		0	
Magenta	Green	+10	
A		1	
Yellow	Blue		
		+15	
-			
Preserve Luminosity			
4 52 8 9	(*	Ģ	3
			010
ADJUSTMENTS			
Color Balance			
Tone: O Shadows			
O Midtones			
 Highlights 			
Cyan	Red		
<u>_</u>		+5	
Magenta	Green	0	
0			
Yellow	Blue		
		-15	
<u> </u>			
de			
Preserve Luminosity			
		0	100
4 2. 8 .	(100
4 2 8 9 9	Ç.	-	1996
4 B 0 0	Ça		
)	(e	•• •靈	
LAYERS			
Color \$) Opacity: 100%	•	4 722	
Color \$) Opacity: 100%	•		
Color Opacity: 100%.	•		
Color Opacity: 100%.	•	10 20 20	
Color Opacity: 100%	•		
Color Opacity: 100%.	•	4 一型	
Color Opacity: 100%.	•	2 	
Color Opacity: 100%.	•		
LAYERS Color Depactry: 100% Lack: Def + Construction Fill: 100%	Color Balance.		
LAYERS Color Depactry: 100% Lack: Def + Construction Fill: 100%	Color Balance.		

Curves adjustment split toning

The Color Balance method is reasonably versatile, but you can also colorize a photograph by using two Curves adjustment layers and taking advantage of the Layer Style blending options to create a more adaptable split tone coloring effect.

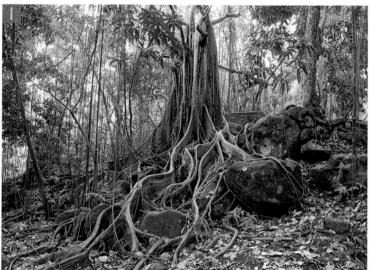

1 To tone this image, I first added a Curves adjustment layer above the Black & White adjustment layer and applied a blue/cyan color adjustment to the photo.

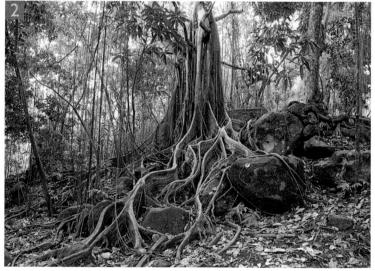

2 I then added a second Curves adjustment on top of the previous one and this time applied a sepia color adjustment.

Black and white

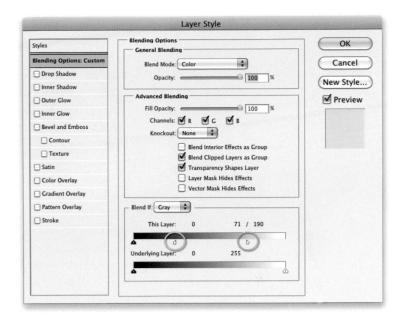

Double-click in this area of the layer to open the Layer Style dialog.

3 I made the first Curves layer active and double-clicked it to open the Layer Style dialog shown here. I then (a) clicked on the divider triangle in the 'Blend If' layer options. This enabled me to separate the two dividers (circled) to split them in two, which allowed me to control where the split occurred between these two adjustments.

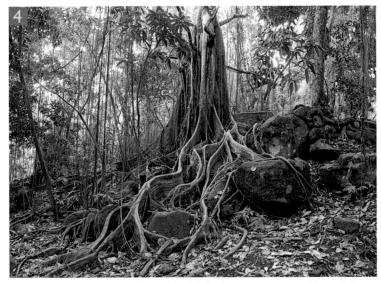

4 The advantage of this method is that you can adjust the layer opacity and Layer Style blending modes of each individual layer, which offers more flexibility when it comes to deciding how best to color the shadows and highlights.

The extra color sliders

Camera Raw provides you with more sliders to play with than the Black & White adjustment. These allow you to adjust the in-between color ranges such as Oranges, Aquas and Purples. The Oranges slider is useful for targeting skin tones and the Aquas is useful for adjusting things like the sea. Having these extra sliders provides you with extra levels of tone control.

Camera Raw black and white conversions

You may already have noticed that you can use Camera Raw to convert images to black and white. However, you are limited in that you can only use the Camera Raw method to process raw, JPEG, or TIFF images (providing the TIFF is flattened).

If you go to the HSL/Grayscale panel and check the Convert to Grayscale box, Camera Raw creates a black and white version of the image, which is produced by blending the color channel data to produce a monochrome rendering of the original. Clicking 'Auto' applies a custom setting that is based on the white balance setting applied in the Basic panel and if you click 'Default', this resets all the sliders to zero. You can manually drag the sliders to make certain colors in the color original lighter or darker, or select the target adjustment tool (circled in Figure 6.4) to click and drag on the image to make certain colors convert to a darker or lighter tone. The overall tone brightness and contrast should not fluctuate much as you adjust the settings here and this makes it easy to

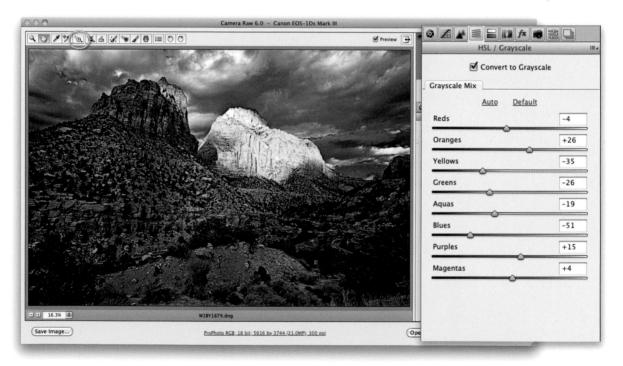

Figure 6.4 In this example, I clicked on the Convert to Grayscale button and made some custom slider adjustments to increase the tonal contrast.

experiment with different slider combinations. For example, if you want the sky to be darker, you would do as I did in Figure 6.4 and drag the Aquas and Blues sliders to the left. I would also suggest sometimes switching over to the Basic and Tone Curve panels to make continued adjustments to the white balance and tone controls there as these can have a strong bearing on the outcome of a black and white conversion.

Pros and cons of the Camera Raw approach

In my view, Camera Raw Grayscale conversions have the edge over using the Black & White adjustment in Photoshop. This is because the slider controls are better thought out and the addition of the in-between color sliders (see sidebar on page 386) makes it possible to target certain colors more precisely. The target adjustment mode correction tool in Camera Raw also performs better than the one found in the Photoshop Black & White adjustment. The other important question is 'when is the best time to convert a photo to black and white?' If you do this at the early Camera Raw stage it limits what you can do to a photo should you then want to retouch the image later in Photoshop. I find it is usually better to carry out the black and white conversion at the end, just prior to print, and have the adjustment be reversible. This is not a problem in Photoshop, because if you add a Black & White adjustment layer, it is easy enough to toggle the adjustment on or off. An alternative approach is to take a Photoshop-edited image back through Camera Raw again. This can be done, but you are limited by the fact that any non-raw image you process through Camera Raw must be a JPEG or a TIFF (PSD won't work), and a TIFF image must not have any layers. This means saving a flattened duplicate of the Photoshop-edited master image and then opening it up via Camera Raw. It's quite a convoluted procedure to go through just to access the Camera Raw controls and also costly in terms of adding to the edit time and amount of hard disk space used. As I say, I do prefer the Camera Raw controls, but the only real practical way to apply Camera Raw black and white conversions is where all the image adjustments and retouching are done in Camera Raw throughout. There is another option though, which is to use Lightroom. Here, you can reimport all your Photoshop-edited images back into Lightroom and use the Develop module to carry out the conversion.

HSL/Grayscale conversions

If you set all the Saturation sliders in the HSL panel to -100, you can then use the Luminance sliders in the HSL panel to make almost the same type of adjustments as the Grayscale mode. One of the chief advantages of this method is that you can use the Saturation and Vibrance controls in the Basic panel to fine-tune the grayscale conversion effect, which you can't do when using the ordinary Grayscale conversion mode.

Camera Calibration panel

Another thing I discovered recently is that you can also use the Camera Calibration panel sliders to affect the outcome of a Camera Raw black and white conversion.

Camera Raw Split Toning panel

After you have used the HSL/Grayscale panel to convert a photograph to black and white, you can then use the Split Toning panel to colorize the image. The controls in this panel allow you to apply one color to the highlights, another color to the shadows and use the Saturation sliders to adjust the intensity of the colors. This is how you create a basic split tone color effect. There is also the Balance slider, which lets you adjust the midpoint for the split tone. In Figure 6.5, the photograph I applied the split tone to was a high-key image and it was therefore more appropriate to offset the Balance slider so that the blue shadows toning was applied more strongly in the shadows. Without such an adjustment the shadow color would have barely registered. The HSL/Grayscale and Split Tone controls are incredibly versatile. Bear in mind these can work equally well with non-raw images. It is just a shame that there isn't a Split Toning panel like this available in Photoshop.

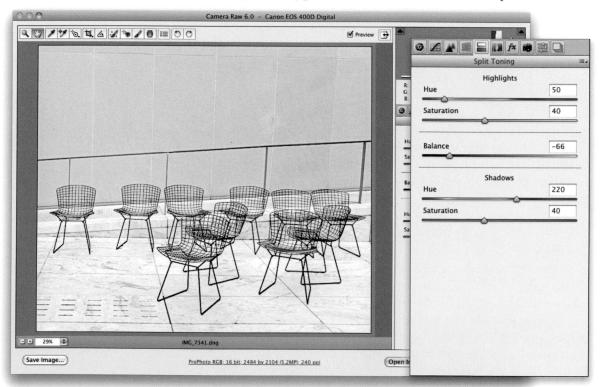

Figure 6.5 This shows an example of the Split Toning panel in action.

Camera Raw color image split toning

Although the Split Toning panel appears to be an extension of the HSL/Grayscale panel, these controls can be just as useful when working on color images. Although there are ways to produce color cross-processing effects in Photoshop, the Camera Raw Split Toning controls can produce similar results, but with less hassle (Figure 6.6).

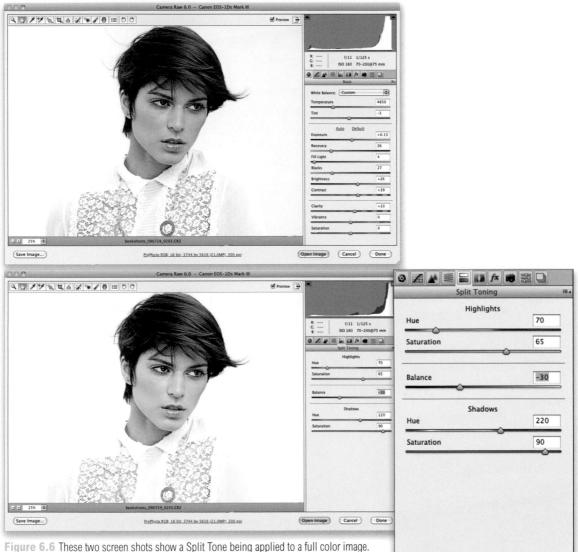

Figure 6.6 These two screen shots show a Split Tone being applied to a full color image In the top screen shot you can see the before version and in the bottom screen shot you can see the result after I had applied a blue/sepia Split Toning effect.

Advanced B&W Photo tips

There are a few things you need to do in order to access and make the most of the Advanced B&W feature for Epson printers. Firstly, this is only available with certain printer models, such as the Epson 4800. You can make a print using RGB or Gravscale, but the printer driver assumes the image to be in neutral RGB (and ignores any colors), or in Grayscale mode. Normally you would convert to Grayscale first, in which case the gamma of the Grayscale space you convert to should match the gamma of your RGB workspace (see page 660). In the Photoshop Print dialog you will want to select 'Photoshop Manages Colors' and select an appropriate printer profile and rendering intent (see pages 690-692). When you click 'Print'. this will take you to the Epson print dialog. where in the Print Settings section you will need to select an appropriate media type, such as Photo Paper > Premium Glossy Photo Paper (to match the profile selected in the Photoshop Print dialog). Note also that not all paper media settings support Advanced B&W. Then select the 'Advanced B&W Photo' from the Color menu (page 694-695). Having done that, click on the 'Advanced Color Settings', to access the Print dialog options shown in Figure 6.7, where the key thing is to leave most of these sliders as they are, apart from choosing a color toning method. You can choose a preset color from this menu, click on the color wheel below, or adjust the Horizontal and Vertical values. The Tone setting says 'Darker'. This is actually the default setting, but you can modify this if you wish.

Black and white output

Black and white printing should be easy, but if you are printing from RGB files you'll meet the exact same issues that affect normal color printing. Your ability to match the print output to the display will, as always, be dependent on the accuracy of the computer display calibration, the type of paper you are printing with and the effectiveness of the printer profile you are using. Mind you, with black and white printing there is perhaps more latitude for the color to be off and still produce pleasing results. If you are aiming for a perfectly neutral black and white print, then the profile used must be accurate. In theory, if the measured Info panel gray values are all neutral, the print output should be neutral too. If you are using one of the more advanced Epson printers you may be interested to know that you can access the Advanced B&W Photo settings shown in Figure 6.7 (to apply coloring effects) via the Epson driver system print dialog.

Figure 6.7 This shows the Advanced Color Settings for the Epson 4800 printer when the 'Advanced B&W Photo' option is selected in the main Print Settings section of the System print interface. This allows you to apply different black and white output toning options.

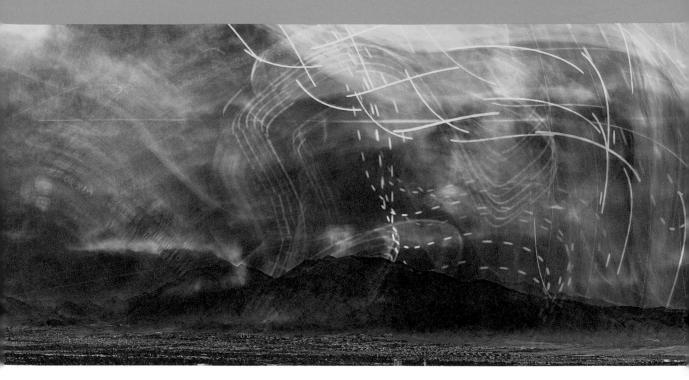

Chapter 7

Extending the Dynamic Range

or many years now, everyone has become preoccupied with counting the numbers of pixels in a digital capture as if this were the one benchmark of image quality that mattered above all else. Yet size isn't everything and it is really the quality of the pixel capture we should be concerned with most. Digital SLR cameras tend to have better quality sensors than compact digital cameras and the large high-end camera backs have features such as built-in cooling mechanisms that help them produce the very best in image capture quality. The one thing people haven't focused on so much is the dynamic range of a camera sensor. Dynamic range refers to the ability of a sensor to capture the greatest range of tones from the minimum recordable shadow point to the brightest highlights and this is what we are going to focus on in this chapter.

Camera Raw Smart Objects

A Smart Object stores the raw pixel data within a saved PSD or TIFF image (you'll learn more about Smart Objects in Chapter 9). This means you have the freedom to re-edit the raw data at any time. Although it is possible to apply the technique shown here to JPEG images, this won't bring you any real benefit compared to processing a raw image original. The important thing to stress here is that this technique really applies to editing raw files only.

Multiple raw conversions

Most of the time it will suffice for you to use the localized correction tools in Camera Raw to dodge or burn a raw photo and bring out more tonal detail where it is needed. However, if you want to extend the dynamic range of an image capture with greater precision than this you can make two or more conversions using Camera Raw, combine them together as layers in a single document and blend them to produce a composite image. In the technique I describe here, I have shown how you can open a Camera Raw image as a Smart Object, process it in two different ways and blend the two versions together using a pixel image layer mask.

Alternatively, if you are able to shoot with the camera on a tripod, another option would be to combine two separate exposures. This would allow you to extend the dynamic range of your camera and blend the results using the manual method described here. This approach also brings you the benefit of being able to edit the individual Camera Raw Smart Object layers.

1 To begin with I went to Bridge and selected a raw image that I wanted to edit and opened this photo via Camera Raw, using File \Rightarrow Open in Camera Raw... (**BR** *ett*).

2 In the Camera Raw dialog I adjusted the Camera Raw settings to achieve the best White Balance, Exposure and Recovery adjustments to reveal the detail outside the windows. Once I was happy with these settings, I held down the Shift key and clicked the Open Image button (circled) to open this as a Smart Object in Photoshop.

3

3 Here is the processed image, placed as a Smart Object layer in a new Photoshop document. Next, I wanted to create a new Smart Object layer of the same image where I could use new Camera Raw settings to adjust for the interior of the room. To do this, I made a right mouse-click on this first Smart Object layer to access the contextual menu and selected 'New Smart Object via Copy' (Mac users can also use the *ctrl* key to access this contextual menu).

AYERS	·=
Normal	Copacity: 100%
Lock: 🖸 🖌 🕂 🔒	Fill: 100% •
· Image	Layer Properties Blending Options
	Duplicate Layer Delete Layer
sə fx. 🖸	Convert to Smart Object New Smart Object via Copy Edit Contents Export Contents Replace Contents
	Rasterize Layer
	Enable Layer Mask Enable Vector Mask Create Clipping Mask
	Link Layers Select Linked Layers
	Select Similar Layers
	Copy Layer Style Paste Layer Style Clear Layer Style
	Merge Layers Merge Visible Flatten Image

2 170.44101000 W.P ew 🔁 f/11 1/3 s 18.3% (Save Image...) RGB: 16 bit: 4992 by 3328 (16.6MP): 240 pt Ope Done

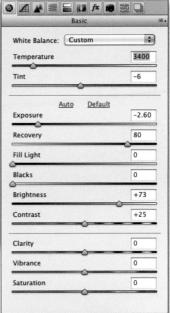

Adobe Photoshop CS5 for Photographers

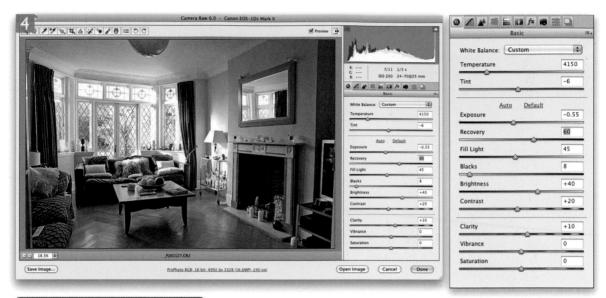

4 This duplicated the original layer and allowed me to edit the new, copied Smart Object layer. The easiest way to do this was to double-click the Smart Object layer thumbnail. This opened the Camera Raw dialog again, where I was able to use the Basic panel controls to apply a lighter adjustment to bring out more detail in the room interior. When I was finished I clicked 'Done' to OK the adjustment, which updated the Smart Object copy layer in the master image document.

5 I then added a layer mask to the Smart Object copy layer and edited the mask to hide the windows and brush in more highlight detail in some of the brighter areas of the room interior. This screen shot shows a full image view of the layer mask that was applied to the Smart Object copy layer.

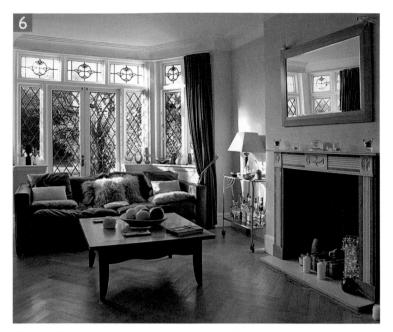

6 This final image shows the lighter processed Smart Object layer overlaying the darker processed Smart Object layer, using a blend opacity of 90%. The carefully drawn mask around the window frames allowed the darker processed version to show through the windows. With this approach you can endlessly fine-tune the Camera Raw processing on each layer until you are happy with the balance achieved for the Camera Raw settings on both layers.

Place-A-Matic script

The steps I just outlined can be carried out more easily by running Dr. Brown's Place-A-Matic script for Bridge. You can download this script for free via the Russell Brown Show website. Go to: www.russellbrown.com and then go to the Photoshop Tips & Techniques page and scroll down to the Scripts section where you can download 'Dr. Brown's Services'. This, among other things, includes the Place-A-Matic script. Follow the installation instructions and when you next launch Bridge you should see this appear as one of the new script options in the Tools menu. Basically, the Place-A-Matic script can automate almost all the steps I have just described here and offers a quicker way to create double raw settings conversions via Smart Objects (note that you will still have to add a layer mask and decide how best to blend the two Smart Object layers).

Normal	Opacity: 90%	
Lock:	Fill: 100%	
•	MU.	_P2E0127 copy
•	P2E0127	

Smart Object layer blending

This technique can be adapted in various ways. You can use the layer blending options to change the layer blend mode, but you can also double-click the Smart Object layer to open the Layer Style dialog where you can adjust the 'Blend if: This Layer' options to adjust the transition between the two Smart Object layers (see page 385 for an example of where I adjusted the Layer Style 'Blend If' sliders).

Other HDR applications

32-bit image editing is also used extensively to create the realistic CGI effects you see in many movies and television programs. These are all created using a 32-bit color space to render the computer-generated characters. It is necessary to do this in order to make them interact convincingly with the real world film footage. What usually happens is a light probe image is taken of the scene in which the main filming takes place. This is an omnidirectional HDR image which can consist of a sequence of six or seven overlapping exposures shot of a mirrored sphere. The resulting light probe image contains all the information needed to render the shading and textures on a computer generated object with realistic-looking lighting. Paul Debevec is a leading expert in HDR imaging and his website www.debevec.org contains a lot of interesting information on HDR imaging and its various applications.

High dynamic range imaging

It is interesting to see how camera sensor technology has evolved over the last few years and speculate what the future might have in store for us in the years to come. In time we may see camera sensors become available that are able to capture high dynamic range scenes in a single exposure. However, HDR cameras are not that common yet, so currently it is all about capturing bracketed sequences of images and blending these together to create single high dynamic range images that can contain the entire scenic tonal scale.

Right now there are certainly a lot of photographers who are interested in exploring what can be done using high dynamic range image editing. For example, by using the Merge to HDR Pro feature in Photoshop CS5 you can combine two or more images that have been captured with a normal digital camera, shot at different exposures, and blend these together to produce a 32-bit floating point, high dynamic range image. You can then convert this 32-bit HDR file into a 16-bit per channel or 8-bit per channel low dynamic range version which can then be edited further in Photoshop.

Basically, high dynamic range image editing requires a whole new approach to the way image editing programs like Photoshop process the high dynamic range image data. Because of this the Photoshop team had to rewrite a lot of the Photoshop code so that some of the familiar Photoshop tools could be made to work in a 32-bit floating point image editing environment. Photoshop now offers a limited range of editing controls such as layers and painting, and these features are available for all current versions of Photoshop CS5 rather than the extended version only (which was previously the case with CS3 and CS4).

HDR essentials

Traditionally, most camera sensors have been designed to record the light that hits the indivi dual photosites. I won't complicate things with a discussion of the different sensor designs used, but essentially the goal of late has been to design sensors in which the photosites are made as small as possible and crammed evercloser together so as to increase the number of megapixels. Camera sensors have also been made more efficient so that they can capture images over a wide range of ISO settings without

Figure 7.1 One approach to increasing the dynamic range of a camera sensor is to have two different sized photosites working together to capture the light hitting the sensor. One can liken this to having a wide rimmed glass and a narrow rimmed glass side by side. When water is poured, the wide rimmed glass is able to capture more water than the narrow rimmed glass and can easily detect small amounts of water, but when more water is poured than the wide rimmed glass is able to pick up the slack and keep measuring the amount of water poured.

generating too much electronic noise in the shadow areas or at the higher ISO settings. The problem all sensors face though is that at the low exposure extreme there comes a point where the photosites are unable to record any usable levels information over and above the random noise that's generated in the background. At the other extreme, when too much light hits a photosite it becomes oversaturated and is unable to record the light levels beyond a certain amount. One way to look at this is to imagine photosites as being like glasses ready to be filled with water. When only a little water is added it can be hard to accurately measure how much water is in there, and if you fill the glass to the brim, the water will overflow and you'll be unable to measure any extra water that is poured (see Figure 7.1).

Fuji Super CCD

So far, Fuji is the only camera company to come up with a new approach to this problem. The Fuji-designed Super CCD comprises of two sets of photosites laid out in an octagonal pattern, where you have a standard size photosite that can record the same dynamic range as a normal photosite and a smaller photosite next to it that can record any detail that is brighter than what the standard-sized photosite is able to record. The data captured using this type of sensor can be extrapolated to create a raw capture image which represents a dynamic range that is wider than most other digital cameras. Fuji classify the two photosites as a single photosite sensor, which means that the latest Fuji S5 camera has in fact a total of 6 million 'combined' photosites, but because of the way the photosites are laid out on the sensor chip and how the data is interpreted, the effective number of megapixels is rated as 12.1 MP. Fuji have had a problem convincing everyone that this can be regarded as a genuine megapixel rating, but wedding photographers in particular have been very impressed with the dynamic range offered by this range of cameras, which is especially important when shooting white wedding dresses alongside dark suits under what can sometimes be less than ideal shooting conditions. Unfortunately some wedding photographers have been sold the idea that JPEG shooting is the best approach for weddings and in turn lost all the advantages that can be gained from high dynamic range raw capture!

Alternative approaches

Other high dynamic range sensor technologies are in the pipeline. One method relies on the ability of a sensor to quickly record a sequence of images in the time it takes to shoot a single exposure. By varying the exposure time value for each of these exposures the camera software can extract a single high dynamic range capture. The advantage of this approach is that it might be feasible to capture a high dynamic range image using a fast shutter speed, although maybe not with a high speed strobe flash unit.

Bracketed exposures

Until we have true HDR cameras, we will have to rely on using bracketed exposures instead (see Figure 7.2). The aim here is to capture a series of exposures that are far enough apart in exposure value that we can extend the combined range of exposures to encompass the entire scenic tonal range as well as extend beyond the limits of the scenic tonal range. The advantage of doing this is that by overexposing for the shadows we can capture more levels information, which can result in cleaner, noise-free shadows. Exposing beyond the upper range of the highlights can also be useful when trying to recover information in certain tricky highlight areas. Shooting bracketed exposures is the only way most of us can realistically go about capturing all of the light levels in any given scene and merge the resulting images into a single HDR file. When this is done right you have the means to create a low dynamic rendered version from the HDR master that can reproduce most if not all of the original scenic tonal range detail.

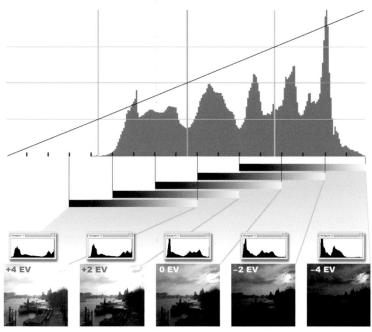

Figure 7.2 This diagram illustrates how individual bracketed exposures, when merged to form a single high dynamic range image, can extend the histogram scale to encompass the entire luminance of the subject scenic range.

Displaying deep-bit color

It is hard to appreciate the difference between 8-bit per channel and 16-bit per channel images, let alone 32-bit images, when all you have to view your work with is an 8-bit per channel display. However, display technology is rapidly improving and in the near future we may see the introduction of displays that use a combination of LEDs and LCDs to display images at greater bit depths and over a higher dynamic range. Dolby already supply such specialist high dynamic range displays and the difference is remarkable. In the future, such displays may allow us to see the images we are editing in greater tonal detail and over a much wider dynamic range.

Capturing a complete scenic tonal range

The light contrast ratio from the darkest point in a scene to the brightest will vary from subject to subject, but in nearly every case it will certainly exceed the dynamic range of even the best digital cameras. Our human vision is able to differentiate between light and dark over a contrast ratio of 1:10,000, which in photography terms is equivalent to about 14 exposure values (EV). Meanwhile, most digital cameras can only capture a tonal range of around 6-8 EV. For the most part we have to choose our exposures carefully and decide in advance whether we wish to expose for the shadows, or for the highlights, or somewhere in between. We also know from experience that we don't always need to record every single tone in a scene in order to produce a good-looking photograph. It is after all OK to deliberately allow some highlights to burn out or let the shadows go black. However, if we wish to capture every level of tonal information in a scene, the only practical solution right now is to shoot a succession of bracketed exposures (Figure 7.2), From this we can create a single image that is capable of capturing the entire scenic tonal range.

Therefore, when capturing a high dynamic range image the objective is to make sure you capture the entire contrast range in a scene from dark to light. You can do this by taking spot meter readings and manually working out the best exposure bracketing sequence to use, plus how many brackets are required. An alternative (and simpler) approach is to use a standard method of shooting in which you first measure the best average exposure (as you would for a single exposure) and bracket either side of that using either 3, 5 or 7 bracketed exposures at 2 EV apart. This may not be so precise a method, but a 5 bracketed sequence should at the very least double the dynamic range of your camera.

There are several benefits to capturing a high dynamic range. First of all, you can potentially capture all the light that was in the original scene and edit the recorded information any way you like. Secondly, providing you manage to capture all the individual brackets without any subject movement, a merged HDR image should contain smoother tonal information in the shadow regions. This is because more levels are captured at the bright end of the levels histogram (see 'Digital exposure' on page 186). Because of this the overexposed brackets will have more levels with which to record the shadow detail. When you successfully capture and create an HDR image, there should be little or no noise in the shadows and you should have a lot more headroom to edit the shadow tones without the risk of banding or lack of fine detail that is often a problem with normally exposed digital photos.

HDR shooting tips

The first thing you want to do is to set up your camera so that it can shoot auto bracketed exposures. This can usually be done via the camera controls. Some cameras only allow you to shoot just three bracketed exposures, others more. With the Canon EOS range you should find that by tethering your camera to the computer you can use the Canon camera utilities software to set the default to five or more exposure brackets. The bracketing should be done based on varying the exposure time. This is because the aperture must always remain fixed so that you don't vary the focus between captures. Next, you want the camera to be kept still between exposures. It is possible to achieve this by shooting the pictures with a hand-held camera and keep as still as possible, but for best results you should use a sturdy tripod with a cable release. Even then you may have the problem of mirror shake to deal with. This is where the flipping up of the mirror on an SLR camera can set off a tiny vibration which can cause a small amount of image movement during the exposure. However, this is mostly only noticeable if using a long focal length lens. When shooting on a tripod this can be a problem, but if you shoot hand-held, the vibrations are usually dampened by your hands holding the camera. So apart from using a cable release, do enable the mirror up settings on your camera if you can. As a Canon user it has been frustrating going through the custom function menu options to set the camera to mirror up mode, but setting the mirror lock up has been made easier with the latest EOS 1Ds MkIII camera.

The ideal exposure bracket range will vary, but an exposure bracket of five exposures of 2 EV apart should be enough to successfully capture most scenes. You can use just three exposures that are 2 EV apart and get good results, but you won't be recording as wide a dynamic range. As you shoot a bracketed sequence watch out for any movement between exposures such as people moving through the frame, cars or where the wind may be causing movement. Sometimes it can be hard to prevent everything in the scene from moving and there are some software programs that are capable of removing some ghosting effects, but it's best to avoid this if you can.

Really still, still life

The Merge to HDR Pro dialog can automatically align the images for you, but it is essential that everything else remains static. You might just get away shooting the HDR merge images with a hand-held camera using an auto bracket setting, but if so much as just two of the pictures fail to register you won't be able to create a successful HDR merge. If you do resort to hand-holding the camera, use a fast motor drive setting, raise the ISO setting at least two stops higher than you would use normally for hand-held shooting and try to keep the camera as steady as possible (hand-holding the camera should absorb some of the mirror shake movement).

If you shoot three or five exposures and separate these by two exposure values (EV), this should allow you to capture a wide scenic capture range efficiently and quickly. You can consider narrowing down the exposure gap to just 1 EV between each exposure and shoot more exposures. This can make a marginal improvement to edge detail in a merged HDR image, but can also increase the risk of error if there is movement in any of the individual exposures.

HDR file formats

True high dynamic range images can only originate from a high dynamic range capture device or be manufactured from a composite of camera exposures using a method such as the Merge to HDR pro option (which is described over the following pages). Photoshop's 32-bit mode also uses floating point math calculations (as opposed to regular whole integer numbers) to describe the brightness values, which can range from the deepest shadow to the brightness of the sun. It is therefore using a completely different type of image mode to describe the luminance values in an image.

If you want to save an HDR-created image out of Photoshop, you are offered a choice of formats. You can use the Photoshop, Large Document format (PSB) or TIFF format to save an HDR image file. These file formats can store Photoshop layers or adjustment layers, but the downside is the file sizes are at least four times that of an ordinary 8-bit per channel image. However, there are ways to make 32-bit HDR files more compact. You can use the Open EXR or Radiance formats to save your HDR files more efficiently and the Open EXR format will very often be only slightly bigger than an ordinary 8-bit version of an image. The downside is you can't save Photoshop layers using OpenEXR, but this could still be considered a good format choice for archiving flattened HDR images, despite the fact that it is utilizing less of the data than a full 32-bit per channel format such as PSB or TIFF.

How to fool Merge to HDR

Some people have asked if it is possible to take a standard single shot image, create versions of varying darkness and merge these together as an HDR image. The thing is, you can't fool Merge to HDR Pro since it responds to the camera time exposure EXIF metadata information in the file rather than the 'look' of the image. However, you can now use Image \Rightarrow Adjustments \Rightarrow HDR Toning to create a

HDR Toning

fake HDR look from a normal dynamic range image. The way it does this is to convert an 8-bit, or ideally a 16-bit per channel image to 32-bits per channel mode and then pops the HDR Toning dialog shown in Figure 7.3, which allows you to apply HDR toning adjustments as if it were a true HDR original. Note, this only works if you are editing an image that is in RGB or Grayscale mode and has been flattened first. This isn't true HDR to LDR photography, but it does provide a means by which you can create an 'HDR look' from photographs that weren't captured using a bracketed exposure sequence.

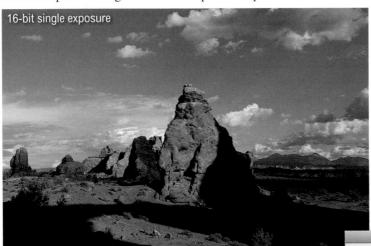

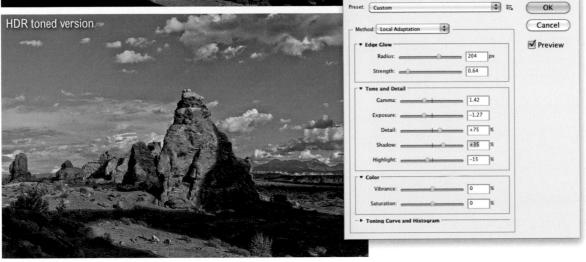

Figure 7.3 This shows an example of HDR Toning being applied to a normal 16-bit per channel image (top) to produce the fake high dynamic range effect shown here (bottom).

Response curve

Each time you load a set of bracketed images, Merge to HDR Pro automatically stores a response curve in Photoshop's preferences for every camera it encounters. As you merge more images from the same camera, Merge to HDR Pro updates the response curve to improve its accuracy. If consistency is important when using Merge to HDR Pro to process files over a period of time, you might find it useful to save a response curve (see Step 3) and reuse the saved curve when merging images in the future.

Merge to HDR Pro

Now that you've learnt what a high dynamic range image is, it's time to put the experience into practice and go out and shoot some pictures. To avoid disappointment, I suggest you choose an easy subject to shoot first and follow the advice on the previous pages about bracketing and using a tripod with a cable release. You can certainly get successful results from shooting JPEG images, so don't feel you have to use raw, but in my view raw gives you more options, like the ability to pre-sharpen correctly and ensure the white balance is synchronized. The Merge to HDR Pro command can be accessed via the File \Rightarrow Automate menu in Photoshop or via the Tools \Rightarrow Photoshop menu in Bridge. I usually find it best to open via Bridge, since the image alignment is applied there automatically.

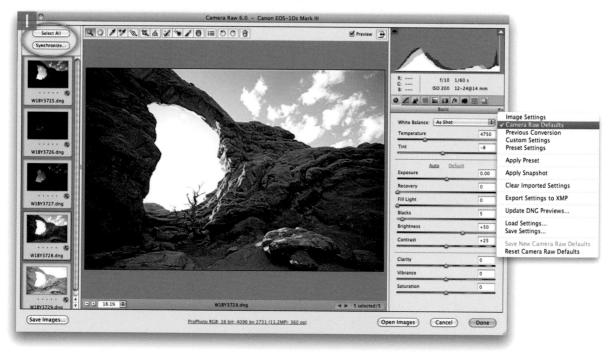

1 The original pictures were bracketed using different time exposures at two exposure values (EV) apart. I began by opening a selection of five raw digital capture images via Camera Raw. It was important that all auto adjustments were switched off. In this example, I made sure the Camera Raw Defaults were applied to the first image and synchronized this setting across all the other selected images (you'll definitely need to check the white balance is included in the synchronization if the camera was set to use an auto white balance setting).

2 I kept the images selected in Bridge and went to the Tools menu and chose Photoshop \Rightarrow Merge to HDR Pro.

3 This shows the Merge to HDR Pro dialog in 16-bit mode. Providing the 8-bit or 16-bit mode is selected you will see the HDR toning options shown here. These allow you to apply an HDR to LDR conversion in one step (the HDR toning controls are described more fully on pages 410-413). If you prefer at this stage to simply save the image as a 32-bit master HDR file, you should select the 32-bit mode, where the only option available is to adjust the exposure value for the image preview. There is also a fly-out menu in the Merge to HDR Pro dialog (circled below) where you can deselect the Automatic Response curve mode and also choose to save or load a custom response curve (see sidebar opposite).

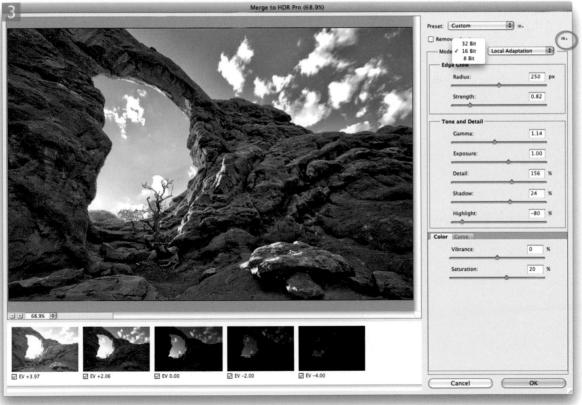

Merge to HDR Pro script

There is a 'Merge to HDR' script you can load from the Presets/Scripts folder that allows you to open files or folders of images to process via Merge to HDR Pro. It does not allow you to process layered files, although there are hooks present that could allow this to be scripted.

Exposure and Gamma

You can use the Exposure slider to compensate for the overall exposure brightness and the Gamma slider to (effectively) reduce or increase the contrast. These controls are rather basic, but they do allow you to create a usable conversion from the HDR image data.

Highlight Compression

The Highlight Compression simply compresses the highlights, preserving all the highlight detail. It can render good midtones and highlights at the expense of losing detail in the shadows.

Equalize Histogram

The Equalize Histogram option attempts to map the extreme highlight and shadow points to the normal contrast range of a low dynamic range Photoshop image, but this will usually make for a rather blunt conversion.

Tone mapping HDR images

After you have created a merged 32-bit per channel HDR image, you can save the HDR master using the PSB or TIFF format to preserve maximum image detail plus any layers. Or, you can use the EXR format, which as I explained earlier is a more efficient, space saving file format for storing 32-bit images (but lossy). You can if you like skip saving the merged HDR image and jump straight into the tone mapping stage by selecting the 16-bit per channel or 8-bit per channel option in the Merge to HDR dialog. I think you will find though that there are some definite advantages to preserving a master image as an HDR file. There is a real art to tone mapping an image from a high dynamic range to a normal, low dynamic range state and you won't always make the best judgement on your first try. It therefore makes sense to save the HDR file first as a 32-bit master image and then use the Image \Rightarrow Mode in Photoshop to convert from 32-bits to 16-bits or 8-bits per channel. This pops the HDR Toning dialog (Figure 7.5), which offers four methods of converting an HDR image to a low dynamic range version (see the sidebars on the left and the section below). With each of these the aim is the same: to squeeze all of the tonal information that is contained in the high dynamic range master down into a low dynamic range version of the image. Here I am mainly going to concentrate on the Local Adaptation method.

Local Adaptation

The Local Adaptation method is designed to simulate the way our human eyes compensate for varying levels of brightness when viewing a scene. For example, when we are outdoors our eyes naturally adjust and compensate for the difference between the brightness of the sky and the brightness of the ground. The difference in relative brightness between these two areas accounts for the 'global contrast' in the scene. As our eyes concentrate on one particular area, the contrast we observe in, say, the clouds in the sky or the grass on the ground, is contrast that is perceived at a localized level. The optimum settings to use in an HDR conversion will therefore depend on the image content. In Figure 7.4 we have a photograph of a scene that has a high dynamic range. The global contrast would be the contrast between the palm tree seen in silhouette against the brightly lit buildings in the background, while the localized contrast would be the detail contrast within both the bright and dark regions of the picture (magnified here).

The Radius slider in the Local Adaptation HDR Toning dialog Edge Glow section (Figure 7.5) is said to control the size of the glow effect, but I prefer to think of this as a 'global contrast' control. Basically, the tone mapping process lightens the shadows relative to the highlights and the tone mapping is filtered via a soft edge mask. Increasing the Radius amount widens the halos. At a low setting you'll see an image in which there may be a full tonal range from the shadows to the highlights, but the image looks rather flat. As you increase the Radius this widens the halos, which softens the underlying mask and this is what creates the impression of a normal global contrast image. You can then use the Strength slider to determine how strong you want the effect to be. At a zero Strength setting the picture will again look rather flat. As you increase the Strength amount, you'll see more contrast in the halos that are generated around the high contrast edges in the image. The Glow Strength slider can therefore be used to soften or strengthen the Radius effect, but you do need to watch for ugly haloes around the high contrast edges.

When the Gamma slider is dragged all the way to the left, there is no tone compression between the shadows and highlights. As you drag the other way to the right, this compresses the shadows and highlights together. The Exposure slider can then be used to compensate for the overall exposure brightness. Note that this slider adjustment can have a strong impact as it is applied after the tone mapping stage rather than before.

The Detail slider works a bit like the Clarity slider that's found in Camera Raw and you can basically enhance the localized contrast by adding more Detail. The Shadow and Highlight sliders are fine-tuning adjustments. These sliders can be used to independently adjust the brightness in the shadows or highlight areas. For example, the Shadow slider can be used to lighten the shadow detail in the darkest areas only. HDR Local Adaptation conversions typically mute the colors so you can use the Vibrance and Saturation sliders to control the color saturation.

Finally, we come to the Toning Curve and Histogram. You can use this to apply a tone enhancing contrast curve as a last step in the HDR conversion. The histogram displayed here represents that for the 32-bit image, but you'll find the Histogram panel in Photoshop more useful when gauging the outcome of a conversion. When you are done you can click on the OK button for Photoshop to render a low dynamic range version from the HDR master.

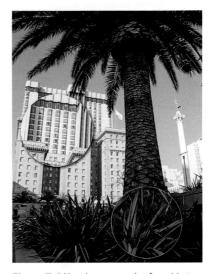

Figure 7.4 Here is an example of a subject that has a wide dynamic range and strong global contrast.

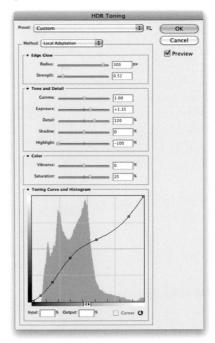

Figure 7.5 The Local Adaptation tone mapping method (also displaying the Tone Curve and Histogram options).

Photomatix Pro

Photoshop's tone mapping methods are designed to help you create naturallooking conversions from an HDR to an LDR image. Photomatix Pro has proved extremely popular with photographers because it offers excellent photo merging (sometimes with more accurate image merging of hand-held shots), ghosting control and, above all, more extensive tone mapping options. Tone mapping with Photomatix Pro is much easier and also allows you to create those illustration-like effects that are often associated with a high dynamic range image look (which we should really call 'HDR to LDR converted images'). One explanation for the difference between the Photoshop HDR conversion method and Photomatix Pro may be because Photoshop uses a bilateral filter for the tone mapping, while Photomatix Pro uses a Gaussian filter which produces more noticeable-looking halos. I like using Photomatix Pro and find it guick to work with, but I do also find the new Merge to HDR Pro in CS5 works extremely well and I now find myself split between working with both.

Removing ghosts

It is important to minimize any movement when shooting exposures, which is why it is best to shoot using a sturdy tripod and cable release. Even then there remains the problem of objects that may move between exposures, such as tree branches blowing in the wind. To help address this the Merge to HDR Pro process in Photoshop CS5 utilizes a new ghost removal algorithm which automatically tries to pick the best base image to work with and discards the data from other images in those areas where there is movement. When the 'Remove Ghosts' option is checked in the Merge to HDR Pro dialog you'll see a green border around whichever thumbnail has been selected as the base image. You can override this by clicking to select an alternative thumbnail and make this the new base image. For example, if the moving objects are in a dark portion of the photograph then in these circumstances it will be best to select a lighter exposure as the base image. In practice I have found the ghost removal to be very effective on most types of subjects, although moving clouds can still present a problem. Skies are also tricky to render because the glow settings can produce a noticeable halo around the sky/horizon edge. This problem can usually be resolved by substituting the medium exposure sky image as a separate layer with a layer mask based on the outline of the sky.

How to avoid the 'HDR' look

It has to be said that HDR to LDR converted images can sometimes look quite freaky because there is a temptation to squeeze everything into a low dynamic range. Just because you can preserve a complete tonal range does not mean you should. It really is OK to sometimes let the highlights burn out or let the shadows remain black. The Photomatix Pro program has proved incredibly popular with HDR enthusiasts, and in the process spawned the classic 'HDR' look, which I personally think has been done to death now. Besides, Photomatix Pro can actually be used to produce nice, subtle tone mapped results, but I suppose people don't notice these types of HDR photos quite so much. The Photoshop approach also lets you produce what can be regarded as natural-looking conversions and I think you'll agree that the Figure 7.6 example shows how the HDR to LDR image process can result in a photo that looks fairly similar to a normal processed image, but with much improved image detail in the shadow regions.

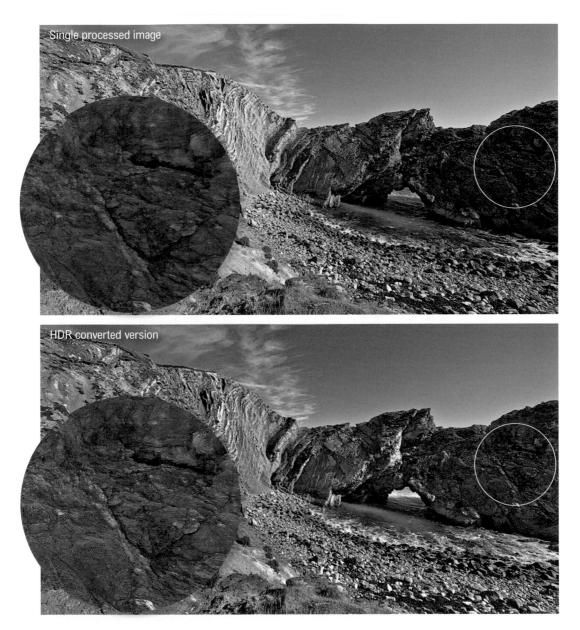

Figure 7.6 On this page you can see a comparison between a single edited image, using an optimum exposed photograph (top), processed via Camera Raw and output as a 16-bit file. Below you can see the HDR edited version that was converted to make a 16-bit low dynamic range image. At first glance the difference is quite subtle. I did after all try to get the two images to match as closely as possible, but you should notice better tone and detail contrast in the rocks in the HDR converted version. The difference was more noticeable though when I examined the shadow areas. In the enlarged close-up views you can see there is much more image detail and virtually no shadow noise in the bottom image.

Exposure slider

It is impossible to represent an HDR image on a standard computer display, which is why the Exposure slider is available as a slider at the bottom of the document window. It allows you to inspect an HDR image at different brightness levels. Since the display you are using is most likely limited to a bit depth of 8-bits, this is the only way one can actually 'see' what is contained in a high dynamic range 32-bit image.

1 I began here with an HDR image that was produced by merging together a bracketed sequence of three photographs, shot at 2 EVs apart. To reduce any movement in the individual exposures, the camera was mounted on a tripod and the pictures were taken using a cable release. This first screen shot shows the merged HDR file as it appeared in Photoshop in 32-bit per channel mode with the Exposure slider adjusted so that I got to see a reasonably good view of the HDR image. In 32-bit per channel mode one can use the Exposure slider to preview the HDR image at different levels of brightness. Here, the Exposure slider allowed me to adjust the preview as I focused on retouching different parts of the picture using the clone stamp tool prior to making the HDR tone conversion.

2	HDR	Toning	
	Preset: Custom	.	ОК
	- Method: Local Adaptation	I	Cancel
	▼ Edge Glow		Preview
Energy It is a second of the	Radius:	61 px	
	Strength:	0.52	
	▼ Tone and Detail		
	Gamma:	1.00	1 de la come
	Exposure:	- Lansand	
	Detail:		
	Shadow:	0 %	
	Highlight:	0 %	
	* Color		
	Vibrance:	0 %	
A Comment of the second	Saturation:	0 %	
	- • Toning Curve and Histogram		
]	
NIE NE			
and the second se			
and the second se			
	A CONTRACTOR OF THE OWNER		
	and the second		

2 To convert this high dynamic range image into a low dynamic range version I had two options. I could go to the Image ⇒ Mode submenu and chose 16-bits / Channel, or choose Image ⇒ HDR Toning... Either of these methods would open the HDR Toning dialog shown here. Of the four tone mapping options that are available in this dialog, I find that the Local Adaptation method usually works the best and in this screen shot I left all the sliders at their default positions. Although the image doesn't look all that great just yet, this is certainly quite an improvement upon how the default HDR converted image preview looked in previous versions of Photoshop.

Martin Evening

Adobe Photoshop CS5 for Photographers

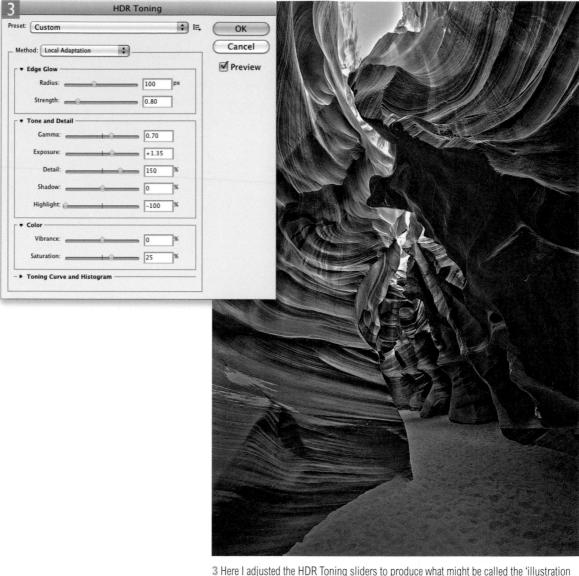

³ Here I adjusted the HDR Ioning sliders to produce what might be called the 'illustration look' that is favored by many HDR photography enthusiasts. If this is the type of effect you are after, I don't think the Photoshop HDR Toning adjustment is really as capable as, say, Photomatix Pro, nor is it as simple to configure, but Photoshop CS5 can now be made to produce the rather obvious 'HDR toned effect'. Looking at the settings shown here, I set the Radius slider to 100 pixels and raised the Strength to 0.80. I took the Gamma slider to 0.7, set the Exposure slider to +1.35 and the Detail slider to 150%. I then reduced the Highlight slider to -100% and increased the Saturation slightly, setting it to 25%.

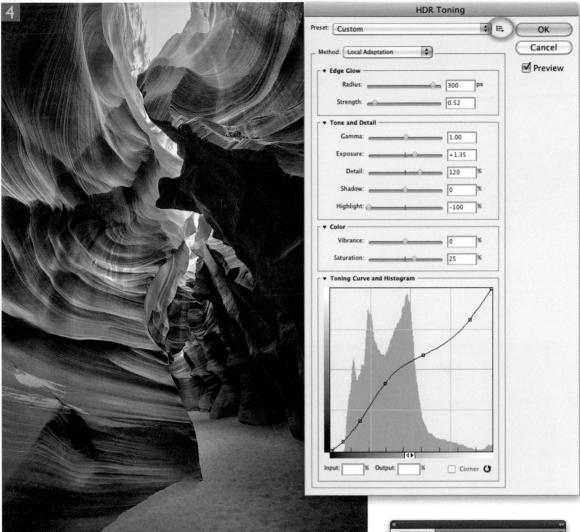

4 In this last step the aim was to produce a more natural-looking result. To start with I set the Radius slider to 300%. This was done to create much wider halo edges. I also took the Strength slider back to it's previous default setting of 0.52 and the Gamma slider back to the default 1.00 setting. I reduced the Detail slider to 120% and the other settings, including the Exposure, Highlight and Saturation sliders were left at the same positions as in Step 3. I then adjusted the Toning curve to fine-tune the final tone mapping and was able to refer to the Histogram panel in Photoshop as I did this. Lastly, I clicked on the HDR Toning options button (circled), selected 'Save Preset...' and saved the Local Adaptation settings as a new preset, since this might serve as a useful starting point for future HDR conversions.

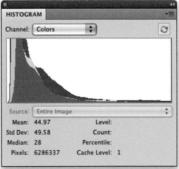

Exposure adjustments

Although you can use the Exposure adjustment to edit 16-bit or 8-bit images, it is really designed as an image adjustment for working on 32-bit images.

Work from the top downwards

When you add a new adjustment layer, it is best to add the newest layer at the bottom of the layer stack just above the Background layer. This reduces the length of time you'll see the 'Building histograms' dialog appear on the screen.

Manual tone mapping

There is yet another way to tone map an HDR image. You can add adjustment layers to a 32-bit image and use these to edit the tone and color. Previously, the ability to paint and add layers was only available in the extended versions of the program, but this is something that you can now do in all versions of Photoshop CS5. In Figure 7.7, you can see a preview of an image that was in 32-bit per channel mode, where I used a combination of Exposure adjustment layers to adjust the contrast and brightness and Levels adjustment layers to adjust the color, and masked each of these individual adjustment layers to selectively apply these adjustments to specific areas of the image. By building up a succession of adjustment layers, I was able to tone map the original HDR image just the way I wanted, but without having to render it as an LDR version just yet. If you wish to preserve all the layers when saving such a file, you will need to use the Photoshop, TIFF, Portable Bit Map or PSB format. Preserving the layers means that the master image file size will be increased, but direct HDR image editing does offer a lot of flexibility.

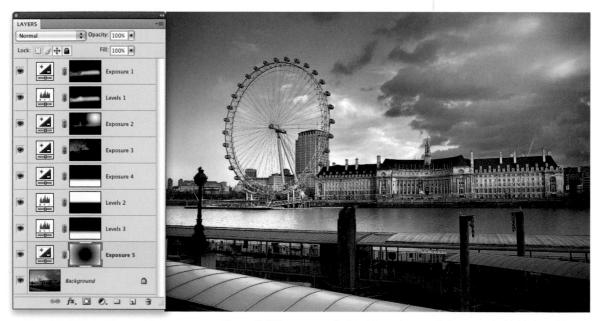

Figure 7.7 You can use adjustment layers to manually tone map the 32-bit data while keeping the HDR image in it's original 32-bit mode.

Chapter 8

Image Retouching

hotoshop has become so successful that it's very name is synonymous with digital image retouching. Photoshop retouching tools such as the humble clone stamp have been around since the very early versions of the program and been used and abused in equal measure. The new retouching tools that have been added since then mean that you can now transform images almost any way you want. As my colleague Jeff Schewe likes to say, 'you know why Photoshop is so successful? Because reality sucks!' Well, that's Jeff's viewpoint, but then he does come from a background in advertising photography where heavy retouching is par for the course. The techniques described in this chapter will teach you some of the basic techniques, such as how to remove dust spots and repair sections of an image. We'll then go on to explore some of the more advanced techniques that can be used to clean up and enhance your photographs.

Martin Evening Adobe Photoshop CS5 for Photographers

Figure 8.1 If you are carrying out any type of retouching work which relies on the use of the paint tools, a pressure sensitive graphics tablet and pen, such as the Wacom[™] device shown here, is absolutely invaluable.

Basic cloning methods

The clone stamp tool and healing brush are the most useful tools to use at the beginning of any retouching session. You can use these to carry out most basic retouching tasks before you proceed to carry out the more advanced retouching steps.

Clone stamp tool

To use the clone stamp tool, hold down $\[\] all \]$ and click to select a source point to clone from. Release the $\[\] all \]$ key and move the cursor over to the point that you wish to clone to, and click or drag with the mouse. If you have the tool set to aligned mode, this establishes a fixed relationship between the source and destination points. If the clone stamp is set to the non-aligned mode, the source point remains the same and the clone stamp will keep sampling from the same spot until you $\[\] all \]$ -click again to establish a new source point. When working with the clone stamp or healing brush I do find it helps to use a graphics tablet like the WacomTM device (shown in Figure 8.1). This can help you work more quickly and efficiently.

Clone stamp brush settings

As with all the other painting tools, you can change the brush size, shape and opacity to suit your needs. When working with the clone stamp I mostly leave the opacity set to 100%, since cloning at less than full opacity can lead to tell-tale evidence of clone stamp retouching. However, when smoothing out skin tone shadows or blemishes, you might find it helpful to switch to an opacity of 50% or less, and you can also use lower opacities when retouching areas of soft texture. Otherwise I suggest you stick to using 100% opacity. For similar reasons, you don't want the clone stamp to have too soft an edge. For general retouching work, the clone stamp brush shape should have a slightly harder edge than you might use normally with the paint brush tools. When retouching detailed subjects such as fine textures, you might want to use an even harder edge so as to avoid creating halos. Also, if film grain is visible in a photograph, anything other than a harder edge setting will lead to soft halos, which can make the retouched area look slightly blurred or misregistered. If you need extra subtle control, lower the Flow rate; this allows you to build an effect more slowly, without the drawbacks of lowering the opacity.

Chapter 8 Image retouching

🔒 🖡 👘 😰 🔝 Mode: Normal 🗘 Opacity: 100% 🛛 🧭 Flow: 100% 🖷 🕼 Aligned Sample: All Layers 🛟 🖏 🧭

1 The best way to disguise clone stamp retouching is to use a full opacity brush with a medium hard edge at 100% opacity. It is also a good idea to add a new empty layer above the Background layer, so you can keep all the clone retouching on a separate layer. It was for this reason I chose to have the 'All Layers' Sample option selected so that all visible pixels were copied to this new layer.

2 The Aligned box is normally checked by default in the Options bar. Here, I used the and key to set the sample point on an undamaged part of the wooden door and clicked again further up the door to set the destination point. I then dragged to paint with the clone stamp. Photoshop retains the clone source/destination relationship for all subsequent brush strokes until a new source and destination are established.

All Layers option

The 'Current & Below' and 'All Layers' options are useful if you want to work with the clone stamp or healing brush and store your retouching on a separate layer. If you select the 'Current & Below' option, Photoshop only samples from the visible layers that are below the current layer and ignores any layers that are above it. If the 'All Layers' option is selected, Photoshop samples from all visible layers, including those above the active layer (see page 427).

3 This screen shot shows how the door looked after I had worked on it a bit more using the clone stamp tool to mend the weathered portions of the woodwork. It is in situations like this that you may find the Clone Source panel overlay proves useful (see page 420).

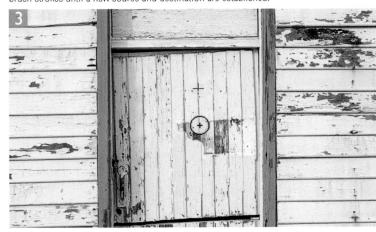

Healing brush

The healing brush can be used in more or less the same way as the clone stamp tool to retouch small blemishes, although it is important to stress here that the healing brush is more than just a super clone stamp and has its own unique characteristics. These differences need to be taken into account so that you can learn when it is best to use the healing brush and when it is more appropriate to use the clone stamp.

To use the healing brush, you again need to establish a sample point by C alt-clicking on the portion of the image you wish to sample from. You then release the **C** all key and move the cursor over to the point where you want to clone to and click or drag with the mouse to carry out the healing brush retouching. The healing brush performs its magic by sampling the texture from the source point and blends the sampled texture with the color and luminosity of the pixels that surround the destination point. The healing brush reads the pixels within a feathered radius that is up to 10% outside the perimeter of the healing brush cursor area. By reading the pixels that are outside the cursor area at the destination point, the healing brush is able (in most cases) to calculate a smooth transition of color and luminosity within the area that is being painted (always referencing the pixels within a feathered radius that is up to 10% outside the perimeter of the healing brush cursor area). It is for these reasons that there is no need to use a soft-edged brush and you will always obtain more controlled results through using the healing brush with a 100% hard edge.

Once you understand the fundamental principles that lie behind the workings of the healing brush, you will come to understand why it is that the healing brush may sometimes fail to work as expected. You see, if the healing brush is applied too close to an edge where there is a sudden shift in tonal lightness, it will attempt to create a blend with what is immediately outside the healing brush area. So when you retouch with the healing brush you need to be mindful of this intended behavior. However, there are things you can do to address this. For example, you can create a selection that defines the area you are about to start retouching and constrain the healing brush work so that it is carried out inside the selection area only (see the example shown on page 425).

Aligned Sampled O Pattern:	ple: Current & Below 🗘 🗞 🧭

1 I selected the healing brush from the Tools panel and selected a hard-edged brush from the Options bar. The brush blending mode was set to 'Normal', the Source button set to 'Sampled' and the Aligned box left unchecked.

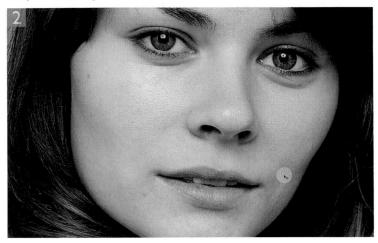

2 Before using the healing brush, I again added a new empty layer and made sure the Sample options were set to 'All Layers' or 'Current & Below'. I Sample options were set to 'All Layers' or 'Current & Below'. I Sample options were set to 'All Layers' or 'Current & Below'. I Sample options were set to 'All Layers' or 'Current & Below'. I Sample options were set to carry out the retouching. Here, I simply clicked on the blemishes to remove them with the healing brush. If you are using a pressure sensitive tablet such as a Wacom[™] tablet, the default brush dynamics will be size sensitive, so you can use light pressure to paint with a small brush, and heavier pressure to apply a full-sized brush.

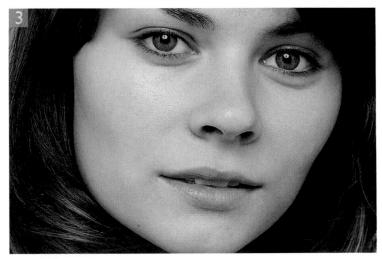

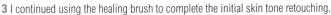

Aligned or non-aligned cloning?

When the source area is unrestricted I suggest you choose the aligned mode for the clone stamp tool. However, when the source area is restricted and you don't want to pick up from other surrounding areas, choose non-aligned.

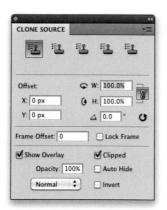

Figure 8.2 The Clone Source panel, shown here with the Show Overlay and Clipped options checked.

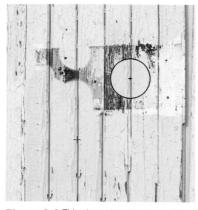

Figure 8.3 This shows how the clone stamp (or healing brush) cursor looks when using the Clone Source panel options shown in Figure 8.2, with the 'Show Overlay' and 'Clipped' options checked.

Choosing an appropriate alignment mode

I usually find it is more convenient to use the clone stamp tool in aligned mode and the healing brush in non-aligned mode (Figure 8.4). This is because when you use the clone stamp you can preserve the relationship between the source and destination points, apply a few clones, then sample a new source point as you continue cloning over other parts of the photograph. You can even clone data from a separate document (as shown in Figure 8.5).

If you try to use the clone stamp over an area where there is a gentle change in tonal gradation, it will be almost impossible to disguise the retouching work, unless the point you are sampling from and destination point match exactly in tone and color. It is in these situations that you are usually better off using the healing brush. For most healing brush work I suggest you use the nonaligned mode (which happens to be the default setting for this tool). This allows you to choose a source point that contains the optimum texture information with which to repair a particular section of a photograph. You can then keep referencing the same source point as you work with the healing brush.

Clone Source panel and clone overlays

The Clone Source panel was first introduced in Photoshop CS3 and was mainly implemented with video editors in mind. This is because it can sometimes be desirable to store multiple clone sources when cloning in exact registration from one frame to another across several frame images in a sequence. The current version offers an improved overlay cursor view where if the 'Show Overlay' and 'Clipped' options are both checked, a preview of the clone source can be seen inside the cursor area. Earlier, on page 417, I made a reference to the Clone Source panel, saying this was just the kind of retouching task that would benefit from having an overlay inside the cursor to help guide where to click when setting the destination point for the clone stamp. Figure 8.3 shows a detail view of the clone stamp being applied using the settings shown in Figure 8.2, where the 'Show Overlay' and 'Clipped' options were both enabled. You could choose to have the 'Show Overlay' option switched on all of the time, but there is usually a slight time delay while the cursor updates its new position and this can at times become distracting. I therefore suggest you only enable it when you really need to.

Chapter 8 Image retouching

Figure 8.5 In this example you can see how I was able to sample the sky from one image window and copy it to another separate image using the clone stamp. I just 💟 alt -clicked with the clone stamp in the source (sky) image, then selected the other image window and clicked to establish a cloning relationship between the source and destination image windows.

Options bar is unchecked, the source point remains static and each application of the clone

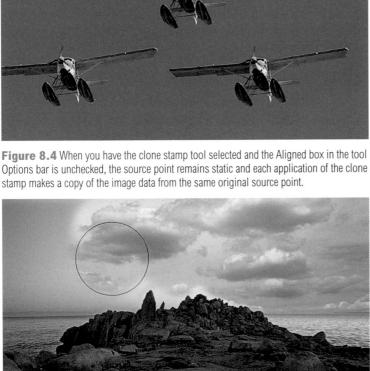

Overlay blend modes

You can adjust the opacity of the Clone Source overlay and change the blend mode. In some instances you may find it useful to work with the Difference blend mode at 100%, as the Difference blend mode shows a solid black preview when identical pixels are in register.

1 Here is a photograph in which I wished to remove the trash bin in the bottom left section of the image. The tricky thing here is that the bin was just in front of a circular alcove, and this would normally make it less easy to remove, but not so when I had access to the Clone Source panel controls.

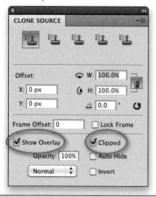

L Mode: Normal

2 To start with, I wanted to remove the bottom of the bin. This could normally be done by placing the source point for the clone stamp on the edge of the black line and 'estimating' where to click with the clone stamp. One would then continue painting along the line 'in register'. By using the Clone Source panel, I was able to switch on the 'Show Overlay' and 'Clipped' options (circled above) so that I could easily align the pixels while moving the cursor into position, before clicking to apply the cloned pixels at the correct destination point. This took away all the quesswork and made it much easier to paint with the clone stamp in perfect alignment with the underlying image.

Upside-down cloning

Here is a further example of how the Clone Source panel can help with tricky retouching jobs. In the following steps I used the Clone Source panel's ability to rotate the clone stamp or healing brush alignment through 180°. The improved cursor overlay display now makes it easier to use the Clone Source panel in this way to retouch a photo.

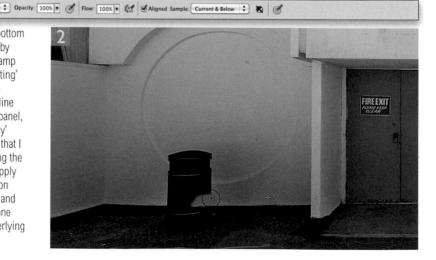

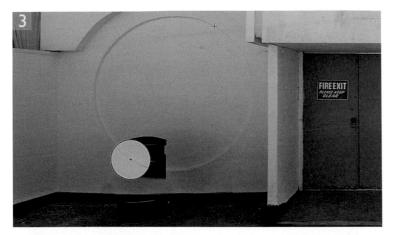

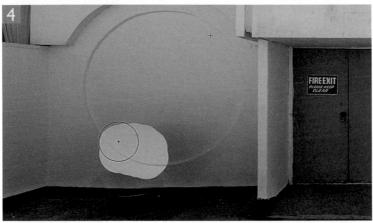

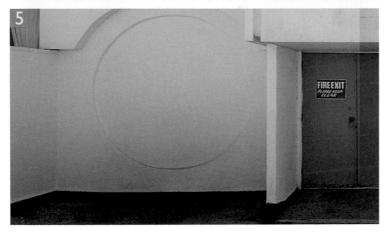

3 I now switched tools and selected the healing brush. This time I went to the Clone Source panel and set the clone source angle to 180° relative to the destination. This meant that when I sampled using the pixels from the top right corner of the circular alcove, the preview showed a 180° rotated preview of where the pixels would be painted at the destination point. Again, the cursor overlay allowed me to precisely align the preview, so that the edge of the circle could be aligned precisely.

Offset:	œ ₩: 100.0%
X: 0 px	G H: 100.0%
Y: 0 px	A 180.0 C
Frame Offset: 0	Lock Frame
Show Overlay	Clipped
Opacity: 1009	Auto Hide

4 Here is a screen shot showing the healing brush in action. Note that it did not matter that the preview showed the cloned pixels as being lighter than the ones I was painting on top of. The healing brush would blend the correct blended luminosity afterwards as soon as I had finished painting.

5 Here is the final result, in which I only had to carry out some minor extra retouching in order to clean up the remaining parts of the picture.

Better healing edges

Since the healing brush blends the cloned source data with the edges that surround the destination point, you can improve the efficiency of the healing brush by increasing the outer circumference size for the healing brush cursor. The following technique came via Russell Brown, who informs me that he was shown how to do this by an attendee at one of his seminars.

If you change the healing brush to an elliptical shape, you will tend to produce a more broken-up edge to your healing work and this can sometimes produce an improved healing blend (Figure 8.6). There are two explanations for why this works. Firstly, a narrow elliptical brush cursor has a longer perimeter. This means that more pixels are likely to be sampled when calculating the healing blend. The second thing you will notice is that when the healing brush is more elliptical, a randomness is introduced into the angle of the brush. Try changing the shape of the brush in the way I describe below and as you paint, you will see what I mean.

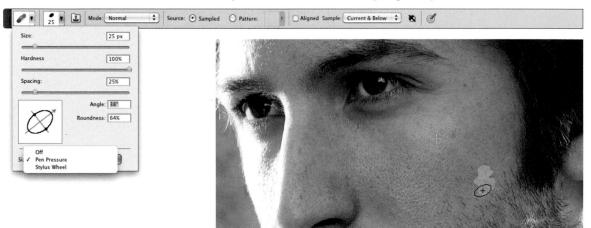

Figure 8.6 To adjust the shape and hardness of the healing brush, select the healing brush tool and mouse down on the brush options in the tools Options bar. Set the Hardness to 100% and drag the elliptical handles to make the brush shape more elliptical. Notice also that if you are using a Wacom[™] tablet or other pressure sensitive input device, the brush size is linked by default to the amount of pen pressure applied.

425

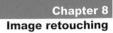

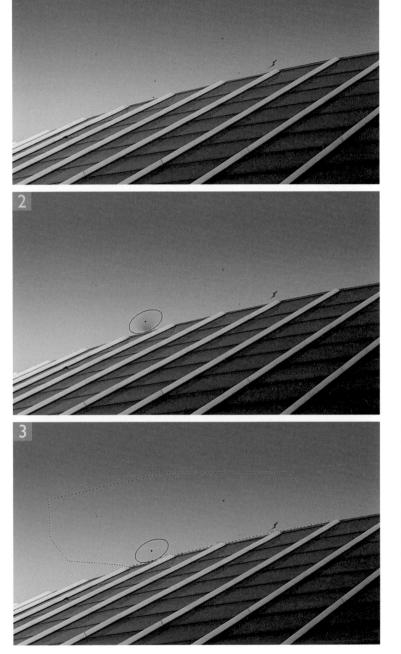

1 The healing brush is a perfect retouching tool to use when you are faced with the challenge of retouching blemishes where the sky contains gentle transitions of tone going from dark to light. It used to be extremely difficult to retouch shots like this when all you had to work with was the clone stamp tool, but not so with the healing brush.

2 One potential problem that can arise is when you wish to retouch a blemish that is adjacent to a sudden change in lightness or color. In this picture you can see that even if I were to use the healing brush with a small, hard-edged brush, as I brushed closer to the roof the healing brush would pick up the dark edge and this would result in the darker pixels bleeding into the healing brush cloned area.

3 One answer to the problem would be to make a pre-selection of the area I wished to heal (with maybe some minimal feathering) and thereby restrict the extent to which the healing brush tool was able to analyze the surrounding pixels. The other alternative would be to switch to working with the clone stamp tool when retouching close to edges like this. Having said this, the new Content-Aware mode for the spot healing brush does now make it easier to cope with these types of retouching problems (see pages 430–431).

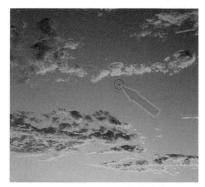

Figure 8.7 In Proximity Match mode, the spot healing brush works by searching automatically to find the best pixels to sample from to carry out a repair, but if you drag with the spot healing brush it uses the direction of the drag as the source for the most suitable texture to sample from. By dragging with the tool you can give the spot healing brush a better clue as to where to sample from.

Spot healing brush

The spot healing brush may not be quite so versatile as the healing brush, but it is in many ways a lot easier to use. The spot healing brush is also the default healing tool in Photoshop. The first time you select it and try to use the solar at keys to establish a source point to sample from, you will be shown a warning dialog explaining there is no need to create a sample source for the spot healing brush and offering you the option to switch to using the normal healing brush instead. To use the spot healing brush just click on the marks or blemishes you wish to remove. The spot healing brush then automatically samples the replacement pixel data from around the area you are trying to heal.

The spot healing brush tool has three basic modes of operation (Figure 8.8). In Proximity Match mode it analyzes the data around the area where you are painting to identify the best area to sample the pixel information from. It then uses the pixel data that has been sampled in this way to replace the defective pixels beneath where you are painting. You can use the spot healing brush to click away and zap small blemishes, but when you are repairing larger areas in a picture you will usually obtain better results if the brush size is slightly smaller than the area you are trying to repair. If you come across a problem like the one outlined on page 425, it is usually best to apply brush strokes that drag inwards from the side where the best source data exists (see Figure 8.7). This is because the spot healing brush intelligently looks around for the most suitable pixel data to sample from, but if you drag with the brush it looks first in the direction from where you dragged.

The Create Texture mode works in a slightly different fashion. The spot healing tool reads in the data that surrounds the area you are attempting to repair. As you do this it generates a texture pattern from the sampled data. So the main difference is that Proximity Match is repairing and blending with actual pixels, while Create Texture is repairing and blending with a texture pattern that has been generated on-the-fly. The Content-Aware mode is discussed later on pages 430–431.

> Multiply Screen Darken Lighten Color Luminosity

Normal Replace Type: O Proximity Match O Create Texture O Content-Aware Sample All Layers

Figure 8.8 This shows the spot healing brush Options bar with the Mode options menu made visible.

Chapter 8 Image retouching

Clone and healing sample options

The clone sample options (Figure 8.9) allow you to choose how the pixels are sampled when you use the clone stamp or healing brush tools. 'Current Layer' samples the contents of the current layer only and ignores all other layers. The 'Current & Below' option samples the current layer and visible layers below (ignoring the layers above it), while the 'All Layers' option samples all visible layers in the layer stack, including those above the current layer. If the Ignore adjustment layers button (circled) is turned on, Photoshop ignores the effect any adjustment layers are having on the image (see sidebar). Meanwhile, the spot healing brush only has the 'Sample All Layers' option in the tool Options bar to check or uncheck.

Ignore adjustment layers

Current Lave

When 'Ignore Adjustment Layers' is switched on, Photoshop ignores the effect any adjustment layers might have when cloning the visible pixels. This is mainly used to prevent adjustment layers above the layer you are working on from affecting the retouching carried out on a layer below when the 'All Layers' sample option has been selected. Prior to this you would have had to temporarily hide such adjustment layers before carrying out the retouching.

Figure 8.9 The layer sample options allow you to carry out all your clone stamp and healing brush work to an empty new layer. The advantage of this is that you can keep all your retouching work separate and leave the original Background layer untouched. In this example, the 'All Layers' option allowed me to sample from layers above and below, but because the 'Ignore Adjustment Layers' option was checked (circled above), Photoshop ignored the effect any adjustment layers had on the sampled pixels.

Client: Eylure Model: Susannah @ Storm

Source and Destination modes

In Source mode you drag the patch tool selection area to a new destination point to replace the pixels in the original source selection area with those sampled from the new destination area. In Destination mode you drag the patch tool selection area to a new destination point to copy the pixels from the original source selection area and clone them to the new destination area.

Use Pattern option

The Use Pattern button in the Options bar lets you fill a selected area with a pattern preset using a healing type blend.

Patch tool

The patch tool uses the same algorithm as the healing brush to carry out its blend calculations, except the patch tool uses selection-defined areas instead of a brush. When the patch tool is selected, it initially operates in a lasso selection mode that can be used to define the area to 'patch from' or 'patch to' (for example, you can hold down the all key to temporarily convert the tool to become a polygonal lasso tool with which to draw straight line selection edges). It so happens you don't actually need the patch tool to define the selection; any selection tool or selection method can be used when preparing a patch selection. Once you have made the selection, select the patch tool to proceed to the next stage. Unlike the healing brushes, the patch tool has to work with either the Background layer or a copied pixel layer. What is useful though is that the patch tool provides an image preview inside the destination selection area as you drag to define the patch selection.

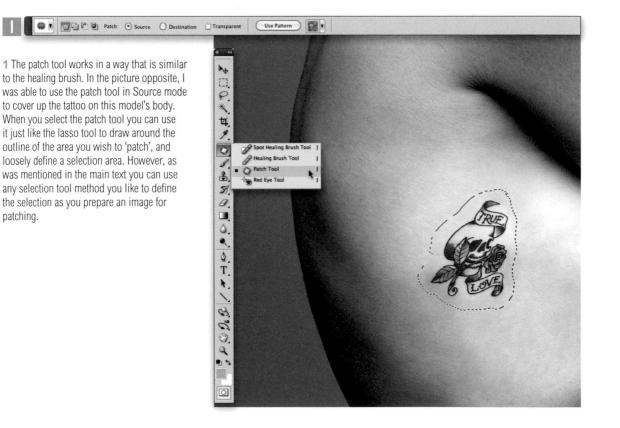

2 Having defined the area I wanted to patch, I made sure that the patch tool was selected (and was in Source mode) and dragged inside the selection to locate an area of the image that could be used to 'patch over' the original area (i.e. remove the tattoo). As I dragged the patch selection this created a second selection area which I could use to define the area to clone from. Meanwhile, I was able to see a live preview in the original patch selection, indicating which pixels would be cloned to this selection area.

3 As I released the mouse, Photoshop began calculating a healing blend, analyzing the pixels from the source area (that I had just defined) and used these to merge them seamlessly with the pixels in the original selection area. The result of this patch transformation was pretty impressive. It managed to remove the tattoo, but you'll notice that a dark shadow remained in the middle of the patch area.

4 This is something that is only to be expected and simply means that the patch tool action wasn't completely successful at removing the tattoo in one single step. The original patch tool selection was still active, so all I had to do was carry out a further patch tool action by repeating Step 2. This screen shot shows what the model's body looked like after applying the patch tool twice. As you can see, all traces of the tattoo were now gone.

Cache limit

The content-aware healing does make use of the image cache levels set in the Photoshop performance preferences to help speed up the healing computations. If you have the Cache limit set to 4 or fewer levels, this can compromise the performance of the spot healing brush in Content-Aware mode when carrying out big heals. It is therefore recommended that you raise the cache limit to 6 or higher.

Spot healing in Content-Aware mode

When working with the spot healing brush in the default Proximity Match mode you have to be careful not to work too close alongside sharply contrasting areas in case this cause the edges to bleed (as was shown on page 425). The spot healing brush now features a new Content-Aware mode which intelligently works out how best to fill the areas you retouch when you use the spot healing brush.

Let's now look at what the spot healing brush is capable of when used in this mode. In the Figure 8.11 example there were a lot of electric cables and wires in the original photograph that spoiled the view. By using the spot healing brush in Content-Aware mode I was able to carefully remove all of these to produce the finished photo shown below it. Although the end result was quite effective I should point out that you do still have to apply a certain amount of skill in your brush work and choice of settings in order to use this tool effectively. To start with I found that the Normal blend mode worked best for retouching the cables that overlapped the sky, since this blend mode uses diffuse edges to blend seamlessly with the surroundings. I also mostly used long, continuous brush strokes to remove these from the photograph and achieve a smooth blended result with the rest of the sky. When retouching the rocks I applied much shorter brush strokes using the Replace blend mode to gradually removed the cables bit by bit (see the blend modes shown in Figure 8.10). I find that you need to be quite patient and note carefully the result of each brush stroke before applying the next. You'll discover that dragging the brush from different directions can also influence the outcome of the heal blend retouching and you may sometimes need to carry out an undo and reapply the brush stroke differently and keep doing this until you get the best result. I also find that you can disguise the retouching better by adding extra, thin light strokes 90° to the angle of the first, main brush stroke and this too can help disguise your retouching work with the spot healing brush used in this mode.

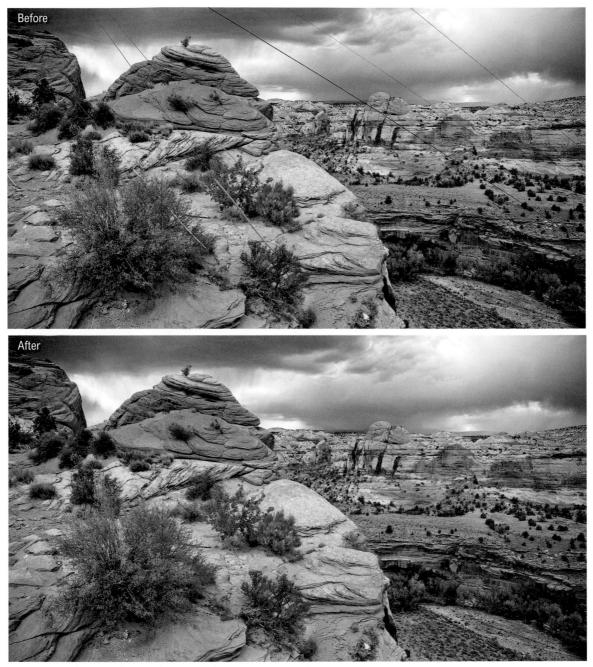

Figure 8.11 This shows a before version (top) and after version (bottom), where I had used the spot healing brush in Content-Aware mode to retouch this photo.

New Delete options

If you make a selection on a Background layer, or a flattened image, and hit 'Delete', you'll see a Fill dialog box pop up. This allows you to choose how you wish to fill the selected areas and will have 'Content-Aware Fill' selected by default. In the past, hitting 'Delete' with a Background layer selected would fill the selected region using the current background color. If you want to bypass this behavior, you can use **36** *Delete ctrl Delete* to fill using the background color.

Content-aware filling

Content-aware blending is also available as an Edit \Rightarrow Fill menu option. This means that you can create a selection and use the Edit \Rightarrow Fill command to let Photoshop work out how best to fill in the gaps in the selection. As you can see in the example shown here, the result was not bad considering Photoshop was using the surrounding image data to replace about a third of the original image. Content-aware filling can usually do a good job of working out which are the best pixels to sample and constructing a fairly convincing fill, but it is inevitable though that further retouching work may sometimes still be required. It is also recommend that you expand the selection slightly before applying a content-aware fill. You can do this by using the Refine Edge command or go to the Select menu and choose Modify \Rightarrow Expand.

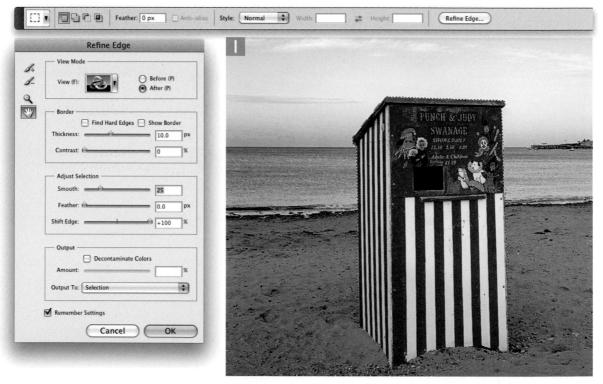

1 Here is a photograph I took of a Punch and Judy booth on a beach. The first step was to use the quick selection tool to define the outline of the Punch and Judy booth (this didn't need to be too precise). I then clicked on the Refine Edge... button in the Options bar and expanded the selection edge using the settings shown here.

Chapter 8

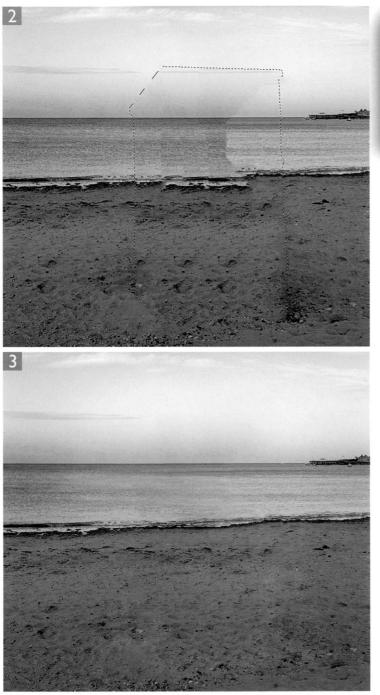

- Conten	ts		OK
Use:	Content-Aware	•	Cancel
	Custom Pattern:	•	
Blendin	g		
Mode:	Normal	•	
Opacity:	100 %		

2 The next step was to go to the Edit menu and choose 'Fill...' (or, you may find it easier to use the **Shift FS** shortcut). This opened the Fill dialog shown here where I selected 'Content-Aware' from the pop-up menu in the Contents section. It may take a minute or two for the processing to complete and as you can see, the initial result was not bad, even if it had failed to make a perfect fill in one single step.

3 As with the patch tool example, you are always going to need to carry out further retouching work in order to produce a convincing looking retouch. In this instance I needed to carry out some additional retouching using a combination of the standard healing brush and clone stamp tools. The main point to make here is that this type of image manipulation, in which a huge chunk of the picture was removed, was only possible thanks to the power of the new content-aware filling algorithm.

Content-aware fill and Puppet Warp

I imagine some people will want to use the new Puppet Warp feature (described in the following chapter) to select an object and manipulate it directly. I therefore think the content-aware fill feature may prove very useful as a preparation step where you would select an object and copy it to a new layer and then use the same selection to apply a content-aware fill to the original background layer.

Replacing film grain

If the photographic original contains noticeable film grain, you may encounter a problem here since even with a selective application of the Dust & Scratches filter, you may end up softening the image as you retouch it. To counteract this it may help to apply a small amount of noise after you have applied the Dust & Scratches filter. Add just enough noise to match the grain of the original (usually around 2–3%). This will enable you to better disguise the history brush retouching.

Lighten/Darken blend mode

The Lighten blend mode was used to remove the dark marks in the image. Similarly, one can use the Darken blend mode to remove any light blemish marks. For example, if you were to retouch a scanned color negative, the dust spots would all show up as white marks.

Alternative history brush spotting technique

This spotting method has evolved from a technique that was first described by Russell Brown, Senior Creative Director of the Adobe Photoshop team. It revolves around using the Remove Dust & Scratches filter, which can be found in the Filter \Rightarrow Noise submenu. If this filter is applied globally to the entire image, you end up with a very soft-looking result. So ideally, this filter should be applied selectively to the damaged portions of the image only. The technique shown here has the advantage of applying the filtered information via the history brush such that only the pixels which are considered too dark or too light are painted out. This modified approach to working with the Dust & Scratches filter avoids doing any more harm to the image than is absolutely necessary. As you can see, the technique works well when you have a picture that is very badly damaged and where using the clone stamp would be a very tedious process. What is really clever is the way that the Lighten (and Darken) blend modes can be used to precisely target which pixels are repaired from the stored Dust & Scratches history state.

1 This scanned photograph serves as a good example with which to demonstrate the history brush spotting technique. A lot of dust marks are clearly visible in the enlarged detail views shown here.

2

Threshold adjustment

I mentioned that the Dust & Scratches filter can be rather destructive. One way to mitigate the destructiveness of this filter is to raise the Threshold value in the filter dialog.

2 I went to the Filter menu and chose Noise
→ Dust & Scratches. I checked the filter dialog preview and adjusted the Radius and Threshold settings until I could verify that most of the dust marks would be removed. I clicked OK to apply this filter to the image.

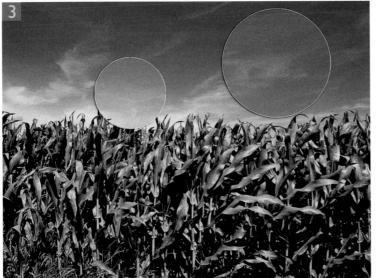

3 I then went to the History panel and clicked on the previous unfiltered image history state, but set the Dust & Scratches filtered version as the history source to paint from. I then selected the history brush and in the tool Options bar changed the history brush blend mode to Lighten. As I painted over the dark spots, the history brush lightened only those pixels that were darker than the sampled history state. All the other pixels remained unchanged. I continued using the history brush in this way until I had removed all the dust spots in the photograph.

Shooting tips

As I mentioned, the flat field capture image must be evenly lit. Since the high-end display I work with has good uniform brightness, I got good results by photographing the computer display with a white desktop. I shot at a low ISO setting to keep the noise to a minimum. I also bracketed the exposures so that I had the opportunity to choose the most suitable image – one that was bright enough to apply a Divide blend mode calibration and required minimal further image adjustments to the brightness.

What is this technique good for?

One of the reasons I chose to include this technique was to show what the new Divide blend mode could be useful for. In all honesty, I think the easiest approach would be to use the Camera Raw Lens Corrections adjustments to take care of the vignetting and use the remove spots tool in Camera Raw to remove the dust marks and synchronize the spotting adjustments across all the other affected photos. This could certainly work well for an image like the one shown here. On the other hand, if you have a problem with a particularly dusty sensor or the dust marks fall on top of areas where it would be tricky to retouch, the flat field calibration technique might just save the day. As you can see in the close-up views in Step 2 opposite, I was able to do a good job of removing most of the spots. However, I was only able to partially remove the big dust mark in the top left corner. It would have been unrealistic to have expected a better result than this for such a large sensor mark.

Flat field calibration

One way to remove image sensor pixel defects and artifacts such as dust spots and lens vignettes is to use the flat field calibration technique shown here. Some specialist digital capture systems, such as those used in astronomy and microscopy, already offer their own software solutions to achieve this. However, Photoshop CS5 now includes a new Divide blend mode that allows you to carry out flat field calibrations for any type of digital camera system. Be warned that this is a tricky technique to get right. This method may in some circumstances help you cut down on the time spent retouching, providing you are able to capture a valid flat field calibration image close to the time the other photos were shot.

1 The first step was to capture an image of an evenly lit white surface, exposed so that the center was 100% white. The key thing was to make sure the illumination was even and defocus the camera so as not to pick up any subject texture. It was also important to capture this image at the same aperture as I was going to shoot with since this would affect the definition of the sensor dust picked up by the camera.

Chapter 8 Image retouching

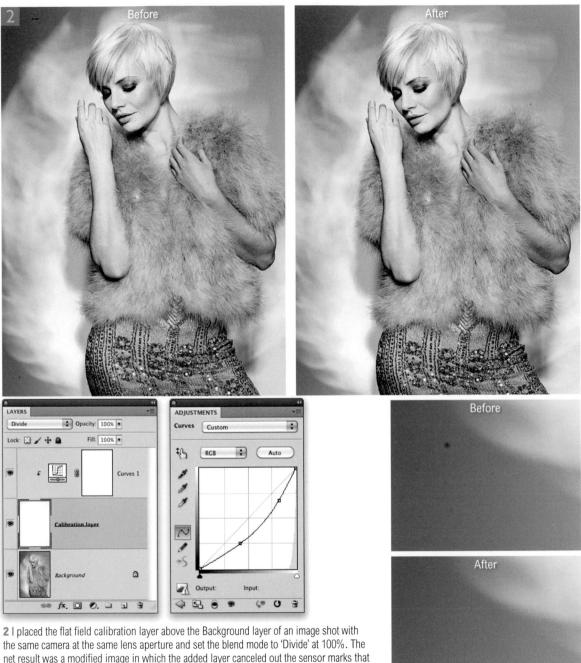

the same camera at the same lens aperture and set the blend mode to 'Divide' at 100%. The net result was a modified image in which the added layer canceled out the sensor marks that were present in the original and removed any lens vignetting. However, it was important to fine-tune the brightness of this layer using a clipping Curves layer so that the calibration layer in Divide mode precisely canceled out the sensor marks on the layer below.

Portrait retouching

Here is an example of a restrained approach to retouching, where only a minimal amount of Photoshop editing was used. Of course you can retouch portraits as if they were fashion shots and some publications may demand this, but I thought I would start off by showing a more subtle approach to portrait retouching.

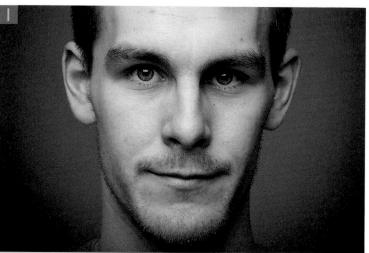

🖉 T 👔 Mode: Normal 🖨 Source: 🕑 Sampled 🔿 Pattern: 😗 🗆 Aligned Sample: Current & Below 🗣 🕱 🧭

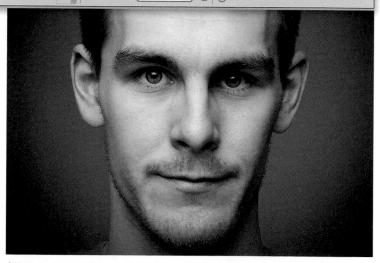

1 The top photograph shows the unretouched before version and below this you can see the results of the initial retouching in which I mainly used the healing brush to remove some of the skin blemishes. The key thing here was not to overdo the retouching. What I did here was more like 'tidying and grooming' rather than 'digital surgery'.

Chapter 8 Image retouching

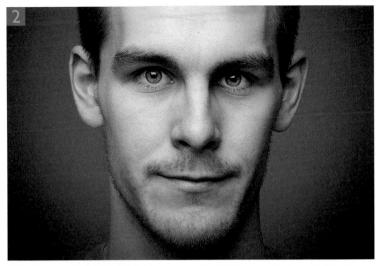

2 For this next step I wanted to lighten the eyes. To do this, I used the lasso tool to define the outline of the pupils. In the Adjustments panel I clicked to add a Curves adjustment and adjusted the curve shape to lighten the selected area. I then selected the whites of the eyes and applied a separate Curves adjustment. The aim here was to add more contrast to the pupils and make the eyes slightly lighter.

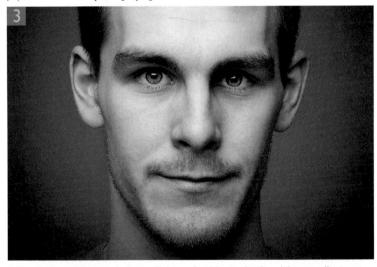

3 You don't want the eyes to be too light, so for this step I reduced the eye adjustment layer opacity slightly. Lastly, I wanted to adjust the shapes of the eyes. To do this, I used the **H C Shift E ctrl all Shift E** command to create a merged copy layer at the top of the layer stack. I made a marquee selection to include the eyes, inverted the selection and hit **Celete** (this was done to keep the file size down). I then went to the Filter menu, and chose Liquify (described later in this chapter), where I made the left eye smaller, opened up the eye on the right and raised the eyebrow slightly. I then clicked OK to complete the retouching shown here.

Getting the balance right

The main thing I show on these pages is how to use the paint brush to smooth the skin tones. I happen to prefer using the manual painting approach (rather than relying on a blur filter). This is because the painting method offers more control over the retouching. An important issue here is 'how much should you retouch?' This is mostly down to personal taste. My own view is that it is better to fade any painting work that's done and let the natural skin texture show through - let there be a few wrinkles and flaws! It is possible to retouch to produce a clean-looking image, while still keeping the model looking vaguely human.

Beauty retouching

Beauty photographs usually require more intense retouching, where the objective is to produce an image in which the model's features and skin appear flawless. This can be done through a combination of healing and painting brush work.

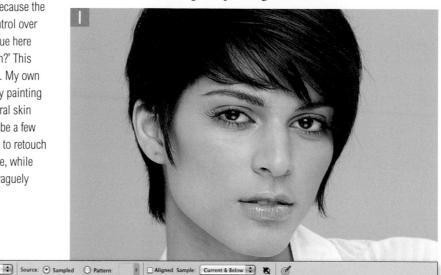

Mode: Normal

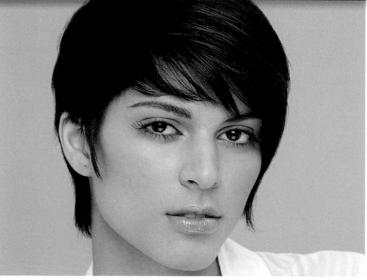

1 The top photograph here shows the before version and, below that, how the same image looked after I had added a new empty layer and carried out some basic spotting work with the healing brush, where I cleaned up the spots and got rid of unwanted stray hairs.

Chapter 8 Image retouching

Dpacity: 100% • 🐼 Flow: 100% • 纪 🕑

3 This shows the finished retouched version in which I faded the opacity of the painted layer to 33% and added a layer mask so that I could carefully mask the areas where the paint retouching had spilled over. I also added another merged layer on which to carry out some liquify work and, lastly, I added a Curves adjustment to lighten the photo slightly.

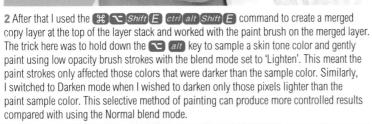

Mode: Lighte

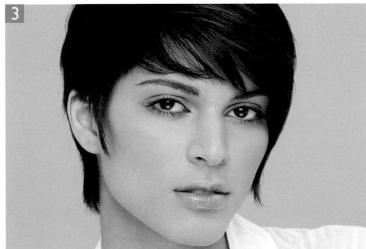

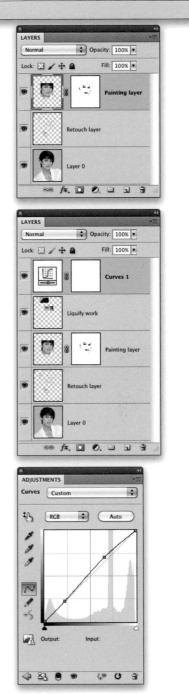

Liquify tools

Warp tool (W)

Provides a basic warp distortion with which you can stretch the pixels in any direction you wish.

Reconstruct tool (R)

Used to make selective undos and restore the image to its undistorted state.

Twirl clockwise tool (C)

Twist the pixels in a clockwise direction (hold down the (alt) key to switch tool to twirl in a counterclockwise direction).

📽 Pucker tool (S)

Shrinks the pixels and produces an effect similar to the Pinch filter.

< Bloat tool (B)

Magnifies the pixels and produces an effect similar to the Bloat filter.

🖛 Push left tool (0)

Shifts the pixels at 90° to the left of the direction in which you are dragging.

Mirror tool (M)

Copies pixels from 90° to the direction you are dragging and therefore acts as an inverting lens.

Turbulence tool (T)

Produces random turbulent distortions.

Freeze mask tool (F)

Protects areas of the image. Frozen portions are indicated by a quick mask type overlay. These areas are protected from any further liquify distortions.

Thaw mask tool (D)

Selectively or wholly erases the freeze tool area.

Hand tool (H)

For scrolling the preview image.

Zoom tool (Z)

Used for zooming in or zooming out.

Liquify

The Liquify filter is designed to let you carry out freeform pixel distortions. When you choose Filter \Rightarrow Liquify (or use the **Shift X ctriShift X** keyboard shortcut), you are presented with what is known as a modal dialog, which basically means you are working in a self-contained dialog with its own set of tools and keyboard shortcuts, etc. The Liquify filter therefore operates like a separate program within Photoshop. To use Liquify efficiently, I suggest you make a marquee selection first of the area you wish to manipulate before you select the filter, and once the dialog has opened, use the **SO ctriO** keyboard shortcut to enlarge the Liquify filter dialog to fit the screen.

Basically, you select one or more of the Liquify tools to manipulate the image shown in the preview area and when you are happy with your liquify work, click *Enter* or *Return* to OK the pixel manipulation. Photoshop then calculates and applies the liquify adjustment to the selected image area.

The Liquify tools are all explained in the column on the left and the images shown in Figure 8.12 visually summarize the effect each of these tools can have on an image. The easiest of these to get to grips with is the warp tool, which allows you to simply click and drag to push the pixels in the direction you want them to go in. However, I also like working with the push left tool, because it lets me carry out some quite bold warp adjustments. Note that when you drag with the push left tool it shifts the pixels 90° to the left of the direction you are dragging in and when you **C** all drag with the tool, it shifts the pixels 90° to the right.

The pucker tool is sometimes useful for correcting overdistorted areas and squeezing the pixels inwards again. The mirror tool is perhaps the most unwieldy of all, as it copies pixels from 90° to the direction you are dragging, and therefore acts like an inverting lens, which if you are not careful can easily rip an image apart. Apparently, retouchers who work on adult magazines are fond of working with the turbulence tool. This is for reasons I have yet to fathom and it is probably inappropriate for me to enquire further! The key to working successfully with the Liquify filter is to use gradual brush movements in order to build up the distortion in stages.

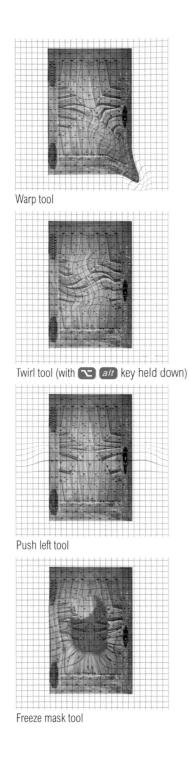

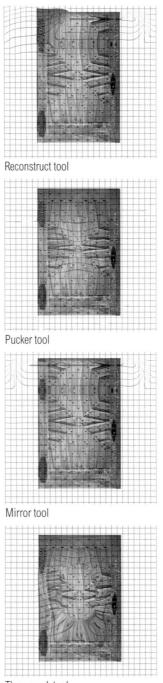

Thaw mask tool

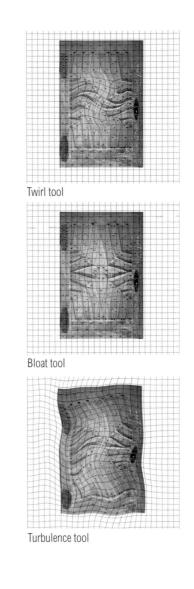

Figure 8.12 These illustrations give you an idea of the range of distortion effects that can be achieved using the Liquify tools described on page 442.

	inneren er)		
Cance	el	D		
Load Mesh		Save M	esh	
Tool Options				
Brush Size:	22	\$		
Brush Density:	50	\$		
Brush Pressure:	10	\$		
Brush Rate:	80	\$		
Turbulent Jitter:	50	\$		
Reconstruct Mode:	Rev	vert		9
Stylus Pressure				
(Reconstruct)(Restore	e All)
Mask Options				
Mask Options	•	0.		
Mask Options	•	0.	vert All	
Mask Options	-] [In the second se	vert All	
Mask Options	-)	O - Inv	vert All	
Mask Options None Mask All View Options Show Image Mesh Size: Mi Mesh Color: Gr	-)	O - Inv	vert All	
Mask Options None Mask All View Options Show Image Mesh Size: M	• She ediu	O - Inv	vert All	
Mask Options None Mask All View Options Show Image Mesh Size: Mi Mesh Color: Gr Show Mask	• She ediu	O - Inv	vert All	
Mask Options None Mask All View Options Show Image Mesh Size: Mi Mesh Color: Gr Show Mask Mask Color: Re	Shoediuu ay	O - Inv ow Mes	vert All	
Mask Options None Mask All View Options Show Image Mesh Size: M Mesh Color: Gr Show Mask Mask Color: Re Show Backdrop Use: Al	Shoediuu ay	ow Mes m	vert All	

Figure 8.13 This shows the Liquify dialog options. The Reconstruct Options are shown circled here in green.

Liquify tool controls

Once you have selected a tool to work with you will want to check out the associated tool options which are shown in Figure 8.13. All the tools (apart from the hand and zoom tool) are displayed as a circular cursor with a cross-hair in the middle. The tool options are applied universally to all the tools and these include: Brush Size, Brush Density, Brush Pressure and Brush Rate. If you mouse down on the double-arrow icon next to the field entry box, this pops a dynamic slider which can be used to adjust the settings. You can also use the square bracket keys **() ()** to enlarge or reduce the tool cursor size, and the rate of increase/decrease can be accelerated by holding down the *Shift* key. I highly recommend that you use a pressure sensitive pen and pad such as the WacomTM system and if you do so, make sure that the Stylus Pressure option is checked and set the brush pressure to around 10-20%. Note that the Turbulent Jitter control is only active when the turbulence tool is selected. In this context the jitter refers to the amount of randomness that is introduced to a turbulence distortion applied with this tool.

Reconstructions

Next we have the Reconstruct Options, of which the default mode is set to 'Revert'. If you apply a Liquify distortion and click on the Reconstruct button, the image will be restored to its undistorted state in gradual stages each time you click the button (while preserving any areas that have been frozen with the freeze tool). If you click on the 'Restore All' button the entire image is restored in one step (ignoring any frozen areas). The default Revert mode produces scaled reversions that return you to the original image state in the preview window. However, there are some alternative options which are more relevant once you have created a frozen area. For example, the Rigid mode provides oneclick reconstruction. 'Stiff', 'Smooth' and 'Loose' provide varying speeds of continual reconstruction, producing smoother transitions between the frozen and unfrozen areas as you revert the image.

You can use esc or \mathfrak{H} . ctrl. to halt the reconstruction at an intermediate stage (but do avoid applying this shortcut twice, as this will exit the Liquify dialog and you'll lose all your work). Another way to reconstruct the image is to click on the options triangle in the Reconstruct Options and select one of the options from the list. This pops a dialog control like the one shown in Figure 8.14, where you can use the slider to determine to what degree you would like to reconstruct the image, expressed as a percentage. A reconstruction can also be achieved by using the reconstruct tool to selectively restore the undistorted image.

Don't forget that while inside the Liquify dialog, you also have multiple undos at your disposal. Use $\mathbb{H} \ \mathbb{Z} \ ctrl \ \mathbb{Z}$ to undo or redo the last step, $\mathbb{H} \ \mathbb{Z} \ ctrl \ alt \ \mathbb{Z}$ to go back in history and $\mathbb{H} \ Shift \ \mathbb{Z} \ ctrl \ Shift \ \mathbb{Z}$ to go forward in history.

Mask options

The mask options can utilize an existing selection, layer transparency or a layer mask as the basis of a mask to freeze and constrain the effects of any Liquify adjustments (Figure 8.15). The first option is 'Replace Selection'((\bigcirc •)). This replaces any existing freeze selection that has been made. The other four options allow you to modify an existing freeze selection by 'adding to' (\bigcirc •), 'subtracting from' (\bigcirc •), 'intersecting' (\bigcirc •) or creating an 'inverted' selection (\bigcirc •). You can then click on the buttons below. Choosing 'None' clears all freeze selections, choosing 'Mask All' freezes the entire area, and choosing 'Invert All' inverts the current frozen selection.

Figure 8.15 Freeze masks can be used to protect areas of a picture before you commence doing any liquify work. In the example shown here a freeze mask was loaded from a layer mask. When you freeze an area in this way it is protected from subsequent distortions so you can concentrate on applying the Liquify tools to just those areas you wish to distort. Frozen mask areas can be unfrozen by using the thaw mask tool.

Figure 8.14 You can control the exact amount by which an image is reconstructed to its original state by going to the Reconstruct Options menu (circled red in Figure 8.13) and selecting a desired reconstruction mode. This pops the dialog shown here where you can set a percentage amount for the degree of reconstruction you wish to take place.

Liquify and Smart Filters

Note that the Liquify filter cannot be applied to a Smart Object or as a Smart Filter.

ОК
Cancel
Load Mesh Save Mesh
Tool Options
Brush Size: 22
Brush Density: 50
Brush Pressure: 10
Brush Rate: 80
Turbulent Jitter: 50
Reconstruct Mode: Revert \$
Stylus Pressure
Reconstruct Options
Mode: Revert \$
(Reconstruct) (Restore All)
- Mask Options
0.0.0.0.0.
None Mask All Invert All
- View Options
Show Image Show Mesh
Mesh Size: Medium
Mesh Color: Gray 🛟
Show Mask
Mask Color: Red
Show Backdrop
Use: All Layers
Mode: In Front
Opacity: 100

Figure 8.16 The Liquify dialog settings, including the View Options at the bottom.

View options

The freeze mask can be made visible or hidden using the Show Mask checkbox in the View Options, where you can also set the color of the mask (Figure 8.16).

The mesh grid can be displayed at different sizes using different colors and this provides you with an indication of the underlying warp structure, which can readily help you pinpoint the areas where a distortion has been applied. You can use the checkboxes in this section to view the mesh on its own or have it displayed overlaying the Liquify preview image (as shown in Figure 8.17).

The 'Show Backdrop' option is normally left unchecked. If the Liquify image contents are contained on a layer, then it is possible to check the 'Show Backdrop' option and preview the liquified layer against the Background layer, all layers, or specific layers in the image. Here is how this option might be used. Let's imagine for example that you wished to apply a liquify distortion to a portion of an image and you started out with just a flattened image. You then make a selection of the area you wish to work on and make a copy layer via the selection contents using **H** *J ctrl J*. Once you have done this, as you apply the Liquify filter you can check the Show Backdrop checkbox and set the mode to 'Behind'. At 100% opacity the Liquify layer covers the Background layer completely, but as you reduce the opacity you can preview the effect of a Liquify distortion at different opacity percentages. This technique can prove useful if you wish to compare the effect of a distortion against the original image or a target distortion guide (as shown in the Figure 8.18 example).

Saving the mesh

If you are working on an extremely large image then it may take a rather long time for Photoshop to process a liquify distortion effect. This is where the Save Mesh... and Load Mesh... buttons can come in useful. If you carry out your Liquify distortions on a scaled-down version of the master image first, you can save the mesh as a separate file. Later, you can open up the original master file, load the mesh you saved earlier and apply it to the master image at a time when you can afford to have Photoshop taking its time to process the calculations.

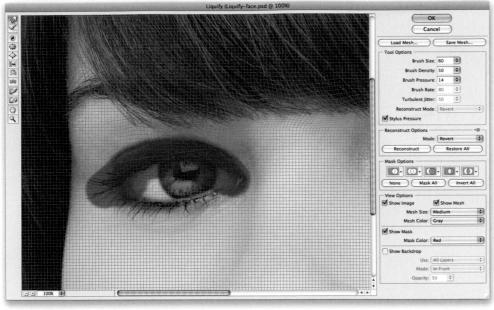

Figure 8.17 This shows the Liquify dialog with the mesh view switched on.

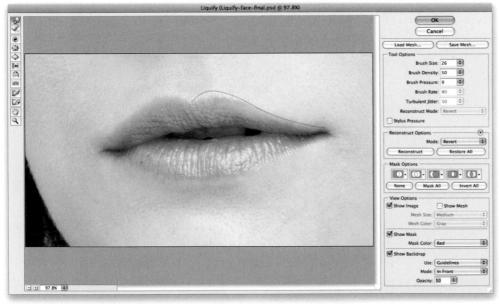

Figure 8.18 If you have a predetermined idea of what the final distortion should look like you can create an empty layer, draw the target distortion shape on this layer, and use the 'Show Backdrop' options discussed here to select that specific layer and be able to switch the guide Layer visibility on or off.

1 The objective here was to straighten the model's fringe using the Liquify filter. First I used the **H Shift C ctrl all Shift C** command to create a merged copy layer at the top of the layer stack, made a selection of the area of interest, inverted the selection, hit *Delete* and used **H D ctrl D** to deselect the selection. I then **H ctrl** -clicked the copied layer to make a selection based on the layer contents (as shown here).

Straightening a fringe with Liquify

With the introduction of the Puppet Warp tool you may be wondering if we still need to use Liquify? After all, Puppet Warp does allow you to work on an image layer directly rather than via a modal dialog. Although I am a big fan of the new Puppet Warp feature, I do still see a clear distinction between the types of jobs that are best suited for use of the Puppet Warp and those where it is better to use Liquify. In the example shown here, the Liquify filter is the best tool to use to straighten the model's fringe because you can use the paint-like controls to carefully manipulate the mesh that controls the distortion. Plus you can also use the freeze tool, which is unique to Liquify, to control those parts of the image that you don't want to see become distorted. Every job is different and you'll need to decide for yourself which is the most appropriate distortion tool to use and which can best help you accomplish the results you are after.

Chapter 8 Image retouching

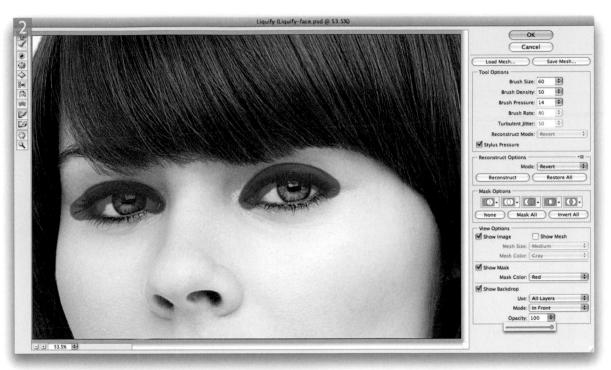

2 I then chose Filter \Rightarrow Liquify and used the freeze mask tool to protect the eyes from being edited. I then selected the warp tool and with a succession of low pressure brush strokes, gradually edited the fringe line to make it straighter.

3 When I was happy with the way the fringe looked, I clicked OK. This screen shot shows how the fringe appeared after applying the Liquify filter.

Martin Evening Adobe Photoshop CS5 for Photographers

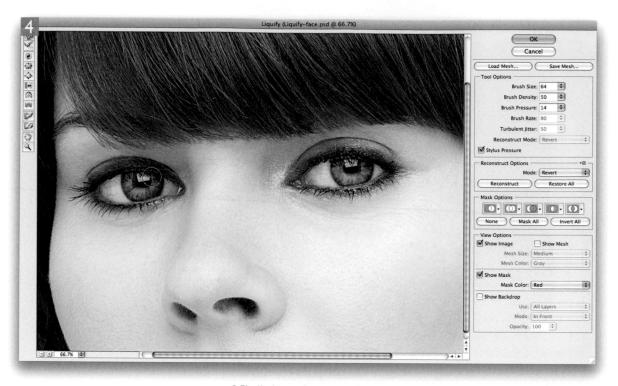

4 Finally, I wanted to even up the eyes and make the left eye bigger. With the layer selection still active, I chose Liquify again. This time there was no need to apply a freeze mask, so I simply selected the warp tool and used more low pressure brush strokes to carefully push the edges of the eye outwards and make the left eye a little bit bigger. When I was done, I clicked OK again to apply the Liquify filter.

Chapter 9

Layers, Selections and Masking

or a lot of photographers the real fun starts when you can use Photoshop to create composite photographs and combine different image elements into a single photo. This chapter explains the different tools that can be used for creating composite photographs as well as the intricacies of working with layers, channels, mask channels and pen paths. To begin with, let us focus on some of the basic principles such as how to make a selection and the interrelationship between selections, alpha channels, masks and the quick mask mode.

Figure 9.1 A selection is represented in Photoshop using marching ants.

Selections and channels

When you read somewhere about masks, mask channels, image layer mask channels, alpha channels, quick masks or saved selections, we are basically talking about the same thing: an active, semi-permanent or permanently saved selection.

Selections

There are many ways you can create a selection in Photoshop. You can use any of the main selection tools such as the lasso tool or the Select \Rightarrow Color Range command, or convert a channel or path to a selection. Whenever you create a selection, you will notice that it is defined by a border of marching ants (Figure 9.1). It is important to remember that selections are only temporary – if you make a selection and accidentally click outside the selected area with the selection tool, the selection will be lost, although you can always restore a selection by using the Edit \Rightarrow Undo command (\Im *ctrl* **Z**). As you work on a photo in Photoshop, you will typically use selections to define specific areas of an image where you wish to edit the image or maybe copy the pixels to a new layer and, when you are done, you'll deselect the selection. If you end up spending any length of time preparing a selection, you will maybe want to save such selections by storing them as alpha channels (also referred to as 'mask channels'). To do this, go to the Select menu and choose 'Save Selection...'. The Save Selection dialog box then asks if you want to save the selection as a new channel (Figure 9.2). If you select a pre-existing channel from the Channel menu you will have the option to add, subtract or intersect with the selected

- Destinatio	n	ОК
Document:	W1BY0100.psd	Cance
Channel:	New	
Name:	Outline Mask	
- Operation		
New Cha	nnel	
Add to C	hannel	
O Subtract	from Channel	
Intersect	with Channel	

Figure 9.2 To save a selection as a new alpha channel you can choose Select \Rightarrow Save Selection and select the New Channel button option.

channel. You can also create new alpha channels by clicking on the 'Save selection as a channel' button at the bottom of the Channels panel, which will convert a selection to a channel. If you look at the Channels panel shown in Figure 9.3, you will notice how a saved selection has been added as a new alpha channel (this will be channel #6 in RGB mode, or #7 if in CMYK mode). You can also click on the 'Create new channel' button, then fill the empty new channel with a gradient or use the brush tool to paint in the alpha channel using the default black or white colors. Once you create a new channel it is preserved when you save the image.

To load a saved channel as a selection, choose 'Load Selection...' from the Select menu and select the appropriate channel number from the submenu. Alternatively, you can **B** *ctrl*-click a channel in the Channels panel, or highlight a channel and click on the 'Load channel as a selection' button.

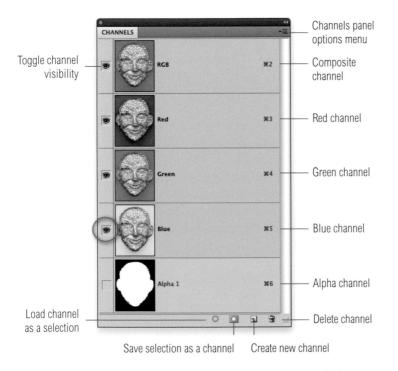

Figure 9.3 When you save a selection it is added as a new alpha channel in the Channels panel. Channels can be viewed independently by clicking on the channel name. However, if you keep the composite channels selected and click on the empty space next to the channel (circled), you can preview a channel as a quick mask overlay.

Recalling the last used selection

The last used selection is often memorized in Photoshop. Just go to the Select menu and choose 'Reselect' (**#** *Shift* **D** *ctrl Shift* **D**).

Omitting channels in a save

As was pointed out in the main text, channels are automatically saved when you save an image. However, if you choose 'Save As...' you do have the option to exclude saving alpha channels with an image should you wish to do so.

Figure 9.4 The left half of the image shows a feathered selection and the right half shows the Quick Mask mode equivalent display.

Color Indicates: Masked Areas	ОК
Selected Areas	Cancel
- Color	
Opacity: 50 %	

Figure 9.5 The Quick Mask Options.

The marching ants indicate the extent of an active selection and any image modifications you carry out are applied within the selected area only. Remember though, all selections are only temporary and can be deselected by clicking outside the selection area with a selection tool or by choosing Select \Rightarrow Deselect (**#D** ctrl**D**). If you find the marching ants to be distracting you can temporarily hide them by going to the View menu and selecting 'Extras'. This and the **#H** ctrl**H** keyboard shortcut can be used to toggle hiding/showing the marching ants.

Quick Mask mode

You can also preview and edit a selection in Quick Mask mode where the selection will be represented as a transparent colored mask overlay (Figure 9.4). If a selection has a feathered edge, the marching ants boundary will only represent the selected areas that have more than 50% opacity. Therefore, whenever you are working on a selection that has a soft edge you can use the Quick Mask mode to view the selection more accurately. To switch to Quick Mask mode from a selection, click the quick mask icon in the Tools panel (Figure 9.6) or use the **Q** keyboard shortcut to toggle back and forth between the Selection and Quick Mask modes. Whether you are working directly on an alpha channel or in Quick Mask mode, you can use any combination of Photoshop paint tools or image adjustments to modify the alpha channel or Quick Mask content. If you double-click the quick mask icon, this opens the Quick Mask Options shown in Figure 9.5 where you can alter the masking behavior and choose a different color from the Color Picker (this might be useful if the quick mask color is too similar to the colors in the image you are editing).

0. Q	0,9

Figure 9.6 The Quick Mask mode button is in the Tools panel just below the foreground/background swatch colors. Shown here are the two modes: Selection mode (left) and Quick Mask mode (right). You can toggle between these two modes by clicking on this button. Double-click to open the Quick Mask Options shown in Figure 9.5.

455

Layers, selections and masking

Creating an image selection

1 I thought I would start with a straightforward example where I selected the elliptical marguee tool and dragged with the tool to define the shape of the mirrored sculpture. In

order to preserve the selection I saved it as a new channel, which then appeared added to the Channels panel. 2

2 Now I had created this selection I could use it to modify the image. Here, I loaded the selection, went to the Adjustments panel and added a new Curves adjustment using the settings shown here. I then went to the Masks panel, clicked on the Invert button to invert the selection and set the mask Feather to 2 pixels. This now applied the adjustment to the selected area outside of the mirrored sculpture.

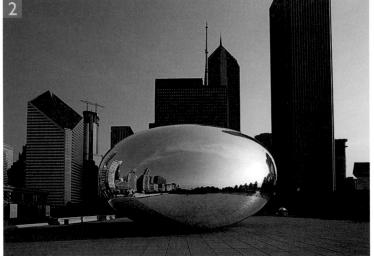

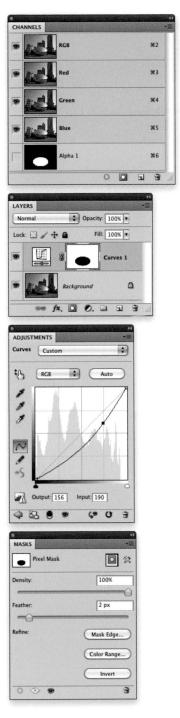

Reloading selection shortcuts

To reload a selection from a saved mask channel, choose Select \Rightarrow Load Selection... You can also \Re *ctrl*-click a channel to load it as a selection. To select a specific channel and load it as a selection, use \Re channel # *ctrl alt* channel # (where # equals the channel number).

One thing to be aware of here is that since CS4, the usual shortcut numbers have been shifted along by two. I have mentioned this a couple of times already, but it is worth repeating since this is something that is likely to catch people out who have been working with previous versions of Photoshop. Basically, #0 ctrl 0 is used (as before) to zoom the image to fit the screen and **H** ctrl 1 is now used to zoom to 100%. Where **H** *ctrl* was once used to select the composite channel, the new shortcut is now 32 ctrl 2. This means that you should use **H**3 ctr/ 3 to select the Red channel, # 4 ctrl 4 to select the Green channel, **#** 5 *ctrl* 5 to select the Blue channel and subsequent numbers to select any additional mask/alpha channels that are stored in an image.

Modifying selections

You can modify the content of a selection using any of the modifier key methods discussed earlier in Chapter 1 (see pages 38–39). Just to recap, you hold down the Shift key to add to a selection, hold down the **C** *alt* key to subtract from a selection and hold down the Shift alt Shift keys to intersect a selection as you drag with a selection tool. The magic wand is a selection tool too, but here all you have to do is to click (not drag) with the magic wand, holding down the appropriate keys to add or subtract from a selection. Note that if you select either the lasso or one of the marquee tools, placing the cursor inside the selection and dragging moves the selection boundary position, but not the selection contents. With Photoshop CS4 and earlier versions this was only possible providing the target layer was visible. With Photoshop CS5 it does not matter whether the layer you have selected is visible or not. You can now move a selection this way without being confronted with a warning dialog.

Alpha channels

An alpha channel is effectively the same thing as a mask channel and if you choose Select \Rightarrow Save Selection..., you can save a selection as a new alpha channel. These are saved and added in numerical sequence immediately below the main color channels. Just like normal color channels, an alpha channel can contain up to 256 shades of gray in 8-bits per channel mode or up to 32,000 shades of gray in 16-bits per channel mode. You can select a channel by going to the Channels panel and clicking on the desired channel. Once selected, it can be viewed on its own as a grayscale mask and manipulated any way you like using any of the tools in Photoshop. An alpha channel can also effectively be viewed in a quick mask type mode. To do this, first select an alpha channel and then click on the eyeball icon next to the composite channel, which is the one at the top of the Channels panel list (see Figure 9.3). You will then be able to edit the alpha channel mask with the image visible through the mask overlay. There are several ways to convert an alpha channel back into a selection. You can go to the Select menu, choose 'Load Selection...' and then select the name of the channel. A much simpler method is to drag the channel down to the Make Selection button at the bottom of the Channels panel, or **H** *ctrl*-click the channel in the Channels panel.

Adding to an image selection

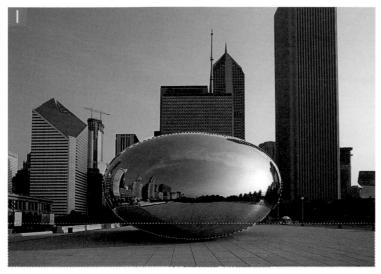

1 Let's add an extra step to the example shown on page 455. Here, I started off with the same elliptical selection. I then selected the rectangular marquee tool and dragged across the image with the <u>Snift</u> key held down in order to add to the elliptical selection.

2 I did actually refine the selection a little more than that, because I also selected the polygon lasso tool and again, with the **Shift** key held down, clicked a few more times to add the outline of the building on the left. As with the previous example I added a Curves adjustment and clicked on the Invert button in the Masks panel so that the adjustment darkened the areas outside the selection. I then added a 2 pixel feather to the selection edge to obtain a smoother edge blend.

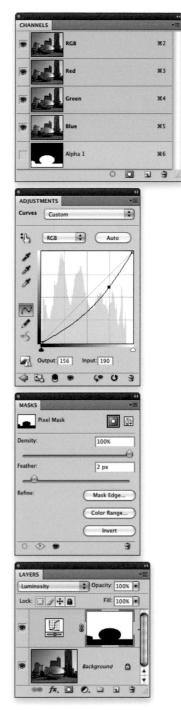

Adobe Photoshop CS5 for Photographers

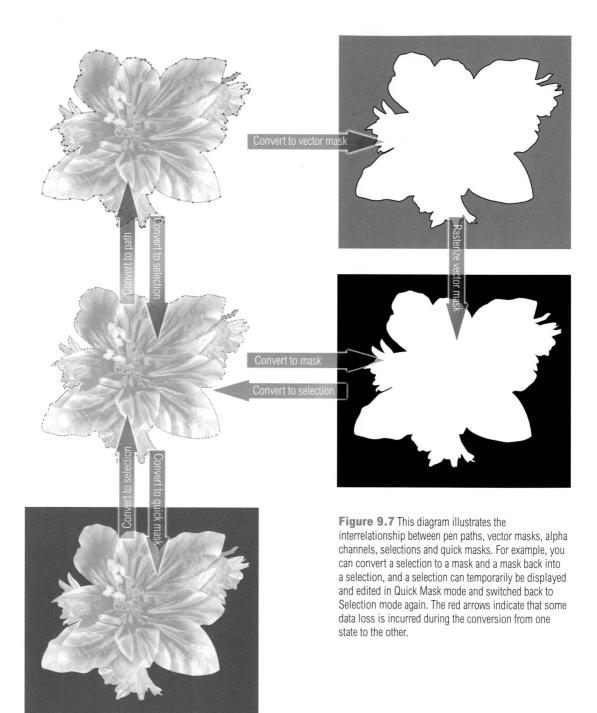

Selections, alpha channels and masks

As was pointed out at the beginning of this chapter, there is always an interrelationship between selections, quick masks and alpha channel masks. This also extends to the use of vector paths and vector masks (vector paths are discussed towards the end of this chapter). The accompanying diagram in Figure 9.7 illustrates these relationships in detail.

Starting at the top left corner, we have a path outline that has been created using the pen tool in Photoshop. A pen path outline can be saved as a path and an active path can be used to create a vector mask, which is a layer masked by a pen path mask (see pages 532 and 536–538). A vector mask can also be rasterized to make a layer mask (a layer that is masked by an alpha channel). Meanwhile, a pen path can be converted to a selection and a selection can be converted back into a work path. If we start with an active selection, you can view and edit a selection as a quick mask and a selection can also be converted into an alpha channel and back into a selection again.

When preparing a mask in Photoshop, most people will start by making a selection to define the area they want to work on and save that selection as an alpha channel mask. This allows you to convert the saved alpha channel back into a selection again at any time in the future. The other way to prepare a mask is to use the pen tool to define the outline first and then convert the pen path to a selection. If you think you will need to reuse the pen path again, such as to convert it to a selection again at a later date, then it is worth remembering to save the work path with a meaningful name, rather than the default 'Path 1', etc. in the Paths panel.

As I say, the business of using vector masks and layer masks is covered in more detail later on, but basically, a layer mask is an alpha channel applied to a layer that defines what is shown and hidden on the associated layer and a vector mask is a pen path converted to a vector mask that defines what is shown and hidden on the layer. There are good reasons for having these different ways of working and I'll be providing some practical examples in this chapter for when it is most appropriate to use either of these two main methods to mask an image.

Converting vectors to pixels

In Figure 9.7 I mention that some of the conversion processes will incur a loss of data. This is because when you convert vector data to become a pixel-based selection, what you end up with is not truly reversible. Drawing a pen path and converting the path to a selection is a very convenient way of making an accurate selection. However, if you attempt to convert the selection back into a pen path again, you will not end up with an identical path to the one that you started with. Basically, converting vectors to pixels is a one-way process. Converting a vector path into a pixel-based selection is a good thing to do, but you should be aware that converting a pixel-based selection into a vector path will potentially incur some loss of data. More specifically, a selection or mask can contain shades of gray, whereas a pen path merely describes an outline where everything is either selected or not.

Figure 9.8 The above illustration shows a graphic where the left half is rendered without anti-aliasing and the right half uses antialiasing to produce smoother edges.

	_	(OK)
eather Radius: 2	pixels	Cancel

Figure 9.9 The Feather Selection dialog can be used to feather the radius of a selection.

Anti-aliasing

Bitmapped images consist of a grid of square pixels. Without anti-aliasing, non-straight lines would be represented by a jagged sawtooth of pixels. Photoshop gets round this problem by antialiasing the edges, which means filling the gaps with in-between tonal values so that non-vertical/horizontal sharp edges are rendered smoother by the anti-aliasing process (Figure 9.8). Wherever you encounter anti-aliasing options, these are normally switched on by default and there are only a few occasions where you might find it useful to turn this option off.

If you have an alpha channel where the edges are too sharp and you wish to smooth them, the best way to do this is to apply a Gaussian Blur filter using a Radius of 1 pixel. Or, you can paint using the blur tool to gently soften the edges in the mask that need the most softening.

Feathering

When you are doing any type of photographic retouching it is important to always keep your selections soft. If the edges of a picture element are defined too sharply, it will be more obvious to the viewer that a photograph has been retouched or montaged. The secret of good compositing is to avoid creating hard edges and to keep the edges of your picture elements soft so that they blend together more smoothly.

There are two ways to soften the edges of a selection. You can go to the Select menu and choose Modify \Rightarrow Feather (*Shift Fb*) and adjust the Feather Radius setting (Figure 9.9). Or, if you have applied the selection as a layer mask, you can use the Feather slider (as shown on pages 455 and 457) to feather the mask 'in situ'. A low Feather Radius of between 1 or 2 pixels should be enough to gently soften the edge of a selection outline, but there are times when it is useful to select a much higher Radius amount. For example, earlier on pages 360–361 I used the elliptical marquee tool to define an elliptical selection, applied this as a Curves adjustment layer mask and feathered the selection by 100 pixels via the Masks panel. This allowed me to create a smooth vignette that darkened the outer edges of the photograph.

Layers

Layers play an essential role in all aspects of Photoshop work. Whether you are designing a Web page layout or editing a photograph, working with layers lets you keep the various elements in a design separate from each other. Layers also give you the opportunity to assemble an image using separate, discrete layers and have the flexibility to make any edit changes you want at a later stage. You can also add as many new layers as you like to a document, up to a maximum limit of 8000 layers! The Photoshop layers feature has evolved in stages over the years and Photoshop CS2 onwards includes new ways for selecting multiple layers and linking them together. Also new to Photoshop CS5 is the ability to drag and drop a file to a Photoshop document and place it as a new layer (see pages 526–527). First let's look at managing layers and the different types you can have in a Photoshop document.

Layer basics

Layers can be copied from one file to another by using the move tool to drag and drop a layer (or a selection of layers) from one image to another. This step can also be assisted by the use of the *Shift* key to ensure layers are positioned centered in the destination file. To duplicate a layer, drag the layer icon to the New Layer button and to rename a layer in Photoshop, simply double-click the layer name. To remove a layer, drag the layer icon to the Delete button in the Layers panel and to delete multiple layers, use a *Shift*-click or **H** *ctrl*-click to select the layers or layer groups you want to remove and then press the Delete button at the bottom of the Layers panel. There is also a Delete Hidden Layers command in both the Layers panel submenu and the Layer \Rightarrow Delete submenu. In addition there is now a File \Rightarrow Scripts menu item that can be used to delete all empty layers (see Figure 9.10).

Image layers

The most common type of layer is an image layer, which is used to contain pixel information. New empty image layers can be created by clicking on the 'Create new layer' button in the Layers panel (Figure 9.14). They can also be created by copying the contents of a selection to create a new layer within the same document. To do this, choose Layer \Rightarrow New \Rightarrow Layer via Copy, or use the **H** of the selection contents, so

Image Processor
Delete All Empty Layers
Flatten All Layer Effects Flatten All Masks Simplify Layers for FXG
Layer Comps to Files Layer Comps to WPG
Export Layers to Files
Script Events Manager
Load Files into Stack Load Multiple DICOM Files Statistics
Browse

Figure 9.10 This shows the File \Rightarrow Scripts menu, where there is now a new script item called 'Delete All Empty layers'.

Application frame windows

Note that when using the Application frame window environment you cannot drag and drop layers from one document to another (or from the Layers panel). You can only do so if the foreground image window is undocked from the Application window.

Figure 9.11 The pen tool and shape tools include a Shape layer mode button for creating shape layer objects defined by a vector path.

Figure 9.12 Text layers are created whenever you add type to an image. Text layers can be re-edited at any time.

Figure 9.13 Adjustment layers are image adjustments that can be placed within an image and applied to individual or multiple layers. Like other layers, you can mask the contents and adjust the blending mode and layer opacity.

that they become a new layer in register with the image below. Alternatively you can cut and copy the contents from a layer by choosing Layer \Rightarrow New \Rightarrow Layer via Cut or use the **#***Shift***J** *ctrlShift***J** keyboard shortcut.

Shape layers

Shape layers is a catch-all term used to describe non-pixel layers where the layer is filled with a solid color and the outline is defined using either a vector or pixel layer mask. A shape layer is created whenever you add an object to an image using one of the shape tools, or draw a path using the Shape layer mode, or when you add a solid fill layer from the adjustment layer menu. Figure 9.11 shows an example of a shape layer that is basically a solid fill layer masked by a vector mask.

Text layers

Typefaces are essentially made up of vector data, which means that Text layers too are basically vector-based shape layers. When you select the type tool in Photoshop and click or drag with the tool and begin to enter text, a new text layer is added to the Layers panel. Text layers are symbolized with a capital 'T', and when you hit *Return* to confirm a text entry, the layer name displays the initial text for that layer, making it easier for you to identify the layer (see Figure 9.12). Note that you can double-click the text layer 'T' icon to highlight the text and make the type tool active.

Adjustment layers

Adjustment layers are image adjustments in the form of layers. With adjustment layers you have the opportunity to edit the adjustments as often as you like, plus you can toggle an adjustment on or off by clicking the layer eyeball icon (Figure 9.13). The chief advantages of working with adjustment layers are that you can re-edit the adjustment settings at any time and you can use the paint, fill or gradient tools to selectively apply the adjustments to an image.

Layers panel controls

Figure 9.14 provides an overview of the Layers panel controls for the layered image shown in Figure 9.15. The blending mode options determine how a selected layer will blend with the layers below, while the Opacity controls the transparency of the layer contents and the Fill opacity controls the opacity of the layer contents independent of any layer style (such as a drop shadow) which might have been applied to the layer. Next to this are the various layer locking options. At the bottom of the panel are the layer content controls for layer linking, adding layer styles, layer masks, adjustment layers, new groups, and new layers, as well as a Delete Layer button. Most of the other essential layer operation commands are conveniently located in the Layer panel fly-out options.

Lock Pixels Lock position Full Laver locking Layer panel fly-out menu options LAYERS Blending mode Layer opacity Normal \$ Opacity: 100% • Lock: 2 0 + 0 Fill: 100% . Fill opacity Lock Transparency Type layer (symbolized with a capital 'T') . Т October 2008 Shape layer with a layer mask and vector mask and a This symbol denotes fx layer style indicated by an fx icon. This layer is also the layer is in a in a clipping group with the layer below clipping group fects Layer style associated with the above text layer Drop Shado 1 Color Fill 1 Shape layer with linked layer mask Layer group Image layers Curves adjustment layer with 1 . Curves 1 layer visibility switched off Eveball icon 1 indicates visibility Linked image layer with a linked layer mask Canvas extens Color coding applied to layers Linked image layer Retouching The Background layer (locked by default) 0 0. 📮 J 3 Delete current laver/laver mask/vector mask/effect Link layers Create new layer Add layer style Add layer mask Create new layer group Add new fill/adjustment layer

Figure 9.14 This is an overview of the Photoshop Layers panel. See also the diagram in Figure 9.15 which shows how this layered image appeared as a final composite.

Layer visibility

You can selectively choose which layers are to be viewed by selecting and deselecting the eye icons. If you go to the History panel options and check 'Make Layer Visibility Changes Undoable', you can even make switching the Layer visibility on and off an undoable action.

Martin Evening Adobe Photoshop CS5 for Photographers

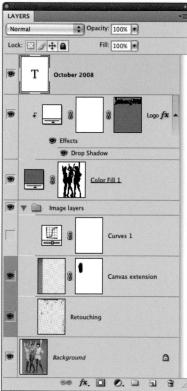

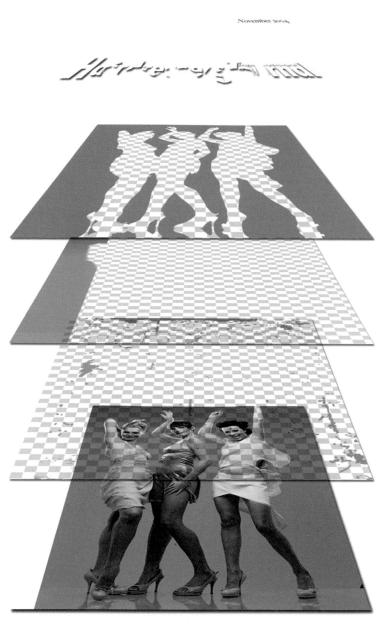

Figure 9.15 Here is an expanded diagram of how the layers in a magazine cover image file were arranged inside Photoshop. The checkerboard pattern represents transparency and the layers are represented here in the order they appeared in the Layers panel.

Client: Goldwell Professional Haircare.

Layer styles

You can use the layer style menu at the bottom of the Layers panel (see Figure 9.14) to apply different types of layer styles to an image, shape or text layer. This feature is really of more interest to graphic designers rather than photographers, but you'll find descriptions of the various layer styles in the DVD Help Guide.

Adding layer masks

You can hide the contents of a layer either wholly or partially by adding a layer mask, a vector mask or both. Masks can be applied to any type of layer: image layers, adjustment layers, type layers or shape layers. Image layer masks are defined using a pixel-based mask, while vector masks are defined using path outlines. Click once on the Add Layer Mask button to add a layer mask and click a second time to add a vector mask (in the case of shape layers a vector mask is created first and clicking the Add Layer Mask button adds a layer mask). You will also notice that when you add an adjustment layer or fill adjustment layer a layer mask is added by default. The layer mask icon always appears next to the layer icon and a dashed stroke surrounding the icon tells you which is active (see Figures 9.16 and 9.17).

The most important thing to remember about masking in Photoshop is that whenever you apply a mask you are not deleting anything; you are only hiding the contents. By using a mask to hide rather than to erase unwanted image areas you can go back and edit the mask at a later date. If you make a mistake when editing a layer mask, it is easy enough to correct such mistakes since you are not limited to a single level of undo. To show or hide the layer contents, first make sure the layer mask is active. Select the paintbrush tool and paint with black to hide the layer contents and paint with white to reveal. To add a layer mask based on a selection, highlight the layer, make the selection active and click on the Add Layer Mask button at the bottom of the Layers panel, or choose Layer \Rightarrow Layer Mask \Rightarrow Reveal Selection. To add a layer mask to a layer with the area within the selection hidden, alt -click the Layer Mask button in the Layers panel, or choose Layer \Rightarrow Layer Mask \Rightarrow Hide Selection.

Lastly, the mask linking buttons referred to in Figures 9.16 and 9.17 allow you to lock or unlock a mask so that you can move the mask or layer contents independently of each other.

Figure 9.16 The Layers panel view shown here contains two layers, and the selected layer is the one that's highlighted here. The dashed border line around the layer mask icon indicates that the layer mask is active and any editing operations will be carried out on the layer mask only. There is no link icon between the image layer and the layer mask. This means that the image layer or layer mask can be moved independently of each other.

Figure 9.17 In this next panel screen shot, the border surrounding the vector mask indicates that the vector mask is active and that any editing operations will be carried out on the vector mask. In this example, the image layer, layer mask and vector mask are now all linked. This means that if the image layer is targeted and you use the move tool to move it, the image layer and layer masks will move in unison.

Copying a layer mask

You can use the **S** *alt* key to drag/ copy a layer mask across to another layer.

Figure 9.18 The remove layer mask options.

Figure 9.19 The layer mask contextual menu options.

Figure 9.20 Click the Add Layer Mask button to add a layer mask where the contents remain visible. and alayer mask filled with black, where the contents are all hidden.

Viewing in Mask or Rubylith mode

The layer mask icon preview provides you with a rough indication of how the mask looks, but if you alt-click the layer mask icon the image window view switches to display a full image view of the mask (see Step 1 opposite). If you **Shift** all Shift-click the layer mask icon, the layer mask is displayed as a quick mask type transparent overlay (see Step 2 opposite). Both these steps can be toggled.

Removing a layer mask

To remove a layer mask, select the mask in the Layers panel and click on the Layers panel Delete button (or drag the layer mask to the Delete button). A dialog box then appears asking if you want to 'Apply mask to layer before removing' (Figure 9.18)? There are several options here: if you simply want to delete the layer mask, then select 'Delete'. If you wish to remove the layer mask and at the same time apply the mask to the layer, choose 'Apply'. Or click 'Cancel' to cancel the whole operation.

To temporarily disable a layer mask, choose Layer \Rightarrow Layer Mask \Rightarrow Disable, and to reverse this, choose Layer \Rightarrow Layer Mask \Rightarrow Enable. You can also *Shift*-click a mask icon to temporarily disable the layer mask (when a layer mask is disabled it will appear overlaid with a red cross). A simple click then restores the layer mask again (but to restore a vector mask you will have to *Shift*-click again). Or alternatively, *ctrl* right mouse-click the mask icon to open the full list of contextual menu options to disable, delete or apply a layer mask (see Figure 9.19).

Adding an empty image layer mask

If you create an empty layer mask (one that is filled with white) on a layer, you can hide pixels in a layer filling or painting with black. To add a layer mask to a layer with all the layer remaining visible, click the Layer Mask button in the Layers panel (Figure 9.20). Alternatively, choose Layer \Rightarrow Add Layer Mask \Rightarrow Reveal All. To add a layer mask to a layer that hides all the pixels, \bigcirc *alt*-click the Add Layer Mask button in the Layers panel. Alternatively, choose Layer \Rightarrow Add Layer Mask \Rightarrow Hide All. This also adds a layer mask filled with black.

1 If you 😒 *att*-click the layer mask icon, you can preview a layer mask in Normal Mask mode.

2 If instead you Shift all Shift-click the layer mask icon, you can preview a layer mask in Quick Mask mode. The mask can be edited more easily in either of these preview modes. The Backslash key (()) can be used to toggle showing the layer mask as a quick mask and return to Normal view mode again.

Figure 9.21 This shows a before shot of the photo that was edited here.

1 This shows a photograph taken from a step-by-step technique in which I applied two paint coloring layers to remove the dark roots from the model's hair. On one layer I painted with the layer set to 'Soft Light' blend mode and on the other I painted with the layer set to the 'Color' blend mode. I was able to do a fairly convincing job of removing the roots, but suppose I wanted to fine-tune the brush strokes? I selected the Color layer shown here, went to the Layer menu and chose Layer Mask

→ From transparency. I then did the same thing with the Soft Light layer.

Creating a layer mask from Transparency

Photoshop CS5 now allows you to create a layer mask from transparent data on a layer. In other words, it allows you to split the contents of an existing layer into color and transparency data. In the example shown here I was able to take an existing paint layer from the image shown in Figure 9.21 and split it into a layer that contained all the color and tone information, masked with a layer mask that defined the transparency of the previously applied brush strokes. From there I was able to edit the layer and layer mask separately and this allowed me to carry out fine-tuned adjustments to the painting layers that would not have been so easy to accomplish before I had separated the layer into these two components. Another suggestion would be to take a paint layer, split it into a layer and a layer mask and then blur the paint colors to blend them better while still preserving the transparency of the brush strokes.

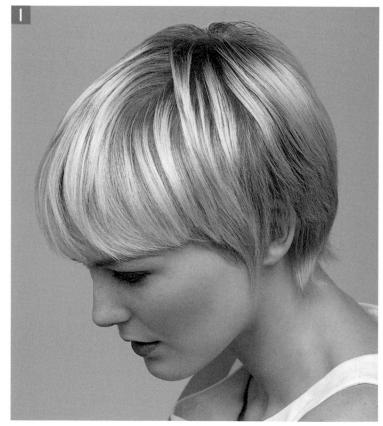

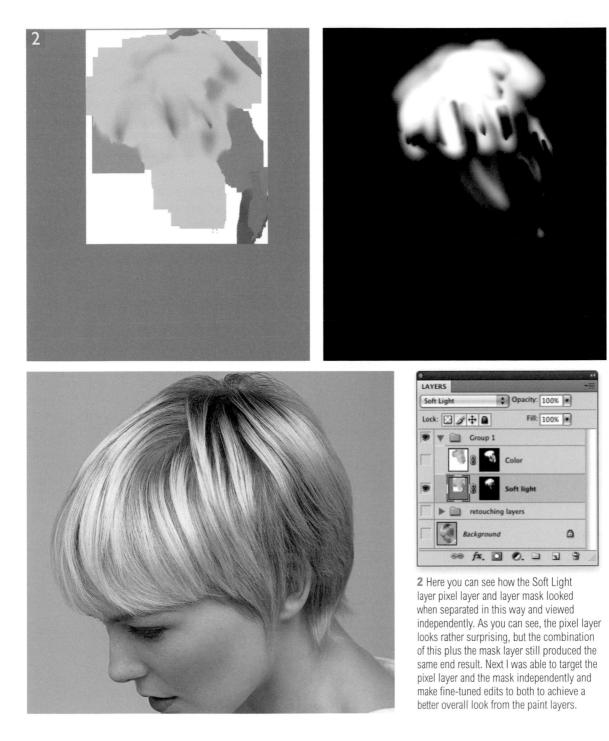

Density and mask contrast

The Density slider answers requests to have some kind of control over the mask contrast. A lot of layer masks will originate as black and white masks where the image adjustments or pixel layer contents are either at full opacity or hidden (the same is true of vector masks of course). The Density slider allows you to preserve the mask outline, but fade the contrast of the mask in a way that is completely re-editable.

Masks panel options

Figure 9.22 shows the Masks panel options menu, where you can use the menu options shown here to add, subtract or intersect the current mask with an active selection. Imagine you want to add something to a selection you are working on. You simply choose the 'Add Mask to Selection' menu option to add it to the current selection.

Figure 9.22 The Masks panel controls are accessible from the menu circled in Figure 9.23.

Masks panel

I have already shown a few examples of how the Masks panel can be used to modify pixel or vector layer masks and the Masks panel controls are all identified below in Figure 9.23. The pixel mask/ vector mask selection buttons are at the top of the panel and can also be used as 'add mask' buttons. Below that are the Density and Feather sliders for modifying the mask contrast and softness. Next are the Refine mask buttons, which are only accessible if a pixel mask is selected. The Mask Edge... button opens the Refine Edge dialog (so why not call it Refine Edge?) where, as you can see in Figure 9.24, you can further modify the edges of a mask. The Color Range... button opens the Color Range dialog, where you can use a Color Range selection (as shown on pages 362-363) to edit a mask. The Invert button inverts a pixel mask, but if you want to do the same thing with a vector mask you can do so by selecting a vector path outline and switching the path mode (see page 536). At the bottom of the panel there are buttons for loading a selection from the mask, applying a mask (which deletes the mask and applies it to the pixels) plus a Delete mask button.

Add pixel mask/ Current mask preview Select pixel mask Masks panel MASKS options Pixel Mask 0 1 Add vector mask/ Select vector mask Density: 100% Density slider 6 Feather: 2 px -Feather slider Refine: Go to Refine Edge Mask Edge.. Color Range. Go to Color Range Invert pixel mask Invert Load selection 3 3 from mask Delete mask Disable/enable mask Apply mask

Figure 9.23 The Masks panel controls.

Refine Edge command

The Refine Edge command is available foremostly as a Select menu item (**# C***tt***/** *at***/ R**) for modifying selections. The dialog says 'Refine Edge' when editing a selection, but if you are preparing a selection in order to create a mask, it makes more sense to use the Refine Edge command when you are working on an active layer mask. You can do this by clicking on the Mask Edge... button in the Masks panel, or by using the above keyboard shortcut. Whichever method you choose the controls are exactly the same, except the dialog is called 'Refine Mask' when editing a layer mask. The Refine Edge controls offer everything you need to modify a selection or layer mask edge. You will notice in Photoshop CS5 that the dialog now not only looks different, but features two new innovations. Firstly, it includes a new Truer EdgeTM algorithm to enable complex outline masking, and secondly, it features output mask refinements for removing color contamination from a masked layer.

Refine Edge is a one-way process

Unlike the Masks panel, once Refine Edge adjustments have been applied they are non-editable after you click OK. For this reason you may want to take the precaution of preserving important mask outlines as saved channels before you use Refine Edge to modify a selection or mask. In any case, the new output options shown in Figure 9.24 below allow you to output a modified selection/mask in different ways, such as a new layer with a layer mask, or a new document even. With this in mind, you may also want to use the Masks panel Feather slider (which can be re-edited) as a primary means for feathering a mask outline.

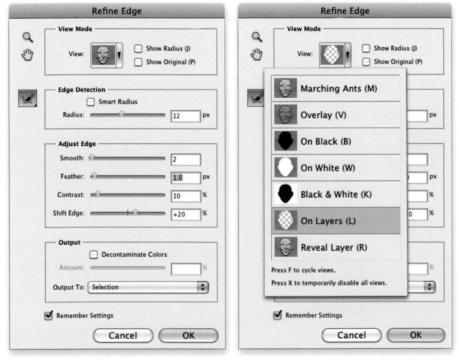

Figure 9.24 The Refine Edge dialog.

Martin Evening

Adobe Photoshop CS5 for Photographers

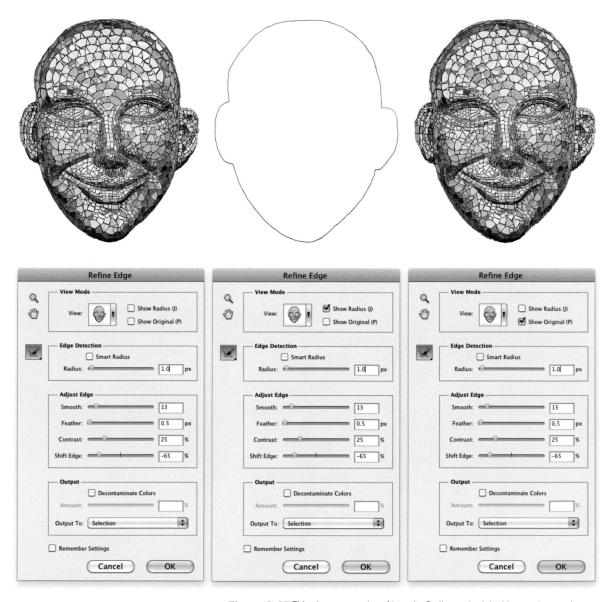

Figure 9.25 This shows examples of how the Radius and original image view modes might be used. Here you can see an image that has been masked using the On White mask view mode. On the left you can see how the masked image looks using the current Refine Edge settings. In the middle is the preview with the Show Radius () option checked. This displays the refine edge boundary only. On the right is the preview with the Show Original (P) option checked. This allows you to view the masked image and compare the original version against the refine edge masked version (left).

View modes

When you first select Refine Edge (Figure 9.24), the initial view mode shows the layer masked against a white background, which isn't so helpful when editing a layer mask, but you can easily switch to the On Layers view by pressing I and once you have done this I suggest you click on the Remember Settings button at the bottom of the Refine Edge dialog to keep this as the new default setting. Without adjusting anything, click OK to close the dialog. You'll then see the On Layers appear by default the next time you open Refine Edge. In the subsequent tutorial (on pages 478–483) I suggest you do all your main Refine Edge adjustments using the 'On Layers' preview mode since this allows you to preview the adjustments you make in relation to the rest of the image. This and the other modes can be accessed from the popup menu shown on the right in Figure 9.24 and you'll notice the keyboard shortcuts are also listed here so that you can quickly switch between view modes. In the View Mode section at the top of the dialog, the Show Radius option (\mathbf{J}) displays the selection border only for where the edge refinement occurs, while the Show Original option (P) allows you to quickly display the image without a selection preview (see Figure 9.25 for more details).

Edge detection

The Edge Detection section gives you some control over how the Truer EdgeTM algorithm processing is used to refine the edge boundaries. This essentially analyzes the border edges in the image and calculates the most appropriate mask opacities to use, primarily according to the Radius setting you have applied. What you want to do here is to adjust the Radius setting to what is most appropriate for the type of image you are masking. If the edges to be masked are mostly fine sharp edges, then a low Radius setting will work best. For example, a Radius of 1 pixel would be suitable for a selection that contained a lot of fine edges such as a wire fence. If the edges you wish to mask are soft and fuzzy, then a wider Radius setting will be most appropriate and it is suggested that you should aim to set the Radius here as wide as you can get away with.

Since a photographic image is most likely going to contain a mixture of sharp and soft edges, this is where the refine radius brush (\checkmark) comes in. This can be used to extend the areas of the

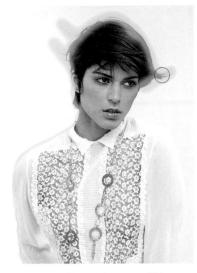

Figure 9.26 You need a narrow thickness edge to refine sharp mask edges and a wider thickness to refine soft, wide mask edges. Here you can see the refine radius brush used at different thicknesses to manually edit a mask. You can set a narrow or wide Radius in the Refine Edge dialog and use the refine radius brush to modify that edge.

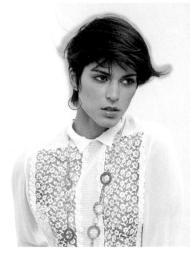

Figure 9.27 This shows the erase refinement tool in use, which shows up as a red overlay when applied in the Reveal Layer mode.

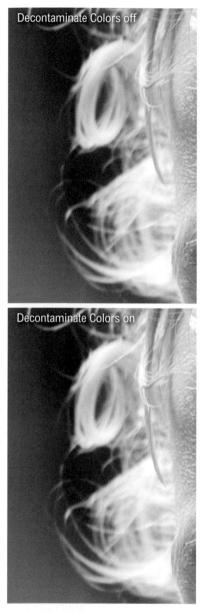

Figure 9.28 Here you can see a close-up comparison between a Refine Edge edited masked layer (top) and below that, one where the 'Decontaminate Colors' option was switched on to help improve the blend between the masked layer and the pixels in the layer below.

edge to be refined. So if you have chosen a narrow Radius setting, which would be appropriate for refining narrow edges, you can paint with the above brush with a wider brush diameter to paint over the softer edges, and thereby apply the most suitable edge refinement algorithm along those sections of the border edge. In use, you select the brush and adjust the cursor size, using the square bracket keys (**[**] **[**]) to determine what size brush you need to work with. Once you have done this you can click and drag to paint along the edges to be refined (see Figure 9.26). Bear in mind here that after each brush stroke, Photoshop needs to recalculate a new edge outline using the new Truer Edge algorithm and this may take a few seconds to complete, during which time you won't be able to edit the edge any further. It may seem a little off-putting at first, but I assure you that the time delay you may experience here is nothing compared with the amount of time you are able to save through the use of this automated masking process. Holding down the **S** alt key switches from the refine radius brush to the erase refinement tool (1). Or, you can select this tool from the same tool menu as the refine radius brush, or use the *Shift E* key to toggle between these two tool modes. This tool can be used to remove areas of the edge to be refined and basically undoes the refined radius mask editing. When working in the Reveal Layers mode, the refine radius painting shows as a green overlay and the erase refinement tool painting shows up as a red overlay (see Figures 9.26 and 9.27).

The Smart Radius option can often help improve the mask edge appearance, as it automatically adjusts the radius for the hard and soft edges found in the border transition area. With hair selections in particular, you should find it helps if you aim to set the Radius slider as high as you can and check the 'Smart Radius' option. I have found that this combination usually produces the best hair mask.

Adjust Edge section

In the Adjust Edge section there are four sliders. The Smooth slider is designed to smooth out jagged selection edges but without rounding off the corners. The Feather slider uniformly softens the edges of the selection and produces a soft-edged transition between the selection area and the surrounding pixels, while the Contrast slider can be used to make soft edges crisper and remove artifacts along the edges of a selection, which are typically caused when using a high Radius setting. When compositing photographic elements you usually you want the edges of a mask to maintain a certain degree of softness, so you don't necessarily want to apply too much contrast to a mask here. Some images need a high contrast, such as the example shown on page 477, but you are usually better off relying on the 'Smart Radius' option combined with the refine radius and erase refinement tools to refine such a selection/mask edge.

If you want to achieve a more aggressive smoothing you can combine adjusting the Feather and Contrast sliders. Simply increase the Feather slider to blur the mask and then increase the Contrast to get back to the desired edge sharpness.

The Shift Edge slider is like a choke control. It works on the mask a bit like the Maximum and Minimum filters in Photoshop. You can use this slider to adjust the size of the mask in both directions, making it shrink or expand till the mask fits correctly around the object you are masking. I usually find that the Shift Edge slider is the one I find the most useful for adjusting the selection/mask shape, followed by the Feather and Contrast sliders when I wish to refine the mask further.

Refine Edge output

Lastly, we have the new Output section, which determines how the masked image layer blends with the image layers below it. This is a crucial component to successful masking, which can so often fail when the pixels around the outer edges of a mask (picked up from the original background) don't match those of the new background. Whenever you need to successfully blend a masked image layer with the other layers in a new image, you can check the 'Decontaminate Colors' option. You can then adjust the Amount slider in order to remove any of the last remaining background colors that were present in the original photo (see Figure 9.28). The best advice here is to only dial in as much decontamination as is necessary in order to achieve the most detailed and smoothestlooking blend.

The 'Output To' section (Figure 9.29) allows you to output the refined selection in a variety of ways, either as a modified selection, as a layer mask, as a new layer with transparent pixels, as a new layer with a layer mask, or as a new document: either with transparent pixels or with a layer mask.

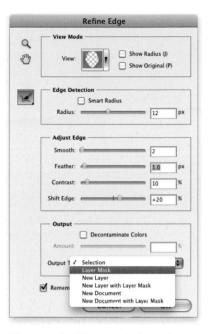

Quick selection brush settings

The quick selection brush settings are the same as for the other paint tools, except adjusting the brush hardness and spacing won't really have any impact on the way the quick selection tool works. If you are using a pressure sensitive tablet it is worth checking that the Pen Pressure option is selected in the Size menu, as this allows you to use pen pressure to adjust the size of the quick selection tool brush (see Figure 9.30 below).

Figure 9.30 This shows the quick selection tool brush settings where the Pen Pressure option has been selected from the Size menu. This links the quick selection tool cursor size to the amount of pen pressure applied.

Working with the quick selection tool

The quick selection tool is grouped with the magic wand in the Tools panel. It is a more sophisticated kind of selection tool compared with the old magic wand and has some interesting smart processing capabilities. You can use the quick selection tool to make a selection based on tone and color by clicking or dragging with the tool to define the portion of the image that you wish to select. You can then keep clicking or dragging to add to a selection without needing to hold down the Shift key as you do so. You can then subtract from a quick selection by holding down the **S** alt key as you drag. What is clever about the quick selection tool is that it remembers all the successive strokes that you make and this provides stability to the selection as you add more strokes. So as you toggle between adding and subtracting, the quick selection temporarily stores these stroke instructions to help determine which pixels are to be selected and which are not. The 'Auto-Enhance' option in the Options bar can help reduces any roughness in the selection boundary. It automatically applies the same kind of edge refinement as you can achieve manually in the Refine Edge dialog using the Radius, Smooth and Contrast sliders.

Sometimes you may find it helps if you make an initial selection and then apply a succession of subtractive strokes to define the areas you don't want to be included. You won't see anything happen as you apply these blocking strokes, but when you go on to select the rest of the object with the quick selection tool, you should find that as you add to the selection, the blocking strokes you applied previously help prevent leakage outside the area you wish to select. In fact, you might find it useful to start by adding the blocking strokes first, before you add to the selection. This aspect of quick selection behavior can help you select objects more successfully than was ever possible before with the magic wand. However, as you make successive additive strokes to add to a selection and then erase these areas from the selection, you'll have to work a lot harder going back and forth between adding and subtracting with the quick selection tool. In these situations it can be a good idea to clear the quick selection memory by using the 'double O trick'. If you press the **Q** key twice, this takes you from the Selection mode to the Quick Mask mode and back to Selection mode again. The stroke constraints will be gone and you can then add to or subtract from the selection more easily since you have now cleared the quick selection memory.

edge.

1 In this example, I selected the quick selection tool, checked the 'Auto-Enhance edge' option and dragged to make an initial selection of the plant interior. Then, with the alt key held down, I dragged around the outer perimeter area to define the areas that were not to be excluded from the selection. I continued clicking and dragging to select more of the plant leaves (while also SC alt) dragging outside) to fine-tune the selection

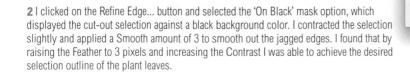

2	

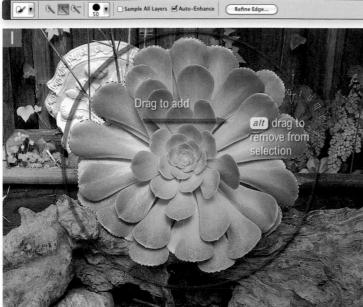

- View Mode		
View:	Show Radius () Show Original {	
- Edge Detection		
Smart Radiu	s	
Radius:	4	рх
— Adjust Edge ————		
Smooth:	3	
Feather:	3	ря
Contrast:	50	96
Shift Edge:	-15	96
- Output		
Decontamir	nate Colors	
Amount: enmounterent		36
Output To: New Layer with	n Layer Mask	\$
Remember Settings		
Cance		<

ofine Edge

Combining a quick selection with Refine Edge

2 . K K C Sample All Layers Auto-Enhance Refine Edge...

 Here I wanted to demonstrate the capabilities of the new, revised Refine Edge/Refine Mask feature and show how, when used in conjunction with the quick mask tool, you can use it to mask tricky outlines such as fine hair. To demonstrate how this works, I have selected here a photograph that I took of my daughter, Angelica. This was a good example to work with since her blonde hair was strongly backlit by the sun. There was a reasonable amount of tone and color separation between her and the background scenery and it certainly helped that the background was slightly out-of-focus. Overall, the conditions were pretty favorable for making a cut-out mask. Having said that, there were a number of areas where the tones and colors between the subject and the background matched guite closely and these would present more of a challenge.

To start with, I selected the quick selection tool from the Tools panel and applied a succession of brush strokes to select Angelica's outline. As is often the case, every now and then I had to hold down the att key to switch to subtract mode in order to fine-tune the quick selection. There was no need for me to be too precise here, but it is usually helpful if you try to achieve the best quick selection you can. I then double-clicked the Background layer to convert it to a normal layer and was ready for the next step.

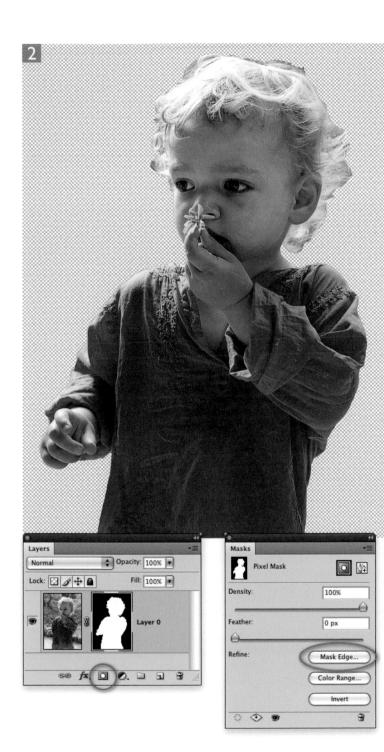

2 With the initial selection prepared, I clicked on the Add Layer Mask button in the Layers panel (circled) to add a layer mask based on the current selection. I then went to the Masks panel and clicked on the Mask Edge... button (or you could just go to the Select menu and choose Refine Edge...). This opened the Refine Mask dialog shown here, where to start with, I selected the 'On Layers' (D) preview option and started adjusting the sliders to achieve a better mask edge. With the Smart Radius option checked, I set the Radius to 20 pixels and Contrast to 25% to improve the mask border edge. I kept the Smooth value low and increased the Feathering to 1.3 pixels to keep the mask outline edges reasonably soft.

View:	2		ow Radius (ow Original	
Edge Detectio	Smart Rad	dius		
Radius: 🥌			20	p
Adjust Edge				
Smooth: 🗎			3	
Feather: 📹)		1.3	p
Contrast: 🖛	-0		25	96
Shift Edge: 🛛	(<u>) </u>	0	96
Output				
Ċ) Deconta	minate C	olors	
Amount:				96
Output To:	iyer Mask			:
Remember Se	ttings			
6	Cance		OH	(

3 Now comes the clever part. I could tell from the current state of the layer mask that while the body outline was looking good, the biggest problem was (as always) how to most effectively mask the hair. In this screen shot the Refine Mask dialog was set to the Reveal Laver (R) preview mode. Here, I selected the refine radius brush (circled) and started brushing over the outline of the hair. There are a couple of things to point out here. By working in the Reveal Layer preview mode, you can see more accurately where you are brushing, as the green overlay allows you to see which areas have been selected. You won't actually see the results of this masking refinement yet, but it helps using this preview mode in the initial stages. The second point is that the Refine Mask recalculates the mask edge after each single brush stroke, so you can't expect to apply a quick succession of brush strokes to define the mask, instead you do so by applying one brush stroke at a time. You'll also notice how Photoshop pauses for a few seconds while it carries out these calculations before it allows you to continue.

		Refine Mask	
a	View Mod	de	
S.	View:	Show Radius (J)	,
	Edge Det		
Ð	Radius:	Smart Radius 20.0]px
	Adjust Ed	dge	
	Smooth:	3]
	Feather:	1.3]px
	Contrast:	25]%
	Shift Edge:	0]%
	Output		
	Amount:	Decontaminate Colors	7%
	Output To:	Layer Mask	•
	Remembe	er Settings	
		Cancel OK	

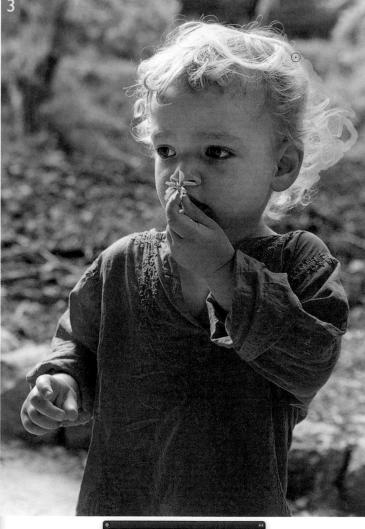

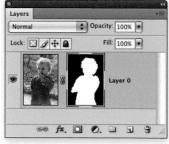

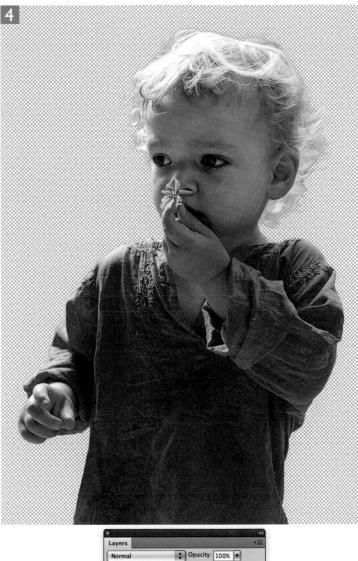

Lock: 🖸 🍠 🕂 🔒

Fill: 100%

∞ fx. □ 0. □ 1 3

4 To refine the mask further, it was now best to revert to the 'On Layers' (**D**) preview option

revert to the 'On Layers' (L) preview option as this allowed me to preview the mask edges against a transparent backdrop. At this stage I continued to work with the refine radius brush to perfect the edges of the hair outline. One can use the 🕥 alt key to select the erase refinement tool (ver) and remove parts of the mask, but in this instance I found that the refine radius brush was the only one that was needed here. As in the previous step, you have to apply a brush stroke and then wait a few seconds for Photoshop to recalculate before applying any further brush strokes. I then adjusted the Shift Edge slider to contract the mask edge slightly and make it shrink more to Angelica's outline.

000000		
Г	— View Mode ——	
	View:	Show Radius (J) Show Original (P)
ΙΓ	- Edge Detection -	art Radius
	-	12 p>
Г	— Adjust Edge —	
	Smooth: 🔒	3
	Feather:	[1.3 pv
	Contrast:	25 %
	Shift Edge:	
Г	Output	
		contaminate Colors
	Amount:	%
	Output To: Layer	Mask 🗘
0	Remember Setting	gs
	C	Cancel OK

481

5 It was all very well looking at the masked image against a transparent background, but the real challenge was how the image previewed against backdrops of different color and lightness. To test this particular masked image, I selected the 'On White' (W) preview. By previewing the image against black I was able to get a better indication of how effective the mask was at separating the subject from the original background. As expected, I needed to check the Decontaminate Colors box in the Output section (circled) if the subject edges were to blend more convincingly with the white backdrop. As you can see, the mask was working quite well by this stage. However, I didn't want to decontaminate the layer just yet, so I unchecked this option for now.

	Refine Mask	L.
q	View Mode	
G	View:	Show Radius (J)
K	Edge Detection	
		20.0 px
	Adjust Edge	
	Smooth:	3
	Feather:	1.3 px
	Contrast:	25 %
	Shift Edge:	-10 %
	Output	
	Amount:	20 %
	Output To: New Layer with L	
	Remember Settings	
	Cancel) (ОК

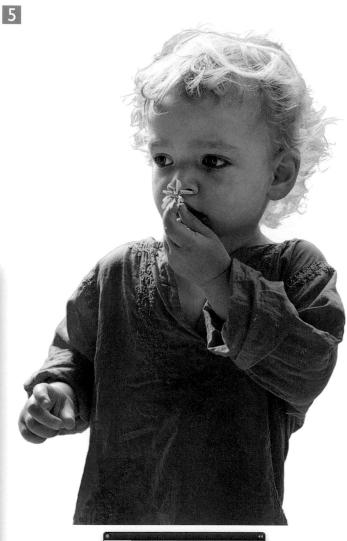

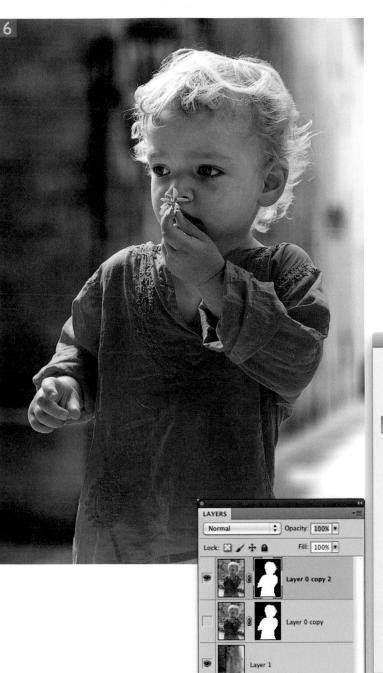

eə fx. 🖸 Ø. 🗆 🖬

3

Chapter 9 Layers, selections and masking

6 The real test though was how the masked layer would look when placed against a different background image. In this final step I took an out-of-focus image and dragged it across to the main image and placed this newly added layer below the subject layer. I then reselected the masked laver, and making sure the layer mask was active, I opened the Refine Mask once more. Now, since the mask edges had already been modified, I did not want to refine them any further, so I therefore set all the settings to zero. I did though want to now check the 'Decontaminate Colors' option in the Output section at the bottom. Now that I was able to preview the masked layer against the final backdrop I could tell how much to adjust the Amount slider. When I was happy with the way things were looking, I clicked OK to apply this final modification to the mask with the 'New Layer with Layer Mask' option selected in the Output To menu at the bottom of the dialog.

Refine Mask

	Sho	w Original (r)
Edge Det			
Radius:	Smart Radius	0.0]p>
Adjust E	dge		
Smooth:	0	0	
Feather:	0	0.0	p>
Contrast:	0	- 0	8
Shift Edge:		0	3%
Output			
	Decontaminate Co	lors	
Amount:	-0	20	%
Output To	New Layer with Layer	Mask	•
Rememb	er Settings		
	(Cancel)	ОК	

1 This shows a photograph taken of a sailing ship mast against a deep blue sky. Obviously, it would be potentially quite tricky to create a cut-out mask of the complex rigging in this photo. One approach would be to analyze the individual RGB color channels and see if there was a way to blend these together using Calculations to create a new mask channel that could be used as a cut-out layer mask. A much easier way is to use the Color Range command. So to start with, I went to the Select menu and chose 'Color Range...'

Color Range masking

So far I have shown how to replace the background using the quick selection tool combined with Refine Edge/Refine Mask command. Let's now look at how to create a cut-out mask of a more tricky subject where the quick selection tool would be of little help. Advanced users might be tempted to use channel calculations to mask a picture like this. That could work, but you know, there is a much simpler way. Since Color Range was updated in CS4 it can now be considered an effective tool for creating mask selections that can be used for compositing images together. In fact, I would say that the quick selection and Color Range adjustment are powerful tools that now offer relatively speedy (and sophisticated) methods of masking.

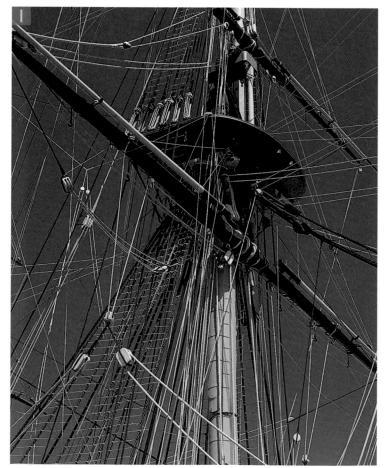

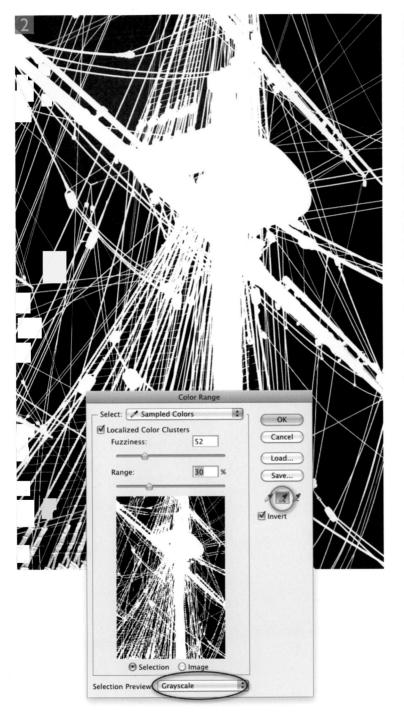

2 This opened the dialog shown below with the standard evedropper selected. I could then simply click with the evedropper anywhere in the image window to sample a color to mask with. In this instance I clicked in the blue sky areas to select the sky and checked the Invert box so that I was able to produce the inverted selection shown here. To create a more accurate selection. I checked the Localized Color Clusters box and used the plus evedropper (circled) to add to the Color Range selection. You can click or drag inside the image to add more colors to the selection and also use the minus evedropper (or hold down the calt key) to subtract from a selection. The Fuzziness slider increases or decreases the number of pixels that are selected based on how similar the pixels are in color to the already sampled pixels, while the Range slider determines which pixels are included based on how far in distance they are from the already selected pixels. The Color Range preview is rather tiny, so you may find it helps to do what I did here, which was to select the Grayscale Selection preview (circled red) so that I could view the edited mask selection in the full-size image window.

3 Having completed the selection I clicked on the Add Layer Mask button in the Layers panel to convert the active selection to a layer mask, which masked the ship mast layer; I then wanted to blend the masked image with a photograph of a cloudy sky. This could be done by dragging the masked ship mast layer to the sky image, or as I did here, by draging the sky image to the ship mast image and placing it as a layer at the bottom of the layer stack. Shown here is the cloudy sky layer on its own with the layer visibility for the masked ship mast layer switched off.

4 This shows a 1:1 close-up view of the masked layer overlaying the sky layer with the ship mast layer visibility switched back on. In the Masks panel there was no need to feather the mask. Instead, I clicked on the Mask Edge... button to open the Refine Mask dialog.

O Maria and States and	and a state of the state of the
MASKS	*=
Pixel Mask	
Density:	100%
Feather:	0 px
Refine:	Mask Edge
	Color Range
	Invert
ି 📀 🖷	3

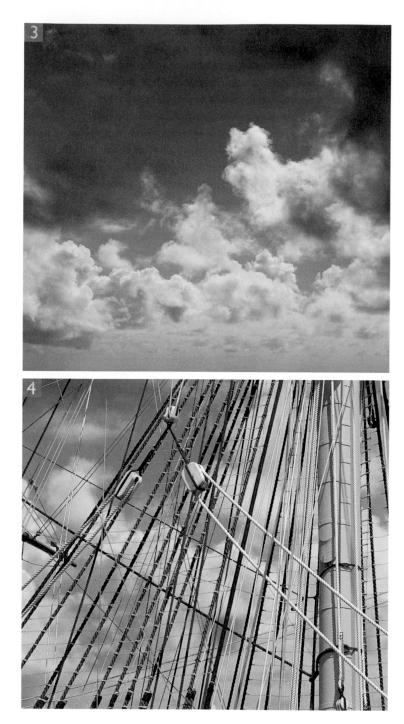

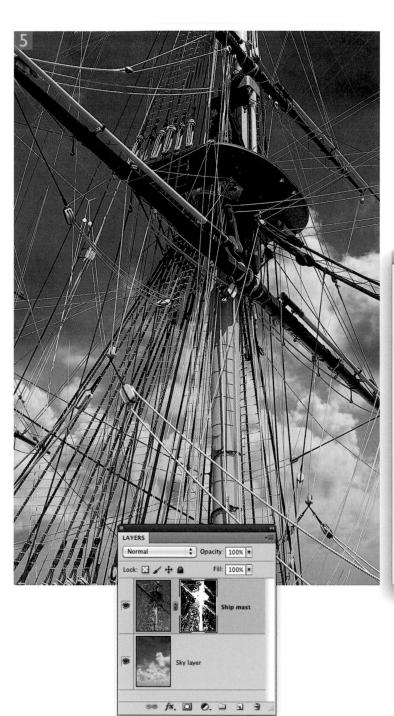

5 This shows the finished composite image, in which I used the Refine Mask controls to fine-tune the mask edges. As in the previous example, I selected the 'On Layers' view mode. I was then able to preview the Refine Mask adjustments on a layer mask that actively masked the ship mast layer. I didn't have to do too much here. I disabled the edge detection by setting the Radius to 0 pixels, applied a Feather of 0.5 pixels and contracted the mask by –15%. I checked the 'Decontaminate Colors' option and set the Amount slider here to 60%. This combination of sliders appeared to produce the best result using the new, revised Refine Edge/Refine Mask dialog.

Refine Mask				
2	View:	Show Radius (J)		
1	view:	Show Original (P)		
	Edge Detection			
	Radius: 🔴	0.0 px		
	Adjust Edge			
	Smooth:	0		
	Feather:	0.5 px		
	Contrast:	0 %		
	Shift Edge:	-15 %		
	Output			
	Mount:	ate Colors		
	Output To: New Layer with			
	Remember Settings			
	Cancel	OK		

Layer blending modes

The layer blending modes allow you to control how the contents of a layer will blend with the layer, or layers, immediately below it. These same blend modes can also be used to control how the paint and fill tools interact with an image. I have already mentioned a few of the blend modes that I like to use when working in Photoshop, such as the Luminosity blend mode which can be used to blend adjustment layer adjustments by targeting the luminosity, but without affecting the color component of an image. To help you learn and understand how the blend modes work, I have provided a summary of all the blend modes currently found in Photoshop CS5 when blending together the two images shown in Figure 9.31.

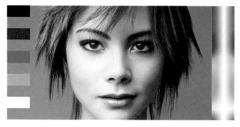

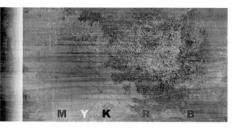

Figure 9.31 The following pages illustrate all the different blending modes in Photoshop. In these examples, the photograph of the model was added as a new layer above a gray textured Background layer and the layer settings recorded in the accompanying panel header screen shots.

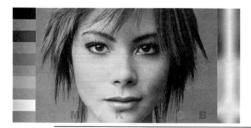

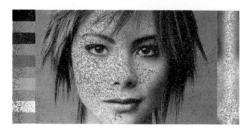

Client: Taylor Phillipps. Model: Tina at FM.

Normal

This is the default mode. Changing the opacity simply fades the intensity of overlaying pixels by averaging the color pixels of the blend layer with the values of the composite pixels below (the opacity is set here to 80%).

Dissolve

LAYERS		- 2
Dissolve	Opacity: 80	2%

Combines the blend layer with the base using a randomized pattern of pixels. No change occurs when the Dissolve blend mode is applied at 100% opacity, but as the opacity is reduced, the diffusion becomes more apparent (the opacity is set here to 80%).

Darken

Looks at the base and blending pixel values and pixels are only applied if the blend pixel color is darker than the base pixel color value.

Multiply

Multiplies the base by the blend pixel values, always producing a darker color, except where the blend color is white. The effect is similar to viewing two transparency slides sandwiched together on a lightbox.

Color Burn

Darkens the image using the blend color. The darker the color, the more pronounced the effect. Blending with white has no effect.

Linear Burn

The Linear Burn mode produces an even more pronounced darkening effect than Multiply or Color Burn. Note that the Linear Burn blending mode clips the darker pixel values and blending with white again has no effect.

Darker Color

Darker color is similar to the Darken mode, except it works on all the channels instead of on a per-channel basis. When you blend two layers together, only the darker pixels on the blend layer remain visible.

Lighten

LAYERS

Looks at the base and blending colors and color is only applied if the blend color is lighter than the base color.

Screen

Cpacity: 80%

Multiplies the inverse of the blend and base pixel values together, always making a lighter color, except where the blend color is black. The effect is similar to printing with two negatives sandwiched together in the enlarger.

LAYERS

Scree

Color Dodge

Color Dodge Opacity: 80% *

Brightens the image using the blend color. The brighter the color, the more pronounced the result. Blending with black has no effect (the opacity is set here to 80%).

Linear Dodge (Add)

LAYERS • Opacity: 100% •

This blending mode does the opposite of the Linear Burn tool. It produces a stronger lightening effect than Screen or Lighten, but clips the lighter pixel values. Blending with black has no effect.

Lighter Color

Lighter color is similar to the Lighten mode, except it works on all the channels instead of on a per-channel basis. When you blend two layers together, only the lighter pixels on the blend layer will remain visible.

Overlay

The Overlay blending mode superimposes the blend image on the base (multiplying or screening the colors depending on the base color) whilst preserving the highlights and shadows of the base color. Blending with 50% gray has no effect.

Soft Light

Darkens or lightens the colors depending on the base color. Soft Light produces a more gentle effect than the Overlay mode. Blending with 50% gray has no effect.

Hard Light

Multiplies or screens the colors depending on the base color. Hard Light produces a more pronounced effect than the Overlay mode. Blending with 50% gray has no effect.

Vivid Light

Applies a Color Dodge or Color Burn blending mode, depending on the base color. Vivid Light produces a stronger effect than Hard Light mode. Blending with 50% gray has no effect.

Linear Light

Applies a Linear Dodge or Linear Burn blending mode, depending on the base color. Linear Light produces a slightly stronger effect than the Vivid Light mode. Blending with 50% gray has no effect.

Pin Light

LAYERS Pin Light Opacity: 100%

Applies a Lighten blend mode to the lighter colors and a Darken blend mode to the darker colors. Pin Light produces a stronger effect than Soft Light mode. Blending with 50% gray has no effect.

Hard Mix

Hard Mix Opacity: 100%

Produces a posterized image consisting of up to eight colors: red, green, blue, cyan, magenta, yellow, black and white. The blend color is a product of the base color and the luminosity of the blend layer.

LAVERS

Difference

Difference Opacity: 100%

Subtracts either the base color from the blending color or the blending color from the base, depending on whichever has the highest brightness value. In visual terms, a 100% white blend value inverts (i.e. turns to a negative) the base layer completely, a black value will have no effect and values in between will partially invert the base layer. Duplicating a Background layer and applying Difference at 100% produces a black image. Dramatic changes can be gained by experimenting with different opacities. Difference is often used to detect minor differences between two near-identical layers in exact register, such as a comparison of images in different color spaces or saved using different JPEG compression.

Exclusion

A slightly muted variant of the Difference blending mode. Blending with pure white inverts the base image.

Divide

LAYERS The Divide Opacity: 100%

This example doesn't really show you anything useful, but the Divide blend mode does have useful applications such as when carrying out a flat field calibration (see pages 436–437).

Hue

Preserves the luminance and saturation of the base image, replacing with the hue of the blending pixels.

Saturation

Preserves the luminance and hue of the base image, replacing with the saturation of the blending pixels.

Color

Preserves the luminance values of the base image, replacing the hue and saturation values of the blending pixels. Color mode is particularly suited for hand-coloring photographs.

Luminosity

Preserves the hue and saturation of the base image while applying the luminance of the blending pixels.

Experimenting with the blend modes

To put all this into practice, try opening the image shown below from the DVD and follow the steps outlined here. In particular, observe how the 'Blend Interior Effects as Group' option works on Layer C, which is using the Difference blending mode. When you check the 'Blend Interior Effects as Group' option, the result will be the same as if you had first 'fixed' the interior layer style using the Normal blend mode and then changed the blend mode to Difference. Other aspects of the Layer Style blending options dialog box are covered in the Layers Styles section in the *Photoshop CS5 for Photographers Help Guide* DVD.

Advanced Blending options

Layer groups allow you to group a number of layers together such that the layers contained within a layer group behave like a single layer. In Pass Through blending mode the layer blending passes through the layer group and the interaction is no different than if the individual layers were in a normal layer stack. However, when you select any of the other blending mode options for a layer group, the blending results are equivalent to what would happen if you chose to merge all the layers in the current group into a single layer and then adjusted the blending mode for the merged layer.

Knockout options

Among the Advance Blending modes, the Knockout blending options (see Step 2 on page 495) allow you to force a layer to punch through some or all of the layers beneath it. A 'Shallow' knockout punches through to the bottom of the layer group only, while a 'Deep' knockout punches through to just above the Background layer.

Blend Interior effects

Layer styles are normally applied independent of the layer blending mode. However, when you check the Blend Interior Effects as Group box, such effects take on the blending characteristics of the selected layer.

ð	and the second	and and the	
LAY	ERS		•=
Pa	ss Through Opacity: 1009	•	
Loc	k: 🖸 🖌 🕂 角 🛛 Fill: 1009		
	🔻 🛄 Group 1		
9	Layer D	f×	-
	Layer C	f×	-
9	Layer B	fx	-
	Layer A	fx	-
	Effects		
	I Outer Glow		
	fern		
	Background	۵	
	eð fx 🖸 Ø. 🗎	5	

1 The four letter layers shown here are grouped together in a layer group. Layer A uses the Multiply blending mode; B uses the Overlay mode; C uses the Difference mode; and D uses the Screen blending mode. The default blending mode of the entire layer group is Pass Through. This means that the layers in the layer group blend with the layers below the same as they would if they were all in a normal layer stack.

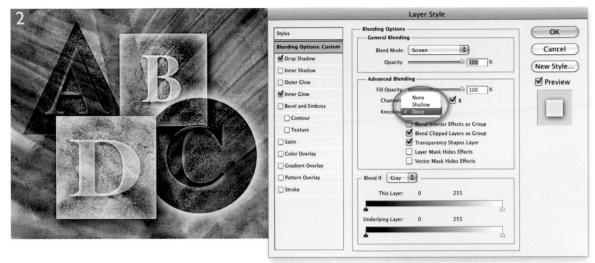

2 If you select 'Layer D' and double-click the layer to open the Layer Style dialog, you can alter the Advanced Blending options. The Knockout options (circled) allow you to 'punch through' the layers. A 'Shallow' knockout punches through the three layers below it to just above the layer or layer group immediately below. A 'Deep' knockout will make the Layer D punch through all the layers below it, straight down to the Background layer. In this example, Layer D uses the Deep Knockout blend and appears as it would if it were positioned directly above the Background layer.

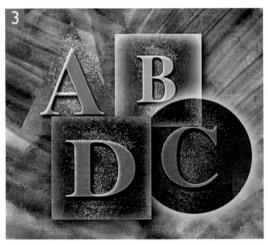

3 The default layer group blend mode is Pass Through. If you change the layer group blending mode to anything else, the layers within the group will blend with each other as before, but not interact with the layers underneath as they did in Pass Through mode. When the layer group blend mode is changed to Normal (shown circled), the group layers appear as they would if the Background and fern layer visibility were switched off.

The Photomerge layout options Auto

The Auto layout works best in most cases and I suggest that you use Auto first to see what it does before considering any of the alternative layout options. Auto tends to flatten the perspective and prevents the corners of a Photomerge from shooting outwards.

Perspective

The Perspective layout can produce good results when the processed photos are shot using a moderate wide-angle lens or longer, but can otherwise produce rather distorted, exaggerated composites.

Cylindrical

The Cylindrical layout ensures photos are aligned correctly on the horizontal axis. This is useful for keeping the horizon line straight when using Photomerge to process a series of photos that make up an elongated panorama.

Spherical

This can transform and warp the individual photos in both horizontal and vertical directions. This layout option is more adaptable when it comes to aligning tricky panoramic image sequences.

Collage

This positions the photos in a Photomerge layout without transforming the individual layers, but does rotate them to achieve the best fit.

Reposition

The Reposition layout simply repositions the photos in the Photomerge layout, without rotating them.

Creating panoramas with Photomerge

The Photomerge feature allows you to stitch individual photos together to build a panorama image and is now much simpler to work with. This is because since CS4, the Photomerge alignment and blending have been improved to the point where the interactive dialog is no longer necessary. In fact, in the majority of cases the 'Auto' layout option is all you need to get good-looking panoramas.

There are two ways to generate a Photomerge image. You can go to the File \Rightarrow Automate menu in Photoshop and choose Photomerge... This opens the dialog shown in Step 2, where you can choose 'Add Open Files' and add these as the source images. Or, you can use Bridge to navigate to the photos you wish to process and open Photomerge via the Tools \Rightarrow Photoshop submenu.

To get the best Photomerge results, you need to work from photographs where there is a significant overlap between each exposure. You should typically aim for at least a 25% overlap between each exposure and overlap the photos even more if you are using a wide-angle lens. For example, Photomerge is even optimized to work with fish eye lenses, providing Photoshop can access the lens profile data (see page 562), but if you do so, you should aim for maybe as much as a 70% overlap between frames. Here are the basic steps you would use.

1 To create the photomerge shown here, I started by selecting the four photographs shown here in Bridge. I then went to the Tools menu in Bridge and chose Photoshop \Rightarrow Photomerge...

-Blend Images Together ☑ Vignette Removal ELE MAR EL Geometric Distortion Correction 2 This opened the Photomerge dialog, where you'll note that the 'Auto' layout option was selected and the four selected images were automatically added as source files. All I really The 'Blend Images Together' option

Blending options

completes the Photomerge processing because it adds layer masks to each of the Photomerged layers (see the Layers panel view in Step 3). You can always choose not to run this option and select the Auto-Blend Layers option from the Edit menu, later to achieve the same end result (see page 499). 'Vignette Removal' and 'Geometric Distortion Correction' are optional and can help improve the result of the final image blending, especially if you are merging photos that were shot using a wide-angle lens.

it aligned the four photos automatically, applied a blend step to blend the tones and colors between the layers followed by an auto layer mask step in which the individual layers ended up being masked so that each part of the Photomerge image consisted of no more than one visible layer.

needed to do here was to check the three options at the bottom and click OK to proceed. 3

1 I began by going to Bridge and selected a group of photographs that had been shot at different points of focus. I then went to the Tools menu and chose Photoshop ⇔ Load Files Into Photoshop Layer.

Depth of field blending

The Edit \Rightarrow Auto-Blend Layers command allows you to blend objects that were shot using different points of focus and blend them to produce a single image with optimal focus.

2 This opened the five selected photos as a multi-layered image in Photoshop. With all the layers selected, I then went to the Edit menu, chose 'Auto-Align Layers...' and selected the Auto projection option. This aligned the layers as shown here.

3

3 The next step was to merge the layered photos together, which I did by going to the Edit menu again and this time I selected 'Auto-Blend Layers...' Here, I selected 'Stack Images' and made sure the 'Seamless Tones and Colors' option was checked.

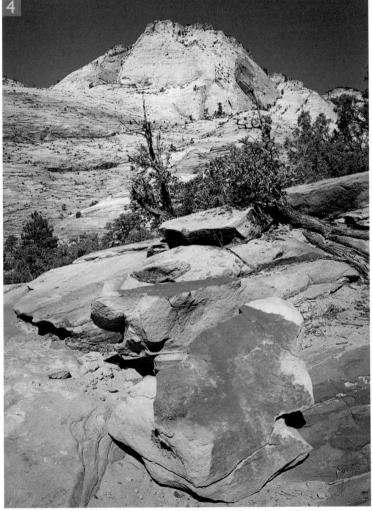

4 To get the best results it is important to carry out the Auto-Align step before you apply the Auto-Blend. As you can see, this last step carried out a pixel blending of the individual layers and added layer masks to each based on a calculation of where the sharpest detail was on each layer. The success of this depth of field blending technique is also down to the care with which you shoot the original photographs. The more photos you shoot, bracketed at different focal distances, the better the end result will be.

Figure 9.32 Layers can be color coded. Choose 'Layer Properties' from the Layers panel fly-out menu and pick a color. Alternatively, you can and alternatively, you can alternatively double-click a layer to open the Layer Properties dialog shown here.

Working with multiple layers

Layers have become an essential feature in Photoshop because they enable you to do all kinds of complex montage work, but as the layer features have evolved there has been an increasing need to manage them more efficiently.

Color coding layers

One way to manage your layers better is to color code them, which can be done by selecting a layer and choosing 'Layer Properties' from the Layers panel fly-out menu. This opens the dialog shown in Figure 9.32, where you can rename a layer and pick a color label. The downside is that you can only adjust the label color coding one layer at a time (unless you are changing the layer properties for a layer group as a whole).

Layer group management

Multi-layered images can be unwieldy to navigate, especially when you have lots of layers placed one above the other, but they can be organized more efficiently if you place them into layer groups. Layer groups have a folder icon and the general idea is that you can place related layers together inside a single layer group and the layer group can then be collapsed or expanded. Therefore, if you have lots of layers in an image, layer groups can make it easier to organize the layers and layer navigation is made simpler.

If you click on the 'Create a new group' button in the Layers panel, this adds a new layer group above the current target layer, while **H** *cttl*-clicking on the same button adds a layer group below the target layer and **C** *alt*-clicking opens the New Group from Layers dialog (see Figure 9.33).

The Layer group visibility can be toggled by clicking on the layer group eye icon. It is also possible to adjust the opacity and blending mode of a layer group as if it were a single layer, while the subset of layers within the layer group itself can all have individually set opacities and use different blending modes. You can also add a layer mask or vector mask to a layer group and use this to mask the layer group visibility, as you would with individual layers. To reposition a layer in a Layer group, click on the layer and drag it up or down within the layer stack. To move a layer into a layer group, drag it to the layer group icon or drag to an expanded layer group. To remove a layer from a layer group, just drag the layer above or below the group in the stack (see page 502).

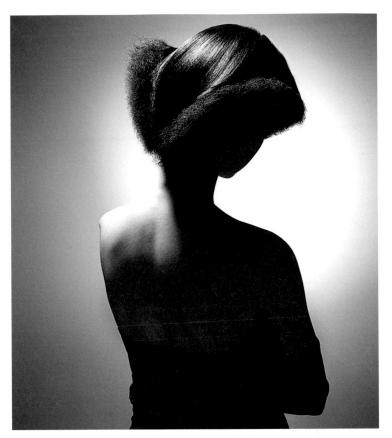

Figure 9.33 When a Photoshop document ends up with this many layers, the layer stack can become difficult to manage, but it is possible to organize layers within layer groups. In this example, I used a **Spiri**-click to select the three spotting layers near the bottom of the layer stack. I then went to the Layers panel fly-out menu and chose 'New Group from Layers...' I entered a name for the new group and selected a violet color to color code the layers within this group. Once I had done this, the visibility of all layers within this group could be switched on or off via the layer group eyeball icon and the opacity of the group could be adjusted as if all the layers in the group were a single merged layer.

Nested group layer compatibility

You can now have a layer group (or groups) nested within a layer group up to 10 nested layer groups deep. As a consequence of this, if a CS5 image with more than five nested layer groups is opened in an earlier version of Photoshop, a warning dialog will be shown. In the case of Photoshop CS3 or CS4, you'll see a 'this document contains unknown data...' warning where you can choose one of the options mentioned in the sidebar to open the image.

Client: Andrew Collinge Hair & Beauty. Hair by Andrew Collinge artistic team, Make-up: Liz Collinge.

Copacity: 100 . %

Mode: Pass Through

Incompatible layer group warnings

'Flatten' preserves the appearance of the document by reading the flattened composite data (provided 'Maximum Compatibility' was switched on). The 'Keep Layers' option attempts to preserve all the layers but this may produce differentlooking results.

1 Layers can be moved into a layer group by mousing down on a layer and dragging the layer into the desired layer group.

Group layer shortcut

Selected layers can be grouped together by choosing Layer ⇒ Group Layers, or by using the **\\$G ctrl G** shortcut. You can also lock all layers inside a layer group via the Layers panel submenu.

Managing layers in a group

The following steps help illustrate the workings of the layer group management discussed on the preceding pages.

Pass Through Opacity: 100% Lock: Image: Constraint of the second
Mascer retouching Face retouching Face retouching If is 1
Master retouching Face retouching Figure 1 Itips 1
🖲 🔛 🖁 😇 lips 1
Basic spotting
S Background
60 fx 🖸 Ø 🗆 🖬 🕯

2 The same method can be used when you want to move a layer group to within another layer group. Mouse down and drag the group to another layer group.

4 To remove a layer or layer group from a group, just drag it out of the layer group until you see a bold line appear on the divider above or below the layer group.

3 IRS		**
Normal	Opacity: 100%	
Lock: 🔝 🖉 🕂 🕻	Fill: 100%	
🗩 🕨 Extra	a retouching	-
🗩 🐺 🛄 Mast	ter retouching]
	Face retouching	5
	lips 1	
Basic sp	potting	
Backgro	ound 🖸	

3 You can move multiple layers at once. Make a *Shift* select, or **H** *ctrl* layer selection of the layers you want to move and then drag them to the layer group.

5 Here is a view of the Layers panel with the Face retouching group now outside and above the Master retouching layer group.

Clipping masks

Clipping masks can be used to mask the contents of a layer based on the transparency and opacity of the layer beneath it. So, if you have two or more layers that need to be masked identically, one way to do this is to apply a layer mask to the first layer and then create a clipping mask with the layer or layers above it. Once a clipping mask has been applied, the upper layer or layers will appear indented in the Layers panel (Figure 9.34). You can alter the blend mode and opacity of the individual layers in a clipping group, but it is the transparency and opacity of the lower (masked) layer that determines the transparency and opacity of all the layers that are in the clipping mask group.

The main advantage of using clipping masks is that whenever you have a number of layers that are required to share the same mask, you only need to apply a mask to the bottom-most layer. Then when you make a clipping mask, the layer (or layers) in the clipping mask group will all be linked to this same mask. So for example, if you edit the master mask, the edit changes you make to it are simultaneously applied to the layer (or layers) above it.

Ways to create a clipping mask

To create a clipping mask, select a single layer or make a *Shift* selection of the layers you want to group together and choose Layer \Rightarrow Clipping Mask \Rightarrow Create. Alternatively, \checkmark *alt*-click the border line between the layers. This action toggles creating and releasing the layers from a clipping mask group. Plus you can use the $\Re \circ G$ *ctrl alt G* keyboard shortcut to make the selected layers form a clipping mask with the layer below.

Whenever you add an adjustment layer you can create a clipping mask with the layer below by clicking on the Clipping Mask button in the Adjustments panel. This allows you to toggle quickly between a clipping mask and non-clipping state (see Figure 9.35).

You can also create clipping masks at the same time as you add a new layer. In the example that's shown on the next few pages, you can see how I all clicked the Add New Adjustment Layer button, which opened the New Layer dialog. This allowed me to check the 'Use Previous Layer to Create Clipping Mask' option (the same thing applies when clicking the Add New Layer button).

Figure 9.34 This shows an example of a clipping mask, where the Gradient Fill layer forms a clipping mask with the masked image layer beneath it. Note how the layer in the clipping mask group appears indented in the layer stack.

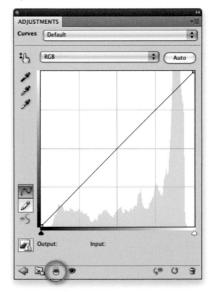

Figure 9.35 This shows the Clipping Mask button in the Adjustments panel that allows you to toggle between enabling and disabling a clipping mask with the layer beneath the adjustment layer.

Masking layers within a group

I use clipping masks quite a lot, but there is also another way that you can achieve the same kind of result and that is to make a selection of two or more layers and place them into a masked layer group (choose Layer \Rightarrow Group Layers). With the layer group selected, click on the Add Layer Mask button in the Layers panel to add a layer mask to the group. If you now edit the layer mask for the layer group, you can simultaneously mask all the layer group contents.

Clipping layers and adjustment layers

The following steps show how clipping masks can be used to group a fill layer with an image layer and how you can group two adjustment layers together so that they form a clipping mask.

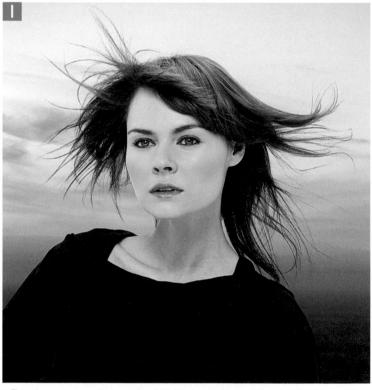

1 This shows a composite image in which I had carried out most of the retouching on the face and added a layer containing a new backdrop image. In this instance, the mask allows the model image layer and retouching layers to show through from below.

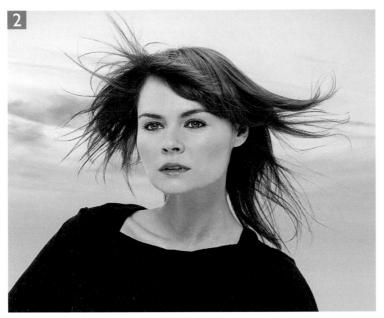

2 In this next step I added a linear Gradient Fill layer with a solid peach color fading to transparency. As you can see, when adding this new fill layer I created a clipping mask with the backdrop image layer. One way to do this was to hold down the set all key as I clicked on the Add New Adjustment Layer button (circled). This opened the New Layer dialog shown here, where I checked the 'Use Previous Layer to Create Clipping Mask'.

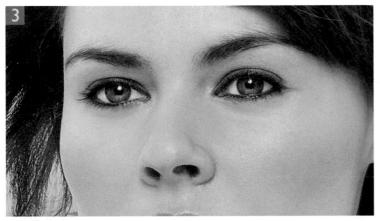

3 Lastly, I made a lasso selection of the model's eyes and added a new Curves adjustment to lighten the eyes. I then did the same thing as in Step 2. I held down the *(i) (a)* key as I clicked on the Add New Adjustment Layer button and chose a Hue/Saturation adjustment. Again, I checked the 'Use Previous Layer to Create Clipping Mask' option. When I desaturated the reds in the Hue/Saturation layer, this adjustment was clipped to the same mask as the one used for the Curves adjustment.

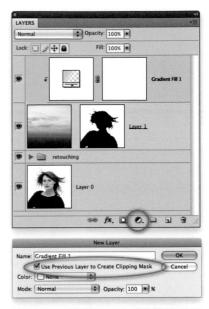

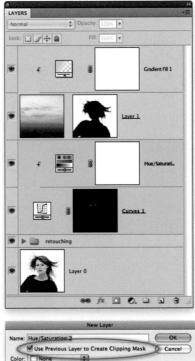

Copacity: 100 * %

Multiple layer opacity adjustments

With Photoshop CS5 if you make a selection of layers, you can use the Opacity or Fill adjustment to adjust the values for all the layers in a layer selection. However, you need to be aware that a multiple layer selection opacity adjustment will override any adjustments already made to individual layers. There are a few restrictions though. In the case of layer groups you'll only be allowed to make opacity changes, and locked layers won't allow changes for either Opacity or Fill. Where these restrictions apply in a layer selection, the most restrictive layer controls which fields are available to edit. So if you try this out and it doesn't appear to work, it may be because you have a locked layer selected.

Layer linking

When working with two or more layers you can link them together by creating links via the Layers panel. Start by *Shift*-clicking on the layers to select contiguous layers, or **H** *ctrl*-clicking to select discontiguous layers. At this point you can move the selected layers, apply a transform or make the layers form a new layer group. However, if you need to make the layer selection linking more permanent, the layers can be formally linked together by clicking on the Link button at the bottom of the Layers panel (Figure 9.36). When two or more layers are linked by layer selection or formal linking, any moves or transform operations are applied to the layers as if they were one. However, they still remain as separate layers, retaining their individual opacity and blending modes. To unlink them, select the layer (or layers) and click on the Link button to turn the linking off.

Selecting all layers

You can also use the **H A** *ctrl alt* **A** shortcut to select all layers (except a Background layer) and make them active.

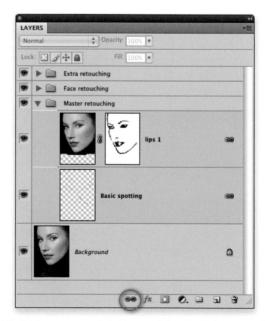

Figure 9.36 To link two or more selected layers, click on the Link button at the bottom of the Layers panel (circled).

Layer selection using the move tool

When the move tool is selected and the 'Auto-Select' and 'Layer' options checked in the move tool options, you can auto-select layers by clicking or dragging in the image (Figure 9.37), plus you can use the contextual menu to auto-select specific layers (Figure 9.38). You can also use H C ctrl alt + right mouse-click to auto-select layers when the move, marquee, lasso or crop tool are selected.

Auto-select shortcut

If 'Auto-Select Layer' is unchecked, you can toggle the behavior by holding down the **(H)** *(ctrl)* key as you click or drag using the move tool.

Figure 9.37 When 'Auto-Select Layer' is checked, you can marquee drag with the move tool from outside the document bounds to make a layer selection of all the layers within the marqueed area, but the move tool marquee must start from outside the document bounds, i.e. you must start from the canvas area and drag inwards. In the example shown here, the 'Auto-Select' and 'Group' options were checked and only the layer groups that came within the marquee selection were selected by this action.

Figure 9.38 When the move tool is selected, you can use the contextual menu to select individual layers. Mouse down on the image using *ctrl* right mouse-click to access the contextual menu shown here and click to select a named layer. The contextual options will list all of the layer groups in the document plus just those layers within the layer group (indented) that are immediately below the mouse cursor.

Selecting Similar layers

The 'Select Similar Layers' option allows you to select layers that are of a similar kind, i.e. if a type layer is selected, the 'Select Similar Layers' option will select all other type layers in the document.

Move tool alignment options

The alignment options are also integrated into the move tool Options bar. To find out more about layer alignment and distribution, refer to pages 514–517.

Client: Hitachi/Ogilvy & Mather Direct. Model: Lidia @ MOT.

Layer mask linking

Layer masks and vector masks are linked by default to the layer content and if you move a masked layer or transform the layer content, the mask is adjusted along with it (as long as no selection is active). When the Link button () is visible, you know the layer and layer mask are linked. It can sometimes be desirable to disable the link between the layer mask/vector mask and the layer it is masking. When you do this, movements or transforms can be applied to the layer or layer/vector mask separately. You can tell if the layer, layer mask or vector mask are selected, as a thin black dashed border surrounds the layer, layer mask or vector mask icon.

1 This photograph contained a clouds layer that had been masked by the outline of the trees. The layer and layer mask are normally linked and here you can see a dashed border surrounding the layer mask, which meant that the layer mask was currently active.

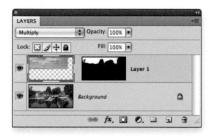

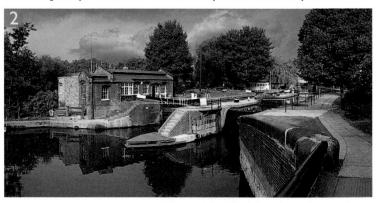

2 I then clicked on the link icon between the layer and the layer mask, which disabled the link between the mask and the layer. Now, when the layer was selected (note the dashed border around the layer thumbnail) I was able to move the sky layer independently of the layer mask.

Layer locking

The layer locking options can be found at the top of the Layers panel just below the blending mode options. Photoshop layers can be locked in a number of ways. To apply one of the locking criteria listed below, you need to first select a layer and then click on one of the Lock buttons. These have a toggle action, so to remove the locking, just click on the button again.

Lock Transparent Pixels

When Lock Transparent Pixels is switched on (Figure 9.39), any painting or editing you do will be applied to the opaque portions of the layer only. Where the layer is transparent or semi-transparent, the level of layer transparency will be preserved.

Lock Image Pixels

The Lock Image Pixels option (Figure 9.40) locks the pixels to prevent them from being edited (with, say, the brush tool or clone stamp). If you attempt to paint or edit a layer that has been locked in this way, you will see a prohibit warning sign. This lock mode does still allow you to move the layer contents though.

Lock Layer Position

The Lock Layer Position option (Figure 9.41) locks the layer position only. This means that while you can edit the layer contents, you won't be able to accidentally knock the layer position with the move tool or apply a Transform command.

Lock All

You can select combinations of Lock Transparent Pixels, Lock Image Pixels, and Lock Layer Position, plus you can also check the Lock All option (Figure 9.42). When this option is selected, the layer position is locked, the contents cannot be edited and the opacity or blend modes cannot be altered. However, the layer can still be moved up or down the layer stack.

The above options mainly refer to image layers. With non-pixel layers you can only choose to lock the layer position or lock all.

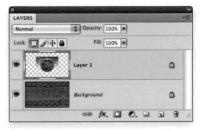

Figure 9.39 This shows the Layers panel with a Layer 1 image layer above the Background layer. Lock Transparent Pixels prevents you accidentally painting in the layer's transparent areas.

LAYERS		++ ≠≣
Normal	Opacity: 100%	
Lock:	Fill: 100%	
• 0	Layer 1	۵
9 Anti-	Background	۵
ar an dimension and the second	se fx, 🖸 🛛	

Figure 9.40 Lock Image Pixels prevents you accidentally painting on any part of the layer.

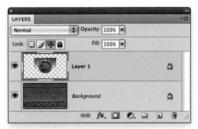

Figure 9.41 Lock Layer Position prevents the layer from being moved when you edit it.

Figure 9.42 The Lock All box locks absolutely everything on the layer.

Image Layer	Select	Filter	Analysis	3D	View	W
Mode		•	an colorador a			10.04
Adjustments		•				
Auto Tone Auto Contrast Auto Color	ቴሳ ቴሳፓ ቴሳ	¢L				
Image Size Canvas Size	87 87					
Image Rotation	an Berlinson	D	180°	and the	anizoust	Sur.
Crop			90° CW			
Trim			90° CCW			
Reveal All			Arbitrary			
Duplicate Apply Image Calculations			Flip Canvas Flip Canvas			
Variables Apply Data Set.		Þ				
Trap						

Figure 9.43 The Image \Rightarrow Image Rotation submenu. This menu can be used to rotate or flip the entire image.

Undo Load Selection	¥KZ		
Step Forward	0.367		
Step Backward	Ϋ́́́́́́́́́́́́́́́́́́́́́́́́́́́́́́́́́́́		
Content-Aware Scale Puppet Warp			
Free Transform	жT		
Transform Auto-Align Lavers	Þ	Again	ΩℋT
Auto-Blend Lavers	1	Scale	
		Rotate	
Define Brush Preset		Skew	
Define Pattern		Distort	
Define Custom Shape.		Perspecti	Ve
		Warp	
Purge	•		
Adobe PDF Presets		Rotate 18 Rotate 90	
		Rotate 90	
Preset Manager		Rotate 90) CCW
Color Settings	Ω.#K	Flip Horiz	ontal
Assign Profile	LOOK	Flip Verti	
Convert to Profile	1	rip veru	
Keyboard Shortcuts	て企業K		
Menus	℃企¥6 M		
Special Characters	THI		

Figure 9.44 The Edit

→ Transform submenu. This menu can be used for transforming and rotating individual layers or linked groups of layers.

Transform commands

The Image menu provides a choice of options in the Image Rotation submenu to rotate or flip an image (Figure 9.43). You can use these commands to flip or rotate the whole image 180°, such as when a photo has been scanned upside down.

The Transform commands are all contained in the Edit \Rightarrow Transform menu (Figure 9.44) and these allow you to apply transformations to individual or linked groups of layers. There are three main ways you can apply a transform. You can select a layer or make a selection of the pixels that you wish to transform and choose either Edit \Rightarrow Transform or Edit \Rightarrow Free Transform. Also, whenever the crop tool or one of the selection tools is active, the Free Transform command is available via the contextual menu. Just *ctrl* right mouse-click on a layer and select 'Free Transform'. The other option is to check the Show Transform Controls box in the move tool Options bar (Figure 9.45). The main Transform commands include: Scale, Rotate, Skew, Distort and Perspective, and these can be applied singly or combined in a sequence before clicking *Enter*, or double-clicking within the Transform bounding box to OK the transformation (which is applied using the default interpolation method selected in the Photoshop preferences to calculate the new transform shape or position).

You can apply any number of tweaking adjustments before applying the actual transform and you can at any time use the Undo command (**H** *C ctrl C*) to revert to the last defined transform preview setting. You can also adjust the transparency of a layer during mid-transform. This means that you can modify the opacity of the layer as you transform it (this can help you align a transformed layer to the other layers in an image).

Of all the options, the 'Free Transform' option is probably the more versatile and the one you will want to use most of the time. Choose Edit \Rightarrow Free Transform or use the **HT** ctrl to keyboard shortcut and modify the transformation using the keyboard controls as indicated on the following pages.

Figure 9.45 The transform options are also available via the move tool Options bar.

1 You can rotate, skew or distort an image in one go using the Edit ⇒ Free Transform command. The following steps show you some of the modifier key commands that can be used to constrain a Free Transform adjustment.

2 You can place the cursor outside the bounding border and drag in any direction to rotate the image. If you hold down the *Shift* key as you drag, this constrains the rotation to 15° increments. You can also move the center axis point to change the center of the rotation.

4

3 If you hold down the **H** *ctrl* key as you click any of the handles of the bounding border, this allows you to perform a free distortion.

4 If you want to constrain the distortion symmetrically around the center point of the bounding box, hold down the signal key as you drag any handle.

5 To skew an image, hold down the **Shift** ctrl Shift keys and drag one of the side handles.

Photograph by Davis Cairns. Client: Red or Dead.

6 To carry out a perspective distortion, hold down the Shift ctrl all Shift keys in unison and drag on one of the corner handles. When you are happy with any of the new transform shapes described here, press Enter or Return or double-click within the Transform envelope to apply the transform. Press esc if you wish to cancel.

Repeat Transforms

After you have applied a transform to an image layer or image selection, you can get Photoshop to repeat the transform by going to the Edit menu and choosing: Transform \Rightarrow Again (the shortcut here is **#***Shift* **7** *ctrlShift* **7**). This can be done to transform the same layer again, or you can use this command to identically transform the contents of a separate layer. I generally find the Transform Again command is most useful when I need to repeat a precise transform on two different layers. There is an example coming up on pages 515–517 that shows a creative application of the Free Transform command, where it was used to create a kaleidoscope pattern effect from a single image.

201

Chapter 9

Numeric Transforms

When you select any of the Transform commands from the Edit menu, or check 'Show Transform Controls' in the move tool options, the Options bar displays the Numeric Transform commands shown below in Figure 9.46. The Numeric Transform options allow you to accurately define any transformation as well as choose where to position the centering reference point position. For example, the Numeric Transform can commonly be used to change the percentage scale of a layer. You just enter the scale percentages in the Width and Height boxes. If the Constrain Proportions link icon is switched off you can set the width and height independently. You can also change the central axis for the transformation by repositioning the black dot (circled). In it's default position a numeric transform will take place around the central axis. If you were to click on the top left corner, you can have all transforms (including numeric transforms) default to taking place around the top left axis of the image.

Manually setting the transform axis

Layers, selections and masking

In addition to the simplified Option bar icon for determining the transform axis, you can move the transform bounding box center point anywhere by dragging to place it where you need it to be.

K 312.5 px Δ Y: 236.0 px W: 100.0% B H: 100.0% Δ 0.0 * H: 0.0 * V: 0.0 *

Figure 9.46 This shows the move tool Options bar in Transform mode. The same Options bar controls are seen when a selection is active and you choose Select \Rightarrow Transform Selection.

Transforming selections and paths

You can also apply transforms to Photoshop selections and vector paths. For example, to transform a selection, choose Select \Rightarrow Transform Selection (note: if you choose Edit \Rightarrow Transform, this transforms the selection contents). Transform Selection works just like the Edit \Rightarrow Free Transform command. You can use the exact same modifier key combinations to scale, rotate and distort the selection outline. Or, you can use *ctrl* right mouse-click to call up the contextual menu of transform options. With Transform Selection, you can modify a selection shape quite effortlessly.

Whenever you have a pen path active, the Edit menu switches to Transform Path mode. You can then use the Transform Path commands to manipulate a completed path or a group of selected path points (the path does not have to be closed). But remember, you won't be able to execute a transform on an image layer (or layers) until after you have deselected any active paths.

Expand/Contract selections

The Select \Rightarrow Modify menu contains 'Expand...' and 'Contract...' menu options. These allow you to expand or contract a selection. One of the downsides of using this approach is that when you enlarge a rectangular selection in this way, you'll end up with rounded corners. If instead, you use the Transform Selection method, you will be able to preserve the sharp corners of a rectangular selection.

Arrange, Align and Distribute shortcuts

Note here that all the Layer menu and Layers panel shortcuts are listed in a separate appendix which is available on the DVD as a PDF document.

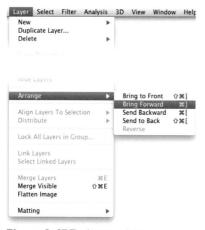

Figure 9.47 The Layer \Rightarrow Arrange submenu.

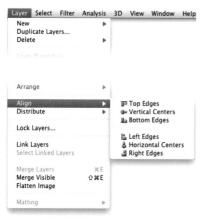

Transforms and alignment

When you have more than one layer in an image, the layer order can be changed via the Layer \Rightarrow Arrange submenu (Figure 9.47), which can be used to bring a layer forward or send it further back in the layer stacking order, plus you can also use the following keyboard shortcuts. Use **H** [1] ctrl [1] to bring a layer forward and **H** [1] ctrl [1] to send a layer backward. Use **H** Shift [1] ctrl Shift [1] to bring a layer to the front and **H** Shift [1] ctrl Shift [1] to send a layer to the back.

If two or more layers are linked, these can be aligned in various ways via the Layer \Rightarrow Align menu (Figure 9.48). To use this feature, first make sure the layers you want to align are selected, linked together, or are in a layer group. The Align commands can then be used to align the linked layers using the different rules shown in the submenu list, i.e. you can align to the Top, Vertical Centers, Bottom, Left, Horizontal Centers or Right Edges, and the alignment will be based on whichever is the top-most or left-most layer, etc. There is also the Distribute submenu, which contains an identical list of options to the Align menu, but is only accessible if you have three or more layers selected, linked, or in a layer group. The Distribute commands allow you to distribute layer elements evenly based on either the Top, Vertical Centers, Bottom, Left, Horizontal Centers or Right axes. So for example, if you had three or more linked layer elements and you wanted them to be evenly spread apart horizontally and you also wanted the distance between the midpoints of each layer element to be equidistant, you would select all the layers and choose Layer \Rightarrow Distribute \Rightarrow Horizontal Centers.

Rather than use the layer menu options you can also click on the Align and Distribute buttons in the move tool Options bar (Figure 9.49). Generally, I would say the Align and Distribute features are perhaps more useful for graphic designers, where they might need to precisely align image or text layer objects in a Photoshop layout.

►	Auto-Select: Layer	Far 1833 232 1444 #
a harmon and it		

Figure 9.49 This shows the move tool Options bar in alignment/distribution mode. Note that the alignment options (shaded blue) will only become available when two or more layers are selected and the distribution options (shaded green) are only available when three or more layers are selected.

Using transforms to create a kaleidoscope pattern

1 The following steps show how I created a kaleidoscope image from a single shoe image that was cut out using a vector mask (see pages: 536–538).

2 I dragged and placed this layer in a new image document, with the layer aligned to the guides shown here. I then converted the layer to a Smart Object (I did this by going to the Layers panel fly-out menu and chose 'Convert to Smart Object').

Photograph by Davis Cairns. Client: Red or Dead.

3 I duplicated the Smart Object layer by dragging it to the New Layer button in the Layers panel. I then selected 'Free Transform' from the Edit menu and positioned the central axis point on the point where the two guides crossed, and dragged outside the bounding box to rotate the layer. I held down the **Source** key as I did this to constrain the rotation to $4 \times 15^{\circ}$ increments (i.e. I rotated it 60°).

4 I repeated this exercise four more times until I ended up with the kaleidoscope pattern image shown here. You can also apply such Repeat Transforms using the **#** *Shift* **T** *ctrl Shift* **T** keyboard shortcut.

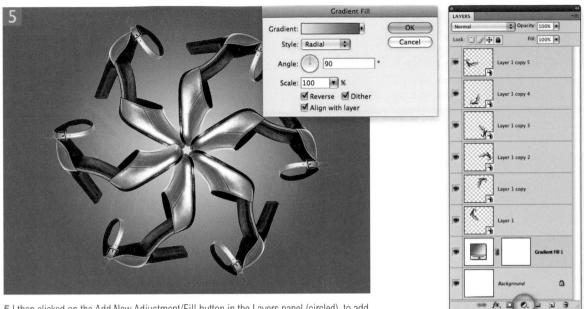

5 I then clicked on the Add New Adjustment/Fill button in the Layers panel (circled), to add a radial Gradient Fill layer just above the Background layer using the colors shown here.

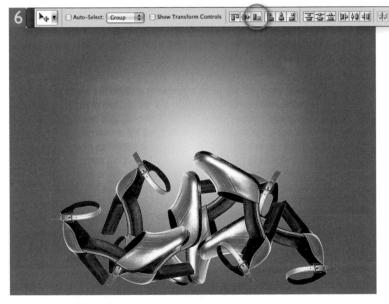

6 Lastly, just for fun, I selected all the shoe layers and clicked on the Align Bottom Edges button in the move tool Options bar. This aligned all the shoe layers to the layer with the bottom-most edge.

Warp transforms

When the Warp Transform first appeared in Photoshop it provided a perfect solution for all those Photoshop users who had longed for a means to carry out direct, on-canvas image warping. The Warp Transform is therefore more like an extension of the Free Transform. All you have to do is to select the 'Free Transform' option from the Edit menu and then click on the Transform/ Warp mode button (circled in Figure 9.50) to toggle between the Free Transform and Warp modes. The beauty of this is that you can combine a free transform and warp distortion into a single pixel transformation. It has to be said that the magic of the Warp Transform has been somewhat superseded by the new Puppet Warp adjustment, but it is still nonetheless a useful tool.

When the 'Warp' option is selected you can control the shape of the warp bounding box using the bezier handles at each corner. The box itself contains a 3×3 mesh and you can click in any of the nine warp sectors, and drag with the mouse to fine-tune the warp shape. What is also great about the warp transform is the way that you can make a warp overlap on itself (as shown on the page opposite).

You can only apply Warp Transforms to a single layer at a time, but if you combine layers into a Smart Object, you can apply nondestructive distortions to multiple layers at once. For more about working with Smart Objects see pages 528–531.

Warp transforms are better suited for editing large areas of a picture where the Liquify filter is less able to match the fluid distortion controls of the warp transform. For example, the warp transform can be used on fashion photographs to change the shape of a portion of the image. However, as I just mentioned, the new Puppet Warp (see pages 520–525) is now also worth considering as an ideal tool for this type of image manipulation work.

None

1 Bend: 50.0 % H: 0.0 % V: 0.0 %

Figure 9.50 To apply a Warp Transform you need to select a layer or an image selection and choose Edit \Rightarrow Transform \Rightarrow Warp. Alternatively, choose Edit \Rightarrow Free Transform ((3)) and click on the Transform/Warp mode selection button (circled) in the Options bar. Once this is selected, you will be in the default Custom warp mode, but you can also select from any of the preset warp mode options that are listed in the Warp menu on the left. When you select one of these preset options, you can adjust the warp settings using the Options bar controls.

101

0 1

1 The easiest way for me to illustrate the power of the Warp Transform is to take a made-up flag layer and use the custom warp controls to distort the flag shape to make it appear as if it were flapping in the wind. In the Layers panel view shown here, you can see that I had the flag layer and a shadow layer above it. I began by selecting both these layers before converting them into a Smart Object.

Normal	Opacity: 100%	
Lock:	Fill: 100%	
	flag pole	
•	Layer 1	۵
• 🔀	flag layer	
•	Background	۵
	ee fx 🖸 O. 🗆 🖬	3

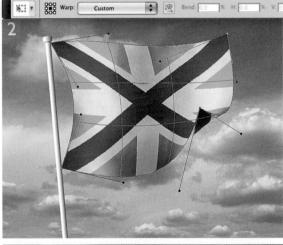

10

Custom

Bend: 0.0

96 H: 0.0 % V: 0.

2 I then went to the Edit menu and selected Edit \Rightarrow Transform \Rightarrow Warp. The default option is the 'Custom' mode, where I had access to the bezier control handles at the four corners of the warp bounding box. These could be adjusted in the same way as you would manipulate a pen path to control the outer shape of the warp. Here, I was able to drag the corner handles and click inside any of the nine sectors and drag with the mouse to manipulate the flag Smart Object layer, just as if I were stretching the image on a rubber canvas.

3 I was able to adjust the warp so that the flag was twisted in on itself to reveal the reverse side of the flag. You will notice below how the distorted flag existed as a Smart Object layer, where the two layers that make up the flag design were both warped in unison.

Including soft edges

The Puppet Warp mesh is mostly applied to all of the selected layer contents, including the semi-transparent edges, even if only as little as 20% of the edge boundary is selected. And if this fails to include all the desired edge content you can always adjust the Expansion setting to include more of the layer edges.

Puppet Warp

The Puppet Warp is available from the Edit menu whenever you are editing a normal, non-background layer in Photoshop. This is a truly outstanding new feature for anyone who uses Photoshop for retouching work. While the Liquify filter is great, the main benefits of working with the Puppet Warp tool are that the warp response feels that much more intuitive and responsive. As you edit the pins, the other elements of the photograph appear to warp in a way that can help the warping effect look more natural. The other advantage is that you can edit layers directly in Photoshop without having to do so via a modal dialog. Or rather, it seems to be non-modal whereas in fact the Puppet tool is really still modal – it's just that you are able to work on a layer directly rather than via a dialog interface, as is the case with Liquify.

The only way to truly appreciate Puppet Warp is to watch a movie demo, such as the one on the DVD, or better still, try it out for yourself. Puppet Warp offers three rigidity modes of operation. The Normal mode applies a standard amount of flexibility to the warp movement between the individual pins, while the Rigid mode is more stiff and good for bending things like human hands. The Distort mode provides a highly elastic warp mode which can be good for warping wide-angle photographs.

The Puppet Warp function is based on an underlying triangular mesh. The Normal default Density setting can be changed to show more or fewer points via the Puppet Warp tool Options bar (Figure 9.51) – the Normal setting is the best one to choose in most instances. The 'More points' Density setting allows for more precise warping control but at the expense of speed since the processing calculations are more intense. A 'Fewer points' Density setting allows you to work faster, but you may also get unpredictable or unusual warp results. There is also a 'Show Mesh' option that allows you to show or hide the mesh visibility. The next thing to do is to add some pins to the mesh. These can be applied anywhere, but it is important that you add at least three pins before you start manipulating the layer, since the more pins you add, the

Rigidity mode Mes options	sh density Transform options expansion		Pin depth options	Set pin rotation	Remove all pins button
Mode: Rigid Density: No	ermal + Expansion: 15 px	Show Mesh Pin Depth	to the test	tuto 🗘 🔽 +	001

Figure 9.51 The Puppet Warp tool Options bar.

more control you'll have over the Puppet Warp editing. The thing to bear in mind here is that as you move a pin, other parts of the layer will move accordingly, and perhaps do so in ways that you hadn't expected. This isn't a bug, this is the Puppet Warp tool intelligently working out how best to distort the layer. As you add more pins to different parts of the layer you will find that you gain more control over the Puppet Warp distortions. The keyboard arrow keys can also be used to nudge the selected pin location, but if you make a mistake with the addition or placement of a pin you can always use the Undo command (**#** Z *ctrl* Z), or hold down the alt key to reveal the scissors cursor icon and click on a pin to delete it. Or, you can simply select a pin and hit the *Delete* key. In order to further tame the Puppet Warp behavior, you can use the Expansion setting to modify the area covered by the mesh, since this can have the effect of dampening down the Puppet Warp responsiveness. This can be considered essential if you want to achieve manageable distortions with the Puppet Warp. The default setting of 2 pixels allows for precise control over the warp distort movements, but this won't help with every image. In the Puppet Warp example that's shown over the next few pages I found it necessary to use a more expanded mesh, since without this the Puppet Warp distortions became rather unwieldy. This was especially noticeable when I tried setting the Expansion setting to 1 pixel or less. If you find that your Puppet Warps feel uncontrolled, then try increasing the Expansion amount.

Pin rotation

The Rotate menu normally defaults to 'Auto'. This rotates the mesh automatically around the pins based on the selected mode option. However, when a pin is selected you can hold down the **(a)** key and hover the cursor over a pin, which reveals the rotation circle that also allows you to set the pin rotation manually (see Figure 9.52). Be careful though, because if you happen to **(a)** *(a)* -click a pin, this will delete it. As you rotate a pin, the rotation value shows in the tool Options bar. This extra level of control allows you to twist sections of an image around a (movable) pin point as well as alter the degree of twist between this and the other surrounding pins. In the case of the puppet image over the page it can give you better control over the angle of the strings. See also Figure 9.53, which shows you the pin contextual menu options.

Multiple objects

If you have multiple objects on a layer, the Puppet Warp mesh is applied to everything on that layer. However, you can apply separate adjustments to each of the layer elements.

Figure 9.52 If you hold down the **S** all key and hover the mouse over an already selected pin, this shows a pin rotation circle that you can adjust to twist the rotation of the selected pin.

Figure 9.53 This shows the pin contextual menu, which offers quick access to a list of useful options associated with modifying the pins added using the Puppet Warp feature (ctr)-click or use a right mouse-click to reveal the contextual menu shown here).

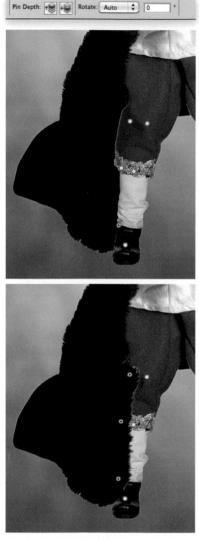

Figure 9.54 The pin depth controls allow you to move the selected pin positions on a Puppet Warp selection up or down. This allows you to control whether certain image areas slide in front of or behind other areas of the image.

Pin depth

The pin stacking order can be changed by clicking on the buttons in the tool Options bar. Where a Puppet Warp distortion results in elements overlapping each other, you can decide which section should go on top and which should go behind. You can either click on the move up or move down buttons shown in Figure 9.54, or use the **1** key to bring a pin forward and use the **1** key to send a pin backward (or use the pin contextual menu shown in Figure 9.53). Basically, this is a mechanism that allows you to determine whether warped elements should go in front of or behind other elements in a Puppet Warp selection.

Multiple pin selection

You can select multiple pins by *Shift*-clicking the individual pins. Once these are selected, you can drag them as a group using the mouse, or use the arrow keys to nudge their positions. You can *Shift*-click again to deselect an already selected pin from a selection. Note though that operations which affect a single selected pin, such as rotation and pin depth, are disabled when multiple pins are selected.

While in Puppet Warp mode, you can also use $\texttt{H} \land \texttt{ctrl} \land$ (or the contextual menu) to select all the current pins and you can use the $\texttt{H} \bigcirc \texttt{ctrl} \bigcirc$ shortcut to deselect all pins. Also, if you hold down the \biguplus key, you can temporarily hide the pins, but leave the mesh in view.

Smart Objects

If you convert a layer to a Smart Object before you carry out a Puppet Warp transform, this will allow you to re-edit the Puppet Warp settings (something you can't do with Liquify). You can also use the Puppet Warp feature to edit vector or type layers. However, if you apply the Puppet Warp command to a type or vector layer directly, the Puppet Warp process automatically rasterizes the type or vector layer to a pixel layer. Therefore, in order to get around this I suggest you select the layer and choose Filter \Rightarrow Convert to Smart Filters first, before you select the Puppet Warp command.

Now for a quick run through of the Puppet Warp in action, for which I chose to use an image of what else, but a puppet!

Chapter 9 Layers, selections and masking

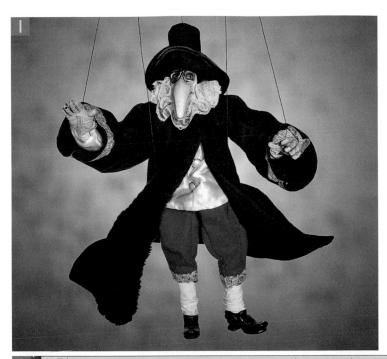

1 The first step was to add the puppet image as a separate layer. One can use the Puppet Warp tool on a complete layer, but it's really designed to function at its best when editing a cut-out layered object such as a type or vector layer or, as in this case, a cut-out pixel image layer. Before doing anything else though, I converted the targeted layer to a Smart Object.

001

:

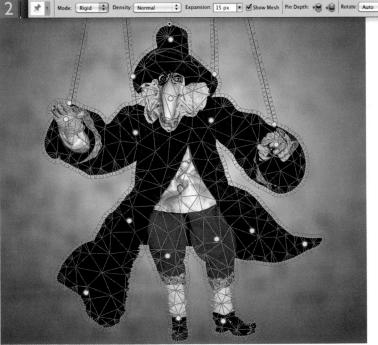

2 I made sure the puppet layer was selected, then went to the Edit menu and chose 'Puppet Warp'. You'll notice here how this step added a triangular mesh to the layer contents and the Tool options bar revealed the options for the Puppet tool. Here, I chose the 'Rigid' rigidity mode and 'Normal' Density option for the mesh. I also set the Expansion option to 15 pixels, as this would give me better control over the warp adjustments. If the Expansion setting was left at the default 2 pixel setting, the strings would bend all over the place. I should also point out that the Expansion setting is dependent on the image pixel size, so although 15 pixels was correct for the full resolution version I edited here, you would need to use a lesser setting when editing the lower resolution test image that's on the DVD. I was then ready to start adding some pins. As was mentioned in the main text, the more pins you add, the more control you have over the warping effect.

3 I was now ready to start warping the layer. All I had to do was to click to select a pin and drag to reshape the image. The interesting thing to note here is that as you move one part of the layer, other parts adjust to suit.

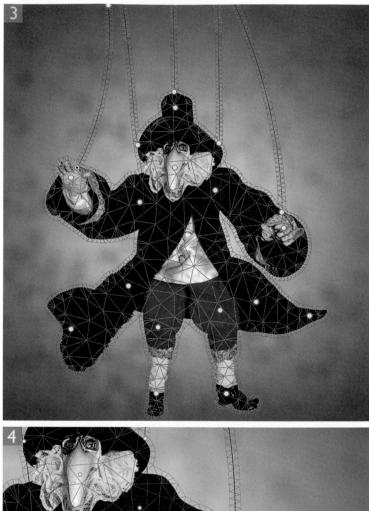

4 As I clicked and moved the pins I was able to create the desired distortion effect. In this close-up view you can see I had moved an arm so that it intersected one of the coat tails. In this instance it was necessary to click on the move upward Pin Depth button (circled) to bring the sleeve of the puppet's left arm in front of the coat tail.

Mode: Rigid Density: Normal

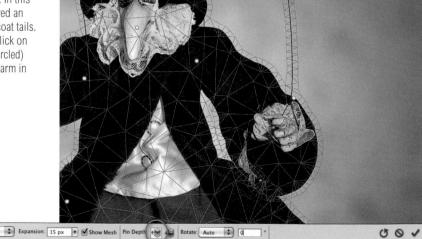

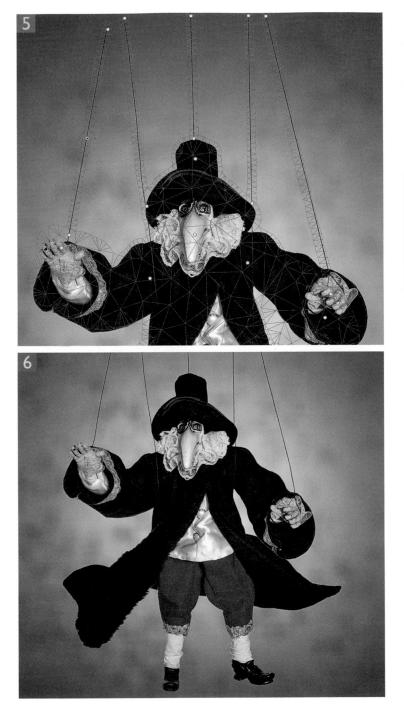

5 What is particularly interesting with this image (and you'll notice this better if you work with the demo image that's on the DVD) is how as I moved different parts of the puppet's body, the puppet strings moved accordingly. In order to counter this, I clicked on the pins that were at the bottom and top of the strings and rotated them to remove the curvature. With some of the strings, such as the one highlighted here, I added an extra mid point and rotated this to make the string even straighter.

6 When I was done, all I had to do was to hit the *Enter* key. Now, because I had prepared this layer as a Smart Object you'll notice how the Puppet Warp adjustment was added as a Smart Filter in the Layers panel. This meant that if I wanted to re-edit the puppet warp settings, I could do so by double-clicking the Puppet Warp Smart Filter and carrying on editing.

Drag and drop a document to a layer

With Photoshop CS5 it is now possible to drag and drop a file onto an open Photoshop document to create a new layer. This applies to all types of image documents and the main thing is that the image file you wish to place in this way must be of a compatible file format. In other words, you can only place image files such as TIFFs, JPEGs, Adobe PDFs, Adobe Illustrator AI files or as in the example shown below, you can also use this method to place a raw DNG image file.

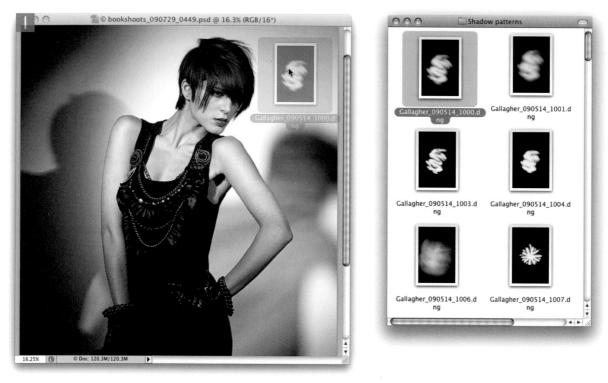

1 In Photoshop CS5 it is now possible to drag a document to an image document window that's open in Photoshop and place the dragged document as a new Smart Object layer. You can drag and drop a document via Bridge or, as shown here, directly via the Finder/ Explorer.

2 In this example I dragged and dropped a DNG file to add it as a layer in the targeted document. When you place a layer in this manner you will be placing it as a Smart Object. First of all you will see the Place Image bounding box as shown here. This allows you to scale the image before committing to the placement, but of course, since this is going to be a Smart Object, one can rescale the layer at any time without degrading the image. I should also mention that since I was placing a raw file this action opened the Camera Raw dialog and allowed me to edit the image file's raw settings before the final placement.

3 Here is a final version of the image in which you can see that I placed the layer centrally and added a layer mask to the placed layer so that I could paint to hide some of the layer contents. Because the newly added layer was placed as a Camera Raw Smart Object, I could double-click this layer at any time to reopen the Camera Raw dialog and re-edit the layer contents.

Screen	Opacity	99%
Lock:	🕂 🕂 🖬 🛛 Fill	100%
•		allagher_090
•	Background	۵

2

Smart Filters

If you go to the Filter menu, there is an option there called 'Convert for Smart Filters'. What this does is to convert a selected layer to a Smart Object, which is no different from choosing 'Convert to Smart Object' from the Layers panel fly-out menu. With Smart Objects you can apply most Photoshop filters, but not all (including some third-party filters). However, you can enable all filters to work with Smart Objects by loading the 'EnableAllPluginsforSmartFilters.jsx' script. I'll be explaining how this is done later, in Chapter 10.

Smart Objects

One of the main problems you face when editing pixel images is that every time you scale an image or the contents of an image layer, the pixel information becomes degraded, and if you make cumulative transform adjustments, the image quality degrades quite rapidly. If you convert a layer or a group of layers into a Smart Object (Figure 9.55), this stores the layer (or layers) data as a separate image document within the master image. The Smart Object data is therefore 'referenced' by the parent image and edits that are applied to the Smart Object layer (such as a transform adjustment) are applied to the proxy only, instead of to the pixels that actually make up the layer.

With Smart Object layers you can use any of the transform adjustments described so far (including Warp Transforms) plus you can also apply filters to a Smart Object layer (known as Smart Filtering). What you can't do is edit a Smart Object layer directly using, say, the clone stamp tool or paint brush, but you can doubleclick a Smart Object layer to open it as a separate image document, where you can then apply all the usual edit adjustments before closing it, after which the edit changes are updated in the parent document.

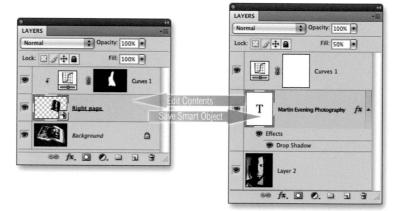

Figure 9.55 You can promote any layer or group of layers to become a Smart Object. A Smart Object becomes a fully editable, separate document stored within the same Photoshop document. The principal advantage is that you can repeatedly scale, transform or warp a Smart Object in the parent image without affecting the integrity of the pixels in the original Smart Object document.

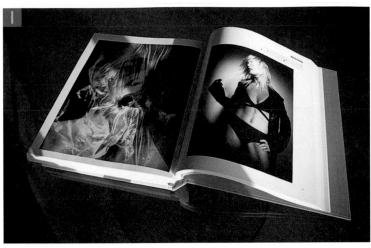

1 We'll now examine in more detail how you would use a Smart Object in Photoshop. Here is a photograph of a book that shows a couple of my promotional photographs, where let's say I wanted to place the male portrait image shown on the right so that it matched the scale, rotation and warp shape of the photograph on the right-hand page.

2 I used the move tool to drag the photograph across to add it as a new layer and then went to the Layers panel options and chose 'Convert to Smart Object'. This action preserved all the image data on this layer in its original form. I then went to the Edit menu and chose 'Free Transform'. Because the layer boundary exceeded the size of the Background layer, I had to zoom out in order to access the corner handles of the Transform box.

In these situations it is useful to remember that you can use the **HO** *ctr***O** keyboard shortcut to quickly zoom out just far enough to reveal the transform bounding box handles.

3 I then scaled the Smart Object layer down in size so that it more closely matched the size of the photograph on the page. I also dragged the cursor outside the transform bounding box, in order to rotate the photograph roughly into position.

4 After that, I clicked on the Warp button in the Options bar (circled). This allowed me to fine-tune the position of the Smart Object layer, by using the corner curve adjustment handles to modify the outer envelope shape. I then moused down inside some of the inner sections and dragged them so that the inner shape also matched the curvature of the page.

5 I was then able to edit the Smart Object layer any way I liked. To do this, I went to the Layers panel fly-out menu and selected 'Edit Contents'. (An alternative option was to simply double-click on the Smart Objects layer in the Layers panel). In the example shown here, I added a Text layer plus a Curves adjustment layer to turn the photograph blue. I then closed the window, and as I did so this popped the prompt dialog shown here, reminding me to click 'Save' in order to save and update the master Smart Object layer.

6 Here is the final image in which I added a Curves adjustment layer in a clipping group with the Smart Object layer so that the shading matched that of the original photograph on the page.

Selections to paths

An active selection can also be converted to a path by clicking on the 'Make work path from selection' button at the bottom of the Paths panel. Alternatively, you can choose the 'Make work path' option from the Paths panel fly-out menu.

Photoshop paths

The selection tools are mostly nice and easy to work with, but there will be times when the standard selection tools just won't give you the precision you are after and you'll really need a more accurate way to define an outline. This is where the pen tools and vector paths come in.

Granted, it's not easy to master the pen tool, but if you are planning to work with large files you will find it quicker to draw a path and convert this to a selection rather than rely on the selection and paint tools alone. Figure 9.56 shows a summary of how a pen path can be converted to a selection or a vector mask that isolates an object.

Figure 9.56 This illustration shows how an active path can be converted to a selection. You can also use a path to make a vector mask (from the Layer menu choose Add Vector Mask \Rightarrow Current Path). Also highlighted here are the Paths panel buttons. The Fill path button fills the current path using the current foreground color. The Stroke path button strokes the current path using a currently selected painting tool. The Load path as selection button converts a path to a selection. Clicking the Create new path button creates a new empty path and you can remove a path by clicking the Delete path button.

Path modes

The pen tool has three operating modes, of which there are only two modes that you should really be interested in using. If the pen tool is in Shape Layers mode (Figure 9.57), when you draw with the pen tool this creates a vector mask path outline that masks a solid fill layer filled with the current foreground color. If you click on the Paths mode button in the pen tool Options bar this allows you to create a pen path without adding a fill layer to the document. You can of course use any path outline to generate a vector mask, so I usually suggest you keep the pen tool in the default Paths mode and leave it set like this.

Drawing paths with the pen tool

Unless you have had some previous experience of working with a vector-based drawing program (such as Adobe Illustrator), drawing with the pen tool will probably be an unfamiliar concept. It is difficult to get the hang of at first, but I promise you this is a skill that's well worth mastering. It's a bit like learning to ride a bike, once you have acquired the basic techniques, everything else should soon start to fall into place. Paths can be useful in a number of ways. The main reason why you might want to use a pen path would be to define a complex shape outline, which in turn can be applied as a vector mask to mask a layer, or be converted into a selection. You can also create clipping paths for use as a cut-out outline in a page layout, or you can use a path to apply a stroke using one of the paint tools.

Pen path drawing tutorial

To help you understand how to draw pen paths we shall start with the task of following the simple contour shapes illustrated in Figure 9.58. You will find a copy of this image as a layered Photoshop file on the DVD and it contains saved path outlines of each of the shapes. The Background layer contains the Figure 9.58 'd' shaped image and above it there is another layer of the same image but with the pen path outlines and all the points and handles showing. I suggest you make this layer visible and fade the opacity as necessary. This will then help you to follow the handle positions when trying to match the path outlines. Let's begin at the basic level with the 'd' shape (Figure 9.59). If you have learnt how to draw with the polygon lasso tool, you will have

Figure 9.57 The Shape Layers mode has in the past been the default setting in the pen tool options. The Paths mode button is now the new default in Photoshop CS5.

Figure 9.59 With this example all you need to do is to click with the pen tool to create a series of straight line segments.

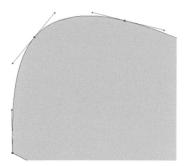

Figure 9.60 To draw a curved segment, instead of clicking, mouse down and drag as you add each point. The direction and length of the handles define the shape of the curve between each path point.

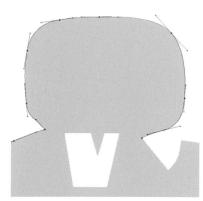

Figure 9.61 When you create a curved segment the next handle will continue to predict a curve, continuing from the last curved segment. To make a break, you need to modify the curve point by converting it to a corner point. To do this, hold down the real key, click on the path point and drag to create a new predictor handle going off in a new direction.

no problem drawing this path outline. Click on the corner points one after another until you reach the point where you started. As you approach this point you will notice a small circle appears next to the cursor, which indicates you can now click to close the path. Actually this is better than drawing with the polygon lasso, because you can zoom in if required and precisely reposition each and every point. To do this, hold down the **H** *cttl* key to temporarily switch the pen tool to the direct selection tool and drag a point to realign it precisely. After closing the path, hit **H** *Enter cttl Enter* to convert the path to a selection, or click *Enter* on its own to deselect the path.

Now try to follow the 'h' shape (Figure 9.60). This will allow you to concentrate on the art of drawing curved segments. Note that the beginning of any curved segment starts by you dragging the handle outward in the direction of the intended curve. (To understand the reasoning behind this, imagine you are trying to define a circle by following the imagined edges of a square box that contains the circle). To continue a curved segment, click and hold the mouse down while you drag to complete the shape of the end of the previous curve segment (and predict the initial curve angle of the next segment). This last sentence is written assuming that the next curve will be a smooth continuation of the last. If there happens to be a sharp change in direction for the outline you are trying to follow you will need to add a corner point. You can convert a curved anchor point to a corner point by holding down the **C** alt key and clicking on it. Click to place another point and this will now create a straight line segment between these two points. Now, if you hold down the (# ctrl key you can again temporarily access the direct selection tool and reposition the points. When you click on a point or a segment with this tool, the handles are displayed and you can use the direct selection tool to adjust these and refine the curve shape.

With the 'v' shape (Figure 9.61) you can further practice making curved segments and adding corner points. These should be placed whenever you intend the next segment to break with the angle of the previous segment. In the niches of the 'v' shape, hold down the *segment* and drag to define the predictor handle for the next curve segment.

Pen tool shortcuts summary

To edit a pen path, you can use the \mathfrak{M} *ett* key to temporarily convert the pen tool to the direct selection tool, which you can use to click on or marquee anchor points and reposition them. You can use the \mathfrak{M} *alt* key to convert a curve anchor point to a corner anchor point (and vice versa). If you want to convert a corner point to a curve, you can \mathfrak{M} *alt* + mouse down and drag. To change the direction of one handle only, you can \mathfrak{M} *alt* drag on a handle. To add a new anchor point to an active path, you simply click on a path segment with the pen tool, and to remove an anchor point, you click on it again (these shortcuts are outlined again in Figure 9.62 opposite).

You can edit a straight line or curved segment by selecting the direct selection tool, clicking on the segment and dragging. With a straight segment the anchor points at either end will move in unison. With a curved segment, the anchor points remain fixed and you can manipulate the shape of the curve as you drag with the direct selection tool.

Rubber Band mode

There are a number of occasions where I find it necessary to use the pen tool to define an outline and then convert the pen path to a selection. In the end, the pen tool really is the easiest way to define many outlines and create a selection from the path. One way to make the learning process somewhat easier is to switch on the Rubber Band option which is hidden away in the Pen Options on the pen tool Options bar (Figure 9.63). In Rubber Band mode, you will see the segments you are drawing take shape as you move the mouse cursor and not just when you mouse down again to define the next path point. As I say, this mode of operation can make path drawing easier to learn, but for some people it can become rather distracting once you have got the basic hang of how to follow a complex outline using the various pen tools.

0.	00		0	0	18	•	Auto Add/	Delete	
					Pen C				

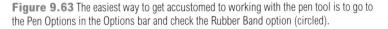

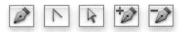

Figure 9.62 Shown here are the main tools you need to edit any pen path. However, with the pen tool (left) selected, you can access all of these tools without actually switching tools in the Tools panel. To add new continuing anchor points to an existing path just click with the pen tool. Instead of selecting the convert point tool (second along) you can use the alt shortcut, and instead of selecting the direct select tool (third along) you can use the (# ctrl key. To add an anchor point to an existing path, rather than select the add anchor point tool (fourth along) you can simply click on a path segment. To delete an anchor point, rather than select the delete anchor point tool (fifth along), you can click on an existing anchor point using the pen tool.

Nudging with the arrow keys

When an anchor point is selected and you need to position it accurately, it can be nudged using the arrow keys on the keyboard.

Hiding/showing layer/vector masks

You can temporarily hide/show a layer mask by *Shift*-clicking on the layer mask icon. Also, clicking a vector mask's icon in the Layers panel hides the path itself. Once hidden, hover over it with the cursor and it will temporarily become visible. Click it again to restore the visibility.

Vector masks

A vector mask is just like an image layer mask, except the mask is described using a vector path (Figure 9.64). A vector mask is therefore resolution-independent and can be transformed or scaled in size without any loss in quality and the mask can be edited using the pen path or shape tools. To add a vector mask from an existing path, go to the Paths panel, select a path to make it active, and choose Layer \Rightarrow Add Vector Mask \Rightarrow Current Path. Alternatively, you can go to the Masks panel and click on the 'Add vector mask' button (see Figure 9.23 on page 470).

▶ Show Bounding Box 日日日日 Combine 可切> 12 日本日 苦苦当 即约相

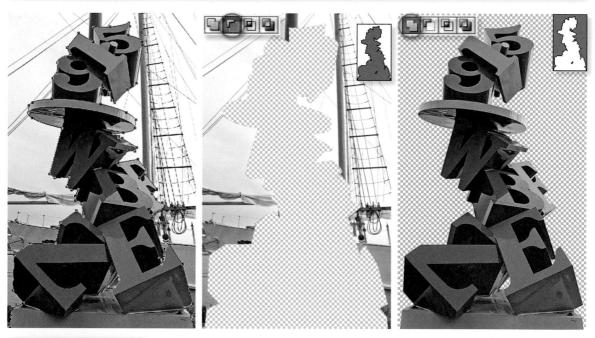

Normal 2	Opacity: 100%
Lock:	Fill: 100% •
•	Layer 0
sa fx OI 🔊	

Figure 9.64 A vector mask can be created from a currently active path such as the one displayed here in the image on the left. The path mode influences what is hidden and what is revealed when the path is converted into a vector mask, and if a path has been created in the 'subtract from path area' mode (as in the middle example), the area inside the path outline is hidden. If the path is created in the 'add to path area' mode (as in the right-hand example) the gray fill in the path icon represents the hidden areas, where everything outside the path outline is hidden. However, it is very easy to alter the path mode. Select the path selection tool (shown above), and click on the path to make all the path points active. You can then click on the path mode buttons in the Options bar to switch between the different path modes.

Isolating an object from the background

Let's now look at a practical example of where you might want to use a vector path to mask an object in preference to using a pixel layer mask. Remember, one of the benefits of using a vector mask is that you can use the direct path selection tool to manipulate the path points and fine-tune the outline of the vector mask.

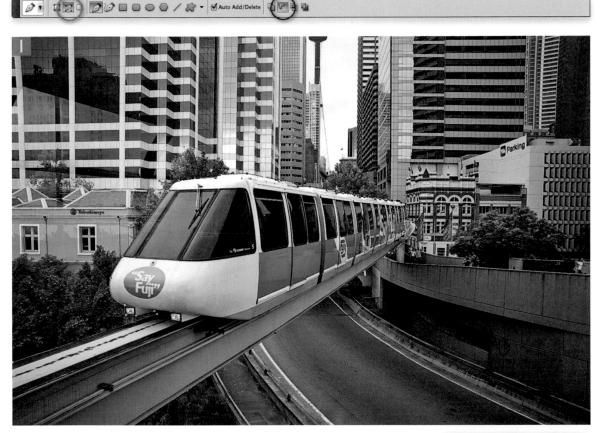

1 Here I used the pen tool to define the outline of the train and the mono rail. Note that the pen tool was in the path mode (circled green in the Options bar). Also, because I wanted to create a path that selected everything outside of the enclosed path, I checked the Subtract from Path Area button (circled in red) before I began drawing the path. When the path was complete, I went to the Paths panel, double-clicked the 'Work Path' name and clicked OK to rename it as 'Path 1' in the Save Path dialog. This saved the work path as a new permanent path. It is important to remember here that a work path is only temporary and will be overwritten as soon as you deselect it and create a new work path.

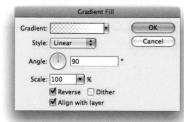

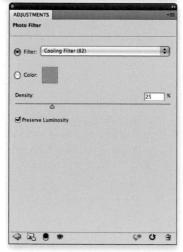

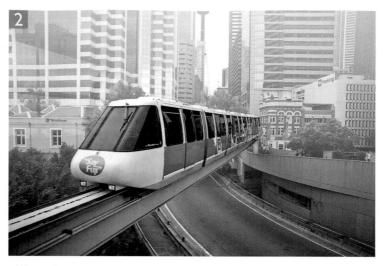

2 With the Path 1 active, and white as the foreground color in the tools panel, I clicked on the Add New Adjustment Layer button in the Layers panel and selected the Gradient Fill option. I chose the foreground color (white) to transparency gradient and added this as a linear gradient using the settings shown here. This added a fog effect to the scene and as you can see, the vector mask prevented the Gradient Fill adjustment from being applied to the train and the mono rail.

3 To make the scene look a little more like winter, I added a Photo Filter adjustment sandwiched between the Background layer and the Gradient Fill layer, then selected a cooling filter color from the Filter menu options.

Chapter 10

Essential Filters for Photo Editing

ne of the key factors behind Photoshop's success has been the program's support for plug-in filters. A huge industry of third-party companies has grown in response to the needs of users wanting extra features

within Photoshop. Instead of covering all the hundred or more filters that are supplied in Photoshop, I have just concentrated here on those filters that I believe are useful for photographic work, everyday production jobs and creative output. I also show you ways you can use the Smart Filters feature to extend your filtering options as well as the new improved Lens Correction filter in Photoshop CS5.

RGB only filters

You will notice that most of the effects filters work in RGB mode only. This is because they can have such a dramatic effect on the pixel values and would easily send colors way out of the CMYK gamut if they were made available while working in CMYK. To unleash the full creative power of Photoshop plug-ins, you really do need to edit in RGB mode.

Filter essentials

Most Photoshop filters provide a preview dialog with slider settings that you can adjust, while some of the more sophisticated plug-ins (such as the Lens Correction filter) are like mini applications operating within Photoshop. These have a modal dialog interface, which means that whenever the filter dialog is open, Photoshop is pushed into the background which can usefully free up already-assigned keyboard shortcuts. With so many effects filters to choose from in Photoshop, there are plenty enough to experiment with. The danger is that you can all too easily get lost endlessly searching through all the different filter settings. There is not enough room to describe every Photoshop filter here, but we shall look at a few of the ways filters can enhance an image, highlighting those that are most useful.

16-bit filters

Photoshop supports a limited number of filters in 16-bit. However, most of the essential filters, such as those used to carry out standard production image processing routines, are all able to run in 16-bit mode.

Blur filters

There are 11 different blur filters in the Filter \Rightarrow Blur submenu and each allows you to blur an image differently. You don't really need to bother with the basic Blur and Blur More filters, but what follows are some brief descriptions of the blur filters I do think you will find useful.

Adding a Radial Blur or Spin Blur to a photo

The Radial Blur can do a good job of creating blurred zoom and spin motion effects. For example, the Zoom blur mode, shown in Figure 10.1, can do a neat simulation of a zooming camera lens, while the Spin blur mode, shown in Figure 10.2, can be used to apply a circular spin effect (I also used a Spin Radial blur to add movement to the car wheels in Step 3 on page 543). The Radial Blur filter may sometimes appear to be sluggish, but it is after all carrying out major distortions of the image. For this reason you are offered a choice of render settings. For top quality results, select the Best mode, but if you just want to see a quick preview of the whole image area, I suggest you select the Draft mode option.

Essential filters for photo editing

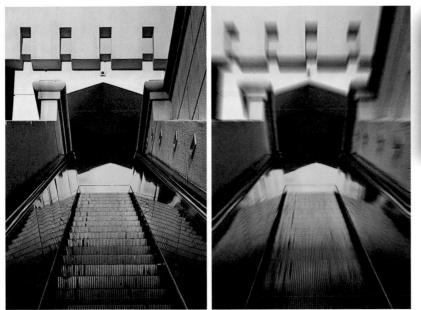

Amount 25	ОК
Blur Method:	Cancel
O Spin	Blur Center
 Zoom 	
Quality:	
⊖ Draft	
⊖ Good	
Best	Enduring

Figure 10.1 When using the Radial Blur filter in Zoom mode, you can create fast zoom lens effects such as in the example shown here on the right. You can also drag the center point in the filter preview dialog to approximately match the center of interest in the image you are about to filter.

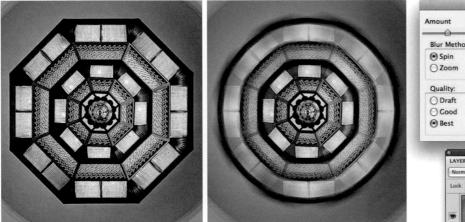

Figure 10.2 When you use the Radial Blur filter in Spin mode, you can apply a circular spin blur effect such as the example shown on the right. Again, you can drag the center point in the filter dialog to match the center of interest of the image you are about to filter.

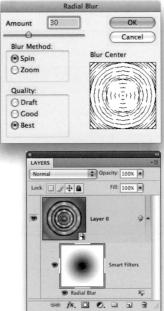

Figure 10.3 The Average Blur can be used to merge the pixels within a selection to create a solid color which can then be used to take an accurate sample color measurement of the average color within that selection area.

Add Noise	
	OK Cancel Preview
100% Amount: 3 % Distribution Uniform Gaussian	
Monochromatic	

Figure 10.4 The Noise \Rightarrow Add Noise filter can be used to add artificial noise to an image. It is particularly useful whenever you wish to disguise banding that may have been caused through excessive use of the Gaussian Blur filter.

Average Blur

The Average Blur simply averages the colors in an image or a selection. At first glance it doesn't do a lot, but it is still a useful filter to have at your disposal. Let's say you want to analyze the color of some fabric to create a color swatch for a catalog. The Average filter merges all the pixels in a selection to create a solid color and you can then use this to sample with the eyedropper tool to create a new Swatch sample color (see Figure 10.3).

Gaussian Blur

The Gaussian Blur is a good general purpose blur filter and can be used for many purposes from blurring areas of an image to softening the edges of a mask. The Gaussian Blur can sometimes cause banding to appear in an image, which is where it may be useful to use the Noise \Rightarrow Add Noise filter afterwards (Figure 10.4).

Motion Blur

The Motion Blur filter can be used to create an effective impression of blurred movement. It adds a Linear Blur that spreads in both directions and you can use the filter dialog sliders to control the angle of the blur as well as the distance of the blur spread. In the example that's shown here, I used the Motion Blur filter to add blurred movement to a static photograph of a car.

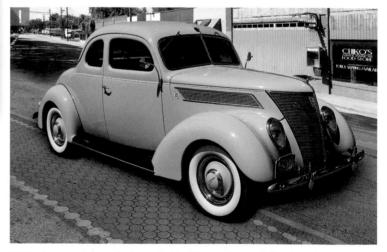

1 This shows a photograph of a car that had been cut out and placed as a new layer against a street scene. While the perspective and shadowing may have looked correct, we don't get any sense of movement in this picture.

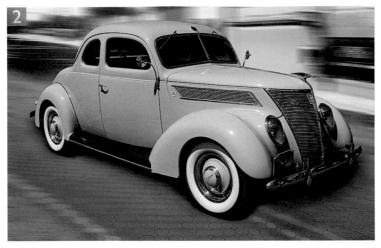

2 Next, I converted the Background layer to a Smart Filter layer (essentially a Smart Object), chose Filter \Rightarrow Blur \Rightarrow Motion Blur and applied a 236 pixel blur at an angle of -3° . This blurred the entire backdrop layer and began to give the impression of movement in the picture.

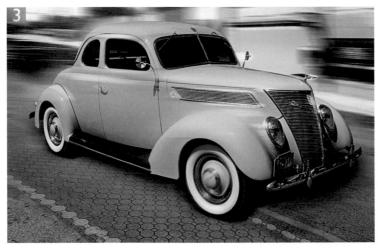

3 To get the car movement to look more realistic, I did several more things. I applied a gradient mask to the background Smart Object layer so that the motion blur appeared strongest in the distance. I then duplicated the car cut-out layer and applied a 100 pixel Motion Blur filter. I also duplicated this layer and applied a 400 pixel Motion Blur filter. I moved both layers slightly so that they trailed behind the car, faded the opacity of the softer blur layer and added a layer mask to each so that I could selectively remove some of the motion blur areas. Lastly I selected each of the wheels, copied each one to a new layer, used a Free Transform to make them circular and then used the Spin Radial Blur filter to add circular movement. I then reversed the transform on each layer so that I ended up with a convincing circular spin on each of the wheels.

OK Cancel ✓ Preview Angle: -3 °	Motion Blur	
		Cancel

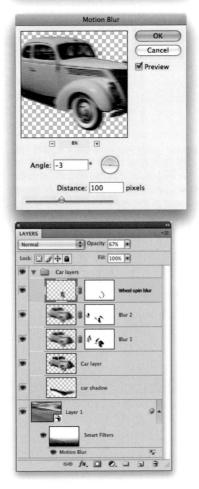

Martin Evening Adobe Photoshop CS5 for Photographers

Figure 10.5 This shows from top to bottom, the Surface Blur, Box Blur and Shape Blur filters applied to the same image.

Surface Blur

This might be considered to be an edge preserving blur filter. The Radius adjustment is identical to that used in the Gaussian Blur filter, so the higher the Radius, the more it blurs the image. Meanwhile, the Threshold slider determines the weighting given to the neighboring pixels and whether these become blurred or not. Basically, as you increase the Threshold this extends the range of pixels (relative to each other) that become blurred. So as you increase the Threshold, the flatter areas of tone are the first to become blurred and the high contrast edges remain less blurred (until you increase the Threshold more).

Box Blur

The Box Blur uses a quite simple algorithm to produce a squareshaped blur. It is a fairly fast filter and is useful for creating quick 'lens blur' type effects. It is also useful for creating certain types of special effects. The Box Blur is no match for the power of the Lens Blur filter, but it is nonetheless a versatile and creative tool.

Shape Blur

The Shape Blur filter lets you specify any shape you like as a kernel with which to create a blur effect and you can then adjust the blur Radius accordingly. In Figure 10.5 (bottom image) I selected a lightning bolt shape to simulate a camera shake effect using this filter.

Fade command

Filter effects can be further refined by fading them after you have applied the filter. The Fade command is referred to at various times in the book (you can also fade image adjustments and brush strokes, etc.). Choose Edit ⇒ Fade Filter and experiment with different blending modes. The Fade command is almost like an adjustment layer feature, but without the versatility and ability to undo later. It makes use of the fact that the previous undo version of the image is stored in the undo buffer and allows you to calculate many different blends but without the timeconsuming expense of having to duplicate the layer first. Having said all that, the History feature offers an alternative approach whereby if you filter an image once, or more than once, you can return to the original state and paint in the future (filtered) state using the history brush or make a fill using the filtered history state (provided 'Non-linear History' has been enabled in the History panel options).

Figure 10.6 The best way to learn how to use the blur filters discussed here is to experiment with an image like the one shown here (which is available on the DVD). In this night-time scene there are lots of small points of light; you can use this image example to get a clear idea of how the Specular Highlights and Iris controls work, and observe how they affect the appearance of the blur in the photograph.

Enabling Lens Blur as a Smart Filter

Smart Filters are mainly intended for use with value-based filters only, such as the Add Noise or Unsharp Mask filter. They are not intended for use with filters such as Lens Blur because the Lens Blur filter can sometimes make calls to an external alpha channel, and if the selected alpha channel were to be deleted at some point, this would prevent the Smart Filter from working.

However, so long as you are aware of this limitation, it is still possible to enable Smart Filters to work with filters like Lens Blur. Go to the File \Rightarrow Scripts menu in Photoshop CS5 and choose 'Browse...'. This opens a system navigation window and from there you will want to use the following directory path: Adobe Photoshop CS5 folder/Scripting/ Sample Scripts/Javascript and select: EnableAllPluginsforSmartFilters.jsx. Once you have located this script, you can click 'Load' or double-click to run it, which will then pop the Script Alert dialog shown in Figure 10.7. If you wish to proceed, click 'Yes'. The Lens Blur, as well as all other filters, will now be accessible for use as Smart Filters. If you want to turn off this behavior, run through the same above steps and click 'No' when the Script Alert dialog shows.

Figure 10.7 The Script alert dialog.

Lens Blur

If you want to make a photograph appear realistically out of focus, it is not just a matter of making the detail in the image more blurred. Consider for a moment how a camera lens focuses a viewed object to form an image that is made up of circular points on the film/sensor surface. When the radius of these points is very small, the image is considered sharp and when the radius is large, the image appears to be out of focus. It is also particularly noticeable the way bright highlights tend to blow out and how you can see the shape of the camera lens iris in the blurred highlight points. The Lens Blur filter has the potential to mimic the way a camera lens forms an optical image and the best way to understand how it works is to look at the shape of the bright lights in the nighttime scene in Figure 10.6, which shows the image before and after I applied the Lens Blur filter.

The main controls to concentrate on are the Radius slider, which controls the amount of blur that is applied to the image and the Specular Highlights slider, which controls how much the highlights blow out. To add more lens flare, increase the Brightness slightly and carefully lower the Threshold amount by one or two levels and check to see how this looks in the preview area. The Iris shape controls should be regarded as fine-tuning sliders that govern the shape of the out-of-focus points in the picture. You can select from a menu list of different iris shapes and then use the Blade Curvature and Rotation sliders to tweak the iris shape. The results of these adjustments will be most noticeable in the blownout highlight areas. If you want to predict more precisely what the Lens Blur effect will look like it is better to have the More Accurate button checked.

Depth of field effects

With the Lens Blur filter you can also use a mask channel to define the areas where you wish to selectively apply the Lens Blur. This allows you to create shallow depth of field effects, such as in the example shown on the right. Basically, you can use a simple gradient (or a more complex mask even) to define the areas that you wish to remain sharp and those that you want to appear out of focus. You can then load the channel mask as a Depth Map in the Lens Blur dialog and use the Blur Focal Distance slider to determine which areas remain sharpest.

Chapter 10 Essential filters for photo editing

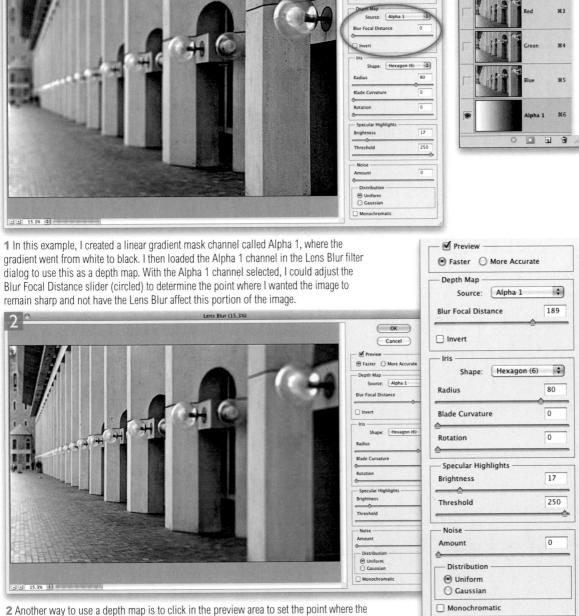

image should be sharpest. Basically, the degree of lens blur is linked to the gray values in the Depth Map source channel.

Lens Blur (15.3%)

Cancel Pr Faster
 More Accurate

(ОК)

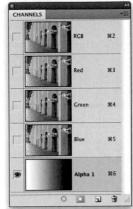

Applying Lens Blur to a composite image

Here is a short step-by-step example which shows how I applied the Lens Blur filter to make the background in this composite image appear out of focus. You will notice that I applied the Lens Blur filter here as a Smart Object (see pages 546 and 550–555).

1 In the following steps I took two separate photographs and created a mask for the outline of my wife in the picture on the left, and placed this as a new layer above a photograph of the Chicago skyline.

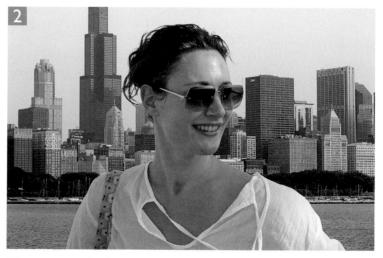

2 As you can see, when the two images were merged, the buildings in the background looked too sharp. So in preparation for applying the Lens Blur filter, I selected the Chicago skyline layer, went to the Filter menu and chose 'Convert for Smart Filters'. This was essentially the same thing as choosing Layer \Rightarrow Smart Objects \Rightarrow Convert to Smart Object. Do read the side panel notes on enabling Smart Objects to work with the Lens Blur filter (page 546), before proceeding to the next step.

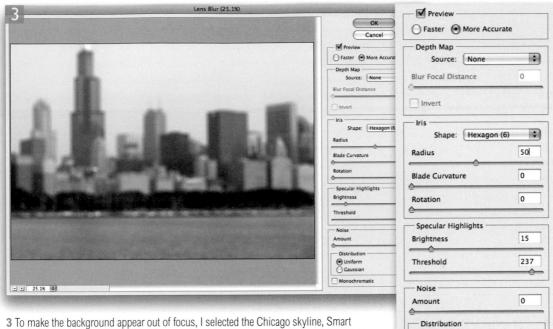

3 To make the background appear out of focus, I selected the Chicago skyline, Smart Filter layer and chose Filter \Rightarrow Blur \Rightarrow Lens Blur. Here, I adjusted the Specular Highlights Threshold setting, bringing it down just enough until the highlights started to bloom. I then adjusted the Specular Highlights Brightness setting to create the desired amount of lens flare. The Iris Radius slider was used to control the width of the blur (the effect of this adjustment was particularly noticeable in the specular highlights).

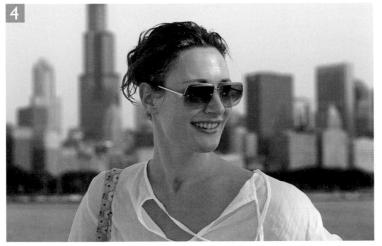

4 This shows the finished result, where you can see the Lens Blur Smart Filter attached to the Smart Object layer. The advantage of this approach is that I retained the ability to re-edit the Lens Blur filter settings and vary the background layer focus.

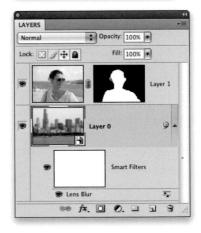

Uniform
 Gaussian

Monochromatic

Third-party plug-ins

With third-party plug-ins, you will find that those plug-ins that have been recently updated for Photoshop will have the embedded 'Smart Filter' marker that automatically makes them compatible with Smart Filters in Photoshop. If that isn't the case, then enabling all filters (as described on page 546) will help you get around such restrictions, but with the proviso that any filter you apply as a Smart Filter must be a 'value-based' filter if it is to fit in successfully with a Smart Filter workflow. Some Photoshop filters, as well as advanced third-party filters, require the use of things like external channels or texture maps in order to work correctly. Since this information can't be stored safely within the Smart Object itself, this can prevent a Smart Filter from working reliably.

Smart Filters

For many years now Photoshop users have requested the ability to apply live filters in the same way as you can apply image adjustments as adjustment layers. Smart Filters is the solution the Photoshop team came with and this feature can be particularly useful when working with the blur filters discussed in this chapter, because you may very often need the ability to re-edit the blur amount. I have already shown a couple of examples of Smart Filters in use with the Spin Blur and Motion Blur filters, plus there was the example on pages 548–549 where I showed how you can apply the Lens Blur filter as a Smart Filter.

When you go to the Filter menu and choose 'Convert for Smart Filters', you are basically doing the same thing as when you create a Smart Object. So, if a layer or group of layers have already been converted to a Smart Object, there is no need to choose 'Convert for Smart Filters'. You can switch Smart Filters on or off, combine two or more filter effects, mask the overall Smart Filter combination as well as adjust the Smart Filter blending options. These allow you to control the opacity and blend modes for individual filters. As I have shown below in Figure 10.8, you can also group one or more layers into a Smart Object and filter the combined layers as a single Smart Object layer.

New Layer. ôЖN Duplicate Lavers... Delete Layer Delete Hidden Layers New Group. New Group from Layers... Lock Lavers Convert to Smart Objec Layer Properties. Blending Options. Edit Adjustment.. Create Clipping Mask 7.#C Link Layers lect L ked Layers Merge Layers ЖE Merge Visible **ŵ**₩E Flatten Image Animation Options ۲ Panel Options .. Close Close Tab Group

Double-click to edit a Smart Object

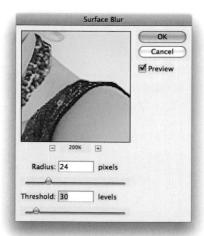

Figure 10.8 You can make a selection of more than one layer in a document and convert these into a Smart Object. From there you can add filter effects that are applied as Smart Filters to a composite version of all the selected layers. The multi-layered image can still be accessed and edited by double-clicking the Smart Object thumbnail.

Applying Smart Filters to pixel layers

Smart Filters are essentially filter effects that are applied to a Smart Object. The process begins with converting a layer or group of layers to a Smart Object, or selecting a layer and choosing Filter ⇒ Convert for Smart Filters. Smart Filters allow you to apply most types of filter adjustments non-destructively. The following steps provide a brief introduction to working with Smart Filters, in which I show how you can also use Smart Filters to apply Shadows/Highlights adjustments non-destructively.

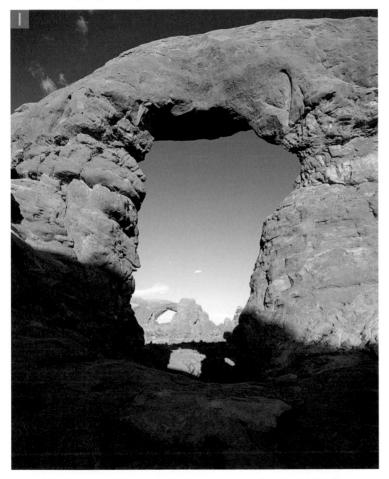

1 To apply a Shadow/Highlight adjustment as a non-destructive Smart Filter, the Background layer (or a group of layers) had first to be converted to a Smart Object. To do this I went to the Filter menu and chose 'Convert for Smart Filters'. This converted the Background layer to a normal, Layer 0 layer.

Pros and cons of Smart Filters

The appeal of Smart Filters is that you can apply any filter non-destructively to an image in Photoshop, but this flexibility comes at the cost of larger file sizes (making the file size four to five times bigger), plus a slower workflow switching between the Smart Object and parent documents, and longer save times. This has been my experience when working with a fast computer with lots of RAM memory. This is not the first time we have come across speed problems like this. We have in the past seen other new Photoshop features that are a little ahead of themselves and we have to wait for the computer hardware to get faster before we can use them comfortably. While Smart Filtering does offer true non-destructive filtering, it is a technique you probably want to use sparingly. In this book I have highlighted a few of the situations where Smart Filters may offer some benefit, like the example shown on pages 548-549 where I blurred the backdrop layer.

Adobe Photoshop CS5 for Photographers

Shadows			OK
Amount:	70	%	Cance
Tonal Width:	35	%	Load.
Radius:	300	px	Save.
-	Û	-	Preview
Highlights			
Amount:	80	%	
	Û	-	
Tonal Width:	35	%	
Radius:	140	px	
Adjustments			
Color Correction:	+10		
Midtone Contrast:	+25		
	0.01		
Black Clip:		-	
White Clip:	0.01	%	
Save As Defaults			

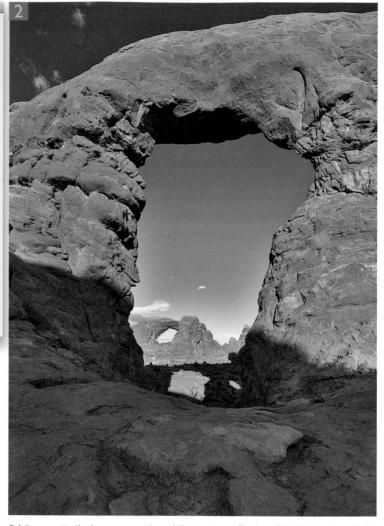

2 I then went to the Image menu, chose Adjustments \Rightarrow Shadows/Highlights and applied the settings shown here. As you can see, I used the Shadows/Highlights adjustment to bring out more detail in both the shadows and the highlights. If you check the Layers panel you will notice that the Shadows/Highlights adjustment added a Smart Filter layer to the layer stack. I could now click the eye icon to switch this adjustment on or off.

Chapter 10 Essential filters for photo editing

Opacity: 100% •

LAYERS Normal

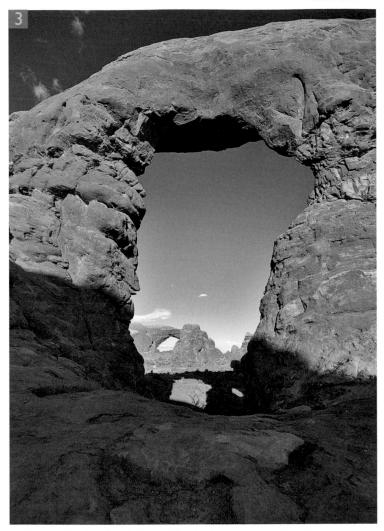

 Lock:
 +
 Fill:
 100X +

 Fill:
 100X +

 Smart Filters
 Smart Filters

 Shadows/Highlights

 Blending Options (Shadows/Highlights)
 OK
 Opacity:
 OK

 Opacity:
 70 %
 Cancel
 Image: Preview

50%

3 When I double-clicked on the Smart Filter blend options button (circled in green), this opened the Blending Options dialog, which allowed me to reduce the opacity of the Smart Filter adjustment to 70% (if I wanted to I could also change the blend mode here as well). I then double-clicked the Smart Object layer itself (circled in red) to edit the layer contents separately. This popped the warning dialog shown right, which indicated that any subsequent changes that I might make to the Smart Object image would need to be saved before closing the document window. It also reminded me that I should always save to the same location (in practice this should never be an issue, so long as you always use the File \Rightarrow Save command rather than File \Rightarrow Save As...)

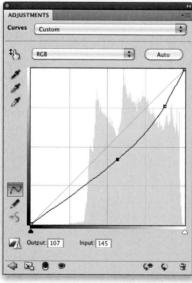

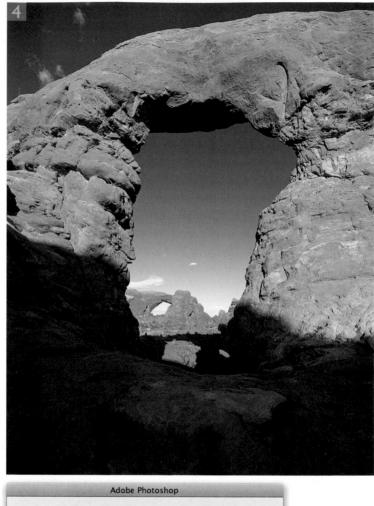

	Adobe Photoshop	
Ps	Save changes to the Adobe Photoshop document "Layer 0.psb" before closing?	
	Don't Save Cancel Save	

4 Here you can see the original Smart Object image document, but without the Shadow/ Highlight Smart Filter adjustment. I could now edit this document as one would do normally. If you look at the Layer panel for the Smart Object you will see that I added a spotting layer for the minor retouching work and a masked Curves layer that darkened the sky inside the main arch window. When I closed the document window a dialog box prompted me to choose 'Save'. As I pointed out in Step 3, this must be done in order to save the Smart Object adjustments back to the parent document.

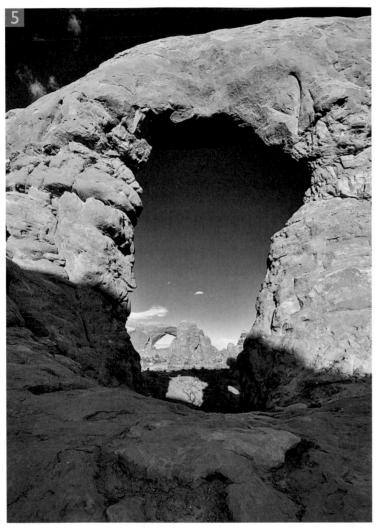

5 Here is the final version in which you can now see a combination of the image adjustments applied to the Smart Object image mixed in with the Shadows/Highlights adjustment that I applied as a Smart Filter. In addition to this, I added a Black & White layer to convert the image to black and white and I also added a Curves adjustment layer to pump up the contrast slightly in the shadows. The key lesson here is that all of the adjustments I had just applied to this photograph remained fully editable.

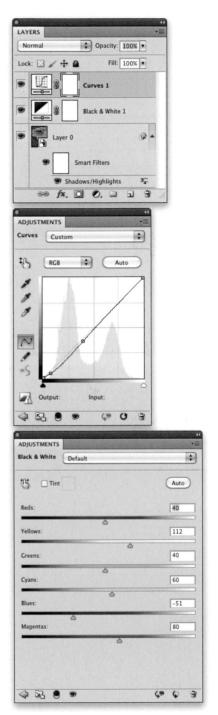

Ragged borders with the Refine Edge adjustment

The latest improvements to the Refine Edge command were primarily designed to provide improved edge masking. However, Gregg Wilensky who worked on Refine Edge discovered that one of the side effects of the new Refine Edge dialog is that it can also be used to create interesting ragged-edge borders that have a natural, darkroom-type look. The main point to bear in mind here is that you primarily use the Radius slider to create the main effect, and a wide Radius will usually work best with the 'Smart Radius' option disabled. Basically, the rough edges you see are actually based on the content of the image itself so it is the image content that is determining the outcome of the Refine Edge adjustment. The Feather, Contrast and Shift Edge adjustments can then be used to modify the main effect. In addition to this you can also select the extend edge brush tool and carefully paint along sections of the edge to further modify the border and generally roughen it up a little more. Above all you have to be patient as you do this and apply small brush strokes a little at a time, but the results you get can be pretty interesting.

1 The first step was to make a copy of the Background layer and fill the original Background layer with a solid color, such as white. I then made a rectangular marquee selection, went to the Select menu and chose Modify ⇒ Smooth and applied an appropriate Sample Radius (in this case 50 Pixels).

Essential filters for photo editing

2 I then went to the Select menu chose 'Refine Edge...' (# CF etr) all B) and in the Output To section I selected 'Layer Mask'. This automatically generated a pixel layer mask for the layer based on the current selection. The main controls I adjusted here were the Radius, to produce a wide border effect. The Contrast slider was used to 'crispen' the edges, Feather was used to smooth them slightly and a positive Shift Edge adjustment was used to expand the border edge. I also used the 'extend edge' brush (circled) to manipulate some sections of the border to create a rougher border.

3 Here you can see an alternative border effect in which I started with a rounded marquee selection that was closer to the edges of the photo. I filled the Background color with black and used a narrower Radius, a higher Contrast and a softer Feather adjustment to create a tighter border edge. As in Step 2, I also applied a few extend edge brush strokes to roughen the edge slightly.

		Refine Edge	e		
d ()	— View Moo		Show R		
	— Edge Det	Smart Radius			
	Radius:			66	px
	— Adjust E	dae			
		0		0	٦
	Feather:	0		0.0	рх
	Contrast:			40	%
	Shift Edge:			+25	%
	— Output –				
		Decontamin	ate Colors		
	Amount:				%
	Output To:	Layer Mask			\$
	Remembe	er Settings			
		Cancel		OK	Distant

	Refine Edge	
C 3	View Mode View: Show Radii Show Origi	
X	Edge Detection	5.0 px
	Adjust Edge 0	
	Feather:	рх
		0 % 20 %
	Output	
	Amount:	%
	Output To: Layer Mask	•
	Cancel	ок

Scanned image limitations

The chromatic aberration and vignetting adjustments are always applied relative to the centre of the image circle. In the case of digital capture images the auto correction adjustments will work precisely so long as the source image has not been cropped. In the case of scanned images things get a little trickier since the auto corrections will only work correctly if the source image has been precisely cropped to the exact boundaries of the frame.

Lens Corrections

The Photoshop Lens Correction filter has been promoted, so that instead of residing in the Filter \Rightarrow Distort submenu, it now appears at the top of the main Filter menu with its own shortcut (**H** Shift **R** ctrl Shift **R**). You will notice there are now two panel modes and the Auto Correction panel is shown by default (Figure 10.9). Here you'll find various options that are designed to correct for common lens problems, starting with the Correction section. The 'Geometric Distortion' option can be used to correct for basic barrel/pin-cushion distortion. Next we have the 'Chromatic Aberration', which can be used to counter the tendency some lenses have to produce color fringe edges towards the corners of the frame. Then there is the 'Vignette' removal option, which can be used to correct for darkening towards the edges of the frame, which is a problem most common with wide-angle lenses. Lastly, if you check the 'Auto Scale Image' option this ensures that the original scale is preserved as much as possible in the picture.

Basically, if you are about to apply an auto lens correction to an image that contains full EXIF metadata, this information will be used to automatically select an appropriate lens profile in the Lens Profiles section below. If the image you are editing is missing the EXIF lens metadata (i.e. it is a scanned photo) and you happen to know which camera and lens combination was used, you can use the Search Criteria section to help pinpoint the correct combination. It is important to appreciate here that the camera body selection is important. This is because some camera systems capture a fullframe image (therefore making full use of the usable lens coverage area, while the compact SLR range cameras mostly have sensors that capture a smaller area. The lens correction requirements will therefore vary according to which camera type is selected. Once you have the correct lens profile selected you can use the Preview button at the bottom of the screen to compare a before and after view of the auto lens correction.

Custom lens corrections

In Custom mode (Figure 10.10), the Geometric Distortion section contains a Remove Distortion slider that can correct for pin-cushion/ barrel lens distortion. Alternatively, you can click to select the distort tool and drag toward or away from the center of the image and adjust the amount of distortion in either direction. Overall, I find the Remove Distortion slider offers more precise control.

Chapter 10 Essential filters for photo editing

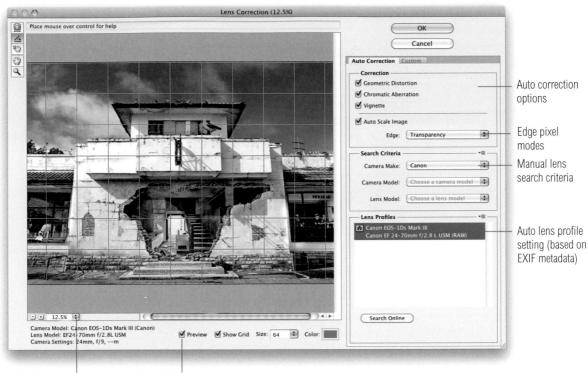

Preview zoom controls Show/hide preview

Figure 10.9 The Lens Correction filter dialog in the default Auto Correction mode.

The Chromatic Aberration section contains color fringe fixing sliders that are identical to those found in the Camera Raw Lens Corrections panel (see page 204), except there are three sliders for fixing red/cyan, green/magenta and blue/yellow fringing.

The Vignette section contains an Amount and a Midpoint slider which are also identical to those found in the Camera Raw Lens Corrections panel and these can be used to manually correct for any dark vignetting at the corners of the frame.

The Transform section controls let you correct the vertical and horizontal perspective view of a photograph, such as the vertical keystone effect you get when pointing a camera up to photograph a tall building, or correct the horizontal perspective where you haven't been photographing a subject straight on. You should only need to use these controls where you need the subject to appear perfectly square on, such as in the example shown on page 561.

Edge pixels

As you apply Lens Correction Transform adjustments, the shape of the image may change. This leaves the problem of how to render the outer pixels. The default setting uses the Transparency mode, although you can choose to apply a black or white background. Alternatively you can choose the Edge Extension mode to extend the edge pixels. This may be fine with skies or flat color backdrops, but is otherwise quite ugly and distracting, although the extended pixels may make it easier to apply the healing brush in these areas.

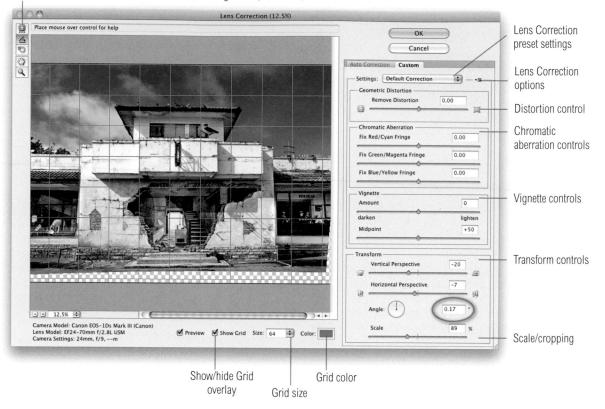

Lens Correction tools: distort tool; rotate tool; move grid tool; hand tool; zoom tool

Figure 10.10 The Lens Correction filter dialog in Custom mode.

You can adjust the rotation of an image in a number of ways. You can click and drag directly in the Angle dial, but I mostly recommend clicking in the Angle field (circled in Figure 10.10) and using the up and down keyboard arrow keys to nudge the rotation in either direction by small increments. The other option is to select the rotate tool and drag to define what should be a correct horizontal or vertical line. The image will then rotate to align correctly.

The Scale slider can be used to crop a picture as you apply a correction. On the other hand you may wish to reduce the scale in order to preserve more of the original image (as shown in Figure 10.10). The Show/hide Grid overlay can prove useful for helping you judge the alignment of the image and you can also use the move grid tool to shift the placement of the grid. The grid controls at

the bottom of the Lens Correction filter dialog also enable you to change the grid color and dynamically adjust the grid spacing, plus toggle showing or hiding the grid.

1 In this example I checked all the Auto Correction options to apply an auto lens correction to this photograph, which in this case was based on the EXIF metadata contained in the original photo (there is a layered version of this image on the DVD for you to compare).

2 I then switched to the Custom mode and applied a custom lens correction to further correct for the perspective angle this photograph was shot from. Basically, I adjusted the Vertical and Horizontal perspective sliders and made a minor adjustment to the angle of rotation. You'll also note that I adjusted the Scale slider to zoom out in order to preserve the sky at the top of the photograph.

uto Correction	Custom	
Geometric Disto	ortion	
Chromatic Aber	ration	
🗹 Vignette		
Auto Scale Imag	je	
Edge:	Transparency	•
- Search Criteria		•= -
Camera Make:	Canon	\$
Camera Model:	Choose a camera model	\$
Lens Model:	Choose a lens model	•
– Lens Profiles –		•= -
Canon EOS-1D		
Canon EF 24-7	70mm f/2.8 L USM (RAW)	
Search Online		

ettings: Default Correction	• - •
Geometric Distortion	
Remove Distortion	0.00
•	
Chromatic Aberration	
Fix Red/Cyan Fringe	0.00
Fix Green/Magenta Fringe	0.00
Fix Blue/Yellow Fringe	0.00
Vignette	
Amount	0
darken	lighten
Midpoint	+50
\$	+50
ransform Vertical Perspective	-26
ransform Vertical Perspective	-26
Midpoint	-26
ransform Vertical Perspective Horizontal Perspective	-26

Martin Evening Adobe Photoshop CS5 for Photographers

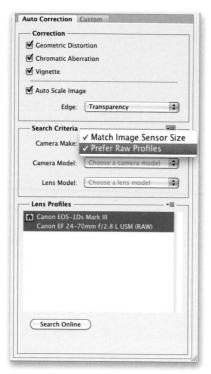

Figure 10.11 You can choose to prefer raw profiles via the Search Criteria section fly-out menu options in the Lens Correction filter dialog.

Selecting the most appropriate profiles

If the camera/lens combination you are using matches one of the Adobe lens correction profiles that was installed with Photoshop CS5, then that is the only option you'll see appear in Lens Profiles (Figure 10.11). If no lens correction profile is available (because the necessary lens EXIF metadata is missing), you'll see a 'No matching lens profiles found' message. The Search Criteria Camera Make, Camera Model and Lens Model menus will then allow you to manually search for a compatible camera/lens profile combination. If you wish to explore some alternative lens profile options, then click on the 'Search Online' button. This carries out an on-line search for lens correction profiles that have been created by other users where the lens profile EXIF data matches and the profiles are publicly available to share. You can initially preview these profiles to see what the results look like before deciding whether to use them and save them locally to your computer. If you create your own custom profiles, as shown on pages 564–565, and wish to share these with other users, you can do so by going to the File menu and choose 'Send Profiles to Adobe...' (# S ctrl alt S) (Figure 10.12). If you can't find any matching lens profiles then you can always select the nearest equivalent via the Search Criteria menus, and fine-tune the result using the Custom panel controls in the Lens Correction filter dialog.

The Lens Correction filter can make use of profiles that have been created from raw files or from rendered TIFF or JPEG capture images. This means that two types of lens profiles can be generated: raw and non-raw lens profiles. In terms of the geometric distortion and chromatic aberration lens correction you are unlikely to see much difference between these two types. With regards to the vignette adjustment, here it does matter more which type of source files were used. In the case of raw files, the vignette estimation and removal is measured directly from the raw linear sensor data. Now, if the Lens Correction filter were able to process raw files directly this would result in more accurate lens vignette correction results. Since the Lens Correction filter is used to process rendered image files such as JPEGs and TIFFs, it is therefore better to use the nonraw file generated lens profiles, where available. It is for this reason that the Lens Correction filter dialog displays the non-raw lens correction profile by default and only shows a raw profile version

if there is no non-raw profile version available on the system. The raw profile versions are therefore only available as a backup. However, if you go to the Search Criteria section and mouse down on the fly-out menu you can select the 'Prefer Raw Profiles' option (see Figure 10.11). When this is checked the Lens Correction filter automatically selects the raw profiles first in preference to the nonraw versions, but overall I recommend you stick to using non-raw profiles as the default option.

Adobe Lens Profile Creator

You can use the Adobe Lens Profile Creator 1.0 program to help characterize optical aberrations such as geometric distortion, lateral chromatic aberration and vignetting and build your own custom lens profiles. It is available as a free download. Go to the Lens Profiles fly-out menu and choose 'Browse Adobe[®] Lens Profile Creator Online...'. This leads you to a page from where you can download the program. Basically you need to print out one of the supplied charts onto matt paper and then photograph it as described on pages 564–565.

Interpolating between lens profiles

The zoom lens characteristics will typically vary at different focal length settings. Therefore to get the best lens profiles for such lenses you may need to capture several sequences of lens profile shots at multiple focal length settings, such as at the widest, narrowest and mid focal length settings. The Adobe Lens Profile Creator program can then use the multiple lens capture images to build a more comprehensive profile for a zoom lens. You can also build lens profiles based on bracketed focusing distances. For example, this might be considered a useful thing to do with macro lenses, where you are likely to be working with a lens over a wide range of focusing distances.

Lens Correction profiles and Auto-Align

The Auto-Align feature now shares the same lens correction profiles as used by the Lens Correction filter dialog. This is why you should mostly see much improved performance in the way the Auto-Align feature is now able to stitch photos together. Adobe have also added caching support so that the Lens Correction and

Send Profiles to Adobe	
Please indic	ate the option which best describes how you send mail
Desktop	Email Application
	his option if you currently use an email applications Aicrosoft Outlook, Entourage, Eudora, or Email.
O Copy Te	xt to Clipboard and Send Manually
service su will then attachme your Inter copy and	his option if you currently use an Internet email uch as Yahoo, or Google, or Microsoft Hotmail. You need to add your lens profiles as email file nets and send it manually to Logfiles@adobe.com using rnet email service. Please also make sure that you paste the following text as part of your email body in mission email.
Adobe, you and fully pa and display	this e-mail containing the attached lens profile data to grant Adobe a nonexclusive, worldwide, royalty-free adi license to use, modify, reproduce, publicly perform <i>x</i> , and distribute such lens profile data in products and eated by or on behalf of Adobe.
	Ok

Figure 10.12 The Send Profiles to Adobe dialog.

Auto-Align Layers dialogs will open more speedily on subsequent launches after the first time you open either dialog. You will also see improved auto-alignment for fisheye photos that have been shot in portrait mode. However, for this to work properly it is necessary that all the source images are shot using the same camera, lens, image resolution and focal length. If these above criteria are not met, then you will most likely see a warning message.

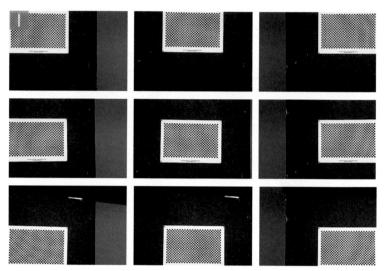

1 This shows the setup I used to photograph the Adobe Lens Calibration chart in preparation for creating a custom lens calibration profile for one of my Canon lenses. To shoot the chart it is important that it is photographed completely flat and that the focus distance is consistent. It helps if you mount the camera on a tripod and shoot at an optimum aperture that is around 4 stops down from the maximum aperture for the lens (unless you normally shoot at the wider apertures on your particular lens). Here, I shot a sequence of 9 frames in which I photographed the chart centered in the frame, along with shots of the corners plus the top, right, bottom and left centers. The aim here is to make sure that the chart fills at least a guarter of the frame in each exposure so that the checkerboard coverage fills the entire image frame when they are all combined together. It is also important that you photograph the corner and edge charts so that they are as close to the boundaries of the frame as possible. Above all, you need to make sure that none of the checker squares are clipped at the edges or corners. When shooting the chart it is best to start with the centered frame. As you shoot all the subsequent frames you should combine moving the camera slightly and tilt the camera angle when recomposing. Refocus if necessary, but you should keep all the other camera settings the same. If you shoot JPEG try to minimize any in-camera processing and if you shoot raw then it is important to make sure that all the subsequent settings are set to their defaults. If your camera provides a Live View facility you can use this to accurately preview the position of the chart relative to the sensor (which you won't be able to do so accurately via the viewfinder).

Photographing a display

Ideally the Adobe Lens Calibration chart should be photographed using a carefully balanced lighting setup, especially if you wish to accurately estimate the amount of vignetting associated with a particular lens. One option is to photograph the Lens Calibration chart directly from the computer display. Providing the display you are using is an LCD type and is evenly illuminated all over, there is no reason why you can't make effective measurements by photographing the chart in this way.

Creator: Martin Evening Website: www.martinveni	Generate Profile
Profiles	Profile Display Names
▼ 🗹 Canon, Canon EOS-1Ds Mark III, EF100-400mm f/4.5-5.6L IS USM JPEG, 3072 x 2048, RGB, 8-Bit	Lens Name: EF100-400mm f/4.5-5.6L IS
☑ 200.0 mm f/11.0 9	
	Calibration Advanced
	Lens
	(Rectilinear
	O Fisheye
	Model
	Geometric Distortion Model
	Chromatic Aberration Model
	Vignetting Model
	Checkerboard Info
Images	Version (Row x Column): 27 x 43
Focus Distance Group - 1	Print Dimension (Points): 36
Aris_091006_0015.jpg	Screen Dimension (Pixels): 30
Aris_091006_0016.jpg	Screen Dimension (rixers). 30
Aris_091006_0017.jpg	-
Aris_091006_0018.jpg	
Aris_091006_0019.jpg	•• 12.5% Aris_06.jpg
Aris_091006_0020.jpg	
Aris_091006_0021.jpg	
Aris_091006_0022.jpg	
Aris_091006_0024.jpg	
	Aris_015.jpg Aris_016.jpg Aris_017.

2 Once I had shot all the frames I loaded these into the Adobe Lens Profile Creator program (**H N** *ctrl* **N**). The camera and lens name should show up automatically in the Profile Display Name section and include the focal length information. This will all be read from the image file EXIF metadata. Next, I needed to configure the Calibration settings to indicate whether this was a rectilinear or fisheve lens I was calibrating. Next, I checked the options I wished to include in the calibration such as: Geometric Distortion, Chromatic Aberration and Vignetting. Lastly, in the Checkerboard Info section, I noted down the information from the bottom of the calibration chart and entered this here. Once I had done all this I clicked on the Generate Profiles button to commence processing the files. I should also mention here that the individual checkerboard squares must be at least 20 imes 20 pixels in size in order for the Adobe Lens Profile Creator program to work properly. This shouldn't be a problem with most digital SLRs but is something to be aware of if shooting with a small sensor camera. Once the processing had been completed, the resulting lens profile was saved to the shared lens profiles folder which Photoshop references when applying automatic lens corrections. The exact location is: Library/Application Support/Adobe/ Camera Profiles\Lens Correction\1.0 (Mac), C:\Program Files\Common files\Adobe\ Camera Profiles\Lens Correction\1.0 (Windows 32-bit), C:\Program Files (x86)\Common Files\Adobe\Camera Profiles\Lens Correction\1.0 (Windows 64-bit), C:\Documents and Settings\All Users\Application Data\Adobe\CameraRaw\LensProfiles\1.0 (Windows Vista/XP).

Selecting the correct file format

Custom user lens profiles can be created from raw, TIFF or JPEG capture images and it is important that you select the appropriate file format from the Add files system dialog when adding photos to the Adobe Lens Profile Creator program.

Rapid filter access

There are around 100 filters in the Filter menu. That's a lot of plug-ins to choose from, of which many are used to produce artistic effects. The Filter Gallery makes 47 of these filters accessible from the one dialog. The following filter categories are available: Artistic; Brush Strokes; Distort; Sketch; Stylize; Texture (but note that not all the filters in the above categories are included in the Filter Gallery).

Filter Gallery

To use the Filter Gallery, select an image, choose Filter Gallery from the Filter menu and click on the various filter effect icons revealed in the expanded filter folders. The filter icons provide a visual clue as to the outcome of the filter, and as you click on these the filter effect can be previewed in the preview panel area. This gives you a nice, large preview for many of the creative Photoshop filters. As you can see in Figure 10.13, you can combine more than one filter at a time and preview how these will look when applied in sequence. To add a new filter, click on the New Effect Layer button at the bottom. As you click on the effect layers you can edit the individual filter settings. To remove a filter effect layer, click on the Delete button.

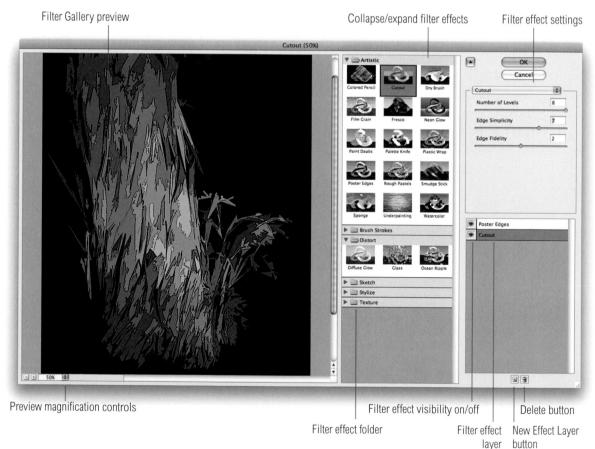

Figure 10.13 The Filter Gallery.

Chapter 11

Image Management

ne of the consequences of working with digital images in Photoshop is that you will soon find yourself struggling to cope with an ever-growing collection of image files. In order to address this, you'll want something more than the system folder browser with which to preview and access all the files that are stored on your computer system. At a minimum you need some kind of file browser program that allows you to preview images easily, choose which ones you want to open in Photoshop and carry out basic file management tasks such as rating the images you like best and adding metadata.

Bridge alternatives

Operating systems may in future offer better image browsing tools and on the PC platform it is interesting to note how the Vista operating system contains a photo browser that offers improved image navigation for photographs. If you are using the Macintosh OS X 10.5 operating system or later, you can use the Spacebar to quickly preview selected images, or use the Cover Flow View folder navigation mode to visually inspect the contents of a folder. In the meantime, there are several dedicated file browser programs on the market that can help you manage your images better such as Extensis Portfolio[™], and PhotoMechanic[™]. There is also Expression Media[™], which is more than just a file browser; it is also a sophisticated database cataloging program that allows you to manage your images efficiently and quickly. More recently, we have seen the emergence of digital photography workflow programs such as Apple's Aperture[™] and Adobe Photoshop Lightroom[™], which are designed to provide a complete workflow management solution from the digital raw processing stage through to image library management and print output.

The Bridge solution

Bridge is included with Photoshop, as well as being part of the Creative Suite package. Bridge is best described as a dedicated file browser program, which also integrates smoothly with Adobe Camera Raw, allowing you to open your raw image files (assuming your camera's raw format is supported) and manage the Camera Raw settings. Bridge may not be as sophisticated as some of the other programs mentioned in the sidebar, but it does provide you with a direct way to manage the photographs you intend working on in Photoshop. On the plus side, Bridge comes free and it integrates nicely with all the programs in the Adobe Creative Suite, as well as many other programs. It also contains most of the tools you need to import and manage your images, plus Bridge allows you to work directly with the automation tools in Photoshop, such as Photomerge and the Image Processor. The interface has been much improved since Bridge CS4. It offers easy workspace switching, one-click full screen previews and revised Collections features. Not a lot has changed with the CS5 version, but there is now a separate Mini Bridge in the form of an Extension panel for Photoshop and I'll be discussing this in more depth towards the end of this chapter. Bridge's performance has been improved since earlier versions, but it still doesn't seem to perform quite as fast as some other browser and cataloging programs. There are now built-in Web and PDF output features, but these too remain as slow as ever, plus inputting metadata and keywords is still an awkward process.

Configuring the General preferences

First things first, let's go to the Bridge preferences (located in the Edit menu in Windows and the Bridge menu in Mac OS X) and look at the General settings. These govern the Bridge interface appearance and basic behavior. The first section contains the Appearance controls where you can adjust the general user interface brightness and below that the brightness for the image Content and Preview panel areas. These are normally set quite light and my preference is to make both a little darker (the Figure 11.1 settings were used to capture most of the screen shots seen in this chapter). The Accent Color menu offers a range of color options for accentuating the image highlighting and Bridge menu items. You'll also note how the Default color switches between orange and blue, depending on the User Interface Brightness setting.

The Behavior section let's you make Adobe Photo Downloader launch by default whenever a new camera card is inserted (or if the camera is connected to the computer directly). The 'Doubleclick Edits Camera Raw settings in Bridge' option allows you to override the default behavior and forces Bridge to be the program that always hosts the Camera Raw plug-in. The 'H ctrl-click Opens the Loupe When Previewing or Reviewing' option applies to the Preview panel and Review modes so that the loupe only shows when the **H** *ctrl* key is held down. Meanwhile, the Bridge program maintains a list of the most recently visited folders to enable fast and easy access. The default number is 10, but you can increase this number if you want. The Favorite Items section contains checkboxes that allow you to select which items you want to see appear listed in the Favorites panel (see Figure 11.30) and lastly, the Reset button, which can be used to reset all the alert warning dialogs in Bridge.

Open anything

Most files can be opened via Bridge. Well, almost anything. You can think of Bridge as being like an advanced file navigation dialog for all the programs in the Adobe Creative Suite, although you are not just limited to opening CS5 Creative Suite documents. For example, you can also open things like Word files in the Word program via Bridge, plus you can drag and drop documents from the Bridge window to an external folder or vice versa.

	Preferences	
General	General	
Thumbnails Playback Metadata Keywords Labels File Type Associations Cache Startup Scripts Advanced Output	Appearance User Interface Brightness: Image Backdrop: Accent Color:	Black
	Double-Click Edits Can	nected, Launch Adobe Photo Downloader nera Raw Settings in Bridge upe When Previewing or Reviewing o Display: 10
	Favorite Items Computer Desktop Pictures Reset All Warning D	i martin_evening I Documents Dialogs
		Cancel OK

Figure 11.1 The Bridge General preferences.

Adding new folders

New folders can be added by choosing 'New Folder' from Bridge's File menu (#Shift N ctrl Shift N), or you can ctrl right mouse-click in the Content area and choose 'New Folder' from the contextual menu.

Override JPEG Camera Raw settings

You can also edit JPEG and TIFF images via Camera Raw, but be warned that this added capability can also lead to confusion when opening images. Basically, you can use the Camera Raw preferences (page 166) to determine how JPEG and TIFF images are handled. Here, you can disable the ability to open JPEGs and TIFFs via Camera Raw, enable automatic opening of all supported JPEGs and TIFFs, or you can enable the automatic opening of only those JPEGs or TIFFs that have previously been processed via Camera Raw. To override these last two preferences, hold down the Shift key as you double-click to open the image. If Camera Raw settings have been added to an image previously, these will be applied as you open. If there are no Camera Raw settings associated with an image, it will open directly in Photoshop as normal.

Launching Bridge

There are several ways you can launch Bridge. The most direct method is to click on the Bridge button in the Photoshop CS5 Application bar (Figure 11.2). Clicking this button launches Bridge and opens the Bridge window shown in Figure 11.3, and whenever you launch Bridge it always displays the contents of the folder you last visited. You can also launch Bridge by going to the File menu in Photoshop and choosing 'Browse in Bridge...'. Or, you can use the $\mathbb{H} \subset O$ *ctrl* alt 0 or \mathbb{H} *Shift* O *ctrl Shift* O shortcuts. Note here that both these commands can also be used when you wish to go from Bridge back to Photoshop. To open an image from Bridge, simply double-click a thumbnail or press the Enter or *Return* key and the image will open directly in Photoshop. If you want the Bridge window to close as you open the image, then simply hold down the **C** all key as you double-click. Now, if you refer back to Chapter 3, you will remember how opening Camera Raw files will vary depending on how the Camera Raw preferences have been configured. When you double-click on a raw image file thumbnail, or multiple thumbnails in Bridge, this normally opens the raw images via the Adobe Camera Raw dialog hosted by Photoshop, and if you go to the File menu in Bridge and choose 'Open in Camera Raw...' (**H** *R ctrl R*) the images open via the Camera Raw dialog hosted by Bridge. The subtle distinctions between which application hosts Adobe Camera Raw are elaborated on further in Chapter 3 (and also in the sidebar on the left), but essentially a double-click opens a raw file via Camera Raw in Photoshop, and if you hold down the Shift key as you double-click, you can open a raw image bypassing the Camera Raw dialog completely.

Rotating the thumbnails and preview

You can apply 90° rotations via the Rotate commands in the Bridge Edit menu or use the following keyboard shortcuts: **#**[*ctrl*] rotates a thumbnail anti-clockwise and **#**[*]ctrl*] rotates a thumbnail clockwise. Alternatively, you can use the Rotate buttons in the top right section of the Bridge window. Note that this doesn't physically rotate the images in Photoshop just yet, the image rotation only takes place when you come to open the actual image.

as thumbnails

grid view

Adobe Bridge CS5 File Edit View Stacks Label Tools Window Help Filter items Switch ascending/descending order Go to parent Return to Get photos Open in Workspace Photoshop folder or Favorite from camera Camera Raw selection by rating Open recent file Sort order Reveal recent Refine Thumbnail options Folder file or folder images Output quality Rotate Create new folder options options Search field buttons navigation Compact mode (toggle) ESSENTIALS FILMSTRIP .e h- s h-+ 10pł uter 🗲 🧱 G5Main HD 🗲 🛲 PSCS5 main Current -Con 📓 🖩 -4 Sort by Date Crea Delete TES FOLDERS directory Compute path f n rtin evening Document Personal Photos troom 3 bool Loupe preview PSCS5 main book RGI PSCSS Ultimate book RGB ** W1BY0530.psd *** W1BY1137.psd 0000 No Labe Camera metadata +0.67 placard display *** File Typ DNG imag 3.psd 9.05d W1BY3510.tif _P2E0633.tif W18Y3532-50 th View content as list Minimum Maximum thumbnail size View content thumbnail size as details Dynamic thumbnail size adjustment Lock thumbnail View content

Figure 11.2 The Photoshop Application bar with the Bridge button (circled).

66)Mb - -

.

ESSENTIALS

DESIGN

PAINTING

PHOTOGRAPHY

3D

MOTION

Figure 11.3 The Bridge interface.

Image management

Chapter 11

NEW IN CS 5 >>>

Workspace shortcuts

You can also make different workspace settings active by using the **H F Ctn F i** through to **H F i ctn F i** through to **H F i ctn F i ctn F i** selects the 'Essentials' workspace). Note though that when you create a new workspace setting, this shifts the keyboard shortcut assignment along one in the order the shortcuts appear listed, so just be aware that the above shortcuts will update each time you save a new workspace setting.

	New Workspace	
Name:	Photo Editing	Save
Save	Window Location as Part of Workspace	Cancel
Save	Sort Order as Part of Workspace	

Figure 11.4 To create a new workspace setting, go to the Window menu and choose Workspace \Rightarrow New Workspace...

Arranging the Bridge contents

You can customize the visibility and order of the various panels and rearrange the Bridge layout to suit your own requirements. For example, you can click on the Workspace settings buttons shown in Figure 11.5 to quickly switch between the different pre-configured Bridge workspaces. These include workspaces that have been designed for different types of Bridge tasks such as Filmstrip viewing or Metadata editing. Or, you can set about creating your own custom workspace layouts. To do this, go to the Window menu where you can highlight a panel item to toggle making it either hidden or visible. Now mouse down on the panel and try dragging it to a new position or grouping arrangement in either of the three main panel sections. The panel sizes can be adjusted in height by dragging the horizontal panel dividers. You can doubleclick a Panel tab to quickly collapse the panel contents to show the tab only and double-clicking the Panel tab expands the panel contents to its former size again. If you double-click on a panel divider (as shown in Figure 11.6) you can collapse all the panels in that section, plus if you hit the *Tab* key, you can toggle collapsing or revealing both the side panels. When you have finished adjusting the Bridge layout, you can save it as a new custom workspace setting. To do this, go to the Window menu and choose Workspace \Rightarrow New Workspace... This opens the dialog shown in Figure 11.4, where you have the option to include both the window location and sort order setting together with the workspace setting. The new workspace setting will now appear first in the list.

You can also rearrange the thumbnails in the Content panel by dragging them to a new position. This changes the sort order to 'Custom' and the new sort order will remain sticky until such time as you change the sort order again. Or, if you click on the 'Lock thumbnail grid view' button (bottom of Figure 11.3) you can lock the thumbnail grid so that as you resize the Content panel area the number of columns always remains locked. Lastly, you can follow the instructions in Figure 11.7 for shrinking the Bridge window.

Figure 11.5 This shows an enlarged view of the Workspace settings list. If the list is partially obscured, then mouse down on the divider line circled here and drag it out to the left to reveal the full workspace list options.

Chapter 11 Image management

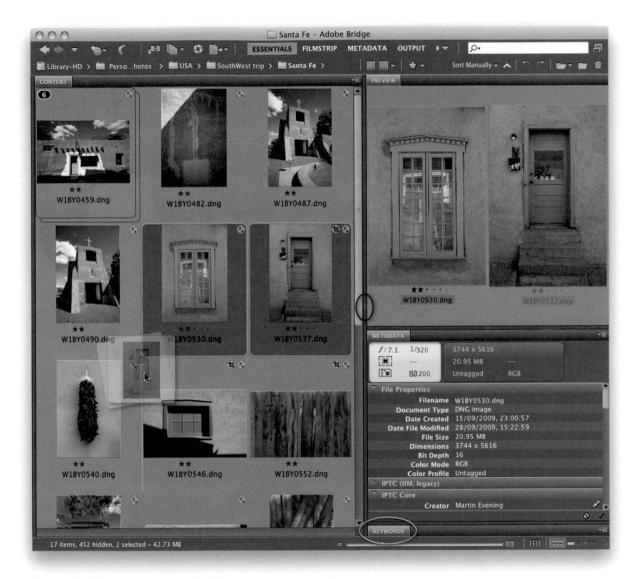

Figure 11.6 The panel arrangements in Bridge can be customized to suit your own preferred way of working, plus the thumbnails can be moved around within the content area, as if you were shuffling photographs on a lightbox. If you double-click on a Panel tab, such as I have done here with the Keywords panel (circled in blue), this collapses the panel to just a tab. The panel sizes can also be adjusted by dragging on the vertical and horizontal dividers, and if you double-click on the divider bar (circled in red) you can toggle showing and hiding the side panel sections. In this example, you can see how some of the images had been grouped into stacks and the Preview panel expanded so that we get to see a large preview of the selected thumbnail (or thumbnails where more than one image is selected in the Content panel).

Figure 11.7 To shrink the Bridge window size, click on the 'Switch to Compact Mode' button (circled in blue), and click on this button again to restore the window to the original view mode and size. If you click on the button to the left (circled in red), you can compact the window to ultra-compact mode. Note that in Compact mode Bridge windows remain in the foreground, in front of any documents or other programs. To change this behavior, go to the compact Bridge fly-out menu and deselect 'Compact Window Always on Top'.

Customizing the panels and content area

Let's now step back a bit and look more closely at how the Bridge interface is structured. Essentially, the Bridge window interface consists of three adjustable sections and these are used to contain the individual Bridge panels, with a main Content panel in the middle that is always visible. The individual panels can be adjusted vertically as well as horizontally and placed in any section of the Bridge interface. Meanwhile, the Content panel has Thumbnails, Details and List viewing modes, and you can switch between these by going to the View menu, or by clicking on the buttons in the bottom right section of the Bridge window. By combining different panel layouts with these three Content panel viewing modes, it is possible to achieve a wide variety of workspace layouts. In Figure 11.8 you can see a bare bones layout of the Bridge interface, where only the Content panel is visible in the middle. In Figure 11.9, I have shown a Bridge layout where the Content panel area remains in the Thumbnails view mode and now the Folders panel is visible as well on the left. In Figure 11.10, I added a Metadata panel to the left panel section and switched the Content panel area view to Details mode.

Figure 11.8 Here is a basic view of the three panel sections that make up the Bridge interface, where just the Content panel is visible (you can't hide the Content panel).

Figure 11.9 One can make more panels visible by going to the Window menu in Bridge and highlighting the ones you wish to add (those panels that are already visible will have a tick mark next to them). Here, I made the Folders panel visible within the left panel section.

Figure 11.10 Here, I made the Metadata panel visible, adding it to the panel section on the left, plus I switched the Content area to the Details mode by clicking on the 'Details' view button (circled).

Content panel scrolling

The Content panel has a small menu icon in the top right corner, where if you mouse down, you can select a Horizontal, Vertical or Auto scrolling layout (this is circled in Figure 11.11). You can use this menu to force the thumbnails in the Content panel to scroll vertically (which is the default used for most of the workspace layouts) or scroll horizontally (such as in the Filmstrip workspace layout in Figure 11.12). If you select 'Auto', Bridge automatically works out which direction is best to scroll the thumbnails in.

Bridge workspace examples

Let's now look at just some of the available workspace settings. The Light Table layout shown in Figure 11.11 is useful should you wish to maximize the Content panel size and have it fill the screen. The Filmstrip setting shown in Figure 11.12 (**#** *F2 ctrl F2*) is great for editing large photos as it uses a large preview panel size with a Horizontal filmstrip running along the bottom of the window and you can use the left and right keyboard arrow keys to navigate through the filmstrip thumbnails. These two workspaces provide nice simplified Bridge layouts that are ideal for navigating photographs. If you look closely, you will notice that the Content panel has a fly-out menu for controlling the Content thumbnail layout (see sidebar). For example, you could create a vertical filmstrip layout with a narrow Content panel in the middle set to vertical scrolling combined with a large Preview panel in the right column. Figure 11.13 shows the Metadata layout where the focus is on the Metadata panel and the Content panel is in Details mode, displaying the main essential image data alongside the thumbnails.

Figure 11.11 Here is a view of a Bridge window configured using the Light Table workspace preset (note the Content panel layout options shown top right).

Figure 11.12 The Filmstrip workspace (**H F ctr**) combines a large Preview panel with a narrow Content panel that runs along the bottom using a Horizontal scrolling layout.

Figure 11.13 The Metadata workspace displays the Content panel in Details view mode with the Favorites, Keywords and Metadata panels on the left.

Synchronized displays

If you choose Window ⇒ New Synchronized Window (ℜ ♥♥ New Ctr) all N), you can create two synchronized windows. These can be on the same monitor screen, or you can have one on each monitor. For example, you could have one window displaying a Light Table workspace and the other using the Preview workspace.

Working with multiple windows

You can also have multiple Bridge window views open at once. This allows you to view more than one folder of images at a time, without having to use the Folders panel or window navigational buttons to navigate back and forth between the different image folders. That's not all though, because multiple windows can also make it easier to make comparative editing decisions when reviewing a collection of images, such as in the Figure 11.14 example shown below.

Figure 11.14 In this example I pointed Bridge at a folder of images using a modified Preview workspace layout, where single images could be previewed large in the preview panel and the Content panel used to display a vertical filmstrip of thumbnails. I then chose File ⇒ New Window to create a duplicate window view and dragged this off to the right. I was then able to navigate through the image thumbnails in the second window and compare alternative shots with the one displayed in the first window.

Slideshow mode

The Bridge Slideshow feature can be considered a useful tool for providing quick on-screen presentations, but I think you will find that the Slideshow viewing mode also offers a nice, clear interface with which to edit your pictures; one that's devoid of all the clutter of the Bridge window interface. Figure 11.16 shows the Bridge Slideshow in Full Screen mode, where you have access to all the usual image rating controls. As you review edit a folder of photos, you can use the rating controls. As you review edit a folder of photos, you can use the rating, or use the apostrophe key to toggle adding or removing a single star rating, or use the skey to increase and the key to decrease the overall star rating. To access the Slideshow settings (including the slide transitions and zoom options) go to the View menu and choose 'Slideshow Options...'. (Figure 11.15)

Display Options		
Black Out Additional Monitors		
Repeat Slideshow		
Zoom Back And Forth		
Slide Options		
ilide Duration: 5 seconds	•	
Caption: Off	1	
When Presenting, Show Slides:		
O Centered		
Scaled to Fit Scaled to Fill		
0		
Transition Options		
Transition: Dissolve	•	
Transition Speed: Faster -		Slower
number of pecu. Parter		
Play		Done

Figure 11.16 The Bridge window contents can be previewed in Slideshow mode by choosing View \Rightarrow Slideshow (\Im \square \square). Press \square to call up the Slideshow commands menu shown here, where you'll note that you can also use the \square keys to zoom in and out during playback. There is also a triple-click shortcut for zooming into the corners at 100%, but in practice it's rather complicated to use.

Limiting preview generation

It can take a long time for Bridge to generate preview images of large image files. If you have the Maximize PSD and PSB File Compatibility preference turned on (see page 105) the layered PSD files will generate a composite image layer when saved. This can certainly reduce the time it takes to build each preview in Bridge. If you limit the file size for rendering previews using 'Do not process file larger than: x MB' this can also help speed up the time it takes to build a cache of previews of very large files.

Thumbnail settings

If you go to the thumbnail quality options in the Bridge window you can select a policy for the thumbnail generation (Figure 11.17). 'Prefer Embedded' uses whatever previews it finds and makes the browsing of non-cached images faster (you can also click on the button to the left to switch to this mode). The 'High Quality On Demand' option aims to rebuild accurate previews, but only when you actually click to select a thumbnail. Lastly, the 'Always High Quality' option rebuilds the thumbnails for all files it encounters that are not already stored in the Bridge cache.

If you go to the Bridge Thumbnails preferences (Figure 11.19) you can limit the thumbnail generation to files that are of a certain

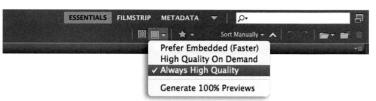

Figure 11.18 Up to four additional lines of metadata can be added beneath the thumbnails in Bridge. You can use the **GRT** curl**T** keyboard shortcut to toggle hiding and showing the text information that appears below the image thumbnails in the content area.

Figure 11.17 The Thumbnail quality options.

	Thumbnails
umbnails yback tadata ywords bels e Type Associations che urtup Scripts vanced tput	Performance and File Handling Do Not Process Files Larger Than: 1500 MB Previously cached files will not be affected by changes to this setting. This settitakes effect after the cache has been purged. Details Additional Lines of Thumbnail Metadata Show: Date Created Show: Dimensions Show: Keywords Show: Size

size or lower (setting a lower limit can help speed up the thumbnail generation). In the Details section you can have extra lines of metadata appear beneath the thumbnails in the content area (as shown in Figure 11.18). The 'Show Tooltips' option is useful if you want to learn about each section of the Bridge interface, and does also allow you to read long file names in the Bridge content area more easily.

Cache management

From the moment you open an image folder in Bridge, the program sets to work: building the thumbnails and previews, reading in the image file metadata as it does so, taking into account things like Camera Raw edits, image rotation instructions, file ratings and labeling. It speedily generates the low res thumbnails first before running a second pass to build the higher resolution thumbnail previews. This is quite a lot of information that Bridge has to process, and if it is your intention to use Bridge to manage large collections of images (especially large numbers of raw files) you really do need a fast computer, or Bridge will appear frustratingly slow. The information that is built up during this process is stored in the form of 'cache data', which has two components: the image metadata and the thumbnail cache. Every time you open a folder, Bridge checks to see if there is an image cache for that folder located in the Username/Library/Caches/Adobe/Bridge CS5/Cache folder (you can change this location via the Cache preferences). If a cache is present, the inspected folder displays the archived thumbnails, previews and metadata almost instantaneously. This works fine so long as the folder is being inspected on the computer that created it and the folder name has not changed since the cache was created. If these two conditions are not met, then Bridge has to start all over again and build a fresh cache for that folder.

Proprietary raw files present a particular problem because the Camera Raw database in the Bridge cache is the only place where the metadata information such as the image ratings and Camera Raw adjustments can be kept, that is unless you go to the Camera Raw preferences (Figure 11.20) and choose to save the image settings to the 'sidecar ".xmp" files'. When you do this, the metadata information is saved to the XMP sidecar files that are stored alongside each raw image (Figure 11.21). Obviously, it is very useful to make the cache information accessible, which is why it is also a good idea in the Cache preferences (Figure 11.23) to

General		
Save image settings in:	Sidecar ".xmp" files	1\$
Apply sharpening to:	All images	\$

Figure 11.20 The Camera Raw General preferences.

Image_0077.CR2

Image_0077.xmp

Figure 11.21 If the Camera Raw preferences are set to save .xmp files as sidecar files, you will see sidecar files like this appear alongside a raw image file that has been modified via Bridge.

XMP and Sidecar files

File-specific information that can generally be read by other programs, such as the custom IPTC metadata and Camera Raw settings (Adobe programs only), is normally stored in the file header XMP space. However, because proprietary raw files are an unknown entity it is only safe to store such data within a separate XMP sidecar file that travels with the raw file when it is moved from one folder to another. The sidecar files will also be renamed if the original master is renamed.

Enabling Backward compatibility

It is a good idea to switch on the Maximize the PSD and PSB compatibility option in the Photoshop File Handling preferences. This forces Photoshop to save a flattened version of the image when saving a file using the PSD and PSB formats. This in turn speeds up the writing of the thumbnail cache file.

Figure 11.22 If you go to the Tools ⇒ Cache submenu, you can choose 'Build and Export Cache'. This opens the dialog shown here, which lets you force-build a cache for the selected folder and any subfolders. You have additional options to select 'Build 100% Previews' and 'Export Cache to Folders'. choose 'Automatically Export Cache To Folders When Possible'. Bridge then automatically updates the cache by adding a couple of cache data files within the same image folder (these will normally be hidden from view). The advantage of doing this is that it does not matter if you move or rename a folder, because the image cache will always be recognized. This is especially important if you are about to share a folder of images that you have edited in Bridge with another Bridge user, or you are about to archive pictures you have edited to a CD or DVD disc, as this ensures the cache data is always preserved. Sometimes a cache may appear out of date and require a forced update. To do this, go to the Tools ⇒ Cache menu and choose the 'Build and Export Cache' option which opens the dialog in Figure 11.22. You can use this to force Bridge to prioritize building a cache for not just the current targeted folder, but include the subfolders as well. You might find it beneficial to get Bridge to cache large folders of images during idle times, such as at night while you are asleep. The other Cache preference items let you manage the cache. For example, when the 'Keep 100% Previews in Cache' option is selected, this potentially

Figure 11.23 The Bridge Cache preferences.

increases the size of the cache, but you'll have faster access to the full-sized previews. The cache size itself can be limited in size to a set number of files. As more files are cached, the older cache items get deleted, so increasing the cache size limit means more cache data is preserved, but at the expense of increased disk space usage. The Compact Cache and Purge Cache items can also be used to keep the cache size under control.

Advanced and miscellaneous preferences

Bridge by default uses hardware acceleration to drive the graphics display, but if you are working with an underpowered graphics card you may find it better to check 'Use Software Rendering' and relaunch Bridge (Figure 11.24). The 'Generate Monitor-Size Previews' option ensures that the cached previews are big enough to fill the screen, such as when using the Slideshow or Review modes. The International section allows you to regionalize Bridge for international languages and for use with international keyboard designs. Note that the changes applied here only come into effect after you relaunch Bridge.

	Preferences
General Thumbnails Playback Metadata Keywords Labels File Type Associations Cache Startup Scripts Advanced Output	Advanced Miscellaneous Use Software Rendering Diables hardware acceleration for the Preview panel and the Slideshow. Settings will take effect the next time the application is launched. Cenerate Monitor-Size Previews Cenerate Monitor-Size Previews Cenerate Spreviews based on the resolution of the largest monitor. Purge cache to regenerate existing previews. Start Bridge At Login Daving system login launch Bridge in the background so that it is instantly available when needed. International Language: English Language settings will take effect the next time the application is launched.
	Cancel OK

Figure 11.24 The Bridge Advanced preferences.

Automatic Bridge launch

If you check the 'Start Bridge at Login' option in the Advanced preferences, you can get Bridge to launch automatically each time you start up the computer.

Are you sure y to the Trash?	ou want to move "W1BY5504.tif"
Don't show again	Cancel OK

Figure 11.25 If you select a document or image in Bridge and click the *Delete* key, the above dialog warns that you are about to send the selected file or files to the Trash (Mac) or Recycle bin (PC).

One-click previews

With Bridge you can use the Spacebar to quickly preview an image at a full size on the display. Once you are in this full display screen preview mode, you can click with the mouse to enlarge a photo to 100%, click to return to the full screen view again and use the arrow keys to navigate to the next or previous photo. To return to the Bridge window, just click the Spacebar again. When it comes to picture review editing, one-click editing offers a speedy and more controllable alternative to the Slideshow view mode. You can navigate easily from one photo to the next and add ratings or labels as you edit. It's simple and very effective.

Deleting contents

The *Delete* key can be used to delete selected images. If you click *Delete* or click on the Delete button (**T**) in Bridge, this pops a dialog asking 'are you sure you want to continue? Clicking 'OK' removes the thumbnail from the Bridge window and sends the original file to the Trash (Mac) or Recycle bin (PC). Even so, files won't be permanently deleted until you empty the contents of the Trash (Mac)/Recycle bin (PC) at the operating system level. If you use *Delete all Delete*, rather than proceed to the delete message, this 'marks' an image with the word 'Reject' in red. You can then use the Filter panel to select the 'mark as rejected' images only and delete them as required. Note that when it comes to deleting folders via Bridge, you can only do so if they are empty.

Stacking images

You can use the Stack menu in Bridge to group files into stacks. In the screen shot steps shown opposite you can see an example of how selected files can be grouped in this way. To use this feature, select two or more files, go to the Stack menu and choose 'Group as Stack' ($\mathfrak{H} \ \mathfrak{G} \ \mathfrak{ctrl} \ \mathfrak{G}$). This groups the images, indicating they are part of a stack with a number showing how many files are included in the stack. To ungroup images from a stack, use: $\mathfrak{H} \ \mathfrak{Shift} \ \mathfrak{G} \ \mathfrak{ctrl} \ \mathfrak{Shift} \ \mathfrak{G}$. To expand a stack use $\mathfrak{H} \ \mathfrak{Shift} \ \mathfrak{G} \ \mathfrak{ctrl} \ \mathfrak{shift} \ \mathfrak{G}$. To expand a stack use $\mathfrak{H} \ \mathfrak{Shift} \ \mathfrak{G} \ \mathfrak{ctrl} \ \mathfrak{shift} \ \mathfrak{$

1 Here, three thumbnails have been selected in the Content panel. To group these images into a stack, I used the **HG** *ctrl* **G** shortcut.

2 Here, you can see how the files were displayed in the Content panel area when the stack was expanded. For this step, I selected the best exposed image (the middle one in the group shown in Step 1) and chose Stacks \Rightarrow Promote to Top of Stack. This made the selected file the key image used to identify all the images in the stack.

View	Stacks	Label	Tools	Window	Help
	Group as Stack		жG		
	Ungroup from Stack		ΦℋG		
	Open Stack		$\Re \rightarrow$		
	Close Stack		₩ ←		
	Promote to Top of Stack				
	Expand All Stacks		∖ટ#→		
	Collap	se All S	tacks	ר₩≁	
	Frame	Rate		•	
	Frame Rate Auto-Stack Panorama/HDR				

Figure 11.26 This shows the Stacks Auto-Stack Panorama/HDR command.

Auto-stacking

Earlier in Chapter 7 we looked at how to merge bracketed exposure images together and in Chapter 9 how to use Photomerge to blend overlapping image sequences to build panorama images. In Bridge vou can use the Stacks ⇒ Auto-Stack Panorama/HDR command (Figure 11.26) to auto-stack such images. The way this works is that Bridge scans the images in a selected folder and where it finds two or more images that have been shot within an 18-second time frame, makes these candidate photos for a panorama or Merge to HDR image set. Once it has done this, it further analyzes the images using Photoshop's auto-align technology. If a sequence of images overlap by 80% or less, these are logically assumed to be part of a panorama sequence. Where a sequence of images overlap by 80% or more and the EXIF data shows that the exposure values are changing by one or more stops, these are assumed to be part of a Merge to HDR pro set. Using this logic, Bridge is then able to organize photos into stacks and at the same time, create and store metadata information that can be used later by Bridge to autoprocess the stacked images either as panoramas or as Merge to HDR sets (Figure 11.27).

The auto-stack feature generates a hidden XML file that is added to the folder and this stores the 'how-to-process' information. The processing can be done later by choosing Tools \Rightarrow Photoshop \Rightarrow Process Collections in Photoshop (Figure 11.28). In actual fact, you can carry out this step directly, without applying an auto-stack first. When you apply this command, the images that have been auto-collected into stacks are automatically processed in Photoshop. Now, the plus sides of this feature are that it will benefit large volume panorama or HDR shooters (especially the ability to group photos into stacks). On the downside, there is no interface that can be used to modify, say, the time frame period from anything other than 18 seconds. There is also no interface that allows you to choose specific options when generating the Photomerge composites. The reliability with which auto-stack manages to successfully detect the images is also rather hit and miss. When it works well it has the potential to be a powerful tool, when it doesn't, you'll just have to redo the work manually. Overall, it's an interesting innovation that is bound to be improved upon in future Bridge updates.

Figure 11.27 Here, you can see a Bridge window view where I had selected the Auto-Stack Panorama/HDR command and the panorama candidate photos were automatically gathered into stacks.

Figure 11.28 Here you can see the same folder after I applied 'Process Collections in Photoshop'. This generated three HDR files and saved them as PSD files. I was then able to open these and apply HDR Toning image adjustments to each.

Martin Evening Adobe Photoshop CS5 for Photographers

Figure 11.29 The Folders panel displays a complete list tree view of all the folders on your main hard drive and any other mounted disks. Bridge allows you to drag and drop folders with ease within the Content panel area and folders panel areas, as well as drag directly to external folders.

Figure 11.30 The Favorites panel contains a list of commonly-accessed folder locations.

Bridge panels

Let's now take a look at some of the other panels in Bridge and what they can do.

Folders panel

The Folders panel (Figure 11.29) displays an expandable list tree view of the folder contents for all the drives that are currently connected to the computer. When you highlight a folder in the Folders panel, all the files in that folder will be displayed as thumbnails in the Content panel area on the right (note that Bridge is only able to create previews of image files it already understands or has a file import plug-in for). While this is happening, Bridge writes a folder cache of all the image thumbnails and previews. which is stored in a central folder location; although, as was pointed out on pages 581–582, you can configure the Bridge preferences so that the cache information is exported locally to the image folder as well. This saved cache should make the thumbnails appear quicker the next time you visit a particular image folder. If a folder contains a cache that was exported from Bridge CS5 or earlier, Bridge will be able to read it, but earlier versions of Photoshop will not be able to interpret Bridge CS5 cache files. Figure 11.31 shows how you can also use the file path directory to quickly navigate to alternative folder destinations.

Favorites panel

The Favorites panel (Figure 11.30) provides a set of shortcuts to various folder locations, such as the Desktop or Pictures folder. The items that appear in the Favorites panel are determined in the Bridge General preferences (see page 569), but you can also add your own Favorites by dragging a folder from the Content panel across to the Favorites list.

Figure 11.31 You can also use the file path name for folder navigation. If you mouse down on the arrow icons, this calls up a menu list for all the other, alternative folders that are available at the same root level.

Chapter 11 Image management

Preview panel

The preview panel (Figure 11.32) displays large previews of the selected images and as you will have seen already (such as in Figure 11.12), the Preview panel can be adjusted to any size to make the preview area as big as you like. When more than one image is selected in the Content panel the Preview panel displays all the images at once up to a maximum of nine images. If you need to inspect any more than this, you are better off using the Review mode (see the following page).

If you click anywhere in the Preview panel, this reveals a loupe magnifying glass adjacent to the point where you clicked. This displays that section of the preview image at a 1:1, actual pixels view inside the loupe (but see sidebar on \Re *ctrl* key behavior). You can then use the *t* keys to zoom in (up to 800%) or zoom out again. To close, click inside the loupe. To reposition it, simply click anywhere inside or outside the loupe and drag with the mouse. You can have an active loupe on each image in the Preview panel: just click to add a new loupe, and if you want to synchronize the loupe position so that you can compare close-up details in two or more images at once, hold down the \Re *ctrl* key as you drag the loupe.

Rotating loupe

When you work with the loupe tool and drag it to the corner of a preview image you may sometimes see the loupe spin round to reveal the corner details of the image. This is normal, intended behavior.

ctrl key behavior

As was pointed out earlier, if you go to the Bridge General preferences, there is an option you can select where a **(H)** *cttl*-click is required to initiate opening the loupe (instead of just clicking). This preference has no effect on using the **(H)** *cttl* key to synchronize the loupe scrolling though.

Figure 11.32 The Preview panel, showing a loupe close-up view of an image.

Review mode

Instead of relying on the Preview panel, you can use the Review mode (Figure 11.33) to inspect large numbers of images at once. The Review mode can be accessed from the View menu (**H**) and presents the selected photos in a carousel type display that has more than a passing resemblance to the Quick View folder navigation in Macintosh OS X 10.5 and 10.6. You can cycle through the selected photos using the arrow keys in the bottom left corner, remove photos from a selection with the downward pointing arrow, open a loupe view on the foreground image and create new collections. Overall, I would say that the one-click preview feature is better suited for the speedy previewing of multiple images. In light of this it is hard to see how the Review feature adds much to the party.

Remove image from review Cycle through images

Current image file name

Open loupe Create new Collection Exit Review mode

Managing images in Bridge

As the number of photographs stored on your computer system continues to grow you'll soon end up becoming frustrated as you struggle to find particular photos. This situation is only going to get worse and not better, unless you choose to change the way you import and manage your photos. The metadata tools in Bridge are designed to help you get started with the task of cataloging your image files. These allow you to add basic metadata and keyword information, which in turn can help you categorize the photographs in your image library. Once you get into a regular habit of doing this you'll soon reap the rewards whenever you need to conduct filtered image file searches.

Let's first consider how metadata information is used to manage other types of files on a computer. A program like iTunes can update its music database automatically. For example, if you insert a purchased CD into your computer, iTunes will query an on-line database and download the album title, artist, track listings and genre of music. This is a good example of metadata in action, because once iTunes has done this, the music metadata information can be used to help you manage your music collections more easily. The iTunes cataloging is effortless because it all takes place in the background and is mostly done automatically. The big difference when cataloging image files is that you mostly have to input all the metadata yourself manually and that can require some additional effort on your part.

Although Bridge has the potential to be used as an image asset manager, it still lacks the sophistication of other fully dedicated asset management programs such as Expression mediaTM or Lightroom. To be honest, I mainly use Bridge for specific file browsing tasks (such as when working on a book project like this). Otherwise, I find that for most image asset management and workflow tasks, Lightroom is the better program to use for this kind of work. This is because Lightroom allows me to import camera files exactly the way I want and has a better and more versatile library management interface for editing and managing the metadata. If you are serious about library management and cataloging your images, you may want to try out Lightroom, or else consider some of the other popular products such as Expression MediaTM or Apple's ApertureTM.

Adobe Photoshop Lightroom

A lot of people have been asking: if I have Photoshop and Bridge, why do I need Lightroom? I usually point out that Lightroom is a workflow program that allows you to manage your images efficiently all the way from import through to Web or print output. For some people, the combination of Bridge and Camera Raw provides them with all the tools that they need to manage their pictures and work in Photoshop. For amateurs and professionals who are looking for a faster and more streamlined approach for their image processing and image management, Lightroom will be the answer. I do still use Bridge for a lot of file browsing tasks, but I find that I now mostly prefer to use Lightroom since it integrates smoothly with Photoshop and offers some rather nice and unique approaches to image processing that you won't find in any other program. Overall, I find I can work much faster and more efficiently using Lightroom.

Canceling and turning off labels

The labeling controls have a toggle action. For example, if you select an image and use **(#) (6** *ctrl* **(6** to label it red, you can use the same keyboard shortcut to cancel the label color. You can also turn off the labeling by selecting 'No Label' from the Label menu.

Stacks	Label Tools	Window Help
	Rating	
	No Rating	¥0
	Reject	N 🛛
	*	H 1
	**	¥2
	***	ж3
	****	₩4
	*****	ж5
	Decrease Rati	ing X,
	Increase Ratin	ng X.
	Label	
	No Label	
	Red	ж6
	Yellow	¥7
	Green	¥8
	Blue	ж9
	Purple	

Figure 11.34 Image ratings and labels can be applied via the Label menu in Bridge, or by using the keyboard shortcuts described in the main text. Note there is no room for a keyboard shortcut for the Purple label. The only way to apply a Purple label is via this or the contextual menu. You can also mark an image as being a reject (see page 584). This is not the same as deleting, you are simply labeling it as a potential delete image.

Image rating and labeling

One of the main tasks you will want to carry out in Bridge is to rate your images, sorting out those that you like best from the rejects and arranging them into groups. The Bridge program provides two main ways to categorize your images. In the Label menu Rating section (Figure 11.34) you can apply ratings to an image in the form of stars, going from one to five. This image rating system lets you apply cumulative ratings to the images you like and it is therefore useful to familiarize yourself with the keyboard shortcuts that can be used to apply ratings to images. These range from # 0 ctrl 0 to # 5 ctrl 5 (to apply 0-5) stars) but you can also use **H** *ctrl* to increase the rating by one star, or **H**, *ctrl*, to decrease the star rating for an image. The above shortcuts can make it easier for you to focus your attention on the images as you use the 🔄 🔿 arrow keys to progress from one photo to the next. In addition to this you can still use the **H** *ctrl* +' (apostrophe) keyboard shortcut as a simple binary rating system that allows you to add or remove a single star rating from an image. How you use the ratings is up to you, but generally speaking it is a good idea to be sparing with your ratings. Unrated images can be the rejects, while one and two stars can be used to mark the images you like best. And three stars upwards should be reserved for those pictures that are really special.

Color labels can be used to signify other things. Author Peter Krogh suggests in his DAM book that labels be used to apply negative ratings, where a zero star represents an image that has been inspected but is rated neutral, a red label means it's yet to be rated, a yellow label means it's an out-take and a green label means 'trash me'. Meanwhile, a wedding photographer might use color labels to quickly separate out shots according to the location they were shot in. It is a simple matter of selecting the individual or multiple images you would like to label and then choosing a color from the list in the Label menu. Or, you can use the keyboard shortcuts that range from # 6 *ctrl* 6 for red, to # 9 *ctrl* 9 for blue, plus you can also use *ctrl* right-mouse to apply label colors via the contextual menu. If you go to the Labels preferences in Bridge (Figure 11.35), you will note that you can edit the text descriptions given to each label color. You can rename these as you see fit, although this can potentially cause confusion where other programs (such as Lightroom) may use different text descriptions for the color labels.

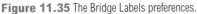

General	File Type Association					
Thumbnails Playback	Alias (.pix)	Adobe Photoshop CS5	- 1			
Metadata	ASP (.asp, .aspx)	Finder Settings	-			
Keywords	Audio (.au)	QuickTime Player 90.3.1	-			
Labels	Audio Interchange Format (.aif,	Finder Settings				
File Type Associations Cache	AutoCAD (.dwg, .dxf)	Adobe Illustrator CS4	•			
Startup Scripts	AVI (.avi)	QuickTime Player 90.3.1	-			
Advanced	Bitmap (.bmp, .rle, .dib)	Adobe Photoshop CS5	-			
Output	BPDX (.bpdx)	Adobe Acrobat Pro 9.2	•			
	Canon Camera Raw (.crw, .cr2)	Adobe Photoshop CS5	•			
	CGI (.cgi)	Adobe GoLive CS2	•			
	Cineon (.cin, .sdpx, .dpx, .fido)	Adobe Photoshop CS5	-			
	CompuServe GIF (.gif)	Adobe Photoshop CS5	-			
	Computer Graphics Metafile (.cg	Adobe Illustrator CS4	•			
	Corel Draw (.cdr)	Adobe Illustrator CS4				
	CSS (.css)	Adobe Dreamweaver CS4	•			
	Desktop Color Separation (DCS)	Adobe Photoshop CS5	•			
	Digital Negative (.dng)	Adobe Photoshop CS5	-			
	Digitized Sound (.snd)	QuickTime Player 90.3.1	-			
	Hide Undefined File Associations (Reset to Default Associa	ations)K			

Figure 11.36 The Bridge File Association preferences.

Universal rating methods

You are not limited to using the rating controls just within Bridge. The rating keyboard shortcuts described here work equally well when you are reviewing your images in the Camera Raw dialog or the Slideshow and Review viewing modes. Just to add to the confusion though, in the Slideshow and Review modes you only need to enter number keystrokes to add ratings or labels, where you can use 0–5 to apply a star rating and use 6–9 to apply a red, yellow, green or blue color label.

File Associations

The Bridge File Association preferences (Figure 11.36) list the default programs to use when opening specific files. Most of the time you can leave these as they are, but there are times when you may want to force certain types of files to open in a specific program. For example, some photographers may still use the EPS file format to save press-ready files. Bridge normally opens these using Adobe Illustrator, therefore you may in this instance want to change the File Association setting to Photoshop CS5.

Refreshing the view

If you alter the contents of a volume or a folder at the System level, outside Bridge, then the Bridge Folder panel and Content panel area won't always know to update the revised volume or folder contents. If you ever need to refresh the view in Bridge, you can choose View \Rightarrow Refresh, or use the F3 keyboard shortcut.

Sorting images in Bridge

You can change the order in which the images are displayed in the Content panel by going to the Sort menu shown in Figure 11.37. If you mouse down on the menu here you can choose from a range of different types of sort criteria and if you click on the arrow button next to this menu list (circled in Figure 11.37), you can choose whether you want to see the images displayed in an ascending or descending order. Normally the sort order is set to the 'By Filename' setting by default. However, if you were to select the 'By Date modified' option (and in ascending order) those files that had been edited most recently would appear first in the Content panel area.

Earlier, in Figure 11.6, I showed how you can manually drag the thumbnails to rearrange their position in the Content panel. Just be aware that if you do this, the Sort option will then default to 'Manually' and you may have to revisit the Sort menu in order to restore the previously applied sort order rule (note that you can also access the Sort options by going to the View menu in Bridge). As we get to looking at the different methods that can be used for filtering the images displayed in the Bridge Content panel, you will see how combining the filtering with the Sort options is perfect for organizing how the thumbnail images are arranged in the Content panel.

Figure 11.37 The Bridge window Sort menu options allow you to arrange the displayed thumbnail images by ascending or descending order (by clicking on the button circled here). You can use any of the criteria listed in the Sort menu to rearrange the Content panel display.

Filter panel

The Filter panel allows you to view all the available metadata criteria associated with the files in the current Bridge window Content panel view. You can then choose single or cumulative criteria for filtering the images in the Content panel area. The Filter panel options are grouped into sections and as soon as you click on any item listed in the Filter panel, the contents of the Content panel are filtered accordingly.

When managing large folders or hierarchies of folders, these filtering controls can really make it easier to narrow down an image search. For example, in Figure 11.38 you can see how Bridge was pointed at a folder where the image files in that folder were labeled using green and red labels and the ratings ranged from no rating to four stars. In this example, I clicked on the Red label plus the one, two and three star filters. This filtered the photos so that only those images with red labels plus one, two, three or four stars were displayed in the Content panel. Similarly, I could have gone to the Keywords section and clicked on one or more of the keywords listed there and made a filtered selection that was based on a combination of specific keywords. But wait, there's more... In the Filter panel you can filter images by other criteria such as: by file type, date created/modified, image orientation, speed ISO rating, camera serial number or copyright notice. You can also use the keyboard shortcuts shown in the sidebar to filter files by label or by rating.

In Bridge CS3 there was a Flatten View button in the Filter panel. This feature is still present in Bridge CS4 and CS5, but you will need to go to the View menu and select 'Show Items from Subfolders'. If you then point Bridge at a folder that contains a nested group of subfolders, you can use this command to get a flattened view of all the subfolders in that particular folder. The only downside is that Bridge temporarily loses track of the master folder in the Folders panel, but this can easily be restored by deselecting 'Show Items from Subfolders' in the View menu. There is also a pin marker button in the Filters panel (circled in Figure 11.38). If you click this, it preserves and locks the filter criteria as you continue browsing. Just click again to cancel and clear the filter completely.

Filtering shortcuts

FILTER COLLECTIONS EXPORT	
Labels	
No Label	663
Green	15
Red	103
Ratings	
No Rating	652
*	
 ✓ ★★ 	22
< ***	2
<pre>****</pre>	2
File Type	
Camera Raw image	87
DNG image	681
JPEG file	6
Photoshop document	2
TIFF image	5
Keywords	
Angelica	24
Camilla	
New York	775
People I know	31
Photo Plus	31
Places	763
Times Square	126
USA	775
Date Created	
Date Modified	a to the second of
Orientation	
Aspect Ratio	
Color Profile	and all the second
ISO Speed Ratings	and the second
Exposure Time	an alter
Aperture Value	
	0

Figure 11.38 The Filters panel.

METADAT	A KEYWORDS	Contraction and and a second second	(
f/7.1	1/500	4064 x 2704	5
		9.56 MB	
0.1	150 160	Untagged RGB	
		Cintaggeu KCB	t-
File P	roperties		
Dree	Filenam served Filenam		
	Document Typ		
	Date Create		
Da	te File Modifie		
	File Siz		
	Dimensior	s 4064 x 2704	
	Bit Dept		
	Color Mod		
	Color Profil	le Untagged	
	IIM, legacy)	and the state of the second states and the	
IPTC (Core		
	Create		1
	reator: Job Tit		100
C	reator: Addres		1
	Creator: Cit		1
	: State/Provinc tor: Postal Cod		*******
	Treator: Countr		2
	reator: Phone(2
	reator: Email(1
	ator: Website(1
	Headlin		
	Descriptio	View from Victoria & Albert	4
	Keyword	Africa; Cape Town; NATURE	1
IPT	TC Subject Cod	e See newscodes.org for guidelines	**
De	scription Write		1
	Date Create		15
In	tellectual Genr		1
	IPTC Scen	e See newscodes.org for guidelines	*
	Locatio		1
	Cit		1
	State/Provinc		*****
Sale of	Countr		1
150	O Country Cod Titl		1
	Job Identifie		1
	Instruction	Use this field to add any special instructions, such as s embargoes or other special	
		instructions not covered by the rights usage	
	Provide		1
	Sourc		1
C	opyright Notic		1
С	opyright Statu		
	ts Usage Term	Available for licensed usages	4
11. A 12. A	a Data (Exif)	only	
	Exposure Mod	e Auto	
	Focal Lengt		
	Len		
		0	-

Figure 11.39 The Metadata panel displays the metadata information contained in a file. The metadata sections can be compacted to make viewing easier and the IPTC fields shown here can all be edited. You can also increase the font size in the Metadata panel via the panel fly-out menu. This can make it easier to add new metadata and locate existing entries.

Metadata panel

The Metadata panel information is divided into several sections (Figure 11.39). The File Properties section lists the main file statistics such as file name and size, etc., while the IPTC sections contain the file-specific metadata information. To edit these, click in the field next to the metadata heading and type in the data you wish to enter (the pencil icons indicate where metadata items can be edited). When you are done, click the tick button at the bottom, or hit *Enter*. How the remaining sections appear listed will depend on how the Metadata preferences have been configured (Figure 11.40). Some of the items you see listed here are specific to other CS5 suite programs, or specialist users. Basically, you can use the preferences dialog to determine which items you want to see displayed in the Metadata panel.

	Preterences
General	Metadata
Thumbnails Playback Metadata Keywords Labels File Type Associations Cache Startup Scripts Advanced Output	▼ File Properties ✓ File name ✓ Preserved Filename ✓ Document Type ✓ Application ✓ Date Created □ Date File Created ✓ Date File Modified ✓ File Size ✓ Dimensions (in inches) □ Dimensions (in cm) ✓ Resolution ✓ Bit Depth ✓ Color Profile Label Rating ✓ Notes Supports XMP ✓ IDcument Title ✓ Headline ✓ Hide Empty Fields
Powered By	Show Metadata Placard

Image metadata

Maybe you are wondering what all the information in the Metadata panel is useful for. Well, quite a lot actually, especially if you are running a photography business or are an amateur who shoots lots of digital photographs. Metadata is usually defined as being 'data about data' and the concept of metadata is one you should already be quite familiar with. Librarians use metadata to classify and catalog books in a library – in the old days you would have used index cards to search by an author's name or by the title of a book. Everything is now computerized of course and it is possible to record much more information about individual files and use this information to carry out more sophisticated searches and crossreference files.

File Info metadata

The File Info dialog (Figure 11.41) has been around since the early days of Photoshop, but it seems that until recently only a few people had bothered using it. The File Info dialog is designed to let you inspect all the metadata relating to an image document as well as edit the IPTC image metadata that relates to the picture content. Photoshop has always supported the information standard

a second s		SAfrica0501	_0164.TIF		and a second
IPTC Extension	Camera Data	Video Data	Audio Data	Mobile SWF	Categories 🕨
Document Title:	Victoria & Albert Wa	terfront			
Author:	Martin Evening				
Description:	View from Victoria & the distance.	Albert Waterfron		ss the harbour to T	Table Mountain in
Copyright Notice:	© Martin Evening 20	005			
Copyright Info URL:	www.martinevening	.com	METERAL		Go To URL
Content Type:		•			
Content Version:					
Persistent Storage:		КВ			
Background Alpha:	84				
Forward Lock:					
Forward Lock:					
Forward Lock:					

Powered by XMP

In 2001, Adobe announced XMP (eXtensible Metadata Platform), which to quote Adobe: 'established a common metadata framework to standardize the creation, processing and interchange of document metadata across publishing work flows'. Adobe has already integrated the XMP framework into Acrobat, InDesign, Illustrator and Photoshop. XMP is based on XML (eXtensible Markup Language), which is the basic universal format for using metadata and structuring information on the Web. Adobe has also made XMP available as an open-source license, so it can be integrated into any other systems or applications. Due to Adobe's enormous influence in this arena it means that XMP has now become a common standard in the publishing and imaging industry. Adobe and also third-party companies are now able to exploit the potential of XMP to aid file management on a general level as well as specific needs such as scientific and forensic work.

Figure 11.41 Here is an example of the File Info dialog showing editable metadata items such as the image description and copyright notice. I have circled here the Import/Export options menu that is discussed in Figure 11.42.

Figure 11.42 You can configure the File Info dialog and create a custom metadata template containing the metadata items you might wish to regularly apply to collections of images. If you mouse down on the Import/ Export metadata options (shown above and also circled in Figure 11.41) you can choose 'Export...' which opens the Export dialog shown above, where you can save the current metadata settings as a new metadata template.

Figure 11.43 Following on from Figure 11.42, once you have done this you can apply the template to other images by going to the Tools \Rightarrow Replace Metadata/Append Metadata menu. Replace Metadata substitutes all pre-existing metadata with that in the template. Append Metadata is the safer option since it only adds to the metadata that is already embedded in the image file.

developed by International Press Telecommunications Council (IPTC), which was designed to help classify and label images and text files using metadata. In early versions of Photoshop, you could access the File Info via the Photoshop File menu and use it to title an image, add the name of the author, add keywords and inspect the camera capture metadata. File Info is still there in Photoshop, but if you highlight an image, or group of images in Bridge, you can also access the File Info dialog via the Bridge File menu, or by using the **H** *Ctrl* keyboard shortcut. The File Info dialog contains 11 sections, some of which are user-editable, such as the Mobile SWF section shown in Figure 11.41, while other sections, like the Camera Data section, provide information only. You can use File Info with single or multiple image selections to edit the IPTC metadata, add your name as the author, mark the images as being copyrighted, add a copyright notice, etc. Marking an image as being copyrighted has the extra advantage of adding a copyright symbol to the title bar of your image window whenever anyone opens it in Photoshop.

After configuring the File Info settings you can also save these as a metadata template. For example, you can select an image, enter some basic custom metadata such as author name, copyright tag, etc., then follow this by going to the Import/Export options (discussed in Figure 11.42) and save as a new metadata template. Or, you can go to the Tools menu and choose 'Create Metadata Template...'. This opens the dialog shown in Figure 11.44, where you can edit the required metadata template settings. Once you have saved a custom metadata template, you can select other images and choose this or any other pre-saved template from the Append Metadata or Replace Metadata menus in the Tools menu (Figure 11.43). When you create a new template it is best to enter the exact information that should be saved and nothing else. I suggest you don't add any keywords or captions, unless these need to be included in the saved template.

IPTC Extensions

Bridge CS5 has now added the IPTC Extension Schema for XMP, which is a supplemental schema to the IPTC Core. It provides additional fields with which to input metadata that can be useful to a commercial photography business. In Figure 11.44 I have provided examples of how you might complete some of the items

	Create Metadata Template	
emplate Name: IPTC Ex	tensions	
hoose the metadata to in	clude in this template:	
IPTC (IIM, legacy)		-
IPTC Core		
	Name or person or persons seen in the image	
	the image was created a	
▼ Location 🔒		
Sublocation	: Location details	
City	1	
Province/State		
Country Name		
Country ISO-Code World Region	*	
✓ ▼ Location Shown 3		
▼ Location 🗃		
	: Location details	
City	:	
Province/State	:	
Country Name	1	
Country ISO-Code World Region		
	il	
Code of Featured Organi	isation : Name or company or organization featured	
-		
Artwork or Object	Name or description of a specific event	
	Information about ethinicity or other facets of the model	
	16	
Minor Model Age Disclos		
	Limited or Incomplete Model Releases	•
Model Release Identifier	A Plus ID Identifying each image	
✓ ▼ Image Supplier 🗊	in the second and cars and the	
▼ Supplier 🕱		
Image Supplier Nat	me: Identifies the most recent supplier of the image	
Image Supplier ID	1	
Supplier's Image ID		
✓ ▼ Registry Entry □		
▼ Entry 🔒	on Identification: Registry organisation name	
	ntifier: ID number of recorded registration	
press a	3800	
	5000	
1000 M		
✓ ▼ Image Creator 国	Original digital capture of a real life scene	· ·
▼ Creator 🔒		
Name	Creator or creators of image	
Identifier	*	
✓ ▼ Copyright Owner		
▼ Owner 🔒		
Name	Name of copyright owner	
Identifier	:	
✓ ▼ Licensor 🖬		
Name	: Comany name	
Identifier	:	
Phone type 1	: work	•
Phone number 1	1	
	Limited or Incomplete Property Releases	T
Property Release Id	Summarize property release status	4
Only checked pro	perties will be added/changed to this template.	
operties selected: 68		
operties selected: 68		
Clear All Values	Cancel	Save

Controlled Vocabulary

David Riecks runs a website with tips and guidelines on how to work with a controlled vocabulary at: www.Controlledvocabulary.com.

Figure 11.44 This shows an example of how you might fill in some of the IPTC Extension metadata sections. You can also obtain more specific information via the www.newscodes.org website.

Viewing IPTC Extensions metadata

Note that the IPTC Extensions metadata is only visible when previewing the File Info dialog shown in Figure 11.45. These items won't be displayed in the Bridge Metadata panel.

listed in the IPTC Extensions section of the Create Metadata Template, and you will see brief explanations of how each of these new fields may be utilized. Also, in Figure 11.45 you can see an example of how the new IPTC Extensions data is presented in the File Info dialog. Basically, the new IPTC Extensions schema can provide additional information about the content of the image such as the name, organization or event featured in a photograph. It provides you with further fields to improve administration, where you can apply globally unique identifiers (known as GUID). It offers fields for precisely defining the licensing and copyrights of a particular photograph. For example, rather than just saying 'this photo is copyright of so and so', it allows you to specify the name of the copyright holder as well as who to contact to obtain a license. This might well be a picture library or a photo agent rather than the photographers themselves. The image supplier can also be identified separately. Again, it might be a photo library that supplies the image rather than the photographer directly.

Photographers who shoot people now have the opportunity to record specific model information, such as the age of the model, whether they are under 18 years old, etc., and you can also provide a summary of the model release status. The same thing applies to photographs of private properties, where under some circumstances a property release may be required.

Other types of metadata

Metadata comes in many forms. In the early days of digital camera technology development, the camera manufacturers jointly came up with the EXIF metadata scheme for cataloging camera information. You may find it interesting to read the EXIF metadata that is contained in your digital camera files, as this will tell you things like what lens setting was used, when a photo was taken and the serial number of the camera. This could be useful if you were trying to prove which camera was used to take a particular photograph when there were a lot of other photographers nearby trying to grab the same shot and also claiming authorship (such as when shooting among a large gathering of other photojournalists). The EXIF metadata can describe everything about the camera's settings, but the EXIF schema cannot be adapted to describe anything but the camera data information. Even so, EXIF metadata searches are useful where you may wish to isolate the photos shot

Chapter 11 Image management

City: Province/State: Country Name: Country ISO-Code: World Region: Copy this location into 'Location shown' Location shown: Sublocation City Province... Country ... Vorld Re... Location details Location details ŧΞ Featured Organisation: Name Code Name or company or organization feat Event: Name or descriprion of a specific event Artwork or Object in the Image Artwork or Object: Title Date creat... Creator Source Source in... Copyright... About models in the image Additional Model Info: Information about ethinicity or other facets of the model Model Age: 16 (i) Semicolons or commas can be used to separate multiple values * Minor Model Age Disclosure: Age 16 -* Model Release Status: Limited or Incomplete Model Releases V Model Release Identifier A Plus ID Identifying each image Administrative Information * Image Supplier Name: Identifies the most recent supplier of the image * Image Supplier ID: * Supplier's Image ID: Registry Entry: Registry Organisation Identifier Registry Image Identifier Registry organisation name ID number of recorded registration Max. available Height: 3800 Max, available Width: 5000 Digital Source Type: Original digital capture of a real life scene . . Powered By Preferences Export... • Cancel OK

SAfrica0501_0164.TIF

Mobile SWF

Categories 🕨 🔻

IPTC Extension Camera Data Video Data Audio Data

with a particular camera and lens combination or where you may wish to filter all the photos that were shot using a particular ISO setting.

Some of the metadata items that can be listed in the File Info and Metadata panel include things like GPS metadata, where if GPS coordinates happen to be embedded in a file, you can crossreference these with another application such as GoogleTM Earth. Currently it is quite tricky to marry up the GPS metadata from a track log file recorded using a GPS device and get the time zones and clock times to match, but still very useful information to have available. Other items have specific uses such as the DICOM metadata section items which have been specifically designed for embedding important medical data information in medical images.

The amount of metadata that can be recorded has now grown to the point where the File Info... has become extremely crowded. One of the niggles I have with the current updated design of the File Info dialog is that, from a photographer user's point of view, the information we need to access and edit is now scattered all over the place. Where the File Info options were once quite limited, the File Info dialog was actually much easier to manage and work with.

Future uses of metadata

It is quite scary to consider the number of freely distributed digital images out there that contain no information about the contact details of the person who created the image. Imagine a scenario in the future where metadata can be used to embed important information about usage rights and do so using an industry-agreed format (as is already the case with IPTC data). Imagine also that a third-party developer could service a website that allowed interested purchasers to instantly discover what specific exclusive usages were currently available for a particular image. You could even embed a self-generating invoice in the image file. If someone tried to strip out the metadata, you could use an encrypted key embedded in the file to re-import the removed metadata, and/ or update specific metadata information. I predict that metadata will offer a tremendously powerful advantage to individual image creators who wish to distribute their creative work more securely over the Internet and profit from legitimate image rights purchases.

Edit history log

If the History Log options are enabled in the General preferences (Figure 11.46), an edit history can be recorded in either the file metadata, as a separate text file log, or both. The edit history has many potential uses. An edit history log can be used to record how much time was spent working on a photograph and could be used as a means of calculating how much to bill a client. In the world of forensics, the history log can also be used to verify how much (or how little) work was done to manipulate an image in Photoshop. The same arguments could apply if validating images used to present scientific evidence. In the case of images that have been processed via the Adobe Camera Raw plug-in, the Camera Raw metadata section also stores a record of the Adobe Camera Raw (or Lightroom) settings used.

Figure 11.46 To record a history log, the History Log option must first be checked in the Photoshop General preferences. A history log can be saved to the file metadata, as a text log file, or as both, and the edit log items can be recorded as session information only, concise or as a verbose record (see Figure 11.47) of what was done to a file in Photoshop.

Hidden metadata

Lastly, I should mention that there may be hidden metadata that won't show up in any of the Metadata panel sections. This could be things like camera manufacturer EXIF metadata that contains proprietary information that only the camera manufacturer's software has access to.

f/13.0	1/125	3	744 x 5616	
		2	97.65 MB	300 ppi
. Å	150 200	P	roPhoto RGB	RGB
File Pro	perties			
	Filen	ame	bookshoots sd	_090729_0449
D	ocument T	ype	Photoshop c	locument
	Applica			os]) Macinto
Dat	Date Crea		29/07/2009	
		Size	297.65 MB	1
			3744 x 561	
Dimensi	ons (in incl Resolu		12.5" x 18.7 300 ppi	
	Color M	lode	RGB	
			ProPhoto RC	B
	M, legacy)			
IPTC Co				
Camera	Data (Exif	0		
Audio	I Kaw			
Video				
Edit His			and the second second second	
Free Transt Master Opz Add Layer I Fill Brush Tool Brush Tool Brush Tool Brush Tool Brush Tool Brush Tool Brush Tool Edit Conter Undo	hange nts hange city Chang form acity Chang Mask Mask	e		
	11T15:13:0 s_090729_(
DICOM Mobile	SWF			

Figure 11.47 If the history log options have been enabled in the Photoshop General preferences, the history log content can record: sessions only (such as the time a file was opened and closed); a concise log listing of what was done in Photoshop; or as shown here, a detailed log that includes a comprehensive list of the settings applied at every step. If you choose to embed the history log in the file metadata, the edit history log can be viewed via the Bridge Metadata panel.

Where keywords are stored

Like other metadata, keyword information (including the keyword hierarchy) is stored directly in the file's XMP space, or in the case of raw files, either to the Camera Raw cache database or as a sidecar file. The Keywords panel displays the accumulated information that it has read from various image files' metadata and can also be used to write keyword metadata back to the files.

Other keywords

As you enter keywords via the File Info panel, any keywords that are unrecognized will appear listed under the category: 'Other Keywords'. You can then use the Keywords panel to rearrange these into a suitable hierarchy and have the option to make them persistent. You will also find that where Bridge is unable to read the hierarchy of keywords that have been entered via another program, these too may appear listed under 'Other keywords'.

Keywording

Keywording provides you with a way to group and organize images within Photoshop. By using keyword tags to describe the image content, you can catalog your files more comprehensively.

It is usually best to add keywords at the same time as you import new images. For example, Figure 11.48 shows a detailed view of the Categories section of the File Info dialog where you can add keywords to an image. It is important to note here that each keyword must be separated by a semicolon or a comma. This is important as it ensures the keywords are clearly separated (see how the keywords are entered in Figure 11.48). Such keyword metadata can also be included when you create a metadata template. For example, every time you shoot a particular sporting event you might want to have a template that applies relevant keyword metadata you always need for these types of assignments, such as the name of the stadium location and home team. Unfortunately, you can't create a keyword hierarchy as you enter the keywords (see sidebar on 'Other keywords'). You also need to know the exact keyword phrases to type if they are to match with the keyword data used elsewhere for other images, which is why it is sometimes better to use the Keywords panel to do this.

		IMG_244	6.CR2		
IPTC Extension	Camera Data	Video Data	Audio Data	Mobile SWF	Categories •
Cate	gory:				
Supplemental Catego	ories: ANIMALS; Bird	is; Falkland Islands	s; Magellan pengui	ns; Saunders Island	4
	(i) Semicolon	s or commas can l	be used to separat	e multiple values	
Powered By		Preference	Export	Cancel	ОК
vink					

Figure 11.48 The File Info Categories section.

Chapter 11 Image management

Keywords panel

The Keyword panel (Figure 11.49) displays all the keywords that are associated with the images you have currently selected. The Keywords panel provides a basic level of organization as it allows you to arrange keywords that you come across into a hierarchy list, plus you can also use the Keywords panel to add new keywords. Click on the 'Add new keyword' button to create a keyword category, such as 'People' or 'Places', type in the name and hit *Enter* to add the keyword (or use *esc*) to cancel). You can then highlight the keyword and click on the 'Add new sub keyword' button to add a new sub keyword. Once keywords appear listed in the Keywords panel you can make a thumbnail selection within Bridge, go to the Keyword panel and click on the empty square to the left of the desired keyword to apply, or click again to remove. This method allows you to assign one or more keywords to multiple images at once. As long as the 'Automatically Apply Parent Keywords' option is checked in the Bridge Keywords preferences (Figure 11.50), checking a sub keyword automatically selects all the parent keywords too.

General	Keywords
Thumbnails Playback Metadata	Automatically Apply Parent Keywords Clicking the keyword check box automatically applies parent keywords. Shift click applies a single keyword.
Keywords Labels	Write Hierarchical Keywords
File Type Associations	Output Delimiter: $\bigcirc \uparrow^{i} \bigcirc \uparrow^{j} \bigcirc \uparrow^{j} \bigcirc \uparrow^{i} \bigcirc \uparrow^{i}$
Cache Startup Scripts Advanced Output	Read Hierarchical Keywords Input Delimiters: יי יי יי יי יי יי יי
	Cancel OK

Figure 11.49 In this view of the Keywords panel an image was selected and I can see that five keywords were assigned, telling me that this was a photograph taken on Saunders Island in the Falklands islands and that the subject matter was of Magellanic penguins. Now, in this instance, 'Magellanic penguins' appears in italics, which indicates this was not an established keyword in the Keywords panel. To make this keyword persistent, I used a color-click (Mac) or right mouse-click to open the contextual menu shown here and chose 'Make Persistent'.

Figure 11.50 The Bridge Keywords preferences.

Search criteria

The search criteria can be for almost anything you want. The source folder will default to the folder you are viewing in the front-most Bridge window, but you can select other folders to inspect as well and if the folder you are searching contains a lot of subfolders, you'll need to make sure that the 'Include All Subfolders' option is checked. The search criteria can also be adapted in various ways. For example you can include search terms where you ask Bridge to search for files that exclude specific criteria. The keyword information accumulates as you select further images and you will notice that some of the 'visited image' keywords appear in italics. This indicates that they are only temporary. If you were to quit Bridge and relaunch, these temporary keywords would be cleared from the list. To make such keywords permanent you should use the contextual menu (as described in Figure 11.49) to make them persistent.

Image searches

Image searching is now mostly faster in Bridge. The search field allows you to use either a standard Bridge search or a systembased file search (such as Spotlight on the Mac). All you have to do is select the folder you want to search in, enter the phrase you want to search for and hit *Enter* or *Return*. This will carry out an instant search that includes all subfolders. If that fails to produce any results or you want to expand the search criteria, you can click on the New Search button which opens the Find dialog shown in Step 3. Here, you'll find more search options such as the ability to combine different match criteria and match policies. If Bridge has not had a chance to cache the files in all folders yet, you can select the 'Include Non-indexed Files' option. However, this will make for slower but more thorough searches.

1 This shows a Bridge window view where I was about to carry out a file search of a master Casting Photos folder, looking for any images that matched the term 'Sundal'. You'll note that there are three search options available. In this instance I used a Bridge search, which would carry out a search by file name and keywords using the Bridge search engine.

No items to display

Z Find Criteria: Find "Sundal" in "Casting photos" an...

2 The standard Bridge search gave no results, so I clicked on the New Search button.

Find	
Source	
Look in: Casting photos	•
Criteria	
All Metadata 🛟 contains 🕏 Sundal	⊡ ⊕
Results	
Match: If any criteria are met	
Include All Subfolders	
Include Non-indexed Files (may be slow)	
Find	Cancel

Skipping the Bridge search field

You can skip the Bridge search field completely and open the Find dialog shown in Step 3 directly. Just go to the Edit menu and choose 'Find...', or use the **HF** ctrl **F** keyboard shortcut.

3 This opened the Find dialog, which allowed me to expand the search criteria used. Here, I changed the 'File Name' criteria to 'All Metadata' (note that, you'll have to retype the search phrase again when you do this) and clicked 'Find'.

4 This time I was more successful, because Bridge now included all metadata search criteria such as the Caption IPTC metadata that had been edited via Lightroom and the results of the search were now displayed in the Content panel area.

New Search

X

Figure 11.51 The Collections panel showing normal and smart collections.

Collections panel

The ability to create collections is an important feature in any image management program (such as Lightroom) but it's even more important for a file browser program such as Bridge. This is because collections allow you to quickly access specific groups of images. The Collections panel (Figure 11.51) was recently updated in Bridge CS4 and is now even smarter than before. To create a new collection, all you have to do is make a selection of images in Bridge and then click on the 'Add new collection' button in the Collections panel. Or, you can click on the 'Add new collection' button first to create a new collection and then drag the files to the collection. You see, with collections you are not limited to refining the images in single folders: you can drag images across from other folders in order to create a new group of images. In Figure 11.51 I highlighted the 'Portfolio' collection and, as the title suggests, this collection could be used to store images that have portfolio potential. To remove photos from a collection, you need to make a selection of the photos and then click on the Remove From Collection button (Figure 11.52). To delete a collection, select the collection in the Collections panel and then click the Delete button.

Figure 11.52 To remove a file (or files) from a collection, click on the Remove From Collection button (circled).

Smart collections

As well as creating normal collections, you can also click on the Add New Smart collection button to open the Edit Smart Collection dialog shown in Figure 11.53, where you can choose the folder group to look in, followed by the various criteria to filter by. In this example, I filtered the images in the SouthWest trip folder to create a smart collection that only contained files with a two star rating or higher.

	Edit Smart Collection
- Source -	
Look in:	SouthWest trip
- Criteria	
Rating	is greater than \Rightarrow $\star\star$ \Rightarrow \Rightarrow
Results	
Match:	If any criteria are met
🗹 Inclu	Jde All Subfolders
🗹 Inclu	ude Non-indexed Files (may be slow)
	(Save) Cancel)

Smart collection rules

The Criteria section can be used to add one or more file selection criteria and each item can have conditional rules. So for example, when you select 'Document Type', you can choose to filter according to whether files equal or don't equal this criteria. When the 'Rating' option is selected you can choose to filter according to whether files have the exact same rating, or the same and greater, etc. Next comes the Match section. If you select the 'lf any criteria are met' option, this acts as an 'AND' sort function, where files are sorted according to whether they meet any one of the individual criteria. If the 'If all criteria are met' option is selected, this acts as an 'OR' sort function, where files are sorted according to whether they meet all the combined filter criteria.

Figure 11.53 This shows the Edit Smart Collection dialog and below, the result that this smart collection setting produced.

Automatic sRGB conversions

Prior to Bridge CS4 you had to make sure that all the RGB source files were in the sRGB color space, otherwise the colors could look very different when viewed in a non-color managed web browser (i.e. just about all web browsers). The good news is that Bridge now automatically converts everything to sRGB.

Output to Web and PDF

Bridge CS4 saw a radical shake-up in the way Web Galleries and contact sheets could be generated via Bridge, and Bridge now has an Output workspace mode that includes Output and Output Preview panels. Not too much has been lost in this transition and there have been a few small improvements, although in my view the changes that were introduced were just a small step forward and there was a missed opportunity to make some really significant improvements to the Web and Contact sheet output.

To put Bridge into output mode, click on the Output workspace. This reveals the Output Preview and Output panels, where you can choose between the PDF and Web Gallery output options.

Figure 11.54 This shows an example of a Web Gallery output preview in Bridge.

Web output

We'll start with the Web Gallery output, which can be used to process selected images and automatically generate all the HTML code that's needed to build a website complete with thumbnail images, individual gallery pages and navigable link buttons. This feature can save you many hours of repetitious work. Imagine you have a set of Photoshop images that need forwarding to a client or colleague. When you build a self-contained Web Gallery (such as in the example shown in Figure 11.54), the processed images and HTML pages can be output to a destination folder or uploaded directly to a designated server address. The source can be any folder of images, regardless of whether they are in RGB or CMYK color mode, because the Web Gallery output process converts all images to sRGB anyway.

The image order can be adjusted by manually dragging the thumbnails in the Content panel. It is not essential that you resize all the photos first to the exact viewing size, as the Web Gallery options allow you to precisely scale the gallery images and thumbnails to the correct size while they are being processed.

There are 22 template styles to choose from, a few of which are shown in Figures 11.55–11.59. Some of these templates use a simple HTML table design, while others utilize frames and basic JavaScript. All these gallery styles can be customized to varying extents by adjusting the panel settings shown in Figures 11.60-11.63. Once you have selected a gallery style and adjusted the settings, you can then click on the Preview in Browser button (circled in Figure 11.54) to see an updated preview in the Output Preview panel. This offers a quick overview of the gallery layout using the photos that you are about to process and does so without leaving Bridge. Alternatively, you can use the Preview in Browser button to generate a temporary website on-the-fly, which can be previewed in an actual browser program. Now, the thing to be aware of here is that whichever method you choose, the Output Preview can only generate a gallery preview from the first 20 photos that have been selected in the Content panel. The reason for this is because the Web Gallery has to rebuild from the original source files each time you make the slightest change to a gallery layout (even if its just a simple change to the banner description). For this reason, the Web Gallery previews are restricted to no more than 20 photos (which is still better than the previous 10 limit).

Web Photo Gallery alternative

If you want to know what happened to the Web Photo Gallery, it has been removed from the default installation, but can still be installed into Photoshop CS5 (but not Bridge). To do this you will first need access to Photoshop CS3 or an older version of Photoshop in order to locate the 'WebContactSheetII.plugin', which you'll find in the Photoshop application/Plugins/ Automate folder. You will also need to access the 'Web Photo Gallery' folder that's in the Photoshop application/Presets folder. Once you have done this, copy these to the corresponding Photoshop CS5 folders. Now, the important thing to realize here is that Photoshop CS5 can only read these files if it is running in 32-bit mode, so you will either have to switch the program to 32-bit mode (Mac) or run the 32-bit version (PC). On the Mac you need to select the Photoshop CS5 application program file at the system level, choose File \Rightarrow Get Info and check the 'Open in 32-bit mode' box. Now restart Photoshop. Once you have done this, you will find that the Web Photo Gallery appears listed in the File \Rightarrow Automate submenu. This will then give you access to all the extra 'old style' gallery templates, which include useful gallery styles such as the Feedback template, where visitors can send you an email that includes their chosen selection of images plus any feedback comments.

Output gallery styles

Figures 11.55–11.59 show you a few examples of the different Web Gallery templates that are available in Photoshop CS5. including the three new Airtight styles that are also found in Lightroom. These pages were created using the default Web Gallery settings.

Output gallery settings

000

As you will read on pages 614–615, there is plenty of scope for you to produce your own customized Web Photo Gallery pages. Here, I have provided a brief run-down of all the Web Gallery output options and included the alternative panel options where these may vary for the different types of gallery styles.

Template: **Refresh Preview**

Figure 11.55 The Standard (Medium Thumbnail) gallery style.

-7- PDF	a u n	WEB GAL	LERY	
Template:	Airtight P	ostcardViewer		
Style:	Custom			1

Figure 11.57 The Airtight PostcardViewer gallery style.

Figure 11.58 The Airtight AutoViewer gallery style.

Figure 11.59 The Airtight SimpleViewer gallery style.

Figure 11.60 The Site Info panel can be used to add extra information such as a title and caption for the gallery pages and contact info. For example, you could type in your name in the 'Your Name' section. If you then enter your email address below, this becomes an active link that is associated with the 'Your Name' field. Visitors to the pages can simply click on this to open a new email window (addressed to you) in their mail program. All this is dependent though on whether you have the 'Show Title Bar' option checked. If this is disabled, no Site Info is added to the gallery pages.

Figure 11.61 The Color Palette panel can be used to customize the appearance of the pages. These screen shots show the default Color Palette settings for (from left to right) the Bridge Standard Flash galleries, Lightroom Flash and Lightroom HTML galleries. As you can see, the options are slightly different for each and there are plenty of opportunities to create different design appearances. For example, why not check out some of the Lightroom Flash gallery templates to see what different options are available here.

Chapter 11 Image management

3

Appearance				Appearance
Slideshow Size:		675	рх	✓ Show Cell
Gallery Image Size:		450	рх	✓ Show File
Thumbnail Size:		75	рх	Pre
Quality:		70		
Layout :	Left			Number of (
DATE OF LOW OF DESIGNATION				Number

adjust the gallery layouts. These screen shots show the default Appearance panel settings for (from left to right) the Lightroom Flash, Lightroom HTML and new Airtight PostcardViewer galleries. So for example, with the Lightroom Flash gallery style you can adjust things like the Gallery image and Thumbnail image size. Obviously, the smaller the thumbnail size, the faster the gallery pages will load. For the Lightroom Flash galleries you can choose from the Scrolling, Left, Paginated and Slideshow Only layout styles. With the Lightroom HTML gallery you can choose to show cell numbers and file names (with or without extensions) and also select the preview size and image quality. When an Airtight gallery style is selected you'll see additional Image Info and Output Settings panels. Here, I had the PostcardViewer style selected and this allowed me to adjust things like the padding space and proportional sizes of the thumbnail and preview image sizes. You can also add metadata to the preview images such as: an IPTC caption, date shot, camera used or exposure.

Columns: Photo Borders: рx 160 Padding: DХ Distant: 96 Near: Image Info Caption: Caption **Output Settings** 640 px Size: Ganata Quality: 70

Appearance

Create Gallery Gallery Name Pompeii Save Location Browse... /Users/martin_evening/Desktop/test Upload Location 1 1 FTP Server: www.photoshopforphotographers.com User Name: admin Password: Remember Password Folder: /book Save Upload

New Preset Preset Name: MEP Ltd Create Cancel

w Cell Numbers

w File Names

Preview Size:

Quality:

er of Columns: 3

mber of Rows: 3

Show Extention

300 px

70

Managing folders on the server

It is great that you can upload galleries direct to a server, but you will still need to use an FTP program to manage the folders once they have been uploaded there. For example, you can only use the Create Gallery panel to add folders to the server. It doesn't let you remove them.

Figure 11.63 The Create Gallery panel can be used when choosing either 'Save', which saves the gallery pages to a folder on the computer, or 'Upload', where the gallery pages can be automatically uploaded to a pre-configured server address. Here, you will need to enter the server address, the user name and password, plus a primary folder location. Once you have done this, click on the Upload button to begin uploading directly to the server. You can save server settings by clicking on the Document button (circled) and naming them. These settings will then be available as an Upload menu option (where it currently says 'Custom').

Output preferences

There are just a few final points to take into consideration when generating Web Galleries via Bridge. If you go to the Output preferences (Figure 11.64), you can check the 'Use Solo mode for Output Panel Behavior'. This allows single-panel clicking to expand the selected panel and close all others at the same time. I would suggest that you keep the 'Convert to Multi-Byte Filenames to Full ASCII' option checked, as this helps overcome any file naming irregularities that might otherwise trip up a web server and prevent any Web Output files from being uploaded. The 'Preserve Embedded Color Profile' option is best left unchecked. Normally, in a color managed workflow you would want to preserve embedded profiles. However, in this instance, preserving the embedded profile overrides the built-in 'convert to sRGB' procedure and keeps the images in their current profile spaces. Since very few web browser programs can actually read embedded profiles, you should leave this unchecked and let everything convert to sRGB. In the case of PDF outputs it can be more important to preserve the embedded profile, however it all depends on whether the output is mainly for print or for screen publishing (see page 619).

	Preferences
General Thumbnails Playback Metadata Keywords Labels File Type Associations Cache Startup Scripts Advanced Output	Output Use Solo Mode for Output Panel Behavior Convert Multi-Byte Filenames to Full ASCII Preserve Embedded Color Profile Reset Panel to Defaults

Figure 11.64 The Bridge Output preferences.

PDF Output

The PDF Output option was introduced at the same time as the Web Output option in Bridge, offering a replacement for the previous Contact Sheet II and PDF Presentation automated plug-ins. Conceptually, PDF Output has the potential to offer improved tools for PDF presentations and contact sheet layouts. Unfortunately, this new feature is badly compromised by a number of design flaws. As with the Web Gallery output, there is no image cache to store the output preview images. Bridge has to read the image data from the selected images in the Content panel each time you make so much as a small change to the layout settings and you have to follow this by clicking on the Refresh Preview button. Once again you are limited to previewing up to a maximum of 20 photos. If you intend to use PDF Output to print contact sheets, you'll also have to go through the additional step of opening the PDF output via a PDF reader program and print from there (rather than being able to print direct from Bridge).

Another problem is that you can't create custom contact sheet layout presets. My advice is if you have Lightroom, you don't need Bridge output. This is because Lightroom does store a cache of the image previews and makes use of this in two ways. It can use the image cache to quickly build a preview of how the contact sheet will look and it also allows you the option to print directly in 'draft mode' from the preview data. The net result of all this is that Lightroom can generate contact sheet prints roughly 100 times faster than Bridge, which is quite a big difference in performance speed between these two programs. Lastly, the Output Preview panel is unable to color manage the images and is therefore a poor visual guide for what the finished prints should actually look like.

That said, for the sake of non-Lightroom users I shall continue to run through the remaining options here, but I do suggest you read through the sidebar on how to install the previous Contact Sheet II feature should you wish to use this as an alternative to PDF Output. One of the benefits of using Contact Sheet II is that it does allow you to print directly out of Bridge, although as with the PDF Output, Contact Sheet II can only generate contact sheets by reading from all the original print data, rather than making use of an image cache.

Contact Sheet II alternative

The Contact Sheet II feature has also been removed from the default installation, but can still be installed into Photoshop CS5 (but not Bridge). To do this you will first need access to Photoshop CS3 or an older version of Photoshop in order to locate the 'ContactSheetII.plugin', which you'll find in the Photoshop application/ Plug-ins/ Automate folder. Once you have done this, copy this plug-in to the corresponding Photoshop CS5 Plug-ins/ Automate folder. Now, the important thing to realize here is that Photoshop CS5 is only able to read the ContactSheetII.plugin if it is running in 32-bit mode, so you will either have to switch the program to 32-bit mode (Mac) or run the 32-bit version (PC). On the Mac you need to select the Photoshop CS5 application program file at the system level, choose File \Rightarrow Get Info and check the 'Open in 32-bit mode' box. Now restart Photoshop. Once you have done this, you will find that Contact Sheet II now appears listed in the File \Rightarrow Automate submenu. This will then allow you to create contact sheets via the old Contact Sheet II interface, where you will find it quicker to preview the grid layout when setting out a cell grid structure for your contact sheets (although you won't be able to see the images previewed of course). Unfortunately, you won't be able to print out from selected photos in Bridge. Your only option will be to print direct from a chosen folder.

Martin Evening Adobe Photoshop CS5 for Photographers

Figure 11.65 The Output panel.

Document		
Page Preset:	Intern	ational Paper
Size:	A4	
Width:	21	cm 💌
Height:	29.7	0 e
Quality:	300 p	pi
Quality:	1 1 1 1 1 10	٥٠٠٠٠ 70
Background:	White	
Open Password:		
Permissions Pass		

Figure 11.66 The Document panel

Image Place	ment:	Acr	oss First (By Row	() *
Columns:	4		Top:	0.43	cm
Rows:	5		Bottom:	0.43	cm
Horizontal:	0.64	cm	Left:	0.43	cn
Vertical:	1.52	cm	Right:	0.43	cm
Use Auto	-Spaci	ng			
Rotate fo	r Best	Fit			
Repeat O	ne Pho	to pe	r Page		

Figure 11.67 The Layout panel

Figure 11.68 The Overlays panel.

The PDF Output panels

We'll start here with the Output panel (Figure 11.65) where you can choose the PDF Output option, which switches the Output panel into PDF output mode. Here, you will see the Template option, where you'll find a choice of eight output templates, which incidentally, are similar to the ones found in the old Contact Sheet II feature. The Refresh Preview works the same as the Web Gallery. It generates a preview of how the template design will look based on the selected photos, using as many photos as are required to fill a full page template. So for example, if you selected the 4 \times 5 Contact Sheet template, Bridge uses the first 20 images only to generate a contact sheet preview.

The Document panel (Figure 11.66) can be used to set the document size based on International, U.S. Paper, Photo or Web page presets. Depending on the option selected here, this will affect the Size options below. Alternatively, you can enter in a custom page size, in a choice of units. The Quality menu allows you to set the desired output pixel resolution and below that the compression quality to use. The Background color can be black or white, or you can click on the color swatch next to this to pick a custom color. If you want, you can use the 'Open Password' and 'Permissions Password' options to make the PDF document password protected (including the ability to prevent people from printing the document).

The Layout panel (Figure 11.67) let's you customize the layout, by editing the number of columns and rows, and set the maximum allowed size for each image plus the margin height and width. The margin spacing should be at least as wide as that allowed by your printer. In most instances, the leading page edge (the right or bottom margin) will require a wider margin gap than the other margin edges. Bridge doesn't provide any clues here, so unless you know what this margin gap should be, your best bet is to use trial and error to work out the safe margin width. One option is to select the 'Auto-Spacing' option, where Bridge uses its knowledge of the maximum printable page area to auto adjust the placement of the images. If the 'Rotate for Best Fit' option is selected, Bridge will auto-rotate landscape and portrait images so that each prints as big as possible within the horizontal and vertical size limits. Lastly, the 'Repeat One Photo per Page' option can be used to create PDF layouts where each image is repeated multiple times on each page document.

The Overlays panel (Figure 11.68) lets you add the filename below each image. The other options let you decide which font, font size and color can be used, plus whether to include page numbers on each page.

The Header and Footer panels are new to Bridge CS5. You can use these panels to create custom headers and footer designs to go on each printed page output. Figure 11.69 shows an example of the new Footer panel layout (these options are identical to the new Header panel).

The Playback panel options (Figure 11.70) apply specifically to the creation of PDF presentations, where you can use these settings to determine whether a PDF is opened automatically in Full Screen mode, how long each image will appear on the screen for and whether to loop the slideshow presentation from the beginning again. The Transition menu provides lots of image transition options from a simple 'Fade' dissolve to more fancy special effects, some of which offer additional parameter options.

The Watermark panel (Figure 11.71) lets you add a custom text 'watermark' overlay. This would typically be used for adding a copyright message to each image so that when someone is viewing the images as a PDF slideshow, they are made aware that they are looking at copyrighted photographs. New to Bridge CS5 is the ability to apply the watermark to each individual image. Previously this feature was really limited to outputting single page images. You can now use it to successfully watermark contact sheet pages as well as multi-image screen presentation views. There are also now more options available in this panel so that you can add watermark logos as well as custom text, plus you can customize the new drop shadow options.

PDF Output options

Once you have configured everything in the above panels, you'll be ready to click on the Save... button. This pops a dialog asking where you want to save the PDF to (but without offering any further PDF options). In the Bridge Output preferences (see Figure 11.64) there is a 'Preserve Embedded Color Profile' option. If this is checked, the files are output using the file's native color space – this is good if you wish to preserve the maximum color detail for print. If this options is unchecked it defaults to creating a color managed sRGB output, which is more suited to screen PDF presentations.

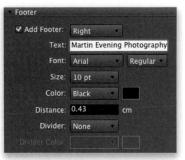

Figure 11.69 The Footer panel.

Playback	
✓ Open in I	Full Screen Mode
Automati	ic advance to the next page
Duration	(second): 5
✓ Loop Aft	er Last Page
Transition:	None
	eed
	A second s

Figure 11.70 The Playback panel.

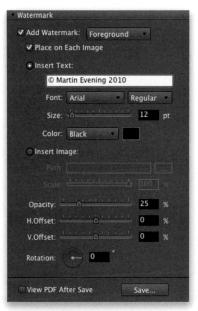

Figure 11.71 The Watermark panel

Photomerge with non-raw images

If you want to process non-raw files as a Photomerge (or using merge to HDR Pro) and reckon you might benefit from working with smaller-sized originals, you might like to consider using the 'Load Files Into Photoshop Layers...' option. This allows you to open all the selected images as layers in a single Photoshop image first. You can then use Image ➡ Image Size to reduce the pixel dimensions before choosing Edit ➡ Auto-Align layers followed by Edit ➡ Auto-Blend images.

Bridge automation

The Photoshop Automate features can all be accessed directly in Bridge by going to the Tools menu and selecting one of the desired options from the Photoshop submenu (Figure 11.72). For example, to apply a Photoshop batch action process, make a selection of images in Bridge and choose Tools \Rightarrow Photoshop \Rightarrow Batch... You can then configure the Batch dialog to apply an action routine to all the selected photos. The Image Processor can be used to batch process images in Photoshop where you typically want to output, say, a set of JPEG versions of an image at a set pixel size and compression setting, or convert to more than one size, color space, or format (see Chapter 15 for more about batch actions and the Image Processor). The Merge to HDR Pro feature was discussed earlier on in Chapter 7 and Photomerge was also discussed in Chapter 8. Using the Tools \Rightarrow Photoshop menu, you can carry out either of these processes directly from Bridge. The thing to watch out for here is the size of your source images. If you are working from raw originals in Bridge, you may want to open these via the Camera Raw dialog first, go to the Workflow options (see page 155) and set the pixel output size to something lower than the full image size, then click on the Done button to apply this setting to the selected images. Then when you choose 'Photomerge' or 'Merge to HDR Pro', Bridge opens all these files at the new size setting you just set in Camera Raw.

Figure 11.72 The Photoshop Automate menu is available from the Tools menu in Bridge.

Renaming images

To rename an image in Bridge, just click and hold the mouse down on the file name to activate it and then type in a new one. To batch rename a selection of images, choose 'Batch Rename...' from the Tools menu (**#** *Shift* **R** *ctrl Shift* **R**), which opens the Batch Rename dialog shown in Figure 11.73. Here, you can rename the files in the same folder or rename and move them to a new (specified) folder. In the New Filenames section you can configure the file renaming structure by clicking on the plus buttons to add new components to the file renaming structure. Bridge CS5 also allows what's called 'string substitution'. This simply means that you can use the Batch Rename dialog to search and replace specified phrases in an existing filename structure and replace them. Suppose all your files start with '_MG_'. You can use the String Substitution to replace this phrase with an alternative. As shown below in Figure 11.73, when 'String Substitution' was selected as a file naming option I was able to replace the above prefix with custom text that related to the shoot (such as 'Casting_') and preserve the fournumber sequence that followed afterwards in the original filename. Note that when you mouse down on a renaming component there will often be further options that you can choose from. In the Figure 11.73 example I included a YYMMDD Date Time file renaming option at the beginning, based on the date the file was created.

Presets			0	Renam
Preset: String Substitution (Modified)	Save	Delete)	Cance
Destination Folder				
Rename in same folder			C	Previe
O Move to other folder				
O Copy to other folder				
Browse				
New Filenames				
Date Time	Date Created	YYMMDD	⊙ ⊕	
Text			• •	
	-		00	
String Substitution	Original Filename		⊕ ⊕	
Find: _MG_	Replace with:	Casting_		
🗌 Ignore Case 🛛 🕅 R	eplace All 🗌 Use Regular E	xpression		
Ontions				
Preserve current filename	in XMP Metadata			
Compatibility: Windows	Mac OS 🗌 Unix			
Preview				
Preview Current filename: _MG_196	7 daa			
	Casting 1967.dng			
New mename. 0/101/_0	_ascing_1967.dhg			

Batch Rename

Editing the Batch Renaming fields

In the Batch Rename dialog, the default mode settings are configured to leave the filenames unchanged, but once you start editing the pop-up menus, you will discover that the renaming options are quite extensive. You can select items such as Text, where you can enter your own text data. You can also incorporate the original file name in parts of the new name, which will make a lot of people I know very happy.

	Preview	
_MG_1967.dng	-> 071017_Casting_1967.dng	r i
_MG_1968.dng	-> 071017_Casting_1968.dng	-
_MG_1969.dng	-> 071017_Casting_1969.dng	
_MG_1970.dng	-> 071017_Casting_1970.dng	
_MG_1971.dng	-> 071017_Casting_1971.dng	1
_MG_1972.dng	-> 071017_Casting_1972.dng	
_MG_1973.dng	-> 071017_Casting_1973.dng	
_MG_1974.dng	-> 071017_Casting_1974.dng	
_MG_1975.dng	-> 071017_Casting_1975.dng	-1
_MG_1976.dng	-> 071017_Casting_1976.dng	1
_MG_1977.dng	-> 071017_Casting_1977.dng	Ŧ
Export to CSV	781 files will be renamed OK	

Figure 11.73 With the Batch Rename dialog you can copy the files to another folder as you rename, or rename in the same folder. Clicking on the Preview button shows you how the files will be renamed. You can also preserve the current file name in the XMP Metadata by checking the option that's circled here in blue.

	A	В	
1	W1BY5268.CR2	Casting090923_0001.CR2	
2	W1BY5269.CR2	Casting090923_0002.CR2	
3	W1BY5270.CR2	Casting090923_0003.CR2	
4	W1BY5271.CR2	Casting090923_0004.CR2	
5	W1BY5272.CR2	Casting090923_0005.CR2	
6	W1BY5273.CR2	Casting090923_0006.CR2	
7	W1BY5274.CR2	Casting090923_0007.CR2	
8	W1BY5275.CR2	Casting090923_0008.CR2	
9	W1BY5276.CR2	Casting090923_0009.CR2	
10	W1BY5277.CR2	Casting090923_0010.CR2	
11	W1BY5278.CR2	Casting090923_0011.CR2	
12	W1BY5279.CR2	Casting090923_0012.CR2	
13	W1BY5280.CR2	Casting090923_0013.CR2	
14	W1BY5281.CR2	Casting090923_0014.CR2	h

Figure 11.74 This shows an example of an exported CSV file opened in a spreadsheet program.

Text	Casting_
New Extension Current Filename	Date Created
Preserved Filename Sequence Number	• -
Sequence Letter Date Time	1
Metadata	
Folder Name	
Preserve current file	ename in XMP Metadata
Compatibility: UWin	dows 🗹 Mac OS 🗌 Unix
Preview	and the second
	IBY6176.CR2
Current filename: WI	LBY6176.CR2 sting_080902_0001.CR2

Figure 11.75 Lots of extra options become available as you mouse down on the pop-up menus. Selecting 'Preserved Filename' allows you to restore the original file name, providing the 'Preserve current filename in XMP Metadata' option (circled in blue in Figure 11.73) was originally checked when you first renamed the master files. If you click on the Preview button this opens a separate window that shows you exactly how all the selected photos will be renamed. You can also click on the Export to CSV button (in the Figure 11.73 Preview dialog) to export a comma separated value file (CSV), which can then be opened via a spreadsheet program (Figure 11.74). This feature is aimed at those users for whom it is important to maintain an exact record of everything that has been done to a file.

Renaming schemes

The renaming scheme you use can be anything you want. There are no hard and fast rules, but whatever method you decide to use it should be done with a view to the future and should avoid the possibility of you creating file names that overlap with other files. I prefer to adopt a naming scheme where a short text description (such as the client name or an abbreviation) is followed by the date shot, using the YYMMDD format, followed by a four digit serial number. You can also use the Preset menu (circled in red in Figure 11.73) to save a renaming scheme as a custom preset. Click on the Save... button, give the preset a name, click OK and it will now be added as a new preset to the Preset menu list.

Undoing a Batch Rename

If you inspect the Batch Rename options closely you will notice there is an option to preserve the original file name. So, if for some reason you slip up, you can use the Batch Rename dialog to locate and reassign the original name to the file. However, this will only be possible if you previously remembered to check the box that says 'Preserve current filename in XMP Metadata' (Figure 11.75).

Applying Camera Raw settings

You can use the Edit \Rightarrow Develop Settings menu in Bridge to apply a saved Camera Raw preset setting to selected images or choose 'Previous Conversion', to apply the last used Camera Raw setting. The settings listed here will be like the ones you also see listed in the Camera Raw Preset panel (see pages 243–244). You can also use this menu to copy and paste settings from one file to another, or better still, use **H C** *ctrl alt* **C** to copy a setting and **H C** *ctrl alt* **V** to paste. The Clear Settings command can remove any applied develop settings and reapply the default Camera Raw settings.

623

Chapter 11 Image management

Mini Bridge

Bridge has been around for a number of years now and it does therefore surprise me to still see people struggling to locate their Photoshop files via the Finder or Explorer. I have even sat through Photoshop seminars where the instructor has preferred to use the system Finder, when Bridge would have been the obvious choice for grouping demo files together in the correct order and making them easy to locate. So why aren't people using Bridge? Part of the reason might be because there are now better catalog management programs available such as Expression Media or Lightroom. As I said earlier, I mainly use Lightroom to manage all my photos, but I do still use Bridge on an almost daily basis to manage big projects, such as this book, or run Photoshop demos. If some Photoshop users aren't taking to Bridge is it because the program is now rather complex? It was perhaps for this reason that Adobe decided to create Mini Bridge, which is essentially an Adobe AIRTM Extension panel that is as easy to access as any other panel in Photoshop.

The Mini Bridge interface

To access Mini Bridge, you can go to the Window menu and choose Extensions ⇒ Mini Bridge. Or, click on the Mini Bridge button in the Photoshop Application bar (Figure 11.76). This opens Mini Bridge in the Home view mode shown in Figure 11.77. If you want to start browsing straight away you can do so by clicking on the Browse Files button, but bear in mind that in order to do so you'll also need to have the main Bridge program running at the same time in the background. This is because Mini Bridge is working in tandem with Bridge. First though, let's look at the other options shown here, starting with the Settings button.

Figure 11.76 Mini Bridge can be launched by clicking on the Mini Bridge icon in the Photoshop Application bar.

Figure 11.78 This shows the Settings view mode, the Bridge Launching settings and Appearance settings.

This opens the Settings view seen at the top of Figure 11.78, where you can click on the settings buttons shown here to configure the Mini Bridge preferences. The middle screen shot shows the Bridge Launching preferences, where you can choose how you wish Mini Bridge to interact with the main Bridge program. The bottom screen shot shows the Appearance settings options where you can adjust both the interface and image backdrop brightness. For example, the interface screen shots shown here were all captured using a darkened User Interface Brightness setting. You'll notice that the 'Color Manage Panel' option is checked by default. By switching this off you can get faster drawing performance, but at the expense of less accurate color previews. Basically, I advise you not to uncheck this. Any time you want to restore the original settings you can click on the Reset Preferences button in the Settings section.

Going back to the Home panel view in Figure 11.77, if you select the 'About' option from the Mini Bridge panel menu, this simply tells you which version you are using, while clicking the Browse Files button takes you to the main Browse view shown in Figure 11.79. If you click on the Panel view menu (circled) this allows you to modify the Content pod appearance. Here, you can turn the Path Bar visibility on or off as well as the Navigation and Preview pods.

View options

At the bottom of the Mini Bridge panel (Figure 11.80) we have the zoom controls, where the thumbnail zoom slider adjusts the thumbnail/icon size in the Content pod area. The default view for the Content pod displays the thumbnails within an invisible cell grid and this allows you to manually reorder the thumbnails by clicking and dragging. On the right are the Preview (Figure 11.81) and View menus. The Preview menu let's you switch to different view modes such as a Slideshow view (see page 579), a Review mode view (see page 590), or a Full Screen Preview option where if you press the Spacebar the most selected photo fills the screen and if you press the Spacebar again, it takes you back to the Mini Bridge panel. This works just like the Full Screen mode for the main Bridge program. You can click to zoom in and click to zoom out again, plus you can use the arrow keys to navigate from one image to the next. You can also select the Preview option at the bottom, for a preview that fills the Content pod area only (Figure 11.82).

In the View menu (Figure 11.84), the 'Show Items in Pages' option allows you to display the Mini Bridge contents in page sections (with page navigation arrows) instead of using a scrollable panel view. For example, Figure 11.79 shows a paginated display, while Figure 11.83 shows a scrolling panel display.

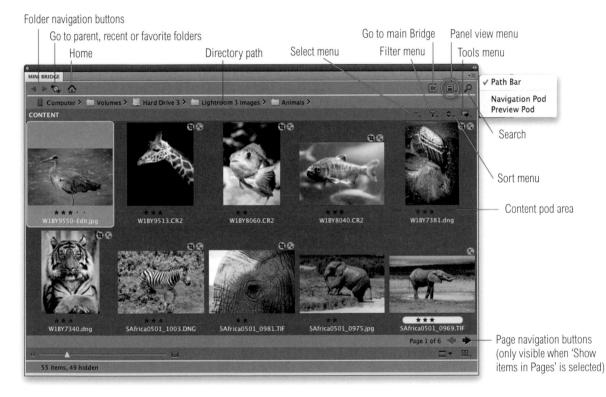

Figure 11.79 This shows the Mini Bridge panel with the main features highlighted, where only the Content pod is visible so far. You can also see the Panel view menu (top right).

Figure 11.80 This shows a close-up of the View display options.

Figure 11.81 This shows the Preview menu options for the Content pod area.

Figure 11.82 You can use the *Shift*+Spacebar shortcut to switch to a full preview within the Content pod area and use *esc* to return to the usual Content pod view.

Figure 11.83 This shows the Content pod area with the Lock Cells option selected.

The 'Show Thumbnail Only' option allows you to toggle showing the thumbnail views in the Content pod area with or without the file name, ratings or cell badge icons. If you select the 'Grid Lock' option, the Content pod will look like the view shown in Figure 11.83, where the cell grid is shown, and this prevents you from accidentally dragging a thumbnail and thereby disrupting the order of the images.

Next we have the Content pod display View options (Figure 11.84). So far we have seen the default 'As Thumbnails' view, but you can also change this to the 'As Filmstrip' view, which displays the thumbnails in a single horizontal row. If you select the 'As Details' option this shows a large thumbnail view with the key metadata information alongside each image, while the 'As List' option shows an icon list view similar to that seen in a Finder/Explorer navigation dialog (both these views are shown in Figure 11.85 below).

	Show Items in Pages	
	Show Thumbnail Only	
	Grid Lock	
000	As Thumbnails	
000	As Filmstrip	
	As Details	
	As List	

Figure 11.84 This shows the View menu options for the Content pod area.

Figure 11.85 This shows the As Details view (left) and the As List view (right) for the Content pod area.

Figure 11.86 This shows the Filter menu options (top) and Sort order options (bottom)

Filter and Sort order menus

The Filter and Sort menus (Figure 11.86) are identical to the ones found in the main Bridge program and these allow you to quickly filter the images in the Content pod, according to the star rating, and reorder according to the rules offered in the Sort order menu.

Navigator and Preview pods

Now let's look at the panel view/pod selection menu, which is in the top right corner next to the Search button. Figure 11.87 shows the 'Navigator Pod' selected. You'll notice how this contains a two column view, where in the first column you can select to view Favorites, Recent Folders, Recent Files or Collections. You basically click on one of these items and in the second column you'll see a list of further subfolder options. What you see here is largely determined by the current settings you have in the main Bridge program as well as recent Bridge activity. For example, you can't create collections via Mini Bridge, but any you have already created in the main Bridge program will show up here in the second column. Although having said that, while the 'Go to parent, recent or favorite folders' menu list is synchronized with that in Bridge, the Recent Folders list in the Navigator pod only lists those that have recently been visited by Mini Bridge itself. So why doesn't Mini Bridge include a full Browser in the Navigator pod? I thought this too at first, but the key thing to understand here is that Mini Bridge is all about economizing on features to allow everything to fit within a smaller panel view. Personally, I find that between the Path Bar and Navigation Pod I am able to locate files with relative ease.

If you go to the pod selection menu again and choose 'Preview Pod', this adds a large preview just below the Navigator pod, which can be adjusted in size by dragging the pod divider handle. You can magnify this preview by clicking on the image, plus don't forget the *Shift*+Spacebar shortcut for filling the Mini Bridge panel with a full-size preview.

The Navigator and Preview Pod selection is a toggle action, so by selecting these items again you can add or remove them from the Mini Bridge panel view, or you can simply click on the Close Pod button in the top right corner of each of these pods. You should also notice that as you resize the Mini Bridge panel, the pod layout auto-adjusts to provide the most effective use of the available panel space.

Image management

Figure 11.87 This shows Mini Bridge with the Navigator Pod added to the panel.

Figure 11.88 This shows Mini Bridge with the Preview Pod now also added to the panel.

Searching images

Lastly, you can click on the Search button to bring up the Search window, shown below in Figure 11.89, where you can select from whatever search engines are accessible on your computer system. For example, Macintosh users will be offered the Spotlight search engine to use.

Figure 11.89 The Mini Bridge Search menu allows you to choose which search engine you would prefer to carry out the search with and also whether you wish to search locally within the current selected folder, or globally on the whole computer.

Chapter 12

Color Management

hotoshop 5.0 was justifiably praised as a groundbreaking upgrade when it was released in the summer of 1998, although the changes made to the color management setup were less well received in some quarters. This was because the revised system was perceived to be complex and unnecessary. Bruce Fraser once said of the Photoshop 5.0 color management system 'it's push-button simple, as long as you know which of the 60 or so buttons to push!' Attitudes have changed since then (as has the interface) and it is fair to say that most people working today in the pre-press industry are now using ICC color profile managed workflows. The aim of this chapter is to introduce the basic concepts of color management before looking at the color management interface in Photoshop and the various color management settings.

The need for color management

An advertising agency art buyer was once invited to address a meeting of photographers. The chair, Mike Laye, suggested we could ask him anything we wanted, except 'Would you like to see my book?' And if he had already seen your book, we couldn't ask him why he hadn't called it back in again. And if he had called it in again we were not allowed to ask why we didn't get the job. And finally, if we did get the job we were absolutely forbidden to ask why the color in the printed ad looked nothing like the original photograph!

That in a nutshell is a problem which has bugged many of us throughout our working lives, and it is one which will be familiar to anyone who has ever experienced the difficulty of matching colors on a computer display with the original or a printed output. Figure 12.1 shows two versions of the same photograph. One shows how the Photoshop image looks previewed on the display and the other is an example of how a printer might interpret and reproduce those same colors if no attempt is made to color manage the image.

So why can there sometimes be such a marked difference between what is seen on the display and the actual printed result? Well, digital images are nothing more than just bunches of numbers, and good color management is all about making sense of those numbers and translating them into meaningful colors at the various stages of the image making process.

The way things were

Sixteen or more years ago, most photographers only used their computers to do basic administration work and there were absolutely no digital imaging devices to be found in a photographer's studio (unless you counted the photocopier). If you needed a color print made from a chrome transparency, you gave the original to the printer at a photographic lab and they matched the print visually to your original. Professional photographers would also supply chrome transparencies or prints to the client, and the photographs then went to the printer to be digitized using a high-end drum scanner, which would be configured to produce a CMYK file ready to insert in a specific publication. That was probably about the limit of the photographer's responsibilities, and if color corrections were required, the scanner operators would carry this out themselves working directly on the output file. These days a significant number of photographers, illustrators and artists are now originating their own files from digital cameras, desktop scanners or directly within Photoshop. This has effectively removed the repro expert who previously did all the scanning and matching of the colors on the press. Therefore, there is no getting away from the fact that if you supply digital images to a printer, you will be deemed responsible should any problems occur in the printing. This may seem like a daunting task, but with Photoshop it really isn't that hard to color manage your images with confidence.

Client: Russell Eaton. Model: Lidia @ MOT.

Figure 12.1 The picture on the left shows how you might see an image on your display in Photoshop and the one on the right represents how that same image might print if sent directly to a printer without applying any form of color management. You might think it is merely a matter of making the output color less blue in order to successfully match the original. Yes, that would get the colors closer, but when trying to match color between different digital devices, the story is actually a lot more complex than that. The color management system that was first introduced in Photoshop 5.0 enables you to make use of ICC profiles, which can match these colors from the scanner to the computer display and to the printer with extreme accuracy.

Color management references

If your main area of business revolves around the preparation of CMYK separations for print, then I do recommend you invest in a training course or book that deals with CMYK repro issues. I highly recommend the following books: *Real World Color Management* by Bruce Fraser, Chris Murphy and Fred Bunting; *Color Management for Photographers* by Andrew Rodney; and *Getting Colour Right*, *The Complete Guide to Digital Colour Correction* by Neil Barstow and Michael Walker.

RGB devices

Successful color management relies on the use of profiles to describe the characteristics of each device, such as a scanner or a printer, and using a color management system to translate the profile data between each device in the chain. Consider for a moment the scale of such a task. We wish to capture a full color original subject, digitize it with a scanner or digital camera, examine the resulting image via a computer display and finally reproduce it in print. It is possible with today's technology to simulate the expected print output of a digitized image on a computer display with remarkable accuracy. Nevertheless, one should not underestimate the huge difference between the mechanics of all the various bits of equipment used in the above production process. Most digital devices are RGB devices and just like musical instruments, they all possess unique color tonal properties, such that no two devices are always identical or able to reproduce color exactly the same way as another device. Nor is it always possible to match in print all the colors which are visible to the human eye, and converting light into electrical signals via a device such as a CCD chip is not the same as illuminating the pixels on an LCD display or reproducing a photograph with colored ink on paper.

Figure 12.2 While some digital devices may look identical on the outside, they'll all have individual output characteristics. For example, in a TV showroom you may notice how each television screen displays a slightly different colored image.

Why not all RGB spaces are the same

Go into any TV showroom and you will probably see rows of televisions all tuned to the same broadcast source, but each displaying the picture quite differently (Figure 12.2). This is a known problem that affects all digital imaging devices, be they digital cameras, scanners, monitors or printers. Each digital imaging device has its own unique characteristics, and unless you are able to quantify what those individual device characteristics are, you won't be able to communicate effectively with other device components and programs in your own computer setup, let alone anyone working outside your own system color loop.

Some computer displays have manual controls that allow you to adjust the brightness and contrast (and in some cases the RGB color as well) and the printer driver will also allow you to make color balance adjustments, but is this really enough? Plus, if you are able to get the display and your printer to match, will the colors you see on your display appear the same on another person's display?

The versatility of RGB

A major advantage of working in RGB is that you can access all the bells and whistles of Photoshop which would otherwise be hidden or grayed out in CMYK mode, and if you use Adobe RGB or ProPhoto RGB, you will have a larger color gamut to work with. These days there is also no telling how a final image may end up being reproduced. A photograph may get used in a variety of ways, with multiple CMYK separations made to suit several types of publications, each requiring a slightly different CMYK conversion (because CMYK is not a 'one size fits all' color space). For example, high-end retouching for advertising usage is usually done in, RGB mode and the CMYK conversions and film separations are produced working directly from the digital files to suit the various media usages.

Photographers are mainly involved in the RGB capture end of the business. The proliferation of Photoshop, plus the advent of high quality desktop scanners and digital cameras, means that more images than ever before are starting out in, and staying in, RGB color. This is an important factor that makes color management so necessary and also one of the reasons why I devote so much attention to the management of RGB color, here and

Color vision trickery

They say that seeing is believing, but nothing could be further from the truth, since there are many interesting quirks and surprises in the way we humans perceive vision. There is an interesting book on this subject titled Why We See What We Do, by Dale Purves and R. Beau Lotto (Sinauer Associates, Inc). There is also a website at www.purveslab.net where you can have a lot of fun playing with the interactive visual tests, to discover how easily our eyes can be deceived. What you learn from studies like this is that color can never be properly described in absolute mathematical terms. How we perceive a color can also be greatly influenced by the other colors that surround it. This is a factor that designers use when designing a product or a page layout. You also do this every time you evaluate a photograph, often without even being aware of it.

Beyond CMYK

There are other types of output to consider, not just CMYK. Hexachrome is a sixcolor ink printing process that can extend the printing color gamut beyond the conventional limitations of CMYK. This advanced printing process is currently available only through specialist print shops and is suitable for high quality design print jobs. Millions have been invested in the four-color presses currently used to print magazines and brochures, so expect four-color printing to still be around for a long time to come, but Hexachrome will open the way for improved color reproduction from RGB originals. Photoshop supports six-color channel output conversions from RGB, but you will need to buy a separate plug-in utility like HexWrench. Multimedia publishing is able to take advantage of the full depth of the sRGB color range (which is probably about the limit of most LCD displays). If you are working in a screen-based environment for CD, DVD and web publishing, RGB is ideal. And with today's web browsers, color management can sometimes be turned on to take full advantage of the enhanced color control these programs can now offer.

elsewhere in the book. So, if professional photographers are more likely to supply a digital file at the end of a job, how will this fit in with existing repro press workflows that are based on the use of CMYK color? Although digital capture has clearly taken off, the RGB to CMYK issue still has to be resolved. If the work you create is intended for print, the conversion of RGB to CMYK must be addressed at some point, and so for this important reason, we shall also be looking at CMYK color conversions in detail later on in this chapter.

Output-centric color management

Printers who work in the repro industry naturally tend to have an 'output-centric' view of color management. Their main concern is getting the CMYK color to look right on a CMYK press and printers can color correct a CMYK image 'by the numbers' if they wish. Take a look at the photograph of the young model in Figure 12.3. Her Caucasian flesh tones should contain equal amounts of magenta and yellow ink, with maybe a slightly greater amount of yellow, while the cyan ink should be a quarter to a third of the magenta. This rule will hold true for most CMYK press conditions and the accompanying table compares the CMYK and RGB space

CMYK ink values	Cyan	Magenta	Yellow	Black
Euroscale Coated v2	09	28	33	0
3M Matchprint Euroscale	07	25	30	0
US Web uncoated (SWOP)	08	23	29	0
Generic Japan pos proofing	07	28	33	0
RGB pixel values	Red	Green	Blue	
Adobe RGB	220	190	165	
Pictrograph 3000	231	174	146	
Lambda	230	184	158	
Epson 9000 RGB	231	179	123	

Figure 12.3 The tables shown here record the color readings in the CMYK and RGB color spaces of a typical Caucasian flesh tone. As is explained in the text, while the CMYK readings are all fairly consistent, this won't be the case if you try to compare the RGB values.

637

Chapter 12 Color management

measurements of a flesh tone color. However, you will notice there are no similar formulae that can be used to describe the RGB pixel values of a flesh tone. If you were to write down the flesh tone numbers for every RGB device color space, you could in theory build an RGB color space reference table. From this you could feasibly construct a system that would assign meaning to these RGB numbers for any given RGB space. This is basically what an ICC profile does except an ICC profile may contain several hundred color reference points. These can then be read and interpreted automatically by the Photoshop software and give meaning to the color numbers.

Profiled color management

The objective of profiled color management is to use the measured characteristics of everything involved in the image editing workflow, from capture through to print, to reliably translate the color at each stage of the process. In a normal Photoshop workflow, the color management begins with reading the profiled RGB color data from the incoming file and, if necessary, converting it to the current Photoshop RGB workspace. While an RGB image is being edited in Photoshop the workspace image data is converted on-the-fly to the profiled display space and sent to the computer display, so that the colors are viewed correctly. When the image is finally output as a print, the RGB workspace data is converted to the profile space of the printer. Or, you might carry out an RGB to CMYK conversion to the CMYK profile of a known proof printer.

A workspace profile is therefore a useful piece of information that can be embedded in an image file. When a profile is read by Photoshop and color management is switched on, Photoshop is automatically able to find out everything it needs to know in order to manage the color correctly from there on. Note that this will also be dependent on you calibrating your display, but essentially all you have to do apart from that is to open the Photoshop Color Settings from the Edit menu and select a suitable preset such as the US Prepress Default setting. Do this and you are all set to start working in an ICC color managed workflow.

Think of a profile as being like a postcode (or ZIP code) for images. For example, the address label shown in Figure 12.4 was rather optimistically sent to me at 'Flat 14, London', but thanks to the postcode it arrived safely! Some labs and printers have been

Figure 12.4 Even if you have never been to London before, you know it's a fairly big place and 'Flat 14, London' was not going to help the postman locate my proper address. However, the all-important ZIP code or postcode was able to help identify exactly where the letter should have been delivered. An image profile is just like a ZIP code – it can tell Photoshop everything it needs to know about a file's provenance.

Translating the color data

One way to comprehend the importance of giving meaning to the numbers in a digital file is to make a comparison with what happens when language loses its meaning. There is an excellent book by Lynne Truss called Eats, Shoots & Leaves: The Zero Tolerance Approach to Punctuation. It is partly a rant against poor punctuation, but also stresses the importance of using punctuation to assign exact meaning to the words we read. Remove the punctuation and words can soon lose their true intended meaning. Another good example is the way words can have different meanings in other languages. So a word viewed out of context can be meaningless unless you know the language that it belongs to. For example, the word 'cane' in English means 'dog' in Italian.

known to argue that profiles cause color management problems. This I am afraid is like a courier company explaining that the late arrival of your package was due to you including a ZIP code in the delivery address. A profile can be read or it can be ignored. What is harmful in these circumstances is an operator who refuses to use an ICC workflow. If you feel you are getting the runaround treatment, it may be time to change labs.

Color Management Modules

The International Color Consortium (ICC) is an industry body that represents the leading manufacturers of imaging hardware and software. The ICC grew out of the original Color Consortium that was established in 1993 and has been responsible for extending and developing the original ColorSync architecture to produce the standardized ICC format, which enables profiles created by different vendors to work together. All ICC systems are basically able to translate the color gamut of a source space via a reference space (the Profile Connection Space) and accurately convert these colors to the gamut of the destination space. At the heart of any ICC system is the Color Management Module, or CMM, which carries out the profile conversion processing. Although the ICC format specification is standardized, this is one area where there are some subtle differences in the way each CMM handles the data. In Photoshop you have a choice of three CMMs: Adobe Color Engine (ACE), Apple ColorSync or Apple CMM. There are other brands of CMM that you can use as well, but this really need not concern most Photoshop users, as I recommend you use the default Adobe (ACE) CMM in Photoshop.

The Profile Connection Space

If the CMM is the engine that drives color management, then the Profile Connection Space (PCS) is at the hub of any color management system. The PCS is the translator that can interpret the colors from a profiled space and define them using either a CIE XYZ or CIE LAB color space. The Profile Connection Space is an interim space. It uses unambiguous numerical values to describe color values using a color model that matches the way we humans observe color (see Figure 12.5). You can think of the PCS as being like the color management equivalent of a multilingual dictionary that can translate one language into any other language.

If an ICC profile is embedded in the file, Photoshop will recognize this and know how to correctly interpret the color data. The same thing applies to profiled CMYK files. Photoshop uses the computer display profile information to render a color correct preview on the computer display. It helps to understand here that in an ICC color managed workflow in Photoshop, what you see on the display is always a color corrected preview and you are not viewing the actual file data. So when the RGB image you are editing is in an RGB workspace, such as Adobe RGB, and color management is switched on, what you see on the display is an RGB preview that has been converted from Adobe RGB to your profiled display RGB via the PCS (see Figure 12.6). The same thing happens when Photoshop previews CMYK data on the display. The Photoshop color management system calculates a conversion from the file CMYK space to the display space. Photoshop therefore carries out all its color calculations in a virtual color space. So in a sense, it does not really matter which RGB workspace you edit with. It does not have to be exactly the same as the workspace set on another user's Photoshop system. If you are both viewing the same file, and your displays are correctly calibrated and profiled, a color image should look near enough the same on both.

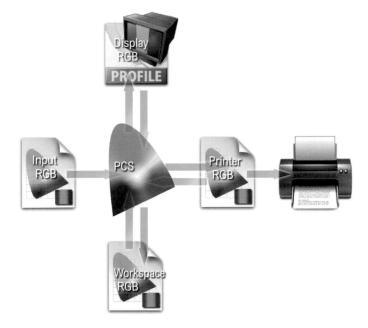

Figure 12.5 A color management system is able to read the profile information from an incoming RGB file and behind the scenes it builds a table that correlates the source RGB information with the Profile Connecting Space values.

Figure 12.6 Photoshop can read or make use of the profile information of an incoming RGB file and translate the data via the Profile Connecting Space and make an RGB to RGB conversion to the current RGB workspace in Photoshop. As you work in RGB mode, the image data is converted via the PCS and uses the display profile to send a profile-corrected signal to the computer display. When you make a print, the image data is then converted from the workspace RGB to the printer RGB via the PCS.

The ideal RGB working space

If you select an RGB workspace that is the same size as the display space, you are not using Photoshop to its full potential and more importantly you are probably clipping parts of the CMYK gamut (see Figure 12.7). For many years I would have advised you to choose Adobe RGB as your workspace, because it appeared to offer the best compromise between encompassing most of the CMYK gamut but without being so large as to be unwieldy. However, a few years ago I was in conversation with the late Bruce Fraser and he convinced me that cautionary warnings against ProPhoto RGB were perhaps a little overstated (even if you are going to end up converting a file from 16-bit to 8-bit RGB). So following Bruce's advice I mostly now use ProPhoto RGB as my principal RGB workspace, although I would still strongly advise making the big tone edits in 16-bit before converting to 8-bit. The only other thing I would caution you about is to never supply clients with ProPhoto RGB master files. If I am sending a file to someone who I believe is ICC color management savvy, I'll send them a profiled Adobe RGB version. If I am sending a file by email or to someone who may not understand color management, I always play safe and send them an sRGB version instead.

Choosing an ideal RGB workspace

Although I highly recommended that you should switch on the color management settings in Photoshop, you cannot assume that everyone else will be doing the same. There are many other Photoshop users and color labs operating from the Jurassic era, who are running outputs from files with Photoshop color management switched off and who are not bothering to calibrate their displays properly either.

If you are using Photoshop 6.0 or later it does not matter so much which RGB color space you choose in the RGB setup, as long as you stick to using the same space for all your work. RGB to RGB conversions are not as destructive as RGB to CMYK conversions, but the space you plump for does matter. Once chosen you should not really change it. Plus whichever color workspace you select in the RGB color settings, you will have to be conscious of how your profiled Photoshop RGB files may appear on a non-ICC savvy Photoshop system. What follows is a guide to the listed RGB choices.

Apple RGB

This is the old Apple 13" monitor standard. In the early days of Photoshop, Apple RGB was used as the default RGB editing space where the editing space was the same as the monitor space. If you have legacy images created in Photoshop on a Macintosh computer using a gamma of 1.8, you can assume Apple RGB to be the missing profile space.

sRGB IEC-61966-2.1

sRGB was conceived as a multipurpose color space standard that consumer digital devices could all standardize to. It is essentially a compromise color space that provides a uniform color space which all digital cameras and inkjet printers and displays are able to match (since sRGB aims to match the color gamut of a typical 2.2 gamma PC display). Therefore, if you are opening a file from a consumer digital camera or scanner and there is no profile embedded, you can assume that the missing profile should be sRGB. It is an ideal color space for Web design but unsuitable for photography or serious print work. This is mainly because the sRGB space clips the CMYK gamut quite severely and you will never achieve more than 75–85% cyan in your CMYK separations.

ColorMatch RGB

ColorMatch is an open-standard RGB display space that was once implemented by Radius, who used to make displays and graphics cards for the Macintosh computer market. ColorMatch has a gamma of 1.8 and is still favored by some Macintosh users as their preferred RGB working space. Although not much larger than the gamut of a typical display space, it is at least a known standard and more compatible with legacy 1.8 gamma Macintosh files. The problem with selecting a small gamut space like this is illustrated in Figure 12.7, where, as you can see, the constraints of a 'displayoriented' RGB edit space can mean you end up losing tonal separation in colors that may be important, such as when carrying out an RGB to CMYK conversion.

Adobe RGB (1998)

Adobe RGB (1998) has become established as a recommended RGB editing space for RGB files that are destined to be converted to CMYK. For example, the Photoshop prepress color settings all use Adobe RGB as the default RGB working space. Adobe RGB was initially labeled as SMPTE-240M, which was a color gamut once proposed for HDTV production. As it happens, the coordinates Adobe used did not exactly match the actual SMPTE-240M specification. Nevertheless, it proved popular as an editing space for repro work and soon became known as Adobe RGB (1998). I have in the past used Adobe RGB as my preferred RGB working space, since it is well suited for RGB to CMYK color conversions.

ProPhoto RGB

This is a large gamut RGB space that has the advantage of preserving the full gamut of raw capture files when converting the raw data to RGB. It is also suited for image editing that is intended for output to photographic materials such as transparency emulsion or a photo quality inkjet printer. This is because the gamut of ProPhoto RGB extends more into the shadow areas compared with most other RGB spaces, resulting in better tonal separation in the shadow tones.

Figure 12.7 A CMYK color space is mostly smaller than the computer display RGB color space and not all CMYK colors can be displayed accurately due to the physical display limitations of the average computer display. This screen shot shows a continuous spectrum going through shades of cyan, magenta and yellow. The image was then deliberately posterized in Photoshop and then screen captured from the computer display. Notice how the posterized steps arow wider in the yellow and cyan portions of the spectrum. This simple exercise helps pin-point the areas of the CMYK spectrum which fall outside the gamut of a typical display. Most LCD displays have a color gamut that is not much bigger than sRGB, while the more advanced displays I mentioned in Chapter 2 are capable of handling an Adobe RGB color gamut.

Figure 12.8 Good color management is very much dependent on having your display calibrated and profiled. This should ideally be done using a hardware calibration device such as the X-Rite Eye-One system.

Profiling the display

To get color management to work in Photoshop you have to calibrate and profile the computer display. This is by far the most important and essential first link in the color management chain. You can live without scanner profiling and it is not the end of the world if you can't profile every printer/paper combination. But you simply must have a well-calibrated and profiled display. It is after all the instrument you rely upon most when you make your color editing decisions.

If you don't have a display calibration device you can always build a profile for your display using a visual calibration method. You could, for example, use the Display Calibration Assistant that comes with the Mac OS X system. However, the problem with relying on visual calibration is that because our eyes are so good at adapting to light, our eyes are poor instruments to use when calibrating a device like a computer display. In Chapter 2 I mentioned some of the equipment and software options that you can buy these days and showed a quick run-through of how to calibrate a computer display with a calibration device. I would strongly urge you to purchase a proper measuring instrument and use this to calibrate the display on a regular basis. A hardware calibration device combined with a dedicated software utility is the only way that you can guarantee getting good color from your system, as this will enable you to precisely calibrate your display and build an accurate display profile. At the time of writing, I have found four basic display profiling packages, which include a colorimeter and basic software program, all for under \$300. Highly recommended is the basICColor Display and Squid combination. Then there is the X-Rite Eye-One Display 2 that comes with Eye-One Match 2 software, the Monaco Optix XR system and lastly the ColorVision Monitor Spyder and Spyder2 Pro Studio. Of these I would probably recommend the X-Rite Eye-One Display 2, since I am very familiar with the (more expensive) Eye-One spectrophotometer system, which I use to calibrate and profile the display in my office (Figure 12.8). It is also an emissive spectrophotometer so I can use it to build custom printer profiles as well. The other units I have listed here are all colorimeters so these can only be used for building monitor profiles, but they are usually regarded as being equally as good as the more expensive spectrophotometers for this type of task.

Chapter 12 Color management

Calibration and profiling

Profile measuring devices can be attached to the display by hanging the device over the edge of an LCD display using a counter weight that gently rests the calibrator against the surface of the screen. Whatever you do, don't use a calibrating device with suckers on an LCD as this can easily damage the delicate surface.

The software packages used will vary in appearance but they essentially all do the same thing. Before you build a profile there are several option settings you have to decide upon. First there is the gamma space which I recommend should be 2.2 (even if it says somewhere that Macintosh users should use 1.8), although for LCD screens you should probably use the 'native gamma'. The white point should be set to 6500 K, or with LCD displays you can use the native white point. If given the option, save a small profile size for CRT profiles and a large profile size for LCD profiles. The first stage is to calibrate the display to optimize the contrast and brightness: 120-140 candelas m² is ideal for a desktop LCD display and 100-110 CD m² is the ideal luminance for laptops. Once this has been done you will want to lock down the hardware controls so they cannot be accidentally adjusted. This should be done before performing the calibration in which a series of colors are sent to the display and the measurements used to adjust the video card settings, which will fine-tune the display to achieve optimum neutralization.

The second part is the profiling process. Once the display has been calibrated a longer sequence of color patches are sent to the display and measured to build a profile describing how the neutralized screen displays these known colors. This data is collected together to build the profile. At the end you will be asked to name the profile and it should be automatically saved to the correct folder location and assigned as the new default display profile. On the Macintosh, the profile should automatically be saved in the Library/ColorSync/Profiles/Displays folder. On a PC, it should be saved to the Windows/System32/Spool/Drivers/ Color folder. Do remember that the performance of the display will fluctuate over time, so it is therefore important to check and calibrate the display at regular intervals.

LCD hardware calibration

Some high-end LCD displays are also beginning to feature hardware-level calibration such as Eizo Coloredge and Mitsubishi Spectraview.

Camera Raw profiling

As was explained in Chapter 3, Camera Raw uses data accumulated from two sets of profiles which have been produced using daylight balanced and tungsten balanced lighting. This method of profiling works really well with most normal color temperature settings, but the data gathered is based on a small sample of cameras (sometimes just one!) and cannot be regarded as offering absolute accuracy. It may be helpful to follow the calibration procedure (described in the same chapter) to obtain the most accurate colors.

Figure 12.9 The ProfileMaker Pro[™] interface.

Profiling the input

Input profiling is possible, but it's easier to do with a scanner than it is with a digital camera. To profile a scanner you'll need to scan a film or print target and use profile creation software such as X-Rite's ProfileMaker Pro[™] program to read the data and build a custom profile based on readings taken from the scanned target (Figure 12.9). The target measurements are then used to build a profile that describes the characteristics of the scanner. This profile should be saved to the Macintosh Library/ColorSync/Profiles folder, or, on a PC, saved to the Windows/System32/Spool/Drivers/ Color folder. It can then be incorporated into your color managed workflow to describe the image data coming into Photoshop (refer back to Figure 12.6). This can be done by selecting the profile in the scanner software or by assigning the profile in Photoshop as the file is opened.

Camera profiling is a lot trickier to do and few photographers feel this is something worth bothering with. This is because the camera sensor will respond differently under different lighting conditions and you would therefore need to build a new profile every time the light changed. This is not necessarily a problem if you are using a digital camera in a studio setup with a consistent strobe lighting setup. In these circumstances it is probably very desirable that you photograph a color checker chart and take measurements that can be used to create a custom input profile for the camera. For example, the X-Rite Eye-One Photo system offers a camera profiling option.

Overall, I would not stress too much about input profiles unless it is critical to your workflow that you have absolute color control from start to finish. For example, a museum photographer who is charged with photographing important works of art would absolutely want to profile their camera, but is it always necessary or desirable? In Figure 12.10 I suggest that the correct white balance and input profiling is sometimes irrelevant, as it is more important to trust what you see on your monitor display and obtain good color management between the image seen on the computer display and what you see in the print.

Profiling the output

Successful color management also relies on having accurate profiles for each type of media paper that's used with your printer. The printer you buy should come with a driver on a CD (or you can easily download one) and the installation procedure should install a set of canned profiles that will work when using the proprietary inks designed to be used with the printer and for a limited range of branded papers. The canned profiles that ship with the latest Epson printers, for their Epson papers, tend to be of a very high quality and these are all you really need for professional print results. However, it is recommended that you carry out custom profiling to build profiles for other types of print/paper combinations. This can be done by printing out a test target like the one shown in Figure 12.11 without color managing it. Once the test print has been allowed to stabilize, it can be measured the following day with a device like the X-Rite Eye-One spectrophotometer (Figure 12.12). The patch measurement results can then be used to build a color profile for the printer. The other alternative is to take advantage of Neil Barstow's remote profiling service special offer which is available to readers (see the back of the book). If you wish to use custom printer profiles, you'll need one to be built for each printer/media combination. You can use a profiled printer to achieve good CMYK proofing, even from a modestly priced printer, which comes close to matching the quality of a recognized contract proof printer.

Figure 12.10 Here are three photographs taken on and around the London Eye ferris wheel. These pictures have each been processed using an incorrect white balance setting. In this situation, input color management becomes irrelevant and it matters more how consistent the appearance is between the computer display and the print output.

Figure 12.11 This Kodat[™] color target can be used to construct a color ICC profile. A profile service company will normally supply you with instructions on how to print it out. When they receive your prints, they can measure these and email the custom ICC profile back to you. For example, Neil Barstow of www.colourmanagement.net is offering a special discount rate to readers of this book (see the back of the book for more details).

Figure 12.12 Once a print profile has been printed out, the color patches can be read using a spectrophotometer and the measurements used to build an ICC profile.

Martin Evening Adobe Photoshop CS5 for Photographers

Figure 12.13 This illustration re-examines the problem encountered at the beginning of this chapter where the skin tones in the original image printed too blue. In the upper workflow no printer profile was used and the image data was sent directly to the printer with no adjustment made to the image data. In the lower example I show a profile color managed workflow. The profile created for this particular printer is used to convert the image data to that of the printer's color space before being sent to the printer. The (normally hidden) color shifting which occurs during the profile conversion process compensates by making the skin tone colors more red, but applies less color compensation to other colors. The result is an output that more closely matches the original. This is a simple illustration of the ICC-based color management system at work. All color can be managed this way in Photoshop, from capture source to the computer display and to the final print.

Chapter 12 Color management

Photoshop color management interface

By now you should be acquainted with the basic principles of Photoshop ICC color management (see Figure 12.13). It is relatively easy to configure the Photoshop system and at the simplest level all you have to do is calibrate and profile your display and then go to the Photoshop Color Settings (Figure 12.14) and select an appropriate prepress setting (don't use the default). A prepress setting will correctly enable the Photoshop color management policies and should be enough to get you up and running in a color managed workflow. But if you want to discover more about how color management works, then do read on.

Color Settings Synchronized: Your Creative Suite applications are synchronized using the same color settings for consistent color management. OK Cancel - Settings: North America Prepress 2 \$ Load. Working Spaces \$ RGB: Adobe RGB (1998) Save... CMYK: U.S. Web Coated (SWOP) v2 \$ More Options \$ Gray: Dot Gain 20% Preview \$ Spot: Dot Gain 20% Color Management Policies RGB: Preserve Embedded Profiles 1.2 CMYK: Preserve Embedded Profiles \$ Gray: Preserve Embedded Profiles \$ Profile Mismatches: Ask When Opening Ask When Pasting Missing Profiles: Ask When Opening Description North America Prepress 2: Preparation of content for common printing conditions in North America. CMYK values are preserved. Profile warnings are

The Color Settings

The Color Settings are located in the Edit menu. The first item you will come across is the Settings pop-up menu (Figure 12.15). Photoshop provides a range of preset configurations for the color management system and these can be edited to meet your own specific requirements. In Basic mode, the default setting will be some sort of General Purpose setting and the exact naming and subsequent settings list will vary depending on the region where you live. Figure 12.14 All the Photoshop color settings can be managed from within the Photoshop Color Settings dialog. Photoshop conveniently ships with various preset settings that are suited to different Photoshop work flows. Unfortunately, the default setting is not an ideal choice for a color managed workflow, so use the Settings menu shown in Figure 12.15 to switch to a prepress setting such as the one shown here. As you move the cursor pointer around the Color Settings dialog, help messages are provided in the Description box area below - these provide useful information which will help you learn more about the Photoshop color management settings and the different color space options.

✓ Custom

Other Monitor Color

warnings.

North America Prepress 2 North America Web/Internet Custom Euro setting ME-custom PP photos_medium black PP screen capture_max black PP scren capture_max	
Figure 12.15 The default settings are just defaults. I advise changing the setting to one of the prepress settings, as this will configure Photoshop to use Adobe RGB as your RGB workspace, and switching on the	

Profile Mismatches and Missing Profiles alert

North America General Purpose 2

✓ Custom

Other

Monitor Color North America General Purpose 2 North America Prepress 2 North America Web/Internet Custom Euro setting ME-custom PP photos_medium black PP screen capture_max P screen capture_max

Color Management Off ColorSync Workflow Emulate Acrobat 4 Emulate Photoshop 4 Europe General Purpose 2 Europe General Purpose Defaults Europe Prepress 2 Europe Prepress Defaults Europe Web/Internet Japan Color for Newspaper Japan Color Prepress Japan General Purpose 2 Japan General Purpose Defaults Japan Magazine Advertisement Color Japan Prepress 2 Japan Prepress Defaults Japan Web/Internet North America General Purpose Defaults Photoshop 5 Default Spaces U.S. Prepress Defaults Web Graphics Defaults

Figure 12.16 Here is a full list of the preset settings (as seen when 'More Options' is selected). The General Purpose presets will preserve RGB profiles, but use sRGB as the RGB workspace instead of Adobe RGB, and CMYK color management will be switched off. This is a little better than the previous Web Graphics default and may help avoid confusion among novice users. In the basic 'Fewer Options' mode, the choice will be restricted so that all you see will be the color settings for your geographical area.

I would recommend that you follow the advice in Figure 12.15 and change this default to one of the prepress settings. So if Photoshop was installed on a European computer, you would select the 'Europe Prepress Defaults' setting from this or the 'More Options' list shown in Figure 12.16. If a preset color setting says 'prepress', this will be the ideal starting point for any type of color managed workflow, especially if you are a photographer. That is all you need to concern yourself with initially, but if you wish to make customized adjustments, then you can make custom changes in the Working Spaces section. For help selecting an ideal RGB workspace, refer back to the section on RGB spaces on pages 640–641 (where I recommend using ProPhoto RGB). I'll be covering the CMYK and Grayscale settings later.

Color management policies

The first thing Photoshop does when a document is opened is check to see if an ICC profile is present. The default policy is to preserve the embedded profile information. So whether the document has originated in sRGB, Adobe RGB or ColorMatch RGB, it will open in that RGB color space and after editing be saved as such. This means you can have several files open at once and each can be in an entirely different color space. A good tip here is to set the Status box to show 'Document profile' (on the Mac this is at the bottom left of the image window; on a PC it is at the bottom of the system screen). Or, you can configure the Info panel to provide such information. This allows you to see each individual document's color space profile.

Preserve embedded profiles

The default policy of 'Preserve Embedded Profiles' allows you to use the ICC color management system straight away, without too much difficulty. So long as there is a profile tag embedded in any file you open, Photoshop gives you the option to open that file without converting it. So if you are given an sRGB file to open, the default option is to open it in sRGB and save it using the same sRGB color space. This is despite the fact that your default RGB workspace might be ProPhoto RGB or some other RGB color space. The same policy rules apply to CMYK and grayscale files. Whenever 'Preserve Embedded Profiles' is selected, Photoshop reads the CMYK or Grayscale profile, preserves the numeric data and does not convert the colors, and the image remains in the tagged color space. This is always going to be the preferred option when editing incoming CMYK files because a CMYK file may already be targeted for a specific press output and you don't really want to alter the numbers for those color values.

Profile mismatches and missing profiles

The default prepress color management policy setting is set to 'Ask When Opening' if there is a profile mismatch (Figure 12.17). This means you will see the warning dialog shown in Figure 12.18 whenever the profile of a file you are opening does not match the current workspace. This offers you a chance to use the embedded profile (which is recommended), convert the document colors to the current workspace or discard the profile.

A newcomer does not necessarily have to fully understand how Photoshop color management works in order to use it successfully. When 'Preserve Embedded Profiles' is selected this makes the Photoshop color management system quite foolproof and the color management system is adaptable enough to suit the needs of all Photoshop users, regardless of their skill levels. Whichever option you select – convert or don't convert – the saved file will always be correctly tagged.

	The document "W1BY3510.tif" has an embedded color profile that does not match the current RGB working space.
Ŏ	Embedded: Adobe RGB (1998)
	Working: ProPhoto RGB
	• Use the embedded profile (instead of the working space)
	O Convert document's colors to the working space
	O Discard the embedded profile (don't color manage)
	(Cancel) (OK

Convert to Working space

If you select the Convert to Working space policy, Photoshop automatically converts everything to your current RGB or CMYK workspace. If the incoming profile does not match the workspace, then the default option is to carry out a profile conversion from

RGB:	Preserve Embedded Profiles
СМУК:	Preserve Embedded Profiles
Gray:	Preserve Embedded Profiles
Profile Mismatches:	Ask When Opening Ask When Pasting
Missing Profiles:	Ask When Opening

Figure 12.17 The Color Management Policies, with the Profile Mismatches and Missing Profiles checkboxes checked.

Figure 12.18 If the 'Preserve Embedded Profiles' color management policy is selected and the 'Ask When Opening' box is checked in the Profile Mismatches section (Figure 12.17), you will see the dialog shown here whenever there is a profile mismatch between the image you are opening and the current working space. You can then open using the embedded profile, override the policy and convert to the working space, or discard the embedded profile. Whatever you do, select one of these options and click OK, because if you click 'Cancel' you'll cancel opening the file completely. I usually prefer to use Preserve Embedded Profiles and deselect 'Ask When Opening', so that I am not constantly shown this dialog.

Include a 'Read Me' file

When you save a profiled RGB file, you might want to enclose a Read Me file on the disk to remind the person who receives the image that they should not ignore the embedded profile information.

Figure 12.19 If the Convert to Working RGB color management policy is selected (but without checking 'Ask When Opening' in the Profile Mismatches section), this dialog will appear whenever there is a profile mismatch between the image you are opening and the current working space. When you see this dialog, click OK to convert the document colors to the current color working space. Click 'Don't show again' if you don't wish to be reminded each time this occurs.

Figure 12.20 If the Convert to Working RGB color management policy is selected and the 'Ask When Opening' box is also checked in the Profile Mismatches section you will see the dialog shown here, where you can make a choice on opening to use the embedded profile, convert to the working space, or override the policy and discard the embedded profile.

the embedded profile space to the current workspace, as shown in Figure 12.19 (when the incoming profile matches the current RGB, CMYK or grayscale workspace, there is of course no need to convert the colors). Or, you will see the dialog shown in Figure 12.20, if the 'Ask When Opening' box is checked in the Profile Mismatches section. Convert to Working space can be a useful option for RGB mode because you may wish to convert all your RGB images to your working space (but not the CMYK files). For batch processing work I sometimes prefer to temporarily use the Convert to Working space RGB setting because this allows me to apply a batch operation to a mixture of files in which all the images end up in the current RGB workspace.

Color Management Off

The other option is to choose 'Off'. When this option is selected Photoshop appears not to color manage incoming documents and it will assume the default RGB or CMYK workspace to be the source. If there is no profile embedded, then the document stays that way. If there is a profile mismatch between the source and the workspace, the dialog shown in Figure 12.21 points out that if you click OK the embedded profile will be deleted. Or, you will see

	Embedded Profile Mismatch
A	The document "W1BY3510.tif" has an embedded color profile that does not match the current RGB working space. The document's colors will be converted to the working space.
	Embedded: Adobe RGB (1998)
	Working: ProPhoto RGB
	Don't show again Cancel OK
	Embedded Profile Mismatch
Λ	The document "W1BY3510.tif" has an embedded color profile that does not match the current RGB working space.
<u> </u>	Embedded: Adobe RGB (1998)
	Working: ProPhoto RGB
	O Use the embedded profile (instead of the working space)
	• Convert document's colors to the working space

the dialog shown on Figure 12.22, if the 'Ask When Opening' box is checked in the Profile Mismatches section. If the source profile matches the workspace, there is no need to remove the profile. In this instance the profile tag will not be removed (even so, you can still remove the ICC profile at the saving stage). Therefore, Photoshop is still able to color manage certain files and strictly speaking is not completely 'off'. Turning the color management off is not recommended for general Photoshop work, so do check the Color Settings to make sure Photoshop's color management hasn't been disabled, especially if working on an unfamiliar computer.

Profile conversions

As you gain more experience you will soon be able to create your own customized color settings. The minimum you need to know is 'which of the listed color settings are appropriate for the work you are doing'. To help in this decision making, you can read the text descriptions that appear in the Description box at the bottom of the Color Settings dialog. The section that's now coming up deals with how to make profile conversions once files have been opened in Photoshop, as well as how to assign different profiles where it is necessary to do so.

	The document "W1BY3510.tif" has an embedded color profile that does not match the current RGB working space. The current RGB color management policy is to discard profiles that do not match the working space.
	Embedded: Adobe RGB (1998)
	Working: ProPhoto RGB
	Don't show again Cancel OK
	Embedded Profile Mismatch
	The document "W1BY3510.tif" has an embedded color profile that does not match the current RGB working space.
<u> </u>	Embedded: Adobe RGB (1998)
	Working: ProPhoto RGB
	What would you like to do?
	O Use the embedded profile (instead of the working space)
	O Convert document's colors to the working space
	Discard the embedded profile (don't color manage)

When it is good to 'turn off'

Sometimes it is desirable to discard a profile. For example, you may be aware that the image you are about to open has an incorrect profile and it is therefore a good thing to discard it and assign the correct profile later in Photoshop. I still would not recommend choosing 'Off' as the default setting though. Just make sure you have the Color Management Policies set to 'Ask When Opening' and you can easily intervene and discard the profile when using the 'Preserve Embedded Profiles' or 'Convert to Working RGB' color management policies settings.

Figure 12.21 If the Color Management 'Off' policy is selected (but without checking 'Ask When Opening' in the Profile Mismatches section), this dialog will appear whenever there is a profile mismatch between the image you are opening and the current working space. When you see this dialog, click OK to discard the embedded profile. Click 'Don't show again' if you don't wish to be reminded each time this occurs.

Figure 12.22 If the Color Management 'Off' policy is selected and the 'Ask When Opening' box is checked in the Profile Mismatches section, you will see the dialog shown here. You can make a choice on opening to discard the embedded profile, use the embedded profile or convert to the working space.

RGB to RGB conversion warning

A Convert to Profile is just like any other image mode change in Photoshop, such as converting from RGB to Grayscale mode, and it is much safer to use than the old Profile to Profile command in Photoshop 5.0. However, be careful if you use Convert to Profile to produce targeted RGB outputs that overwrite the original RGB master. Any version of Photoshop since version 6.0 will have no problem reading the embedded profiles and displaying the image correctly; and will recognize any profile mismatch (and know how to convert back to the original workspace). As always, customized RGB files such as this may easily confuse other non-ICC savvy Photoshop users. Not everyone is using Photoshop, nor does everyone have their color management configured correctly. Some RGB to RGB conversions can produce RGB images that look fine on a correctly configured system, but look very odd on one that is not (see page 658).

Convert to Profile

Even if you choose to preserve the embedded profile on opening, it can be useful to convert non-workspace files to your current workspace after opening. This is where the Convert to Profile command comes in, because you can use it to carry out a profile conversion at any time, such as at the end of a retouch session, just before saving. Let's suppose you want to open an RGB image that is in Adobe RGB and the current working space is sRGB. If the 'Preserve Embedded Profile' option is selected then the default behavior would be to open the file and keep it in Adobe RGB without converting. You could carry on editing the image in the Adobe RGB color space up until the point where it is desirable to carry out a conversion to another color space. To make a profile conversion, go to the Edit menu and choose 'Convert to Profile...'. The Source space shows the current profile space and in 'Basic' mode, there will be a single Destination Space menu that will most likely default to 'Working RGB' (which in this case would be sRGB). This menu lists all of the available profiles on your computer system (see Figure 12.24). However, if you click on the

		Convert to Profile Advanced		
- Source Space - Profile: ProPhot	o RGB		1983 1983	OK Cancel
- Destination Sp	ace —			Preview
() Gray	Profile:	Working Gray - Gray Gamma 1.8	•	Preview
• RGB	Profile:	Working RGB - sRGB IEC61966-2.1	•	
OLAB				Basic
О СМУК	Profile:	Working CMYK - Coated FOGRA39 (ISO 12647-2:	•	
() Multichannel	Profile:	Std Photo YCC Print	\$	
O Device Link	Profile:		\$	
Abstract	Profile:	Blue Tone	•	
Conversion Op Engine: Adobe	Section and the section of the secti	•		
Intent: Relativ	e Colorin	netric 🗘		
Use Black Poi	nt Comp	ensation		
Use Dither			i shek	
🗌 Flatten Image	to Prese	rve Appearance		

Figure 12.23 Convert to Profile (shown here in Advanced mode) is located in the Edit menu and can be used to convert color data from one profile color space to another profiled space, such as when you want to convert a file to the profiled color space of a specific output device.

Color management

Chapter 12

Advanced button, you will see the Convert to Profile Advanced dialog (Figure 12.23) where the Destination Space options are broken down into color mode types, such as: Gray, RGB, Lab and CMYK, plus other more esoteric options such as Multichannel and Abstract profile modes. Because the color modes are segmented in this way, this makes it easier for you to access specific types of profiles when carrying out a conversion.

The Convert to Profile command is also useful when you wish to create an output file to send to a printer for which you have a custom-built profile but the print driver does not recognize ICC profiles. For example, one of the printers I used to use was the Fuji Pictrograph. I had built a custom profile for this printer, but unfortunately there was no facility within the File Export driver to utilize the output profile. Therefore, I used the Convert to Profile command to convert the color data to match the space of the output device just prior to sending the image data to the printer.

Whenever you make a profile conversion the image data will end up in a different color space and you might see a slight change in the on-screen color appearance. This is because the profile space you are converting to may have a smaller gamut than the one you are converting from. If an opened image is not in the current working color space, or has been converted to one that is not, Photoshop appends a warning asterisk (*) to the color mode in the title bar (Mac) or status bar (PC) to indicate this.

Assign Profile

When an image is missing its profile or has the wrong profile information embedded, the color numbers become meaningless. The Assign Profile command (Figure 12.25) can be used to correct mistakes as it allows you to assign correct meaning to what the colors in the image should be. So, for example, if you know the profile of an opened file to be wrong, you can use the Edit \Rightarrow Assign Profile command to rectify this situation. Let's suppose you have opened an untagged RGB file and for some reason decided not to color manage the file when opening. The colors don't look right and you have reason to believe that the file had originated from the sRGB color space. Yet, it is being edited in your current ProPhoto RGB workspace as if it were a ProPhoto RGB image. By assigning an sRGB profile, you can tell Photoshop that this is not a ProPhoto RGB image and that these colors should be considered as ✓ Working RCB – sRCB IEC61966-2.1 Custom RCB... Other

Adobe RGB (1998) Apple RGB ColorMatch RGB ProPhoto RGB sRGB IEC61966-2.1

1290 HRAG 190304.icc 2 1290 SemiGloss_1-5-06 1290 SemiGloss 1-5-06 1 1290 SemiGloss 300306 1290 SemiGloss 310306.icc 23inchLCD 1-5-08 1 4800-FP-SmoothHW-010907 7600_HMRag-081007 7600 Hrag 030406 7600 HWM 30-4-06 9600 SomVelvet SV1 Std v2.icc Adobe RGB (1998) +20 Saturation Adobe RGB (1998) -15 Saturation Adobe RGB (1998)+15 Saturation ARRIFLEX D-20 Daylight Log (by Adobe) ARRIFLEX D-20 Tungsten Log (by Adobe) CIE RGB Cinema HD Cinema HD Display Dalsa Origin Tungsten Lin (by Adobe) e-sRGB EP1290-HPAdvglossy Epson1290-BI-HWM.icc fijipictro-210904.icc Fujifilm ETERNA 250 Printing Density (by Adobe) Fujifilm ETERNA 250D Printing Density (by Adobe) Fujifilm ETERNA 400 Printing Density (by Adobe) Fujifilm ETERNA 500 Printing Density (by Adobe) Fujifilm F-125 Printing Density (by Adobe) Fujifilm F-64D Printing Density (by Adobe) Fujifilm REALA 500D Printing Density (by Adobe) Generic RGB Profile HDTV (Rec. 709) HP PSPro B9100-Advanced Photo Glossy HP PSPro B9100-Advanced Photo Satin HP PSPro B9100-Advanced Photo Soft-Gloss HP PSPro B9100-Aquarella Art Paper HP PSPro B9100-Artist Matte Canvas HP PSPro B9100-Everyday Photo Matte HP PSPro B9100-Hahnemuhle Smooth Fine Art HP PSPro B9100-Hahnemuhle Watercolor HP PSPro B9100-Premium Paper HP9180-AdvG-010907 HP91800-EpsonHWM HP9180 Fibraprint glossy-F HP9180 FP-SmoothHW-010907 HRag-7600-220107 Kodak 5205/7205 Printing Density (by Adobe) Kodak 5218/7218 Printing Density (by Adobe) Kodak 5229/7229 Printing Density (by Adobe) Kodak DCS RGB Kodak ProPhoto RCR KODAK sRGB Display Monitor_1-2-08_1 Monitor 11 0 06

Figure 12.24 The profile list displays all the profiles that are available on your computer.

Incorrect sRGB profile tags

Some digital cameras won't embed a profile in the JPEG capture files or worse still, embed a wrong profile, yet the EXIF metadata will misleadingly say the file is in sRGB color mode. The danger here is that while you may select Adobe RGB as the RGB space for your camera, when shooting in JPEG mode the camera may inadvertently omit to alter the EXIF tag which stubbornly reads sRGB.

This can be resolved by going to the Photoshop menu and choosing: Preferences ⇒ File Handling... If you check the 'Ignore EXIF Profile tag' option, Photoshop always ignores the specified camera profile in the EXIF metadata and only relies on the actual profile (where present) when determining the color space the data should be in. being in the sRGB color space. Most of the time, assigning sRGB will bring the colors back to life and if that doesn't work, then try one of the other commonly used RGB workspaces such as Adobe RGB or Colormatch.

You can also use Assign Profile to remove a profile by clicking on the Don't Color Manage This Document button, which allows you to strip a file of its profile. However, you can also do this by choosing File \Rightarrow Save As... and deselect the Embed Profile checkbox in the Save options.

Assign Pr	ofile:	6	ОК
ODon't Color Manage This Document			
Working RGB: ProPhoto RGB			Cancel
Profile:	sRGB IEC61966-2.1		Preview
) Profile:	sRGB IEC61966-2.1		g Previe

Figure 12.25 The Assign Profile command is available from the Edit menu in Photoshop. Edit ⇒ Assign Profile can be used to assign a new correct profile to an image or remove an existing profile.

Profile mismatches when pasting

One problem with having images in multiple color spaces open at once concerns the copying and pasting of color data from one file to another. Whenever you copy and paste image data, or drag copy an image with the move tool, it is possible that a profile mismatch may occur; although this will very much depend on how you have the Color Management policies configured in the Color Settings (see Figure 12.26). If the Profile Mismatches: Ask When Pasting box is unchecked in the Color Settings and a profile mismatch occurs, you will see the dialog shown in Figure 12.27. This asks if you wish to convert the color data to preserve the color appearance when it is pasted into the new destination document. If the Profile Mismatches: Ask When Pasting box is checked in the Color Settings, then you will see instead the dialog box shown in Figure 12.28. This dialog offers you the choice to convert or not convert the data. If you select 'Convert', the appearance of the colors will be maintained when you paste the data and if you choose 'Don't Convert' the color appearance will change but the numbers will be preserved.

Suite a	pplication			Cancel
ttings:	Cust	om	:	
Working !	Spaces —			Load
	RGB:	ProPhoto RGB	•	Save
	CMYK:	Coated FOGRA27 (ISO 12647-2:2004)	•	
	Gray:	Gray Gamma 2.2	•	More Options
	Spot:	Dot Gain 15%		Preview
Color Ma	nagemen	t Policies		
	RGB:	Preserve Embedded Profiles		
	CMYK:	Preserve Embedded Profiles		
	Gray:	Preserve Embedded Profiles		
ofile Misn	natches:	Ask When Opening Ask When Pasting		
Missing	Profiles:	Ask When Opening		
Descripti	on			
			1.1.1.1	Des and the state

Figure 12.26 The Profile Mismatches settings in the Color Management section of the Color Settings dialog will influence Profile Mismatch behavior.

	Paste Profile Mismatch
	Are you sure you want to convert colors to a destination document with a color profile that does not match the current RGB working space?
0	Source: Adobe RGB (1998)
	Destination: sRGB IEC61966-2.1
	Working: ProPhoto RGB
	Don't show again Cancel OK
	Paste Profile Mismatch
	You are pasting content copied from a document with a different colo profile.
Ó	Source: Adobe RGB (1998)
	Destination: sRGB IEC61966-2.1
	Convert (preserve color appearance)
	O Don't convert (preserve color numbers)
	Cancel OK

Figure 12.27 If you attempt to paste image data from a document whose color space does not match the destination space (and the Profile Mismatches: Ask When Pasting box is unchecked), this dialog warning alerts you to a profile mismatch between the source and destination documents. If you click OK, Photoshop converts the data and preserves the color appearance of the image data.

Figure 12.28 If the Profile Mismatches: Ask When Pasting box is checked in the Color Settings dialog and you attempt to paste image data from a document whose color space does not match the destination space, this dialog warning gives you the option to 'Convert' the colors (as in Figure 12.27 above), or 'Don't Convert' and preserve the numbers instead.

Saving a Color Setting

If you have configured the settings to suit a particular workflow, you can click on the Save... button to save these as a custom setting that will appear in the Color Settings menu the next time you open this dialog. When you save a setting you can enter any relevant comments or notes about the setting you are saving in the text box (see Figure 12.29). This information will then appear in the Color Settings dialog text box at the bottom. You might name a setting something like 'Client annual report settings' and write a short descriptive note to accompany it, reminding you of situations where you would need to use this particular custom setting.

Color Settings Comment	
The comment entered here will appear in the Description area of the Color Settings dialog when this setting file is selected. Enter your comment here:	OK Cancel
trento Printers, Italy. Use these settings for light Black Gen CMYK conversions for the Photoshop for Photographers book series.]	

Figure 12.29 Custom color settings can be loaded or saved via the Color Settings dialog. The relevant folder will be located in the username/Library/Application Support/Adobe/Color/Settings folder (Mac OS X) or Program Files/Common Files/Adobe/Color/Settings folder (PC). When you save a custom setting it must be saved to this location and will automatically be appended with the '.csf' suffix. When you save a color setting you have the opportunity to include a brief text description in the accompanying dialog. Color Settings files can also be shared between some Adobe applications and with other Photoshop users.

Reducing the opportunities for error

When you adopt an RGB space such as ProPhoto RGB as the preferred workspace for all your image editing, you must take into account how this might cause confusion when exchanging RGB files between your computer (which is operating in a color managed workflow) and that of someone who is using Photoshop with the color management switched off. When sending image files to other Photoshop users, the presence of a profile can help them read the image data correctly, so long as they have the Photoshop color settings configured to preserve embedded profiles (or convert to the working space) and their computer display is calibrated correctly. They will then see your photographs on their system almost exactly the way you intended them to be seen. The only variables will be the accuracy of their display calibration and profile, the color gamut limitations of the display and the environment in which it is being viewed. Configuring the Color Settings is not so difficult to do, but the recipient does have to be as conscientious as you are about ensuring their display is set up correctly. The situation has not been helped either by the way the default color settings have shifted about over the last nine versions of the program. The default settings in Photoshop CS5 use Preserve Embedded Profiles, but prior to that we had settings like 'Web Graphics' in which color management was switched off. Consequently, there are a lot of Photoshop users out there who have unwittingly been using sRGB as their default RGB workspace and with color management switched off. Even where people do have the color management switched on, the displays they are using may not have been profiled in months or are being viewed in a brightly lit room!

It is important to be aware of these potential problems because it is all too easy for the color management to fail once an image file has left your hands and been passed on to another Photoshop user. With this in mind, here are some useful tips to help avoid misunderstandings over color. The most obvious way to communicate what the colors are supposed to look like is to supply a printed output. In fact this is considered routine when supplying images to a printer. If you are sending a file for CMYK repro printing, it is sensible to also supply a CMYK targeted print output. Supplying a print is an unambiguous visual reference, which if done properly can form the basis of a contract between yourself, the client and the printer.

Playing detective

How you deliver your files will very much depend on who you are supplying them to. I often get emails from readers who have been given the runaround by their color lab. One typically finds that the lab may be using a photo printer such as the Fuji Frontier[™] which does not read incoming profiles and is simply calibrated to expect sRGB files. So far so good. As long as you send an sRGB file, you shouldn't have any problems. But if the color lab operator has Photoshop color management switched off, they will not know how to handle anything other than an incoming file that is in sRGB. If you then supply them with an Adobe RGB file they may not read the profile. The colors will end up looking different in the final print and then they blame the customer!

It helps to do a little detective work to ascertain the skill level of the recipient. The first thing you need to know is what color settings are they using? This will help you determine which RGB space they are using and whether the color management is switched on or off. The other thing to ask is 'do you have your computer display calibrated and profiled?' And if the answer is ves, then ask how often they calibrate and profile their display. The answers to these questions will tell you quite a bit about the other person's system, how you should supply your files and also how accurate their computer display is at displaying colors. Basically, if you have any doubts, the safest option is to convert to sRGB before sending.

Martin Evening Adobe Photoshop CS5 for Photographers

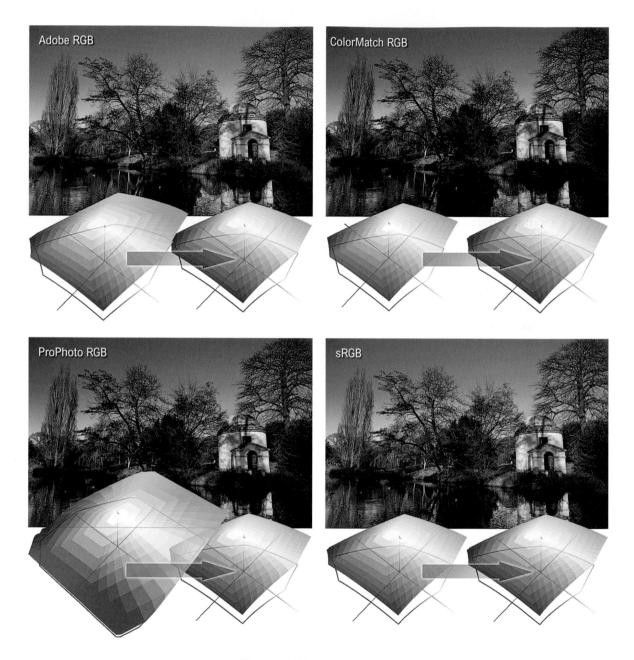

Figure 12.30 The purpose of this illustration is to show what happens if you submit an RGB file originating in different RGB spaces to a Photoshop user who has their Photoshop system configured using sRGB as their RGB workspace and with the color management policies set to 'Off' (ignoring incoming profiles).

If the person you are supplying the file to is in the same building or you are in regular contact with them, then you probably have a clear idea of how their system is set up. If they have Photoshop color management switched on, they can read any file you send them in any color space and it will be color managed successfully. However, you cannot always make too many assumptions about who you are sending image files to and it is for this reason that you should sometimes adopt a more cautious approach. I am often asked to supply RGB files as large JPEGs for initial approval by the client before making a finished print. In these situations I find it safer to supply a profiled sRGB image. I do this by choosing Edit \Rightarrow Convert to Profile... and select sRGB as the destination space. If the recipient is color management savvy, then the version of Photoshop they are working with should be able to read the sRGB profile and handle the colors correctly. If the recipient has not bothered to configure their color management settings then one can be almost certain that they are using sRGB as their default RGB workspace. So in these instances, converting to sRGB means they stand a better chance of seeing the colors correctly regardless of whether they have the color management on or off.

Figure 12.30 shows a comparison of how a photo that was edited using different RGB workspaces would look on a Photoshop system configured using a Color Management 'Off' setting and where the person receiving the file ignores the embedded profile. If the photo was delivered as an Adobe RGB file, the gamma would match, but because Adobe RGB has a larger gamut than sRGB the colors would appear slightly desaturated. If supplied as a ColorMatch RGB file, sRGB would interpret this as a darker image because ColorMatch has a lower gamma of 1.8. If supplied using ProPhoto RGB, the colors would appear even more muted when brought into sRGB without any color management. This is because ProPhoto RGB has a much larger color gamut. The bottom right example shows how the photo would look if the supplied image was in sRGB and opened in Photoshop with color management switched off, but with sRGB as the default RGB workspace. In this instance this is the most correct version. Of course, I am certainly not advocating you use sRGB as your standard RGB workspace, because it is still a poor space to use for photographic work, but it can be a useful 'dumbed down' space to convert to when communicating with unknown users.

Matching grayscale gamma

If you are using the Epson Advanced B&W options to print grayscale images, it is best to make sure that the Gray working space matches the gamma of the RGB working space. If this is the case, use the following Gray gamma settings: Colormatch RGB: 1.8 gamma Adobe RGB: 2.2 gamma sRGB: 2.2 gamma ProPhoto RGB: 1.8 gamma

Grayscale for screen display

If you intend creating gravscale images to be seen on the Internet or in multimedia presentations, I suggest you choose the 'Default Web Graphics' color setting. The Grayscale workspace will then be set to a 2.2 gamma space, which is the same gamma that's used by the majority of PC and Mac computer displays. The truth is, you can never be 100% sure how anybody who views your work will have their display calibrated, but you can at least assume that the majority of Internet users will have a display set to a 2.2 gamma. The Macintosh 1.8 gamma setting should really be relegated to ancient history. The reason it exists at all is because in the very early days of the Macintosh computer (and before ICC color management) a 1.8 gamma monitor space most closely matched the dot gain of the Apple monochrome laser printer.

Working with Grayscale

Grayscale image files can also be managed via the Color Settings dialog. The color management policy can be set to either 'Preserve Embedded Profiles' or 'Convert to Working Gray'. If the profile of the incoming grayscale file does not match the current Gray workspace (and the Ask When Opening box is checked), you will be asked whether you wish to use the tagged grayscale space profile, or convert to the current Gray workspace.

If you examine the Gray workspace options, you will see a list of dot gain percentages and display gamma values. For prepress work you should select the dot gain percentage that most closely matches the anticipated dot gain of the press. It is important to note that the Gray workspace setting is independent of the CMYK workspace. If you want the Gray workspace dot gain value to match the black plate of the current CMYK setting, then mouse down on the Gray setting and choose 'Load Gray...'. Now go to the Profiles folder, which will be in the Library/Application Support/ Adobe/Color/Settings folder on a Mac and in the Program Files/ Common Files/Adobe/Color/Settings folder on a PC. Select the same CMYK space as you are using for the CMYK color separations and click the Load... button. This loads the black plate dot gain value and sets it as the new Gray workspace setting. This means that when you convert images to the current Gray workspace, they will do so using the correct black plate dot gain setting to match the current CMYK setting.

If you are using grayscale mode to make prints via the Advanced B&W print options for an Epson printer, you should make sure that the Grayscale workspace uses a gamma setting that matches the gamma of your current RGB workspace. This ensures there is no gamma compensation when you convert from RGB to Grayscale (see sidebar: Matching grayscale gamma)

If you are preparing grayscale images for screen display use, such as on a website or in a multimedia presentation, then you will want to select 'Gray Gamma 2.2' (see the sidebar: Grayscale for screen display). If you want to know what existing prepress grayscale images will look like on the Web in grayscale mode, I suggest you select the View \Rightarrow Proof Setup and choose Windows RGB or Macintosh RGB. You can then select Image \Rightarrow Adjust \Rightarrow Levels and adjust the Gamma slider accordingly to obtain the right brightness for a typical PC or Mac display (to be honest, most Mac users these days are using the same display gamma as PC users).

Advanced Color Settings

The advanced settings are normally hidden, but if you click on the More Options button, you'll see the expanded Color Settings dialog shown in Figure 12.31. These advanced settings unleash full control over the Photoshop color management system. However, don't attempt to adjust any of these expert settings until you have fully understood the intricacies of customizing the RGB, CMYK, Gray and Spot color spaces. I suggest you read through the remaining section of this chapter first before you consider customizing any of these settings.

	Color Sett	ings	
	Your Creative Suite applications are n r consistent color.	ot	OK Cancel
Settings: Custom			
- Working Spaces -			Load
RGB:	ProPhoto RGB	•	Save
CMYK:	Coated FOGRA39 (ISO 12647-2:2004	0	More Options
Gray:	Gray Gamma 1.8	\$	
Spot:	Dot Gain 20%	•	Preview
- Color Managemer	t Policies		
RGB:	Preserve Embedded Profiles		
CMYK:	Preserve Embedded Profiles		
Gray:	Preserve Embedded Profiles		
Profile Mismatches:	Ask When Opening Ask Whe	n Pasting	
Missing Profiles:	Ask When Opening		
- Conversion Optio	15		
Engine:	Adobe (ACE)		
Intent:	Relative Colorimetric		
	Use Black Point Compensation		
	Use Dither (8-bit/channel images)	
	Compensate for Scene-referred P	rofiles	
- Advanced Contro			
Desaturate Monitor Colors By: 20 %			
Blend RGB Color	s Using Gamma: 1.00		
Description			
]
		the statistic and the second	

Figure 12.31 This shows the Photoshop Advanced Color Settings dialog. Clicking on the More Options button (circled) unleashes full control over all the Photoshop settings. The following sections of this chapter show how you can customize the color management settings in the Advanced mode. Note that the button in this Color Settings dialog view normally says 'Fewer Options'; I edited the screen shot to say 'More Options', simply to make it more obvious where you should click.

Custom Gray space settings

When the 'Advanced Color Settings' option is checked you can enter a custom gamma value or dot gain curve setting (see 'Dot gain' on page 667).

Scene-referred profiles

Photoshop CS4 and CS5 contain a new advanced preference called 'Compensate for Scene-referred Profiles'. This isn't of any real significance for photographers. It is switched on by default and designed to automatically apply video contrast when converting between scene and outputreferred profiles. This basically matches the default color management workflow for After Effects CS4 or later.

Conversion options and rendering intents

You have a choice of three Color Management Modules (CMMs): Adobe Color Engine (ACE), Apple ColorSync or Apple CMM. The Adobe color engine is reckoned to be superior for all RGB to CMYK conversions because the Adobe engine uses 20-bit per channel bit-depth calculations to calculate its color space conversions.

The rendering intent influences the way the data is translated from the source to the destination space. The rendering intent is like a rule that describes the way the conversion is calculated and we will be looking at rendering intents later on pages 670–673.

Black Point Compensation

This maps the darkest neutral color of the source RGB color space to the darkest neutrals of the destination color space. Black Point Compensation plays a vital role in translating the blacks in your images so that they reproduce as black when printed. As was explained in Chapter 3, there is no need to get hung up on setting the shadow point to anything other than zero RGB values. It is not necessary to apply any shadow compensation at the image editing stage, because the color management will automatically take care of this for you and apply a black point compensation obtained from the output profile used in the mode or profile conversion. If you disable Black Point Compensation you may obtain deep blacks, but you will get truer (compensated) blacks if you leave it switched on.

You will want to use Black Point Compensation when separating an RGB image to a press CMYK color space. However, in the case of a conversion from a CMYK proofing space to an inkjet profile space, we must preserve the (grayish) black of the press and not scale the image (because this would improve the blacks). For this reason Black Point Compensation is disabled in the Print dialog when making a proof print to simulate black ink.

Use Dither (8-bit per channel images)

Banding may occasionally occur when you separate to CMYK, particularly where there is a gentle tonal gradation in bright saturated areas. Any banding which appears on the display won't necessarily always show in print and much will depend on the coarseness of the screen that's eventually used in the printing process. However, the Dither option can help reduce the risk of banding when converting between color spaces.

Blend RGB colors using gamma

This option allows you to override the default color blending behavior. There used to be an option in Photoshop 2.5 for applying blend color gamma compensation. This allowed you to blend colors with a gamma of 1.0, which some experts argued was a purer way of doing things, because at higher gamma values than this you might see edge darkening occur between contrasting colors. Some users found the phenomenon of these edge artifacts to have a desirable trapping effect. However, many Photoshop users complained that they noticed light halos appearing around objects when blending colors at a gamma of 1.0. Consequently, gamma-compensated blending was removed at the time of the version 2.5.1 update. If you understand the implications of adjusting this particular gamma setting, you can switch it back on if you wish. Figure 12.32 illustrates the difference between blending colors at a gamma of 2.2 and 1.0.

Desaturate monitor colors

The 'Desaturate Monitor Colors By' option helps you to visualize and make comparisons between color gamut spaces where one or more gamut space is larger than the monitor RGB space. Color spaces such as ProPhoto RGB have a gamut that is much larger than the computer display is able to show. So turning down the monitor colors saturation allows you to make a comparative evaluation between these two different color spaces. It is in essence a 'hurt me' button, because if you don't understand how to use this feature, you might inadvertently leave it on and end up assuming all your images are desaturated.

Figure 12.32 In this example we have a pure RGB green soft-edged brush stroke that is on a layer above a pure RGB red Background layer. The version on the left shows the combined layers using the normal default blending where 'Blend RGB Colors using Gamma' is deselected, and the version on the right shows what happens if you check this item and apply a gamma of 1.0. As you can see, the darkening around the edges where the contrasting colors meet will disappear.

Custom RGB and workspace gamma

Expert users may wish to use an alternative custom RGB workspace in place of one of the listed RGB spaces. If you know what you are doing and wish to create a customized RGB color space, you can go to the Custom... option in the pop-up menu and enter the information for the White Point, Gamma and color primaries coordinates (Figure 12.33). My advice is to leave these expert settings well alone. Avoid falling into the trap of thinking that the RGB workspace gamma should be the same as the monitor display gamma setting. The RGB workspace is *not* a display space.

Adobe RGB is considered a good choice as an RGB workspace because its 2.2 gamma provides a more balanced, even distribution of tones between the shadows and highlights, while others, like myself prefer the 1.8 gamma ProPhoto RGB space for its wide color gamut. Remember, you do not actually 'see' Adobe RGB or ProPhoto RGB and the RGB workspace gamma has no impact on how the colors are displayed on the screen (so long as Photoshop ICC color management is switched on). In any case, these advanced custom color space settings are safely tucked away in Photoshop and you are less likely to be confused by any apparent discrepancies between the display gamma and the RGB workspace gamma.

Custom RCB		Custom RGB	
Name: Bruce RCB		Load RGB Save RGB	
Gamma Cancel		Other	
Gamma: 2.2	Unsynchronized	Monitor RGB - Monitor_15-8-08_2 ColorSync RGB - Generic RGB Profile	OK Cancel
- White Point: 6500° K (D65) x y White: 0.3127 0.3290	Settings: CL Working Space	Adobe RGB (1998) Apple RGB ColorMatch RGB ProPhoto RGB sRGB IEC61966-2.1	Load
x y Red: 0.6400 0.3300 Green: 0.2800 0.6500 Blue: 0.1500 0.0600	CM Gri Spi — Color Managen RC CM Gri	1290 HRAG 190304.icc 2 1290, SemiCloss, 1-5-06 1290, SemiCloss, 1-5-06, 1 1290, SemiCloss, 300306 1290, SemiCloss, 300306 1290, SemiCloss, 310306 1290, SemiCloss, 310306 1290, Hag, 030406 7600, HMR, 0-4-06 9600 SomVelvet SVI 364 2.icc Adobe RCB (1998) + 20 Saturation	Fewer Options Preview
Figure 12.33 You can use the Custom GB dialog to create custom RGB workspaces. he settings shown here have been named Bruce RGB', after Bruce Fraser who once evised this color space as a suggested repress RGB space for Photoshop.	Profile Mismatch Missing Profile Conversion Op Engit Inte	Adobe RCB (1989) -15 Saturation Adobe RCB (1989) -15 Saturation ARBIFLEX D-20 Daylight Log (by Adobe) ARBIFLEX D-20 Daylight Log (by Adobe) CIE RCB Cinema HD Cinema HD Cinema HD Dalsa Origin Tungsten Lin (by Adobe) e-sRCB EP1200-HPMdvglossy EP1200-HPMdvglossy Ep1200-HPMdvglossy Ep1200-HPMdvglossy	

RGB to CMYK

Digital scans and captures all originate in RGB but professional images are nearly always reproduced in CMYK. Since the conversion from RGB to CMYK has to happen at some stage, the question is: at what point should this take place and who should be responsible for the conversion? If you have decided to take on this responsibility yourself then you need to understand more about the CMYK settings. When it comes to four-color print reproduction, it is important to know as much as possible about the intended press conditions that will be used at the printing stage and use this information to create a customized CMYK setup.

CMYK setup

If you examine the US prepress default setting, the CMYK space says 'U.S. Web Coated (SWOP) v2'. This setting is by no means a precise setting for every US prepress SWOP coated print job, because there can be many flavors of SWOP, but it does at least bring you a little closer to the type of specification a printer in the US might require for printing on coated paper with a Web press setup. If you mouse down on the CMYK setup pop-up list, you will see there are also US options for Web uncoated and Sheetfed press setups. Under the European prepress default setting, there is a choice between coated and uncoated paper stocks, plus the latest ISO coated FOGRA39 setting. Then there is also Custom CMYK... where you can create and save custom CMYK profile settings.

There is not a lot you can do with the standard CMYK settings: you can make a choice from a handful of generic CMYK profile settings or choose 'Custom CMYK...'. If you check the More options box, you'll be able to select from a more comprehensive list of CMYK profile settings in the extended menu (depending on what profiles are already in your ColorSync folder).

Creating a custom CMYK setting

Figure 12.34 shows the Custom CMYK dialog, which is better known as the familiar 'classic' Photoshop CMYK setup. Here, you can enter all the relevant CMYK separation information for a specific print job. Ideally you will want to save each purpose-built CMYK configuration as a separate color setting for future use and label it with a description of the print job it was built for.

Photoshop CMYK myths

There are some people who will tell you that in their 'expert opinion', Photoshop does a poor job of separating to CMYK. I bet if you ask them how they know this to be the case, they will be stumped to provide you with a coherent answer. Don't let anyone try to convince you otherwise, because Professional quality CMYK separations can be achieved in Photoshop. You can avoid gamut clipping and you can customize a separation to meet the demands of any type of press output. The fact is that Photoshop will make lousy CMYK separations if the Photoshop operator who is carrying out the conversion has a limited knowledge of how to configure the Photoshop CMYK settings. For example, a wider gamut RGB space such as Adobe RGB or ProPhoto RGB is better able to encompass the gamut of CMYK and yield CMYK separations that do not suffer from gamut clipping. This is one big strike in favor of the Photoshop color management system. Remember, CMYK is not a one-size-fits-all color space and CMYK conversions do need to be tailor-made for each and every job.

Saving custom CMYK settings

Custom CMYK settings should be saved using the following locations: Library/ColorSync/Profiles/Recommended folder (Mac OS X);

Windows/System32/Spool/Drivers/Color folder (PC).

Once you have configured a new CMYK workspace setting, this becomes the new default CMYK workspace that is used when you convert an image to CMYK mode. Note that altering the CMYK setup settings has no effect on the on-screen appearance of an already-converted CMYK file (unless there is no profile embedded). This is because the CMYK separation setup settings must be established first before you carry out the conversion.

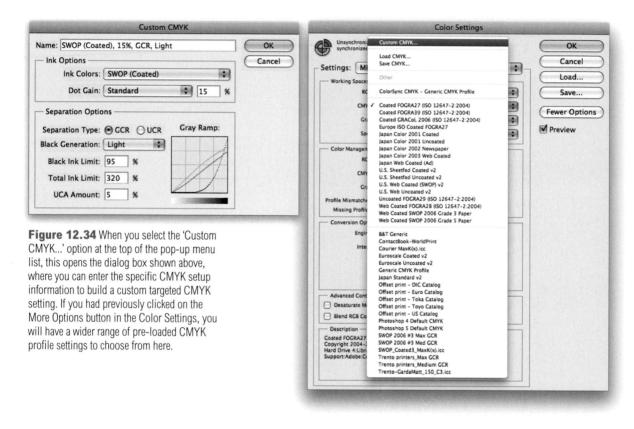

Ink Colors

If you click on the Ink Colors menu, you can select one of the preset Ink Colors settings that are suggested for different types of printing. For example, European Photoshop users can choose from Eurostandard (coated), (uncoated), or (newsprint). These are just generic ink sets. If your printer can supply you with a custom ink color setting, then select 'Custom...' from the Ink Colors menu. This opens the dialog shown in Figure 12.35.

Figure 12.35 Here is a screen shot of the Custom Ink Colors dialog. For special print jobs such as where non-standard ink sets are used, or the printing is being done on colored paper, you can enter the measured readings of the color patches (listed here) taken from a printed sample on the actual stock that is to be used. You could measure these printed patches with a device such as the X-Rite Eye-One and use this information to create a custom Ink Colors setting for an individual CMYK press setup.

Figure 12.36 If you select 'Dot Gain:

Curves...' from the CMYK setup shown in

Figure 12.34, this opens the Custom Dot

Gain Curves dialog. If your printer is able to provide dot gain values at certain percentages, then you can enter these here. You can make

the dot gain curves the same for all channels.

but since the dot gain may vary on each ink plate, you can enter dot gain values for each

plate individually. Note that when you select

'Custom Dot Gain...' from the Grayscale

workspace menu, a similar dialog appears.

If you are preparing to save a color setting

black plate dot gain setting is consistent.

designed for separating prepress CMYK and

grayscale files, you will want to check that the

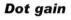

Dot gain refers to an accumulation of factors during the repro process that will make a dot printed on the page appear darker than expected. Among other things, dot gain is dependent on the type of press and the paper stock that's being used. The dot gain value entered in the CMYK setup determines how light or dark the separation needs to be. If a high dot gain is encountered, the separated CMYK films will need to be less dense so that the plates produced lay down less ink on the paper and produce the correctsized printed halftone dot for that particular type of press setup. You can see for yourself how this works by converting an image to CMYK using two different dot gain values and comparing the appearance of the individual CMYK channels. Although the dot gain value affects the lightness of the individual channels, the composite CMYK channel image is always displayed correctly on the screen, showing how the final printed image should look.

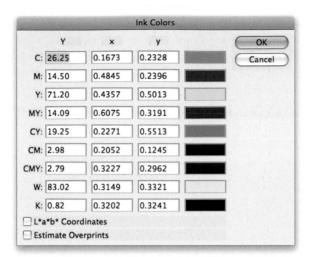

CMYK previews in Proof Setup

Once the CMYK setup has been configured, you can use View ⇒ Proof Setup ⇒ Working CMYK to see a CMYK preview of what a photograph will look like after a CMYK conversion, while you are still editing the image in RGB mode. If you select the 'Dot Gain Curves' option, you can enter custom settings for the composite or individual color plates. In the preparation of this book I was provided with precise dot gain information for the 40% and 80% ink values (these are shown on the previous page in Figure 12.36).

Gray Component Replacement (GCR)

The default Photoshop setting is GCR, Black Generation: Medium, Black Ink Limit 100%, Total Ink Limit 300%, UCA Amount 0%. If you ask your printer what separation settings they use and they quote you these figures, you'll know they are just reading the default settings from an unconfigured Photoshop setup. They either don't know or don't want to give you an answer. The black ink limit should typically be around 95% for most separation jobs, but in the region of 85–95% for newsprint. The total ink limit should roughly be in the region of 300–350% for Sheetfed coated and Web press coated jobs, 260–300% for Sheetfed uncoated and Web uncoated jobs, and 260–280% for newsprint. If you prefer, you can just stick to using the prepress CMYK setting that most closely matches the output (such as US Sheetfed/Web Coated/Uncoated, or one of the European FOGRA settings).

Black generation

This determines how much black ink is used to produce the black and gray tonal information. A light or medium black generation setting will work best for most photographic images. I would therefore advise leaving this set to 'Medium' and only change the black generation if you know what you are doing.

You may be interested to know that I specifically used a maximum black generation setting to separate all the dialog boxes that appear in this book. Figure 12.37 shows a view of the Channels panel after I had separated the screen grab shown in Figure 12.35 using a Maximum black generation CMYK separation. With this separation method only the black plate is used to render the neutral gray colors. Consequently, this means that any color shift at the printing stage has no impact whatsoever on the neutrality of the gray content. I cheekily suggest you inspect other Photoshop books and judge if their panel and dialog box screen shots have reproduced as well as the ones shown in this book!

Undercolor Addition (UCA)

Low key subjects and high quality print jobs are more suited to the use of GCR (Gray Component Replacement) with a small amount of UCA (Undercolor Addition). GCR separations remove more of the cyan, magenta and yellow ink where all three inks are used to produce a color, replacing the overlapping color with black ink. By dialing in some UCA one can add a small amount of color back into the shadows. This can be particularly useful where the shadow detail would otherwise look too flat and lifeless. The percentage of black ink used is determined by the black generation setting. When making conversions, you are usually better off sticking with the default GCR, using a light to medium black generation with 5–10% UCA. This will produce a longer black curve with improved image contrast.

Undercolor Removal (UCR)

The UCR (Undercolor Removal) separation method replaces the cyan, magenta and yellow ink with black ink in just the neutral areas. The UCR setting is also favored as a means of keeping the total ink percentage down on high-speed presses, although it is not necessarily suited for every type of print job.

Choosing a suitable RGB workspace

The RGB space you choose to edit with can certainly influence the outcome of your CMYK conversions, which is why you should choose your RGB workspace carefully. The default sRGB color space is widely regarded as an unsuitable space for photographic work because the color gamut of sRGB is actually smaller than the color gamut of CMYK (and that of most inkjet printers). If you choose a color space like Adobe RGB or ProPhoto RGB, you'll be working with a color space that can adequately convert from RGB to CMYK without significantly clipping the CMYK colors. Adobe RGB has long been a favoured space for professional photographers and you should really notice the difference here if you are able to view the photos you are editing on a decent display like the high-end Eizo or NEC displays I mentioned earlier in Chapter 2. These are capable of displaying something like 98% of the Adobe RGB gamut and therefore just about all the gamut of a typical CMYK space. It can make a big difference if you can use such a display to accurately preview the colors you are editing and soft proof them for print (see Chapter 13).

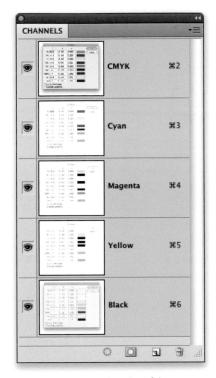

Figure 12.37 Here is a view of the Channels panel showing the four CMYK channels after I had separated the screen grab shown in Figure 12.35 using a Maximum black generation CMYK separation. Notice how all the neutral gray information is contained in the Black channel only. This is a good separation method to use for screen grabs, but not so good for other types of images.

Which rendering intent is best?

If you are converting photographic images from one color space to another, then you should mostly use the Relative Colorimetric or Perceptual rendering intents. Relative Colorimetric has always been the default Photoshop rendering intent and is still the best choice for most image conversions. However, if you are converting an image where it is important to preserve the shadow colors, then Perceptual will often work better. For these reasons, I recommend that you use the Soft proofing method described in the following chapter to preview the outcome of any profile conversion and check to see whether a Relative Colorimetric or Perceptual rendering will produce the best results.

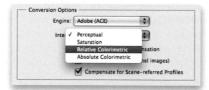

Figure 12.38 The default rendering intent is set by choosing 'More Options' in the Color Settings dialog and mousing down on the Intent menu in the Conversion Options.

Rendering intents

Whenever you make a profile conversion, such as when converting from RGB to CMYK, not all of the colors in the original source space will have a direct equivalent in the destination space. RGB spaces are mostly bigger than CMYK and therefore those RGB colors that are regarded as being 'out of gamut' will have to be translated to their nearest equivalent color in the destination CMYK space. The way this translation is calculated is determined by the rendering intent. In the Color Settings dialog you can choose which rendering intent you would like to use as the default method for all color mode conversions (Figure 12.38), but you can also override this setting and choose a different rendering intent whenever you use the Edit \Rightarrow Convert to Profile command (Figure 12.39), or soft proof an image using View \Rightarrow Proof Setup \Rightarrow Custom (Figure 12.40). I have provided here a guide to the four main rendering intents you'll find in Photoshop and their suggested uses.

Perceptual

Perceptual (Images) rendering is an all-round rendering method that is sometimes suitable for certain types of images. Perceptual rendering compresses the out-of-gamut colors into the gamut of the target space in a rather generalized way (so that they don't become clipped), while preserving the visual relationship between those colors. More compression occurs with the out-of-gamut colors, smoothly ramping to no compression for the in-gamut colors. Perceptual rendering provides a best guess method for converting out-of-gamut colors where it is important to preserve tonal separation (such as in the shadow detail areas), but it is less suitable for images that happen to have fewer out-of-gamut colors.

Saturation (Graphics)

The Saturation rendering intent preserves the saturation of the out-of-gamut colors at the expense of hue and lightness. Saturation rendering preserves the saturation of colors making them appear as vivid as possible after the conversion. This rendering intent is best suited to the conversion of business graphic presentations where retaining bright bold colors is of prime importance.

Relative Colorimetric

Relative Colorimetric is the default rendering intent utilized in the Photoshop color settings. Relative Colorimetric rendering maps the colors that are out of gamut in the source color space (relative to the target space) to the nearest 'in-gamut' equivalent in the target space. When doing an RGB to CMYK conversion, an out-of-gamut blue will be rendered the same CMYK value as a 'just-in-gamut' blue and out-of-gamut RGB colors are therefore clipped (see the example over the page in Figure 12.41). This can be a problem when attempting to convert the more extreme out-of-gamut RGB colors to CMYK color, but if you are using View \Rightarrow Proof Setup \Rightarrow Custom (Figure 12.40) to call up the Customize Proof Condition dialog you can check to see if this potential gamut clipping will cause the loss of any important image detail when converting to CMYK with a Relative Colorimetric conversion.

Absolute Colorimetric

Absolute Colorimetric maps in-gamut colors exactly from one space to another with no adjustment made to the white and black points. This rendering intent can be used when you convert specific 'signature colors' and need to preserve the exact hue, saturation and brightness (such as the colors in a commercial logo design). This rendering intent is seemingly more relevant to the working needs of designers than photographers. However, you can use the Absolute Colorimetric rendering intent as a means of simulating a target CMYK output on a proofing device. Let's say you make a conversion from RGB to CMYK using either the Relative Colorimetric or Perceptual CMM and the target CMYK output is a newspaper color supplement printed on uncoated paper. If you use the Absolute Colorimetric rendering intent to convert these 'targeted' CMYK colors to the color space of the proofing device, the proof printer can reproduce a simulation of what the printed output on that stock will look like. Note that when you select the 'Proof' option in the Photoshop print dialog, the rendering intent menu appears grayed out. This is because an Absolute Colorimetric rendering is selected automatically (although the Print dialog doesn't actually show you this) in order to produce a simulated proof print.

- Source	Space		OK
Profile:	ProPhoto RGB		Cancel
Destin	ation Space		Preview
Profile:	Working CMYK - Co	ated FOGRA27 (ISO 12647-2	
Conve	rsion Options		
Engine:	Adobe (ACE)	(Advance
Intent:	Perceptual	•	
Use 8	lack Point Compensa	tion	
Use D	Dither		
Flatte	in Image to Preserve	Appearance	

Figure 12.39 The default rendering intent setting can be overridden when using the Convert to Profile command.

Custom Proof Condition:	Custom		OK
- Proof Conditions		1	Cancel
Device to Simulate:	Working CMYK - Coated FOGRA27 (IS	D 12647-2	Load
	Preserve Numbers		Save
Rendering Intent:	Perceptual	•	M Preview
	Black Point Compensation		Preview
- Display Options (On	-Screen)		
Simulate Paper Col	Dr	A STATISTICS OF	
Simulate Black Ink			

Figure 12.40 You can also change the rendering intent in the Custom Proof Condition dialog. This allows you to preview a simulated conversion without actually converting the RGB data.

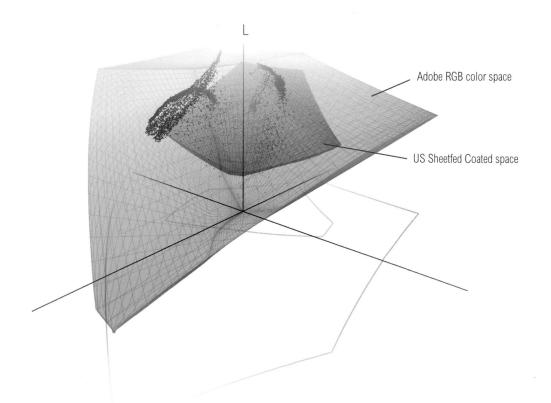

Figure 12.41 To illustrate how the rendering intent can influence the outcome of a color mode or profile conversion I used Chromix ColorThink 2.1.2 to help me create the diagrams shown on these two pages. The above diagram shows the Adobe RGB color space overlaying a US Sheetfed Coated CMYK color space. As you can see, Adobe RGB is able to contain all the colors that may be squeezed into this smaller CMYK space. The photograph opposite has been plotted on this diagram so that the dots represent the distribution of RGB image colors within the Adobe RGB space.

When the colors in this image scene are converted to CMYK, the rendering intent determines how the RGB colors that are outside the gamut limits of the CMYK space are assigned a new color value. If you look now at the two diagrams on the opposite page you will notice the subtle differences between a relative colorimetric and a perceptual rendering (I have highlighted a single blue color in each to point out these differences). The upper example shows a Relative Colorimetric rendering, where you will notice that the out-of-gamut blue colors are all rendered to the nearest in-gamut CMYK equivalent. Compare this with the perceptually rendered diagram below and you will see that these same colors are squeezed in further. This rendering method preserves the relationship between the out-of-gamut colors but at the expense of sometimes (not always) producing a less vibrant separation.

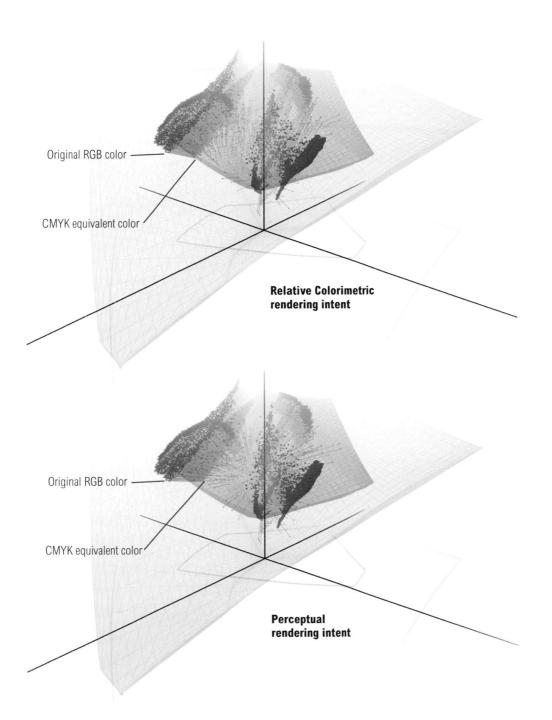

When levels have to be set manually

You should be aware that some repro companies operate what is known as a 'closed-loop system' where they edit files in CMYK and do not necessarily use a profiled workflow. This is something that may only affect high-end repro users of Photoshop and if this is the case, you may need to target the shadows manually according to the conditions of the printing press. The same is also true if you are editing a grayscale file in Photoshop that is going to print.

Fine-tuning the CMYK end points

You can use the black point and white point tools in the Levels or Curves adjustment dialogs to assign specific pixel values to the shadows and the highlights. Normally you can rely on an image mode conversion to adjust the shadow points for you, but there are certain situations where it may be desirable to fine-tune the endpoints manually, such as when you are working on grayscale images that are destined to be printed in a book, magazine or newspaper. It may also be necessary if the image is already in CMYK mode but is missing an embedded profile, but you know what the press output should be. Instead of relying on the profile conversion to assign the end points, you can assign these manually. The eyedropper tools can also be used to color correct an image and remove color casts from the shadows or highlights, plus the gray point tool can be used to assign a target gray color to the midtones (this was covered earlier in Chapter 5).

Let's now run through the basic steps for assigning the end points via the shadow point and highlight point tools. Before you do anything else, I suggest you select the eyedropper tool in the Tools panel and go to the eyedropper Options panel and set the Sample Size to 3×3 Average (or perhaps higher, such as 5×5 Average). Now open the Levels or Curves dialog. The default values for the shadow point and highlight point tools are 0% and 100%, but if you want to set the shadows and highlights in a grayscale or CMYK image for repro output, you will need to set these differently. The shadow point should obviously be higher than 0% (in order to take into account the dot gain) and may typically need to be set to 4%, while the highlight point for the non-specular highlights should be slightly darker than 100% (this ensures that the highlight detail will hold on the press) and should be set to around 96% or lower. This method of assigning the end points allows you to decide exactly where the highlight and shadow points should be. Bear in mind here that when setting the highlight clipping point it is only important to set the highlight clipping point to the value suggested here for the non-specular highlight areas, as was discussed earlier in Chapter 3 on pages 180–183. In the case of specular highlights, such as highlight reflections off metal surfaces, there is no need to worry about these being clipped to pure white.

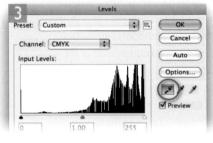

1 I double-clicked the highlight point tool in the Levels dialog box (circled blue) and set the highlight target value (circled red) to match that of the press. A brightness setting of 96% should be OK for most printing situations.

2 I then zoomed in on the image and clicked on the area I wanted to assign as the highlight target point (this should be a non-specular highlight and not a specular highlight such as a reflection or glare).

3 Next, I double-clicked the shadow point tool (circled blue) and set a shadow target brightness value of 4% (circled red) or higher, depending on the press.

4 I then zoomed in on the image to identify the darkest shadow point and clicked with the shadow point tool to set the new shadow value (having done this, you may want to use the Levels Gamma slider to adjust the relative image brightness).

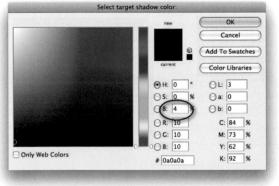

CMYK to **CMYK**

It is not ideal for CMYK files to be converted to RGB and then converted back to CMYK, as this is a sure-fire way to lose data fast. I always prefer to keep an RGB master of each image and convert to CMYK using a custom conversion to suit each individual print output. Converting from one CMYK space to another is not really recommended either, but in the absence of an RGB master, this will be the only option you have available: just specify the CMYK profile you wish to convert to in the Convert to Profile dialog box. Remember, the Preserve Embedded Profiles policy ensures that tagged incoming CMYK files can always be opened without converting them to your default CMYK space (because that would be a bad thing to do). This means that the color numbers in the incoming CMYK files are always preserved, while providing you with an accurate display of the colors on the computer display.

Lab color

The Lab color mode is available as a color mode to convert to via the Image \Rightarrow Mode menu and the Convert to Profile command. but note that the Lab color space does not use embedded profiles since it is assumed to be a universally understood color space. It is argued by some that converting to Lab mode is one way to surmount all the problems of mismatched RGB color spaces. You could make this work, so long as you didn't actually do anything to edit the image while it was in Lab mode, but I wouldn't really advise this. In fact, these days I see less and less reason to use the Lab color mode in Photoshop. Now, a few people have taken me to task over not covering Lab mode image editing in this book, so let me clarify why I don't see editing in Lab mode as being so useful now for high-end image editing. In the early days of Photoshop I would sometimes use the Lab color mode to carry out certain tasks, such as sharpening the Lightness channel separately. This was before the introduction of layers and blending modes, where I soon learnt that you could use the Luminosity and Color blend modes to neatly target the luminosity or the color values in an image without having to convert to Lab mode and back to RGB again. While it is true that Luminosity blend mode sharpening is not exactly the same as sharpening the Lightness channel, such arguments have been further superseded by the latest improvements to Camera

Chapter 12 Color management

Raw sharpening, where it is now possible to filter the luminance sharpening using the Detail and Masking sliders (see Chapter 4).

Let's just say that there are no right or wrong answers here. If you can produce good-looking prints using whatever methods work best for you, and you are happy with the results, well who can argue with that? However, I would hope by now that having learnt about optimizing tones and colors in Camera Raw, followed by what can be achieved using Photoshop, you'll realize that these are all the tools you'll ever need to process a photograph all the way through to the finished print stage. My response to the Lab color argument is that it is simply adding complexity where none is needed. There are good reasons why in recent years the Adobe engineering teams have devoted considerable effort to enhancing the Camera Raw image editing for Photoshop and Lightroom. Their aim has been to make photographic image editing more versatile, less destructive and above all, simpler to work with.

Info panel

Given the deficiencies of typical computer color displays, such as their limited dynamic range and inability to reproduce certain colors like pure yellow, color professionals may sometimes rely on the numeric information to assess an image. Certainly, when it comes to getting the correct output of neutral tones, it is possible to predict with greater accuracy the neutrality of a gray tone by measuring the color values with the eyedropper tool. If you use the eyedropper tool to measure the colors in an image that's in a standard RGB space, such as sRGB, Adobe RGB or ProPhoto RGB, and the RGB numbers are all equal, it is unquestionably a gray color (see Figure 12.42). Interpreting the CMYK ink values is not so straightforward. This is because a neutral CMYK gray is not made up of an equal amount of cyan, yellow and magenta. If you compare the Color readout values between the RGB and CMYK Info panel readouts, there will always be more cyan ink used in the neutral tones, compared with the yellow and magenta inks. This is because a greater proportion of cyan ink is required to balance out the magenta and yellow inks to produce a neutral gray color in print (if the CMY values were equal, you would see a color cast). This is due to the fact that the process cyan ink is less able to absorb its complementary color - red - compared with the way magenta and yellow absorb their complementary colors. This

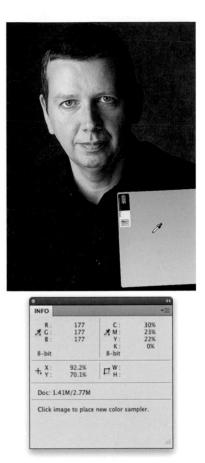

Figure 12.42 When you are editing an RGB image, the Info panel readings can help you determine the neutrality of a color. If the RGB values are all equal, and the RGB color space you are editing in is one of the standard spaces, such as Adobe RGB, sRGB or ProPhoto RGB, etc., then equal values of R, G & B equate to neutral gray.

₿: # G:	177 177 177	C: XM: Y:	30% 23% 22%
8-bit		K: 8-bit	0%
+, X : Y :	92.2% 70.1%	□ = = = = = = = = = = = = = = = = = = =	
Doc: 1.4	1M/2.77M		
Click ima	age to place	new color sa	mpler.

Figure 12.43 You can use the CMYK values in the Info panel to help check if the skin tones are the correct color or not by comparing the percentage of cyan with the magenta and yellow inks.

also explains why a CMY black will tend to look reddish/brown, without the help of the black plate being present to add depth and neutrality.

When you are retouching a portrait (such as in Figure 12.43), you can use the Info panel CMYK readout numbers to help judge if the skin tones are the right color. Set the panel options to display RGB and CMYK readouts. Then use the eyedropper to measure the skin tone values. Caucasian skin tones should have roughly a third or a quarter as much cyan as magenta and slightly more yellow than magenta. Black skin tones should be denser, have the same proportion of cyan to magenta, but usually a higher amount of yellow than magenta and also some black.

Keeping it simple

Congratulations on making it through to the end of this chapter. Your head may be reeling from all this information about Photoshop's color management system, but successful color management doesn't have to be complex. Firstly, you need to set the Color Settings to the prepress setting for your geographic region. This single step configures the color management system with the best defaults for photographic work. The other thing you must do of course is to calibrate and profile the display. As I have said before, if you want to do this right, you owe it to yourself to purchase a decent colorimeter device and ensure the computer display is profiled regularly. Do just these few things and you are well on your way to achieving a reliable color management workflow.

Chapter 13

Print Output

he preceding chapter considered the issues of color management and how to maintain color consistency between digital devices, while this chapter deals with the process of creating prints from your images. Photographers reading this book will probably own a color desktop printer and the print quality that you can get from the latest inkjets has improved enormously over the last decade. It is therefore important to have a good understanding of the Photoshop Print and system print dialog interfaces and how to configure the settings to obtain the best quality prints. There are other important issues to address here too, such as how to use soft proofing to anticipate as best you can how the colors will actually be reproduced in the final print. Rather than go into all the details about different print processes, the different ink sets and papers that you can choose from, I have pared this chapter down to concentrate on just the essentials of inkjet printing. These other topics have been elaborated upon in a joint book I wrote with Jeff Schewe called *Adobe Photoshop CS4 for Photographers: The Ultimate Workshop*, which is also due to be updated soon after this book comes out in print. However, one of the most important things you need to do before making a print is to sharpen the image before sending it to the printer. So to start with we are going to look at print output sharpening.

Print sharpening

Earlier in Chapter 4, I outlined how you can use the Detail panel sharpening sliders in Camera Raw to capture sharpen different types of images. This pre-sharpening step is something that all images require. The goal in each case is to prepare an image according to its image content so that it ends up in what can be considered an optimized sharpened state: the aim is to essentially sharpen each photograph just enough to compensate for the loss of sharpness that is a natural consequence of the capture process.

Output sharpening is a completely different matter. Any time you output a photograph and prepare it for print – either in a magazine, on a billboard, or when you send it to an inkjet printer – it will always require some additional sharpening beforehand. Some output processes may incorporate automatic output sharpening, but most don't, so it is therefore essential to always include an output sharpening step just before you make any kind of print output. The question next is how much should you sharpen? While the capture sharpening step is tailored to the individual characteristics of each image, the output sharpening approach is slightly different. It is a standard process and one that is dictated by the following factors, namely: the output process (i.e. whether it is being printed on an inkjet printer or going through a halftone printing process), the paper type used (whether is glossy or matte) and finally, the output resolution.

Judge the print, not the display

It is difficult, if not impossible to judge just how much to sharpen for print output by looking at the image on a display. Even if you reduce the viewing size to 50% or 25%, what you see on the display bears little or no resemblance to how the final print will look. The ideal print output sharpening can be calculated on the basis that at a normal viewing distance, the human eye resolves detail to around 1/100th of an inch. So if the image you are editing is going to be printed from a file that has a resolution of 300 pixels per inch, the edges in the image will need a 3 pixel Radius if they are to register as being sharp in print. When an image is viewed on a computer display at 100%, this kind of sharpening will look far too sharp, if not down right ugly (partly because you are viewing the image much closer up than it will actually be seen in print), but the actual physical print should appear nice and sharp once it has been printed from the 'output sharpened' version of the image. So, based on the above formula, images printed at lower resolutions require a smaller pixel radius sharpening and those printed at higher resolutions require a higher pixel radius sharpening. Now, different print processes and media types also require slight modifications to the above rule, but essentially, output sharpening can be distilled down to a set formula for each print process/ resolution/media type. This was the basis for the research that was carried out by the late Bruce Fraser and Jeff Schewe when they devised the sharpening routines used for Photokit Sharpener (see sidebar) and also elaborated upon in Real World Image Sharpening with Adobe Photoshop, Camera Raw, and Lightroom (2nd Edition), also by Bruce Fraser and Jeff Schewe (ISBN: 978-0321637550).

High Pass filter edge sharpening technique

The technique that's described on pages 682–683 shows an example of just one of the formulas used in Photokit Sharpener for output sharpening. In this case I have shown Bruce Fraser's formula for sharpening a typical 300 pixel per inch glossy inkjet print output. You will notice that it mainly uses the High Pass filter combined with the Unsharp Mask filter to apply the sharpening effect. If you wish to implement this sharpening method, do make sure you have resized the image beforehand to the exact print output dimensions and at a resolution of 300 pixels per inch.

Photokit Sharpener

A demo version of Photokit Sharpener is available on the DVD and there is also a special discount coupon available at the back of this book which entitles you to a 10% discount. Photokit Sharpener provides Photoshop sharpening routines for capture sharpening, creative sharpening and output sharpening (inkiet, continuous tone, halftone and multimedia/Web). The Camera Raw sharpening sliders are based on the Photokit Sharpener methods of capture sharpening, so if you have the latest version of Photoshop or Lightroom, you won't need Photokit Sharpener for the capture sharpening. If you have Lightroom 2, you will find that the output sharpening for inkjet printing is actually built in to the Lightroom print module. Therefore, if you don't have Lightroom 2, you'll definitely find the Photokit Sharpener output sharpening routines useful for applying the exact amount of output sharpening that is necessary for different types of print outputs and at different pixel resolutions.

Martin Evening Adobe Photoshop CS5 for Photographers

Styles	Blending Options OK
Blending Options: Custom	Blend Mode: Normal Cancel
Drop Shadow	Opacity: 66 % New Style
Inner Shadow	
Outer Glow	
Inner Glow	Fill Opacity: 100 % Channels: V R V C V B
Bevel and Emboss	Knockout: None
Contour	Blend Interior Effects as Group
Texture	Blend Clipped Layers as Group
⊖ Satin	Transparency Shapes Layer
Color Overlay	Layer Mask Hides Effects
Gradient Overlay	Vector Mask Hides Effects
Pattern Overlay	Blend If: Gray
Stroke	This Layer: 0 230 / 250
	▲ b
	Underlying Layer: 10 / 20 255

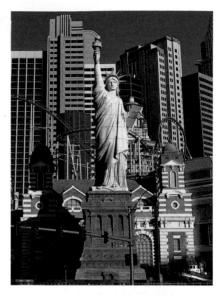

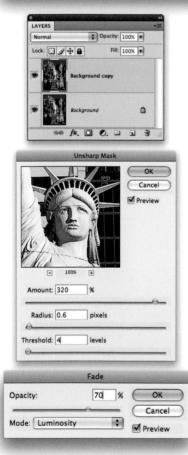

1 The sharpening method described here is designed for sharpening an inkjet print on glossy paper at 300 ppi. To begin with, make a duplicate copy of the Background layer and set the layer opacity to 66%, then double-click on the duplicate layer to open the Layer Style options and get the Blend If sliders to match the settings shown here.

2 Next, apply the Unsharp Mask filter to the layer using an Amount of 320, Radius of 0.6 and Threshold of 4. Then choose Edit \Rightarrow Fade, change the blend mode to Luminosity and reduce the opacity to 70%.

3 Now change the Layer blend mode from Normal to Overlay, go to the Filter menu, choose Other \Rightarrow High Pass filter and apply a Radius of 2 pixels. Here is a 1:1 close-up view of the sharpened image. Remember, you can't judge the sharpening by looking at the display, but you should be able to judge the effectiveness of the technique by how sharp the photograph appears here in print. Note that the sharpening layer here can be increased or decreased in opacity or easily removed and that the underlying Background layer remains unaffected by the preceding sharpening steps.

Gamut warning

The View menu contains a 'Gamut Warning' option that can be used to highlight colors that are out of gamut. The thing is, you never know if a highlighted color is just a little or a lot out of gamut. Gamut Warning is therefore a fairly blunt instrument to work with, which is why I suggest you use the soft proofing method described here.

Print from the proof settings

The Customize Proof Condition is also important because when it is active and applied to an image, the Photoshop Print dialog can reference the soft proofed view as the source space. This means you can use the Customize Proof Condition to select a CMYK output space and the Photoshop Print dialog allows you to make a simulated print using this proof space.

Soft proof before printing

Color management can do a fairly good job of translating the colors from one space to another, but for all the precision of measured targets and profile conversions, it is still essentially a dumb process. When it comes to printing, color management can usually get you fairly close, but it won't be able to interpret every single color or make aesthetic judgements about which colors are important and which are not, plus some colors you see on the computer display simply can't be reproduced in print. This is where soft proofing can help. If you use the Customize Proof Condition dialog as described here, you can simulate pretty accurately on the display how the print will look when printed. Soft proofing shows you which colors are going to be clipped and also allows you to see in advance the difference between selecting a Perceptual or Relative Colorimetric rendering intent. All you have to do is to select the correct profile for the printer/paper combination that you are about to use, choose a rendering intent and make sure 'Black Point Compensation' plus the 'Simulate Paper Color' (and by default simulate black ink) are checked.

1 To begin with, I opened the image shown here, went to the Image menu and chose 'Duplicate...' to create a duplicate copy image, which is shown here on the left next to the original on the right. In this screen shot you can see a slight difference between the color of the sky. This is because I had applied the Customize Proof Condition shown in Step 2 to the original master image (seen here on the right).

685

Chapter 13 Print output

stom Proof Condition:	Custom		(OK
Proof Conditions			Cancel
Device to Simulate:	Pro 4800 IF-WGloss_PH_BK	•	Load
	Preserve RGB Numbers		Save
Rendering Intent:	Relative Colorimetric	•	
	Black Point Compensation		Preview
- Display Options (On	-Screen)		
Simulate Paper Col	Dr		
Simulate Black Ink			

Customize Proof Conditi

100

uplicate image

with the Duplicate image on the left).

2 To soft proof the master image I went to the View menu and chose Proof Setup \Rightarrow Custom... Here I selected a profile of the printer/paper combination that I wished to simulate, using (in this case) the Relative Colorimetric rendering intent and with the 'Simulate Paper Color' option checked in the On-Screen Display Options.

W1BY6785-1 copy @ 25% (RGB/16) *

ADJUSTMENT LAYERS ADJUSTMENTS . Curves C Opacity: 100% • Color • 扔 Lock: 3+0 Fill: 100% • the RGB 1 . Hue/Saturation 1 \$ \$. Curves 1 1 255*\285* 195*/225 0 60 fx. 🖸 🖉. 🖬 🕏 N (* 0 *) 4 23 0 0 **3** I now had a soft proof prediction of how the master file would print that could be viewed alongside a duplicate of the original image. The goal now was to add a Curves adjustment Input: 132 Output: 144 layer to tweak the tones (using the Luminosity blend mode) and a Hue/Saturation 4 2 0 0 adjustment to tweak the colors (using the Color blend mode). A few minor adjustments were enough to get the soft proofed master to match closer to the original (which I was comparing

Martin Evening

Adobe Photoshop CS5 for Photographers

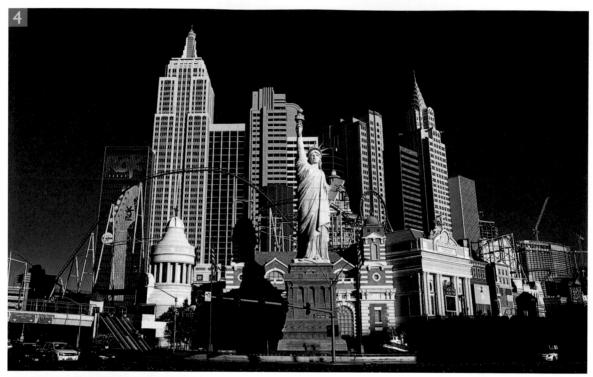

Pass Throug	gh 🗘 Opacity: 100% 🔹	
Lock:	Fill: 100% •	
🔊 v 🗎	Group 1	
9	Hue/Saturation 1	
	Curves 1	
•	Background	۵

4 In this final version you can see the corrected, soft proofed master image. When this corrected version is sent to the printer, the print output should match very closely to what was seen here on the computer display. I recommend the correction adjustment layers be preserved by grouping them into a layer group. You should then turn the visibility off before saving and only switch the layers back on again when you need to make further prints.

Making a print

The print menu items can be accessed via the File menu and are fairly straightforward. We now have just two Photoshop Print options File \Rightarrow Print... (**#***P ctrlP*), which takes you directly to the Photoshop Print dialog and the File \Rightarrow Print One Copy command (**#***ShiftP ctrlaltShiftP*). You can use 'Print One Copy' should you wish to make a print using the current configuration for a particular image, but wish to bypass the Photoshop Print dialog.

The big news is that the print workflow has been refined in CS5 to make the print process more consistently repeatable as well as more consistent between operating systems. To start with, the operating system 'Page Setup' option has been removed from the File menu and is now accessed solely within the Photoshop Print dialog via the Print Settings button, from where you can now manage all the remaining operating system print driver settings.

The net result is that by incorporating both the Mac and PC operating systems into the Photoshop Print dialog, this also makes the process of scripting and creating actions more reliable. Previously, the vagaries of the operating system print dialogs meant that it was not always possible to write print output actions that could work reliably on another system. With these new improvements to the Photoshop Print workflow, the Photoshop print process can be made more consistent.

Photoshop Print dialog

When you choose 'Print...' from the File menu, Photoshop takes you to the Photoshop Print dialog (Figure 13.1), where we shall start by looking at the printer selection, print scaling and output settings.

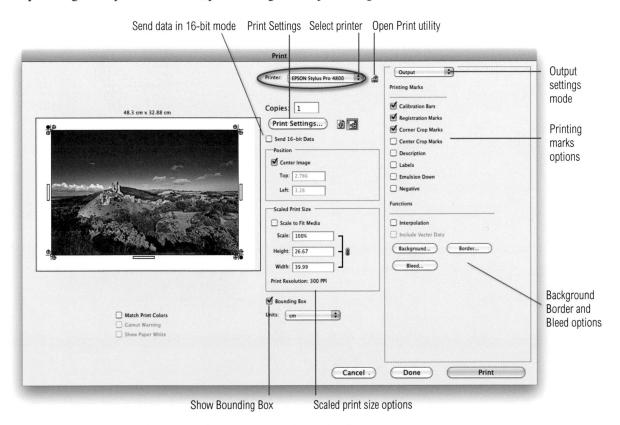

Figure 13.1 The Photoshop Print dialog, showing the Output settings mode options.

Printer selection and print scaling

If you have just the one printer connected to your computer network, this should show up in the Printer list by default (circled in Figure 13.1). If you have more than one printer connected you can use this menu to select which printer you wish to print to. Below this are the Print Settings and print orientation buttons. This is where you click to open the operating system print driver dialog for Mac or PC and select a paper size to match the paper or media you wish to print to. So for example, if you look at Figure 13.2, you see the Mac OS dialog where you can select the printer model and appropriate paper size. Ditto, Figure 13.3 shows a Windows Vista dialog, where in the Advanced panel section you can go to the paper size menu (circled) and do the same. Once you are done, you can click on the Save or OK button to return to the Photoshop Print dialog.

	A4	▶ A4	21.00 by 29.70 cm
	A4 (Roll Paper - Borderless Banner)	A4 (Sheet Feeder – Borderless)	Top 0.32 cm Bottom 0.32 cm Left 0.32 cm Right 0.32 cm
	10 x 15 cm (4 x 6 in)	A4 (Roll Paper)	
	13 x 18 cm (5 x 7 in)	A4 (Roll Paper - Borderless)	
	A6	A4 (Manual - Roll)	
	AS	A4 (Manual - Roll(Borderless))	
	A3	A4 (CD/DVD)	
	A3 (Roll Paper – Borderless Banner)	The second s	ê
	A3+	•	
	A3+ (Roll Paper - Borderless Banner)		
	JB4	•	
	JB5		
	9 x 13 cm (3.5 x 5 in)	•	
	13 x 20 cm (5 x 8 in)	•	
	20 x 25 cm (8 x 10 in)	•	
	30 x 30 cm (12 x 12 in)		
	30 x 30 cm (12 x 12 in) (Roll Paper - Borderless Banner		
	16:9 wide size (102 x 181 mm)		
	100 x 148 mm		
	US Letter	•	
Contraction of the second second second	US Letter (Roll Paper – Borderless Banner)	- ma	
	US Legal	>	
	US Legal (Roll Paper – Borderless Banner)	-	
Printer	os Legai (Koli Faper - Bordeness Banner)		
	A3 centered		
Presets	Untitled		
Paper Size	✓ Other		
	Manage Custom Sizes		
	Pages per Sheet: 1		
	rages per sneet.		
1	Layout Direction: Z S VA N		
	Border: None		
- International			
	Two-Sided: Off		
	Reverse Page Orientation		
PDF Y Prev	view Cancel Prin	t	

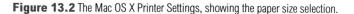

Main 🔇 Advanced 💮 Page Layo	ut 🚱 Maintenance		
Paper & Quality Options Sheet Settings(0) Epson Premium Glossy	Color Management Color Controls PhotoEnhance CM		
Photo RPM A4 210 x 297 mm	Off (No Color Adjustment)		
Borders O Borderless	*		
Orientation	Input Profile		
Portrait	Ŧ		
Print Options	Intent		
Reverse Order	Printer Profile		
Gloss Auto -	~		
In High Speed	Printer Profile Description		
Crayscale	¢		
Edge Smoothing Print Preview	Show all profiles.		
Custom Settings Save Setting Reset Defaults Technical Supp	Show this screen first		

Figure 13.3 The Windows Vista Printer Settings, with the Paper Size section circled.

When the 'Show Bounding Box' option is enabled in the Photoshop Print dialog, you can position the image anywhere you like, by dragging inside the box, or scale it by dragging the bounding box handles. In the Position section you can choose to center the photo, or position it precisely by entering measurements for the Top and Left margins. In the Scaled Print Size section, if the image overflows the currently selected page size, you can choose 'Scale to Fit Media'. This automatically resizes the pixel resolution to fit the page and the Print Resolution PPI adjusts. You can also enter a specific Scale percentage, or Height and Width for the image, but I don't advise you to do this unless you absolutely must. It is always much better to resize the image in Photoshop first and print using a 100% scale size.

Output settings

To adjust the Output settings, make sure that 'Output' is selected from the top menu (see the close-up view in Figure 13.4). Here, you can select any extra items you wish to see printed outside

Printing Marks	
Calibration Bars	
Registration Mar	rks
Corner Crop Mar	rks
Center Crop Mar	rks
Description	
Labels	
Emulsion Down	
Negative	
Functions	
Interpolation	
Include Vector D	Data
Background	Border
Bleed	\
Bleed	,

Figure 13.4 A close-up view of the Photoshop Print dialog Output options.

Output options

To apply some of the Output options mentioned here, you must be using a PostScript print driver and you should also allow enough border space surrounding the print area to print these extra items. For example, when the 'Include Vector Data' option is unchecked, it will rasterize the vector layer information, such as type at the image file resolution. However, if it is checked, it rasterizes the vector information (such as type) much crisper at the full printer resolution, provided that you are outputting from a PostScript RIP.

Width:	3	mm	\$ ОК)
			Cancel)

Figure 13.5 The Bleed option works in conjunction with the Corner Crop Marks option and determines how far to position them from the edge of the printed image.

		Bord	ler	-	
Width:	2	mm	•	C	ОК
				C	Cancel

Figure 13.6 The Border option allows you to add a black border and set the border size.

the image area. When 'Calibration Bars' is checked, this prints an 11-step grayscale wedge on the left and a smooth gray ramp on the right. If you are printing CMYK separations, tint bars can also be printed for each plate color and the Registration Marks can help a printer align the separate plates. The Corner and Center Crop Marks indicate where to trim the image and the Bleed button (Figure 13.5) determines how much the crop marks are indented. Checking the Description box prints any text that was entered in the File ⇒ File Info box Description field and check the Labels box if you want to have the file name printed below the picture. Click on the Background... button to print with a background color other than paper white. For example, when sending the output to a film writer, you could choose black as the background color. Click on the Border... button (Figure 13.6) to set the width for a black border, but just be aware that the border width can be unpredictable. If you set too narrow a width, the border may print unevenly on one or more sides of the image.

Image data is normally sent to the printer in 8-bit, but some more recent inkjet printers such as the Canon ipf5000 are now enabled for 16-bit printing (providing you are using the correct plug-in and the 'Send 16-bit data' box is checked). There are certain types of images that may theoretically benefit from 16-bit printing and where using 16-bit printing may avoid the possibility of banding appearing in print, but I have yet to see this demonstrated. Let's just say, if your printer is enabled for 16-bit printing, Photoshop now allows you to send the data in 16-bit form.

Color Management

Now let's look at the Color Management settings for the Photoshop Print dialog (Figure 13.7). The source space can be the document profile (which in this case was ProPhoto RGB) and if you click on the Proof button it defaults to using the current CMYK workspace or can use whatever Custom Proof Condition you might have set (see page 685).

Next we come to the Color Handling section. If printing from an RGB image, there are two options. The 'Printer Manages Colors' option can be used if you want to skip to the Photoshop Print dialog settings and let the printer driver manage the color output. However, if you want the most print control, you should really select the 'Photoshop Manages Colors' option (as shown in Figure 13.7). When this option is selected you can use the Photoshop Print dialog to manage the print pipeline. First of all you will need to mouse down on the Printer Profile menu, where you'll see a list of profiles. Here you need to select the printer profile that matches the printer/paper you are about to print with. It used to be the case that canned profiles were frowned upon as being inferior, but with the latest Epson printers at least, the printers themselves are very consistent in print output and the canned profiles work well, so you would be advised to use their own brand profiles for the papers that their printers support. In Photoshop CS5, selecting the printer in Print Settings also filters the ICC profiles that are associated with the printer, so these now appear at the top of the profile list (see Figure 13.8). Also, the printer selection and profiles are sticky per document, so once you have selected a printer and associated print settings, these are saved along with everything else in the document.

Accessing canned printer profiles

A set of canned printer profiles should be installed in your System profiles folder at the same time as you install the print driver for your printer. If you can't find these, try doing a reinstall, or do a search on the manufacturer's website.

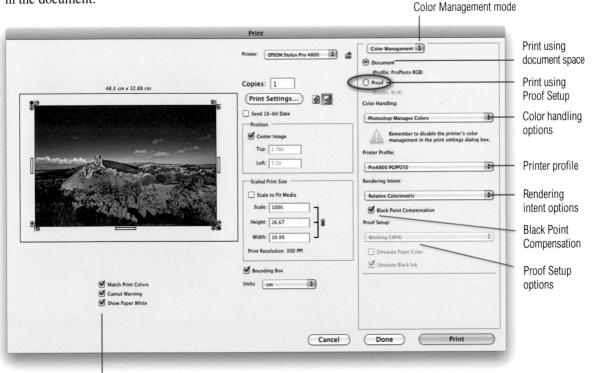

Color proofing options

Figure 13.7 The Photoshop Print dialog, showing the Color Management options.

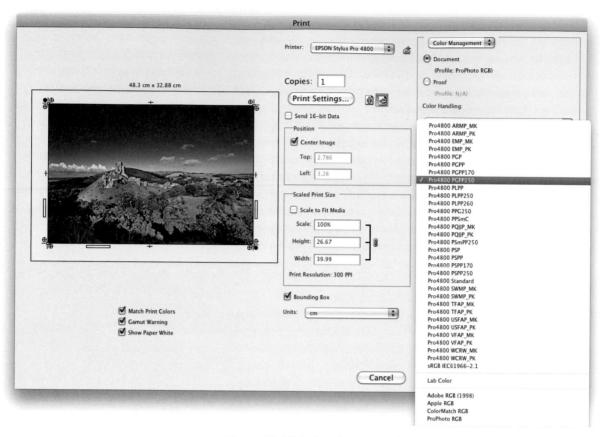

Figure 13.8 This shows the printer profile list, with the printer manufacturer profiles for the currently chosen printer placed at the top of the list.

No Color Management missing

The Color Management Color Handling options no longer include an option for printing with 'No Color Management'. This is due to the fact that updating the Mac code to Cocoa 64-bit has made it problematic to retain the 'No Color Management' print route. This option was required for producing neutral target prints intended for reading and generating ICC profiles. However, do check out labs.adobe.com for news of a future 'no color management' print utility. The Rendering Intent can be set to Perceptual, Saturation, Relative Colorimetric or Absolute Colorimetric. For normal RGB printing the choice boils down to two settings. Relative Colorimetric is the best setting to use for general printing as it will preserve most of the original colors. Perceptual is a good option to choose when printing an image where it is important to preserve the detail in saturated color areas, or when printing an image that has a lot of deep shadows, or when printing to a smaller gamut output space, such as a fine-art matte paper. Whichever option you choose, I advise you to leave 'Black Point Compensation' switched on, because this maps the darkest colors from the source space to the destination print space. Black Point Compensation preserves the darkest black colors and maximizes the full tonal range of the print output. The Print dialog preview can be color managed by checking the 'Match Print Colors' option. Admittedly, the preview could be made a bit bigger, but it does at least give you some indication of how a photograph will print and you will notice that as you pick a printer profile or adjust the rendering intents, you can preview on-screen what the printed colors will look like. When proofing an RGB output in this way you can also check the 'Show Paper White' option to see an even more accurate simulation, one that takes into account the paper color of the print media. There is even a 'Gamut Warning' option, but as I pointed out on page 684, this isn't as useful as using the soft proofing method described earlier to gauge your print output.

Proof Setup in the Print dialog

Earlier, in the 'Soft proof before printing' section (page 684), I described using the soft proof setup to predict how an RGB photograph might actually print via an inkjet or when printed in CMYK or other print output space. If the soft proofing is active for a document window and you check the Proof button in the Photoshop Print dialog (circled in Figure 13.7), this can become the new source space to print from (providing you also have 'Current Custom Setup' selected in the Proof Setup section below). You can therefore use a custom CMYK setting in the Customize Proof Condition dialog and then use this as the source space when printing to any profiled printer output. Alternatively, you can check the Proof button in the Photoshop Print dialog and select 'Working CMYK' in the Proof Setup menu. 'Simulate Black Ink' is always checked by default, but you can also include 'Simulate Paper Color' when creating a proof print.

Proof print or aim print?

Basically, if you are in a situation where someone asks you to produce RGB inkjet prints that simulate the CMYK print process, you can use the 'Proof' option to create what are sometimes referred to as 'cross-rendered aim prints'. This is not quite the same thing as a certified contract proof print, but a commercial printer will be a lot happier to receive prints made in this way, rather than prints made direct from an RGB image using the full color gamut of your inkjet printer. As I say, these will not be official 'contract proof' prints, but even so, they are accepted by many repro houses as a welcome guide to how you anticipate the final print image should look.

Managing print expectations

When you use soft proofing to simulate a print output your initial response can be 'eek, what happened to the contrast?' This can be especially true when you also include 'Simulate Paper Color' in a soft proof setup. If we assume that you are using a decent display and that it has been properly calibrated, the soft proof view should still represent an accurate prediction of the contrast range of an actual print, compared with the high contrast range you have become accustomed to seeing on an LCD display. One solution is to look away as you apply the soft proof preview so that you don't notice the sudden shift so much in the on-display appearance.

Overcoming dull whites

When 'Simulate Paper Color' is selected, the whites may appear duller than expected. This does not mean the proof is wrong, rather it is the presence of a brighter white border that leads to the viewer regarding the result as looking inferior. To get around this try adding a white border to the outside image you are about to print. When the print is done, trim away the outer 'paper white' border so that the eye does not get a chance to compare the dull whites of the print with the brighter white of the printing paper used.

Print quality settings

In the Print Settings, a higher print resolution will produce marginally betterlooking prints, but take longer to print. The 'High Speed' option enables the print head to print in both directions. Some people prefer to disable this option when making fine quality prints, but with the latest inkjet printers the 'High Speed' option shouldn't give you inferior results.

Configuring the Print Settings (Mac and PC)

The following dialogs show the Mac and PC Print Settings dialogs for the Epson 4800 inkjet printer (Figures 13.9 and 13.10). In both the examples shown here, I wished to produce a landscape-oriented print on a Super A3 sized sheet of Epson glossy photo paper using the best quality print settings and with Photoshop handling the color management.

The system print settings dialog options will vary a lot from printer to printer. As well as having Mac and PC variations, you

Contract of the second second	Print
Printer: Presets:	EPSON Stylus Pro 4800
Paper Size:	Super A3 / B 32.89 by 48.30 cm Print Settings
Color: Color Settings: Print Quality:	Manual Feed
PDF V Previ	ew Cancel Print

Figure 13.9 This shows the Mac Print Settings for the Epson 4800 printer. You will now need to select a media type that matches the paper you are going to print with. Go to the Media Type menu and choose the correct paper. Next, you will want to select a print quality setting that might say 'Super-duper Photo' or 'Max Quality'. Lastly, look for the Print Settings menu and set this to 'Off (No Color Adjustment)'. This is because you do not need to make any further color adjustments. All you have to do now is click on the Save button at the bottom of the dialog to return to the Photoshop Print dialog from where you can click on the Print button to make a print.

might have a lot of other options available to choose from and the printer driver for your printer may look quite different. However, if you are using Photoshop to manage the colors, there are just two key things to watch out for. You need to make sure you select the correct media setting in the print settings and that you have the printer color management turned off. This will mean selecting 'No Color Adjustment' in the Print Settings or Color Management sections and ignoring any of the other options you might see such as: 'EPSON Vivid' or 'Charts and Graphs'.

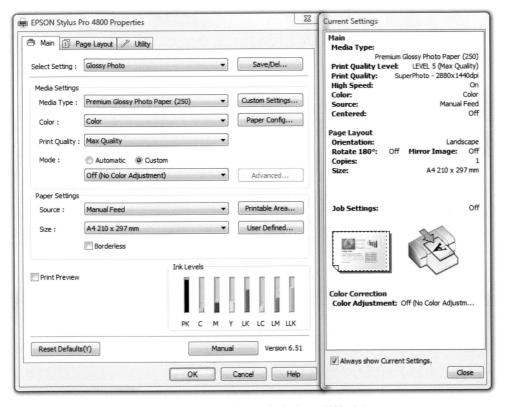

Figure 13.10 This shows the Windows Vista Print Settings for the Epson 4800 printer. Again, you will need to use the Media Type menu to select the correct paper to print with. For the Print Quality, select a high quality setting, such as the Max Quality setting selected here. For the Color settings mode you will need to look for the advanced or custom options. In this dialog I needed to check the Custom button, which enabled the menu below, where I could select the 'Off (No Color Adjustment)' option. If you look back at the Figure 13.3 example, you'll notice that for the Epson R1900 printer I had to go to the Advanced panel mode, click the ICM button and check the 'Off (No Color Adjustment)' option. Lastly, click on the OK button to return to the Photoshop Print dialog from where you can click on the Print button to make a print.

Figure 13.11 Saving the print settings as a preset.

Figure 13.12 Photoshop actions can now be used to record the complete print process. Once you have done this you can make further prints by simply replaying the action.

Saving the print presets

Once you have established the operating system print dialog settings shown here for a particular printing setup, it makes sense to save these settings as a preset that can easily be accessed every time you want to make a print using the same printer and paper combination. To do this, apply all the required page setup and print settings, then pull down the Print Presets menu (see Figure 13.11), choose 'Save As...' and give the setting an appropriate name.

Print output scripting

Up till now it has not been possible to make the combination of the Photoshop Print dialog and system print dialog settings a scriptable process. In the past, the Page Setup... settings had to be configured first, *before* the Photoshop Print dialog, and that made scripting rather difficult and error-prone. In Photoshop CS5 all the system print settings come after the Photoshop Print dialog. This means it is now possible to record a Photoshop action in which you select the printer model, the media size, type and orientation plus the system print settings, followed by the Photoshop Print dialog settings. Once recorded, you can use this action to make print outputs with the click of a button (Figure 13.12). You can also convert such actions into Droplets (as shown in Figure 13.13), where you can simply drag and drop a file to a droplet to make a print (I'll be discussing actions and droplets later in Chapter 15).

Print A5 Landscape glossy

Figure 13.13 You can automate the print process further. If you convert an action like the one shown in Figure 13.12 into a droplet, you can make it possible to simply drag and drop files to the droplet to initiate the desired print output. This allows you to bundle the printer model selection, the page setup, the media type and Photoshop print settings all into the one droplet/action.

We would all love Photoshop printing to be simpler, but unfortunately there are no easy solutions and this is not necessarily all Adobe's fault either. The problem is that you have a multitude of different printer devices out there and in addition to this, you have different operating systems, each of which has its own protocols as to how the system print dialogs should be organized.

Making sure a print is centered is just one of several problems that require a little user intervention. If you center a print in the Photoshop Print dialog, but it doesn't print centered, this is probably due to the default margin settings being uneven. The reason for this is that some printers require a trailing edge margin that is wider than all the other margins. However, as I have shown below in Figure 13.14, you can overcome this by creating your own custom paper sizes and margin settings.

	US Letter
Settings	US Letter (Borderless (Retain Size))
	US B 11 x 17 in
	US C 17 x 22 in
Format for	US C 17 x 22 in (Borderless (Retain Size))
	A4
	A4 (Borderless (Retain Size))
Paper Size ✓	A3
	A3 (Borderless (Retain Size))
	Super A3 / B
Orientation	Super A3 / B (Borderless (Retain Size))
	A2
Scale	A2 (Roll Paper - Borderless (Retain Size))
	JB4
	JB4 (Borderless (Retain Size))
	JB3
0	8 x 10 in
	8 x 10 in (Roll Paper - Borderless (Retain Size))
	11 x 14 in
	16 x 20 in
	16 x 20 in (Borderless (Retain Size))
	40 x 60 cm
	40 x 60 cm (Borderless (Retain Size))
	30 x 40 cm
	30 x 40 cm (Borderless (Retain Size))
	Untitled

A3 centered	Page Size:	29.7 cm	42.2 cm
		Width	Height
	Printer Margir	ns:	
	User defined		
		1.45 cm	
	0.63 cm	Тор	0.63 cm
	Left	1.45 cm	Right
		Bottom	
+ - Duplicate			
0		Cancel	OK
0		Cancer	Con

Figure 13.14 On Mac OS X, go to the Page Setup menu and choose 'Manage Custom Sizes...' from the Paper Size menu. In the Custom Page Sizes dialog check the margin width for the bottom trailing edge margin for the selected printer. If you want your prints to always be centered, all you have to do is to adjust the Top margin width so that it matches this bottom measurement. Set a Width and Height for the new paper size and save this as a new paper size setting and add 'centered' so you can easily locate it when configuring the Page Setup or Paper Size settings

Figure 13.15 Here is an example of an X-Rite color target that can be used to build an ICC color profile. The target file must be opened without any color conversion and sent directly to the printer without any color management and the print dimensions must remain exact. If it is necessary to resize the PPI resolution, make sure that the 'Nearest Neighbor' interpolation mode is selected.

Replacing canned profiles

I don't have room to go into too much detail here, but on the Mac system at least, if you are familiar with using the ColorSync Utility, you can go to the Devices section, select a canned profile, click on the Current Profile name, choose 'Other...' and select a custom profile to replace it with. This will promote a custom profile to appear in the filtered profile list for that printer.

Custom print profiles

As I have mentioned already, the profiles that are shipped with the latest inkjet printers, and especially those for the Epson models, can be considered reliable enough for professional print quality work (providing you are using the manufacturer's branded papers). If you want to extend the range of papers you can print with, then you will either have to rely on the profiles supplied by these paper companies or consider having a custom printer profile built for each paper type.

One option is to purchase a complete calibration kit package such as the X-Rite Eye-One Photo with ProfileMaker software. The other alternative is to get an independent color management expert to build a profile for you. There are quite a few individuals who are able to offer these services, such as Andrew Rodney, who is based in the US (www.digitaldog.net). If you refer to the back of this book, you'll see that a company called colourmanagement.net are also offering a special coupon to readers that entitles you to a discount on their remote printer profiling services.

Remote profiling is a simple process. All you have to do is to follow the link to the provider's website, download a test target similar to the one shown in Figure 13.15 and follow the instructions closely when preparing a target print for output. The system print dialog settings used to produce the target print should also be saved so that these exact same print settings can be used again when you then follow the steps outlined on pages 690–695.

You then send the printed target to the supplied address, where the patch readings are used to build an ICC profile that represents the characteristics of a particular paper type on your individual printer. You'll then usually receive back an ICC profile via email.

The important points to bear in mind are that you must not color manage the target image when printing. The idea is to produce a print in which the pixel values are sent directly to the printer without any color management being applied. With previous versions of Photoshop you could do all this directly within the Photoshop Print dialog. However, Photoshop CS5 no longer has a 'No Color Management' print option, but as I mentioned earlier on page 692, you should look out for a special 'no color management' print utility coming soon from Adobe that will allow you to print out non-color managed print targets for custom profiling.

Chapter 14

Output for the Web

here is the well-known saying 'a picture is worth a thousand words', and it is so true – pictures allow us to communicate visually with clients, friends and family in ways that words alone cannot. The Internet is something most of us use every day and having the means to transmit images has become extremely important to us. The most obvious advantage of sending or displaying images via the Web is its immediacy. Pictures can be sent around the world almost instantly and it is quick and easy to prepare a photo to be distributed in this way. The downside is that, unlike producing a finished print, you have little or no control over the way your images are viewed, plus there are many other pitfalls associated with the limitations of some Internet software. This chapter aims to guide you with suggestions on how best to output your work via the Web.

Sending multiple images by email

Email programs can accept single or multiple attachments of any format, but not as a folder, unless it has been compressed as an archive first. Aladdin[™] Software make the ubiquitous Stuffit[™] program. which is great for compressing files in this way. It's available for Mac or Windows and handles ZIP compression as well as having its own proprietary format, which uses lossless compression. A Stuffit archive will have a .sit extension, which requires expansion by Stuffit (which is incorporated into the Mac OS), but this can also be saved as a self-extracting archive. In this instance, the archive bears the .sea extension and either WinZip or Stuffit can expand such Mac created archives. If you are using the latest Mac OS X system, you can also use the contextual menu to select the 'compress file' option, to quickly create a ZIP archive on-the-fly. If the pictures in the source folder are JPEGs, then you will probably not notice a big difference in the final file size. But don't worry, this compression does not compromise the quality of the JPEG images any further.

Sending images over the Internet

Let's first look at some of the ways you can distribute images over the Web. With the increasing popularity of Broadband, cable and ADSL connections, you can effectively use any fast connection to the Internet to transmit or receive large files.

Email attachments

The easiest way to send image files is to send them as attachments via email. Email programs may differ, but most should let you simply drag a file from a folder on your computer into the body text area of an email. Click 'Send' and the attached document will be distributed along with the text message in the email. This is something that's relatively easy to do, but not completely flawless. For example, there is no reliable way of knowing if the recipient's email program can decode an attachment that has been sent via your email program. If you communicate using email this way, it is also a good idea to keep the attachments small. As a rule, I tend to keep all attachments under 2 MB, and before sending anything bigger I generally check with the recipient first to see if they mind receiving attachments that are bigger than this. The Internet suffers quite enough already with bandwidth being consumed by unwanted junk emails. So don't add to the problem by sending large, unsolicited attachments. If it is OK to send a big file, I suggest you ask the recipient if there is a limit in place for the size of attachments they can receive in a single email, because if you exceed this your email will only bounce back.

As long as you are aware of the restrictions of using email, and the possible limitations of the recipient's server, email can be an effective way to transfer smallish documents. Lots of people use email this way to share photographs and the advanced email programs are also capable of displaying image file attachments within the body text area. Just remember, this is by no means a foolproof way to send all images. If you place too much faith in email you will soon come unstuck.

Uploading to a server

With email you are sending a message that has the image or images embedded in it. Another alternative is to upload the image file to a server. You can then send an email that contains a clickable link that launches the recipient's web browser and takes them directly to a page from where they can view the file or download it directly. The advantage of this is that the email you send is small since it only contains a text link to the server. There is also less risk of such emails being rejected and if the person you are sending the email to needs to share the image link with someone else, they only have to forward the message – they don't have to forward the entire image attachment all over again. First you need to know how to upload to a server. If you connect to the Internet using a subscription service, your Internet Service Provider (ISP) will most likely have provided you with a limited amount of server space that you can use to host your own website and upload files to. If you don't have a subscription service or your ISP doesn't provide an adequate amount of server space, you can always rent space from a company that provides a web hosting service on a dedicated server.

FTP software

Once you have you server space sorted out you'll need a dedicated FTP program to upload and manage the files held on the server. Figure 14.1 shows how I would normally go about making an FTP connection to a server using the FetchTM program for Macintosh OS X (www.fetchsoftworks.com). If you are working on a PC, try using WS_FTP Pro www.ipswitch.com or Flash FXPTM www.flashfxp.com. All FTP software is more or less the same. To establish a connection you need to provide a link address to connect to the server. Next, you need to enter your user ID and finally your password. If you are familiar with the steps required to configure your email account, you should already have the username and password information to hand. You may need to enter a subdirectory folder as well, but if you have trouble configuring the connection, speak to your ISP. They are the best people to help you in these instances.

To avoid having to re-enter the information each time you connect, it should be possible to save this information (along with the password if you wish) as a shortcut so that logging on to the server is almost as easy as opening a folder on your hard disk. Once the FTP connection window opens this is like any other hierarchically structured folder and the main connection window displays the website documents and subfolders. In Figure 14.1 you can see how I have created new subfolders with names like 'portraits' and 'Snaps'. I use these specific folders to upload Web

Macintosh iDisk

Another option available to Macintosh users is iDisk, which is part of the now superseded Mac.com package, renamed MobileMe. iDisk is an online server space that you can use for off-site backup storage or as a space to place publicly accessible files and folders. If you want slightly more control, with the added benefit of being able to use space that any of your computers can reach, then there is 'DropBox' which offers 2 GB of free server space, and your access can be via the menubar (www.dropbox.com).

Yousendit.com

In the last few years, www.yousendit.com[™] has become extremely popular as an FTP replacement file delivery service. All you have to do is go to the above website address, create a new user account and use this website to upload files that can be sent to recipients. The service is free for single file transfers up to 100 MB.

Download a sample image file

I have uploaded a photograph to my server which you can access by typing in the following URL address in your web browser: www.martinevening. com/portraits/evening.pdf. This image document was saved as a Photoshop PDF file. You will probably be asked if you want to save the file to the desktop. Click 'Save' and the file will start to download. The reason I saved this image as a Photoshop PDF was to demonstrate the security features that are available when using this file format. To open the PDF file you will need to enter the password 'evening' when prompted. galleries and images to so that they do not get mixed up with the folder structure of the main website. I can then double-click on a folder such as 'portraits' to reveal the subfolder contents and drag the Internet-ready files or folders across into this window. That's all there is to it. The time this takes to accomplish will depend on the size of your files and Internet connection speed. All you have to do is to supply people with a weblink such as the one in the accompanying sidebar, so that they can access these files. When they click on the link you give them, the file should start to download automatically to their computer.

In the case of Bridge and Lightroom, you can now upload Web galleries directly to a server, without the need for additional FTP software. When using the Create Gallery panel in the Bridge Output workspace, you'll need to enter the same login information and password as you would to establish an FTP connection, but you'll still probably need FTP software to manage and delete these files and folders when they are no longer required.

k Path Recent	Get Put View Edit Get Info WebView	Back Path Recent 33 items	Get Put Vie	w Edit Get I	nfo WebView
Hostname	: www.martinevening.com	Name	A Kind	Size	Date
		fashion	Folder		01/01/2008
Username	admin2	Footer.html	HTnt	482 bytes	07/01/2008
Connect using	FTP 🗘	Hairawards-2.html	HTnt	5.3 KB	07/01/2008
connect using		Hairawards-3.html	HTnt	4.4 KB	07/01/2008
	Enable encryption	Hairawards-4.html	HTnt	5.0 KB	07/01/2008
Dagsword	. []	Hairawards-5.html	HTnt	4.3 KB	07/01/2008
Fassworu	· [Hairawards-6.html	HTnt	5.1 KB	07/01/2008
	Add to keychain	Hairawards-7.html	HTnt	5.8 KB	07/01/2008
•		 Hairawards-8.html Hairawards.html 	HTnt	3.8 KB 6.8 KB	07/01/2008
8		Header.html	HTnt HTnt	5.8 KB 3.0 KB	26/08/2008
0		images	Folder	3.0 KB	07/01/2008 26/08/2008
0	Cancel Connect	index.html	HTnt	1.4 KB	26/08/2008
		andscape	Folder	1.4 KB	01/01/2008
		lasvegas2008-4	Folder	ind in a state	07/09/2008
		photoshop7	Folder		09/10/2007
		polaroidcasting	Folder	an sain Pressie	01/01/2008
		portraits	Folder		09/10/2007
		production.html	HTnt	4.8 KB	26/08/2008
		ps6book.css	Caent	539 bytes	07/01/2008
		review	Folder		29/08/2008
		Snaps	Folder	-	06/09/2008

Figure 14.1 This shows the Fetch[™] 5.5.3 FTP software interface with the log-in window on the left and a server directory view on the right.

File formats for the Web

Now that we have covered the fundamentals of how to access a server and administer your allocated server space, let's look at preparing images to be displayed on the Web, some of the different file formats you can use and which are the best ones to choose in any given situation.

JPEG

The JPEG (Joint Photographic Experts Group) format provides the most dramatic way to compress continuous tone image files. The JPEG format uses what is known as a lossy compression method. This means the heavier the compression, the more the image becomes irreversibly degraded. If you open a moderately compressed JPEG file and examine the structure of the image at 200%, you will probably notice that the picture has a discernible pattern of 8×8 pixel squares, and when using the heavier JPEG settings this mosaic pattern is easily visible at a 1:1 pixels view. JPEG compression is usually more effective if the image contains soft tonal gradations as detailed images do not compress quite so efficiently and the JPEG artifacts will be more apparent (see Figure 14.2). The JPEG format is used a lot in web design work, because a medium to heavy amount of JPEG compression can make most photographs small enough to download quickly over the Internet. Image quality is less of an issue when the main object is simply to reduce the download times. Apart from that do you really want the pirate to steal your treasured image at the highest technical quality?

Photoshop compresses images on a scale of 0–12, where a setting of 12 applies the least amount of compression and yields the highest image quality, while a setting of 0 applies the greatest amount of compression and is therefore the most lossy. When you choose to save as a JPEG and have the 'Preview' option checked in the JPEG Options dialog (Figure 14.3), you are able to preview the effects of the JPEG compression in the image document window as you adjust the Quality in the Image Options section. This shows how the image will look when it is reopened as a JPEG. The JPEG Options dialog box also indicates the compressed file size in kilobytes, although this is just an approximation.

If you save a master file as a JPEG and then decide the file needs further compression, you can safely overwrite the last saved JPEG using a lower JPEG setting. For as long as the image is open

Orphan works

With any photos that you upload to the Web, it is important to take precautions against future government legislation that may permit others to use photographs that are deeemed to be 'orphan works', because the orginal copyright owner cannot be found. It is possible to upload photos to sites such as Flickr and retain all the copyright metadata, while other upload processes may delete this data. One way to be absolutely sure is to incorporate a visible watermark in everything you publish to the Web.

Figure 14.2 This shows a close-up view of a JPEG image that was saved using the '0' Quality setting in Photoshop. This clearly reveals the underlying 8×8 pixel mosaic structure, which is how the JPEG compression method breaks down the continuous tone pixel image into large compressed blocks. At the higher quality settings it is impossible to see a difference between JPEG compressed and uncompressed images.

Saving 16-bit files as JPEGs

For those who prefer to edit their images in 16-bit, it was always frustrating when you would go to save an image as a JPEG copy, only to find that the JPEG option wasn't available in the Save dialog File Format menu. The reason for this was because 16-bit isn't supported by the JPEG format. With Photoshop CS5, when you choose 'Save As...' for a 16-bit image. the JPEG file format is now available as a save option, where the file is converted on-the-fly to an 8-bit JPEG, without further intervention. This allows you to quickly create JPEG copies without having to temporarily convert the image to 8-bit mode. Note that only the JPEG file format is supported in this way.

in Photoshop, all data is held in Photoshop's memory and only the version saved to the disk is degraded. It is therefore possible to repeat saving an image using the JPEG format. However, once an image has been compressed using the JPEG format and is reopened, it is not a good idea to repeatedly resave it as a JPEG again, since this will only compound the compression that's already been applied to the structure of the image. Having said that, unlike other programs, the JPEG compressor used in Photoshop converges, so that after repeated opening and saving using the same JPEG settings (and without modifying the pixels), the data loss diminishes with every save, to the point where there is little or no further loss.

The JPEG format can primarily be used to send smaller-sized email attachments and ensure that visitors to your website don't have to hang around while the images download. You can also use the JPEG format to archive images for faster electronic distribution or when you are forced to save a large file to a restricted amount of disk space. For example, a $10" \times 8"$ RGB file at 300 ppi resolution would normally be about 20 MB in size, if saved as a TIFF. By saving it as a high quality JPEG this same file can often be reduced to as little as 1 MB with hardly any degradation to the image quality. Some purists argue that JPEG compression should never be used under any circumstances when saving a photographic image.

latte: None	ОК
Image Options	Cancel
Quality: 6 Medium	Preview
small file large file	66.9K
- Format Options	
Baseline ("Standard")	

Figure 14.3 This shows the JPEG Options dialog box. The 'Baseline ('Standard')' option is the most universally understood JPEG format option and one that most web browsers will be able to recognize. The 'Baseline Optimized' option will often yield a slightly more compressed-sized file than the standard JPEG format and most (but not all) web browsers are able to read this correctly. The 'Progressive' option creates a JPEG file that will download in an interlaced fashion (the same way you can encode a GIF file).

It is true that if a TIFF file is saved using JPEG file compression there are some instances where this can cause problems when sending the file to some older PostScript devices. Otherwise, the image degradation is barely noticeable at the higher quality compression settings, even when the image is viewed on the screen in close-up at a 2:1 view.

Figure 14.4 Here are two JPEG images: both have the same pixel resolution and both have been saved using the same JPEG quality setting. Yet the Sahara desert image compresses to just 21 kilobytes, while the gas works picture is over three times bigger at 74 kilobytes. This is because it contains a lot of extra detail. The more contrasting sharp lines there are in an image, the larger the file size will be after compression.

Keeping files small

Only one thing matters when you publish images on the Web and that is to keep the total file size of your pages as small as possible. The JPEG format is the most effective way to achieve file compression for continuous tone photographic images, but graphics that contain fewer, distinct blocks of color should be saved using the GIF format. Some web servers are case sensitive and won't recognize capitalized file names. If this is likely to be the case, you can go to the Photoshop Preferences File Handling section and make sure the 'Use Lower Case Extensions box' is checked.

Lossless and lossy compression

The LZW and ZIP methods of compression are lossless. They can reduce the file size, but without degrading the image. The JPEG compression is lossy and you can only use it when saving TIFF images that have been converted to 8-bits per channel (although you can preserve the layers when saving a TIFF image using the JPEG compression method).

Choosing the right compression type

JPEG compression offers the most effective way to reduce file size, but this is achieved at the expense of throwing away some of the image data (as was demonstrated in Figure 14.2). JPEG is therefore known as a lossy format, so you need to be careful not to apply any more compression than is necessary. If you refer to Figure 14.5 below you can compare the different file sizes that were obtained when saving a 500×600 pixel image using different JPEG settings. As an uncompressed, 8-bit RGB TIFF, this file was 1.8 MB in size. When saved using the highest JPEG quality setting there was barely any degradation to the image, yet the JPEG file size was just 232 kilobytes, or 12% of its original file size, which is quite a saving. When a medium (8) JPEG quality setting was used the file size was reduced further to just 72 kilobytes. This is probably about the right amount of compression to use when preparing photographs to go on a website where you wish to strike the right balance between maintaining decent image quality, yet still keep the files compact in size. The lowest compression setting squeezed the image down to just 34 kilobytes, but at this level photographic images are likely to appear extremely 'mushy' and the lower quality settings are therefore best avoided.

000	Compa	rison		
Name	Datfied	Size ▼	Kind	110.000
Uncompressed-image.tif	Today	1.8 MB	Adobe Photoshop TIFF file	
JPEG-12.jpg	Today	232 KB	Adobe Photoshop JPEG file	
2 Compuserve-GIF.gif	Today	140 KB	Adobe Photoshop GIF file	
IPEG-8.jpg	Today	72 KB	Adobe Photoshop JPEG file	
JPEG-4.jpg	Today	44 KB	Adobe Photoshop JPEG file	
JPEG-0.jpg	Today	32 KB	Adobe Photoshop JPEG file	

Figure 14.5 Here we have one image saved six different ways, where each method produces a different file size. The opened image measured 500×600 pixels and the uncompressed TIFF file size was 1.8 MB. Below that are the JPEG versions which were saved using different quality settings. Lastly, a GIF version was saved, which as you can see does not offer the most efficient compression method and is unsuitable anyway for saving most kinds of photographic images.

OK

Cancel

TIFE Options

Maximum 1

large file

Image Compression

NONE

OLZW

() ZIP

OJPEG

Quality:

small file

Pixel Order

Byte Order
Byte Order
But Drec
Macintosh
Save Image Pyramid
Save Transparency
Layer Compression
RLE (faster saves, bigger files)
ZIP (slower saves, smaller files)
Discard Layers and Save a Copy

Interleaved (RGBRGB)
 Per Channel (RRGGBB)

TIFF compression for FTP transfer

I mention the TIFF format again here because it is the standard file format used for transferring files used for pre-press work. If you save a layered image as a TIFF using no image compression beyond the Run Length Encoding (RLE) layer compression, the uncompressed TIFF format doggedly records every pixel value and will therefore be large in size. If you need to speed up the time it takes to transfer TIFF files via the Internet, such as when sending TIFF files via the www.yousendit.com FTP service, you might want to employ one of the compression methods described below in Figure 14.6. As you can see, TIFF files compressed with LZW, ZIP or JPEG, and with ZIP-compressed layers, can cut the file size down by half or more. The only downside is that the save times will be noticeably slower and not all RIPs accept files in a compressed TIFF format.

00	TIFF com	parison		C
Name	Date Modified	Size 🔻	Kind	
No-compression.tif	Today	57.7 MB	Adobe Photoshop TIFF file	
LZW-compression.tif	Today	22.2 MB	Adobe Photoshop TIFF file	
ZIP-compression.tif	Today	21.8 MB	Adobe Photoshop TIFF file	
JPEG-compression.tif	Today	16.8 MB	Adobe Photoshop TIFF file	

TIFF Options		TIFF Options	A State of the second se	TIFF Options	
- Image Compression NONE 2 ZW 2 IP JPEC Quality: Maximum small file large file - Pixel Order - Pixel Order (RGBRGB) Per Channel (RRGCBB)	OK Cancel	Image Compression NONE LZW ZIP JPEG Quality: Maximum small file large file Pixel Order Pixel Order Pixel Order Pixel Order Pixel Order Pixel Order	OK Cancel	Image Compression NONE LZW ZIP @ JPEG Quality: 8 High small file targe file Pixel Order @ Interleaved (RGBRGB) Per Channel (RRGCBB)	OK Cancel
Byte Order () IBM PC () Macintosh		Byte Order Byte Order BM PC Macintosh]	Byte Order BIBM PC Macintosh]
□ Save Image Pyramid □ Save Transparency □ Layer Compression ○ RLE (faster saves, bigger files) ④ ZIP (slower saves, smaller files) ○ Discard Layers and Save a Copy		Save Image Pyramid Save Transparency Layer Compression RLE (faster saves, bigger files) ZIP (slower saves, smaller files) Discard Layers and Save a Copy		Save Image Pyramid Save Transparency Layer Compression RLE (faster saves, bigger files)	

Figure 14.6 Here, I took an 8-bit, layered, RGB TIFF image saved with no compression (which was 57.7 MB in size) and saved it using three different methods of TIFF compression. The lossless LZW and ZIP compression methods efficiently reduced the file size to less than half the original size, while the JPEG compression method had the potential to reduce the TIFF file size even further (while being lossy).

Martin Evening Adobe Photoshop CS5 for Photographers

Figure 14.7 The GIF file format is mostly used for saving graphic logos and typography. The picture shown here is one that was used for the cover design of an earlier edition of this book. This is also a good example to illustrate the type of image that would be suitable for saving in the GIF format for use on a web page design. Note that the image contains a large amount of solid red and few other colors. This photograph was reduced in size to around 350×300 pixels. I then converted the image to Index Color mode using a palette of 16 colors. When the image was saved as a GIF it measured a mere 19 kilobytes.

Run Length Encoding (RLE)

This is a simple and popular data compression algorithm in which a long sequence of identical pixel values is replaced by a shorter sequence which summarizes the pixel content. For example, where you have, say, a continuous tone color value repeated in an image, rather than record every pixel value individually, the pixel sequence can be summarized more compactly.

GIF

The GIF (Graphics Interchange Format) is normally used for publishing graphic style images such as logos. Some people pronounce GIF with a soft G (as in George) and others use a hard G (as in garage). Neither is right or wrong as both forms of pronunciation are commonly used. Or as Julieanne Kost likes to say: 'it's pronounced, get a life!'

To save an image using the GIF format, it must start off in 8-bit RGB mode. Saving as a GIF converts the image to Indexed Color mode. This is an 8-bit color display mode where specific colors are 'indexed' to each of the 256 (or fewer) numeric values. You can select a palette of indexed colors that are saved with the file and choose to save as a CompuServe GIF. The file is then ready to be placed in a web page and be viewed by web browsers on all computer platforms. Photoshop contains special features to help web designers improve the quality of their GIF outputs (Figure 14.7), such as the ability to preview Indexed mode colors whilst in the Indexed Color mode change dialog box and an option to keep matching colors non-dithered. This feature can help you improve the appearance of GIF images and reduce the risks of banding or posterization. Be aware that when the Preview is switched on and you are editing a large image, it may take a while for the document window preview to take effect, so make sure that you resize the image to the final pixel size first.

You will find that when designing graphic images to be converted to a GIF, those with horizontal detail compress better than those with vertical detail. This is due to the GIF format using Run Length Encoding (RLE) compression.

PNG (Portable Network Graphics)

The PNG file format can be used for the display and distribution of RGB color files on-line and is also available as a file format option in Save for Web. PNG (pronounced 'ping') features improved image compression and allows the saving of alpha mask channels (for creating transparency) to be saved with the image. Other advantages over JPEG and GIF are higher color bit depths, support for channels and limited built-in gamma correction recognition, so you can view an image at the gamma setting intended for your monitor. Mozilla's Firefox and Microsoft's Internet Explorer web browsers support the PNG format, as does Apple's Safari web browser program.

JPEG quality option

Save for Web & Devices

The 'Save for Web & Devices' option (**# S***hift***S**) can be accessed via the File menu. This comprehensive dialog interface (Figure 14.8) gives you complete control over how images can be optimized for Web use, offering a choice of JPEG, GIF, PNG-8 or PNG-24 formats. The preview display options include: Original, Optimized, 2-up and 4-up views (Figure 14.8 shows the dialog window in 2-up mode display). With Save for Web & Devices you can preview the original version of the image plus up to three variations using different web format

Saving for devices

The saving for devices was first introduced in CS3 and allows you to preview how a Photoshop image looks when displayed on various types of devices such as mobile phones. The details aren't really so relevant to a book on photography, so they're not covered in this chapter.

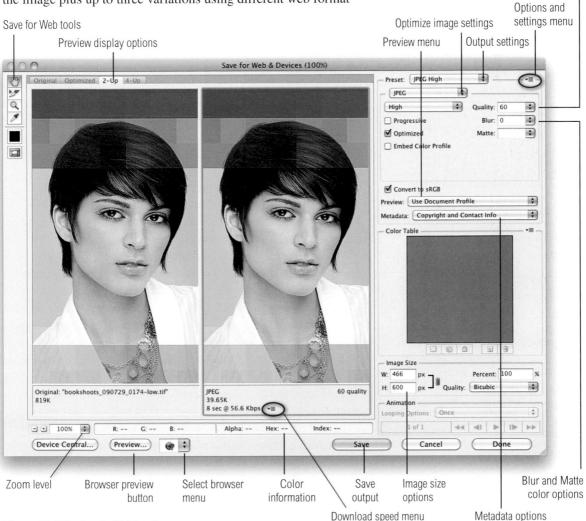

Figure 14.8 The Save for Web interface.

Figure 14.9 When you click on the browser preview button, it opens a temporary page like the one shown here. This allows you to preview the Save for Web processed image as it will appear on the final web page. This is especially useful for checking if the RGB editing space used is recognized differently by the browser. So if you are relying on embedded ICC profiles to regulate the color appearance on screen, you can check to see if the profile is indeed being recognized by the selected web browser program. settings. In the annotation area below each preview, you can make comparative judgements as to which format and compression setting provides the best payoff between image quality and file size, and also determine how long it might take to download at a specific modem speed. Use the N-up Download speed menu (circled in purple in Figure 14.8) to select from a list of modem and Internet connections on which these download times are based.

Web browser previews

The Select Web Browser menu allows you to select which web browser to use when you preview a document that has been optimized for the Web, such as the example shown in Figure 14.9, where I was able to preview the Save for Web & Devices image using the Firefox web browser. You can use the Preview menu list to select a preview setting and simulate how the web output will display on either a Macintosh display, a Windows PC display or with Photoshop compensation. Although these days I reckon it is safe to assume that everything will be viewed on a monitor using the PC 2.2 gamma standard.

Optimize image settings

The Optimize image settings section has an option that allows you to apply Progressive JPEG formatting. Most browsers such as Firefox and Internet Explorer support this enhancement, whereby JPEGs can be made to download progressively interlaced, the way GIFs can. If you check the 'Optimized' checkbox this option can be used to apply more efficient compression, but again is not generally compatible with older web browser programs. The quality setting can be set as Low, Medium, High, Maximum or set more precisely as a value between 1 and 100%. The 'Embed Color Profile' option can be considered useful for those few browsers that do recognize profiles (such as Safari). However, many don't and the downside of including an ICC profile is that this simply adds to the overall web image file size, so I suggest you only use this option in special circumstances. The Blur control allows you to soften an over-sharpened original and obtain further file compression when using the JPEG format. You can also refine the amount of metadata that is saved with the Web output images. Limiting the amount of saved metadata can help keep the file size small.

Once you have configured these settings, you can go to the Options and settings menu (circled in red in Figure 14.8) and choose 'Save Settings...'. You can then name the settings so that you can access them again in the future via the Presets menu.

The Image Size options are fairly similar to those found in the Image \Rightarrow Image Size dialog box. Simply enter the new percentage with which to scale the image and check what impact this has on the file size (this changes the file size in all the optimized windows). An alternative approach is to select 'Optimize To File Size' from the fly-out menu (see Figure 14.10). You can use this to get the optimized file to match a specific kilobyte file size. If you wish, you can have Photoshop automatically determine whether it is better to save as a GIF or JPEG.

Save options

The Save for Web dialog lets you save your output using: 'Images only', 'HTML only' or 'HTML and Images' (Figure 14.11). If you select 'Images Only', this simply saves a Web-ready image that you can use to place in a website design such as a blog entry, or as an image ready to email. If you select the 'HTML and Images' option, you can generate an HTML file with a link to the image, which will be placed in an accompanying 'images' folder.

Figure 14.11 The Save for Web & Devices save options.

Efficient JPEG saving

The Save for Web & Devices dialog may look intimidating, but once you figure out which settings need concern you, simply save these as a custom setting. I have also recorded the Save for Web & Devices as an action step, so that I don't even need to look at this dialog. The main thing to be aware of here is that Save for Web & Devices offers the most efficient way to prepare images for Web use, since it automatically strips out all previews which can make your web images dramatically smaller compared with using File \Rightarrow Save As... to save as a JPEG.

Figure 14.10 If you mouse down on the Options and settings menu (circled in red in Figure 14.8) you can choose 'Optimize to File Size', which opens the dialog shown here, where you can set a desired file size to optimize an image to.

Edit Output Settings

The 'Edit Output Settings' option (in the Options and settings menu) lets you determine the various characteristics of the Save for Web output files such as: the default naming structure of the image files and slices: the HTML coding layout; and whether you wish to save a background file

Desired File Size: 64 OK K Start With Cancel Current Settings O Auto Select GIF/JPEG -Use Current Slice C Each Slice ○ Total of All Slices

Optimize to File Size

Web palette colors

The Web palette contains the 216 colors common to both platforms and is therefore a good choice for web publishing if viewers are limited to looking at the image on an 8-bit color computer display. Now to be honest, restricting your colors to a Web palette should not really be that necessary these days, but the option is still there. However, the Web Snap slider lets you modify the color table by selecting those colors that are close to being 'browser safe' and making them snap to these precise color values. The Web Snap slider determines the amount of tolerance and you can see the composition of the color table being transformed as you make such an adjustment.

GIF Save for Web & Devices

The GIF Save for Web & Devices options (Figure 14.12) are also quite extensive. You have the same control over the image size and can preview how a resulting GIF will appear on other operating systems and browsers – the remaining options all deal with the compression, transparency and color table settings that are specific to the GIF format. The choice of color reduction algorithms allows you to select the most suitable 256 maximum color palette to save the GIF in, which includes the 8-bit palettes for the Macintosh and Windows systems. These are fine for platform-specific work, but such GIF files may display differently on the other system's palette. The Perceptual setting produces a customized table with colors to which the eye is more sensitive. The default Selective setting is similar to the Perceptual table, but more orientated to the selection of web safe colors. This is perhaps the best compromise solution to opt for now as every computer sold these days is able to display 24-bit color. The Adaptive table palette samples the colors which most commonly recur in the image. In an image with a limited color range, this type of palette can produce the smoothest representation using a limited number of colors.

The Diffusion dithering algorithm is effective at creating the impression of greater color depth and reducing any image banding, and the Dither slider allows you to control the amount of Diffusion dithering (the 'Pattern' and 'Noise' options have no dither control). If the image to be saved has a transparent background, the 'Transparency' option can be kept checked in order to preserve the image transparency in the saved GIF. To introduce transparency in an image you can select the color to make transparent using the eyedropper tool and then click inside the image preview area. The color chosen will appear selected in the color table. Select one or more colors and click on the Map Selected Colors to Transparent button in the Color Table (see Figure 14.13). You can then apply a diffusion, pattern or noise dither to the transparent areas, which can help create a smoother transparent blend in your GIF images.

The 'Lossy' option allows you to reduce the GIF file size by introducing file compression. This can be helpful if you have an overlarge GIF file, but applying too much compression will noticeably degrade the image until it looks like a badly tuned TV screen. The 'Interlaced' option can make the image appear to download progressively in strips, but adds slightly to the file size.

Figure 14.12 The Save for Web interface showing the GIF settings.

Transparency options Color table

Figure 14.13 This shows a close-up of the color table showing the Color palette options menu.

A: Maps the selected color to transparency. B: Shifts/unshifts selected colors to the Web palette. C: Locks the color to the palette to avoid deletion. D: Adds an eyedropper-selected color to the palette

Zoomify[™] Export

The 'ZoomifyTM Export' option in the File menu allows you to create an output folder containing all the necessary components to produce zoomable image web pages (Figure 14.14). Visitors are then able to view the pages created with the Zoomify export plug-in so long as they have an up-to-date Flash plug-in for their browser. Zoomify pages are ideal for portfolio presentations and commerce websites, where customers can easily view large images in close-up. If you go to the Zoomify website at www.zoomify. com, you can see some examples of customer sites where the Zoomify Export plug-in has been used.

Zoomify™ Export		
emplate: Zoomify Viewer with Navigator (Black Background)	0	ОК
Output Location	C	Cance
Folder Hard Drive 4:Users:martin_evening:Desktop:Output folder:		
Base Name: W1BY0961-Edit	C	Load
Image Tile Options Quality: 10 Maximum Image Image Im		
Optimize Tables		
Browser Options Width: 600 pixels Height: 500 pixels Open In Web Browser		
Comity Cet more features and customizable viewer at http://www.zoomify.com		

Figure 14.14 Here is the Zoomify[™] Export dialog box, showing the typical settings that might be used to create a zoomable image. When you click OK this creates a folder containing all the necessary components to display a zoomable image on the Web. Once created, all you have to do is upload the folder to your website and add the /foldername/ basefilename.htm/ to the usual URL weblink (note that the base file name referred to here is based on the image's file name). Visitors to such pages can left mouse-click on an area of interest to zoom in and *au*-click to zoom out. You can mouse down and drag to scroll, or use the navigator preview to select an area of interest to scroll to. There are no usage fees or restrictions on the usage of this plug-in. As is mentioned on the Zoomify website: We simply ask you not to decompile the Zoomify Viewer SWF file, not to redistribute the Zoomify Converter. Your content is yours, and redistributing the Zoomify Viewer swf is encouraged.'

Chapter 15

Automating Photoshop

etting to know the basics of Photoshop takes a few months, although it will take a little longer than that to become a fluent Photoshop user. One way you can speed up your Photoshop work is by learning how to use many of the various keyboard shortcuts. There are a lot of these in Photoshop, so it is best to learn a few at a time, rather than try to absorb everything at once. Throughout this book I have indicated the Mac and PC key combinations for the various shortcuts that are in Photoshop. While I have probably covered nearly all those one might use on a regular basis, there are even more shortcuts you can learn. Most of these are listed in the Shortcuts table PDF which is on the DVD that comes with the book and which you can also print out. Or, you can go to the Keyboard Shortcuts dialog in the Photoshop Edit menu to see what's available.

Sourcing ready-made actions

When you first install Photoshop you will find some actions are already loaded in the Default Actions Set and you can load more by going to the Actions panel fly-out menu and clicking on one of the action sets in the list (see Figure 15.1). There are also many more Photoshop actions that are freely available on the Internet. A useful starting point is the Adobe Studio Exchange site at: www.adobe.com/cfusion/ exchange/index.cfm. This site offers readyprepared actions or sets of actions with examples of the types of effects achieved with them for you to freely download for use in Photoshop.

Figure 15.1 Here is the Actions panel showing the panel fly-out menu options. You can easily add more action sets by selecting them from the list.

Working with actions

You can record a great many operations in Photoshop using actions. Photoshop actions are application scripts you can use to record a sequence of events that have been carried out in Photoshop and any actions you record while working in Photoshop can then be replayed on other images. If there are certain image processing routines that you regularly need to carry out when working in Photoshop, recording an action can save you the bother of having to laboriously repeat the same steps over and over again on subsequent images. Not only that, but you can also use actions to batch process several images at once.

Actions are always saved within action sets in the Actions panel and these can then be saved and shared with other Photoshop users so that they can replay the same recorded sequence of Photoshop steps on their computers.

Playing an action

The Actions panel already contains a set of pre-recorded actions called *Default Actions.atn.* If you go to the Actions panel fly-out menu you can load other sets from the menu list such as 'Frames' and 'Image Effects' (Figure 15.1). To test these out, open an image, select an action from the menu and press the Play button. Photoshop then applies the recorded sequence of commands to the selected image. However, if the number of steps in a complex action exceeds the number of available histories there will be no way of completely undoing all the commands once the action has completed. As a precaution, I suggest you either take a Snapshot via the History panel or save the document before executing the action. If you are not happy with the result of an action, you can always go back to the saved snapshot in history or revert to the last saved version.

The golden rule when replaying an action is 'never do anything that might interrupt the progress of the action playback in Photoshop'. If you launch an action in Photoshop you must leave the computer alone and let Photoshop do it's thing. If you click on the finder while an action is in Playback mode this can often cause an action to fail.

Photoshop actions are normally appended with the *.atn* file extension and saved by default to the Photoshop Actions folder, inside the Photoshop Application Presets folder, but you can store them anywhere you like. If you want to install an action that you

have downloaded or someone has sent to you, all you have to do is double-click it and Photoshop will automatically load the action into the Actions panel (and launch Photoshop in the process if the program is not already running at the time).

Recording actions

To record an action, you'll first need to open a test image to work with and you must then create a brand new action set to contain the new action. Next, click on the 'Create new action' button at the bottom of the Actions panel (Figure 15.2), which adds a new action to the action set. Give the action a name before pressing the Record button. At this stage you can also assign a custom keystroke using the Function keys (fi-fib) combined with the *Shift* and/or **H** *ctrl* keys. In future you will then be able to use the assigned key combination to initiate running a particular action. Now carry out the Photoshop steps you wish to record and when you have finished click the 'Stop recording' button.

When recording a Photoshop action, I suggest you avoid recording commands that rely on the use of any named layers or channels that may be present in your test file, as these will not be recognized when the action is applied to a new image. Also try to make sure that your actions are not always conditional on starting in a specific color mode, being of a certain size, or being a flattened image. If the action you intend recording is going to be quite complex, the best approach is to carefully plan in advance the sequence of Photoshop steps you intend to record. A Stop can always be inserted in an action which will then open a message dialog at a certain point during playback (see page 721 and Figure 15.5). This can be used to include a memo to yourself (or another user replaying the action), reminding what needs to be done next at a certain stage in the action playback process. Or if the action is to be used as a training aid, a Stop message could be used to include a teaching tip or comment.

If you want to save an action, it must be saved within an action set. So if you want to separate an action out to have it saved on its own, click on the 'Create new set' button in the Actions panel to create a new set, drag the action to the set, name it and choose 'Save Actions...' from the Actions panel fly-out menu (the action set must be highlighted, not the action). The following steps show how to record a basic action.

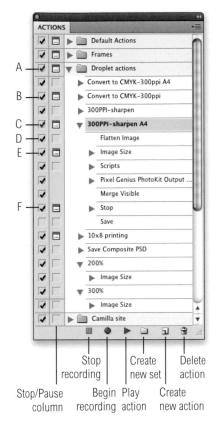

Figure 15.2 The Actions panel column showing the different action state icons.

- A: This action set contains inactive actions.
- B: Action contains a Pause to reveal a dialog.
- C: Indicates one or more action steps are inactive and contains a Pause.
- D: An active step.
- E: An active step with a Pause which will open a dialog box.
- F: An active step with a Stop which will open a message dialog.

Descriptions of all actions

If you hold down the **B c**trl alt keys as you choose 'Save Actions...' this saves the text descriptions of the action steps for every Photoshop action currently in the Actions panel. Adobe Photoshop CS5 for Photographers

2

a and a started		
Name	Print sharpening actions	ОК
		Cance

1 Here, I wanted to offer a practical example of how to create an action, by showing how the print sharpening steps shown on pages 682–683 could be recorded as an action. The first step was to create a new action set. To do this, I clicked on the 'Create new set' button (see Figure 15.2), named this 'Print sharpening actions' and clicked OK.

	44
Default Actions	0
Print sharpening actions	
T 300ppi-glossy-inket	
🔽 🔜 🕨 🛅 Frames	
✓ 🗔 ► 📄 Droplet actions	
Camilla site	
Lightroom-newsactions	- A
V N misc	Ŧ
	1. E
New Action	
	Record
Set: Print sharpening actions	Cancel
n Key: None 🔹 🗌 Shift 🗌 Command	
	Print sharpening actions 300ppi-glossy-inket Frames End of the propert actions Set: Print sharpening actions

2 I then clicked on the 'Create new action' button (circled) in the Actions panel, named this action '300ppi-glossy-inkjet' and clicked the Record button.

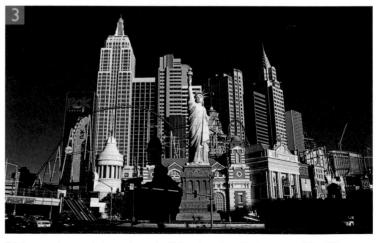

3 I then used a sample image to apply all the steps described on pages 682–683.

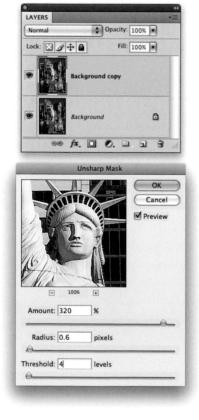

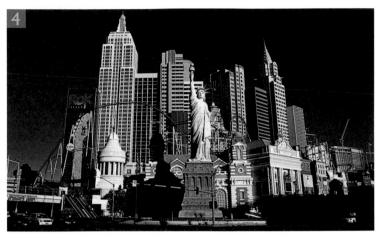

4 When I had finished recording all the steps, I clicked the Stop button to end the recording. In the Actions panel view shown on the right you can see a fully expanded list of all the steps, including the settings used. The action could be applied to other images by clicking on the Play button, or applied as a batch action process. You can also switch the Actions panel to Button mode (Figure 15.3), which makes the actions playback even simpler.

Troubleshooting actions

If an action doesn't seem to working, first check that the image to be processed is in the correct color mode. Many actions are written to operate in RGB color mode only, so if the starting image is in CMYK, the color adjustment commands won't work properly. Quite often, assumptions may be made about the image data being flattened to a single layer. One way to prevent this from happening is to start each action by using the **1** *alt shortcut* (to select the top-most layer), followed by the Merge Visible to new layer shortcut (**H Shift** *E ctrl alt Shift E*). These two steps will always add a new, flattened merged copy layer at the top of the layer stack. Some pre-written actions require that the start image fits certain criteria. For example, the Photoshop-supplied 'Text Effect' actions requires that you begin with an image that contains layered text and with the text layer selected.

If you have just recorded an action and are having trouble getting it to work, you can inspect it command by command. Open a test image, expand the action to display all the items, select the first step in the action, hold down the **fit** *ctrl* key and click on the Play button. This allows you to play the action one step at a time. You need to have the **fit** *ctrl* key held down and keep clicking the Play button to continue playing the remaining steps. If there is a

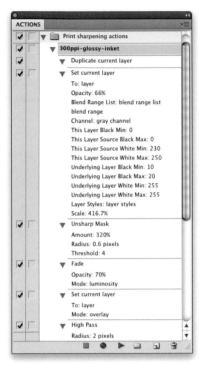

Figure 15.3 This shows the Actions panel in Button mode, where all you have to do is click on a button to initiate a recorded action (like the 300ppi-glossy-inkjet action circled above).

Recording ruler units

For actions that involve recording the placement of objects or drawing of marquee selections, it is a good idea to record setting the ruler units as part of the action. For example, if you go to the Photoshop preferences and choose 'Units & Rulers', you can set the rulers to 'Percentage'. By recording this as part of an action, any subsequent placement of Photoshop guides, placement of the type tool or use of the marguee tools can be recorded relative to the proportions of the document. When you then replay an action, the action should work effectively no matter what the size or proportions of the image.

Volatile actions

One thing you have to be aware of is that although actions will remain stored in the Actions panel after you guit Photoshop, a newly installed or created action can easily become lost should you suffer a computer or program crash before you quit. Photoshop actions can also become lost if you trash the Photoshop preferences or uninstall Photoshop. It is therefore always a good idea to take the precaution of saving any newly created or newly edited action sets so you don't lose them! These can be saved anywhere you like, but the Photoshop CS5/Actions/Presets folder is where they need to be stored if they are to be seen listed at the bottom of the Actions panel fly-out menu (see Figure 15.1).

problem with one of the action steps then double-click the relevant action step in the list to re-record it. You will then need to make sure that action step is selected, keep the **H** *ctrl* key held down again and click on the Play button to continue.

Limitations when recording actions

Most Photoshop operations can be recorded as an action, such as image adjustments, History panel steps, filters, and most Photoshop tool operations, although you should be aware that tools such as the marquee and gradient fills are recorded based on the current set ruler unit coordinates (see sidebar on recording ruler units). Avoid using commands which as yet cannot be recorded within an action, such as brush strokes. These go beyond the scope of what can be scripted in Photoshop.

Actions only record changed settings

One of the problems you commonly face when preparing and recording an action is what to do if certain settings are already as you want them to be. Actions only record a setting as part of an action if it actually changes something. For example, let's say you are recording an image size adjustment where you want the image resolution to end up at 300 pixels per inch, but the image is already defined in the Image Size dialog as being 300 pixels per inch. In these situations, Photoshop doesn't record anything. To resolve a problem like this you have to deliberately make the image size something different before you record the step. Then when you change the pixel resolution this will get recorded. In this particular example, you would go to the Image Size dialog and temporarily make the image, say, 200 pixels per inch, then record setting the resolution to 300 pixels per inch and when you are fnished, delete the 200 pixels per inch step from the completed action.

Background layers and bit depth

The lack of a Background layer can also stop some actions from playing. There is not always much you can do about this, other than to convert the current base layer to a Background layer by choosing Layer \Rightarrow New \Rightarrow Background from Layer before playing the action. This isn't always advisable since you wouldn't want to accidentally flatten all the layers in an important image. Alternatively, you could make a flattened duplicate of the current

image and then run the action. You may also want to check the bit depth of the image you are applying the action to. If the bit depth is 16-bit, not all Photoshop filters will work and you will need to convert the photograph to 8-bit per channel mode first.

Action recording tips

Action recordings should be as unambiguous as possible. For example, if you record a step in which a named layer is brought forward in the layer stack, in Playback mode the action will look for a layer with that exact same name. Therefore, when adding a layer include naming the layer as part of the action. Do not use Layer 1, Layer 2, etc. as this may only cause confusion with Photoshop's default layer naming. Also, use the main Layer menu or Layer key command shortcuts to reorder the layer positioning. Doing this will make your action more universally recognized.

Inserting menu items

There are some things which can be added as part of a Photoshop action that can only be included by forcing the insertion of a menu item. For example, Photoshop doesn't record zoom tool or View menu zoom instructions. However, if you select 'Insert Menu Item' from the Actions panel fly-out menu, as you record an action, you will see the dialog in Figure 15.4. The Menu Item dialog will initially say 'None Selected', but you can now choose, say, a zoom command from the View menu and the zoom instruction will be recorded as part of the action, although frustratingly the image won't actually zoom in or out until you replay the action! I often use the Insert Menu Item as a way to record actions that open certain Photoshop dialogs that I regularly need to access, such as the various Automated plug-ins. This saves me always having to navigate the Photoshop menus to access these specific items.

ОК
Cancel

Figure 15.4 The Insert Menu Item dialog will initially say 'None Selected'. You can then select a menu item such as Window \Rightarrow Arrange \Rightarrow Tile, and click OK. When the action is replayed the inserted menu item will be included in the playback list.

Stops and Pauses

When editing an action, you can insert what is known as a Stop. This allows you to halt the action process to display an alert message. This could be a useful warning like the one shown in Figure 15.5, which could be displayed at a key point during the action playback. If you click in the Stop/Pause column space to the left of the action step, next to a step where a dialog can be shown, you can instruct Photoshop to open the dialog at this point (see the red icons in the Stop/Pause column in Figure 15.2). This allows you to custom edit the dialog box settings when playing back an action.

Message:	ОК
Use marquee tool to make selection	Cancel
]

Figure 15.5 The Record Stop dialog.

'Override Action "Open" Commands'

If there is a recorded Open item, such as an ACR processing step in an action, checking 'Override Action "Open" Commands' overrides popping the ACR dialog for each image and simply applies the ACR processing. However, if you check this and there is no open step recorded in the action, this will prevent the action from running, so select this option with caution.

Batch processing actions

One of the great advantages of actions is having the ability to batch process images. The Batch dialog can be accessed via the File \Rightarrow Automate menu, plus it can also be accessed via the Tools \Rightarrow Photoshop menu in Bridge. You first need to select an action set and action from the Play section and you'll then need to set the Source and Destination. The Source can be all currently open images, the selected images in the Bridge window, an Import source, or a specific folder, in which case you'll need to click on the Choose... button below and select a folder of images. The following items in the Source section will only show if the 'Folder' or 'Bridge' options are selected. These allow you to decide how to handle files that have to be opened first in Photoshop before applying an action. The 'Override Action "Open" Commands' is a tricky one to understand (see side panel), but basically you'll

	Batch	A STATE OF STREET, STR	
Play Set: Droplet actions			ОК
	•	Mr. Astronom	Cancel
Action: Convert to CMYK-300ppi A	4 🗘		
Source: Folder			
Choose			
Override Action "Open" Commands			
Include All Subfolders			
Suppress File Open Options Dialogs			
Suppress Color Profile Warnings			
Choose Override Action "Save As" Commands — File Naming Example: Bookimage_101_190908			
Bookimage_	+ 3 Digit Serial Number	+	
_	+ ddmmyy (date)	+	
	+	•	
Starting serial#: 101 Compatibility: 🗹 Windows 🗹 Mac OS			
Errors: Stop For Errors			
Errors: Stop For Errors			

Figure 15.6 This shows an example of the Batch Action dialog set to apply a pre-recorded action. The 'Windows' box has been checked here to ensure file naming compatibility with PC systems.

want to leave this unchecked most the time. Only check the 'Include All Subfolders' option if you want to process all the subfolders within the selected folder. If you are processing a bunch of raw files and wish to override seeing the ACR dialog then do check the 'Suppress File Open Options Dialogs' option. Lastly, if you want to prevent the Missing Profile and Profile Mismatch dialogs appearing when you batch process images, then check the 'Suppress Color Profile Warnings' option. As a consequence of doing this, if there is a profile mismatch, Photoshop checks what you did previously. If you previously chose to keep the image in its own profile space, then this is how the images will be batch processed. If there is no profile present, Photoshop checks to see if your previous preference was set to: Ignore, Assign a profile, or Assign and convert to the working space, and acts accordingly.

In the Destination section you have three options. If you choose 'None', Photoshop processes the selected files and leaves them open. If you choose 'Save and Close', Photoshop does just that and overwrites the originals, and if you choose 'Folder', you'll need to click on the Choose... button to select a destination folder.

Now it might so happen that the action you have selected to run the batch process with may contain a Save or Save As command that uses a specific file format and format settings, and this action step will contain a recorded Save destination. It might be the case that the Save destination is an important part of the action, but if the destination folder no longer exists, the action will fail to work (besides, you can specify a destination folder within the Batch dialog itself). So in the majority of instances, where the action contains a Save instruction, I recommend you check the 'Override Action "Save As" Commands' checkbox. If the action does not contain a Save or Save As command, then leave this option unchecked.

If a folder is selected as the destination, you have six editable fields at your disposal. You can use any combination you like, but if you select a custom file extension option this must always go at the end. As you edit the fields, you will see an example of how the naming will work in the 'Example:' section above. The file naming options let you define the precise naming and numbering structure of the batch processed files (Figure 15.7 shows the complete list of naming and numbering options).

Customized file naming

It is easy to customize the File Naming with your own fields. In Figure 15.6, I created a batch process where the images were renamed 'Bookimage_' followed by a three-digit serial number, followed by an underscore '_' and with the date expressed as: day; month; and year. Note that the numbering was set to start at '101'. So in this example the file name structure would be something like: Bookimage_101_190908.

> ✓ Document Name document name DOCUMENT NAME 1 Digit Serial Number 2 Digit Serial Number 3 Digit Serial Number 4 Digit Serial Number Serial Letter (a, b, c...) Serial Letter (A, B, C ...) mmddyy (date) mmdd (date) yyyymmdd (date) yymmdd (date) yyddmm (date) ddmmyy (date) ddmm (date) extension **EXTENSION** None

Figure 15.7 The Batch interface naming and numbering options.

Error handling

If 'Stop For Errors' is selected, this will halt the batch processing in Photoshop any time an action trips up over a file for some reason. You can prevent this by selecting the 'Log Errors to File' option instead. This allows the batch processing to complete, but creates a log report of any files that failed to process.

Cross platform droplets

You can name a droplet anything you like, but to be PC compatible you should add a .exe extension. If someone sends you a droplet that was created using a PC, it can be made Mac compatible by dragging it on top of the Photoshop application icon.

Photoshop actions can also be converted into self-contained, batch processing applications, known as 'droplets', which can play a useful role in any production workflow. When you drag a document or a folder on top of a droplet icon this will launch Photoshop (if the program is not already running) and initiate the action sequence that's contained within the droplet. The beauty of droplets is that you only need to configure the batch processing settings once and they are then locked into the droplet. Droplets can be stored anywhere you like, although it makes sense to have them readily accessible such as in an easy-to-locate system folder (Figure 15.8).

To make a droplet, go to the File \Rightarrow Automate menu and choose 'Create Droplet...'. Figure 15.9 shows the Create Droplet interface and you will notice that the Create Droplet options are identical to those found in the aforementioned Batch Actions dialog. Choose a location to save the droplet to and, if required, you can also choose a destination folder for the droplet processed files to be saved to. When you are done, click OK.

	Create Droplet		
Save Droplet In			
Choose		Car	ncel
- Play			
Set: Droplet actions	•		
Action: Convert to CMYK	(-300ppi A4 🛟		
Override Action "Open" Co	ommands		
Include All Subfolders			
Suppress File Open Option			
Suppress Color Profile War	rnings		
Destination: Folder	·		
Channel Black	Users:martin_evening:Desktop:Output folder:		
Override Action "Save As" File Naming Example: MyFile.gif Document Name		B +	
Example: MyFile.gif	Commands	() +	
File Naming Example: MyFile.gif	Commands + extension +		
File Naming Example: MyFile.gif	Commands		
File Naming Example: MyFile.gif [Document Name] Starting serial#: 1 Compatibility: Windows	Commands		
File Naming Example: MyFile.gif [Document Name] Starting serial#: 1 Compatibility: Windows	Commands		

Figure 15.9 This shows the Create Droplet dialog.

Figure 15.8 When you drag and drop an image file on top of a droplet, this will launch Photoshop and perform a single or batch processing operation within the program. Droplets can perform Save and Close operations (overwriting the original) or can be configured to save the processed images to an accompanying folder as a new version of the master image.

Image Processor

The Image Processor (Figure 15.10) is located in the File \Rightarrow Scripts menu in Photoshop and can also be accessed via the Tools \Rightarrow Photoshop menu in Bridge. The Image Processor is a fine example of what Scripts can do when they are presented via an easy-to-use interface. The Image Processor basically allows you to select a folder of images (or select all open images) to process and select a location to save the processed files to. The Image Processor can then be configured to run a Photoshop action (if required) and save the processed files using either the JPEG, PSD or TIFF file formats. However, it will also allow you to simultaneously process and save files in multiple file formats. This can be very handy if you wish to produce, say, both a TIFF version at high resolution and a JPEG version ready to place in a web page layout.

	Image	Processor	
O Select	O ose open integes	ide All sub-folders mages have been selected ly settings	Run Cancel
O Select	location to save processed ima Save in Same Location Select Folder /Use		Load Save
File T	ype Save as JPEG Quality: 10	Resize to Fit W: 2800 px	•
	Convert Profile to sRGB	H: 2800 px	
	✓ Save as PSD ✓ Maximize Compatibility	Resize to Fit	
	Save as TIFF	Resize to Fit	
	LZW Compression	W: px H: px	
	rences In Action: Droplet actions	300PPI-sharpe 🛟)
	right Info: © Martin Evening clude ICC Profile	2008)

Preparing JPEGs for the Web

When you are preparing images that are destined to be shared by email or published via the Web, the Image Processor is a handy tool to use because you can not only resize the images as part of the image processing, but you can instruct the Image Processor to convert the image from its current profile space to sRGB, which is the ideal RGB space for general purpose Web viewing.

Figure 15.10 This shows the Image Processor (formerly known as Dr. Russell Brown's Image Processor). This Scripting dialog can be configured to process single or multiple images, apply Photoshop actions, add copyright info and save the files to a designated folder location in one or more of the following file formats: JPEG, PSD or TIFF. The destination folder will contain the processed images and these will be separated into folders named according to the file formats selected. Once configured, you can click on the Save... button to save these settings and load them again at a future date.

Figure 15.11 The Photoshop Scripts menu.

Destination:	
/Users/martin_evening/[Browse	Run
ile Name Prefix:	Cancel
Web-layout	
Visible Layers Only	
File Type:	
Include ICC Profile	
TIFF Options:	7
Image Compression: None	
Quality: 8	
Please specify the format and location for saving e file.	ach layer as a

Figure 15.12 An example of the Export Layers to Files script dialog.

Figure 15.13 The Script Event Manager is located in the File \Rightarrow Scripts menu. The dialog shown here has been configured to trigger popping the File Info dialog whenever a document is saved.

Scripting

One of the most neglected aspects of Photoshop has been the ability to write scripts to automate the program. For most of us, the prospect of writing scripts is quite scary and I freely confess I am one of those who has looked at the scripting manuals and simply shuddered at the prospect of having to learn scripting code. Steps have been taken though to make scripting more accessible to the general user. You can start by referring to the Photoshop Scripting Guide and other PDF documents about scripting that can all be found in the Photoshop CS5/Scripting Guide folder. You can also download pre-made scripts from the Adobe Studio Exchange website: http://www.adobe.com/cfusion/exchange/index.cfm.

To start with, go to the Scripts menu in the Photoshop File menu (Figure 15.11). There you will see a few sample Scripts that are readily available to experiment with. Among these is a script called 'Export Layers to Files' (Figure 15.12). This can be used to generate separate file documents from a multi-layered image. Other scripts I like to use include the 'Load Files into Stack...', which I find useful when preparing images for stacks image processing or before choosing Edit ⇒ Auto-Align layers.

Script Event Manager

The Script Event Manager can be configured to trigger a Javascript or an action in Photoshop whenever a particular operation is performed. Figure 15.13 shows a simple example of what can be done using the Script Event Manager.

Enable Eve	ents to Run Scripts/Actions:	Done
Start Applica	tion: Update File Info.jsx	
		Remove
		Remove Al
Photoshop	Event: Save Document	Add
Script:	Clean Listener 👻	
	Manage your events by adding and removing. Select different JavaScript files to get detailed descriptions.	
O Action:	Default Actions Vignette (selection)	

Automated plug-ins

The Automation features described on this page are examples of Automated plug-ins. What distinguishes these from normal plug-ins is that they enable Photoshop to perform a complex set of procedures based on simple user input. Adobe has also made Automated plug-ins 'open source', which means it is possible for third-party developers to build their own Automated plug-ins for Photoshop. I believe that Pixel Genius (of which I am a co-founder) is so far the only company who has made use of this feature in Photoshop to produce the PhotoKit, PhotoKit Sharpener and PhotoKit Color Automated plug-ins.

Crop and Straighten Photos

This Automated plug-in is very straightforward to use, if you have scanned images that need to be rotated and cropped. You can gang up several images at once on your scanner, scan the pictures in as one image and choose 'Crop and Straighten Photos' from the Automate submenu (note: this option is not available in Bridge). Photoshop then creates a rotated and cropped copy version of each picture (Figure 15.14). It kind of works, but only if the background has a reasonably solid color. Crop and Straighten therefore works best if the border is a clear white or black. If Crop and Straighten fails to work on all images at once, it sometimes helps if you make a selection around the individual images first and process them one by one.

Fit Image

Fit Image... is a very simple Automated plug-in that allows you to bypass the Image \Rightarrow Image Size menu item (Figure 15.15). It is well suited for the preparation of images for screen-based design work. You enter the pixel dimensions you want the image to fit to, by specifying the maximum pixel width or height. Note that if you enter the same pixel dimensions for the width and height, Fit Image can be used to simultaneously batch process landscape and portrait format images. Note here that scripts can be made to call other scripts and it is often useful to include Fit Image within a more complex script, or as part of a recorded action sequence. **Figure 15.14** The Crop and Straighten Photos plug-in can be used to extract scanned photos that need to be rotated and cropped.

Figure 15.15 The Fit Image dialog.

Index

Symbols

16-bit 307
color space selection 309
32-bit 396, 402, 414
Exposure 15
64-bit processing 86

A

Absolute Colorimetric 671 Access CS Live panel 28, 123 ACR compatible cameras 216 Acrobat format (PDF) 75 Actions 696, 716-723 actions panel 53 actions sets 716-717 background layers 720 batch actions 53, 722-723 customized file naming 723 destination options 723 error handling 723 file naming options 723 handling save commands 723 'Override Action "Open" Commands' 722 'Override Action "Save as" Commands' 723 selecting the source 722 suppress color profile warnings 723 suppress file open dialogs 723 batch actions via Bridge 620 bit depth 720 Button mode 719 Create new action 717-718 creating droplets 724 default actions 716 editing an action 720 History panel steps 720 including text 719 inserting a Pause 717, 721 inserting a Stop 717, 720-721 inserting menu items 721

inspecting actions 719 interrupting playback 716 limitations of actions 720 playing an action 716, 719 readymade actions 716 recording actions 717-720 recording ruler units 720 recording tips 721 safeguarding actions 720 save actions descriptions 717 saving actions 717 sourcing actions 716 Stop and Pause 721 stop recording 719 troubleshooting actions 719 volatile actions 720 Activating Photoshop 7 ADC 126 Add anchor point tool 49 Adjustment layers 462 cumulative adjustments 357 Adjustments panel 4, 312, 378-379 adjustment panel controls 315 adjustments panel edit mode 313 auto-select targeted adjustment 322 reset adjustment 315 Adobe AIR 28, 623 Adobe Color Engine 638 Adobe DNG Converter 220 Adobe Drive 106 Adobe ID 7 Adobe Lens Profile Creator 563-565 and Auto-Align 563 browse Adobe Lens Profile Creator on-line 563 Interpolating lens profiles 563 Adobe On-line 21 Adobe PDF 75 Adobe RGB 310-311, 640-641, 664 Adobe Studio Exchange 716, 726 Adobe Transient Witticisms 84 ADSL Internet 700

Advanced layer blending 494 blend interior effects 494 Aim prints 693 Aladdin 700 Albon, David xxii Align layers 55 Alpha channels 452, 456, 459 Alternative Raw processors 130 AMD processors ideal cache tile size 112-113 Anti-aliasing 460 Aperture 130, 137, 568, 591 Appending file names 105 Apple Cinema display 89 Apple RGB 640 Application bar 9, 18-19, 78, 570 N-up document lavout 18-19 Zoom Scale box 18-19 Application frame windows 8-9, 461 Art history brush 62, 65 Assigning shadows and highlights 674 ATA drives 114 Auto adjustments 344 Automate menu 620 Automated plug-ins 722, 727 Automating Photoshop 53 Auto-select layer 54

B

Background eraser tool 50 Backing up your data 99 backup preferences 101 backup strategies 100 Backward compatibility 580 Banding use dither option 662 Barroso, Clicio 192 Barstow, Neil xxii, 634, 645 Batch processing 722 Batch renaming 621–622 Bibble 130, 143–144 Bicubic interpolation 101, 299 bicubic sharper interpolation 300 bicubic smoother interpolation 300 Big data 376 Bilinear interpolation 299 Bird's-eye view 10, 57 Bit depth 306 32-bit floating point 396, 403 raw images 307 Bitmapped images 306 Black and white black and white adjustments adjustment presets 381 black and white output 390 converting color to B&W 378-389 dumb black and white conversions 378 Lab mode conversions 378 split toning 384 Blending modes 52, 488-492 advanced blending options 494 blend mode adjustments 364 Color 41, 330, 382, 493, 685 Color Burn 489 Color Dodge 490 Darken 434-435, 489 Darker Color 489 Difference 492 Dissolve 488 Divide 436-437, 493 Exclusion 492 Hard Light 491 Hard Mix 492 Hue 493 Lighten 434-435, 490 Lighter Color 490 Linear Burn 489 Linear Dodge (Add) 490 Linear Light 491 Luminosity 330, 493, 685 Multiply 364, 489 Normal 488 Overlay 364, 491, 683 Pin Light 492 Saturation 493

Screen 364-365, 490 Soft Light 468-469, 491 Vivid Light 491 Blu-ray Discs 100 Blur filters 540-542 Blur tool 40 Box Blur filter 545 Bracketed exposures for HDR 398 Bridge 76-80, 568-621 add new folders 570 apply Camera Raw settings 622 automatic launching 583-584 automation 620-621 auto-stacking 586 batch actions 620 batch rename 621-622 editing renaming fields 621 export to CSV 622 preview button 621-622 undoing a batch rename 622 Bridge interface 78-79, 81-82 Bridge panels 588 Bridge workspaces 576 cache cache management 581 collections panel 608 smart collections 609 color labels 592, 595 compact mode 78, 574 content area thumbnails view 574 content panel 574-575, 594 scrolling 576 customizing panels 574 custom views 573 custom workspaces 79 deleting contents 584 develop settings menu 622 Favorites panel 588 file info 598 copyrighted images 598 filtering shortcuts 595 Filter panel 78, 595 find images 607 flatten view (changed) 595

folder cache 588 Folders panel 588 image cache 581 image rating 592 image rotation 570 image searches 606 search criteria 606 keywords panel 604-605, 605 other keywords 604 labeling images 592 launching Bridge 570 layout 572-577 lightbox workspace 576 loupe tool 589 marking reject images 584 metadata append metadata 598 hidden metadata 603 replace metadata 598 Metadata panel 596-599 EXIF camera data 600 file properties 596 GPS metadata 602 IPTC 596 **IPTC Extensions** 598 metadata template 598 multiple windows 578 opening camera raw 152-155 output for web sRGB conversions 610 output preferences 616 output to Web and PDF 610-620 output workspace 79 PDF output 617-619 Document panel 618 Layout panel 618 Output options 619 Output panels 618 Overlays panel 619 Playback panel 619 printing route 617 refresh preview 617 Watermark panel 619 preferences Accent Color 568

advanced 583 automatically export cache 582 cache management 581-582 compact cache 583 edit history log 603 file associations 593 file type associations 68 general 568 generate monitor size previews 583 interface brightness 568 international languages 583 most recently visited folders 569 opening in Photoshop 570 purge cache 583 thumbnails 580 use software rendering 583 preview generation 580 Preview panel 589 rating images 579, 592 refreshing the view 594 renaming images 621 preserve current filename 622 renaming schemes 622 undoing a batch rename 622 Review mode 590 rotating images 570 sidecar files 581 slideshow view 79-80, 80, 579-580 slideshow options 579 sorting images 594 sort menu 594 stacking images 584-585 synchronized displays 578 tethered shoot imports 143 tools menu automation 620, 722 build and export cache 582 view menu Show Items from Subfolders 595 Web output 611-617 Appearance panel 615

Color Palette panel 614 Create Gallery panel 615 output gallery settings 612 output gallery styles 612 Site info panel 614 workspace settings 572 light table 576 metadata focus 577 workspace shortcuts 572 BrightSide technologies 89 Broadband cable 700 Brown, Russell xxii, 395, 434, 725 Browser safe colors 712 Bruce RGB 664 Bruno, Andrea xxii Brushes bristle shape brushes 40, 47 brush attributes 43 brush cursor 118 brush picker 41 brush preset menu 41 brush size limits 46-47 dual brush control 44 jitter control 44 on-the-fly brush changes 41 pressure sensitive control 44 shape dynamics 44 texture dynamics 44 Brush panel 43 bristle preview 47 bristle qualities options 47 brush panel options 44 color dynamics 44 flow jitter 44 scattering controls 44 Brush preset picker 40 Hardness slider 40 Size slider 40 Brush tool 40 Brush tool presets 45 Bunting, Fred 320, 634 Burn 358 Burn tool 40 Bus connection 88

Byer, Scott 86 Byte order 74

С

Cable Internet 700 Calibration 90, 642-643 calibration hardware 90 eyeball calibration 97 Camera exposure 129, 303 Camera histograms 163, 187 Camera JPEG previews 128 Camera Raw 82-83, 152-192, 302, 568 ACR preferences 154 adjusting hue and saturation 202 adjustment brush 227 add new brush effect 229 auto masking 232 brush settings 228 color mode 234 density 228 edit brush 230 erase 230 feather 228 flow 228 hand-coloring 234 negative sharpening 271 pin markers 229 resetting the sliders 236 sharpening 271, 273 show mask option 230 size 228 speed limitations 234 alternative raw processors 130 applying Camera Raw settings 622 as a JPEG editor 130 auto corrections 82, 167 apply auto grayscale 167 apply auto tone 167 Basic panel 131, 174-175 blacks 176 brightness 188 clarity 191 clipping points 180

contrast 190 exposure 176, 180, 188 fill light 177, 341 fill light dangers 177 midtone corrections 188 negative vibrance 194 recovery 176, 180, 341 saturation 194 vibrance 194 white balance 174 bit depth 154 black and white conversions 378. 386-387 cache size 169 Camera Calibration panel 170, 216-219, 222-223 black and white conversions 387 Camera Raw profiles 216-218 camera profile calibrations 218 Camera Raw/Photoshop workflow 131 Camera Raw profiles 216, 216-218 camera look profiles 217 Camera Raw support 136 camera-specific default settings 167 capture sharpening 681 chromatic aberration 204 color sampler tool 154 copying settings 245 correcting high contrast 198 cropping 154, 171, 172 database 581 defaults 243 deleting images 164 demosaic processing 83, 254-256 Detail panel 257, 272 amount 259 Color Detail slider 275, 277 Color slider 275-276 Detail slider 261 gravscale preview 263 interpreting grayscale previews 263 Luminance Contrast slider 275, 277 Luminance Detail slider 275

Luminance slider 274, 277 Masking slider 264 noise reduction 274-277 radius preview 263 Radius slider 256, 260 save sharpen settings 269 sharpening a landscape 267 sharpening a portrait 266 sharpening defaults 258 sharpening effect sliders 258 sharpening examples 266 sharpening fine-detail 268 Smart Object sharpening layers 271 suppression controls 261 Develop settings 223 DNG update embedded JPEG previews 242 DNG file handling 169 does the order matter? 128 Effects panel grain effects 214-215 Post Crop Vignetting 208–213 emulating Hue/Saturation 202 export settings to XMP 242 file format compatibility 249 full size window view 156 Gradient filter 236 adding clarity 239 angled gradients 239 negative sharpening 271 pin markers 236 selective sharpening 271 hand tool 154 hiding shadow noise 183 histogram 154, 163, 188 histogram and RGB space 163 how Camera Raw calculates 76, 180 HSL/Grayscale panel 200-202 auto grayscale 386 color sliders 386 convert to grayscale 386-387 HSL grayscale conversions 387

saturation 202 Lens Corrections panel 204-205 defringe 205 lens settings 202 lens vignetting control 206 load settings 242 localized adjustments 227 maintaining ACR compatibility 250 matching JPEG rendering 216 multiple file opening 156 multiple raw conversions 392-394 new demosaicing 205 noise removal 274-277 open as a Smart Object 158, 392 opening JPEGs 107, 170 opening multiple files 156 opening TIFFs 107, 170 opening via Bridge 570 override JPEG Camera Raw settings 570 Post Crop Vignetting 208 preferences 106, 166-167, 581 general preferences 166 sharpening 166 preserve cropped pixels 162 preserving highlight detail 180 Presets panel 223, 243-244 process versions 170, 216 profiling 644 recovering out-of-gamut colors 201 red eye removal 154, 226 rotate clockwise 154 rotate counterclockwise 154 Saturation slider 194 saving 162, 171 save options 162 save settings 171, 242 saving presets 243 saving a JPEG as DNG 162 selecting rated images only 164 settings 241 sharpening micro detail 215 sidecar files 166

single file opening 154 Smart Objects 247, 392 snapshots 246-247 Lightroom snapshots 246 softening skin tones 192 Split Toning panel 387-388, 388-389 spot removal tool 154, 224-225 straighten tool 154, 171, 172 suggested workflows 127 synchronized spotting 225 synchronize settings 156, 245 target adjustment tool 154, 197, 203 thumbnails filmstrip 156 Tone Curve panel 190, 196-199, 394 parametric curve editor 196 tools 154 update DNG previews 242 white balance tool 154 workflow options 154-155, 620 resolution 154 zoom tool 154 Canon Canon DPP 249 Canon EOS Utility 144 Canon ipf5000 printer 690 Canon Viewer 143 Canvas color 102, 104 size 371 relative canvas size 371 Caplin, Steve xxii Capture One 130, 143, 147 Capture sharpening 680 Cataloging images 591 Cataloging programs 568 Causa, Ettore 192 CCD 126 CD media 100 Centrinos 86 Chan, Eric xxii, 217, 256 Channel Mixer 538 Channels 452-454

omitting channels in a save 453 Chip speed 88 CIE LAB 638 CIE XYZ 638 Cintig input device 99 Clipboard 102 Clipping masks 503-505 clipping adjustment layers 504-505 Clipping the shadows 183 Clone Source panel 420-421 overlay blend modes 422 upside down cloning 422 Clone stamp tool 50, 416-417, 420-422 alignment mode 420 ignore adjustment layers 427 layer selection options 417 sample all layers 427 sample current & below 417, 427 tool settings 416 Cloning 416-418 CMOS 126 **CMYK 635** black generation 668 black point compensation 662 classic Photoshop CMYK setup 665 CMYK conversions 180, 665 CMYK myths 665 CMYK numbers 636 CMYK setup 665-666 CMYK skin tones 678 CMYK to CMYK conversions 676 custom CMYK settings 665 custom ink colors 667 dot gain 667, 668 dot gain curves 667 GCR separations 668 ink colors 666 proofing 662 separation setup 666 SWOP print settings 665 UCA separations 669 UCR separations 669 Color blend mode 493 Color Burn blend mode 489

Color corrections 342-356 Color Dodge blend mode 490 Colorimeters 92 Colorize Hue/Saturation 352 Color management 631-678 aim prints 657 assign profile 653 black point compensation 692 camera profiling 644 CMMs 638 color management interface 647-655 color management modules 638-639 color management off 650 color management policies 651 color policies 648 color settings 97, 637, 647, 678 advanced color settings 661 ask when pasting 655 color settings files 656 general purpose presets 648 save custom CMYK settings 666 saving color settings 656 synchronization 98 use dither 662 conversion options 662 convert to profile 652-653, 659, 676 advanced dialog 653 convert to workspace 649, 657 customizing RGB color 664 desaturate monitor colors 663 display profiling 642-643 document profiles 648 grayscale management 660 grayscale workspace custom Gray space settings 661 for screen display 660 gamma values 660 matching grayscale gamma 660 ICC profiles 637-640 incorrect profiles 651 incorrect sRGB EXIF data 654 input profiling 644

missing profiles 649 output profiling 645 prepress settings 678 preserve embedded profiles 648-650, 657, 676 printing no color management 692, 698 profile connection space 638-639 profile conversions 651 profiled color management 637-639 profile mismatches 649 ask when pasting 654 read me files 650 reducing errors 657-659 RGB to CMYK 665-677 RGB to RGB conversions 652 saving a color setting 656 scene-referred profiles 662 setting the endpoints 184 ColorMatch RGB 641 ColorMunki Photo 92 Color Picker 101 gamut warning 119 Color Range 36-37, 484 localized color clusters 36 masking 362 out-of-gamut selections 36 Color replacement tool 50 Color sampler tool 56, 350 Color Settings 97, 310 synchronizing 98 Color temperature 175, 356 Color toning 382 ColorVision 92, 642 Color vision trickery 635 Color wheel 342 colourmanagement.net 645, 698 Configurator 2 27-28 Connor, Kevin xxii Contact Sheet II 123, 617 Content-aware filling 432-433 See Edit menu Content-aware scaling 372-375 See Edit menu Contextual menus 38

Controlled vocabulary 599 Convert for Smart Filters 278 Convert point tool 49 Convert to Smart Object 529 Converting vectors to pixels 459 Copyright marking images as copyrighted 598 Corrupt files 68 Corruptions in raw data 151 Count tool 56 Cox. Chris xxii Create layer mask from transparency 468-469 Creating a droplet 724 Creating a new document 297 Crop and straighten photos 727 Crop tool 50 Cropping 366-369 aspect ratio crops 368 crop tool 366 crop tool presets 366 front image cropping 366 hide crop 376 perspective cropping 369 Cross-processing 389 CRT displays 88 CS Live 18 CS Review panel 28 Curves 318-327, 348-352 See also Image adjustments Custom keyboard shortcuts 23-24 Custom shape tool 48 Customize proof condition 684

D

Darken blend mode 489 Darker Color blend mode 489 Dead pixels 274 Debevec, Paul 396 Delete new delete fill options 432 Delete anchor point tool 49 Delete preferences 101 Deleting camera card files 142, 145 Denne, Ben xxii

Depth of field blending 498-499 brush 282 effects 546 Determining output size 296 Device calibration and measurement 94 DICOM 602 Difference blend mode 492 Digital exposure 186 Digitizing pad 99 Direct selection tool 49, 534 Disk performance 114 Displays 88 dual display setup 89 gamma 90, 93 luminance 94 white point 92 wide dynamic range displays 89 Dissolve blend mode 488 Distribute layers 55 Distribute linked layers 514 DNG Converter 250 DNG Profile Editor 220-223 Create Color Table 221 Document profile 15 Document windows 14 floating windows 11-14 switching between windows 11-14 Dodge tool 40, 358 Dolby 399 Dots per inch 292 Drag and drop documents drag and drop as a layer 526-527 Drag Raster Images as Smart Objects 102 Dreamweaver, Adobe 71 DropBox 701 Droplets 696, 724 cross platform droplets 724 Dual display setup 26-27 Duplicate an image state 66 Dutton, Harry xxii DVD archive discs 582 DVD/CD drives 99 DVD media 100 Dynamic color sliders 102

Dynamic range 391 Dynamic zoom views 14

E

Easter eggs 84 Eclipse cleaning solution 225 Edit history log 603 Edit menu auto-align layers 498, 563 auto-blend layers 499 seamless tones and colors 499 color settings 637 content-aware scaling 372-375 Amount slider 373 Fill 433 content-aware filling 432-433 menu options 22-23 Paste Special paste into 34 Puppet Warp 433, 520-525 adding pins 520 distort mode 520 expansion setting 521, 523 multiple pin selection 522 normal mode 520 pin depth 522, 524 pin rotation 521, 525 rigid mode 520, 523 show mesh 520 using Smart Objects 522 Transform free transform See Free Transform manually set transform axis 513 transform commands See Transform command Editing JPEGs & TIFFs in Camera Raw 129 Efficiency 15 Efficiency readout 111 Eismann, Katrin xxii, 4 Eizo displays 88-90 ColorEdge display 90, 643 Electronic publishing 75 Elliptical marquee tool 34

Elliptical shape tool 48 Email attachments 700 Endpoints setting them in Levels 674 Epson printers 645 advanced B&W photo 390, 660 Epson 4800 dialog 694 Eraser tool 50 Exclusion blend mode 492 EXIF metadata 402, 598, 600 Export Clipboard 102 Expression Media 591, 623 Extensions panels 28, 81 Adobe AIR 623 Internet connect preferences 123 Mini Bridge 623 Extensis Portfolio 568 Eyedropper tool 56, 674 eyedropper wheel display 56 Eye-One 92-93, 642, 645 Eylure XXII EZ Color 92

F

File Browser 137 File compression LZW compression 74 File extensions 105 File formats 71-77 CompuServe GIF 708 DNG 150, 169, 242, 248-250 compatibility 136, 249 adoption 249 DNG Converter 250 DNG file handling 169 Filmstrip 74 for FTP transfer 707 for the Web 703 GIF 105, 708-709 adaptive table palette 712 Color palette 713 diffusion dithering 712 GIF transparency 712 interlaced GIFs 712

map colors to transparent 712 perceptual table 712 Save for Web of Devices dialog 712-713 selective palette 712 transparency 712 Web Snap slider 712 JPEG 105, 703-707 baseline optimized 704 baseline standard 704 compression 703, 706 image processor 725 JPEG compression 74 JPEG noise removal 287-288, 288 JPEG Options dialog 704 most efficient JPEGs 711 optimize to file size 711 progressive JPEG 704, 710 save for Web image size 711 saving 16-bit as 8-bit 72, 704 Large Document format (PSB) 402 Open EXR 402 PDF 75-78, 702 PDF security 75 Photoshop 71 maximize compatibility 71 smart PSD files 71 PICT 74 PNG-8 709 PNG-24 709 **PSB** 72 Radiance 402 TIFF 72, 108, 402, 704, 707 compression options 74, 707 flattened TIFFs 74 pixel order 73 save image pyramid 74 File header information 68 File Info 597 File menu automate 722 new document 297 pixel aspect ratio 297 open in Camera Raw 152 preferences 101

Scripts Merge to HDR Pro 406 Film grain retouching 416 Filter Gallery 566 Filter menu 16-bit filters 540 Blur Average Blur 542 Box Blur 545 Gaussian Blur 542 Lens Blur 546-549 Motion Blur 542-543 Radial Blur 540, 543 Shape Blur 545 Surface Blur 545 Convert for Smart Filters 551 Fade filter 545 Lens Correction 204, 309, 558-565 Adobe Lens Profile Creator See Adobe Lens Profile Creator and EXIF metadata 558, 562 Auto-Scale Images 558-559 chromatic aberration 558-559, 562 custom lens corrections 558 geometric distortion 558-559, 562 grid overlay 560 lens corrections profiles 562 lens profile types 562–563 lens profiles 558 remove distortion 558 rotation 560 scanned image limitations 558 search criteria 558, 562 selecting appropriate profiles 562 send profiles to Adobe 562 transform section 559 vignette removal 558 vignette section 559 Liquify 309, 442-450, 518 bloat tool 442-443 freeze mask tool 442-443, 445 Liquify tool controls 444 Liquify tools 442

mask options 445 mesh grid 446 pucker tool 442-443 push left tool 442-443 reconstructions 444 reconstruct tool 442-444 reflection tool 442-443 saving the mesh 446-448 shift pixels tool 442-443 show backdrop 446 straightening a fringe 448 thaw tool 442-443 turbulence tool 442-443 twirl clockwise tool 442-443 view options 446-447 warp tool 442-443 Noise Add Noise 542 Dust & Scratches 434-435 Reduce Noise 286-287 Other High Pass 680, 683 Sharpen Smart Sharpen 278-281 Unsharp mask 254, 682 Smart filters 539, 548 Filters third-party plug-ins 550 FireWire 115, 143 Fit image 727 Fit to screen view 12 Flash 714 Flash FXP 701 Flat field calibration 436-437 Flick panning 57, 102 Flickr 703 Flip a layer 510 FM screening 296 Font Size custom UI font size 104 FotoStation 130 Fraser, Bruce xxii, 4, 171, 364, 634, 640, 664 Freeform lasso tool 34 Freeform pen tool 49

Free Transform 510, 513 FTP FTP programs 615, 701 Fetch 701 FTP transfers 707 managing folders 615 Fuji Frontier printer 657 S5 camera 398 Super CCD 254, 397

G

Gamma for the display 93 Garner, Claire xxii Gaussian Blur filter 542 Godden, Alex 109 Gorman, Greg xxii GPS 602 GPU settings 117 Gradient tool 48 Graphic Converter 69 Graphics tablets 99 Grayscale color management 660 Grayscale mode grayscale conversions 378 Grid 16-17, 122 **GUID 600** Guides adding new guides 16

H

Halftone factor 295 Hamburg, Mark xxii, 66 Hamilton, Soo xxii Hand tool 56 Hard drives 114 Hard Light blend mode 491 Hard Mix blend mode 492 HDR 396–410 bracketed exposures 398, 401 capturing HDR 400 displaying deep-bit color 399 exposure bracket range 401 HDR essentials 396

HDR file formats 402 Large Document format (PSB) 402 Open EXR 402 Radiance 402 **TIFF 402** HDR shooting tips 401 limits of human vision 400 Photomatix program 408 tone mapping HDR images 406 equalize histogram 406 exposure and gamma 406 highlight compression 406 local adaptation 406 manual tone mapping 414 Healing brush 50, 416-420 alignment mode 420 better healing edges 424 elliptical brush setting 424 sample options 427 Help Guide (DVD) 5 Help menu 22 Hexachrome 636 HexWrench 636 High dynamic range imaging See HDR Highlight detail how to preserve 180 High Pass sharpening 681-683 Hince, Peter xxii Histogram 302-303 curves histogram 324 Histogram panel 185, 303-306, 316, 318-321, 336-337 History 54, 62-66, 69 brush 62, 434 log 102, 603 make layer visibility changes undoable 63 non-linear history 63, 67 options 63 panel 62, 435, 716 preferences 112 purge history 64 settings and memory usage 63

Holbert, Mac 4 Holm, Thomas xxii, 645 Horwich, Ed xxii HSB color model 352 HUD Color Picker 42, 100–101 Hue blend mode 493 Hue/Saturation 352–353

I

i1 Match software 92 Iannotti. Kate xxii iChat 28 IDE drives 114 iDisk 701 iMac 89, 137 Image adjustments adjustment layers 312-315, 358 adding adjustment layers 313 adjustment layer masks 358 adjustment presets 315 Auto Color 344 Auto Contrast 344 Auto Levels 316, 344 basic Levels editing 305 Black & white 378-381 adjustment presets 381 Brightness/Contrast 336-337 Color Balance 382 Curves 318-320, 348-352 adjustment layers 320-323 auto 320 channel selection 320 color correction 348-351 curve presets 332 curves histogram 321 direct Curves dialog 324 draw curve mode 321 dual contrast curve 335 loading curves 324 locking down curve points 334 luminance and saturation 328 on-image editing 322 Point Curve editor mode 321 saving curves 324 target adjustment tool 322

using Curves in place of Levels 326 using Curves to improve contrast 328 data loss 304 direct image adjustments 312 Gradient fill neutral density gradient 48 HDR Toning 339, 402-403 Hue/Saturation 342, 352-353, 685 saturation 352 Levels 184, 343, 346-347 color correction 346-347 output levels 326 threshold mode 318 multiple adjustment layers 357 Photo Filter 356 Shadows/Highlights 307, 338-343, 551-557 amount 338 CMYK mode 341 color correction 341 midtone contrast 341 radius 338 tonal width 338 Variations 342 Vibrance 355 Image editing tools 50-51 ImageIngester 147 Image ingestion 137-150 Image interpolation 299 Bicubic 299 Bicubic Sharper 300 Bicubic Smoother 300 Bilinear 299 Nearest Neighbor 299 step interpolation 300 Image menu Canvas size 371 Duplicate 684 Image Size 720 Mode menu 406 Image metadata 597 ImagePrint 72 Image Processor 568, 620, 725

Image rotation 370 Image searches 606 Image size 298 altering image size 298 determining output image size 296 Import Dialog (Lightroom) 149-151 InDesign, Adobe 71-72, 108 Indexed Color mode 288, 708 Info panel 14, 348, 350, 677-678 Information tools 56 Installing Photoshop 7 Intel processors ideal cache tile size 112-113 Intel Xeon 86 Interface connections 114 customizing the interface 9 preferences 10, 103 International Color Consortium 638 Internet Service Providers 701 Interpolation 299 **IPTC Extensions** 598 IPTC metadata 596-599 ISO settings 129 iTunes 591

J

JavaScript 611 Johnson, Carol xxii Jones, Lisa xxii JPEG capture 129 JPEG file format 703–707

K

Kaleidoscope patterns 515 Keyboard shortcuts 22–23 Keystone correction 369 Knoll, Thomas xxii, 136, 174, 216 Knowledge panel 28 Kodak 645 Kost, Julieanne xxii, 708–709 Krogh, Peter xxii, 592 Kuler 28

L

Lab color conversions 676-677 Lasso tool 34, 456 Lave, Mike xxii, 632 Layer menu merge visible 719 Layers 52, 461-483 adding a layer mask 465 adding an empty layer mask 466 adjustment layers 462 align linked layers 514 auto-select shortcut 507 color coding layers 500 copy layer 461 distribute linked layers 514 drag and drop layers 52 flattening layers 719 image layers 461 knockout blending 494 blend interior effects 494 deep knockout 494 shallow knockout 494-495 laver arrange menu 514 layer basics 461 layer groups 500-502 group layer shortcut 502 group linked 503 incompatible layer group warnings 501 layer group management 500 lock all layers 502 managing layer groups 502 masking group layers 504 moving layers in a group 500 pass through mode 495 layer linking 506-509 laver locking 509 lock all 509 lock image pixels 509 lock layer position 509 lock transparent pixels 509 layer masks 459, 465-466 adding a layer mask 465

copying a layer mask 466 create layer mask from transparency 468-469 density and mask contrast 470-471 linking layer masks 508 layer properties 500 laver selection 55 layer style options 283, 384-385, 682 layer styles 463, 465 layer visibility 463 layers panel controls 462-463 managing layers 461 move tool alignment 507, 513 multiple layer opacity adjustments 506 multiple layers 500 new laver 461 refine edge 470 removing a layer mask 466 selecting all layers 506 select similar layers 507 select top-most layer 719 shape layers 462 text lavers 462 vector masks 465, 536-537 LCD beamer projectors 92 LCD displays 88, 90 LCD hardware calibration 643 Leica 136 Levels 316-326, 343-344 Lighten blend mode 490 Lighter Color blend mode 490 Lightroom 130, 137, 147, 149-52, 568, 591, 617, 623, 681 Import Photos 148 Lightroom 3 beta 134 Lightroom imports 148 Lightroom/Photoshop workflow 134 Line tool 48 Linear Burn blend mode 489 Linear Dodge blend mode 490 Linear Light blend mode 491 Lines per inch 291

Liquify filter 442–450 See also Filter menu Load Files Into Photoshop Layers 498 Lock image pixels 509 Lossy compression 706 Lotto, R. Beau 635 Luminance of the display 94 Luminosity blend mode 493 Lyons, Ian xxii LZW compression 74, 707

Μ

Macintosh 1.8 gamma 94 Mac OS X Cover Flow View 568 iDisk 701 Magic eraser tool 50 Magic wand tool 34, 456 Magnetic lasso tool 34 Managing images in Bridge 591-607 Marchant, Bob xxii Marquee selection tool 34, 456 Masks 459 clipping masks 503-505 mask channels 453 panel 313, 358-363, 470 Color Range 359 density 359 feather 359, 460 Invert 470 mask edge 470 masks panel editing 360 masks panel options 470 refine mask edge 359 Match Location 12 Match Zoom 12 Maximize backward compatibility 71, 108-109, 580 Maximize PSD compatibility 109 Measurement scale 15-18 Megapixels 293 Memory management 115 Merge to HDR Pro 396, 404, 586, 620 local adaptation Detail slider 407 Exposure slider 407

Gamma slider 407 Highlight slider 407 Radius slider 407 Saturation slider 407 Shadow slider 407 Strength slider 407 Toning curve and histogram 407 Vibrance slider 407 removing ghosts 408 response curve 404 script 406 Merlin 84 Metadata 596-601 DICOM metadata 602 Edit history log 603 EXIF metadata 598-599 File info 597-598 keyword categories 605 preferences 580 Metadata panel 596 Mini Bridge 28, 81-83, 568, 623-630 appearance settings 624 content pod area 624-625 as list view 627 details view 627 filmstrip view 627 show thumbnails only 627 Filter menu 628 interface 623-629 navigator pod 628-629 view collections 628-629 view favorites 628-629 view recent files 628 view recent folders 628 preview pod 628-629 search button 630 settings 623 appearance settings 624 color manage panel 624 content pod appearance 624 path bar visibility 624 slideshow view 624 sort menu 628 view options 624-627 Mitsubishi Spectraview 643

Mixer brush tool 31, 40, 45-46 clean brush 46 flow rate 47 mix ratio 46 paint wetness 46 Modifier keys 38-39 Monaco Systems Monaco Optix XR 642 Monitor gamma (PC) 660 Monitor Spyder 92, 642 Motion blur filter 542 how to remove 281 Move tool 50, 54-55 align/distribute layers 55 auto-select layers 54, 507 layer selection 54, 507 show transform controls 54 Multiple undos 62 Multiple window views 12-15 Multiply blend mode 489 Murphy, Chris 634

N

Nack, John xxii, 86 Nearest Neighbor interpolation 299 NEC displays 89-90 Neutral gray tones 348, 677 Newscodes.org 599 Nikon Capture software 143 Noise Ninja 285 Noise reduction 285-288 Noiseware 285 Non-linear history 66 Normal blend mode 488 Notes tool 59 Numeric transform 54, 512 N-up document layout 18-19 N-up window options 12 **NVIDIA GeForce** 90

0

Onyx PosterShop 72 Open command 68 Open Documents as Tabs 10 OpenGL 10–13, 17–18, 42, 56, 57– 58, 90, 101–102, 117, 118 advanced OpenGL settings 118 optimum performance 90 Open Raw website 249 OptiCal software 92 Options bar 9, 32–33 Orphan works 703 Outlying pixels 274 Output sharpening 680–683 Overlay blend mode 491 Oxford Chipset 115

P

Page Setup 696 manage custom sizes 697 Paint bucket tool 48, 104 Painting tools 40-44 Panasonic Panasonic G1 camera 254 Panels 19-20 closing panels 21 collapsing panels 19-20 compact size panels 20-21 docked layout 19-20 docking 20-21 organizing panels 19-20 panel arrangements and docking 20 - 21revealing hidden panels 20-21 Panoramas (with Photomerge) 496-497 Parametric curves 196 Pass through blending 494 Patch tool 50, 428-431 source and destination modes 428 source mode 428-429 use pattern option 428 Path selection tool 49 Paths 459, 532-535 convert path to a selection 534 curved segments 534 make path 532 nudging with arrow keys 535 path modes 533

rubber band mode 535 selections to paths 532 shape layers mode 533 vector masks 536-538 Pattern stamp tool 50 Pawliger, Marc xxii Pavnter, Herb xxii PDF file format 75-78 reader programs 617 Pen tool 49, 459, 533 rubber band option 535 Pencil tool 40 Pentium 4 86 Perceptual rendering 670 Perspective cropping 369 Photo Downloader 137-142 backing up data 139 Bridge preference 569 convert to DNG 141 deleting camera card files 142 get photos 141 Rename Files 140 Photo Filter 355 PhotoCal 92 Photographic Solutions Inc 225 PhotoKit Sharpener 681 Photomatix 408 PhotoMechanic 568 Photomerge 496-497, 568, 586, 620 auto 496 blending options 494, 497 collage 496 cylindrical 496 geometric distortion correction 497 perspective 496 reposition 496 spherical 496 vignette removal 497 Photoshop activation 7 Photoshop license 7 Photoshop On-line 84 Photoshop preferences 100-119, 720 activating preferences 109 cursors preferences 118

brush preview overlay color 42 brush tip settings 118 ensuring preferences are saved 122 file handling preferences 105–107 file compatibility 106-107 ignore EXIF profile tag 108 maximize PSD compatibility 109 prefer Adobe Camera Raw 107 recent file list 109 general preferences 101-102 animated zoom 102 auto-update open documents 101 history log 603 image interpolation 101 maximize backward compatibility 582 Zoom Clicked to Center 102 Zoom Resizes Windows 102 guides, grid & slices preferences 122 interface preferences 11-14, 103 auto-collapse icon panels 104 open documents as tabs 10 screen view modes 103 show menu colors 104 show tool tips 315 UI text options 104 performance preferences 109-116 GPU settings 110 History & Cache preference 112 RAM memory and scratch disks 110 RAM setting 111 scratch disks 110, 113 scratch disk settings 112 Photoshop cursors brush preview overlay color 42 Plug-ins 28 plug-ins preferences 123 preference file 100 preference file backup 101 resetting the preferences 101 saving the preferences 122 transparency & gamut preferences 119 type preferences 124

show asian text options 124 units & rulers preferences 120 new document preset options 121 Photoshop Print dialog 687-692 background color 690 black point compensation 692-693 bleed option 690 border option 688-690 calibration bars 690 color handling 690 color management 690 description box 690 gamut warning 693 include vector data 690 match print colors 693 output options 690 output settings 689-690 Photoshop manages colors 690 printer manages colors 690 printer profile menu 691 printer selection 688 print from proof setup 684 print orientation 688 print scaling 688 print settings 688 filtered ICC profiles 691 proof settings 693 proof setup 693 registration marks 690 rendering Intents 692 scaled print size 689 scale to fit media 689 select a paper size 688 show bounding box 689 show paper white 693 simulate black ink 693 soft proofing 693 Photosites 397-398 Pin Light blend mode 492 Pixel aspect ratio 297 Pixel Genius 727 Pixel grid view 17-18 Pixels per inch 291 Pixels versus vectors 290 Pixl xxii

Place-A-Matic script 395 Place raster images as Smart Objects 102 PNG file format 708 Polygon lasso tool 34 Polygon shape tool 48 PostScript and JPEG files 705 PostScript print driver 690 PostScript RIP 292 Preset manager 60-61 saving presets as sets 61 Presets folder 716 Primary scratch disk 114 Print output scripting 696 Print settings color management off 695 Mac 694-695 PC 694-695 Print (system) dialogs color management 695 media type 694 print resolution 694 print settings 696 Printing See also Print (system) dialogs canned printer profiles 691 centering prints 697 color management 690-693 no color management 692, 698 making a print 686-695 optimum pixel resolution 293 printing resolution 292, 681 print one copy 686 print quality settings 694 print sharpening 680-683 profiles canned profiles 691 custom print profiles 698 saving print presets 696 sharpening actions 718 viewing distance 298 Process versions 170-171, 254-257, 276 ProfileMaker 92, 644-645

Profile Mismatch 649 Profiling 90, 94, 643 profiling the display 642–643 remote profiling 698 Prohibit sign 30 Proof printing 693 Proof Setup 668 grayscale 660 ProPhoto RGB 98, 309–311, 640– 641, 664 Puppet Warp *See* Edit menu Purge memory 114 Purves, Dale 635 pyramid cache structure 118

Q

QuarkXPress 73 Quick masks 454–456, 476 Quick selection tool 34, 476–478 add to a selection 476 blocking strokes 476 brush settings 476 double Q trick 476 subtract from a selection 476

R

Radial blur filter 540 RAID drives 115 external RAID 117 internal RAID 116 RAID 0 (striping) 116 RAID 1 (mirroring) 116 software RAIDs 116 RAM memory 110-111 64-bit RAM limits 111-112 RAM limit on a Macintosh 111 RAM memory efficiency 113 RAM memory upgrades 111 Raw capture 128 forward compatibility 136 Raw processing comparisons 216 Read me files 650 Real World Color Management 634 Recent File list 109

Rectangular marquee tool 34 Rectangular shape tool 48 Red eye tool 50 Red or Dead Ltd xxii Reducing noise through HDR merging 398 Refine Edge 432, 471-484 adjust edge contrast 474-475, 479, 556-557 feather 474-475, 556-557 radius 479 shift edge 475, 481, 556-557 smooth 474 auto-enhance 476 decontaminate colors 474-475, 482-483 edge detection 473 radius 473 smart radius 474, 479, 556-557 output 475 ragged border effect 556-557 refine radius brush 480-481 truer edge algorithm 471 view modes 473 on layers 473, 479, 481 on white 482 reveal layer 480 show original 473 show radius 473 Refine Mask See Refine edge Relative colorimetric 670, 671 Reloading selections 456 Remote shooting controls 145 Removing noise 285-286 Rendering intents 670-673 absolute colorimetric 671, 692 perceptual 670, 692 relative colorimetric 671, 685, 692 saturation (graphics) 670, 692 Replacing film grain 434 Repro considerations 294 Resetting preferences 101 Resize Image During Place 102 Resnick, Seth xxii, 4

Resolution film 293 output resolution 294-296 pixels 293 screen resolution 121 terminology 291 Resolution and viewing distance 298 Retouchartists.com 109 Retouching beauty shots 440 Retouching portraits 438 Reveal All 376 RGB color management 634-635 RGB color space selection 309 RGB to CMYK conversions 636 RGB workspaces 640-641, 664 ideal RGB working space 640, 669 Richmond, Eric xxii Riecks, David 599 Rochkind, Marc 147 Rodney, Andrew xxii, 4, 634, 698 Roff, Addy xxii Rosettes (halftones) 294 Rotate a layer 510 Rotate image 370 Rotate view tool 58 Rounded rectangle shape tool 48 RSA gray balance 345 Rubylith mode 466 Rulers 16 Ruler units 120 Ruler tool 56, 370 Run Length Encoding 707-708, 708

S

Safari Web browser 710 SATA drives 114, 117 Saturation and curve adjustments 330 Saturation blend mode 493 Saturation rendering 670 Save for Web & Devices 105, 709– 713 Blur slider 710

browser preview button 710 efficient JPEG saving 711 embed color profile 710 GIF 712-713 lossy option 712 Web palette colors 712 ICC profiles 710 JPEG 709 optimize image settings 710 options and settings edit output settings 711 Save options 711 Save settings 711 web browser previews 710 Saving 69 previews 105 Save As 70 Scanning resolution 296 Schewe, Becky xxii Schewe, Jeff xxii, 4, 66, 248, 681 Scratch disks performance 114 preferences 113 sizes 15 Screen angles 294 Screen blend mode 490 Script Event Manager 726 Scripting 726 guide 726 Scripts 726-727 export layers to files 726 image processor 725 Scroll wheel settings 102 Select menu Deselect 454 Modify Contract 513 Expand 513 Reselect 453 Selection tools 33-36, 34 elliptical selection tool 34 magnetic lasso tool 34 marquee selection tool 34 quick selection tool 34

single column selection tool 34 single row selection tool 34 Selections 452-459, 459 adding to a selection 457 anti-aliasing 460 converting to paths 532 creating a selection 455 feathering 460 load selections 453 marching ants mode 454 modifying 456 recalling last used selection 453 reloading selections 456 save selections 452 selection shortcuts 456 selections to paths 532 Sensor cleaning 225 Sensor swabs 225 Shadows/Highlights 338-343 Shape tools 48 Sharpen tool 40, 278 protect detail 278 Sharpening and JPEG captures 253 and raw mode capture 253 capture sharpening 252 depth of field brushes 282 edge sharpening technique 681 for scanned images 253 high pass edge sharpening 680 Lab mode sharpening 254 localized sharpening 252 PhotoKit Sharpener 253 print sharpening 252, 680-683 Real World Image sharpening 252 sample image 257 smart sharpen filter advanced mode 278 Motion Blur 281 Save settings 280 when to sharpen 252 Show all menu items 22 Show tool tips 104 Sidecar .xmp files 581 Simmons, Jason xxii Single column marquee tool 34

Skin tones CMYK numbers 678 Skype 28 Smart filters 528-531, 550-555 See also Smart Objects enabling the Lens Blur filter 546 Smart guides 16, 122 Smart Objects 108, 392, 515-531, 550-556 and layer blending 395 convert for Smart Filters 278 edit contents 531 Smart Object layer blending 395 Smart Object sharpening layers 271 transform adjustments 528 Smith, Graham xxii SMPTE-240M 641 Smudge tool 40 Snap to behavior 17 Snap to edge 369 Snapshots 65-66, 716 Snow Leopard 86 Soan, Martin xxii Soft Light blend mode 491 Soft proofing 684-686 via Photoshop Print dialog 693 SOLUTIONS photographic 745 Spectrophotometer 87, 92, 645 Speed test 109 Split toning 384 Sponge tool 40 Spot healing brush 50, 426-427 cache limit 430 content-aware mode 430-431 normal blend mode 430 replace blend mode 430 create texture mode 426 proximity match mode 426 sRGB 311, 640, 648, 659 and Fuji Frontier 657 incorrect tags 654 Stacking images (Bridge) 584-585 Status Information box 14, 15 Step interpolation 300 Stochastic screening 296

Stuffit 700 Surface Blur filter 545 Synchronized scroll and zoom 12–15 System requirements 86

Т

Task-based workflows 4 Tethered shooting 143-146 file transfer protocols 143 Third-party plug-ins 550 Threshold mode preview 326 Timing 15 Title bar proxy icons 14 Tool preset picker 45 Tool presets panel 33 current tool only 33 Tool switching behavior 30 Tool tips 32, 581 info 30 Toolbox panel 28 Tools panel 30-31 Transform command 510 aligning layers 514 create a kaleidoscope pattern 515 distribute layers 514 free transform 510 numeric transforms 512-513 perspective 512 rotate 511 skew 512 transforming paths 513 transforming selections 513 transform menu 510 warp transforms 518-519 Transparency 119 checkerboard 120 preferences 119 Type preferences 124 Type tool initialization 124

U

Uninterruptible power supply unit 88 Units & Rulers preferences 120 Uploading to a server 700 USB devices 99 USB 2 99, 115, 143 Use lower case extensions 705 User interface font size 104 preferences 103 UV filters and edge detail 206

V

Variations 342 Vector masks 459, 536-538 isolating an object 537 Vector programs 291 Vectors converting vectors to pixels 459 Version Cue 15, 106 Video cards 89 View menu fit to window 366 gamut warning 120, 684 grid 16 guides 16 proof setup CMYK previews 668 custom 685 customize proof condition 693 Snap to 17 view extras 16 Vignetting 206 Virtual memory tricks 115 Vista 86 Vivid Light blend mode 491

W

Wacom 41, 45, 99, 416, 444 Walker, Michael 634 Warp transforms 518–519, 530–531 Watermarking photos 703 WebDAV 14 Web Output 611–615 Web Photo Gallery 123, 611 Web safe colors 712 Weisberg, Gwyn xxii Weston, Stuart 48 What Digital Camera xxii WhiBal cards 175 White point 93 Wilensky, Gregg 556 Williams, Russell xxii Window documents 12 floating windows 12 image tiling info 14 N-up windows 12 title bar proxy icons 15 Window menu cascade windows 12 move to a new window 10 tile windows 12 workspace settings 24-25 Windows 7 10, 86 multi touch support 57 Windows Vista 86 Windows XP 86 themes 90 WinZip 700 Wireless tethered shooting 143 Woolfitt, Adam xxii, 248 Work Group Server 14 Workspaces 24-25 save workspace 24-25 workspace settings 20 workspace settings menu 18-19 Wreford, Matt xxii WS_FTP Pro 701 Wynne-Powell, Rod xxii, 4 WYSIWYG menus 124

Х

Xeon Dual processor 86
XML 597
XMP metadata 581, 597, 604
powered by XMP 597
sharing XMP metadata 170
XMP sidecar files 166, 581
X-Rite xxii, 92, 218, 642
ColorChecker chart 175, 218, 220
i1 Photo 94, 645, 698
ProfileMaker Pro 644–645, 698

Y

Yousendit.com 701, 707

Z

ZIP compression 74, 700, 707 ZIP compressed archives 700 Zoom blur filter 540 Zoom tool 56 Zoomify 714 Zooming animated zoom option 102 scrubby zoom 14 zoom clicked to center 102 zoom keyboard shortcuts 57 zoom percentage info 14 zoom shortcuts 11, 57 zoom with scroll wheel 102

colourmanagement.net

Remote profiling for RGB printers

You have just been reading one of the best digital imaging books in the marketplace. Now you'll probably want to be sure your color is as good as it can be, without too much back and forth when printing. Lots of print testing to achieve expected color really does use up the ink and paper, but, more importantly, it uses up the creative spirit. We'd like to offer you a deal on a printer profile. Just download the profiling kit from: www.colourmanagement.net/profiling_inkjets.html.

The kit contains detailed manual and colour charts. We ask you to print the charts twice, so we can compare the sets to check printer continuity. You post them to us. We will measure both sets of charts using a professional auto scanning spectrophotometer. This result is then used within high-end profiling software to produce a 'printer characterization' or ICC profile which you will use when printing. Comprehensive instructions for use are included.

You can read a few comments from some of our clients at: www.colourmanagement.net/about.html.

Remote RGB profiles cost £95 plus VAT. For readers of *Adobe Photoshop CS5 for Photographers*, we are offering a special price of £50 plus VAT. If our price has changed when you visit the site, then we will give you 30% off.

Coupon code: MEPSCS5-10

We also resell the colour management gear that you need: profiling equipment, LCD displays, print viewers, RIPs, printers and consumables, etc. http://www.colourmanagement.net/profilegear.html.

Consultancy services

Neil Barstow, color management and imaging specialist of www.colourmanagement. net, offers readers of this fine book a discount of 12.5% on a whole or half day booking for consultancy (subject to availability and normal conditions).

Coupon code: MEPSCS5-10

Please note that the above coupons will expire upon next revision of *Adobe Photoshop for Photographers*. E&OE.

Rod Wynne-Powell

Over the several editions of this series of books, I have been able to elicit the technical help of Rod Wynne-Powell to check the accuracy of what I have written, and double-check, and sometimes modify, the techniques I have discussed. His enthusiasm and dedication to this task continues to be invaluable — if I am puzzled by some aspect and ask his advice, he will diligently seek out the answer either through his contacts or via the Web, and provide me with a comprehensive reply accompanied by his own evaluation.

Mac OS X for Photographers

Rod Wynne-Powell is also author of *Mac OS X for Photographers: Optimize Your Mac for Digital Image Workflow and Run Photoshop Fast*, which is also published by Focal Press. This book is an indispensible guide to the operating system that underpins the Mac user's platform for Photoshop, Bridge and Lightroom.

SOLUTIONS Photographic

Rod Wynne-Powell also offers training, consultancy and retouching under the banner 'SOLUTIONS photographic' and is able to boast having trained photographers in both France and Italy as well as those from all over the UK, mainly on a one-to-one basis. A useful way to contact Rod can actually be found within Photoshop's File menu! – Acrobat Connect uses the 'Share my Screen...' feature which allows a user to use the Web to set up 'Meetings' to which Rod can be invited via an email link. Remote help like this is very reasonably charged by the hour. Contact details are below:

Email:	rod@solphoto.co.uk
Skype:	rodders63
iChat:	rodboffin
T:	+44(0)1582-725065
M:	+44(0)7836-248126
Blog:	http://rod-wynne-powell.blogspot.com

Photograph and retouching: Rod Wynne-Powell

РнотоКіт[™]

PHOTOKIT SHARPENER

Pixel Genius PhotoKit plug-in www.pixelgenius.com

PhotoKit Analog Effects for Photoshop

This Photoshop compatible plug-in is designed to provide photographers with accurate digital replications of common analog photographic effects. PhotoKit is quick and simple and allows for a greatly enhanced workflow. Priced at \$49.95.

PhotoKit SHARPENER A complete 'Sharpening Workflow' for Photoshop

Other products may provide useful sharpening tools, but only PhotoKit SHARPENER provides a complete image 'Sharpening Workflow'. From capture to output, PhotoKit SHARPENER intelligently produces the optimum sharpness on any image, from any source, reproduced on any output device. But PhotoKit SHARPENER also provides the creative controls to address the requirements of individual images and the individual tastes of users. PhotoKit SHARPENER is priced at \$99.95.

PhotoKit Color

Creative color effects for Photoshop

PhotoKit Color applies precise color corrections, automatic color balancing and creative coloring effects. This plug-in also provides a comprehensive suite of effects that lets you recreate creative effects like black and white split toning and cross processing. PhotoKit Color is priced at \$99.95.

Pixel Genius is offering a 10% discount on any whole order, which must be placed from the Pixel Genius store at: www.pixelgenius.com. This is a one-time discount per email address for any order made from Pixel Genius. This coupon will not work on affiliate sites. Also it cannot be combined with other discounts or programs except for certain cross-sell items. Please note that this coupon will expire upon next revision of *Adobe Photoshop for Photographers*.

Coupon ID: PSFPCS5ME